The Business of Being an Artist

FOURTH EDITION

The Business of Being an Artist

FOURTH EDITION

DANIEL GRANT

**ALLWORTH
PRESS**
NEW YORK

14 13 12 11 10 5 4 3 2 1

Published by Allworth Press
An imprint of Allworth Communications
10 East 23rd Street, New York, NY 10010

Cover design by Tamara Gildengers Connolly

Interior design by Tamara Gildengers Connolly

Page composition/typography by Integra Software Services, Pvt., Ltd., Pondicherry, India.

ISBN: 978-1-58115-673-7

Library of Congress Cataloging-in-Publication Data
Grant, Daniel.
 The business of being an artist / by Daniel Grant.—4th ed.
 p. cm.
 Includes bibliographical references and index.
 ISBN 978-1-58115-673-7 (pbk.)
 1. Art—United States—Marketing. I. Title.
 N8600.G7 2010
 706.8—dc22 2009039893

Printed in Canada

Contents

Rejection Letters
Handling Art World Publicity
Love and Marriage
The Benefits and Pitfalls of Censorship and Controversy
Out of the Spotlight
Thomas Hart Benton Has a Message for Artists

Commissions for Percent-for-Art Projects
The Commissioning Process
General Services Administration
State and Municipal Agencies
Thin Skins and Strong Stomachs
The Efforts to Contain Public Art Controversy
Private Public Art Commissions
Damage and Neglect of Public Art
Who Decides Artistic Merit?
Jurying Art—Descending from the Ideal
When Jurors May Not Seem Fair
Jurors with Clear Biases

Applying for Loans
Applying for Emergency Assistance
Artists' Foundations
Applying for Grants and Fellowships
Fiscal Management
So Who Will Provide the Funding?
 Foundations
 Corporations
 Corporate Foundations
 Government
 Local Arts Agencies
 State Arts Agencies
 Regional Arts Agencies
 National Endowment for the Arts
Individuals
 Miscellaneous Funders
Asking for Money
 The Proposal Package
Reporting Requirements for Grant Recipients
Keeping Perspective

Introduction

Artists, like everyone else, enter their careers with certain expectations, realistic or otherwise: perhaps it is a van Gogh-influenced idea that they will produce great work but go unappreciated during their lifetimes; possibly, they see themselves as the next Damien Hirst, earning millions and living the high life, or as the Cindy Sherman of a new generation, keeping critics and theoreticians busy rewriting contemporary art history in the wake of their innovative creations. Underlying all these assumptions is the belief that someone will eventually see their work and recognize what makes it good and unique. Of course, it is better if people see the artwork sooner rather than posthumously, and earning money—dare one say a living?—from the art would be nice, too.

The fact is, most artists today are college graduates, many with Masters degrees in their fields, and they expect that their training should lead to something tangible. At times, it may lead them to a related field, such as art conservation or arts administration or art therapy or art teaching, which becomes their identity and life work more than producing artist. Career shifts are not unknown in modern life. What would seem to be disappointing, however, is to end the pursuit of an art career—for which there has been extensive training and hopes over a period of years—simply because one doesn't know how to pursue a career in art.

Business and art may seem like unrelated concepts; developing a marketing plan, writing press releases, devising a sales pitch, networking, establishing pricing and discount policies, setting up contractual agreements, applying for loans and funding, licensing, leasing, preparing taxes, and protecting copyright appear to defy the reasons that most people choose to become artists in the first place.

Small wonder, then, that so many artists find themselves needing help understanding how the art world works and how to find their place in it. Some pick up information in the few "survival" courses offered at various art schools; others hire publicists and advisers to help promote, or give direction to, their work; most others

glean what they can from the growing number of business and legal guides for artists that are available these days, or they just improvise.

A strong case can be made for improvising, as there is little rhyme or reason in the way that certain artists become successful while most others do not. All of the hard work of researching galleries, making telephone calls, sending out slides, and developing a portfolio and a long résumé of exhibitions may amount to nothing, while someone right out of art school who happens to know the right person or to be at the right place at the right time is lionized. Luck really cannot be talked about, and talent is not a subject for advice.

Still, throwing up one's hands or waiting for lightning to strike is no answer either. The business side of being an artist means knowing what the options are and making informed choices. Too many artists are unaware that they have choices, or that they have more than one way to achieve success—defined here as the ability to make a living as an artist.

Every known method of attaining career goals has worked for certain artists, failed for others. Therefore, to prescribe a path for success—advising artists to write this sort of letter to a print publisher, sign this type of contract with an art dealer, dress in this manner for a potential corporate buyer—is doomed to fail most artists. It makes the most sense for artists to know what the possibilities are for helping themselves, allowing them to improvise but with informed choices.

Each artist has his or her own measure of achievement. To some, that might mean being written up in a textbook or getting work into a major museum collection; perhaps it is being represented by a prominent art gallery or any gallery, or just having one's works displayed somewhere for the public to see. Artists who are starting out are likely to have career objectives different from those of artists who have been working for a number of years.

"Poverty," Anaïs Nin wrote, "is the great reality. That is why the artist seeks it." Perhaps poor and undiscovered is another way to define the artist, but an artist with a romantic view of the opposition of art and commerce will find little sustenance in this book. Artists need to understand how the art world operates and develop strategies for carving out a market for themselves—a type of knowledge that is never in fashion. Artists whose aim is to sell their work are still accused of "selling out" or, to use a more current term, "careerism" (only in the art world would the idea of establishing a career be viewed with embarrassment and guilt). From art school into the larger society, the myth of the artist as alienated, poor, marginalized, and secretly superior to everyone else, is maintained steadfastly. Sadly, other artists are the most fervent in protecting and enforcing this myth.

Perhaps the worst insult aimed at an artist is "Sunday painter," meaning amateur, hobbyist, dabbler, or other words that are also derogatory. An "amateur psychologist," for instance, is a busybody, and a Sunday painter competes for refrigerator door space with the children. To be taken seriously as an artist, one must be a professional, but how is that defined? If that means earning one's living through the sale of artwork, the

number of people who could call themselves professional artists drops significantly. Most studio art instructors, from the college level on down, probably couldn't support themselves for one month on what they might sell in the course of a year, yet they would insist on seeing themselves as professionals. If the definition depended on how much time during the day or week someone actively creates artwork, a lot of retirees would come out on top. Defining professionalism through membership in an artists' association or society would produce a mixed bag of people who earn all, some, or none of their income through art and who have extensive, limited, or no professional training in studio art. The Internal Revenue Service has its own definition, based on earnings and expenditures, because professional artists are permitted to deduct certain costs, such as materials and studio rent, while amateurs and hobbyists may not. The U.S. Bureau of the Census has its own, different definition, based on what an individual worked at as of April first of the decennial year. Among themselves, artists have other ways of making classifications. Defining "artist" is an unanswerable parlor game, but the question of what makes an artist a professional is a highly contentious issue.

A great deal of cultural baggage is associated with the word "artist," and overcoming psychological barriers to success is a major component to becoming a professional artist, successful or otherwise. Many artists experience a variety of stresses as a result of the expectations they have for themselves and the assumptions that others in the larger society make about them. Chapter 10 is devoted specifically to the emotional side of developing a career as a professional artist.

This book aims to describe the art market and the possible approaches that artists may take for success. This is not a how-to book. It is unrealistic to claim that a certain set of steps—or any one method, for that matter—will work for everyone. A good marketing plan will not compel people to purchase art objects that they don't like, that they cannot afford, or that strike them as inferior to the work of other artists. And, of course, a marketing plan that proves successful for one artist may be inappropriate for another, based on differences in personality, temperament, medium, and the specific type of work. Instead, this book examines different ways that different artists have used to bring their work before potential buyers. There are no right or wrong answers to many of the challenges of developing a career; rather, some approaches may work for certain artists but not others. The experiences and approaches of a wide variety of artists are described by artists themselves, and individual readers may pick the methods that make sense for them. The question for artists is not, What is the trick? but, How have successful artists achieved their success? I am often struck by the failure of biographies of artists to include just this kind of information: How did they get their first exhibitions? When did they start selling their work? When were they able to support themselves from the sale of their work, and what did they do before that? When and why did art dealers start taking an interest in their work? The narratives about well-known artists treat these subjects, if they do at all, as amusing anecdotes, preferring to focus on artistic influences, successes and personal troubles, and what other famous people they knew. In no

other field than the arts is the nuts and bolts of a career path viewed as too embarrassing to mention.

Fortunately, the art world is not monolithic. There are niches for every type of artist and specific markets for all varieties of art. Picasso may be better known and more widely acclaimed than other artists in the past century, but only a small fraction of art collectors ever show interest in owning something the Spanish artist created, let alone are able to afford it. Other fractions of the market exist for miniatures, performance art, cowboy art, abstraction, portraits, illustration art, installations, landscape painting, mixed media and collages, still-lifes, videos, art copies, and the list goes on. Buyers of one type may or may not collect in any other category. Some buyers focus exclusively on a particular medium, such as sculpture or works on paper, while other concentrate their collecting on a certain style or movement (minimalism or pop art, for example). An artist must first find his or her artistic voice and then locate his or her market. Both surely exist.

A final point: the art world isn't fair in the sense that strengths that generally pay off in other professions, such as hard work and good skills, may go unrewarded for artists. The student who is number one in his or her class at some prestigious law school can rightfully expect lucrative job offers from top law firms around the country. Major—or minor, for that matter—art dealers, curators, and collectors, on the other hand, are unlikely to know or care about an artist's grades, and they generally don't recruit students. What would it even mean to be the best student one year at, say, the Rhode Island School of Design?

Artists may also discover that recognition is unequal, as certain dealers and collectors are more prized than others, regardless of who sells more (isn't everyone's dollar the same?). A doctor isn't esteemed professionally on the basis of who his or her patients are, but the opposite is true with artists.

After leaving school, one may endeavor to work one's way up the ladder—exhibiting first on the local level, winning acceptance to a regional or national juried art show, moving on to a larger urban gallery—and still find that sales and name recognition never materialize. Breaking into the part of the commercial gallery world where real money is involved, many artists learn, has a lot to do with whom they know and who is interested in them. For many young artists, the question seems to be, How do I get a show of my work? Presumably, a show leads to sales and more shows. Finding somewhere to exhibit one's work, however, is not all that difficult. Every bank lobby, restaurant or café, community center, and school seems to have art for exhibition and sale. I once saw an artist's résumé that listed, under the heading "one-person shows," an exhibition at Cheesecake Charlie's in Lenox, Massachusetts. The issue isn't whether or not an artist can get work on display somewhere, but how to make sales. For young artists, the question must be, How do I work my way into the art world of collectors and dealers?

Artists cannot wait, hoping to be discovered. They cannot assume that their artwork, just because it is as good as someone else's, will be rewarded equally. Rather,

artists must aggressively pursue the marketing of their work, and part of that process is meeting the people who may be of assistance to their careers as well as associating with other artists.

In most biographies, major artists are described as loner geniuses who come to their ideas through reflection and personal experimentation and are later discovered by dealers and collectors who only vaguely sense their importance. Art history is the last refuge of Romanticism. In real life, however, artists develop their ideas in association with like-minded artists, and these artists make referrals (to collectors, critics, curators, and dealers) for each other. One sees too many capable artists who will not become personally involved in the marketing of their work. They want that romantic myth to work for them and allow them to just pursue their art and be discovered by someone who makes their career. The current example of this tendency is the burgeoning number of artists' Web sites, created hastily and promoted poorly, which simply permits artists to continue to be undiscovered now in the realm of cyberspace. This book presumes the willingness of artists to take a hands-on approach to their careers. Following a list of recommendations will not guarantee anyone success. However, understanding the options for starting and promoting a career will enable artists to make clear-eyed choices and increase their chances for success.

1

Exhibiting
and Selling Art

Artists aren't people who simply create art and then drift off into oblivion; they want their work to be seen and to receive some sort of reaction from those who see it. Putting art in front of the public establishes an artist as a professional and, for many, the quest for a show is the primary goal. Fortunately, there are many venues for exhibitions available.

For the past hundred or so years, art dealers and galleries have been the principal route to success in the art world—salons or group shows of establishment-picked artists predominated for a couple of centuries before that. Some artists have been very closely identified with their dealers, such as Renoir and Picasso with Ambroise Vollard or Jasper Johns with Leo Castelli or Richard Serra with Larry Gagosian. Dealers frequently have a select clientele of one or more principal backers who do the bulk of the buying, and it is the ability to steer these important collectors to certain artists' work that establishes a dealer's prestige. Few long-term successful dealers survive without this clientele, and gallery owners who rely on walk-in traffic for their sales tend to go in and out of business in a hurry. The main exceptions to that are galleries in resort and tourist towns, where buyers may want something by which to remember their vacation. However, relatively few galleries anywhere generate the volume of sales that would support any of the artists whose work is displayed, which requires those artists to place their artwork with a large number of galleries. Some artists do just that, but it behooves them to keep good records of where their work is and to monitor the gallery owners regarding sales and what they may be owed.

Finding the right dealer who will lead the artist's work to major collections is a challenge, and few generalizations can be made. Dealers become interested in potentially representing artists largely in one of two ways. The first is when dealers personally know the artist (meeting him or her at an art opening or on a studio visit) as well as hear about the artist from people they trust, such as other artists they represent, curators, critics, and collectors.

The second way is through the strength of an artist's work and market. Artists usually send dealers images of their work and proof that there is a market for it. To that end, artists who are starting out need to build a track record of group and one-person exhibitions and, along with that, develop a group of consistent buyers. Dealers don't like to try to build a market for an artist but, instead, tend to look for artists who already have a market that can be expanded. Art galleries and dealers are but one, if a highly publicized, means for artists to exhibit and sell their work. Success in the art world may lead to critical acclaim and financial rewards, but many artists find the process of currying favor with dealers and even spending so much of their time in the large cities where the major art dealers are located to be grating on their nerves and therefore contrary to why they sought to be artists in the first place.

There are alternatives—opportunities for artists to sell their work outside of the gallery structure, and many artists have been able to gain exposure or make a living in these ways. The French impressionist exhibitions in Paris of the 1870s and 1880s were all organized by the artists involved (one of Mary Cassatt's main values to this group was in convincing wealthy American collectors to come take a look). The German Expressionists of the 1910s staged exhibits and published the Blue Rider almanac to promote their work; a sprawling group of American artists put together the 1913 Armory Show, which is credited with establishing modernism to the United States; Dadaist artists in the 1920s created "manifestations," and pop artists of the early 1960s put on "happenings." The group of art students at Goldsmiths College in London, interested in conceptual and installation art, who became known as the Young British Artists, gained notoriety through a 1988 exhibition titled, "Freeze," which was put together by the group's leader, Damien Hirst, at the Saatchi Gallery. Eventually, those artists found their way into mainstream galleries, but they made their start outside of them, and they did it by uniting themselves for a common effort. These days, such exhibitions are called artist-curated shows, and they often take place in nonprofit art spaces, but the intent of today's artists is the same as it was for the impressionists, expressionists, Dadaists, and pops: artists with similar interests and artistic ideas band together to promote themselves as a group and individually. Hey, art world, something new has arrived! Being an artist is a business, requiring artists to act entrepreneurially and to be as creative in efforts to generate attention to themselves and their work as they are in their own art.

The first step on this path is putting work before the public.

SO, WHERE CAN I SHOW MY WORK?

There is a wide variety of exhibition spaces available for the starting-out artist. Banks, libraries, corporate headquarters, community centers, hospitals, real estate offices, and cafés and restaurants, for example, are frequently willing to allow artists to hang up their works on the walls where the public may see them. The likelihood of sales is often low and the possibility of damage to the work (fingerprints, coffee splashes, cigarette smoke) is considerable, but this type of show offers a chance for feedback and for the artist to circulate press releases, announcements, and exhibition cards and be remembered the next time his or her work is on display.

Many towns and smaller cities have arts centers where exhibits can be seen in an actual gallery setting. A notch above the art show in the bank or library, the arts center is likely to have its own means of promoting activities and increasing the number of people who may come to view the artwork. This may be a first opportunity for a write-up in a local newspaper, again increasing the number of people who know about the exhibit and the artist.

One might also look outside the usual sites where art is displayed to places where people with money and thoughts of making a purchase tend to go, such as furniture stores, wine stores, and jewelry shops. The clientele is a bit more select, and the connection between artwork and furniture, for instance, is reasonably close; buyers are apt to think about one in relation to the other. Real estate companies cater to people shopping for a home (they will want to decorate it), while social clubs and country clubs have dues-paying members who have demonstrated that they have discretionary income.

Who will come to an artist's early shows? The answer is, any number of people, but first artists must start out with their own network of friends, families, and associates, all of whom are predisposed to think well of the work. Artists have friends who might come, and those friends have friends and business associates, some of whom may be persuaded to come. An artist who works in an office has coworkers, supervisors, a boss, clients, and suppliers who may be willing to come to a show. Family members, such as parents, may also have friends, business colleagues, clients and suppliers. Out of all these people, there may be some who buy a piece because they like it or as a show of support. A more informal style of exhibiting work that frequently results in sales is for friends or relatives to host private showings in their homes, inviting ten people they know to meet the artist and examine the work close-up.

"Everyone is a potential client," said Walter Wickiser, a Manhattan gallery owner and former artists' career advisor. "The important thing is to let people know that you are an artist because you never know who might become a collector." For that reason, artists need to develop a client list, one that changes and (it is hoped) grows over the years, which will be used to contact people about art exhibitions or open studio events. That list can grow with the help of some of those friends and family members who suggest other people to be contacted (their friends and business acquaintances, for instance), and those friends and family members may be persuaded to write or call on the artist's behalf. Using people the artist knows to locate new prospects is a pyramid approach that ensures that more than the same group of potential collectors shows up at each exhibit.

Barbara Ernst Prey, a watercolor artist in Long Island, New York, began selling work by finding buyers through people she knew. Her mother's friends were some of the first collectors, quickly followed by the friends and associates of her husband's parents, and later, friends from college became buyers. Her brother, who lives in Manhattan, also set up a show of her work in his apartment, and other friends in Massachusetts and Pennsylvania did the same—all of which resulted in sales. Word-of-mouth advertisement and people she met at art openings and other social get-togethers also increased her client base. Eventually, her work came to the attention of art galleries, which became the principal venue for sales. "Between them all," Prey said, "I'm selling everything."

It is advisable for artists to be always on the lookout for potential buyers, attending the kinds of social and civic activities where they would likely be found, such as art exhibition and performing arts openings, charity events, and parties. Art buyers are people with disposable income. Artists should keep a pen and paper on them at all times in order to write down these people's names for a client list. According to Nina Pratt, a New Yorker who has taught sales techniques to artists and gallery owners, "the artist should then send a letter to these new prospects, following up with a telephone call within ten days, in which the artist says something along the line of, 'Hi. My name is Nina Pratt and I am a painter. So-and-so suggested that you might like to come to my studio—or come to such-and-such gallery, where an exhibition of my art is taking place—to see the work I am doing now.'"

It may be advisable for artists to set a goal of contacting so many prospective buyers, or arranging a certain number of studio visits, per week or month. Getting someone into the studio is a large first step, and the artist will have already passed through a major stage of awkwardness.

JURIED ART COMPETITIONS

The closest events we have nowadays to the old style salon is juried art competitions, which are often organized by membership organizations of artists, such as the American Watercolor Society, the National Watercolor Society, or the numerous state watercolor societies, pastel societies, sculpture societies, western art societies, miniature art societies, and many others. The Cape Cod Art Association in Massachusetts, which holds an annual Art in the Village juried show, is a membership society for artists of all media. Artists submit images of their work—it is rare that the actual artworks are viewed—for an art judge or group of judges (known as a jury) to pick the pieces that are deemed most appropriate or of highest quality or both. Juried art competitions are large-scale group exhibitions that offer the public the chance to artwork in a particular medium or style, or with a specific content (landscapes, maritime or equine images, Christian themes, the figure, or something else), while others are more general, in the manner of the Art in the Village show. Of greatest interest to participating artists is that these shows attract potential and actual buyers who may only purchase art at these exhibitions and never go into commercial art galleries. There are relatively few galleries that display contemporary watercolors, for instance, because these paintings tend to cost less than oils and gallery rents are high (for the same expenditure of time and energy, dealers are more interested in promoting and selling the more expensive works).

Within the realm of juried art competitions and art fairs—shows in which selected artists will set up a booth in which numerous pieces are displayed—there is a hierarchical range of prestige. The more renowned shows have strong visitor attendance and generally more sales, usually at higher price points. Most juried art competitions take place indoors, while a large percentage of the art fairs are held outside, but the setting tends not to be determinant of status. Some of the larger outdoor events are

coordinated with agencies of the particular cities and local businesses in order to turn an art show into a community-wide festival, drawing in more people visitors than ordinarily might come just to see the art.

Many of the art fairs are sponsored by private companies that run a number of events throughout the year in different cities states. As an example, since 1980, the Greensboro, North Carolina–based Gilmore Enterprises has staged its annual Arts & Crafts Festival in early November. The festival draws an average of 30,000 visitors, according to Clyde Gilmore, president of the company. He noted that exhibitors hailed from thirty-three states and Canada, and visitors were predominantly from Virginia (90 percent, with 25 percent of that from Richmond), Maryland, North Carolina, and West Virginia. He noted that his company doesn't track sales results at this or any of the other ten shows it stages in the Southeast, but there is more information on visitors. "The best part is that 80 percent of our visitors are return visitors," Gilmore said. "We have reason to think that people like this show, because they keep coming back." Artists who participate in these shows want the sponsors—whether they be membership groups or private companies—to actively promote these events to likely buyers. The Northampton, Massachusetts–based Paradise City Arts Festival, which stages weekend-long events in Massachusetts and Pennsylvania, specifically targets "new, younger collectors" through its targeted mailings of brochures, according to Linda Post, the company's founder and president. "Regular visitors are getting old; they don't want to collect as much. In fact, a lot of them are moving into condominiums and deaccessioning. When I started out doing shows twenty years ago, I could already see that the regulars were getting on in years. They were more interested in looking than buying." She noted that each show is put together as a unique event, with a different mix of artists and a special theme, so that there is no sense of "sameness from one year to the next."

Participating in these shows is dependent on being selected by a judge or jury (see chapter 11), and it is not free. Most shows require a jurying or application or administration fee that may range from $5 to $50, and that's just where the costs begin. For juried competitions, artists are responsible for crating and shipping their work to and from the exhibition site, and the only insurance that the sponsoring organization is apt to offer is for the artworks while they are on view. Art fair sponsors often require artists to send in payment for the booth fee (which may go as high as several thousand dollars) along with their applications. Artists who are accepted to participate in the fair have made a significant commitment, because if they choose or need to withdraw they may not get all or even part of their money back, depending on the reason for not taking part or when the sponsor is notified. Additional costs for art fair participants are travel, lodging, food, and insurance.

Because the investment is often significant, artists should have as much information about the shows in which they might enter as possible. There are between 10,000 and 15,000 art competitions and art fairs in the United States and Canada every year, many of them listed on the Web sites of state arts agencies (look for "State and Regional

Partners" on the home page of the National Endowment for the Arts, *www.arts.gov*), Art Deadline (*www.artdeadline.com*), Art Job (*www.artjob.org*), WorldWide Art Resources (*http://wwar.com/employment*), artists' membership organizations, and in a variety of art journals (*American Artist, Art Calendar, The Artist's Magazine, Southwest Art*, and *Sunshine Artist*, among others—see this book's index for addresses and subscription information). The most complete evaluation of juried shows is *Sunshine Artist*'s (Palm House Publishing, 4075 L.B. McLeod Road, Suite E, Orlando, FL 32811; 800-597-2573; *www.sunshineartist.com*) forty-nine-dollar publication, *The Audit Book*, which is published every September and contains information about the number of participants, the number of visitors and the volume of sales for 5,000 shows. In a more subjective vein, comments from participating artists about the shows' sponsors (did they do everything they promised? how did they treat the artists?) are also included. Another, similar source of information is *The Harris List* (P.O. Box 142, La Veta, CO 81055; 719-742-3146; *www.harrislist.com*), which costs $65.

The primary source of information about a show, or at least the sponsor's intentions, is found in the prospectus, and artists should never submit an application or any money for an event without first carefully reading this document. The prospectus may be downloadable online or sent to artists who are considering whether or not to apply, but all artists must answer these basic questions:

- Who is the show sponsor? There should be a physical address (rather than a post office box or only a Web site) and landline telephone number, because prospective applicants might want to check with a local Better Business Bureau. It also is advisable to know the names of the people who run the sponsoring organization.
- Where and when is the show is taking place? Does the sponsor have permission or a signed agreement allowing them to hold the event in a particular site on a specific date?
- If the event is to take place outdoors, are there contingencies for rain? What if it is an indoor show and there is a power blackout or brownout? Under what circumstances might artist-participants receive their money back?
- Is there an application fee? If so, how much is it?
- Has this event taken place in the past with the same sponsors? Artists will want to know that the sponsors have a track record (ask for visitor totals and any sales information—perhaps there were articles in a local newspaper); if this is a first-time event, it is important to feel confident that the sponsors have the wherewithal to stage a successful show.
- For artists setting up booths, how much electrical power is provided, and is there cell phone reception?
- Who is assigned responsibility in the event of damage, fire, loss, or theft?
- How is art to be shipped and insured (and who pays for shipping and insurance)? Will artists be charged a "recrating" fee when their work is sent back

from a juried competition? The show organizers should assume curatorial and financial responsibility for the artworks in their care. As an example of what should be done everywhere, the loan agreement between participating artists and the National Trust for Historic Preservation for the annual "Contemporary Sculpture at Chesterwood" exhibition in Stockbridge, Massachusetts stipulates that "Works selected for exhibition will be insured for 80 percent of their established retail value while installed on the Chesterwood grounds. Additional restrictions will also apply. A condition report will be completed upon installation."

- Will prizes be offered to the artists, and in which categories?
- Will the show sponsor take commissions on sale of artwork, and will the artist report sales to the sponsor or route sales through the sponsor?
- Must every item be for sale or within a certain price range?
- Are artists obliged to provide "door prizes" or other donations for visitors to the sponsor?
- How many artists are to be selected (as well as the names and affiliations of the judges who will be making the determination)? In general, it is the prestige of the juror(s) that gives importance and validity to the event. Also, artists may better gauge their chances of being selected if they know something about the person making the decisions. A juror who is an artist known for sculptural installations may seem like a longshot for a potential applicant painter of traditional realism, but maybe not. The people picked as judges might have a wide range of knowledge, interests, and discernment, but more information helps would-be applicants make their decision.
- What type of art (subject matter and media) will be featured? If only original art, does that allow for reproductions of an exhibitor's original art, such as an offset lithograph or digital print?
- Will the show have a catalogue available (either free or for sale) to visitors? Catalogues with images and contact information of the participating artists permit visitors to refresh their memories and perhaps make purchases after the event has concluded.
- Does the show sponsor charge admission, and if so, what is the amount? Are there corporate sponsors of the event, and will they have booths, too? What types of concessions will be run at the event? Will there be music (live musicians or piped in by loudspeakers)? Some artists may balk at having a cell phone company or hot dog stand or loudspeaker placed right next to their booths.
- What types of marketing (to potential visitors and collectors) and promotion (to the media) are planned to ensure strong attendance and media coverage? Is there a budget for advertising?

The prospectus may not answer every question, and artists ought to make inquiries, which is one of the reasons that reliable contact information should be available.

JURIED SHOW ETIQUETTE

Arts and crafts fairs tend to have fairly similar rules (and participants can get a bit fussy about them), including: everything in the booth must have been designed and created by the artist whose name is on the booth (no manufactured items), the artwork in the booth must correspond to what the artist submitted on slides (no abstract paintings by an artist who submitted slides of figurative work, no sculpture for an artist who sent in images of paintings—unless those people submit in separate jurying categories), exhibited items and chairs must stay within the booth (no impinging on walkways or other artists' spaces), and the artists may not engage in any "active solicitation of the public" (no hawking) or post signs that indicate a sale or potential discounts, exhibitors must provide their own liability insurance, all work submitted for jurying must be for sale, the artwork on display was all created after some specific date (no crowd-pleasing picture from twenty years ago), loading and unloading only takes place during scheduled times (no disrupting other exhibitors or the public) and vehicles are not permitted on the site, no music or videos playing in the booth (disruptive), and the artist must be present at the booth for the entirety of the event (no proxies).

All these rules make sense, but they may not work for every artist. The everything-designed-and-created-by-the-artist rule, for instance, may not work for those who have assistants (or who use a foundry or print studio), and requiring that everything on display be for sale may work against the interests of artists who look to enter a particular piece in another show or who may have already found a buyer. Regular visitors to art galleries know that not everything on display is for sale—some pieces may be on loan. A "proxy" (someone other than the artist manning the booth) may be very useful for artists who have other commitments; an art dealer, for instance, is a "proxy" when taking visitors through a gallery exhibition and can do a very adequate job—perhaps even a better one than the artist—of selling artwork. These rules reinforce certain beliefs (artists create alone and fair visitors require their presence for sales to take place, for instance) but also set a certain tone for these events: the things you see in the booth were made by that person in the booth. People like to meet artists, whether or not they buy anything directly from them, and artists find that developing relationships with prospective buyers does help make sales.

Bans on mood-setting music or videos that demonstrate the artist's technique would seem to go against the interests of exhibitors who, within the crush of hundreds of booths, seek to put their work in some context; unfortunately, not everyone can be trusted to adjust the volume control to low. The rule that all pieces on view were created within the past year or two may rule out artists who create very slowly and do not produce a lot of artwork; however, it is unlikely that anyone has surveyed visitors to art fairs, finding that they refuse to buy paintings that aren't fresh off the easel. Newness isn't an artistic criterion, but the emphasis on it by show sponsors reflects an arguable belief that visitors want the up-to-the-minute.

Other rules sometimes can seem plain arbitrary—the Palm Beach County's annual "Artigras" disallows the display of "ribbons or awards from other shows," as

though an artist's past success should be hidden—or overly broad. Many fairs describe themselves as "family-friendly." The Miami Beach Festival of the Arts announces that it is "an outdoor public event for visitors of all ages. Artwork must be in keeping with this atmosphere." Does that mean no nudes, no images of war, no social or political commentary? Family-friendly is also not an artistic criterion, and the lack of specificity leaves room for potentially avoidable conflict. Rules may be stupid but are unchangeable: there is no reason to apply to a sponsor, pay for travel and insurance, then set up a booth, only to be told to take things down.

No less annoying to artists looking to take part in a juried art show, a high percentage of sponsors stipulate the types of frames, mats, and protective glass that must be used, which often differ from one event to the next. The Watercolor Society of Oregon, for instance, requires "metal frames only" and "Plexiglas, Acrylic or Lucite" glazing ("no glass"), while "glass is permitted in wood frames" at the annual art show of the Arts Council of Cheatham County in Ashland City, Tennessee. For hanging wire, the annual juried competition of the California Watercolor Association stipulates the "center of wire should reach two inches below [the] top of [the] frame," while the New Mexico Watercolor Society requires that the wires must "peak at 3½ inches below the top of the frame." Artists who take part in numerous shows may find the cost of complying with these different rules—or the time it takes to comply with them—to be prohibitive. Additionally, the costs are rarely offset by prize money (or merchandise certificates) that winners are awarded. The Watercolor Society of Oregon, for example, has twenty cash and merchandise awards whose total combined value is approximately $4,000, while the top (best of show) prize at the annual international exhibition of the San Diego Watercolor Society is one thousand. It only may make sense to take part in some shows when the likelihood of sales and exposure is high.

NONPROFIT ART SPACES

To many artists, art gallery owners and dealers are the gatekeepers of the art world, leading to exposure, sales, a seat at the table. Will anyone come to see my artwork? Will any critic write about it or any collector buy it? Will it have any stature as art if it isn't exhibited in a commercial gallery? Getting into and being represented by a gallery becomes their highest career objective. Galleries, of course, are businesses that don't exhibit artwork just because it is good but, rather, because there is an audience and there are buyers for it. So, what of the artists who don't have a long and active client list? Fortunately, there are exhibition sites that judge art solely on the basis of quality, and among the most notable of these are nonprofit art centers.

"Our aim is to show work by underrepresented artists," said Ed Shalala, assistant director of New York City's The Painting Center, defining "underrepresented" as "not represented by a gallery." That and being painters are the only specific criteria for artists to have their work exhibited, and there are two ways in which that may happen: painters may submit images of their work to the Center, where twice a year, a committee selects artists for an invitational show that takes place in the main gallery; the second possibility

is being part of a group of artists that an outside curator proposes to exhibit, usually based on a particular theme involving content or style. There are eleven of those four week-long exhibitions that take place throughout the year. Shalala stated that the organizers of these shows are often art historians, critics, and independent curators, but it is not at all uncommon that artists themselves take on the role of curator, assembling the work of artists who are united by some type of shared interest ("as long as it pertains to painting").

Being a nonprofit organization, The Painting Center is dependent on funding from one source or another to maintain its operation. Those who curate an exhibition agree to raise money by applying for grants from a foundation, corporation, or state agency, and if that doesn't materialize the individual artists in the show will "split the cost to pay the rent," Shalala said. Sales of artists' work sometimes take place at these shows, and the Center receives a commission of 25 percent for those, but the aim is not sales as much as presenting art that is largely unknown to the public. "We have gotten some reviews over the years in the *New York Times* and *Art in America*," he said, which may be the larger goal.

The Painting Center is not the customary nonprofit arts organization; it is actually a cooperative gallery with sixteen dues-paying members who exhibit their work in one- and two-person shows throughout the year in a project room gallery, but they formed a nonprofit group to serve a larger realm of artists. However, there is no prototypical nonprofit arts organization. The hundreds of these organizations that exist around the country—the best source of information on where they are can be found in *Art in America's* summertime issue, *Sourcebook to the U.S. Art World*—range widely in their goals and target audiences, with some acting as educational centers, where art classes and workshops are taught to young and old, or as venues for performing arts events. Many nonprofit arts organizations are focused on the local or regional community (the degree to which an artist could be classified as a "professional" may or may not matter), while others look to exhibit the work of artists from elsewhere in the country or even from other nations. Some offer artist residencies and have grant programs. Uniting them all is the aim to show work by up-and-coming artists who haven't received wide exposure.

The public is probably the largest beneficiary, as it receives a first look at emerging artists, and that public includes many people who don't regularly visit commercial art galleries or museums and feel less intimidated in an arts center. The artists, however, gain experience in showing their work, sometimes making sales and otherwise developing their credentials as exhibiting artists. "My show was hugely helpful to my career," said Jennifer Mattingly of Baltimore, Maryland, who exhibited her miniature dioramas at the Arlington Arts Center in Virginia in 2007. Seven works were sold to visitors to that show but, more importantly, her artwork was seen by curators at two Washington, D.C. nonprofit arts organizations—Washington Project for the Arts and the Civilian Arts Project gallery—who both invited her to participate in group exhibitions.

Something that leads to something else is the goal of artists who show work at nonprofit arts organizations. Jesse Bransford, artist of large-scale drawings and paintings and director of undergraduate studies at New York University, had been invited to exhibit at Locust Projects in Miami, Florida, in 2003 by Locust's director, who had seen

his work online and at shows at other nonprofit arts centers—"maybe he saw my work at Los Angeles Contemporary Exhibitions or at White Columns [in New York City]," Bransford said. "I don't remember, but it was one of those." Unlike many other nonprofit arts groups, Locust brings in artists specifically to create site-specific installations. Perhaps not unexpectedly, none of Bransford's works sold at the Locust Projects exhibit, but "I met a lot of people with whom I'm still in contact," including Miami gallery owner Kevin Bruk, who began to show Bransford's work and currently represents him. A painting sold at that gallery was eventually donated to the Miami Art Museum, adding yet more heft to Bransford's C.V.

"We've worked with artists early on in their careers, and some of them have gone on to big things," said Edwin Ramoran, exhibition director of Aljira, a contemporary arts space in Newark, New Jersey, which was founded in 1983 by artists but has no allegiance to any particular medium or style. (Among these now well-known artists are Willie Cole and Fred Wilson.) Exhibitions (some guest-curated and others organized by Ramoran and others) and a career development program for fine artists are the core components of Aljira, although it also works with area public schools in area of arts education and art classes. The artists whose work is exhibited are not required to pay anything, as Aljira staff does extensive fundraising, earns a 33 percent commission on sales, and holds a charity auction.

COLLEGE ART GALLERIES

Yet another type of nonprofit exhibition site is art galleries at colleges and universities, many of which welcome inquiries from artists looking to show their work. Often, schools express greatest interest in local and regional artists, as well as alumni, but they will set up exhibits of artists who live and work further away and have no association with the institution, simply because the artwork appeals to the gallery director. "You'll find a fairly positive attitude toward exhibiting regional artists in the art galleries of colleges and universities because these galleries are these schools' main portal, main form of outreach, to the larger community," said Brent Tharp, a museum director at Georgia Southern University and vice president of the Association of College and University Galleries and Museums. "The galleries' role and purpose is to connect with both the campus and the community."

Not all college and university galleries hold that view. Stephanie Snyder, director of the Cooley Memorial Art Gallery of Reed College in Portland, Oregon, noted that "it's not in our mission to show regional artists' work. Our mission is to bring in exceptional work and significant artists from around the world," and some schools use their galleries only to display student or faculty work. However, of the more than three thousand schools offering baccalaureate degrees and the 1,100-plus community colleges around the country, the majority have exhibition spaces and a high percentage of them will show work by contemporary artists. Actually, many schools have more than one exhibition gallery, such as one exhibition space for student shows; another for a permanent collection; and a third for mixed programming that may include traveling exhibitions, faculty shows,

and shows of contemporary artists within the region. St. Norbert College in De Pere, Wisconsin, for instance, has its Godschalx Gallery for student exhibitions; a permanent collection gallery; and the Baer Gallery, whose shows "include senior art major exhibits, the Annual Juried Student Art Show, the Biennial Art Faculty Exhibition and the major showings obtained form local, regional, national and international sources."

Interested artists should look at the type of exhibitions the gallery has staged in order to obtain a sense of the desired aesthetic and media, as well as whether or not there is a prescribed method of submitting a proposal. This information is likely to be found online. For example, the art gallery at Saginaw Valley State University in Michigan places the following notice on its Web site:

ARTISTS INTERESTED IN EXHIBITING IN THE UNIVERSITY ART GALLERY
Complete entry form and submit with slides, high-quality photos, and/or a DVD of work for review, as well as a written exhibition proposal, names and examples of work from all artists included in the proposal, and also a SASE for return of materials to David Littell, Director, University Art Gallery, 7400 Bay Road, University Center, MI 48710, or for further information, contact...

David Littell stated that an exhibition committee meets regularly to review artists' proposals and that their work may be shown in one-person or group shows. On occasion, visitors to the gallery express an interest in buying works on display, and "we act as intermediaries, putting the visitors in touch with the artists." However, "sales are not our main function," adding that the gallery does not take a commission from any sales.

Similarly, the Web site of Gallery 210 at the University of Missouri at St. Louis posts a statement directed to artists:

ATTENTION: ARTISTS
Gallery 210 accepts submissions on an ongoing basis. Our exhibitions are planned two to three years in advance and we review all submissions twice every year. To submit work for consideration in one of our upcoming exhibitions, please submit the following:

- Up to twenty images in slide or JPEG format (please label slides or include a list of the images with the title, date, medium, and dimensions)
- CV or artist résumé
- Additional materials, such as reviews or brochures from previous exhibits

Place all materials in a large manila envelope with return postage if you would like your materials back after they have been reviewed.

- Send all items...

Perhaps the artists who are most aware of opportunities to exhibit in college galleries are those who already work in academia, many of whose résumés list numerous shows in campus art spaces. "It is a requirement in academia to show widely," said Beth Edwards, a painter and instructor at the University of Memphis, whose work has been exhibited

at Arkansas State University, Southeastern Louisiana University, San Francisco State University, Eastern Kentucky University, Wilmington College in Ohio, Indiana University, and the University of New Hampshire, among other schools. The necessity also becomes a virtue as "you get your work known through a network of other galleries and artists," and one show leads to another. Edwards noted that her goal had been to get more shows in commercial galleries, which has taken place through referrals from college art gallery directors who had seen or exhibited her work.

Some college and university galleries have high visibility in their communities because of a lack of commercial galleries in the area. However, sales of artwork from exhibitions in college art galleries tend to be rare events. Diane Ayott, a painter in South Hamilton, Massachusetts, who teaches at Montserrat College of Art and has shown her work in one-person and group shows at a variety of New England colleges and universities, noted that these galleries "are not commercial, and they don't promote or market works for sale." The audience for these exhibits tends not to be the buying public, but it can be an appreciative group of people. "I'm always surprised when I get a call from a curator or director of a gallery who has seen my work a number of years ago and remembered it," she said. "They tell me they have been following my career."

REGIONAL ART MUSEUMS

A growing number of museums not affiliated with colleges and universities also specialize in contemporary art, which is less expensive to collect than works by more established artists, and some focus exclusively on regional artists. The DeCordova Museum and Sculpture Park in Lincoln, Massachusetts, for instance, is devoted exclusively to showing and collecting contemporary New England art. It is the plan of the DeCordova to become "the largest collector of New England artists in the region," according to the museum's former director, Paul Master-Karnik, and through its exhibition and acquisitions programs, the museum hopes to spur sales of this art among private collectors. He noted that, traditionally, museums have been the passive recipient of donations from collectors for the bulk of their holdings and have conservatively relied on "accepted wisdom and what the critical mass of art historians have decided" about these works in the institutions' presentation to the public. "The contemporary art museum has to be much more dynamic than the traditional museum. We hope to form tastes and judgments, and part of the way we can do that is by buying work and presenting that work in a way that interests the public."

There are other museums that focus on regional art in the United States, such as the Louise Wells Cameron Art Museum in Wilmington, N.C., which is specifically dedicated to North Carolina art; the Museum of Contemporary Art Jacksonville in Florida, which "welcomes submissions from artists for review"; the Morris Museum of Art in Augusta, Georgia, which holds an extensive collection of Southern fine and decorative arts; the Museum of Nebraska Art in Kearney, which displays contemporary and deceased Nebraska artists; the Nicolaysen Art Museum in Casper, Wyoming, which shows contemporary and traditional western art; the Noyes Museum of Art in Oceanville, New

Jersey, which features fine and folk artists from the Garden State and the Museum of Wisconsin Art in West Bend shows and collects produced within Wisconsin; the Elmhurst Art Museum in Illinois, which provides "wide exposure to Illinois artists"; the South Bend Museum of Art in Indiana, which "highlights current art activity taking place on a local, regional and national basis;" and the Anchorage Museum of History and Art in Alaska, which contains indigenous art and artifacts from over a period of centuries in Alaskan history. The Morris Museum's concept of Southern art is also an expansive one that includes artists who were born or who worked in the South, such as Georgia O'Keeffe and Cy Twombly, who painted in South Carolina and Georgia, respectively, for small periods of time, and Jasper Johns, who was born in Georgia and grew up in South Carolina.

Other museums that take a more historical approach to collecting and exhibitions may display the work of local and regional artists in yearly shows. The Muskegon Museum of Art in Michigan, for instance, whose collection consists of European and American from the sixteenth to the twentieth century, holds an annual regional art exhibition in which two- and three-dimensional works of art are solicited from Michigan artists eighteen years of age or older to be judged by someone picked by the museum. Similarly, the Mabee-Gerrer Museum of Art at St. Gregory's University in Shawnee, Oklahoma, has a collection of ancient Egyptian, Greek, and Roman objects, as well as Native American, African, and Oceanic artworks, and holds an annual regional art exhibition.

A valuable source of information about museums is *The Official Museum Directory* (National Register Publishing Company, $315), which is an annually published directory of museums in the United States, with more than eleven thousand entries listed by state and alphabetically. Many municipal and college libraries have a copy in their reference sections.

GOVERNORS' ART SHOWS

State budgets always seem to come up a bit short, so what's a governor who wants to provide more support for the arts supposed to do? A few examples from around the country may reveal some possible answers. Donald L. Carcieri, a retired businessman who became governor of Rhode Island in 2003 on a platform of cutting taxes and reducing state government spending, developed the idea of an annual juried art exhibition to promote the artistic talent of Rhode Island artists, with the first-place winner receiving a one-thousand-dollar purchase award and the second- and third-place winners, $250 apiece. The money to pay these artists comes from his own pocket—he did very well in business, having retired in 1997 from his post of chief executive officer of Cookson America, a worldwide materials science company—and he and his wife, Suzanne, permit themselves the right to pick the artworks out of a group of thirty-five or forty that had been previously whittled down from one hundred or so by staff members of the Rhode Island State Council on the Arts. Since the Carcieris buy the art, it officially belongs to them.

The annual juried exhibition of two-dimensional artwork, titled "Scenes of Rhode Island," is hung throughout the month of January in an atrium gallery in the state's Department of Administration Building, and the winning piece will be displayed in the

State House for the entirety of the Carcieri Administration. Along with purchasing the artwork, Governor Carcieri insists on the right to make an edition of one hundred posters of the image (signed by both the artist and the governor), which are given to charity auctions in Rhode Island as a means for them to raise money.

Rhode Island isn't the only state to mount a governor's art exhibition, but the financial arrangement that Governor Carcieri makes is specific to him. A number of other governors also sponsor art shows as a means of spotlighting in-state talent. In Michigan, Nebraska, and Oregon, for instance, artwork by artists living in those states is featured in exhibitions at the governor's residence or office. The Governor's Invitational Art Show in Loveland, Colorado, and the Kansas Masters' Invitational Art Exhibit in Manhattan, Kansas (both annual events), are fundraising efforts for non-art causes (the Kansas Park Trust, an eleven-thousand-acre nature preserve, and the Rotary Club of Loveland) that involve the display and sale of in-state artists' work. Both events produce a catalogue with a brief introduction by the respective state's governor, and participating artists receive half of all proceeds from the sale of their work with most or the entire remaining portion applied to the charitable cause. "The governor's name adds prestige to the show," said Judy Archibald, director of the Loveland event, "the way that having a show at a museum is more prestigious than having a show at a bank. Otherwise, the only active role taken by the governor is as a cheerleader."

Often, a governor creates partnerships with nonprofit or for-profit organizations, using those groups' wherewithal and the governor's office's imprimatur to produce a noteworthy event. For instance, the governor of South Dakota teams up with the State Historical Society, the Dahl Arts Center in Rapid City, the South Dakota Art Museum, the University of South Dakota, and the South Dakota Arts Council to create the Governor's Biennial Art Exhibition to highlight artists of two- and three-dimensional work living and working within the state. The resulting exhibit travels to five museums and arts centers around South Dakota.

Similarly, the Governor's Capitol Arts Exhibit in Wyoming, a juried show for in-state artists taking place each summer at the Wyoming State Museum in Cheyenne, is sponsored by the state museum, the Wyoming Arts Council, and a number of area businesses. The pooled money is used to purchase works from the exhibit for the state's art collection, and a 25 percent commission on any other sales from that show goes to buy yet more pieces from the exhibition n for the collection.

ART IN EMBASSIES

America may look like many things to the rest of the world—Uncle Sam, Wall Street billionaires, a Hollywood movie set, the current president, or some pop singer—or it may look like painter Margaret Huddy of Alexandria, Virginia. In the spring of 2005, she represented the U.S. Department of State in Paraguay for ten days, teaching free watercolor workshops to college students and even some of their instructors in several towns throughout the country as part of its American Artists Abroad program. The aim is to make American art and artists the face of America to people in the rest of the world.

The American Artists Abroad program, which began in 2002, is part of the larger Art in Embassies initiative (begun in 1964) of the State Department that seeks to bridge the cultural divide between the U.S. and other countries through displays of American art in American embassies abroad. It is a relatively low-cost program for the American public, since the artists who are brought overseas are not paid for their time and efforts (their travel and lodging—usually in the ambassador's own residence—costs are picked up by the State Department) and almost all of the artworks displayed in the embassies are three-year loans (the State Department handles the crating and shipping), but the public relations benefits can be significant. "We look to spread the best of American culture with the rest of the world," said Anne Johnson, director of the Art in Embassies program. "We want to share it and give a positive image of the U.S." Exhibiting American art in the embassies or bringing in American artists for short-term teaching stints outside of the embassies helps people around the world better understand the United States and gain a better opinion of our country. "In the hostile, post–Iron Curtain world," she said, "it's better to be preemptive."

Margaret Huddy's preemptive strike was to solicit a donation of art supplies from Cheap Joe's Art Stuff, because where she was teaching there were few appropriate materials to be had. "My workshops were about watercolor basics," she noted, "a medium that is rarely used in Paraguay and yet is a requirement in the school of architecture. The State Department had only $250 for supplies, yet I had 90-100 students pre-enrolled." She contacted Joseph Miller, founder and president of Cheap Joe's, "who was wonderful and supplied twenty-five palettes, twenty-five sets of brushes, enough paint to fill the palettes, and one hundred sheets of Arches Cold Pressed paper, which he cut into quarters for me before shipping them to the ambassador's address. I then carried the supplies from venue to venue and then left them in Paraguay to be given to schools. Without his generosity, the workshops would have been a failure, since the $250 did not begin to cover his cost. Good-quality supplies are essential in watercolor, and none are available in Paraguay, nor do the people have the money for them."

She took a ten-week crash course in Spanish before going, which didn't help much, but the American embassy provided native Paraguayans who translated her teaching and pointers and even anticipated when students needed more water for their paints (calling out "mas agua!"). Mission accomplished: her students "learned a lot about art and watercolor paint" and, perhaps just as significant, "I think my efforts showed the country the amazing generosity of the American people."

Fifty artists have participated in the American Artists Abroad program, while far more—approximately ten thousand, with two to three hundred added every year—have had their work displayed in American embassies abroad. The entire Art in Embassies program is a minor part of the State Department, with a small budget ($1.8 million) and a small staff (Anne Johnson, three full-time registrars, a few administrative staffers, and six full-time curators), whose job it is to provide artworks to, and exhibitions at, the 180 or so American embassies around the world. Those six curators are kept busy visiting art galleries and art fairs, as well as looking at contemporary American art images

submitted by artists and art gallery owners online (*http://aiep.state.gov/submit.html*). They even rent a booth at the annual College Art Association conference in order to spread the word.

The six curators learn of artists in even more ways, and the information is retained until there is a good fit. The work of Brad Story of Essex, Massachusetts, for instance, who specializes in wood and Fiberglas sculptures of birds, was seen by one of the curators at the Smithsonian Craft Show in 2003, and three works were borrowed for the embassy in Seoul, South Korea, in 2007. Grimanesa Amoros, a Peruvian-born sculptor in New York City, won a National Endowment for the Arts fellowship in 1993, which put her on the radar of the Art in Embassies curators, who borrowed her work for embassies in both Turkey (2001) and Peru (2003). Margaret Huddy became known to the curators through then Paraguayan ambassador, John F. Keane, whose wife, Graciela, had been one of Huddy's former students. Sometimes, art dealers contact the Art in Embassies curators directly (that brought the paintings of Syracuse, New York, artist Sarah McCoubrey to the attention of the State Department, which borrowed one work for the embassy in Venezuela), and painter Ephraim Rubenstein of Ellicott City, Maryland, credits some Washington, D.C., art consultants with whom he had worked for alerting the Art in Embassies curators to his work (his work was borrowed for embassies in Turkey and Uzbekistan).

Some of the artists whose work has been selected are quite well-known (including Ellsworth Kelly, Maya Lin, and Robert Rauschenberg), but most have much smaller reputations. "We maintain a balance of the well-known and the less well-known," Johnson said. "You don't have to be a star, and most of them aren't, but you have to be a professional artist. We don't want amateurs." In general, the curators "decide things visually" rather than on the strength of their names.

Most artworks in the embassies are on three-year loan, although since 2005, the Art in Embassies program also has been purchasing pieces for its collection that are housed in one embassy or another. Four hundred works are currently in the collection, including fifty that were purchased for the recently completed embassy in Beijing, China ($700,000 was spent on the art and another $300,000 on shipping the artwork there) and thirty for a new embassy in Ciudad Juarez, Mexico ($400,000 for buying and shipping the art).

These curators assemble an array of art images by a variety of artists on a particular theme—for instance, women or Latino artists, artists from the ambassador's home state, artists whose work has been influenced by Asian culture—and the particular ambassador to that country makes the final selection. Additionally, artwork that looks perfectly fitting and at home in an American art gallery may cross cultural taboos in other lands, Johnson said, which would disqualify it or create a need for some alteration. Nudes are not allowed in the Middle East, and a painting with a depiction of the Buddha's head was not permitted in India, because the Buddha must always be represented with a full body. A three-panel, antique-style map of the world by artist Joyce Kozloff, which was purchased for the consulate in Istanbul, Turkey, created a stir

because she had labeled the Turkish city Constantinople—the ancient Roman name—rather than Istanbul, which the Turks renamed it in 1930. (Kozloff agreed to make a change in her artwork and was flown by the State Department to China to do it.)

The benefits of participating in either (or both, in some instances) the Art in Embassies or the American Artists Abroad programs are limited. A party and exhibition will be arranged when the artworks are first installed, often coinciding with the advent of a new ambassador, and local cultural bigwigs (artists, collectors, dealers, museum directors) are invited. However, most visitors to U.S. embassies are students, professors, and businesspeople seeking visas, rather than buyers of art. The poverty in many or most of the countries in which the U.S. has embassies would severely limit the number of people who could pay American prices for art. On occasion, lightning strikes. Paraguayan Ambassador John F. Keane bought one of Margaret Huddy's paintings, and a resident of Ascuncion—one of the towns in which she taught—commissioned another painting. For Rubenstein, however, the Art in Embassies program "takes a painting out of circulation for a few years, and that's a bit of a minus," although the fact that a work was selected by the government adds some pedigree to it. "Anyway, I prefer to send artwork overseas [rather] than bombs."

Karen Gunderson, a painter in New York City who spent a week in the small African nation of Togo in 2002, claimed that collectors back in the U.S. "think it was cool" that she represented the State Department abroad, adding that "no one knows where Togo is or what continent it is on. I tell them first; I don't want them to founder."

The obvious benefit of any exhibition program is exposure. A reproduction of a painting by Josette Urso, whose work had been displayed in embassies in Brunei, Cambodia, Croatia, Dublin, and Turkey, was included in the Department of State's 2006 Desk Diary Calendar, which was printed in an edition of eighteen thousand and distributed as an official gift by U.S. Ambassadors and other American Embassy diplomats to members of the international diplomatic community and host country nationals. Participating in the State Department's programs is more than just an additional line on one's résumé to these artists—a small catalogue for each embassy exhibition is prepared by the Art in Embassies curators, which is sent to the participating artists—although the benefits may be somewhat intangible. Arlene Shechet, a sculptor in New York City who took part in the American Artists Abroad program in 2006 by spending two weeks in Vietnam, notes that there were no sales or offers to exhibit her work at a gallery there. "It's a very poor country," she said. "Whatever career ambitions I have, I didn't want to confuse them with my role as a representative of the United States." The benefits may accrue to artists less abroad than back in the U.S. where collectors are interested in the exotic tale of the travels of the artwork before them. "It gives me credibility to collectors," said Evergreen, Colorado, painter Don Stinson, whose Texas landscape painting, "Cisco No Services," was displayed in the American embassy in Saudi Arabia from 2001–2004. "When I'm introduced at a talk, or when I'm having an exhibition, the fact that I was in the Art in Embassies program is always mentioned. I don't pick what is said about me; someone just looks down the list of things on my résumé and picks it out, and that one is picked out every time."

SALES AND RENTAL GALLERIES AT MUSEUMS

Artists generally try to put their work where art collectors go, which is why getting into a commercial gallery tends to be so important to many of them. However, it is never clear that all their potential collectors will go that one gallery, and then there are the people who might become collectors if only they went to art galleries. Many artists find that they cannot rely on one place to provide all their public exposure and all their sales but must continually seek out new and different venues to show and sell their artwork. Kim Osgood of Portland, Oregon, has had good luck finding buyers for her monotypes at the Lisa Harris Gallery in Seattle, Washington, and the Margo Jacobsen Gallery in Portland, selling twenty or so (at $1,200 to $1,400 apiece) at one-person shows and one every month or so at the galleries during the intervals between exhibitions. Those intervals can last up to two years, so it has proven quite welcome that, in the one year Kim Osgood has been exhibiting her artwork at the Seattle Art Museum's sales and rental gallery, eight works have been sold and some smaller amounts of money have shown up as rental income.

"There is a different pool of buyers—especially corporate collectors—at the Seattle Art Museum than you find at the Lisa Harris Gallery," Osgood said. "I get another chance to make a sale."

The museum's sales and rental gallery was established in 1970 for the twin purposes of helping to create opportunities for artists and create additional revenue for the institution. It has accomplished the second by achieving the first, since the gallery takes a 40 percent commission on sales (more than three hundred artworks are sold annually) and rentals, generating over $100,000 in income for the museum. The sales and rental gallery serves as a perquisite for museum membership, because only members may rent artworks or purchase them on a year-long installment plan (one needn't join the museum to purchase a work outright).

"There is a limited number of commercial galleries and nonprofit spaces in Seattle," said Barbara Shaiman, director of the museum's sales and rental gallery, "and this represents a way for the museum to support local artists, and the local gallery community, too. The museum is easy to find, and we tell people about the area galleries." In fact, it was gallery owner Lisa Harris herself who originally contacted Shaiman about showing the work of Kim Osgood—the two galleries make a split of the commission from any sales of the artist's work. "A number of our regular clients were referred to us by the sales and rental gallery after they showed interest in an artist we represent," Harris noted, adding that she "may place a work at the sales and rental gallery that's been at our gallery for a while and hasn't sold."

Approximately 160 regional artists have consigned their work to the Seattle Art Museum's sales and rental gallery, and "almost all of them receive some money in the course of the year," Shaiman said, the majority of which is from rentals. Rather than purchasing pieces outright, a number of the museum's corporate members prefer to rent works for office decor, returning them after the three-month rental period in exchange for others. These companies may take twenty or more pieces at one time, paying the

sales and rental gallery between 7 and 9 percent of the purchase price for the three months; that money is then paid to the various artists, less the gallery's commission. The amounts that artists receive is often low—Carl Kock of Chicago and Nina Weiss of Highland Park, Illinois, received checks for $20 and $35 per month, respectively, when their work was shown at the now-closed sales and rental gallery of the Art Institute of Chicago—but may add up over time.

The price range for works in museum sales and rental galleries is generally on the lower side—$600 to $3,000 at Seattle, $500 to $5,000 at the Delaware Art Museum, and $200 to $600 at the Charles MacNider Museum of Art in Mason City, Iowa—and the majority of sales tend to be in the lower to middle area. A higher price point may work against an artist whose market is strong, making sales and rental galleries a more appropriate jumping-off place for emerging artists.

There are a number of benefits and a few drawbacks for artists in showing their work at a museum sales and rental gallery. Certainly, there is the opportunity for considerable exposure, since far more people visit art museums than art galleries and a certain percentage may stop by the museum's gallery to see what's on view. Museums tend to be less intimidating to the general public than commercial art galleries, which attract a more select group of visitors. Most galleries don't have regular leasing agreements for the art they carry, which limits their ability to attract corporate clients (some of whom do eventually purchase the art they start out renting). In some cities, there may not even be many commercial art galleries where area artists can show and sell their work, so the local museum is the main cultural venue. In 2000, the sales and rental gallery of the Delaware Art Museum was voted Best Gallery by the readership of the *News-Journal*, the state's largest newspaper.

Additionally, although there is rarely any curatorial involvement in the selection of artists or the operation of sales and rental galleries (they are usually started and run by a museum volunteer committee with, perhaps, one paid employee), artists recognize the value of being associated with an art museum. "My work was shown in a prestigious museum," Nina Weiss said, "so I'm happy to keep it on my résumé."

However, it is for the very reason that some institutions do not wish to be associated with otherwise untested artists that they have closed their sales and rental galleries. "There is a belief at some museums that the artwork in the sales and rental gallery isn't at a professional level, that it's not in keeping with the rest of the museum," said Patty Howard, gallery manager at the Los Angeles County Museum of Art's sales and rental gallery. "Even here, we feel a little insecure." When the Art Institute of Chicago opened its gallery in the 1950s, "Chicago was a much more sleepy place in terms of an art community, and there was a real need for the museum to do something for artists," a spokeswoman for the museum said. However, as more galleries emerged and the museum sought to focus its attentions on internationally renowned artists rather than perform a favor for locals, justifying the continued presence of the sales and rental gallery became more difficult. The space was converted into an architectural studies center in 1990.

Sales and rental galleries also tread a thin line between cooperation and competition with commercial galleries. As part of a nonprofit institution, they do not charge any sales tax on artworks sold, which makes the same priced piece of art less expensive there than if purchased through a regular dealer. Francine Seders, a gallery owner in Seattle, noted that she has allowed but does not encourage artists she represents to also show their work at the museum, since, "in a small town like Seattle, the rental sales gallery becomes competition." One of her stable of artists, painter Juliana Heyne, had shown at the sales and rental gallery of the Seattle Art Museum but no longer does because the rental fees she receives "are very low, and the work is taken out of the market for months at a time." The museum allows renters to take the artwork for a three-month period with an option to renew for another three months. As a result, the same piece may be rented several times by different clients for as long as six months apiece before they decide to either buy or return it. By the time a previously new work is returned to Heyne, she added, "it may be three or four years old," and thereby less desirable both to her dealer and to collectors.

Except for an occasional feature article in a local newspaper, museum sales and rental galleries suffer from neglect from the media, and their shows—some galleries create thematic exhibitions and do not just place artwork on the walls or in bins—are rarely reviewed, perhaps also reflecting their lower status. Jennifer Zika, manager of the sales and rental gallery of the Portland Art Museum in Oregon, stated that local newspapers do not review her exhibitions "because we don't do one-person shows, and we don't do one-person shows because we don't want to compete with the commercial galleries."

The quality of the operation of the sales and rental gallery is often uneven, reflecting the fact that some groups of volunteers may be very committed to the endeavor while others lose interest or do not follow through. Sales and rental galleries at the Fort Wayne Museum of Art in Indiana and the Springfield Museum of Fine Arts in Massachusetts never generated any revenues and were closed down; in both instances, it was difficult to find volunteers to just sit in the gallery during the hours it was open. Museum administration may also waver in its commitment to helping local artists, instead showing a preference for higher revenue-producing museum shops, where notecards, T-shirts, posters, and books sell in greater volume, and for opportunities for licensing images in the institution's collection. "In the last twenty years, museums have been pushed to generate more income and become more self-sufficient," said Sheila Perry, director of the Charles MacNider Museum of Art, which continues to operate a sales and rental gallery. "There is just not as much income to be made with a sales and rental gallery. The unit costs are high, the turnover is low, and it takes a lot more work to sell a unique work of art than a mass-produced poster."

The 1990s saw a number of museum sales and rental galleries fall by the wayside. Those that remained have created paid positions and generated, in some cases, significant revenues for their institutions. The sales and rental galleries of both the Albright-Knox Gallery of Art in Buffalo, New York, and the Delaware Art Museum

both generate $30,000 for their respective institutions; the Portland Art Museum receives $100,000 to $150,000 per year, while the gallery at the Los Angeles County Museum of Art produces a net income for the institution of between $125,000 and $175,000 annually, based on gross sales of $800,000. A similar amount is earned by the San Francisco Museum of Modern Art, whose Artist Gallery had gross revenues in fiscal year 2001 of $1,883,740—of that amount, artists received commissions of $1,029,432.

Among the sales and rental galleries at museums are:

CALIFORNIA
Laguna Art Museum
307 Cliff Drive
Laguna Beach, CA 92651-1530
(949) 494-8971, ext. 213
The museum no longer has a sales and rental gallery but continues to arrange rentals and sales of artists

Los Angeles County Museum of Art
5905 Wilshire Boulevard
Los Angeles, CA 90028
(323) 857-6000

San Francisco Museum of Modern Art
151 Third Street
San Francisco, CA 94103
(415) 614-3206

DELAWARE
Delaware Art Museum
2301 Kentmere Parkway
Wilmington, DE 19806
(302) 571-9590, ext. 550

IOWA
Charles H. MacNider Museum
303 Second Street, S.E.
Mason City, IA 50401-3925
(641) 421-3666

MICHIGAN
Flint Institute of Arts
1120 East Kearsley Street
Flint, MI 48503-1915
(810) 234-1695

NEW YORK
Albany Institute of History and Art
Rice Gallery
135 Washington Avenue
Albany, NY 12210-2296
(518) 463-4478

Albright-Knox Art Gallery
1285 Elmwood Avenue
Buffalo, NY 14222
(716) 882-8700

OREGON
Coos Art Museum
235 Anderson Avenue
Coos Bay, OR 97420
(541) 267-3901

Portland Art Museum
1219 S.W. Park
Portland, OR 97205
(503) 226-2811

PENNSYLVANIA
Philadelphia Museum of Art
Benjamin Franklin Parkway and 26th Street
Philadelphia, PA 19130
(215) 684-7965/7966

WASHINGTON
Northwest Museum of Arts & Culture
2316 West First Avenue
Spokane, Washington 99201
(509) 363-5317

Seattle Art Museum
Rental/Sales Gallery
1334 First Avenue, Suite 140
Seattle, WA 98101
(206) 748-9282

In addition, a couple of artists' membership organizations—the Cambridge Art Association (25 Lowell Street, Cambridge, MA, 02138; 617-876-0246) and the Salem Art Association (600 Mission Street S.E., Salem, OR 97302; 503-581-2228)—also operate sales and rental services, charging a 50 percent commission.

GAINING MEDIA ATTENTION

Besides creating the opportunity for public comment and developing a mailing list, exhibitions allow the media to become aware of one's work. Artists should think about writing a press release (what to say about their work) and to whom it might be sent well in advance. A press release reads almost exactly like a regular newspaper article, with the most important information at the top ("An exhibition of photographs from the Civil Rights movement of the 1960s will be held . . . "), followed by a statement or two about what makes this event newsworthy ("first time shown," "using a new technique," "marking the anniversary of . . . "). From there, the press release should note where and when the exhibit will take place (address, dates, and time) and mention the artist. The artist may be discussed higher up in the release if the artist figures into the news event of the story ("was chased up a tree and needed to be rescued while sketching a leopard . . . ") or if the artist is local to the area or received training there. If the artist has a Web site, or a page on another site, the address should be listed on every page.

The press release is often part of a press package, which consists of the news release, one or more photographs or slides or a CD-ROM containing images of the work, information about the artist and perhaps an artist's statement. The biographical information about the artist may be in the form of a narrative or a C.V. (curriculum vitae), which is a professional history, listing solo and group exhibitions, commissions, names of collectors, a list of articles or reviews written about the artist (or possibly by the artist), and professional training. A C.V. is different from a résumé, which is a history of employment and an indication of one's job skills. The documents are two distinct ways of describing oneself and should be separate in most cases. An art editor or gallery owner, for instance, doesn't need to know that the artist works at Wal-Mart, and this information might actually work against the artist. (Some dealers believe an artist is not fully committed to art if he or she has a steady job.) Conversely, a prospective employer might not be pleased to see that the person applying for a job is putting so much time and energy into getting exhibitions, because that shows a different type of lack of commitment.

Other types of information to be included in the press packet are clippings—reviews and articles that mention or feature the artist—as these indicate that other writers and editors have seen fit to discuss the artist and/or the art. Most clippings are

not read thoroughly or at all; they add physical and metaphorical weight to the artist's presentation. Even a clipping that is a negative review won't work against an artist.

To whom this package should be sent is not clear, so artists should be familiar with the media to which they are submitting material and also have a number of copies to send to any one place: at a newspaper, it might be the arts editor, art critic, features editor, calendar editor, magazine editor, Sunday editor, weekend editor, or managing editor—a telephone call in advance might whittle down the list somewhat. Artists should also think not only about obvious places where a notice might be placed but elsewhere. There may be a women's editor or a reporter who writes largely about women who are doing something noteworthy in one field or another. There may be a news angle for the business, sports, or travel editor.

If submitting a press package to magazines, it need not be an art journal but could be a travel publication or one devoted to retirees or collectibles and other luxury items. If the target readership has money, that group is likely to be interested in buying artwork. Press releases and other material should be sent to newspapers between two and six weeks before the event is scheduled to take place, and telephone calls should follow the expected receipt of the notice to make sure that it arrived and went to the appropriate person. It is very possible that the same release may need to be sent again (followed again by a phone call), because reporters and editors are flooded with announcements. Magazines have a much longer lead time, and press material should be submitted at least six months in advance.

One may also e-mail announcements to editors and writers, with click-on links that connect the reader to the artist's own Web site. However, an e-mail notice should be sent in addition to the hard copy mailing rather than in place of it. Editors and writers— all of us, really—receive so much e-mail from senders they don't know, and their tendency is to delete unread mailings *en masse*, often without looking at which individual e-mails might be of interest. One may try to circumvent the mass deletions by sending the same e-mail numerous times in order that a single notice isn't deleted by mistake, but that practice may be seen as spamming, which will irk some recipients. Better to send the hard copy and the e-mail, then follow up in the hope that something will be read.

As important as developing personal relationships with potential and current collectors is creating a rapport with editors and reporters. A critic might be invited to one's studio, or an editor asked out to lunch or to a gallery opening, in order to build an investment of time and interest in an artist's work and career. This relationship should be ongoing, so that the editor doesn't feel used and so that the artist's name isn't forgotten if a year or two passes between exhibitions or other events. It should also be noted that journalism is a nomadic profession, in which critics, reporters and editors change their jobs frequently and regularly: Artists should be flexible and tolerant enough to like the new editor or critic as much as the old one.

KEEP YOUR NAME CURRENT

Most artists tend to think about publicity in relation to exhibitions, which certainly are major events in their lives and careers. However, exhibits are brief things, lasting several weeks perhaps and then disappearing (usually without a trace, unless there is a

catalogue) and being replaced by some other artist's show, and the time between exhibits can be long—a year or two or three. Would-be collectors who expressed interest in someone's work can't be expected to remember the artist's name and images over a span of years, and the newspaper writer or editor who appreciated the last show may not be around for the next. Artists need to establish a regular presence so that they don't risk being forgotten, and each activity creates another opportunity to alert the media and the public to the artist's work. This may include hosting an open studio event, on one's own or in concert with other artists, in which a select group or an entire community is invited into an artist's studio to meet the artist and view current and older artworks. (Some artists schedule open studios in early December, timed for holiday shopping, for instance.) Another type of event is a demonstration or lecture, in which a particular medium is presented ("What is Encaustic Painting?") or a topic of art world note ("Where is the Public Art Field Twenty-Five Years after Richard Serra's 'Tilted Arc'?") is discussed. Artists also might offer an art workshop at a community center or in their own studios; they may donate a work of art for a charity auction, and they can arrange for smaller exhibits in between the larger ones at a school or nonprofit space.

MAKE SURE YOU HAVE GOOD IMAGES

A major part of promoting artwork is offering an opportunity for people to see what it looks like. Art gallery owners want to know; so do juried exhibition sponsors; public art commissioning bodies; the media; university art departments hiring instructors; foundations and public arts agencies that provide grants and fellowships; and exhibition curators and prospective buyers. It is a rare event when someone wants to display or buy a work of art sight-unseen, but a good-quality image may lead to an interest in viewing artwork in person. Those images may be in the form of slides, photographs, or digital images on a CD-ROM (perhaps a DVD) or on a Web site.

For decades, artists have photographed their work and sent slides (in slide packets) to gallery owners, the media, and others, and some still do. However, slides are on the wane these days, since few dealers, art departments, editors, or anyone else have slide projectors (ones that work, at least), and these machines are not being produced anymore. Slides are conveniently compact, but it is not easy to tell much about a work of art that is reduced to a one-inch square and held up to a light source, which is how those without projectors or light tables need to look at them. Another method is making prints from the photographic images and producing an album of, say, twenty images that could be sent. Art dealers generally don't object to receiving albums, which show the art larger and without the glare of a light source on the other side. Photographs, especially those in an album, are apt to be looked at longer than slides, and the album may be left open on the gallery owner's desk, enabling that person to take a second look. On an individual basis, photographs are less expensive to produce than slides, although the savings may be offset by the increased cost of mailing a bulky album to a dealer or somewhere else. Digital images printed on plain white paper are less expensive, too.

Increasingly, artists are taking digital images of their work and creating CDs or DVDs that can be sent. Everyone who owns a computer has the ability to view the

images on these discs and, in fact, a growing percentage of the juried art competitions and art fairs require images to be sent online (along with the online application).

The larger question is not whether to send slides or photographs or CD-ROMs but what the recipient actually wants (and if that person wants them at all). Artists should call or write the dealers (or galleries or corporations or art schools or juried competitions or magazine editors) to find out what type of presentation is wanted and when they are interested in receiving images and other information. Some dealers, for instance, only think about expanding their gallery roster look once a year—in the summer, for instance. Artists who send images to such a dealer in January are likely to miss the viewing opportunity.

Whether one uses slides or photographs or digital images to represent one's work and career, they should be made with care. A high quality 35mm camera with a 50mm or longer lens (a wide-angle lens may cause distortion) should be used, set on a tripod (especially when shutter speed is below one-sixtieth of a second) to prevent accidental movement. Using a grey card when shooting slides of white-ground work is important, as is employing a black fabric backdrop, clean white wall, or white paper background to hang the work being photographed. The camera will be placed parallel to the work (in order to reduce distortion and blurriness), and the alignment should be checked with a small level on both the camera and the artwork. The photograph should be taken indoors in order to control the direction and distance of the light source. All natural light should be eliminated from the room so that the set-up is the only light source. Tungsten light bulbs should be used for correct color temperature, set at forty-five-degree angles on either side of the flat artwork. Of course, any protective glass should be removed from the framed artwork. If the work reflects light, one might use polarizing filters on the lights and camera, increasing the exposure by 1½ stops to compensate for the camera filter. One might also experiment with the light source (diffused or aimed directly on the object, perhaps bounced off a white wall) to determine how the work being photographed looks best. It is usually less expensive to take the same picture more than once than to make duplicates. The artwork should fill the photograph; furniture, wallpaper, or other artworks in the image are distracting and may work to the detriment of the art (What if the viewer doesn't like the upholstery on the sofa below the painting?). If it all seems overly complicated, hire a professional photographer (particularly one who specializes in this kind of work). It may be expensive, but it's worth it.

The artist's name, the title of the artwork, its medium and size, a copyright notice and the year in which the piece was created should accompany each image. In general, fifteen to twenty is the customary number of images that are sent to dealers, corporations, foundations, exhibition sponsors, or schools, unless they specifically request more—juried art competitions usually specify how many slides they will look at. Gallery owners and the agencies that provide fellowships prefer to see an artist's current body of work and subject matter, with an emphasis on consistency rather than a retrospective of one's entire career. However, art schools are likely to be interested in a more retrospective approach that indicates an artist's versatility and capability of teaching a wide variety of students.

Artists should prepare a package of information for the recipient that includes the images, the C.V. (or list of exhibitions and critical notices), a cover letter that introduces the artist and mentions what he or she is looking for (gallery representation, a job, a commission), and a self-addressed, stamped envelope (if the artist desires to have the images returned). The return postage envelope is very important, as galleries may be unwilling to spend money to return something that was generally unsolicited to begin with, and they also resent the artist's failure to include it. However, galleries often place images and information on artists in file cabinets, look back on this material months or perhaps a year or two later, and then call the artist to ask if he or she is willing to show work at the gallery. Requesting the return of artwork often results in closing the door on an opportunity. Other dealers, however, don't want to hold onto artists' images and written material because of storage problems. Still other galleries are not interested in receiving over-the-transom submissions and want only to see images of artists they solicit. Again, it is best to make an inquiry before sending or dropping off information.

The more contained this packet is the better, as a cumbersome package of loose clippings and other bits of information that are difficult to contain or to put into the return postage envelope makes a poor first impression. Many art dealers receive between ten and thirty of these packages a day; by necessity, they approach them hurriedly, and a messy presentation engenders an irritation with the artist, which is a poor way to begin a relationship.

MARKETING AND SALES

The business term for making the public aware of what one has to offer is marketing, which simply means finding an audience. Who are the people most likely to understand and appreciate the type of artwork you create? Not everyone will get it or like it, and it shouldn't be assumed that everyone should; more people have seen and not purchased a work by renowned painter Chuck Close, for instance, than have bought pieces, and it isn't just because of the high prices. His paintings are too large for some would-be buyers; other collectors may appreciate his techniques but aren't interested in his self-portraits or portraits of his artist friends. Yet other collectors of postwar contemporary art prefer abstraction or sculpture. And then there is the price. The universe of prospective art collectors gets whittled down more and more until we come to a very small number of people who actually buy the work of this famous artist.

MARKETING

All artists who have achieved success—defined as the ability to sell their work, particularly the ability to live off the sales of said work—have needed to find that audience. In some cases, geography offers some help: artists of the western landscape are more likely to find buyers in the western half of the country than in the East, while marine artists are apt to interest collectors along the Atlantic and Pacific coastlines. Practitioners of performance art, installation art, and conceptual art have narrower avenues to pursue within a few cities and some college campuses.

Exhibiting artwork and eliciting reactions is how artists begin and, over time, refine the process of marketing. First and foremost, artists want to know if people understand and like what they are doing. A negative reaction may indicate that the wrong people are looking at one's work, or it may mean that the art still needs improvement and isn't ready for general exhibitions and sales. It is wise to solicit the responses of professional artists in the area, perhaps faculty from art schools, who can evaluate the artwork and offer suggestions for the art or, perhaps, where else it might be shown. The next question is, which people are most likely to appreciate the art. Artwork that contains references to contemporary pop culture is more likely to be enjoyed by younger people, for example. Avid golfers are frequently interested in paintings of the thirteenth hole at Augusta.

Exhibitions often have guest comment books in which visitors are invited to record their reactions, and it is a good idea for artists to have someone else at an art show—friend, relative, spouse—direct people to these books and ask them also to leave contact information so that they may be notified of future exhibits, lectures, demonstrations, and open studio events. As valuable as the comments may be, artists will want to know something about these people: are they homeowners or renters, city dwellers or suburbanites? Do they regularly go to art exhibits and, if so, do they collect? What do they collect? Do they belong to any clubs or associations? The income level, age, gender, nationality, and race of the visitors who offer the most positive responses to the artwork will enable artists to better determine where future exhibitions might be planned and who should be invited. If there is a sale, it is advisable for the artist to personally deliver the piece to the collector's home in order to learn more about them: What is their color scheme? What rooms in their home might be suitable for art?

Visitors who show significant interest in an artist's work could be invited to his or her studio, where they can see more pieces and more privately. If that seems a bit pushy, the meetings could be at museums or art galleries, or just cafés. What often sells collectors on art is a personal investment they make in the artist through time and conversation. For artists, the conversations operate on two levels: on the one hand, they are presenting themselves as professionals while discussing art or non-art subjects, or even something more personal; on the other hand, they are obtaining information as a marketer that may help them in their careers. For instance, a collector's (or a collector's spouse's) birthday or anniversary may become an opportunity to purchase something from the artist, and having learned when these events happen, the artist may use that knowledge to send out an e-mail or flyer. If the collector is Jewish, an artist may send a note suggesting a Hanukkah present. Christmas, a graduation, a family reunion, anniversary, Mother's or Father's Day, Valentine's Day, and other, perhaps more personal events are also occasions to contact prospective buyers about making purchases. Art is a long-term career, and the relationships with buyers should be maintained on an ongoing basis, with regular communication and get-togethers. No one wants to feel wooed and then dropped after the check clears, and that will diminish the likelihood of further sales.

SALES

Marketing and sales are often spoken of in the same breath, but the two are distinct, if related, concepts. While marketing involves identifying one's audience of potential buyers, sales concern the steps leading up to an actual transaction. Certainly, both marketing and sales require words and images: press releases, lectures, flyers, demonstrations, and advertising are important components of marketing, while specific conversations about an artist's background, influences, techniques, types of media, sources of inspiration, and intentions inform what might be called the sales pitch. (The ability to discuss and negotiate price is also important, but that conversation comes after likely collectors have been alerted to one's artwork and have shown a willingness to buy.)

Artists represented by galleries expect dealers to speak on their behalf. However, artists who sell directly to the public (out of their studios or at art fairs or other exhibitions) need to feel comfortable speaking about themselves and their work as well as have some idea of what to say. It is also important to know when and when not to talk. An artist holding an open studio event or manning a booth at a fair would not want to rush at people coming in nor would he or she let visitors who have spent time looking at artworks go completely unattended until they just wander off. A visitor to the booth who lingers over a few landscapes might be approached with a comment about where they were painted and when. Has the visitor ever been there? The artist might say, "I like the way the hills catch the light at a certain time of day," "I was reminded of a Cezanne landscape," "The two women over to the left are my wife and her sister," or, "I started the paintings outdoors but ended up finishing it back in my studio, because a coyote seemed to be circling me." Exactly what is said, and where a conversation leads, depends on individual circumstances, but having something (not obvious) to say that gives viewers some insight or back story usually helps to drive interest in artworks. The more people understand what they are seeing (especially information that they have but others won't), in most cases, the more they are apt to like it, and that connection to the artwork is a step on the road to a possible sale.

It isn't necessary that artists be polished speakers when conversing with prospective buyers, but they should formulate a certain group of topics to bring up on which they feel comfortable speaking. They should not speak in art-school critique jargon ("using a post-structuralist analysis . . . "), and it is wise to gauge from the faces of the booth visitors how much information is too much information. It is best to speak positively about other artists and collectors (dishing can be fun, but can make people wonder what you say about them when their backs are turned), and it is advisable to bring the other person into the conversation by asking questions. What type of art do you like? Are there any pieces here you especially like? Do you have any paintings or prints in your home? Do you do any painting yourself? The back-and-forth of conversation creates a tie between artist and visitor—an investment in time and interest—that makes sales more likely to occur.

Nina Pratt stated that artists "need to know how to shut up. You want to draw out the client, because most people like to talk while they look at something new, by asking leading questions, such as, 'How do you feel about this? What's your reaction to that?'

You want to get the buyer to thaw out. If the artists do all the talking, it feels like they are imposing their own views, and potential buyers don't want to commit themselves to anything."

She added that "comments may frequently be inane, such as, 'Well, it certainly is a large painting,' and the artist should respond with something like, 'I'm glad you noticed that. What else do you see in my work?' You have to decide which is more important, wounded pride or one's pocketbook. Most artists prefer their pocketbook."

Artists have other ways to communicate with would-be collectors as well. Many prepare artist statements, which may be displayed along with the art at an exhibition or on a Web site, and a growing number of artists maintain Weblogs, or blogs, on their own sites or somewhere else. It should be remembered that written communication is different from the spoken kind; people tend to be more forgiving of errors of agreement or usage, for instance, in the spoken word than they are in a written document. Speaking in a folksy manner in person can seem natural and intimate to listeners, while a folksy written statement looks artificial and pretentious. All this makes blogs and especially artist statements more problematic. They are an opportunity for artists whose work may be quite pleasing to make a poor impression.

ARTIST STATEMENTS

In general, I don't like Artist Statements, because I've read so many of them that aren't interesting ("My landscapes reflect my interest in painting the natural world") or that can be said about any artist ("I have been drawing and painting ever since I was a child") or that are poorly written or say something beside the point. It doesn't seem fair that artists, who excel at expressing themselves artistically, are forced to re-express the same ideas in another form. The problem is, more people can read and understand what they read than can look at and understand art. Museum directors and curators often note that long explanatory labels next to artworks dominate the attention of visitors, who spend the same amount of time in the galleries whether there are long labels or not; when the labels are long, they spend more of that time reading than looking. The words become their art experience. The artist statement that doesn't lead directly into a long look at the artworks on display may be detrimental, because visitors may keep the words in mind rather than the images. A poorly conceived or written statement is apt to make visitors think badly of the artist.

Artist statements tend to be used at an early stage of an artist's career—better-known and more established artists don't use or need them, instead relying on their dealers or published critical essays (often available as handouts to visitors or viewable in a notebook or catalogue) to describe who they are and what their art is about—and, as a result, they are associated with not having progressed far in one's career.

However, some exhibition sponsors may require artists to post a statement. As with introductory conversations with potential collectors, a useful artist statement should offer insight into the creative process or the artwork on display in plain language,

for instance, "These paintings were done while on a visit to Morocco." "I became interested in welded metal sculpture through looking at the work of David Smith." "Outrage over the genocide in Darfur led me to depict the victims of ethnic violence there and elsewhere."

Artists should ask several people to read their statements before posting them. They should check for spelling, grammar, sense, and how interesting it is. Better yet, artists can ask people who aren't friends or relatives—maybe, people who don't like them very much—to look over the statement in order to determine whether or not it presents the artist in a positive light.

COMMUNICATING IN THE DIGITAL AGE

Cutting costs is the byword of our time, but it is not always clear which expenditures are essential and which can be eliminated more painlessly. For instance, a growing number of artists and art galleries are experimenting with getting rid of printed and mailed event announcements and flyers. It is a clear source of savings and allows people to feel ecologically conscious. In the digital era, too, a paper trail can seem superfluous, and modern, online forms of communication have offered a variety of other ways for people to be in touch. What remains to be seen is if the buying public responds to e-announcements in the same way they do to printed ones.

"We just started doing e-mail announcements of our shows this past September," said San Francisco gallery owner Rena Bransten, "and it's a big cost savings." The old flyers, which needed to be designed, printed, and mailed, cost the gallery between $30,000 and $36,000 per year. The gallery still hires a designer to create eye-catching announcements, but otherwise the "e-mail announcements cost almost nothing."

Other art galleries are experimenting in this area, too. New York's Maxwell Davidson Gallery began sending out e-mail announcements for all its exhibits in the beginning of 2009, in addition to printing and mailing the traditional flyers to its list of collectors, critics, and other interested parties. Based on turnout at openings and sales, the gallery has been attempting to ascertain which type is most effective. Maxwell Davidson's costs for those flyers are similar to Rena Bransten's, between $2,000 and $3,000 per month, and "in the future, we will separate out which of our shows get mailers and e-mails and which will only get e-mails," said Cara Marino, the gallery's registrar.

"I would like to switch completely to e-mail announcements," said Kat Parker, director of the Rhona Hoffman Gallery in Chicago, noting that "a lot of people say they don't want paper or anything else sent to their homes." When enough people claim they don't want regular mail, perhaps the gallery will make that switch. Until then, it will continue to both mail and e-mail flyers, not saving any money but casting its web more widely.

To a certain degree, the move toward e-mail-only communication is becoming less of a choice for gallery owners and, by extension, for artists. Fewer and fewer actual and prospective collectors offer their traditional home addresses and home telephone numbers on those sign-in books at the gallery desk or when they meet dealers at galleries or

art fairs, preferring the more anonymous cell phones and e-mail addresses. Jessica Martin, a painter in Healdsburg, California, stated that between one-quarter and one-third of her mailing list is e-mail addresses only, and she claimed that "the Internet is the primary source of information for more and more of the people interested in my work." The artist sends "physical announcements"—postcards and flyers—for major events, such as solo exhibitions but e-mails for everything else (inclusion in a group show, updates about her career, and notices about newly produced paintings and new galleries representing her work). When people on her mailing list move, the postcards are often returned by the postal service, "but people keep their e-mail addresses, so they get the information anyway."

These modern forms of communication allow would-be buyers to be more accessible wherever they are and whatever they are doing, and it is also a way of being "green" by opting out of the cut-down-trees system of information dissemination.

Sometimes, of course, round-the-clock accessibility sounds better than it actually is. "I called up one collector on his cell phone to ask, 'Are you still interested in that $35,000 painting?' and he said, 'I'm in the bathroom now,'" Louis Newman, director of New York's David Findlay, Jr., Fine Art, said. "Another time, I called up a collector who told me that he was in his doctor's office." After that, Newman specifically began to request landlines when asking for contact information of gallery visitors and collectors. Those kinds of awkward moments occur with increasing regularity these days. "It's not a big deal," said Andrew Witkin, director of Boston's Barbara Krakow Gallery, who has had similar experiences. "Everyone's polite and understanding."

Few galleries have jumped head-first into cell phone and online-only communications. "We use e-mails when we send announcements out to critics and the press, telling them that a show opens in x number of weeks, for instance," said David Lieber, director of New York's Sperone Westwater gallery. For regular visitors and their clientele, however, the gallery mails out postcards, flyers, and invitations, which is a major expenditure, between $100,000 and $150,000 per year. "There is something unique about an announcement for a show. It's a piece of ephemera connected to the show that you can hold in your hand."

No one really sings the virtues of $150,000 ephemera, however. Sperone Westwater pays to print and mail announcements because the gallery doesn't trust people to read and save emails. "People wake up to fifty e-mails in their inbox every morning, and the first thing they do is look for the ones they can delete," Lieber said. "I routinely delete batches of e-mails." He also doesn't bring a datebook to the computer in order to jot down exhibition openings, and even the e-mails Lieber doesn't immediately delete, he rarely keeps for more than a day or two. A printed announcement, on the other hand, takes more looking at; it can be left somewhere that he will see it again or attached by magnet to the refrigerator door. If prospective buyers at the gallery or at an art fair booth only offer their e-mail addresses, "we'll ask for more information, and we usually get it."

Next to the crowd of e-mails stuffing inboxes, an interesting piece of regular mail can be a treat. Several art dealers noted that a postcard can be unique in look and texture, while e-mails tend to be more alike than different. "The feel and typography is different with every one of our announcements," said Ron Warren, director of the Mary Boone Gallery in New York, noting that "e-mails have a sameness to them." Being unique has its price, however, as each gallery card may cost $5 to print and mail to people on its three-thousand-person mailing list.

To a certain degree, there may be a generational divide in the e-mail vs. regular mail discussion. "Clients who are forty-five to sixty-five need a postcard or something that they can hold in their hands," said Deborah-Jean Harmon, director of the San Francisco art gallery Hang Art, while younger buyers prefer e-mails, text messages, and tweets. Hang Art, which features local, emerging artists and sells to a younger clientele, also communicates through social networking sites, such as Facebook and Myspace. "That really brings people to openings, keeps the buzz going, keeps us in the scene," she said. Slowly, the gallery is weaning itself off of printed mailers, down from seven thousand postcards per month (costing almost $2 per postcard) to between two and three thousand. "It's earth-saving," and money-saving, too.

Sending out a large number of e-mails at one time—the term of art is an "e-mail blast"—is usually forbidden by Internet Service Providers such as Yahoo! and AOL, requiring artists, galleries, and other small businesses to hire an e-mail marketing service, of which there are dozens around the country. The costs are generally low and based on usage: Constant Contact, which is based in Waltham, Massachusetts, charges a $15 fee for sending up to five hundred e-mails per month, $30 for between 501 and 2,500 e-mails, $50 for 5,001-10,000, and on and on. The San Francisco-based Vertical Response has a $10 fee for up to five hundred e-mails in one month, and Benchmark Email in Long Beach, California charges $9.95 for up to six hundred e-mails per month, $12.95 for up to 1,000 and $19.95 for 2,500. All of these e-mail marketing service companies provide JPEG templates on which one may create a new message or announcement, along with images, hyperlinks, and the opportunity to group lists of e-mail contacts (for instance, only recipients living in Illinois and Indiana) for blasts that are more targeted. They also offer other services that might be useful, such as being able to tell whether a particular recipient opened an e-mail or just deleted it outright, whether the recipient linked to another site from the e-mail, and if the e-mail bounced back because the address is no longer valid.

Phillip Hua, a painter in San Francisco, stated that he uses the Belgian-based YourMailingListProvider.com, which charges $3.75 to send out up to five hundred e-mail newsletters per month. "I let people know about special events, such as open studios or exhibitions, and new works I've completed and updates on my artistic progress," he said. "I want to remind people that I'm still here and that, if they are thinking about purchasing artwork, they should think about me."

In the gallery world, a rule of thumb says that dealers need to make seven "touches" for every sale. Those touches now come in many forms, from the traditional

face-to-face meetings to calls to mobile, office, and home phones; e-mail and regular mail; texting; tweeting; and any combination thereof. New technology allows more ways to keep in touch, and each of these forms of communication have their own weight with different audiences.

THE DISAPPEARING ART CRITIC

We are living in the great age of opinion writing, of critiques and commentaries, so why are so many of the art critics disappearing from major metropolitan newspapers? (Hint: It's not just fine arts but book and performing arts critics as well.) Perhaps more importantly, what does this mean for artists looking to advance their careers?

For most of the postwar era, and even before that, critics have acted as the conduit between artists and the general public, and artists have relied on reviews to generate discussion of and interest in their work. Sometimes, that has led to contentious relationships between artists and critics, but even an unfavorable review produces awareness. As the songwriter George M. Cohan reportedly said, "I don't care what you say about me, as long as you say something about me, and as long as you spell my name right."

These days, a lot less is being said. Newspapers that used to have full-time art critics—the *Boston Globe*, the *Dallas Morning News*, the *Detroit Free Press*, the *Fort Worth Star-Telegram*, the *Hartford Courant*, the *Houston Chronicle*, the *Indianapolis Star*, the *Miami Herald*, the *Philadelphia Inquirer*, the *Wall Street Journal*—no longer do, and the jobs of writers who were hired originally as critics have morphed into general assignment feature writers who may get to do an occasional review. "I was hired as an art critic, but I'm increasingly doing other things, some of which have nothing to do with art," said David Bonetti of the *St. Louis Post-Dispatch*, who still refers to himself as "the only salaried art critic in St. Louis." Fighting with his employers for the job he was originally hired to do "would not be to my advantage."

Other newspaper writers tell the same story. "I write about the visual arts but, if I'm writing about an exhibition at a museum or gallery, I'm not talking about the show curatorially or aesthetically," said Jonathan Marx, who once reviewed but now just reports on the fine arts for the Nashville-based *Tennessean*. "If I express opinions, they have to be quotes from different people." Sara Pearce, once the designated art critic and now a features writer for the *Cincinnati Enquirer*, is permitted to offer opinions about art, but only on her blog on the newspaper's Web site. "I'm certainly critical there, and I say a lot of things, but otherwise I'm a reporter, covering architecture and books as well as the arts." She added, "No one really does art criticism here anymore."

The declining number of newspaper art critics alarms Eleanor Heartney, a past president of the United States section of the International Association of Art Critics, who described "a trend in publications away from substance. Artists are treated as entertainment." However, Sara Pearce's job downgrade does not reflect an antipathy to the arts, according to her boss, William Cieslewicz, assistant managing editor for features at the *Enquirer*. That newspaper and most others across the country are losing readership and advertising revenues, resulting in staff cutbacks. "Full-time critics are viewed as a

luxury," he said. "The only critic we have left is our dining critic, but there has been discussion about keeping that." The *Enquirer* still encourages airing reviews of arts and other cultural events, he noted, through the newspaper's Web site, where readers are "invited to post their opinions on what's going on locally. Most of these reader reviews are for restaurants and movies."

However, the lack of art reviews hasn't had an adverse effect on museum and gallery attendance in Cincinnati, nor on sales, according to several art dealers there. "Our business is very active and good," said gallery owner Carl Solway, attributing the growth in sales to new buyers that are met at the art fairs he attends as an exhibitor in Chicago and New York City. Business is also good at the Phyllis Weston-Annie Bolling Gallery, even though "we haven't gotten a print review for over a year," according to gallery director Kate Yellig. The Malton Gallery is only "doing OK," said its owner Sylvia Rombis, who ascribed lackluster sales to the state of the economy and the gallery's difficulty in expanding its buyer base to younger collectors. "To have a viable section in the paper where you could read an intellectual discussion about art would be awesome," she said. Still, that might not solve all her problems, because "younger customers aren't newspaper readers anyway."

Certainly, the disappearing newspaper critic has made the job of promoting artists and their exhibitions much more difficult, which has led to the development of different strategies. Shannon Wilkinson, president of Cultural Communications, a New York City-based public relations company specializing in the arts, noted that newspaper executives have found "the level of art advertising is too low to merit paying critics' salaries." She recommended advertising in newspapers and magazines, because advertisers "are more likely to get reviewed, although that's not a guarantee." She also stated that arranging an exhibition overseas, particularly Europe where the major newspapers still have salaried critics, is a way of obtaining critical attention, and "writers in the U.S. pay more attention to artists who have been written up in Europe."

The experience in Cincinnati demonstrates that galleries don't necessarily require reviews to promote their exhibits to the public and have strong sales. Perhaps, it also reveals that individual artists may not need critics to validate their careers either. Artists often stockpile reviews, which are placed in media kits that are mailed to editors and writers at newspapers and magazines in advance of an exhibition. The kits usually contain a brief biography (in narrative or résumé form), images of their work (slides, photographs, or a CD-ROM), and occasionally an artist statement (noting sources of inspiration, the technical process involved in the art-making, artistic influences, or past projects), as well as past reviews and feature articles about the artist. These reviews and articles are important both to editors, who want to know that the artist has been deemed worthy to be written about in the past, and to writers, who want to know what others have said. Media kits still have their place, but in the new world of declining newspaper readership and growing use of the Internet as a primary source of information, artists, galleries, and museums are also finding different, increasingly online ways to promote themselves to journalists, collectors, and the general public.

"We're a 100 percent online company," said Christina Duren, publicity director at New York City's Ariel Publicity Artist Relations. "We work with bloggers, Webzines, podcasts, and Internet radio stations to get reviews and interviews for the artists we represent." Marketing to the Internet, she noted, has proven successful in various realms of the arts, adding that correlations have been found between popular music albums that are mentioned in numerous blogs and increased sales of these recordings, as well as the fact that heavily blogged news stories are more likely to air on the evening news.

Blogs often solicit responses by readers. Often, one blog "links" to—that is, allows readers to access by clicking on—other blogs and Web sites, which increases the likelihood that it will be visited and read. Some blog writers have greater influence than others, which can be charted by how many links are made to that site. "It's a very good idea to promote yourself to bloggers selectively and strategically, depending on what you are trying to engage them with," said Sasha Freudenheim, vice president of the Manhattan-based Resnicow Schroeder Associates, a public relations agency that works with many museums. "Bloggers seed the attention of the mainstream journalists," which may lead to reviews, articles, or other coverage.

A first step to find the most appropriate bloggers is using a blogging directory, of which there are many (www.*blogsearchengine.com*, www.*bloghub.com*, *http://blog-search.google.com*, and www.*bloggeries.com*, among other—one of the more all-encompassing sources is *http://dir.yahoo.com/News_and_Media/Blogs/Blog_Directories*). Bloggers usually offer an e-mail address for responses, and artists may contact them informally, inquiring whether they would be interested in receiving information on the artist or upcoming exhibition or new project or anything else. They may also attach a press release or link to the artist's own Web site.

Joan Stewart, a publicist in Port Washington, Wisconsin, also recommended that artists create their own blogs and add comments in the "forum" sections of artists association Web sites, all as a way of increasing the opportunity for their names and sites to come up in an online search. "Nine out of ten journalists do their research online," she said, adding that more and more collectors learn about artists not just by reading print reviews or feature articles but by making a search using an Internet search engine, such as Google or Yahoo! In this new world, artists may get their work looked at and talked about without necessarily having a gallery exhibition—or through creating a "virtual" exhibit—by posting images online on their own Web sites, linking them to other sites and even making a video of themselves at work (or just of their work) and posting that on YouTube or other video-sharing sites. "People love videos, search engines love videos," she said. "You'll love that you can post it for free."

CRITICAL ESSAYS DISAPPEARING, TOO

Customarily, when painter Ben Aronson's work is exhibited in a gallery, a catalogue is published filled with images of artworks in the show and an appreciative essay by a critic. Karen Jenkins-Johnson had a catalogue for the late fall 2008 Aronson show at her

San Francisco gallery, but this one didn't have an essay. "People—clients—aren't read-ing essays," she said. "They just want to see the images and a C.V." Essays are also expensive, costing several thousand dollars, "and I have to recoup that by selling another painting, or maybe half or quarter of a painting." Every penny counts these days; in a world of ever-rising rents and intense competition for sales, a $1 to $3 per word essay may be the most expendable luxury.

Emily Mason is another artist whose solo gallery exhibits are accompanied by catalogues with both words and pictures, but the catalogue for her February 2009 show at David Findlay, Jr., Fine Art in New York City has images but no critical essay. The reason, gallery director Louis Newman noted, is that Mason has "a large and loyal cli-entele who just want to see the images, to see what she's doing now. Her clients think they know more than any writer. They don't need some thirty-year-old telling them why they should like her work."

Many gallery exhibition catalogues continue to include essays, offering bio-graphical, art historical, and technical insights about the artists, but a trend is emerging: the catalogue essay is slowly fading away, replaced by a dealer's penned tribute, by a brief question-and-answer page, or by nothing at all. "The word has become just a lot less important in these days when everyone has computers and iPods," said art critic Dore Ashton, who used to write catalogue essays frequently for gallery shows but now only for exhibitions that take place in Europe. "No one here reads that much." Or, more properly, visitors to galleries may not read exhibi-tion catalogue essays as much as they once might have done. Both Newman and Jenkins-Johnson stated that they have received blank stares when mentioning to prospective buyers an idea written up in the catalogue essay. "Most times, no one notices if an essay isn't included," Andrew Arnot, director of Manhattan's Tibor de Nagy gallery, said. The essay is rarely a part of conversations he has with collectors, and it does not appear to be a factor in a collector's decision if or what to buy. As a result, the Tibor de Nagy gallery also has foregone catalogue essays, at least some of the time.

Not every dealer takes this view. New York gallery owner June Kelly stated, "I have essays in every catalogue, and I always have," claiming that part of her role is educator. "I see the general public needing information. I want to give people a sense of what the work is about, a point of reference." She added that essays are helpful to visitors to the gallery who are not collectors—yet—and simply need a way to understand what they are seeing. Still, the connection between the information essay and actual sales is tenuous, and their continued inclusion is based on the belief that it is the right thing to do rather than it is a proven marketing tool.

There may be no way of knowing who, if anyone, reads these essays. "Art critics read them," said Kim Levin, an art critic and past president of the International Association of Art Critics, adding that what critics write is influenced by what others have written. She added that exhibitions come and go, and the ideas about the art found in the written essays may have a longer resonance than the memory of the images. For

many professional critics, writing catalogue essays form a substantial portion of their income; catalogue essays indicate, among other things, who's hiring.

The artists themselves read them. George Schectman, owner of New York's Gallery Henoch, stated that the essays "are more important to the artists than to the gallery." When the choice is made to hire a writer, which is frequently an economic decision (at many galleries, artists contribute to the cost of exhibitions), the critic is approved by the artist in advance (sometimes, the artist proposes an essayist), and the essay also must be OKed by the artists before being published. However, Schectman said, "artists are much more critical about the color reproductions in the catalogue than about the essay."

The artists are probably onto something, since most gallery owners claim that buyers are sold on the images rather than what is said about them and who is saying it. Emily Mason claimed that she prefers "not to have an essay, as it takes up space that could be used for reproductions. Essays take time that could better be spent looking at the art." Stuart Shils, whose paintings are currently being exhibited at the Tibor de Nagy gallery, stated that he doesn't regret the lack of an essay in the exhibition catalogue, since he claims to have "read some pretty vacuous, self-serving stuff in their catalogues" in the past. He added that the absence of an essay seemed a bit jarring at first, but "maybe, it is just a matter of something to get used to."

In general, according to San Francisco gallery owner John Pence, "the vast majority of collectors go straight to the pictures," adding that "museums and libraries are more likely to be interested in the essays." The usual print run for an exhibit at his gallery is 4,500, and only 10 percent of that group—150 to members of the press, 150 to schools and 150 to libraries—may focus on the text.

THE ACTUAL SALE

Selling art without intermediaries takes some getting used to. The last major area of awkwardness is the actual sale, as the subject of money often makes everyone a bit squeamish. Again, the artist needs to take the initiative in closing the deal, although it may be easier to proceed by focusing attention on which piece(s) the collector seemed to prefer as well as how, when and where the art should be delivered. The payment question can be brought up in the form of "Do you want to pay me now or upon delivery?" Other possibilities include being paid half now, half later or some form of barter.

When artists sell their work directly, rather than through a third party, they need to utilize many of the same sales techniques as gallery owners. For example, artists should have brochures, postcard images, and other written materials (such as a bio and a price list) readily at hand. Fumbling in a desk or file cabinet for an exhibition history takes away from the impression of the artist as a professional who is prepared to sell work, and prices that are not committed to paper may suggest to potential buyers that they are made up on the spot with the amounts dependent upon the artist sizing up the

collector's financial resources and whether the artist likes the buyer or not. Art is a form of communication: the better the level of understanding is between artists and collectors, the more interaction between them, the greater the investment that the would-be buyers make in the artists. There is no rule-of-thumb concerning how much conversation results in sales, but purchases and commissions become more likely when there has been ample communication.

If would-be collectors are expected to purchase works from the artist's studio, there should be some area within the studio set up for displaying art. Artists should follow a collector's interests, determining an individual's preferences in media, size, colors, and subject matter and showing additional works that correspond with those tastes, rather than attempt to direct a potential buyer to particular works they would like to sell. Artists may offer to bring a selection of works to the collector's home or office in order that the buyer can choose the piece(s) that work best in the environment. In most cases, the delivery of the sold work of art should be at no additional charge to the collector.

Delicately, artists should try to discern the buyer's budget, leading that person to pieces that are priced in that category, rather than attempt to urge the collector to spend more than he or she feels comfortable with. Artists may also offer a returns policy, allow a buyer to change his or her mind about the piece within a week or two, or permit collectors to take the object home on a trial basis (again, a week or two) before paying. Collectors may want to pay over time or pay through trade (other artwork or goods and services), which is taxable income but not the hard cash with which to pay the tax (see chapter 3, "Bartering and Leasing Art"). A measure of flexibility in price and the manner of payment entails increased risk for the artist, but it may also inspire greater confidence on the part of the collector.

Some written document, either a straight bill of sale or a sales agreement, should accompany the transaction. The bill of sale will indicate all relevant facts about the transaction, such as the artist's name, the name of the artwork, the work's medium and size, the year the work was created and if it is signed (and where), the price of the piece, and the date of sale. A sales agreement will include all those facts as well as add some points that are advantageous to the artist, such as reminding the buyer of the artist's rights under the copyright law, as well as allowing the artist to borrow the work (at his or her own expense) for up to sixty days once every five years in the event of a gallery or museum exhibition and permitting the artist access to the work in order to photograph it for his or her portfolio.

Artists who sell directly to customers should obtain a sales tax number through the state department of taxation (the number usually is one's social security number, and there is rarely any charge for receiving this number) and add a sales tax to the price of the artwork they are selling. Every state has its own percentage tax for sales. An added benefit of having a sales tax number is being able to either deduct the sales tax that one pays for art materials or not pay sales tax at all if the materials are incorporated

into a work for resale. The artist should contact the sales tax bureau in his or her own state concerning the sales tax laws (see "A Word about Taxes" below).

Those pieces that one does not want to sell should be clearly marked ("NFS"— not for sale—for example) in order to eliminate the potential for misunderstanding between artist and buyer (if the object isn't marked in advance, a collector might wonder why the artist won't sell that work to him or her). Collectors may ask for discounts, sometimes rather steep discounts if they know that the artist isn't going to pay a 50 percent commission to a gallery owner. (5 to 10 percent discounts are not uncommon in the gallery world for regular clients.) At art fairs, there are buyers who wait until the last hour of the show to approach the artist and offer 50 cents on the dollar for one or more pieces, knowing full well that the artist has to pack up and transport everything that doesn't sell, and some artists will take that deal. Whatever artists decide, they need to have thought some policy through before entering in on a sale, because it is awkward and difficult to come up on the spot with a stance on the subject of discounts, especially when dealing with a buyer who may be particularly skilled at negotiating, and it can be even more troublesome if the conversation comes up when other prospective collectors are nearby. Again, artists may want to follow the lead of gallery owners, offering a small discount to longtime buyers or to new collectors who are purchasing more than one piece.

A problem with discounts is that it brings up a level of gamesmanship that seems to be less about the art and more about how crafty the buyers like to see themselves. Some dealers won't allow discounts but will throw in the frame for free or provide free delivery as a way of assuaging collectors who need to feel that they received some sort of price break that others did not. The largest problem with discounts is that it turns artists into car salesmen, and no one likes or trusts car salesmen; automobile buyers, even those who have dickered the price as low as possible, drive away thinking that someone else might have done even better. The simplest policy and the cleanest answer is not to give discounts to anyone, although it certainly may be difficult to watch someone with money walk away empty-handed.

Bypassing commercial galleries and selling directly to the public does not eliminate the need for artists to rub elbows and socialize with critics and customers. In fact, the successful ones usually find themselves doing more of it. Dealers and their commissions are truly the only things sure to be avoided. Selling directly involves a greater interaction with one's audience, which, for some artists, is beneficial both for the art and the sales.

MARKETING AND SALES IN A WEAK ECONOMY

Between the third edition of this book and the current edition, the U.S. economy has suffered two serious and prolonged recessions. One might assume reasonably that before the next edition is published, there will be at least another. The U.S. economy is resilient, but knowing that better times will return eventually doesn't help anyone in the middle of a downturn. Some full-time artists may find that they need to get a

part-time job, while others will put renewed effort into strengthening ties with current collectors and establishing awareness among prospective ones. In that latter category, artists should become more involved in their communities in a public way, such as giving a talk or writing an article in a local newspaper on some arts-related subject—any way of establishing themselves as experts in their fields. Similarly, taking part in a local charity benefit or community project has the potential of generating free publicity. The local media may be willing to profile a specific artist only once every so often, but teaming with other groups (Chamber of Commerce, Habitat for Humanity, Rotary International, or a local museum or school, for instance) offers additional opportunities for one's name and work to be brought up in a positive way.

Artists should make a greater than usual effort to remember the names of the people they meet, and to follow up with a written nice-to-meet-you note and the hope of meeting again. Additionally, responses to e-mails and telephone calls should be prompt, because a prospective buyer's interest may wane if that person is kept waiting. Creating a lasting and favorable impression can make the difference between finding and losing a possible buyer.

Artists with Web sites should take a second look at how easily they can be found by someone making a search; if their site doesn't come up high in a search, they might alter their meta tags or improve their links (see chapter 5). Perhaps, text messaging and videos might be added to their methods of alerting current and would-be buyers to the completion of new work, exhibitions, or other events.

Of course, when finances are strained, ordinarily enthusiastic buyers may show reluctance toward making any purchases, which may prod artists to offer extended payment terms, such as layaway (down payment now, then monthly installments for two or three months until the object is paid for and can be taken by the buyer) or just letting the collector take the work (putting down, say, half the purchase price and paying off the rest over a negotiated period of months). This type of flexibility creates potential risks for artists—will the artist need to hire a repossession company if the buyer stops making payments?—but is more likely to generate good will and more sales.

Another possibility is to accept payment (in full or in part) in the form of barter, such as goods (appliances, food, furniture, or an automobile, for instance) or services (such as the preparation of a tax return, legal advice, or dentistry). Barter is taxable at the ordinary market rate—a lawyer may charge hundreds of dollars per hour—and must be reported as income to the Internal Revenue Service, so it might be advisable for artists in, say, the 15 percent tax bracket to be paid at least that amount in cash. However, the absence of any actual cash as payment could make sense if a new buyer is a good prospect to become a regular collector. Yet another option is to create a loyalty or rewards program for regular and long-time collectors, which many companies offer to their customers, offering a discount on their fourth purchase after they have bought three, for instance. "Easier terms are better than discounting prices," said William B.

Conerly, an economist in Lake Oswego, Oregon who consults to businesses, "and the best customers are the ones who pay you."

On the other side, artists should examine their work and home expenses to determine if there are ways they could reduce spending. For example, artists who rely on professional photographers to produce images of their work may want to learn how to use a camera, or advertising that hasn't produced new buyers over a period of time might be eliminated.

2

Operating as a Professional

Whenever we enter a store, we assume that the business has certain policies (to clearly list the prices of items, for instance, and to take back items found to be defective, offering store credit or a full refund) and adheres to certain standards (treats employees and customers respectfully, as well as provides information on whatever is being sold). No one would enter the store a second time if it didn't do these basic things, and these policies and practices need to be in place from the opening day. The same is true for fine artists, who need to know what of their work is and isn't for sale, the prices of each of their pieces, whether or not they will offer discounts (what percentage discount and to whom), payment methods, whether or not paintings and works on paper are sold with frames (or sculpture with pedestals), how artwork will be transported from one place to another (and who pays for that), and what to say about both themselves and their work.

GETTING READY TO EXHIBIT

What art should cost and how it should be presented are matters that only its creator can decide. These decisions are sometimes made in consultation with a dealer, but they often affect others as well. Sculptor David Smith defied his dealer by keeping prices out of the reach of all but his most ardent and well-heeled admirers—a scornful attitude to a world that he believed had too long ignored and disdained him—and it resulted in very few sales during his lifetime and great misery for his heirs and the executors of his estate immediately after his death. Joseph Cornell bought dime-store frames for some of his works, giving them a sort of mock-elaborate quality, and it turned off some potential buyers.

Artists can clearly be quirky, which may or may not work to their benefit, but most prefer not to do anything that will harm the possibility of sales. There are no hard and fast rules to pricing and framing, but there are ways of playing it safe.

PRICING ARTWORK

Deciding what price to put on artwork is one of the most difficult problems for lesser-known or "emerging" artists, since there is no obvious point of reference. (Artists who have had a history of sales, on the other hand, will have a better idea of prices that are more suitable for particular buyers.) The best way to establish one's market value—the price a collector is likely to be willing to pay—is by going to art fairs, art galleries, and other places where artworks of comparable size, imagery, and quality by artists of similar standing in the art world are sold. Those prices should offer some guidelines for what an artist may charge for his or her works. One should never ask prospective buyers what they would pay for art; that is the artist's decision. One may have some flexibility in this, perhaps offering a discount of, say, 10 percent for collectors who like to negotiate, but the pricing decision should never be taken out of the artist's hands.

As noted in chapter 1, discounts can be tricky, since there is great potential for situations to get out of hand: if an artist offers a discount to one collector, word may get around and every potential buyer may not only ask for but demand the same discount or better; if an artist negotiates a discount with a collector in front of other people but the sale never takes place, the artist may look a little foolish and even desperate. Artists should prepare themselves for these conversations with would-be buyers, steeling themselves to say (for example) that the stated price is the actual price. If a collector says, "So-and-so Artist, whose work is similar to yours, lowered her price, so why won't you?" artists will need to remember that not all art is interchangeable and that those buyers who want a work badly enough will pay the asking price. An artist might say to a discount-seeking collector, "I'm not going to lower the price, but I will throw in a brochure and a personal invitation to my next exhibit." (One may be tempted to say something catty, such as, "If saving money is your goal, she probably is your kind of artist," but that could embarrass and offend the would-be buyer and poison relations with another artist.)

It is often the case that an artist looks to price items in such a way as to achieve a certain per-hour wage, and some attempt to develop a complicated equation that includes cost of materials, rent, utilities, and labor. Such an equation, and a final price for a given object, may exist somewhere, but it does not (and cannot) reflect the market, especially for someone who is new to the field. One artist's painting should not be priced twice as high as everyone else's simply because either that artist's rent is high or he or she doesn't want to feel like a slave. The reasonable price needs to be established first, and all other related expenses need to be adjusted accordingly—if one's rent is too high, one should find a less expensive studio, for instance. If an artist cannot bear to part with a particular work for a low price, he or she shouldn't sell it.

Of course, prices for works will vary greatly from a small town to a major city. An artist whose market is (or is more likely to be) smaller town collectors would want to set prices at the level of those buyers. Similarly, for those artists whose goal is to be represented in the larger urban center, those cities' prices should determine value. The prices an artist sets should be uniform, however, as dealers in cities won't want to have the same works sold more cheaply somewhere else (known as regional pricing). Artists

should feel confident that collectors everywhere will pay what something is worth if they want it badly enough.

When a work is sold directly by the artist to a collector, the artist should create a copy of a bill of sale listing the buyer's name, address, and telephone number; the title of the artwork; and its dimensions, media, and sale price. A copy of the bill of sale should go to the buyer, the original to stay with the artist. The artist's sales record is important for tax preparation, and information about the collector will be useful to have when sending out announcements of upcoming exhibitions.

Raising prices becomes justified as one's market grows and a heightened demand for a fixed supply itself gives the sought-after works increased value. Consider the case of Scott Fraser, for example, a painter in Longmont, Colorado. His paintings were first shown in an art gallery in Denver and sold for $300 in the early 1980s. Some sales took place and, the following year, his prices went up to $900. The value of his work continued to rise to $1,500 and beyond; at present, an average oil painting of his sells for $7,000, with some works fetching as much as $20,000.

"Each time you make a jump in pricing, you have to get a new set of buyers," he said. "I've lost some of the people who bought my work in the early years because they can no longer afford me. Every time you break the couple of thousand dollars barriers with your prices, you have to look to get new collectors."

For Fraser, the plan for attracting new buyers involves keeping in touch with current collectors by letter ("I write to them, telling them what I'm working on, [and] when and where I'm having a show") and also writing to potential buyers when a "lead" is mentioned to him, either by a friend, associate or dealer at one of his galleries. That letter usually includes a biography, slides of his paintings, and a statement about his artistic purpose, as well as some mention of the person known in common (who gave Fraser the "lead" in the first place).

For other artists, raising prices may require finding another gallery or dealer, where opportunities are greater for having works purchased by collectors who will pay more or lend enhanced prestige to the work. Some dealers may only be able to work with emerging artists and not have the contacts to help an artist who is selling work steadily. Changing galleries may be a difficult decision for an artist who got his or her first big break with a particular dealer, and it can be doubly hard in the art world because the relationships between artists and dealers are often on a personal, friendship level.

The issue can be discussed with other artists, some of whom may have experienced the same situation or might facilitate an introduction to their own dealers, or by making direct contact in one form or another with a dealer whose gallery and contacts better reflect the artist's current situation. Networking, passing on information, and using the "favor pool" are the most common ways for artists to advance their careers.

"You have to be discreet when you're looking for a new dealer," painter Nancy Hagin said. "Dealers certainly don't like it if you badmouth them but, of course, why are you shifting and looking around if you aren't unhappy?"

Hagin noted that she "sniffed around . . . put out the word that I was looking for other representation . . . talked to people who knew me and knew which dealers were looking for what," and finally found the right match. She had been represented since 1973 by New York City art dealer Terry Dintenfass and found that she "got a fair number of sales, but I didn't get a lot of shows and the prices were low."

She began sending out announcements for her shows at Dintenfass to the director of New York City's Fischbach Gallery in the late 1970s, later adding a note "that said, in essence, I was restless and had a body of work ready to go. Would he be interested in talking?" The Fischbach Gallery, as it turned out, was happy to represent her work. At the outset, she requested a show every two years, higher prices for her work, and faster payment, all of which she obtained.

"Fischbach doubled my prices immediately"—from $2,400 for a four-by-five-inch picture to $5,000 and up—"and began paying me monthly installments instead of in one lump sum, which is a lot better for me," Hagin stated.

TO FRAME OR NOT TO FRAME

It would be easy to say that most contemporary painting seems to call for relatively simple, unadorned frames—New York City's Museum of Modern Art thinks this way, having reframed a large portion of the works on display in solid metal frames—but many works look even better in a fancier casing, and sometimes the frame becomes an integral part of the artwork. Picasso sometimes placed his own paintings in seventeenth-century Dutch frames, which not only worked aesthetically but also fit his overall concept of viewing each piece as within an artistic tradition.

Inappropriate frames—those that seem to clash inadvertently with the picture—may turn off the person looking at the art, who, at best, will try to edit out the frame mentally. Many dealers report that badly stretched and poorly framed paintings work against the artists seeking sales and representation.

Not all pictures need frames all the time; frames are usually required when the works are being moved around (corners and edges may otherwise get banged up) and when they are being displayed. Diane Burko, a Philadelphia painter, said that she sometimes exhibits her work unframed—in order to emphasize the edges in her all-over style of work—and other times framed. "It depends on whether the work is going to be traveling," she noted. "If the pieces are just going to stay in the gallery, I may leave them unframed. If they are going to travel to other galleries or to another city, as some shows of mine have done, I generally put frames on them for protection."

Another reason to keep works unframed or not to spend much money on the matting and framing is that a potential buyer may like the picture but not the frame or may find that the frame doesn't go with the decor in his or her house. "Some people like to do the framing themselves and they may not like the mat and frame that the artist put on it," said Carol Becraft, customer service manager at Westfall Framing in Tallahassee, Florida, a mail-order frame company. "It's better for artists to keep it simple and inexpensive."

Others note that many pictures don't look complete without a frame and find that an attractive frame can help sell the work. The prices of frames vary widely, based on whether the artist plans to fit a picture into an existing frame, whether the frame has to be built to a special size, and whether the artist does the work him- or herself or uses a frame shop (these range widely in services and quality), which will do the entire job of matting, framing, and setting behind a protective glass (possibly costing hundreds of dollars).

"It depends on where you're showing the work," Ronald Cohen, manager at MADD Frames in Philadelphia, which provides frames for a number of galleries in that city and Manhattan, stated. "The air of certain better galleries just seems to demand a high-quality frame while, probably, a nice frame doesn't matter so much at an outdoor art show."

Artists who are unsure how best to frame a particular work may want to ask their dealers or show organizers for some advice, if their good favor is important to the artist, or check with a museum curator. In the past, dealers automatically took charge of framing the pictures that were going on display; now, fewer gallery owners are willing to pick up that tab. Dealers nowadays, however, still want some say over what kind of frame is used even when they don't (or only partially) reimburse the artist for the expense.

In many cases, the gallery look in frames is stark and clean, made of thin pieces of hardwood (stained or varnished) or metal (black, silver or, rarely, with a gold color), and many artists lean in that direction. One of the simpler types of framing that is increasingly being recommended is a casing of four thin strips of lattice wood (one-eighth-inch to one-quarter-inch thick). Frequently, artists will also place another four strips of (thinner) lattice wood between the outer perimeter of the picture and the strip frame. Those thinner strips are recessed (and sometimes painted black or some other dark color) in order that the paintings seem to "float" within the frame, and the distance between the picture and the strip frame keeps the artwork from looking visually compressed.

More expensive frames may or may not also have some sort of protective glass in front—that decision is usually based on how sensitive the artwork is to light and dust. Plexiglas or ultraviolet Plexiglas, which filters out the most harmful of the sun's rays, is frequently used, although it is considerably more expensive than regular clear glass. Ultraviolet Plexiglas may be as much as ten times more costly than regular glass, and it also scratches easily. The major benefits of Plexiglas (either regular or ultraviolet) over glass is that it is more shatter-resistant and doesn't carry the slight green tinge that glass does.

Some artists use different types of frames for different kinds of artwork. Larger paintings may be given strip frames, partly because this is less expensive than buying big frames and partly because the paintings get pushed around and bashed a lot in galleries. An important consideration is that an artist may spend $200 or $300 for a nice frame and find that it gets damaged by the gallery, forcing the artist to pay to reframe it when a buyer decides to purchase the work.

Smaller pieces, on the other hand, may seem to call out for a real frame of some sort. Works on paper are almost always framed for their protection with a protective glass (Plexiglas) in front, although the work should never touch the glass itself but be separated from it by an acid-free mat. The backing for a work must also be acid-free, not cheap cardboard and not wood. Paper can easily absorb resins, pollutants and acids from its backing and mat. The only time never to use Plexiglas is for a pastel drawing. Plexiglas has a static charge that acts like a magnet to draw dirt and dust to it. Pastels, which have a chalky consistency, can be problematic as the glass would tend to pull the medium off the paper.

With works on canvas or panels, the fragility of the surface of a painting may become a consideration in the decision of whether or not to frame. Of course, the framing question may be less pressing for artists whose work is generally the same size from one picture to the next, because that way, if one buyer wants the art but not the frame, the frame can be reused for another painting.

ACCEPTING CREDIT CARDS FOR SALES

In days past, one measure of someone's wealth was the thickness of his or her wallet. Nowadays, the richest among us carry hardly any cash at all, relying instead on the gold or platinum cards issued to them by major credit card companies. Most artists recognize that an increasing percentage of the people who buy from them directly at juried arts and crafts shows, expositions, and art fairs—wealthy and middle-class alike—are more likely to pay with a credit card than with cash or a check.

That's a blessing because 1) carrying large amounts of cash or checks make a seller more vulnerable to robbery, and 2) financial institutions credit one's bank account faster with a credit card payment than for a check, often within one to three days. In addition, the availability of credit permits buyers to make impulse purchases even when they don't have sufficient funds in their wallets or bank accounts. As a result, more and more artists and craftspeople who make their living from selling objects directly to the public rather than through a middleman have sought to receive authorization from banks and other financial institutions to accept payment by credit card.

Getting set up with a credit card terminal (an electronic device that records the information from a "swiped" card and transmits it to a payment processing service that sends the authorization request to the card issuer, which approves or prohibits the purchase in a matter of seconds) is relatively easy. Banks used to be wary of individual entrepreneurs, especially those with "home-based" operations, fearing that these businesses were too marginal and would go in and out of business, run into debt and declare bankruptcy, and relocate elsewhere without revealing their new addresses or resolving complaints from customers, but there is less of that now. So many people work in home-based and micro-businesses these days, many of them selling goods online, that bank brokerage firms and other financial institutions treat them as any other customer. A poor credit history is more of a concern to financial institutions than the fact of a business being a startup or having a relatively small volume of sales, although these still may have a somewhat more difficult time obtaining a merchant status agreement, which

means that an artist may need to make more than one inquiry. The fact is, there are several thousand banks, called "acquiring banks," that set up such accounts. If banks prove to be unwilling, one may try independent credit card processing companies, which can be found in the Yellow Pages or online. There are also independent sales organizations, which are field representatives from out-of-town banks that, for a commission, help businesses find banks willing to grant them merchant status. Again, they can be found in the Yellow Pages or online. Once the right bank or company is found, one can be approved in a day or two and set up to accept credit cards within seven to ten days.

The larger problem now is the ability of buyers to make purchases. Credit is harder to come by these days, however, as the banks that issue MasterCard and Visa cards are unwilling to lend to each other and even less willing to lend to consumers. Many long-time cardholders report that their credit limits have been reduced significantly, particularly if they have carried a balance from one month to another or missed a payment, and even those with strong credit scores have found it more difficult to obtain a credit card or loan during the current credit crisis.

The bank or credit card processing company will set up an account that allows a merchant to accept bank credit cards (MasterCard and Visa), and some will also work with the charge card companies, American Express and Discover. (A charge card has no spending limit, as credit cards do, and members are not permitted to carry a balance from one month to the next, which keeps them from accruing high interest charges.) However, one may apply directly to American Express (800-445-2639; *https://home.americanex-press.com/homepage/merchant_ne.shtml?*) or Discover (800-347-6673; *www.discover-network.com*), which will set up vendor accounts without the intercession of a bank.

Whether it be either American Express, Discover, or another company that processes credit card payments, all applicants are asked basically the same information, frequently over the telephone and sometimes in the form of a written application: The name, address, social security number, and telephone number of the craftsperson (also, the home address and telephone number of the artisan's place of business if different); the bank he or she uses (if there is a separate business checking account); how long the person has been in business; what products are being sold; the average price for pieces that are sold; how the pieces are marketed to the public; the volume of sales (monthly and annually); the state sales tax number or federal tax identification number; business references (suppliers, patrons, craft shops, or galleries). Additionally, the craftsperson may be asked to submit federal tax statements for the preceding two years and bank statements for the preceding three months.

Applicants are asked how they plan to process credit card payments. Most will use an electronic terminal, either wireless (operating on rechargeable batteries) or countertop (needing to be plugged in), although some will call in credit card information to a toll-free number using a cell phone. (Like cell phones, terminal rentals are multiyear leases with additional charges for early termination. There are benefits and drawbacks to each type.) Renting a wireless terminal from First Data, for example, costs $39.95 per month (plus a $20 one-time hosting or access fee, as well as a twenty-cent fee for each

transaction), while the countertop terminal costs a monthly $24.95 (with additional hosting and transaction fees). A plug-in terminal, however, may not be useful if an artist is exhibiting at a fair where there are no electrical outlets handy. Both types of terminals also have keypads, enabling sellers to key in a transaction when the machine cannot read the magnetic strip. The call-in service eliminates the cost of the terminal rental (there still is the twenty-cent transaction fee), but approval for each sale may take longer to complete and poor phone reception may hamper the ability to complete a sale.

One also may rent or purchase terminals and printers (many of the newer models have both elements), which range in sales price from $300 to $900. They are available at many stores and online dealers where office machines are sold.

Additional costs are added by the banks issuing the credit cards, and the rates are variable, depending upon the type of card. Vendors (the artists selling their work) are charged on a tiered system, with the lowest being a "qualified" rate (say, 1.6 percent) and next a "mid-qualified" rate (2.3 percent) for cards with rewards, then finally a "non-qualified" rate (3.0 percent) for business cards. That means that Visa or MasterCard keeps $2.30 when an artist sells a $100 print to a buyer using a credit card with a cash-back rewards program. For its part, American Express takes a higher percentage, although there is no transaction fee and the monthly service charge is $5; the only fee paid by those using debit cards is a flat twenty-cent transaction fee. (Some of the fees noted are approximate, ultimately based on expected volume of sales and whether the seller is a sole proprietor, restaurant, franchise, or some other type of business. Transaction fees may be different depending on whether the sale is over-the-telephone, online, or in person.)

A monthly statement will be issued for sales. Wells Fargo charges $7.50 per month when it is a hard copy mailed to sellers, nothing if it is simply posted online to the seller's account. Other company fees include a one-time set-up fee of $50, a monthly processing fee of $25, a $5 monthly service fee, and a yearly charge of $85 ($45 annual fee plus a $40 annual "compliance support" fee), as well as a $25 "charge-back" (paying for the paperwork when a customer returns an item he or she has purchased or disputes a charge) fee and a seventy-five-cent fee whenever the seller requires authorization for a charge from an actual person (for instance, when Internet service is down and a seller must phone in the credit card information). Adding up Wells Fargo's basic charges for the first year, not including the rental of a terminal or imprinter and not having any chargebacks or the need of voice authorization, would come to $495. The difference between one credit card processing company or bank and another is less in the services offered than in the fees. Startup fees may go as high as $200, and equipment rentals can exceed $1,000 per year. Transaction fees range from five to fifty cents, and monthly statement fees can hit $20. Businesses with a lower volume of sales are likely to pay higher rates to the credit card companies. Too, artists who process their credit card sales electronically enjoy a better discount rate (and receive their money faster) than those who just use a telephone and a $20-$30 imprinter, but the less expensive device is one way to keep costs low. It makes sense

to get price quotes from at least three different banks or processing agents. Just as merchants in every other field include these costs when they set their pricing, so should artists.

Sellers usually receive money from the sales through an electronic transfer directly to their bank accounts within twenty-four to forty-eight hours. There is a charge when a paper check is issued. American Express issues payment in three, fifteen, or thirty days, lowering the rate it charges per transaction the longer it keeps the customer's money.

In all cases, sellers need to examine the credit cards that are used for purchases, making certain that a card has not been physically altered or mutilated, that the buyer's signature on the receipt is identical to the one on the card, that the name on the receipt is the same as that on the card, and that the card has not passed its expiration date. Somewhat more complicated are credit card sales in which the seller cannot physically see and swipe the card, such as those made over the telephone or online. When speaking over the telephone, the card user must be asked the name as it appears on the card, the card number, the expiration date, a billing address, and whether the items are to be shipped to the same or to a different address. (Because of the potentially greater risks involved in these telephone and online sales, the rates charged by the credit card companies is at the higher end.) Whether cards are present or absent, information is submitted electronically for processing, and a six-digit authorization code will come back in a matter of seconds, approving the charge and allowing the sale to be completed.

A WORD ABOUT TAXES

Artists and craftspeople may receive money in a variety of ways, including awards and prizes at shows, project grants, scholarships, and fellowships. The prize money or the monetary value of an award (the cash value of a gift certificate, for instance) that an artist receives at a show is taxable at normal state and federal rates. The same taxability is true for money received through project grants from a private or governmental agency. On the other hand, there is no tax on fellowships and scholarships if the craftsperson is studying for a degree at an educational institution (including tuition, lodging, equipment, and travel expenses), nor is an award taxable if it comes from a governmental agency or school. If the award is contingent on the recipient teaching or offering demonstrations or some other part-time service, however, a portion of the fellowship or scholarship will be taxed.

The sale of one's work, of course, also occasions the payment of taxes to state and federal agencies on a monthly, quarterly, or annual basis. Those artists and craftspeople who sell their work at retail or wholesale shows in or out of the state where they live are required to apply for a resale tax number both in their home state and the state where the shows will be held. Usually, one applies with a state's department of revenue, and the cost of registering to sell work is in the area of $10, although some states have no charge. In some cases, registration is for one year, although some states permit applicants to receive a two-day or weekend resale tax number. Most show promoters require a state

resale tax number as a condition of taking part in the event. The artist or craftsperson will receive from the state information about how much sales tax to collect (generally, between 3 and 8 percent) and how to pay it—often, a coupon book is enclosed (the coupons are to be mailed back with sales tax receipts). Usually, applicants receive their number and paperwork from the state in a couple of days.

When selling out-of-state, one must pay that state's sales tax (and not one's home state sales tax), an amount that, in most cases, may be deducted on one's federal income tax form. If the state one is selling in has no sales tax, no sales tax need be paid to one's home state either. Around the United States, artists and craftspeople may apply for resale tax numbers to their state departments of revenue.

THE NEED FOR GOOD RECORDKEEPING

The end stages of anyone's life are likely to be somewhat chaotic. Ailments consume one's thoughts, strength wanes, memory fades, and the ability to take care of ordinary activities, including work or just shopping for food, declines. Those with jobs are apt to retire—the business will go on—and devote the remainder of their lives to a less stressful existence. In 1996, multimedia sculptor Nam June Paik (1932–2006) suffered a stroke that largely curtailed his ability to create new installations, but his career was far from over. Exhibitions of his work were being planned, new pieces were still being fabricated, and existing works continued to be put up for sale at galleries. What's more, a series of sculptures that were purportedly by Paik, but that the artist denied were his, were put up for sale, leading to two lawsuits against Paik, which his lawyers chose to settle, because Paik was not deemed mentally competent to testify at trial. "You can see this as people taking advantage of a senile artist," said Paik's nephew and estate executor, Ken Hakuta. "He was sick."

The lawsuits were eventually resolved out of court. Had Paik maintained a documentary record for all his work—"So-and-so Gallery or studio assistant is authorized to produce this many pieces, to be titled this, this, and that, and sold for these prices," signed and initialed by all parties involved—the confusion might have been resolved more quickly and with less expense. Good recordkeeping, unfortunately, is not one of the characteristics of highly successful artists. Diminished brain function, however, may prove catastrophic for an artist whose business is run completely out of his or her head. "Just getting old is hard," said Dr. John Zeisel, director of the Woburn, Massachusetts-based organization Artists for Alzheimer's. "Bills don't get paid; things don't get put away. Most creative types have things lying around anyway and, when they develop dementia, it becomes much harder to organize."

Among the problems that may occur are:

- Artworks that have been loaned to a gallery, collector, or museum and are forgotten. The recipients may construe the loans as gifts and sometimes sell the works.
- Artworks consigned to a gallery and forgotten. Galleries, too, sometimes forget to pay artists.

- Images that are licensed for commercial use are also forgotten. "Postmortem royalties, with few exceptions, tend to taper off," said Elliot Hoffman, a lawyer with an arts practice in New York City, "but sometimes royalty payers forget to pay the artist or the artist's estate or heirs. Sometimes, they just stop paying and wait to see if anyone complains."
- Elements involved in the process of creating a multiples edition, such as mock-ups, proofs, maquets, molds, or drawings, are overlooked by the artist but are subsequently used or sold by the publisher, fabricator, or foundry.
- Artworks that are not documented with photographs or written information (title, size, year, medium) may pose later problems of attribution. Artists are generally thought to be the best judges of their own work (although there are instances where some have been less than truthful, denying early pieces they now dislike or, in the case of Giorgio di Chirico, intentionally misdating works) but, when the artist suffers memory loss (as in the case of Nam June Paik) or dies, the problem of attribution is magnified. Determining when a work was created and by whom becomes a more drawn-out and expensive process.

"Artists, by definition, are not business-minded," Hoffman said, which is neither true nor a definition, but there have been numerous instances of artists neglecting to keep good records on their artwork, loans, licenses, and consignments, leading to headaches and lawsuits during an artist's lifetime and beyond.

If artists kept better records on their work and careers, there might be less need for lawsuits, authentication committees—art fakes hardly would be profitable—and catalogue raisonnés. Toward that goal, the Joan Mitchell Foundation (155 Avenue of the Americas, New York, NY 10013; 212-524-0100; *www.joanmitchellfoundation.org*) established a grant program enabling artists to document their work. The foundation will underwrite this process by hiring an archivist and paying for a computer (if need be) and the creation of an image and text database rather than providing money to an artist directly. "If you just give artists money, they might not spend it on archives," said Carolyn Somers, executive director of the foundation. "While they are alive, artists can do their own catalogue raisonné."

WORKING SMALL, WORKING LARGE

In the art world as in other arenas, size matters. Some artists prefer to work small, but their dealers tell them that large is priced more highly and is taken more seriously by critics, collectors, and curators. Other artists choose to work on a larger scale, but their dealers inform them that few collectors have room in their homes for such big pieces and that they need to make art that is more affordable and portable. Quite often, art is judged by non-art criteria.

There are many reasons that artists create works in different sizes or, perhaps more pertinent, make small pieces when they are best known for larger ones. William Beckman, a painter in Millford, New York, may "spend months on one big painting, but I can do a small one in a day." During that day, he may go outside to paint a landscape;

a large canvas is apt to be blown about by the wind, so by necessity he must limit the size to under two or three feet. "If you're carrying it around outside, it also has to be able to fit under your arm," he noted.

Working smaller also affects his attitude toward the work. "I don't ponder every brush stroke, so I feel freer when I'm painting." Changing his technique allows Beckman to experiment, and the results eventually may wind up on a larger painting, or maybe not. "I don't think of my small paintings as seriously. They're expendable; I call them 'throw-away paintings,' because it doesn't matter so much if they don't work." Works that he produces in his studio—and he only creates three large paintings per year, on the average— "I think of more as commodities. They're more expensive, and they have to be right."

Other artists also note that smaller works feel different than larger ones and "allow a lot more freedom to make mistakes, and also some happy accidents that lead to exciting new developments," according to Burlington, Vermont, painter Peter Arvidson. For Scott Prior, a painter in Northampton, Massachusetts, his method doesn't change when moving from big to small, but he "may try out different subject matter" that will be expanded at some other time on a larger canvas. In that regard, the small painting could be seen as a preliminary artwork, except that there hadn't been a larger one in mind when he started.

Completing one large work and then moving on to the next large work can make art seem like an endless chore. "Big paintings are hard work," Prior said. "They're a leap of faith when you're beginning, because you look at the canvas and see days and days of work ahead, and you have to hope that it all comes out alright. After I have finished one and step back to look at it, I'm impressed that I have accomplished this thing, but I need a break before I begin the next one." With a small painting, "I can finish it in a day and think, 'Hey, I can take tomorrow off.'"

What smaller works may lack in finish they perhaps make up in a level of intimacy, both for the viewer and the artist. One generally backs up to take in a larger work of art, limiting the ability to see all at one time what the image is and how the artist created it. There is none of that with smaller works, which usually are viewed at arm's length. It is not always the case that smaller works take less time than larger ones (although "most galleries price works by size, which means that smaller is always less valuable, which is really unfair," Beckman said) or that artists change their techniques based on scale. More often, the subject may be simplified—fewer figures in a painting, for instance, or a head instead of a full body—but the small scale requires the artist to focus more intently.

"There is something magical about a small work," said New York City painter Jacob Collins. "It seems very modest, because it's so small but guilefully announces itself the more you look at it. Big paintings are never really modest. They announce themselves immediately as big paintings."

Big artworks also announce an artist's career, while smaller pieces simply let people know that something is for sale. Very few artists are known for their diminutive pieces, regardless of how much larger a percentage of them may be sold than more floor-to-ceiling works. In fact, a giantism has taken out whole segments of the contemporary

art world: big really seems to be better. "Typically, I recommend that my artists work larger," said Manhattan art dealer Kathryn Markel. "My clients have large walls, and they won't be able to see a work if it's only twenty by twenty inches." The fact that larger works cost more than smaller ones is another reason that dealers press artists to work on a larger scale. Sarah Hatch, a painter in Decatur, Georgia, was told by her New York City art dealer, the late Monique Goldstrom, that "it wastes her time having to deal with smaller pieces [if] she can do the same amount of work to sell a larger pieces."

For many dealers, in fact, it takes more time to sell smaller and less expensive works than it does larger ones. San Francisco art dealer John Pence noted that "when people want a big work, they can afford it. There's no scraping of pennies and thinking of what they might have to give up. With smaller works, the client is often not so wealthy and will have to think long and hard whether or not he or she can really afford it." With gallery rents reaching tens of thousands of dollars per month in a number of major cities (Pence's gallery costs $50,000 per month to run), artists need to produce a lot of work and dealers are required to sell them in significant quantities when the individual pieces are small and modestly priced.

Large, sprawling artworks—huge canvases, monumental sculptures, room-sized installations—sometimes provide an inaccurate impression of an artist's actual body of work. Far more of Mark di Suvero's table-top (twenty-eight by sixteen inches) and medium-sized (from four to ten feet in height) sculptures sell in any given year than the larger outdoor works that are assembled with cranes and for which he is better known. In fact, di Suvero told one of his studio assistants, Zachary Coffin, who lives in Atlanta and is a full-time sculptor in his own right that "the key to keeping everything flowing is to have small works to sell." Coffin has also gained a reputation for his massive public art pieces, which weigh up to ninety tons and can cost $200,000, but he, like di Suvero, additionally produces smaller works of only thirty-five to forty pounds that cost $5,000 to $25,000. Dealer prodding pushed him in that direction. "Gallery owners have told me, 'People love your work, but we can't move it,'" Coffin said. "'Collectors want the work in their houses; our customers don't own sculpture parks.'"

At times, however, galleries may seek smaller works by an artist, or at least a balance of small and large, in order to give potential buyers a choice. Smaller and less expensive pieces provide a safe entry point for new collectors and those who are being introduced to an artist's work for the first time. "Smaller works are easier to sell, ship, and store," said Julie Baker, an art dealer in Grass Valley, California. She noted that one of the artists represented by her gallery, the San Francisco painter Nellie King, is known for her eight-by-eight-foot paintings, the average sale price of which is $6,000, but "I've specifically asked her for smaller pieces." King has brought in both "painting strips" that measure nine inches by eight feet and twelve-by-twelve-inch paintings that are priced at $600. Those have sold well, Baker said, to both budget-conscious collectors and to others who "don't have to worry where an eight-by-eight-foot painting is going to go. People love her work, but many don't want to spend $6,000. They get the flavor without making a huge commitment."

This area of the art market has been accorded its own forum with the AAF (afford-able art fair) Contemporary Art Fair, which takes place annually in New York City in late October and featuring art priced under $5,000. Almost every two-dimensional piece in the fair could be carried out under the arms of the buyers. Approximately 13,000 visitors came to the 2003 fair, making 2,500 purchases at an average price of $1,300. According to the organization that sponsors the fair, half of the buyers were new to the galleries that had set up exhibition booths; most of them were also new to art collecting. Lower priced artwork doesn't need its own event for dealers to have pieces on hand, however. "It's nice to have things that sell for $200 or $300," Kathryn Markel said. "Gifty, present-y things."

Collectors may not be the only reason that a dealer suggests the artist create smaller pieces. "We can't show paintings that are bigger than six by nine feet," Penelope Schmidt, co-owner of New York City's Schmidt-Bingham Gallery, stated. "Larger than that, the painting won't fit through our front door or in the elevator. With sculpture, too, there is a storage problem, especially for very large works."

PROTECTING ONESELF FROM THEFT

In the "Selected Collections" section of his résumé, Irvine, California, artist Jeffrey Frisch lists a variety of private buyers of his work and one "anonymous thief," referring to the person who stole one of his sculptures from an exhibition. That's putting a good face on the fact that the $500 artwork was uninsured, so all that remains for him is a laugh.

Purchasing insurance for one's own artwork tends to be an investment few artists make. It is not at all unusual that artists will take out business owners' or a general lia-bility policies, which cover injuries to visitors, damage to equipment and materials, and losses when pieces are harmed while in transit or on display at a gallery or fair, for their studios and fair booths. Those policies offer a minimum of $1 million in coverage and start at $300 to $400 per year with a $250 deductible. (Premiums are also based on the state—California and New York are the most expensive, because of large awards resulting from lawsuits, along with hurricane-prone Florida—and the existence of fire and burglar alarms, as well as the age and type of building (wood-frame or concrete block), the proximity to a fire or police station, and the type of door locks in use.)

Insurance coverage of the completed artwork, however, usually requires a sepa-rate fine arts rider, just as some art collectors include on their homeowner's policies, which are considerably more expensive. For artists, a fine arts policy includes artwork in their home, studio, and temporary locations (such as exhibitions or loans or on approval to a customer or at a frame shop), as well as while being shipped from one place to another. "Claims usually happen in transit," said Armanda Bassi, an insurance writer for the Washington, D.C.-based Flather & Perkins, which writes policies for artists and craftspeople. In many cases, the artists seek payment for a total loss rather than the cost of restoration, because "they don't want to show or sell work that is dam-aged." Flather & Perkins charges $1,250 per year for a fine arts policy that provides $50,000 in coverage, while Thompson & Pratt in Lancaster, California, offers a $1,500

plan that includes $100,000 in coverage. BRI/Partners USA, an insurance carrier rec-
ommended to members of the American Craft Council, offers a property and liability
package for artists and artisans, with premiums based on the insured's own stated
values of artwork.

All-risk fine arts riders that are part of a homeowner's policy by law include ter-
rorism coverage, but those who live in likely areas of potential acts of terrorism, such as
Chicago, Las Vegas, Los Angeles, New York City, and Washington, D.C., may pay more
for their policies than those residing elsewhere. For artists who have incorporated and
whose artwork is owned by the corporation, they may find that insurance carriers no
longer automatically provide coverage for damage resulting from a terrorist act to their
commercial customers, a repercussion from the 2001 attack on the World Trade Center.
However, because of the federal Terrorism Risk Insurance Act, insurers are required to
provide separate terrorism coverage for commercial customers, costing an additional
two-and-a-half to seven-and-a-half percent of the annual premium. The vast majority of
art galleries in high target areas have added these policies.

However, even modestly priced policies may strike many artists as unnecessary,
since the problem of theft or horrific damage seems remote, and most will be proven right.
There is, of course, the exception. "I hadn't any insurance on my art because I couldn't
afford it," said Joel Fisher, a sculptor in North Troy, Vermont who had forty-three bronze
statues stolen from his yard and house last November. "It's a lifetime of work for me,"
adding that he estimates the total value of the artwork at more than $1 million.

Art or cultural property theft, thought to be the third largest dollar-wise area of
criminal trafficking in the world after drugs and illegal arms sales, typically affects
private collectors, as well as museums and houses of worship. Police investigators of art
thefts describe the robbers' intentions as one of three possibilities: a quick sale, insur-
ance ransom, or a card in negotiating down the charges for a different crime. Stealing
from the artists themselves occurs perhaps more often but at a lower price point at
shows, in which a number of visitors may be crowded into a small booth at one time.
Bruce Gray, a sculptor in Los Angeles who had a $3,000 tabletop piece stolen off a
Hollywood set when he had rented the work for a movie production, speculated that the
thief "just wanted it. The person wasn't looking to resell." That point of view, seeing
thefts from artists as a form of shoplifting, accords with a number of sponsors of arts
and crafts shows as well.

For Joel Fisher, however, the purpose of the theft of his sculptures was none of
those. "It wasn't the art, it was the metal," he said, noting that the cost of bronze has
tripled since many of the artworks were first made. State police found eleven of the forty-
three stolen sculptures in a truck en route to an out-of-state smelter.

THEFTS AT ART FAIRS

Unzipping her booth tent the second morning of an arts fair, mixed-media artist Patricia
Hecker of Bloomington, Indiana, knew that someone had been there the night before.
Her artwork was OK, but a cabinet had been broken into. "I'm sure someone was looking

for money," she said. Fortunately, she had made sure to take all cash and receipts back to the motel the evening before, so there was no loss on that end—just a damaged cabinet. Hecker mentioned the break-in to the fair sponsors, who had hired security guards and had otherwise required all of the participating artists to sign a contract in which they acknowledge that all property at the site is left there at the vendors' own risk, but not to her insurance company. Why bother? The $1,000 deductible on her policy far exceeded the value of the cabinet, and "if you report a claim they'll just raise your rates."

Thefts are an occasional, sometimes regular, nuisance for artists and craftspeople who sell their work at fairs and festivals, despite the sincere efforts of the event sponsors and the artists themselves to stop them. They take place at night, when the artists aren't around to watch their booths, and during the day when the artists are busy making sales and talking to would-be buyers.

Some thieves, like Hecker's intruder, are looking for money, while others may be more interested in the truck in which the art was transported; a drill was stolen from the tent of Gregory Reade, a sculptor in La Jolla, California, when he participated in a fair in Scottsdale, Arizona, while the art was untouched. David Bigelow, a printmaker in Ozark, Missouri, said that thieves have broken into his truck on several occasions, stealing the crates that contained his etchings—he has no idea what the robbers assumed they might be taking. The lesson he learned is: "Only eat at a restaurant when you can sit at the window and see your vehicle."

Yet other thieves simply want a piece of art and not want to pay for it. "Two girls who had had too much to drink and had seen my work earlier in the day" crawled under the tent of Michael Baker, a sculptor in Salisbury, North Carolina, when he took part in a show in State College, Pennsylvania, and grabbed one of his statues. Walking back to their Penn State residence hall, they were spotted by a campus police officer, at which point they dropped the sculpture (it wasn't damaged) and tried to get away. Instead, they and the sculpture were brought to the campus police headquarters, where their parents (and Baker) were called. "I was brought down and asked if I wanted to bring charges against them, but I didn't want to do that," Baker said. "The next day, the girls came to my tent, and I gave them a lecture on how stupid it was to be going to college and doing something like that. I hope they learned."

No time of day appears to be more likely to see thefts than any other; fair sponsors around the country state that reports of stolen items are too rare to make an analysis (they often blame the artists for carelessness or a lack of vigilance), and insurers indicate that claims almost never take place. "We all know thefts happen, but we don't really know with what frequency," said Sally Bright, board chairman of the National Association of Independent Artists, many of whose members show and sell their work at arts and crafts fairs. Her own experience of theft took place in the middle of a fair when a woman came into her tent, picked up an object, and walked out with it. "I caught her in the act. She was mentally disturbed."

There are different precautions to take during the day than in the evening. Bright recommended that artists wear their money, such as in a money belt, and that they not

let any other cash box, purse, or register out of their sight. Having someone else in the tent, such as a friend or spouse, provides another pair of eyes that could foil a thief, especially one who uses a partner to distract the artist. Art fair rules often prohibit the use of "proxies"—someone, such as a dealer or agent or relative, manning the booth in place of the artist—but a second person is generally allowed. Artists should not leave their tents unattended, and it would be unwise of them to ask neighboring exhibitors to watch their booths while they take a bathroom or lunch break. However, many fair sponsors offer "booth sitters," volunteers who agree to spell exhibitors for brief periods of time, although these sitters don't pitch the artwork in the tent and are not allowed to make sales in the artists' absence.

Protecting the contents of one's tent overnight is less clear-cut. Fewer people are around the spot and stop suspicious activity, and overnight security guards tend to be few in number. The two-day Greenwich Village Art Fair in Rockford, Illinois, for instance, holds 120 tents on the gated grounds of a municipal park and is guarded at night by two police officers. "The police officers are armed," said Nancy Sauer, one of the managers of the Art Fair. The odds are not in an artist's favor: store owners can lock their doors and pull down metal grates, but participants at fairs just zip their tents closed; even if they manage to put a lock on the zipper, the tent is just canvas, which any knife can cut through. "In the early years of doing fairs, I used to remove works every day from my booth," Hecker said. "The logistics were against me, though," as it required her to bring her van to the site every morning and evening, unpacking and repacking. "When you handle the works so much, you're very likely to cause damage, especially when you're doing it at the end of a long day."

The end of the day (or the end of the fair) offers opportunities to thieves, who may have been looking at desirable objects in the booth and use the time that an artist is getting or loading the van to make a grab. Robbers also may have been paying attention to which artists have sold a lot of work on a particular day, following the artists out of the fair. "You should stay in areas where they are other people," Bright said.

Insurance policies that are relevant to artists and craftspeople who participate in arts and crafts fairs come in two basic types: business owners', or general liability, policies provide property (business vehicle, fire damage, loss of equipment not including computers), medical (slip-and-falls) and product liability coverage for artists in their studios and at an exhibition site (any damage caused to the facility). Art fair sponsors usually require vendors to have these policies, with liability coverage of at least $1 million. The deductible—the initial amount of money that an insurer is exempted from paying on a claim—is variable, ranging from $250 to $1,000, as is the level of liability ($300,000, $500,000, or $1,000,000). Policies with lower premiums usually have higher deductibles and lower liability limits.

Fine art policies, on the other hand, simply insure the artwork—in one's studio, in transit, and at an exhibition. "Most of the time that a loss takes place," said Armanda Bassi of the Washington, D.C.-based insurer Flather & Perkins, "is when the work is in transit."

Some insurers offer a combination of business and personal property liability that covers artists at home, in transit, and when attending a fair. Complications, however, don't disappear. RLI Corporation, which is based in Peoria, Illinois, and offers combination coverage to artists and craftspeople in all fifty states, insures only home-based studios and not ones that are offsite. "If where you work is more than one hundred feet from your home, the risk for us becomes too great," said Chris Alexander, an RLI agent.

Settling claims for theft and damage of artwork may also not be quick and easy, which may lead artists not to bother. "I tried to file a claim once, and the company said it wasn't covered," Bigelow said. "I didn't want to spend my time in small claims court, so I just gave up." Insurers may require a condition report on pieces before they were shipped, photographs of both damaged items and the shipping boxes, and detailed estimates for repairs. Stolen items also need to be documented. Alexander noted that artists need to have taken "reasonable precautions," such as locking their cars and zipping up and locking their tents. If a thief crawls under a tent at night or shoplifts an item during show hours, RLI will "take things into consideration." Insurers frequently balk at paying full retail price settlements for objects that haven't sold, requiring artists to present proof that similar items have been purchased for those amounts. Even with such proof, they only may be willing to pay a fraction of that amount. "We pay replacement costs— the cost of the raw materials and a reasonable hourly wage, for instance, $20 an hour— but not the retail price," Alexander said. And then there is a $250 deductible. For artists, losses from theft may not be recoverable but just a part of doing business, and they should put their faith in vigilance rather than in insurance providers.

ARTISTS WHO WORK AT HOME

If Barre Pinske, an artist in West Barnstable, Massachusetts, decided to paint a picture in his own garden, would it be in violation of the town's zoning restrictions? West Barnstable's home occupation ordinance permits artists and other entrepreneurs to operate businesses out of their own homes in a residential neighborhood "if the business has no employees, if there is no sign, if it doesn't create traffic problems, if you can't tell it's a business from the outside, and if it doesn't produce a lot of noise and bother people," said Ralph Crossen, the town's building commissioner.

Pinske's work, which incorporates painting but is predominantly sculpture, bothers a neighbor who has repeatedly contacted local, state, and federal authorities about the noise and visibility of the art. As a result, the artist has been cited by the town's zoning board "and told to cease all artwork production outside" of one of the buildings on his property, Pinske said. "Any one of my neighbors, who aren't artists, would be allowed to paint outside because they are hobbyists. But because I am a professional artist, if I did it I would be in violation of the zoning board."

Most artists are probably more discreet than Pinske, who once put an eight-foot sign with the word "Aaaaaahhh!" out a window of his house as an artistic protest against domestic violence (the placement of which resulted in his first citation), but many more are likely to face questions from town and city officials about their ability or

right to work in their homes. Home occupation ordinances exist in the majority of towns and cities of the United States, but there is a greater effort at present to require home-based entrepreneurs to take out licenses and pay business taxes. "Cities are looking for additional revenue sources, and permits, licenses, and business taxes for home businesses may be for cities the growth area of the future," said Fay Dolnick, a researcher at the Chicago-based American Planning Association.

Anyone with a home-based business should assume that he or she may need to get a permit from the town or county, according to Raymond L. Boggs, director of home office research for IDC/Link, a private research firm in New York City. The zoning board for the jurisdiction will state the requirements for operating a home business, and the fees and requirements vary wide from one municipality to another. Those who earn under a certain income (under $5,000) or whose work is not likely to create traffic or noise in the neighborhood (such as a writer or painter) may not need to obtain a license in some towns but are required to in others. "Some cities don't care if you make or lose money," Boggs said. "They just want their license fee." Yearly permits and licenses to operate a home-based business cost between $25 and $200, and taxes range from $1 to $6 per $1,000 in gross income. A certificate of occupancy may also be required for those taking a deduction for a home office (for instance, a studio) on their income taxes.

There are believed to be far more people who earn their livelihood from a home-based business than pay the necessary permit fees and taxes or follow zoning regulations required by the jurisdiction. According to the U.S. Bureau of Labor Statistics, more than twenty-one million people in nonagricultural industries are doing work at home for which they are being paid, although perhaps half of them are simply taking work home from the office. Between eleven and twelve million households rely on a home-based business as a primary source of income. This total number has grown steadily during the 1980s and '90s, "brought about by economic downturns that eliminated jobs for white-collar positions in companies and aided by the use of computers, which has enabled people to do all the same types of work they did at an office but now at home," Dolnick said.

Home occupation ordinances are used to control negative impacts on residential neighborhoods. Numerous deliveries (especially those involving large trucks) and vehicular traffic (employee parking or clients coming throughout the day to a psychologist or accountant, for instance), as well as the use of loud machinery or toxic substances (such as those used in automobile servicing), create a burden on neighbors, whose quality of life is adversely affected. These ordinances often stipulate that the home-based businesses have no employees (or perhaps just one or two employees) outside of the family, that the activity poses no danger to the community (such as animal training or gun sales), that clients are permitted only by appointment rather than as walk-ins and that the work involved takes up no more than between 25 and 50 percent of the space in the home.

Another stipulation is that signs not be placed in sight of neighbors, which proved a stumbling block for Upper St. Clair, Pennsylvania, artist Nancy Bellamy, whose

four-by-eight-foot painting of butterflies placed on her lawn was cited by the town for being a commercial sign in a residential neighborhood. She was told to remove the painting within five days or face fines up to $300 per day. The Pittsburgh chapter of the American Civil Liberties Union represented Bellamy in her dispute with the town, claiming the painting is a work of artistic rather than commercial expression.

"If I had a sculpture on my lawn, there wouldn't be any problem," Bellamy said. "But, because it is a painting and I happen to have painted it, it is being treated as though it were a billboard."

Pinske's Fiberglas sculpture, carved by a gas-powered chain saw and a sandblaster, created noise and dust that irritated neighbors. In most instances, however, "problems occur when there is an unrelated problem with a neighbor about the dog that got loose or the window that your child's baseball broke and the neighbor decides to also inform on you about operating an unlicensed business in your home," said Joshua Kaufman, a lawyer in Washington, D.C. who represents both visual and performing artists. One of his clients, a puppeteer in Maryland who worked out of her home, was sued by a neighbor for a matter unrelated to her puppeteering. Kaufman advised her to get a permit for her work shortly after the suit was filed, "because we didn't want opposing counsel to hassle her [or] report her to the county or to the IRS."

Some activities are more likely to reveal that a business is being operated than others. "Building a kiln in your backyard is different than [sic] painting in your den," Kaufman said. Knowing when to contact local authorities is not always clear to many artists and entrepreneurs, who often start out casually as hobbyists rather than with the expectation of earning all or part their income from their work. "At what point do you cross over?" Boggs said, adding that if their earnings are small or they use a residential telephone for business or they do not deduct business expenses, artists may or may not need to obtain a permit, depending upon the jurisdiction.

"It's advisable to know what the local law is," said New York City attorney Barbara Hoffman, who represents a number of fine artists, "but compliance is another issue. Do you really need to comply with a law that no one remembers enacting and that no one bothers to enforce?" Artists may see themselves as having a choice whether or not to obey an ordinance, or obey it while seeking to overturn it—after a period of advocacy and lobbying, artists in Chicago, Illinois, won the right to be exempt from the city's home-office ordinance.

Compliance may have its drawbacks for artists because they are entering an indeterminate relationship with a governmental agency. Mark Ryavec, a lobbyist for the Writers Guild of America, which successfully brought a lawsuit in 1997 to force the Los Angeles City Council to rescind a requirement that artists and writers pay a $25 city permit before working out of their homes, noted that licensing creates privacy concerns. "Their names and addresses, which wouldn't otherwise be public, end up being on a city register," to which many people have access, Ryavec said. This was of particular concern to many Hollywood screenwriter members of the Writers Guild, "who were concerned that stalkers and other criminals could get their addresses," he added.

As any other business, artists might be required to post their business licenses prominently where they work, and they are potentially subject to unannounced inspections of the work place in order to insure compliance, reviewing one's documents and records at the same time. Artwork that is deemed pornographic by a city inspector might be subject to a municipality's adult entertainment laws, "which gives cities a say in what artists do, making this a first amendment issue," said Brian Zick, a graphic artist in Los Angeles who was involved in the effort to eliminate the permit requirement. "Just giving an official the right to deny a license to someone is an unconstitutional bar on free expression in your own home."

The penalties for noncompliance are perhaps as varied as the home office ordinances in existence around the country. According to Kaufman, a fine may be as low as $25, "or it can be a misdemeanor—$1,000 and a year in jail, although I doubt there are any cases in which an artist has been thrown in jail for not having a license to paint in his home." He added that the costs of noncompliance may add up "if an artist builds a studio and then gets told that the studio is illegal and can't be used. Town officials may fine an artist again and again or get an injunction against the artist." A legal problem may also arise if an artist deducts home office expenses for the IRS while claiming to the town that the art is only a hobby in order to avoid obtaining a license or certificate of occupancy.

THE NEED TO SPECIALIZE

Artists not only make images but project to the world an image they create of themselves through their artwork. That is to say, we know artists by what they do. We say, she is a landscape painter, he is a minimalist sculptor, and we know that through seeing a body of work that allows us to identify their respective subject matter, style, and media. The more coherent the artist's work, the more easily we may recognize the creator.

To achieve that recognition, therefore, enabling a viability in the marketplace, artists must become specialists. The landscape painter must forgo the photography and the performance art; the minimalist sculptor needs to spend less time with the rock-and-roll band and the theater company. Unfortunately, what makes sense in the market defies a basic element of creativity: most creative people are interested in a variety of artistic doings, and choosing one that is most likely to earn them money and recognition may be a wrenching decision.

This is not to say that artists must be confined to just one type or style of work for their entire careers. Robert Rauschenberg's body of art, for instance, has included painting, sculpture, installations, and graphic prints; to say "I bought a Rauschenberg" necessarily requires some clarification. Of course, as an artist, Robert Rauschenberg has pursued a series of recognizable ideas through a variety of media, and those who collect the artist's work know him for his ideas—the stamp of personality he places on everything he creates.

The same cannot be said for Edward Betts, a painter who works in two completely different styles: large, abstract acrylics and smaller, traditional landscape watercolors. "If I'm known for anything, it's for the abstractions," he said. The owner of Contemporary Arts, a New York City gallery with which he had a relationship, told him that "I could continue to do the watercolors if I liked, but it would be best if I used another name—Edward

Howards or something like that." Another Manhattan gallery that had previously handled his paintings, Midtown-Payson Galleries, "told me simply that they weren't interested in representing those works." In both cases, dealers were concerned that the watercolors might confuse buyers as to exactly what type of artist Betts is. As a result, he exhibits and sells the watercolors in galleries in his home state of Maine—"where there still is a strong demand for realism," he stated—and the abstractions in New York and other larger cities.

In a similar vein, more than one West Coast gallery owner has told Santa Monica, California, artist John White, "Don't let anyone know you do performance art." Distinguishing his art between "static work" (paintings, drawings, sculpture) and "nonstatic work" (performance art, video), he stated, "To the gallery owner's mind, the fact that this isn't the only kind of art I do takes away some of the punch from the paintings, and the public thinks of performance art as suspect anyway."

At times, there is a direct connection between White's static and nonstatic art, as the paintings, drawings, and sculpture have served as stage sets for performances. Still, performance art has been traditionally anti-object, and pairing the two sometimes makes for a precarious mix.

There are only so many hours in the day, and White had to give up the performances for a number of years in the late 1980s and early '90s in order to make time for his studio work. Working in a number of different styles and media concurrently may reflect an active, creative mind at work, but real life often intrudes. Artists find that it is difficult to have more than one focus of their attention. They may become frustrated as they are pulled in different directions, and ideas, works-in-progress, and deadlines begin to pile up at the same time. Many artists find that if they don't necessarily have to give up a certain portion of their artistic work, they may need to place it on a back burner for extended periods of time in order to produce the work that sells better.

Take, for example, Elizabeth Busch, whose first love is what she calls her "quilt painting," in which she paints a picture, cuts it up, and sews it back together in a different configuration, adding a variety of fabrics and other elements. These pieces have been exhibited in galleries in New York and California with somewhat limited sales. Since 1990, the vast majority of her income has come from public commissions, in which she uses colored plastics that are cut into strips and hung from atrium ceilings. As with White, there are connections between the quilt paintings and the public artworks, "but the quilts are more personal; they come from a different part of me than the public art, which I think of more like an assignment," she said.

Busch called the success she has earned with public art pieces "a mixed blessing: it's how I make a living, and I have to live, but it doesn't allow me a lot of time to do the other work, which I really want to do."

Bonnie Bishop, an artist in Athens, Maine, faces an even harder choice in her career. Balancing graphic design, children's book illustration and teaching with her primary art interest, book art, Bishop stated that "I struggle with the questions of, Am I doing too many things? When is the right time to do what?" She had worked full-time in graphic design at various companies, quitting that life to work at home and take

graphic work and illustration on a freelance basis in 1992 in order to free up time for her book art, which has only had moderate success in finding buyers.

Making time for nonpaying work, however, has not been easy because she has to work harder to obtain freelance assignments, and "I have to do any graphic design that I get, because I have to make money." It is her fear that, within the next year, "I will probably have to give up the book art, because I need more than just the amount of graphic design work I am currently getting to help pay for it."

In most cases, the reason for choosing one style, medium or subject matter is money. One thinks of artists doing what they do out of love and zeal; having to give up that work and devote themselves to a type of art that may not interest them as much, as a result of market considerations, seems to defy why they became artists in the first place. Art skills are put to use, although they may be tangential to their main interest in art. On the other hand, artists who find something within their creative realm that earns them money may feel quite fortunate.

Over time, many artists learn these hard truths, or they may be told the same by artists' advisors. "You have to decide," Sue Viders, an advisor to artists, said, "—are you looking to please yourself or the marketplace? If your goal is to make money in the marketplace, eliminate the work that makes the least money." She noted that some artists may work in three different media, "but that requires you to have three different marketing plans, because painting galleries usually won't take your sculpture, and most painting and sculpture galleries don't handle photography. Also, do you have time to do all three media well? A problem I see is that artists get pulled in too many directions, and everything they do looks mediocre."

Another advisor, Susan Joy Sager, stated that "artists are not seen as serious by collectors and dealers if they do a lot of different things." She also pointed out that, when dealers or show sponsors are aware that an artist works in a number of different styles and media, they may be concerned that the artist will not have enough of one kind of work to fill the gallery (for a one-person show) or exhibition booth.

Artists, by nature, like to experiment throughout their careers, but collectors and dealers frequently view an artist working in more than one style at the same time as a sign that he or she hasn't yet matured artistically. Establishing a market for an artist's work is a matter of developing acceptance among would-be buyers. Art dealers spend a considerable amount of time educating their collectors about artists they represent and are loath to discover that one of their artists has suddenly changed styles, as that involves rebuilding acceptance.

"What I tell artists," Sylvia White, founder and director of Contemporary Artists' Services and the wife of John White, "is that they have to put all their eggs in one basket. In the same way that you don't send the same résumé out for five different job openings, but tailor the résumé for each particular job, artists have to decide, 'How am I going to present myself to this particular dealer?' Once the artists gets someone interested in their work, once that relationship is secure, then they may be able to say to the dealer, 'Would you like to see some of the other artwork that I do?'"

TOO MUCH ART

Underneath the beds in Barbara Nechis's house in northern California are framed paintings—her framed paintings—and Indianapolis, Indiana, artist Charles Mundy has more than one hundred of his paintings hanging on (or leaning against) the walls of his house (twenty in the living room alone!), but what are artists supposed to do with all their output? The prospects are not limitless: sell it, lend it, throw it away, give it away, or put it in storage. In general, artists want to exhibit and sell their work; however, most pieces on exhibition eventually come back, and few artists can boast of selling everything they create. The result is that they will end up with more stuff every year, which creates a what-to-do-with-it problem of varying magnitude. Storage, at least initially, is every artist's first recourse.

Watercolorists, printmakers, and others who create works on paper may have it the easiest, since large numbers of their pieces can fit in flat files, but those who paint on canvas usually keep their works on stretchers, which adds substantially to the thickness and calls for vertical shelving. Frames make the problem worse, but not to the degree that sculptors face, since generally they cannot stack works on top of each other.

Most of Nechis' work is matted and kept "in a large deep bin that I designed, that is recessed into a cabinet in my studio. I can fit over a hundred matted watercolors in it and the paintings are easily accessible. I also have a flat file to store stacks of unfinished work and paper." The studio is an obvious place to keep art, but over time it can get filled up, lessening the amount of available space for creating new pieces. William Reese, a painter in Wenatchee, Washington, built a climate-controlled sixteen-by-twenty-foot studio over the garage a few years back, but already half the combined studio-garage space is used for storage, which he does not view as a liability. "Overproduction serves a purpose," he said. "If you get sick and can't work, you have artwork to sell. It's a retirement plan, too."

Still, too much is too much, and the two artists have differing ways of dealing with excess. Nechis distributes paintings to family and friends "as gifts and loans. I have also given work to hospitals, schools, and libraries." Reese takes the more final solution approach of incinerating paintings he considers poor. "Over the years, I have burned a lot of them, sometimes a hundred paintings at a time," he said. The process of editing or weeding out less accomplished pieces in his body of work is not an annual event but comes up "when I hit a dry point in my work, when I need some ideas." Looking back at earlier paintings is "a tool" that enables him to "find something fresh to do" while also identifying works that fail to measure up in one way or another. The decision to destroy paintings reflects an evolving—one presumes heightened—sense of standards and taste.

"There's enough bad art in the world," Charles Mundy said. "I want to spare the public bad art, especially if it's mine." Because city ordinances in Indianapolis prohibit bonfires, he has knifed unwanted paintings, cutting them up and putting them in trash bags. In 2001, he destroyed 180 paintings at one time. Still, the production continues, and Mundy generates approximately one hundred paintings annually, down from 150 per year in the past. "Quantity is a good goal," he said, "because the more you produce the more experience you have. Being prolific means accelerating one's talent."

Another prolific artist, Frank Webb of Pittsburgh, Pennsylvania, takes a simi-
larly ruthless approach to work that doesn't measure up: "I store surviving paintings in
boxes labeled A, B, C, and D. If inventory becomes unmanageable, I destroy the paint-
ings in the D box, then some of the grade C are downgraded to the D box."

Discarding art can be quite freeing, unburdening an artist of the weight of every
piece of paper or canvas he or she has touched over time, but it is not something to be done
lightly. Some artists (and some art collectors) put excess work in storage facilities that are
temperature- and humidity-controlled, the costs of which may vary widely. New York
City painter Will Barnet, who rents a storage space in another area of town (for $200 per
month) for works that aren't on display, in his gallery's storage room, or housed in his
apartment and studio, stated that "once in a while, there might be a leak in the roof," more
often damaging works on paper than canvases, but added that he has never "had any
serious disputes with storage companies." Still, an offsite storage site only postpones but
doesn't solve the too-much-art problem, and Barnet said that he has "destroyed many
canvases with great regret. I don't like them, or I'm not working that way anymore, or I
just don't want to show them. I want people to get their money's worth." Of course, one's
style or ideas can change over time, but the old ideas and style may still be valid. Larry
Fane, a metal sculptor in Manhattan who rents (with two other artists) a storage facility
in New Jersey for his excess work, paying $900 per year for his portion, stated that he has
"weeded out works I no longer like, but that has sometimes turned out to be a mistake. I'll
see a slide of one of those works sometime later and think, 'Wait a minute, I threw out the
wrong piece.'" When he has reflected on why certain works were discarded, it often results
from discouragement offered by the market. "I'll think, 'This piece hasn't done very well,
and it probably won't ever get shown, and I've done better versions of the same idea.'"

Other techniques of dealing with too much art exist. Some artists have put works
on display in their local city hall or in trust for their children as part of early estate
planning. Geraldine McKeown of Elkton, Maryland, and Lee Weiss of Madison,
Wisconsin, both watercolor artists, regularly donate works to local charity auctions for
civic and cultural groups. Ken Austin, a painter in Orlando, Florida, holds annual open
studio sales for long-time collectors who are offered discounts of up to 30 percent. To
Louisiana painter Rolland Golden's mind, "artists should hang their own artwork in
their homes," so that visitors might picture how the art might look where they live,
although probably there are limits to just how many pieces should be on display: artists
can get sick of always seeing their own art, and they are more apt to gain inspiration and
ideas from looking at the work of other artists. In fact, it is not uncommon for artists to
swap their work with others, which doesn't lessen the amount of stuff in their midst but
does hold other rewards for them.

For artists who also produce print editions of their original paintings, the increas-
ing use of digital technology, creating what are commonly called "giclees" rather than
photolithographs, has meant far less storage. Digital prints are usually produced on a
custom-order basis, while offset lithographs tend to be printed in quantities of several
hundred or more for reasons of price.

Unless artists decide to go on strike, however, the problem of too much art will remain, leading to internal or other types of conflicts. On occasion, Austin has thrown out sketches ("free association stuff to get my imagination going") or demonstration pieces from the watercolor workshops he holds. "If I don't think it's worth keeping, I just chuck it," he said. However, his studio is next door to the gallery that represents him, and "the gallery owner goes through my rubbish can and finds things I threw out. She'll frame it and put it on display. She's an artist, too, and has a good eye." Now, it's her problem.

GIVING UP THE DAY JOB

After ten years of working as a mason and carpenter in New York City, fixing up lofts that other artists would live and work in, Bill Jensen decided that he would become a full-time painter himself. Actually, he had been painting, exhibiting, and selling throughout that decade but, at age 35, the sales of art were steady enough "that I knew I could afford to pay my rent and feed my family. I had some money in the bank and thought, it's now or never." Jensen has done quite well, but he still has his old tools. "I've always worried about having to go back to masonry one day," he said. "In the art world, they love you one year, hate you the next."

The life of most artists is a continual effort to juggle gainful employment and the pursuit of creating art; if there is any conflict between the two, the artwork is most likely to take a back seat. Over time, serious artists become adept at carving out time in the evening, on weekends, during vacations, and even on sick days in order to produce artwork and find exhibition opportunities. For some, critical notice and sales take place that build and take on momentum; the sideline needs more time if it is going to be given a fair chance to succeed. Eventually a tipping point is reached, and the something-hyphen-artist asks him- or herself: should I give up the day job?

For Lynn Basa, a textile artist in Chicago, that tipping point occurred in 2000, when she earned $60,000 from individual and corporate commissions, which was more than she was being paid as a corporate art curator. "My husband said to me, 'You're actually losing money by staying in that job,'" she said. "We penciled it out, and he was right." Part of Basa's success in selling her work stems from working seventeen years in the corporate art field, since she knows many of these curators or "how to find them." A large percentage of her sales come from just these private and corporate art buyers. "I talk their talk, and I know how to quickly assess what they're looking for."

The term "day job" itself has a pejorative sound, like "paperwork," that suggests a degree of unimportance or time being filled. If an artist proves successful, art critics and art historians tend to omit mention of the day job, or it becomes a point of trivia— Julian Schnabel worked as a cook and Richard Serra was a man-with-van mover— because the job has little to no relationship with the art that they create. However, those jobs paid the rent and bought the groceries, and it was not—and is not—an easy decision to give up even the least interesting salaried job for the uncertainty of an art career. Schnabel decided that he would quit cooking when his paintings reached the $6,000

mark, and probably every artist needs some objective benchmark that confirms not only that they feel ready but are ready to devote all their time to art.

That point arrived for Washington, D.C., painter Sam Gilliam after he received fellowships from the National Endowment for the Arts in 1967 and the Corcoran Gallery of Art in 1968, enabling him to quit his job as a public school art teacher in the nation's capital. "With that kind of money and time to pursue my art, I thought the risk of being a full-time artist was worth it," he said. Actual sales of his paintings were infrequent events at the time, and he hadn't prepared himself by saving money. "It scared my wife to death that I was leaving my job," he stated. "I'd be talking with people about art in one part of the room and, in the other side of the room, people were telling my wife, 'You're going to starve.' It became an issue for us. For a while, my wife's name for me was, Oh, You Poor Baby."

Leaving his teaching job may have afforded Gilliam more than just time, since in 1968 he moved artistically in the direction for which he is now well-known, getting rid of his easel and staining banner-length pieces of canvas that hang from ceilings. Exhibitions and sales began to take place with regularity. "Just working on my art for eight months without the sky falling in or my falling off a cliff gave me the confidence that I could make it," he said.

Sometimes, however, would-be full-time artists leave their jobs before they have the means to support themselves from their art. Barbara Cowlin, a painter in Ajo, Arizona, with a degree in printmaking from Northern Arizona University, who had two young children and operated a home-based daycare center, "just felt desperate about never having time to do my art" in 1992. "One day, I sat myself on the kitchen floor and told my husband that I was doing art full-time now." She called the ensuing two years "glorious. My day was focused on making art." However, household finances were the next thing to become desperate, and she returned to school to earn a teaching degree from the University of Phoenix in order to gain certification as an art teacher, then worked for the next dozen years in both public and private schools. In mid-2007, with a safety net of savings and the proceeds from the sale of their house, she and her husband moved to a new live-work rental artist building in Ajo to try the full-time artist bit again. She has had some success, having had a painting accepted into the U.S. State Department's Art in Embassies program, selling a few artworks from her Web site, and trading paintings for dental care with her dentist.

Chris Martin of Brooklyn, New York, also jumped the gun back in the late 1980s, after having "sold a bunch of paintings" through a gallery led him to give up his part-time work as an art mover. The recession of the early 1990s, however, hit him quite hard and drove his gallery out of business. In 1992, with young children to provide for, he went back to school to obtain a degree in art and recreation therapy, a field in which he worked for twelve years, most of it at a long-term care facility for people with HIV/AIDS in Manhattan. Throughout those years, he "was working incredibly hard, painting, and having shows, but not making a living." (The job paid him $45,000 per year, with benefits.) In 2002, he was awarded a Guggenheim grant of $42,000, and the AIDS facility allowed him a year's leave of absence, affording him the opportunity to create a lot of

artwork. "It was very difficult to go back to work after that year," he said, and he spent the next year figuring out how to quit his job, giving himself a make-or-break chance to become a full-time artist.

In 2004, Martin assembled $90,000 from savings and, borrowing against the value of his house in Brooklyn in order to support himself for three years, quit his job: "I decided that, if after three years, I found myself needing to go back to work, I would do so with no regrets." This time, things worked out better. His work appeared in several exhibitions in 2005, receiving favorable reviews (a *Village Voice* critic called him "one of the better underappreciated painters around"); in 2006, major galleries in New York City and Los Angeles began representing his work. He earned "over $100,000" in 2007 ("I don't feel comfortable saying how much"), claiming that "things are very, very successful right now."

Like any business venture, setting up as an artist requires some sort of business plan that includes a clear-eyed sense of an audience (interested buyers and galleries), a track record of sales, and some capital reserves. Perhaps a model of this type of efficiency is Carmel, California, painter William Hook, who left the world of advertising for fine art in 1987. Between 1971 and 1987, he worked as an art director and a creative director for an ad agency, devoting more and more of his spare time from 1982 on to art. It was in 1982 that Hook "gave my sister a painting. She took it to a framer, who really liked the work, asking her who made it and did he have any more." That frame shop show was his first actual exhibition; some of the works were priced as low as $150. For the year, he earned approximately $3,000. However, every year after that, he doubled his art income, earning almost $50,000 in 1987. "I was making more in part-time painting than through advertising," he said. Because of a stock ownership arrangement Hook had with his agency, he was able to cash out at a favorable rate, providing a safety net that would assist him as he began to paint full-time. He declined to reveal his income but stated that he sells over one hundred small (twelve-by-twelve-inch) to large (four-by-six-foot) paintings per year, which were priced at last checking between $2,500 and $40,000.

3

Expanding the Area
of Sales and Income

T he traditional view of what artists do to earn money is create a work, sell
it, then create another, and on and on. In this entrepreneurial age, artists
have a variety of ways to generate income from their work.

LICENSING

No fine artist begins a career with the thought, "Gee, I'd like to see my work on a
throw rug or plate." The idea that one's artwork might have other uses than hanging
on a wall somewhere comes later and requires a certain tolerance and maturity on the
part of the artist. So it was with Stephen Morath of Manitou Springs, Colorado, who
earned his Bachelor of Fine Arts degree at the School of the Museum of Fine Arts in
Boston in 1979.

Like many artists before him, he took various jobs (taxi driver, book store employ-
ee, layout and paste-up artist) while attempting to sell his acrylic paintings. Eventually,
the paintings began to sell—Morath was represented by the Wilde Meyer Gallery in
Scottsdale, Arizona—and he was approached to make photo-offset print and poster
editions of them by Leslie Levy Fine Arts, also of Scottsdale. It was through the wide
distribution of the posters that his work was seen by manufacturers, who suggested
using the images for products. Morath's images currently appear on book and CD cov-
ers, calendars, greeting cards, menus, jigsaw puzzles, and T-shirts, and even a label for
a skin care lotion.

"It wasn't my original intent as an artist to get into licensing, but the idea didn't
come as a shock," he said. "Once you move into posters, the idea that other possibilities
exist for your images doesn't seem so outlandish."

In fact, Morath has a lot of positive things to say about licensing, especially the
royalties. "You sell a painting once, and that's all the money you'll ever make from it,"
he said. "When you sell the rights to a painting, you can still have royalties coming in
years after you've sold the actual work." Having made a study of licensing, he feels no

need to consult an attorney when a contract is offered by a manufacturer and, in fact, has written his own licensing agreements from time to time ("they're really not that hard to understand").

Licensing art images has become the fastest growing segment in the entire licensing industry, according to Charles Riotto, executive director of the Licensing Industry Merchandisers' Association (350 Fifth Avenue, New York, NY 10118; 212-244-1944; *www.licensing.org*), generating $130 million in royalty revenues (the amount the property-holder actually receives) in 1998. The association holds an annual stationery trade show every May at the Jacob Javits Center in New York City, and one section of it is reserved for artists and art licensing agents. Other than attending the annual show, one may purchase the association's Directory ($250), which lists names, addresses, telephone numbers, e-mail addresses, and Web sites of licensing companies, and the type of goods licensed.

"Demand for art by companies is growing all the time," said Laura Levy, director of art licensing for Leslie Levy Fine Arts. "People are burned out on character licensing"—Bugs Bunny or Pokemon, for instance—"and they want something pretty that artists can do." She cited the influence of Martha Stewart on home decoration in companies' desire for tasteful and attractive imagery on products and objects bought by homeowners.

Some artists handle their own licensing arrangements with corporations, but most use an agent. An agent will pursue manufacturers and other prospective licensees—looking widely (for instance, game, furniture, or apparel manufacturers, or publisher) or at a niche market, such as baby products—depending upon the type of artwork. They will also insure that a contract is advantageous to the artist. Among the key elements of a licensing contract are:

- RIGHTS: What are granted to the licensee. The art, referred to as "property," will be defined as a particular image or a collection (for instance, twelve images for a calendar). The specific products (such as a calendar, poster, jigsaw puzzle, or T-shirt) on which the images will be used should also be specifically identified. An artist's work should not be used on a variety of products if only T-shirts are agreed upon. The term of the license should also be indicated, limiting the licensee's use of the imagery for a specified period of time, after which the art may be licensed to other manufacturers and other products.
- TERRITORY: Where the products with the licensed imagery will be sold. An artist may license the use of imagery for one or more products to be sold in the United States but license the same imagery for other products elsewhere in the world.
- DISTRIBUTION CHANNELS: In what market the products will be sold. Products may be sold mail-order, at department or discount stores, at gift shops or high-end stores. This matters because an artist may or may not want his or her name associated with a particular marketplace. For example, artists with

a prestigious gallery may not want their work sold at K-Mart. Artists may also license images for products sold through one distribution channel, while another licensee sells products at a different channel.

- ROYALTIES: Payment. Licensing royalties are customarily between 5 and 10 percent of the "net sales" or wholesale selling price of the item, which is evenly split between the artist and agent (the division may be 60/40 in favor of the artist when the artist is well-known). The contract should not only indicate the percentage but define the term "net sales" so that the licensee cannot take numerous deductions that lessen the actual royalty. There is usually an advance against royalties paid to the artist by the licensee, which insures that an artist needn't wait until the items sell before receiving any remuneration. There may also be a guaranteed royalty, stipulating that over a specified period of time, the artist will receive a specified amount of money. The artist may be paid monthly, quarterly, semi-annually, or annually—it needs to be written out, and agreed to, in a contract. There may also be a royalty audit clause, which permits the artist or someone assigned by the artist to audit the manufacturer to insure that the artist is properly remunerated. Some contracts also describe penalties if the correct royalties are not paid.
- APPROVAL: The artist is allowed to approve or disapprove the final product. The artist may request layouts, pre-product samples, or a copy of the actual object to evaluate.
- MARKETING DATE: When the product is introduced into the market (for instance, at a trade show) and when it will be shipped to retailers.

For Julia Cairns, a painter in Davenport, California, whose work has been licensed to book publishers and the manufacturers of thermal beverage holders and refrigerator magnets, "almost all of the money I make from licensing comes from advances, not the royalties themselves. The license may be only for two years, so the license expires before additional royalties kick in."

"I'm looking for artists who have a specific style or subject matter that people can grasp easily," said Shirley Henschel, owner of the New York City-based art licensing agency Alaska Momma. "When I look at art, I think, 'Can it provide a direction for the market or does it reflect an existing direction in the market?'"

Unlike the relationships of artists and their dealers, there is rarely a strong personal bond between artists and licensing agents. Helen Lee, a painter of impressionistic landscapes in Kansas City, Missouri, has had her work licensed to the makers of over two hundred products (including journals, note pads, paper plates and napkins, books, coffee mugs, shower curtains, shopping bags, photograph albums, and jigsaw puzzles) for ten years by Shirley Henschel without ever having met her. "I read something about Shirley in a magazine article somewhere, and I sent her some examples of my work," Lee said. "Within a few days, she called me up to get more samples. She started selling my work right away."

A variety of factors determine how much an artist will earn. The state of the economy, the market for particular items (what else is competing on store shelves), how effectively the manufacturer sells the product line, and where retailers place items on their shelves all factor into the success and failure of a product. It can be quite difficult to determine, when an object does not sell well, the degree to which the artist's image is or is not the problem.

The world of art licensing, even more than the art world, is also limited by fads and changing tastes: what looks fresh and interesting for a certain period of time becomes stale after a period of time. A gallery artist may receive a considerable amount of acclaim for his or her work at one point, which eventually and inevitably recedes as new artists and styles come to the fore, but a group of collectors are still likely to continue buying the artist's work over the years. Manufacturers, on the other hand, make rapid and abrupt shifts. As the market for products with impressionist garden scenes became saturated in the 1990s, there was less interest on the part of manufacturers in licensing Helen Lee's images. She continues to earn some royalties for her images, but she needed to pursue gallery sales of her originals in order to make up the lost income. "Those sales have actually become easier because of how many people had become familiar with my work through licensing," she said. "That familiarity has also made them willing to pay more for my work."

Sometimes, fine art and art licensing are an easy mix, and sometimes they are not. In one series of landscape paintings, for instance, Morath included roadside crosses, which one sees at various places in the western United States where there has been an automobile accident. However, the representative of a Japanese calendar company, told him, "I'm sorry, grave marker not pleasant image for calendar." The ideal scenario, he noted, is when "I do a painting and someone says, 'That's really cool. We could use that for something.' It has been less successful when manufacturers try to tell me what to do. The images are generally not as good, I think because everyone is trying too hard."

Somewhat frustrating for him, too, as the relationship between his fine art and licensing is all one-way: Morath's images may be picked up by a manufacturer for a product, but he hasn't seen any buyers for his originals from those who first encountered his work as a product. "People who have seen the greeting cards have contacted me about the originals," he said, "but when I tell them the price of an original painting"—between $3,000 and $5,000—"they're just flabbergasted. I try to direct them to where they can buy my posters."

PUBLISHING PRINTS

Print publishers offer different kinds of potential rewards to artists. Prints allow artists to get paid for the same image again and again. Art prints clearly sell for less than original works but, because of their greater numbers, are disseminated more widely. The lower prices of prints may also bring artists an entirely new clientele, some of whom may later purchase the more expensive original pieces, as well as provide money to tide them over until the larger works begin to sell.

There are different ways in which a line of prints may come into being. A wide range of agreements may be made between artists and print publishers, and the differences reflect the broad range of publishers around. Some publishers, such as Tyler Graphics or Gemini, which publish limited editions by some of the most renowned contemporary artists, allow artists maximum artistic control and guarantee income. Others, such as Franklin Mint, are mail-order houses and offer artists what are actually work-for-hire agreements that take away copyright in exchange for a flat, up-front fee.

SELF-PUBLISHING

The most common approach is that artists themselves locate a fine art printer in order to self-publish an edition (limited or not) of an image from an original painting, produced through photo-offset or by computer ink-jet printer. Self-publishing is customary for artists who sell their work directly to buyers at art fairs, shows, and expos, or through subscription, and it requires an extensive knowledge of their collectors. Artists who have a limited track record in terms of showing and selling their work would be unlikely to want to print 3,000 copies of a particular image, because they might never recover their initial costs. Some fine art printers, however, encourage artists to print in large quantities, offering price breaks for each thousand.

It is rare that an artist starts a career selling prints; instead, the market for original pieces should be tested, with prints following as the number of potential buyers grows. Early in their career, artists should forgo the price breaks, creating smaller editions that are in keeping with the expected size of the actual number of people likely to purchase a print.

Fine art printers can be located in a number of ways. Many of them advertise in art periodicals, and *Decor: The Magazine of Fine Interior Accessories* (Commerce Publishing Company; 330 North Fourth Street, St. Louis, MO 63102-2036; $20 for twelve monthly issues), which sponsors the Art Buyers Caravan shows around the United States, has an annual "sources" issue every July that lists many of the fine art print publishers and distributors in the country. Of course, one may also inquire of other artists, who could report their own experiences and levels of satisfaction. Certainly, artists would want their work printed on archival acid-free, pH-neutral paper with tested inks (not soy-based, for instance) that will not fade in normal light. Printers that do not specialize in fine art prints are likely to use inks and papers that are not sufficiently durable. Some printers have consultants on staff, who will help artists plan for the appropriate publication size and marketing plan (asking questions like, Do you have a mailing list? or, Do you want a postcard version of the image to send to potential buyers?).

PRINT PUBLISHERS

Many galleries that sell prints obtain these works directly from publishers who have established a distribution network. Mill Pond Press, Greenwich Workshop, Wild Wings, Applejack, and other publishers are regularly contacted by artists who would like

photo-offset prints of their work sold in galleries, and these companies are also regularly on the lookout for artists whose works would both reproduce well and appeal to their clientele. These companies produce catalogues of the prints they sell, and artists should examine them to see if their work would fit in. The size of these editions is generally under 1,000, and artists receive a royalty of between 10 and 20 percent (the amount determined by the prestige of the artist and how well their work has sold in the past). The company doesn't itself print the editions but contracts out to other printers.

A number of points should be kept in mind when negotiating a contract with a print publisher: the artist should retain copyright and should also demand that the seller always plainly state the name of the artist and that the artist holds the copyright; second, the contract must state the number of copies that the company is permitted to sell.

Another point to be considered in a contract with a publisher is the time period during which the distributor may advertise and sell the works, since the artist may choose to make his or her own edition to sell at some future date—that, of course, is only possible if the artist holds copyright and the contract allows it. Another way in which artists may maintain their control is by selling only a certain number of prints to a distributor. For example, L.L. Bean catalogues contain descriptions of "limited quantities" for certain prints, which refers to the number of prints in stock and not the entire edition. In such cases, the artist has sold L.L. Bean a stack of prints but remains free to print up more for him- or herself to sell.

The percentage of the earnings from the sale of prints (or royalties) payable to the artist should be covered by the contract. It is important to stipulate that any advance paid to the artist is not refundable if the works do not sell. This is known as an advance against royalties. In addition, some artists may also be reluctant to proceed on an all-royalty basis. Certainly, none of the publisher's costs of printing, advertising, framing, paying taxes on, or distributing these works should be borne by the artist. If the publisher wishes to purchase not only limited reproduction rights but also the original work itself, artists may try to divide this sale, offering the original for one price and the reproductions on a percentage basis. That may not always be possible.

A final point involves maintaining some artistic control over the reproductions whenever possible in order to ensure that the copies best represent the artist's intentions. Poor quality reproductions or any malfeasance, such as prints that have duplicate numbering or are misrepresented as being approved by the artist when they weren't, may reflect badly on the artist's reputation and diminish the value of the artist's other work.

DEALERS AND GALLERIES

At times, the process of selecting, creating, and paying for an edition will be taken over by an artist's gallery or dealer, who may sponsor the artist in creating an original work at a print studio or photo-offset an existing piece. When they are commissioning an original work, the artists are more likely to work with high-end printers, such as Gemini

or Tyler Graphics. The sizes of these editions are often smaller than the runs in self-publishing—galleries are marketing pieces to their select clientele rather than to the thousands of people attending an art fair, and the number is often under one hundred and sometimes closer to ten or twenty—and the dealer will receive the same commission as for original works.

CERTIFICATES OF AUTHENTICITY

Walton Mendelson, an artist in Prescott, Arizona, who creates drawings, collages, and photographs, doesn't have a high opinion of certificates of authenticity—the documents accompanying digital prints of his work that provide basic information on the edition—but he has come to see that many collectors hold a different point of view. "Just shy of 50 percent of the hits on my Web site are for the certificate of authenticity page," he said. "People obviously think this is an important thing to have, so I guess I have to, also." Otherwise, Mendelson associates these certificates with commemorative plates and other art-tinged knick-knacks. They are "a hoax, a funny way to con somebody into believing that a $7 plate is really worth $50. I'm embarrassed by it, but well. . . . "

For potential buyers of his work, which averages $600 a print, however, a certificate of authenticity serves just the opposite purpose: to convince them that the prints aren't knock-offs worth only the price of the paper they are printed on. This fear is never far from the minds of collectors in the art multiples field: Do copies of an original image have any intrinsic value? Does the print itself have value, or are buyers only paying for the expense of operating a printer? Does limiting the number of prints in an edition actually increase that value? Does providing more information about a given print or edition of prints add value to it? It was to give consumers greater protection when entering the multiples market that art print disclosure laws were enacted in fourteen states around the country (Arkansas, California, Georgia, Hawaii, Illinois, Iowa, Maryland, Michigan, Minnesota, New York, North Carolina, Oregon, South Carolina, and Wisconsin). These consumer protection laws vary from one state to another, and some are more stringent than others, but they all require the sellers of multiples to provide information to buyers, such as the name of the artist, the year in which the work was printed, and the printing plate created, the number of prints that are signed and numbered (or signed only, or unsigned and unnumbered), the number of proofs that are signed and numbered (or signed only, or unsigned and unnumbered), and the total size of the edition. The majority of print disclosure laws also require collectors to be notified of the type of print (digital, lithograph, or etching, for instance), whether or not the edition was produced after the artist's death and if the edition is a restrike (a later printing that is not part of the original edition), whether or not the artist actually signed the print or if the signature was printed mechanically along with the image, the name and location of the printer, and whether or not the printing plate has been destroyed or is in storage (and able to be used again). Most of the states follow California's lead in identifying the applicable prints as selling for more than $100, not including the frame. These

statutes protect buyers in their respective states, regardless of where the prints were actually created, making dealers and gallery owners who sell prints in those states liable for incorrect or absent information.

As a result, galleries throughout the United States regularly provide documents for the art multiples they sell, usually referred to as certificates of authenticity. Artists who sell their own prints directly are responsible for providing this same documentation, although it is far less common to see them offering certificates of authenticity when making sales at exhibitions, in their studios or through a Web site. Perhaps many artists believe that the laws only apply to dealers and galleries. In fact, New York state law specifically assigns liability to the artists if the information they provide to a gallery owner in writing about their prints is incorrect. In all fourteen states, sellers of prints— artists or dealers—could face prosecution by the state attorney general.

There is no print disclosure statute in Arizona, but Mendelson is aware that, through the Web site, his work may be sold to buyers all over the country, some living in any of the fourteen states with these laws. Mendelson's certificate of authenticity offers a limited amount of information about the prints he sells—their title, medium, size, type of edition, when it was printed, the type of printer and paper used, some care and handling advice, and a statement that "all information and statements contained herein are true and correct" (signed by Mendelson)—which probably reflects his intuitive sense of what collectors want to know rather than what state laws require. Many artists' own certificates can be somewhat free-form in nature, suggesting good intentions rather than a strict interpretation of the law. The certificate of authenticity of Baton Rouge, Louisiana, painter Angela McGraw lists only the artist's name, date and size of the edition, title of the work, number in the edition, and physical size of the print, while that of painter T. Kelley Tagas of Bozeman, Montana, is more like a sales receipt, indicating title, size, medium, date of sale, price, buyer's name and signature, and the artist's signature (twice). Tagas' certificates are almost works of art in themselves, with background colors that pick up the colors on the prints themselves and thumbnail images of the prints on the upper right- and left-hand corners. JerriAnn Holt, an artist in Windsor, Maine, stated that she regularly provides certificates of authenticity for digital, or giclée, prints on canvas but only occasionally for prints on paper. "It depends on the price point, since giclees cost more, and the venue," she said. "I always have certificates when prints are in galleries, not so much for when I'm selling works at an art fair or on the street. No one has ever asked her for a certificate of authenticity, and most people don't really care."

Washington, D.C., arts lawyer Joshua Kaufman stated that artists should have their certificates comply with the strictest state laws—particularly California and New York, since their work may be sold there. He added that all state laws require information to be provided to "potential purchasers when a print is offered for sale. It is incumbent upon each Web site to either have this information next to the print or have a link from the image to a certificate of authenticity. A copy must be shipped with the print as well."

Since it is not utilitarian, all art has more a perceived than an intrinsic value, and part of the job of an artist or seller of art is to suggest that this piece of paper, this canvas, or this piece of wood or metal (or whatever it is) is worth more than the materials involved. Many artists who offer certificates of authenticity claim that their collectors believe—or hope they believe—that these documents both indicate uniqueness and add value to the prints. "From a marketing standpoint, you are promoting the integrity of the artist, and from a sales standpoint you want customers to know what they are buying," said Robert Westerfell, business manager for Noble Powell III, a painter of golf course scenes in Port Hueneme, California. The word "integrity" frequently comes up when artists describe their certificates of authenticity, and in this case, integrity can mean a variety of things, such as the prints "were done by the artist whose name is on the piece," according to Washington, D.C., painter Jenne Glover, or that "I'm being held to my word that there are only so many prints in the edition, and no more than that," for T. Kelly Tagas. Loopholes exist in even the most stringent print disclosure laws—it is possible to have more than one limited edition of a particular image if they are different sizes or use different types of numbering or different printing processes (an offset lithograph and a digital print, for example), and the number of proofs available for sale may be quite large—and collectors have become wary of paying top dollar in a market flooded with prints of supposed limited quantity. Required by law and generally a good sales tool, certificates of authenticity offer artists selling their own work an opportunity to display their commitment to their art.

"SIGNED BY THE ARTIST"

The art print market is one where signatures count for a lot. An artist's name on a print can bring up the price by two or three times, and artists generally view signing and numbering works as a valuable source of income for themselves.

That is not to suggest that signed prints have intrinsic value only to the autograph hound; many artists and their dealers contend that by signing a print the artist approves and endorses it and implicitly claims it as his or her own work. In some cases, however, the entire economic value of a print is in the signature. Salvador Dalí and Marc Chagall, for instance, signed blank pieces of paper on which reproductions of their works were to be made. Picasso's granddaughter, Marina, also published a posthumous series of the artist's prints. In none of these instances did the artists ever see the finished works. Nonetheless, those prints were marketed at prices that would lead collectors to assume they were original works of art in some way.

The tradition of artists signing their prints is about one hundred years old—before that, they frequently used monograms. Artists such as Henri de Toulouse-Lautrec and Pierre Bonnard signed some and not others, depending upon the wishes and ego of the buyer. They signed works as they sold them, and those for which there was no demand in the artists' lifetimes went unsigned. The value of their signed and unsigned prints is the same, as there is no question of the artists not authorizing or approving them for sale. The more recent convention of artists signing all of the prints in an edition at one time is

said to date from the 1930s when a Parisian dealer, Leo Spitzer, convinced a few of the major artists of the day, including Henri Matisse and Pablo Picasso, to produce elegant reproductions of their work that they would sign and he would sell.

Most artists are now well aware that their signatures mean more money for their works. Picasso did one series of etchings in the 1930s called "The Vollard Suite," which he began signing in the 1950s and '60s as a way of increasing contributions to political causes he championed. Norman Rockwell signed a series of prints to help support the Cornerhouse Museum in Stockbridge, Massachusetts, which featured his paintings, and Andrew Wyeth did the same on behalf of the Brandywine River Museum in Pennsylvania, where his paintings are on display. Other artists have less philanthropic uses for the money that they make from their signatures.

The high prices that these signatures mean have led to fake signatures, signatures that are printed on the paper along with the image, and false or misleading statements about these works by their sellers. While artists may be altogether innocent of false claims made about their work, prosecution of their dealers or complaints by collectors may adversely affect the market for a significant degree. Such has been the case with Salvador Dalí for a number of years, a result of the large number of prints on the market that may or may not be "original."

Artists should carefully review any promotional material associated with their work as well as make certain that their copyright is noted (on the same or an adjoining page where artwork is reproduced) and, if this is a limited edition, that there is no duplicate numbering. Publishers sometimes print more than the stated number in an edition, in case there is a smudge on or damage to the paper or something else. Extras may be sold accidentally or intentionally as part of the edition unless the artist sees that they are destroyed.

BARTERING AND LEASING ART

More than anything else, artists prefer straight sales of their work and prompt cash payment, but this doesn't always happen. At times, agreements can be made to barter artworks for something else; at other times, works may be leased. Potential problems abound with these situations, but there are also great benefits for artists in both.

BARTERING

Bartering is probably the oldest form of economics—money, on an historical scale, is the new kid on the block—and artists who are rich in canvases if short on cash have kept barter alive. A lot of people have benefited from bartering with artists. Jack Klein was Larry Rivers's landlord for a number of years and was able to retire and move to Paris on the paintings his tenant gave him in lieu of rent. Sidney Lewis, president of Best & Company, built up a collection of paintings by major and lesser-known artists swapped for washers, dryers, and other appliances.

Dr. Frank Safford is another. He tended to the health of Willem de Kooning during the 1930s and '40s, in the years before the artist's works began selling. He was paid in

half a dozen paintings, one of which the doctor later gave to the poet and dance critic Edwin Denby, who sold it to buy a house.

In general, it is doctors and lawyers who do the biggest bartering business due, not surprisingly, to the fact that their fees are often beyond the reach of most artists. Of course, many professionals will not accept artwork in exchange for their goods and services, and it is best to discuss methods of payment and how bartered objects will be valued in advance. Bartered property is taxable income and must be declared as such. For various reasons, the artist may give his or her work a high value while the recipient, wishing to keep taxes low, might pick a low value. Most artists who exchange their work for goods or services have not sold before, and there are few objective criteria available for valuation. An agreement must be made between the two parties, as discrepancies may pique IRS interest. This can be a testy area for negotiations.

Some people will accept art in total or in partial payment from some clients, but not all of the time. They, too, have to pay rent and employees' salaries, and the partners of a law firm cannot share art as they would a cash payment for services. The fact of not being able to accept art as payment does not imply that the professional thinks less of the artist and will not do his or her best work, but artists are free to shop around for people who will accept artwork as payment.

Dealers also from time to time accept something other than money for consigned works in their galleries, such as jewelry or other pieces of art. The artist, of course, should be paid only in cash and at the price level established between artist and dealer—not at whatever the appraised value of the jewelry or artwork is found to be.

LEASING

Over the years, Jenny Laden's paintings been purchased by homeowners, but perhaps even more important than that, her art "looks like something you'd see in someone's home." That may be good enough for the film industry. Several of the Brooklyn, New York artist's figurative pictures of women have been used as set décor by small-scale movie makers who have rented the paintings for the few days it took to design a set and film a scene. Her art does more than just look like art, and her work has been exhibited in galleries in the United States and Europe. The big screen is now one more place that people can see her art.

"It's exposure," she said, "and exposure leads to a wider audience of people who might like what you do." However, Laden has no illusions that her paintings as backdrop in a movie, even if it were to have international distribution, will be a big break in her career. For one thing, few moviegoers pay attention to what's on the set (Academy Awards go to set designers, not to the individual makers of props), and the film credits won't list her work. The claim that a particular painting appeared in a movie isn't likely to raise the value of the piece, "although it will make an interesting story when I talk with collectors. It always helps when you have something to say about your work." And, it's money in her pocket ($300 per painting), plus she gets to keep—to rent again or sell—the artwork.

Sales of art always seem to get the headlines, but rentals have become a major growth area in the art market, catering to an audience of corporations, film and television producers, realtors, and homeowners. This grouping has its own individual reasons for wanting to rent rather than to buy.

For instance, corporations that may be facing economic uncertainty, takeovers or mergers, and possible relocations want art for office decoration but don't want to invest in a collection that may need to be put into storage or sold; renting is less expensive, less permanent, and tax-deductible. "They're not married to the art," said Barbara Koz Paley, chief executive officer of Manhattan-based Art Assets, which has leased works of art ("some valued in the six figures") to businesses since 1993. The objects that Art Assets rents out come from a variety of sources, including galleries, museums, and private collectors, but increasingly from individual artists. "It's just so much easier to deal directly with artists than with their dealers," she noted, "and in the age of the Internet it's just so much easier to get to artists." Many of Art Assets' almost fifty clients are office building owners and managers who are using art as a tool to sell their properties, upgrade their buildings, and set a "cultural tone." The rental of artwork is three percent of the object's value over a negotiated period of time. The cost to the corporate client, she noted, is usually passed along to tenants. In addition, "by renting, they pay a fraction of the cost of buying, and there are distinct tax benefits."

Among the artists who have leased their work through Art Assets is Jill London of New York City, whose art involves gold leaf on paper and other surfaces. She earned between $3,600 and $3,800 for the rental of sixteen pieces on two separate occasions, each lasting one month. The income was welcome, as was just getting some artwork out of her studio. "I live in the Lower East Side in a small, cramped apartment-studio, and it's great for me when I can move work out," she said. The opportunity for having her work seen was no less valuable. "People ask if my work is being shown anywhere, and I tell them, 'Yes, you can see my work over there in that building.'"

On a smaller realm, realtors seek artwork when "staging" houses and apartments, giving a property a more lived-in look that may entice buyers. Shawn McNulty, a painter in Minneapolis, Minnesota who has sold his artwork at gallery exhibitions and through his Web site, entered the art rental business in 2007 when "a realtor working with a stager asked me to lease some paintings" for some properties she was working to sell. Six of his large-scale (three-by-four-foot) abstract paintings were used in a downtown Minneapolis loft, and another five medium-sized (two-by-two-foot) works were placed in a house in St. Paul. Both properties sold (maybe the art helped), and he earned $780 and learned a new way to earn money as an artist. "I offer rentals now on my Web site," he said. "I'm pretty prolific, and I'd be happy if I can move some older work out of the studio this way, at least temporarily."

More and more artists have taken the same direction as McNulty, soliciting rental business and developing art rental agreements that cover the cost (his prices range from 7 to 10 percent of the retail value for a three-month rental), insurance (renter is liable for lost, stolen or damaged artwork), transportation (renter pays), the manner of payment

(credit card, usually, since the rental agreement automatically is renewed at the same terms unless the item is returned), and the process by which a leasing agreement turns into a purchase ("half of the rental money goes toward the purchase price," he said).

In large measure, artists have left the particulars of art rental agreements up to organizations (for instance, Santa Monica Art Studios in California and the Peoria Art Guild in Illinois both promote and arrange leases) to which they belong. A number of art galleries—the Monsoon Galleries in Bethlehem, Pennsylvania; HANG ART gallery in San Francisco; and Larsen Gallery in Scottsdale, Arizona—promote art leasing plans, while others rent pieces more informally and only occasionally, for the artists they represent. Art galleries tend to structure their rentals as lease-to-purchase agreements, while companies such as Art Assets tend to offer straight leasing agreements, although "sales take place maybe 10 or 12 percent of the time," Paley said.

Sales haven't take place for Jill London, who stated that building lobbies "aren't selling spaces, and people who look at art there don't think of it as something to buy." However, the work of Serena Bocchino, a painter in Hoboken, New Jersey, which was rented through Art Assets for the Manhattan headquarters of the tax accounting firm PriceWaterhouseCoopers (for which she earned a leasing fee of over $4,000), so favorably impressed the company that it purchased twenty of her paintings for its corporate collection. "I got paid for exhibiting my paintings and I got paid for selling my paintings," she said. "All in all, it was a very good experience for me."

Another market for art leasing is the entertainment industry, which continually needs props (preferably ones that don't require storage), and the rental of objects frequently fits into a budget better than purchases. Artwork isn't the only cultural objects rented—antiques and crafts items also are used on film sets, in magazine advertising shoots, and as displays in store windows (Bijan Nassi, owner of Bijan Royal antiques shop in New York City, claimed that he rents between three and four hundred objects per month for use as props)—but it tends to be the largest category in terms of dollar value. Sometimes, homeowners rent artwork on a lease-to-own arrangement that allow them to pay over time while making sure they really like the artworks; if, after a month or six months or a year, they decide the art isn't right for them, they may return it.

Jenny Laden herself did not look for rental business from movie studios but was part of a Brooklyn-based company, Art for Film (*www.artforfilmnyc.com*), which promotes the work of two dozen painters and sculptors to the film industry in New York City and elsewhere. Jessica Heyman, the owner of Art for Film, noted that her pricing is flexible, because "some studios have bigger budgets than others, and you have to work within their budgets rather than have a set price." A rental payment is split evenly between the company and the individual artist. Frequently, the film studio set decorator doesn't take the physical painting but, rather, a digital image of it, which can be printed out at a size that better fits the actual set. One of Laden's watercolor paintings, a seventy-five-by-forty-foot work titled "Lady," "needed to be smaller than it was," she said, and was reduced through a computer printer. At the end of the shoot, the digital print was returned to her, "which actually gave me something else I could sell."

In effect, the artist is allowing a studio a one-time right to license the image for a relatively brief period of time. The benefit to the studio of working directly with artists or through a company like Art for Film is that they gain clearance, or permission, to use the image; the failure to acquire those rights when copyrighted artworks are purposefully or inadvertently included in scenes has resulted in lawsuits and judgments against studios.

Film and television studios don't usually have large budgets for set props (Heyman noted that some artworks have been rented but not used on a set, simply because the set designer wants to have a variety of choices), which makes this type of income supplemental rather than primary for most artists. Set designers sometimes find artwork online, but they are more apt to use local artists or local galleries, simply because they don't tend to travel hundreds of miles for a two-day, $300 rental; as a result, artists in southern California, New York City, and Vancouver, Canada—the three largest areas of filmmaking in North America—tend to benefit the most. Sculptor Bruce Gray of Los Angeles and painter Susan Manders in Sherman Oaks, California, had their first art rentals to film studios through galleries, but they both moved to represent themselves in rentals, doubling the amount of money they earned. "I started to notice that there was a lot of art in TV shows and movies and thought, 'That could be mine,'" Gray said.

Still, for them, the money doesn't add up to a livelihood—thousands rather than tens of thousands of dollars per year. Art rentals don't "happen all that often, maybe a few times a year," said Gray, whose sculptures have been in the backgrounds of all three Austin Powers movies, *Meet the Fockers, The Truth about Cats and Dogs,* and *Sleeping with the Enemy,* as well as over one hundred commercials (Honda and Sprint among them) and television shows (including *CSI* and *Six Feet Under*). He has advertised in industry publications and sent postcards to set designers about his work, but "most of my art rentals have come about through word-of-mouth."

There are benefits and drawbacks to renting works of art. Gray had one sculpture stolen off a movie set ("I got paid for it, though maybe not what it was worth") and another scratched ("They actually rented it a second time in order to repaint it. Turned out good as new"). Yet a third sculpture was repainted in different colors ("a crappy job") to match the colors on the set. "If you can't bear to see something happen to your work," he said, "you shouldn't rent it out."

Manders noted that she has been lucky in terms of no thefts and no damage and even luckier that arrangements that started out as rentals turned into purchases. "Doing business with studios has other benefits," she stated, noting that she has been commissioned each year since 2005 to create an edition of prints that are included in the gift bags for presenters at television's Emmy Awards. "It brings my work to well-known celebrities, and that leads to other sales, because a number of the presenters became buyers."

There is no industry standard for rental agreements between artists and those who would lease their artwork. Among the clauses that Susan Manders includes in

her rental and sales agreements are the term (the length of the rental period), the monthly rental fee, the option to purchase rented artworks, changes in rental or purchase prices (no more than once per year), the responsibility for safely transporting the artwork (the artist's responsibility), the care of the work while rented (the renter's responsibility), insuring the work (the renter's responsibility), and prohibiting both the display of the artwork in a commercial gallery and reproductions of the art.

Artwork rentals can be arranged through a variety of sources, starting with artists themselves. One New York City real estate developer, for example, leased a wall sculpture from Jeffrey Brosk for the lobby of the Fifth Avenue apartment building he had erected "in order to give the place cachet for prospective tenants," according to the artist. It seemed to work, as the building filled up and the developer decided to purchase the sculpture.

Art dealers and corporate art advisors also arrange rentals and leases for clients who want to "try works out" for an extended period of time. Dealers often allow prospective buyers to take art home for up to ten days without charge to see if it "works," and may also devise rental agreements for collectors who take longer to decide or whom they would like to cultivate as long-term clients.

"Some people need a breathing space of time in order to consider the purchase, and renting can allow that," Christopher Addison, owner of the Addison-Ripley Gallery in Washington, D.C., said. "More than half of the people who rent end up buying the work, partly because of laziness—they've grown accustomed to the work."

The art rental field is generally one for younger, lesser-known, or "emerging" artists, since the more famous artists are likely to have waiting lists for their work and have less incentive to let pieces go out on rental. Being associated with a museum, even though it is with the sales and rental gallery of the institution, does attach to the artist a museum imprimatur that adds stature to the artist's work.

Renting a work is usually a short-term event, lasting from one to four months, while leasing may range up to two years with payments applied to the sales price should the customer decide to buy. Fees for renting or leasing are usually based on the market value of the art, ranging between two and five percent a month, although it can go as high as 15 percent. Discounts for leasing more than one piece at a time can be negotiated with dealers, and sales and rental galleries frequently have discounts for museum members.

Some rental agreements stipulate that the renter provide insurance for the work for the entire term of the lease as well as pay for crating and shipping. In addition, the schedule of payment, perhaps monthly or in total at the outset, may be negotiated or specified in a contract.

Leasing has generally become more attractive to businesses since the enactment of the 1986 Tax Reform Act, which lengthened the period of depreciation for office equipment that a company buys. Art has usually been lumped in with "property, plant, and equipment" for business accounting purposes and viewed as office decoration rather

than a separate category of investment. The Internal Revenue Service has increasingly disallowed deductions based on a depreciation of corporate art (because, the IRS claims, art actually increases in value over time and isn't subject to wear and tear). Furthermore, the new, slower payback resulting from the 1986 law's extension of the period of depreciation has led companies to look more favorably on leasing telephones, automobiles, and a host of office-related equipment.

"With leasing, a company can deduct all of the expenses now instead of waiting for years," Janice M. Johnson, partner at the accounting firm of BDO Seidman, stated. "Leasing lets you get around the depreciation problem. Leasing works of art instead of buying them also solves other problems: How long will the company managers have the same tastes? Some people just like change. How permanent are the company's facilities? Maybe the company will move in a few years and will want different art. There's also the issue of the quality of the art—you may rent cheap stuff now while saving up to buy something more substantial later."

Not all art dealers and advisors are pleased to let work out on a rental basis, however. It can be a bookkeeping, insurance, and inventory headache for dealers who must keep track of lease payments, establish rental agreements, protect these pieces from damage, arrange insurance coverage, and arrange for the work to be returned at the end of the rental period.

"Facilities people" at many companies have no idea of how to care for artwork and may place pieces where they will fade from exposure to direct light or where employees smoke or there is inadequate ventilation. Vandalism and theft are also concerns. In addition, because they are not buying it, the corporation is more apt to view the art as mere decoration and not shield it from damage in the same way as it would protect something the company owned. Other dealers and art advisors have mentioned that artists aren't as likely to lease their best work.

"There are questions you have to ask," Jeffrey Brosk said. "Who is renting it? Where is it going to go? How will it be protected? You have to be more selective when you're renting a piece but, if you are more selective, you can give better quality work."

For artists, there are a number of very clear benefits and practical concerns with renting and leasing their work. Their pieces may be seen by a wider range of people than the limited group of art gallery "regulars," stimulating interest in the work by those who may become future collectors.

Stephen Rosenberg, a New York City art dealer who has consigned work to the Philadelphia and Delaware museums of art, notes that "people have come in here when they're in New York to see the work of some artist they saw through a rental arrangement somewhere else. I've had quite a few sales that way."

The potential for positive exposure may also convince artists to loan works to banks or restaurants, or charge only minimal fees, stipulating that the work must be returned in good condition. If there is any damage, all restoration costs should be paid by the institution, not the artist.

Any contract between an artist (or an artist's dealer) and a renter should include specifics about the following:

- the length of the rental arrangement
- the rental price (which the artist is likely to decide with his or her dealer, who may know a lot more about going rates)
- how the artist or artist's dealer is to be paid (documentation that the art is insured is needed for the entire period of the lease, to be provided by the renter or artist's dealer but not by the artist)
- that the artwork is credited to the artist (it also doesn't hurt to have information on the artist noted somewhere)
- that the art not be harmed, but if it is, the renter must pay for all repairs (the artist should be given first refusal on making any repairs) or cleaning (if a lot of cigarette smoke or coffee splashes have discolored it)
- that the renter (or the artist's dealer but not the artist) should bear all expenses of packing and shipping the work

Artists may also wish to have some say over where and how their work is displayed and may want some veto power over certain companies with which they do not wish to be associated. In addition, the work should be available for the artist (or dealer) in the event of an exhibition.

"There should also be an affirmative obligation on the part of the renter to return the work after the lease has expired," Kate Rowe, a New York City lawyer who frequently works with artists, said. "It must be stipulated on the rental agreement that the renter is obligated to return the work at the end of the rental period. It's not uncommon that no one takes responsibility and the work just sits there indefinitely. If a long time passes or someone dies or the paperwork is lost, no one quite remembers who owns the work."

When the work is rented through the artist's dealer or gallery (or consigned to a sales and rental gallery by the dealer), the contractual agreement between the artist and his or her dealer should resolve some of these same points. Specifically, it should indicate that the artist not bear any expenses and that any rental payments to the dealer will be split between the artist and the dealer on the same percentage basis as when a work is sold.

Some dealers consign works they represent to the sales and rental galleries of museums (see chapter 1) as a way to help out the institutions, which use the sales and rental galleries as fundraising tools. A painting consigned by the dealer may be sold at the sales and rental gallery; the artist receives the same percentage (for instance, 60 percent) as if the picture had been sold regularly by the dealer, with the dealer and sales and rental gallery splitting the amount of the customary dealer commission (40 percent)—usually, that gets divided in half.

It should also be remembered that an artist receives no tax deduction for renting a work of art to or through a museum. Tax deductions are, for artists and everyone else, available only for outright gifts to nonprofit institutions.

STARTING ONE'S OWN GALLERY

After a period of time spent beating their heads against the wall trying to get into the traditional art market, husband and wife Bob and Michelle Kennedy of Key West, Florida, decided to open their own galleries—Kennedy Galleries (for paintings) and Kennedy Studios (for prints and photographic reproductions of the paintings). The works have sold well ("Just in Key West, we do $2 million a year," Bob Kennedy noted), and the two painters pay nothing to a middleman or need to play politics with a gallery owner to get a show every couple of years or just be one of the many artists clamoring for attention in a gallery.

"I didn't want to have to tip-toe around dealers," said Michelle Kennedy. "I didn't want to convince a gallery owner that my painting works." She also didn't want to wait a long time to see any sales. Her experience of other galleries and dealers had left her frustrated for other reasons as well. "I had been in other galleries, but they all tended to pigeon-hole artists," she said. "When something works, they're afraid of anything different. Some artists find their bliss and keep repeating it, but I don't want to rely on a style." Her work covers a wide territory in terms of subject matter and style, from academic realist still-lifes to abstract landscapes and satiric German expressionistic images. For reasons of marketing, dealers generally want the artists they represent to have a defined look, which further turned off the Kennedys to the traditional gallery world. "If I work in one style one day and in another style the next day, it never seems to have bothered the people who buy my work," she said.

There is a price to this kind of freedom: as the sellers of their own art, they have less time and privacy to paint, more need to make nice to walk-ins eight hours a day, and if works don't sell they need to come up with money to pay the rent and utilities. Also, if works don't sell, there is no one to blame but themselves, but that is the deal they chose, and it has paid off.

Some artists wait for the "big break" to come in their careers—their work is selected to be in a prestigious exhibition or gallery, their work wins an award, a major private or public collector purchases their work—while some others try to create their own breaks. Monterrey, California, sculptor Richard MacDonald's complaint with galleries was simply that they didn't work hard enough at actually selling the pieces on display, and he believed that the problem was that dealers were content to consign rather than buy outright the artworks they represented, which limits their risk and therefore their incentive to make sales. "What kind of business relationship is this, where the artist puts out all the effort and money, and the gallery does nothing?" he said. "A car dealer buys a certain number of cars and has a certain amount of time in which to sell them. That drives the market. Why shouldn't art dealers meet the same kinds of performance requirements?"

Unlike the Kennedys, MacDonald did not start his own gallery but fashioned a relationship with the seventy-plus galleries representing his work that largely takes over their operations. The galleries handling MacDonald's work are referred to as "subscribing galleries," as they sign on to purchase—rather than take on consignment—a

minimum of ten sculptures ("I need to show enough of my work to have free expression," MacDonald said. "If someone has only three of my works on the floor, you're not representing me"). When a gallery expresses interest in representing MacDonald's work, "someone from our staff flies out to visit the gallery, in order to make sure it is compatible with the work," the artist's son and business manager, Richard MacDonald, Jr., said, continuing, "Is the gallery large enough for sculpture? Will the work be given its own space? We don't want my father's work mixed in with other sculpture." Both MacDonalds look to see that the prospective gallery is well capitalized by running credit checks and demanding to see financial records.

The demand that MacDonald be the principal sculptor in whatever gallery he is represented, that his work be shown in depth and without the distraction of various other artists, upends the traditional artist-dealer relationship, but his subscribing galleries play ball. "When you're doing $1.2 million in sales, which is what my galleries average for my work annually, you can get what you want," he said. "Success leads to different assumptions."

Marvin Carson, director of New York City's Gallery Revel, which represents MacDonald, noted that "every dealer asks himself two questions about the art in his gallery: does it have integrity—and, certainly, Richard's work has the quality—and can you make money from it? Richard's work does sell. There are so few saleable sculptures in the world, and his work captures peoples' hearts. It's so pretty."

Contracts between MacDonald and the subscribing galleries not only include provisions for their purchasing outright at least ten pieces but also that they sell a certain number annually. They must also reorder whenever a sale is made ("Nothing leaves the floor until a replacement arrives," MacDonald said) and regularly place local advertisements ("They can't run an ad without our shooting the image and OK'ing the text"). For his part of the deal, MacDonald not only provides the artwork but runs national ads in magazines. "The yearly advertising budget is in the six-figure range," MacDonald, Jr., said. It includes marketing brochures for all galleries handling the artist's work, photographs of each piece, cards with a history on the back for each piece, letters for galleries to send out to prospective buyers (the artist employs an in-house writer), and videos on the artist and his manner of working to show to collectors. When an agreement to sell to the gallery is made, a sales training seminar is conducted for gallery staff, describing how to present and light the work, how orders should be filled, and what should be said about each piece (a mock sales presentation takes place).

MacDonald runs a medium-sized corporation, with forty-five employees that include a sales force of twenty-eight, six account representatives, several supervisors, and support staff. His rent for studio and office space amounts to $70,000 per month. With so many galleries relying specifically on him, MacDonald needs to be highly productive. While large editions mean that more people are able to purchase an artist's work, there is also a downside in terms of the artist's lowered reputation in the mainstream art world. "Serious collectors are serious snobs," Marvin Carson said. "They want to buy works where the edition is eight or fewer. They see someone like Richard

MacDonald putting out works in editions of ninety or so, and they say, 'That's not a real artist.'" Recognizing this as a problem, MacDonald has reduced the size of some of his editions, from 175 to ninety and a few editions have gone as low as nine or ten pieces.

The need to keep putting out "product" can also wear on an artist. According to Bob Kennedy, who tends more to the business aspects of the gallery than his wife, Michelle produces "around one hundred paintings a year, maybe two or three a week," and the majority of them are turned into limited print editions (980 photographic reproductions and two hundred giclees). "Sometimes, I feel it's a curse to have to keep the studios well stocked, but it's also very motivating," she said. "I produce a lot because I know I have to." Her one lament is that "I've never been able to build a body of work. As soon as I've finished something, it's out of here."

ART PARTNERSHIPS

Up until the eighteenth century or so, artists did not have collectors so much as patrons, wealthy people who commissioned new work from them, providing them housing, protecting them from their enemies, or giving them travel money and the materials they needed, and then just money after that. Nowadays, patrons are still wealthy people, but they tend to give their money to nonprofit arts organizations, permitting them to deduct that amount from their earnings when figuring their tax payments. Patrons of individual artists still exist but, in the modern way, they behave more like investors, setting up corporate entities that permit them to deduct any losses or add to their ordinary income.

Often, patrons join in partnerships or limited liability companies with artists for short-term projects that require an up-front infusion of dollars, such as when the artists seek to create an edition of prints or bronzes. On occasion, the relationship is more long-term. "One of my patrons decided to partner with me," said Memphis sculptor Roy Tamboli, and the two formed Roy Tamboli, LLC, in October 2006. "My partner contributes the casting costs, and we share the proceeds of the sales." He added that the two own the bronzes equally.

The artists and their financial backers work out the terms privately, but lawyers frequently are involved in writing up the agreements between artist and patron, as well as setting up these corporate entities through the appropriate state agency. "Someone contributes capital; the other contributes sweat equity," said Mark A. Costello, a lawyer in Rochester, New York, who has set up numerous limited liability companies for visual and performing artists. "You set up an LLC, which is technically the owner of the artwork being created, in order to structure distributions. Then, the artist and the patron have to figure out how the distributions are made." The agreement they reach is part of the partnership or LLC filing with the state, describing the basic set-up of the business: how the company will be managed, how profits and losses will be divided, the rights and responsibilities of each member, the ownership percentage of the business by each member, when meetings are to be held, and how votes will be tallied.

In many instances, money earned is split on a 50/50 basis, although Costello stated that the patron may want to receive his or her return on investment before the artist is paid. Other agreements make a split of 80/20 (favoring the patron) for the first

series of sales, changing to 50/50 and finally to 20/80 as the available artworks sell out. At other times, the investor may be repaid in actual artworks (negotiations in advance would determine whether the value is based on wholesale or retail prices), although copyright for the art would remain with the artist.

In addition to the expense of a lawyer or accountant in setting up the company, there are filing fees charged by the individual states, ranging from $100 to $800, as well as business licenses and zoning permits required by the municipality and a federal employer identification number from the federal government.

For the patron, the benefits of setting up an LLC with an artist is that "the business entity acts as a tax shelter, with the flexibility of allocating losses and expenses any way you want, any time you want," said Peter Jason Riley, a certified public accountant in Newburyport, Massachusetts, who has set up numerous limited liability companies for fine artists, writers, and filmmakers. "You can have your basic agreement that all proceeds from sales are split 50/50, or however you want it, but you can also determine when you see how things are selling or not selling that the investor can take 90 or 99 percent of the losses, which he can write off against other income." Additionally, other business-related expenses, such as travel and entertainment, may be tax-deductible.

Without setting up an LLC, he noted, providing money to an artist is a loan, which can be written off on tax returns as a personal loss, "but you then might have to prove to the IRS that this really was a loan, with an interest rate and a repayment schedule." The loss may be written off against capital gains (sales of artwork) but, if there are few or no sales, the maximum amount of loss that may be declared would be only $3,000 per year. A loan of $9,000 would take three years to recoup on one's taxes, making the LLC more attractive to wealthy patrons.

For both the artist and patron, the business entity protects their personal assets (such as their homes, cars, and bank accounts) in the event of a lawsuit, although some accountants and lawyers recommend the purchase of a liability insurance policy for the LLC in the event that a court ignores the limited liability status when making an award.

There is a variety of ways in which artists obtain up-front money with which to pursue their projects. Gallery owners sometimes provide certain artists they represent with monthly stipends, which is recouped from sales. Artists planning to create a print edition, or the print publisher, may "syndicate" the publication costs to collectors who become subscribers or shareholders in the enterprise. A small number of artists have solicited investors for a particular project with a prospectus, selling shares that would be redeemable as cash when the particular artwork is sold.

SELLING TO CORPORATIONS
Just as artists need to research potential galleries that might show their art, those looking to sell work to or have it commissioned by corporations must find out which companies are buying and what kinds of artwork they purchase. That is more difficult than it used to be: the heyday of corporate art collecting is over, replaced increasingly by corporate art deaccessioning, leasing art (as noted above), and budget-priced decoration.

"The 1980s was the high point in corporate art collecting, but the crash at the end of the '80s started the process of killing it off," said David Galenson, economics professor at the University of Chicago. "Company executives found out that the art market could be a very volatile thing that they didn't want to be part of."

Other factors contributed as well. The prices for top-flight art have risen to astronomical levels, draining corporate resources, and the type of art that is expected to appreciate in value "costs money to maintain, in terms of storage and climate control and state-of-the-art facilities in which to display it," said Mary Lanier, former director of the Chase Manhattan Bank art collection and now a private corporate art advisor. In addition, "shareholders get no value from the art collection and are irritated by it," said Princeton University economist Orley Ashenfelter. "Firms, especially when the economy starts to sour, recognize their need to stick to their core business." Added to that, the Internal Revenue Service began in the 1980s to enforce more strictly its rules that artwork cannot be depreciated along with the office furnishings and equipment. Yet another element has been the number of corporate mergers and acquisitions—in 2007, there were over nine thousand of them, resulting in the expenditure of more than $1.576 trillion—that places long-standing art collections at risk. "Most of the CEOs of these companies don't even know they have art and don't know the depth of these collections," Donald Rubin, a health insurance entrepreneur who founded New York City's Rubin Museum of Art, said. "They have thousands of people working for them, and the art holdings are just one more thing that, if they even think about, they want to reduce." The result has been a twenty-year-long disposal of one corporate art collection after another.

FINDING CORPORATE BUYERS

Corporations continue to be involved in the arts, primarily as benefactors but also as buyers, and it is often the case that companies that provide financial support to arts organizations also purchase artworks for their offices. Among the sources of information on which corporations underwrite arts institutions is Grantmakers in the Arts (604 West Galer Street, Seattle, WA 98119-3253; 206-624-2312; *www.giarts.org*), a membership organization of foundations, community organizations, and corporations united by their interest in making grants to the arts. Americans for the Arts (1 East 53 Street, New York, NY 10022; 212-223-2787; *www.artsusa.org*) is the umbrella organization for the Arts and Business Council and Business Committee for the Arts, both of which have a roster of corporate names associated with funding. The most often used book for corporate collectors, however, is the *Directory of Corporate Art Collections* (The Humanities Exchange, PO Box 1608, Largo, FL 33779; 514-935-1228; *http://home.netcom.com/~the-iaa/corpart.html*, $175), which is revised biannually on even numbered years and contains names, addresses, telephone numbers, contact persons, and both general and specific information on the collecting practices of almost 1,200 companies around the United States and Europe. This book is a favorite among art consultants who are looking to offer their services to new clients. Some libraries, particularly those in art museums or at universities, have reference room copies of the directory.

Corporations, unlike governmental agencies and foundations, generally have no standardized applications for artists and seeking commissions or sales and project funding. The president of the company may be in charge of all arts-related initiatives, the job may be delegated to the head of marketing or communications, or there may be a corporate curator or committee responsible for acquiring office art. Artists exist in a realm that is not accountable to the public (unlike governmental agencies and private foundations), and their success in selling to corporations is dependent on how they present themselves, their works, or their projects to the person in charge of the art collection or budget.

Artists should look carefully at the style or media of artwork that a corporation collects in the same way they would when looking at prospective art dealers or galleries. A collection of abstract paintings and minimalist sculpture would be an unlikely market for a realist watercolor artist, for example. Certainly, if the company hasn't purchased artwork in the past, one cannot know what the executives will like. What one sees increasingly is businesses purchasing objects by local and regional artists as a way of showing themselves to be good corporate citizens. Corporations in North Carolina, for instance, tend to buy work by artists in that state, while Arizona-based companies purchase and display western and Native American art and objects.

Again, corporations looking to build an art collection is more the exception than the rule. There is rarely a separate art budget for acquisitions; art is just office decoration, in most cases, and is treated as disposable. Most art in offices is not the stuff that auction houses or commercial art galleries will take on consignment (most artwork has no secondary market) or that museums want or even can be donated to community centers or retirement homes. So what happens to it? (It ain't pretty.) In 2006, Sears arranged for the sale of Kmart Corporation's art collection (including prints and posters, sculptures, photography, a fifteenth-century Chinese Ming Dynasty watercolor, and a Picasso tapestry) through National Retail Equipment Liquidators, now called J.G. Resources, in Grand Rapids, Michigan. Liquidators around the country are kept busy with art and other things found in offices. "Yeah, we got stuff—posters, paintings, I don't know," said whoever answered the phone at AAAA Office and Warehouse in Philadelphia, a business liquidation firm. "There's one picture I'm looking at right now that's, uh, $25, framed."

MAKING CONTACT

Artists should start with a simple telephone call in order to determine who is in charge of buying artwork (that person's name should be spelled correctly), the name of the company, and its address. Additional information about the company may be available on its Web site (if it has one) or in standard business reference publications in a local library. If the company has collected artwork in the past, artists should know what type (two- or three-dimensional) was purchased, the size of the works in the collection and where it is displayed. Some companies are thematic in the types of art they purchase (Campbell's Soup, for instance, has a collection of soup tureens) or buy pieces by local artists; Pepsi, on the other hand, has a sculpture garden.

The next step should be a letter or telephone call to the individual in charge of buying artwork, describing succinctly what the artist has in mind (selling a work or being commissioned, who will benefit and how, and what the work looks like—stated as graphically as possible), the cost, when the project might take place, how it is to be publicized, and the artist's own background and qualifications for this work). Even after a telephone call, this information should be put in a letter to either the person with whom the artist spoke or to whomever in the company makes the decisions about artwork.

Of course, corporate employees are not generally as immersed in the arts as the creator, and the work or project should be described in very lay terms that would be understandable to a wide audience. Additional materials, such as reviews of past exhibitions by the artist, published profiles of the artist, and slides or good quality photographs of the artist's work, should be included with the letter. Pictures often explain better than verbal descriptions, and the reviews of a newspaper critic—and the reviews of a newspaper critic are likely to be written in plain, non-jargon English—are likely to be closer to the company executive's level of understanding than the commentary of the artist. A résumé is optional, depending on the strength of the other materials.

Also, ask for a personal interview and call a day or so after the expected receipt of the letter to set up a meeting. It's easier to reject someone unmet than a person with whom a personal rapport may have developed.

In any meeting, an artist must present him- or herself as a professional, someone who deserves to be accorded respect, rather than as a supplicant. Self-respect garners respect from others. Many people secretly (or not so secretly) wish that they were artists, and artists should understand that this vicarious feeling about art and artists is part of the reason the company sponsors cultural activities or a collection in the first place.

4

Developing
Relationships with
Art Dealers

S uccess for an artist is measured over a long period of time, while a big career break is an event. Without some type of break—an important exhibition, a major write-up or sale to a renowned collector, a grant from a foundation, low rent on a studio, or a word of encouragement from a well-placed source, among other possibilities—success is less likely to occur. Some big breaks increase the name recognition for an artist among potential buyers and make his or her art seem especially current ("He's hot!").

The most important breaks are those that give artists and their work wide and (one hopes) positive exposure. In a world where there appears to be an oversupply of artists, one needs to stand out from the crowd and receive recognition. But will artwork that shocks the public or blocks traffic do the trick?

It is not always clear at the time, however, which events are the big breaks and which perhaps will be interesting footnotes to a career. An innocuous-seeming encounter may later result in great things, while a presumably significant honor— say, a major museum acquiring one's artwork or receiving some prize—could have no discernible career benefit. And, when it is a big break, how does one take fullest advantage of it?

FINDING REPRESENTATION

For many artists, having a third party (someone other than themselves, such as an agent or dealer) speak on behalf of their work is a major stepping stone in their careers. Someone not only says that he or she appreciates the artwork but agrees to make an investment of time, space, and money to promote and sell it. The artist's time is freed to create more work, which now merits the attention of the mainstream art world (artists who sell work on their own are rarely reviewed in art periodicals). For others, a middle-man lessens the relationship between artist and buyer, resulting in an increase in prices and a decrease in sales.

ART CONSULTANTS

That middleman can be an agent or representative (see chapter 6, "Artist Representatives"), an art consultant, or a dealer (or gallery). At times, art consultants are gallery owners and even museum curators who advise individuals and companies in the area of decorating or building a collection on the side. Those who are free agents, only serving the interests of their clients, generally don't have galleries or represent particular artworks or artists; rather, they tend to work from their offices or homes, maintaining information (bios, slides, press clippings) on a variety of different artists whose work may be of interest to particular clients. Most focus exclusively on contemporary art—works created by living artists—while others will hunt through all styles and periods, depending upon the interests and budgets of their clients. "Our criteria for selection revolves around our clients' tastes," said Josetta Sbeglia, a consultant in St. Louis, Missouri. "We hope we like it, too."

Consultants learn of artists in a variety of ways: they attend exhibitions at galleries, as well as at art fairs and juried competitions; they receive recommendations from other artists; they go to "open studio" events; or they are contacted directly by the artists through the postal service, telephone, or e-mail. Some consultants encourage artists to send them material, while others do not—it makes sense to inquire by telephone or letter what, if anything, a particular consultant is interested in seeing before mailing a portfolio. Lorinda Ash, a New York City art dealer and consultant, said, "I get phone calls, faxes, and slides from artists all the time, but that's not how I ever become interested in an artist. I find artists through going to galleries." On the other hand, Jennifer Wood-Patrick, an art consultant at the firm of Art Advisory Boston in Massachusetts, welcomes receiving material from artists but notes that "we have a limited amount of time for telephone conversations and sorting through packages sent by artists. I much prefer when artists e-mail us about themselves and include images. It's a lot faster and a lot easier for storage." Lester Libo, an art consultant in New Mexico, solved the storage problem by scanning the artists' images that he is sent into a computer to be recorded on a compact disc. Since he works from an office in his home, Libo makes presentations at the home or office of a client using the CD with a Kodak player hooked up to a television.

The relationship that artists develop with art consultants can be long-term and lucrative. During the 1980s, New York City painter Joseph DeGiorgio was contacted by various consultants who had seen his work in New York gallery exhibitions ("I never called any consultants. They called me," he said). Many consultants from around the United States come to Manhattan to look at galleries and make notes on artwork that may be suitable to client interests and needs. For DiGiorgio, these consultants arranged both purchases from his studio and commissions for new pieces. "I was getting these gallery shows, but not making much money from them," DiGiorgio said. "Three-quarters of my income came through consultants. The same people who might have seen my work in a gallery now became quite interested in buying it when a consultant pointed it out to them."

Another painter, William Barron of Falmouth, Massachusetts, specifically chose to market his work through consultants, having been represented by galleries here and there. "I've done all right with galleries, but not as well as with consultants," he said. "Consultants bring stuff to clients—clients don't have to go anywhere—and these are people who have money and are ready to buy something. My galleries couldn't get these people to look at my work, but consultants have. Consultants work harder for their money and take a smaller commission, too." To satisfy the "ego thing of having a show," Barron created his own gallery in Falmouth in which to maintain an ongoing one-person display of his work.

There is one association of art consultants (International Association of Professional Art Advisors, 433 Third Street, Brooklyn, NY 11215; 718-788-1425; *www.iapaa.org*) from which one may obtain a list of members, but many others advertise in *ARTnews* and *Art in America*, and the galleries identified in *Art in America's Sourcebook to the U.S. Art World* are coded to indicate those in which the dealers also offer private consulting. The *International Directory of Corporate Art Collections* (which costs $125 and can be ordered from The Humanities Exchange, 2840 West Bay Drive, Belleair Bluffs, FL 33770; 514-935-1228; *www.humanities-exchange.org/corporateart*) is another useful source of information, as it notes who the art consultant for each collection is. James Cavello, a consultant with Corporate Art Associates in New York City, noted that "some of my clients and some of my artists have found me through the Yellow Pages." Obviously, some people who call themselves art consultants are going to be more effective in garnering wealthy clients and placing expensive art than others. In the who-you-know and who-knows-you art world, it is important to determine a consultant's reputation through word-of-mouth, such as from artists whose works have sold, experienced collectors, and dealers.

Art consultants who are also gallery owners may primarily look to sell artworks that they own or have on consignment; in that case, the consultant/dealer will receive the customary commission. Most art galleries have a particular focus, such as realist painting or minimalist/conceptual art, but their owners who moonlight as consultants are free to present artwork to clients in very different styles. Gallery owners also may try out artists by representing them in their capacity as consultants. Consultants who are not otherwise dealers do not purchase artworks or take pieces on consignment. Instead, they make a search of appropriate art determined by the client's needs and interests (size, subject matter, colors, price, medium, style) and make a presentation to that person of eligible pieces. In some cases, the client will be brought by the consultant to a gallery or to the artist's studio in order to make a selection first-hand, and it usually is the client who will pay for the work, not the consultant. The client may also choose to commission a new work from an artist, which increases the contact between the two even more.

The studio visit will be directed by the consultant, but the underlying purpose is for the artist and client to meet, requiring the artist to be tolerant, friendly, nonjudgmental, and responsive to questions. DiGiorgio noted that visits to his studio by corporation

executives "can be very comical in a weird way. The big honcho would say, 'I like it,' and everyone around him would agree emphatically. If he said, 'I don't like it,' everyone would shake their heads. These guys can be so full of themselves, and they're supported by those around them. Should I nod and shake my head, too?"

The consultant's commission may range widely, from 10 to 50 percent. The commission tends to be smaller if the consultant has found work represented by a gallery, because the gallery and the consultant will be splitting the regular commission (the artist doesn't earn any more money, but the gallery keeps less). The consultant's percentage is likely to be higher when a new work is commissioned, although the exact amount is often negotiable with the artist. In general, an art consultant should not take as large a commission as a dealer or gallery, because the consultant has not made the substantial investment in the artist's marketing (putting on exhibitions, promoting the artist, paying for advertising, publishing catalogues, and printing and mailing exhibit announcements, among other activities) that the dealer has.

Art consultants are frequently associated with corporate collecting, since many companies spending sizable amounts of money look for help in making decisions, and they either hire staff or (more often) retain the services of an outside art advisor or art consultant. These advisors advise the company executives on which works to buy, how many, where they should be purchased, and how they ought to be displayed in the corporate offices.

ART GALLERIES

There are three ways by which artists tend to look for galleries to represent their work, and some are more promising than others. The first is by purchasing a mailing list of galleries, listing names and addresses of hundreds or thousands of shops to which artists might send material (slides or photographs, bio, statement). For businesses in the direct mail field, it is believed that a response rate of 2 or 3 percent makes a mailing profitable. However, these gallery lists are not vetted for the type of gallery (art, antiques, furniture— many framing and poster shops call themselves galleries) or the type of artwork represented or even if they wish to be contacted by artists at all. There may be a lot of money simply thrown away. Additionally, even if 2 or 3 percent of the contacted galleries express interest in an artist's work, they are not buying—as they would from a company's direct mailer—but consigning pieces. More time and money would have to be spent in order for any sales to take place and, as a matter of fact, the type of gallery that would take on an artist in this manner is unlikely to have regular buyers and generate sizable sales.

Artists should research the galleries that they hope will represent them in order to determine not only whether or not they show work that is thematically similar to their own, but whether the galleries will look at new, unsolicited art (that can be discovered through a telephone call). A second (and a more time- and cost-efficient) way in which artists search for galleries is through various publications, such as the national magazines *Art in America*, *Art & Antiques*, *Art & Auction*, *Art Forum*, and *ARTnews*. *Art in America* publishes a summer issue—*Sourcebook to the U.S. Art World*—listing art

dealers around the United States, as well as the type of art that each gallery represents. *Art Now* gallery guides, which are published regionally around the country—New York greater metropolitan area, Boston and New England, Philadelphia, Southeast, Southwest, West Coast, and Chicago-Midwest, as well as one for Europe and an international edition—are another source of information. A growing number of galleries also have Web sites, which can be explored to ascertain the preferred style of art. The Internet addresses of these galleries are often listed in art magazine gallery advertisements and in gallery association Web sites, as well as in the *Sourcebook to the U.S. Art World*. One can also conduct a Web search for galleries, which may be time-consuming and offer largely irrelevant information but may also help find an appropriate site if the keyword is precise.

The third method, and the best, is by artists actually visiting the galleries that are of interest to them. Not only do artists want to see that their artwork would fit in stylistically to the other pieces on display, they would be interested in knowing whether or not the space is suitable for their work (tall and spacious enough for sculpture or large-scale paintings), how the other artists' work is displayed (attractively with good lighting and information available about the artist or the pieces on view) and the general price level of the works in the gallery. Dealers and gallery owners look for art that has a specific price range by artists of certain renown, because that is what their regular buyers seek or can afford. Dealers are very reluctant to represent $2,000 paintings in a gallery where the average is $20,000; they are also not likely to raise a lesser-known artist's work ten times in order to bring it up to the gallery level of pricing.

Personal contact usually makes a substantial, if not crucial, difference. Knowing the dealer or knowing (or favorably impressing) someone who has the ear of the dealer is likely to turn the tide for a dealer who is unsure about the audience for an artist's work. That is why artists cannot hide away from the world, maintaining some romantic myth of the artist who must be alone, but need to associate with other artists.

Both painter John Hull and sculptor Donna Dennis, for instance, were "discovered" through the intercession of friends who prodded their dealers. Hull worked as a machine operator in a cardboard box–producing factory on the 3:00 p.m. to midnight shift for two years, and he also ran an alternative space gallery in Baltimore, Maryland, for five years. Dennis lived in New York City for seven years before she began to exhibit her art (starting as a painter and gravitating toward sculpture). She worked as a secretary at the Whitney Museum of American Art in New York City for one year ("I was fired because I couldn't type") and as a picture researcher for various publishing houses. Eventually, the two artists found time to make and exhibit their art—she at the cooperative West Broadway Gallery in lower Manhattan, where she was spotted by the collector Holly Solomon, who had just opened her own commercial gallery and invited her to show work there; he at alternative spaces such as W.P.A. in Washington, D.C., and at P.S. 1 in Long Island City, as well as at New York's New Museum, where he caught the eye of Manhattan art dealer Grace Borgenicht. In both cases, friendships paid off. Hull knew one of the artists in Borgenicht's gallery, David Saunders, who spoke on his behalf. "Grace liked my work and she had read reviews of my shows," Hull said. "No one talked

her into liking it. But Grace had some questions about me that David could answer: Is Hull a serious artist? Does he do a lot of work? Is he a reasonable person?"

Holly Solomon was led to one of Dennis' shows by Denise Greene, whom she had known from a consciousness-raising group and who was already represented by the collector-turned-dealer. Personal connections served her again when artist Harriet Shorr, whom she had known "from the group of poets I hung around with when I first lived in New York," gave Dennis her first show outside of New York, at Swarthmore College, where Shorr was then teaching. Later, in 1990, Shorr was teaching at the State University of New York at Purchase and suggested to Dennis that she apply for a faculty position.

Meeting people who can be of help to one's career—call it "making connections" or "networking"—is vital to artists, although this may be a difficult course to plot: those who are obviously looking to make headway with the "right people" are apt to be seen as opportunists. Sharing ideas and information and attempting to interest others in one's work and showing enthusiasm for theirs, on the other hand, are essential to advancement, as the art world picks winners and losers primarily on the basis of what people say. "I've never lived in New York City," Hull said, "but I go there regularly to meet people and see art. It's as important for me to talk to other artists as it is to see a Goya."

"I didn't think of meeting various women artists as a business thing," Dennis stated. "It was the early years of the women's movement, and we all knew the statistics of how few women were in galleries or in the Whitney Biennial. It just felt good to find people who appreciated my work and what I was trying to do, who understood and faced the same problems I faced."

Connections can be made throughout the art world. For Claire Romano, a printmaker who teaches at Pratt Institute in Brooklyn, New York, societies and artist associations were a source of important contacts. Romano was one of the jurors for a show sponsored by the American Society of Graphic Artists in the early 1960s; another juror was Jacob Landau, who was then a teacher at Pratt Institute. "He liked my way of looking at art, the way I articulated my ideas, and he also liked my art," Romano said. "Not long after, he was named chairman of the fine arts department at Pratt and asked me to take over his classes." That Romano was selected to be a juror for this show and there met her future employer was serendipitous. "I never looked for a job," she said. "I was just offered it."

Besides personally knowing people, artists also need to have their work shown as widely as possible—a critic, collector, curator, or dealer may spot it (for instance, as a juror in a competition) and pass the word on about an interesting find—and to make themselves available to potential buyers and gallery owners. Showing art involves more than simply hanging up a picture in front of someone who agrees to look at it. It requires an affirmative effort on the part of artists to place their work in front of people who can be helpful in their careers and be part of the process of marketing their work.

IS THE ARTIST'S AGE AN ISSUE?

When they want to introduce themselves, most people put out a hand to shake or say, "Hello," but that only works if they are there in person. In most other circumstances, artists rely on their artwork to make a first impression and often some accompanying

written material. Generally, artists feel more confidence in their artwork than in the printed matter, and for good reason. It is not clear what readers want, for instance, in an artist's statement—if they want it at all.

The introduction that many art gallery owners have to artists is through information packets, usually containing a letter of introduction, photographic images of one's artwork, clippings of past reviews, and a C.V. The hope is that something catches the dealer's eye. Of course, what attracts the gallery owner's notice may be something odd or something taken the wrong way.

An example of this is one's age. Of course, the age of the artist has no bearing on the quality of his or her art but, according to New York City gallery owner Edward Winkleman, "age tends to be an issue for certain kinds of collectors and, as such, is an issue for dealers." He noted that sees "collectors' body language shift when they learn that artist is older." Other art dealers agree, if sometimes grudgingly. "To some clients, age does matter, and we are here at the service of our clients," said Kristen Dodge, a co-owner of Boston's Judi Rotenberg Gallery, adding, "I personally think age is irrelevant." Certainly, one might make the argument that lengthy experience deepens one's technical and conceptual abilities; however, emerging artists over a certain age are found to be less appealing to dealers, who think in terms of building a career, not just selling things right now. "There aren't many Grandma Moseses around," said Ron Cavalier, owner of Cavalier Galleries in Greenwich, Connecticut, referring to the untrained backwoods artist who had her first solo show at age eighty and still lived (and painted) another twenty-one years. "People who have worked in one career for decades and then decide to become artists are less of an interest to me."

Cavalier regularly receives packets from artists that contain images and written materials, and he meets with those in whom he is interested. Subjects that the applicant may have omitted, such as age, are likely to be clarified in a face-to-face meeting. "The fact that they're older isn't necessarily a problem," he said, "but if their physical health is deteriorating, that could be a serious consideration."

Age isn't usually a category on a bio or résumé, but it may be suggested through particular dates, such as the year someone earned a baccalaureate degree or when exhibitions are cited for some distant decade. An artist may think that omitting his or her age is a matter of discretion, but if Winkleman doesn't see the age he wonders, "Is this person trying to hide something?" He recommended including on a bio one's age or the year one was born—"Just put it out there"—in order to alleviate the mystery and weed out the gallery owners who "would reject you for reasons of age alone anyway."

However, he doesn't want to know an artist's major in college unless that person studied art or another subject—say, anthropology—that is thematically related to the content of the individual's artwork. Omitting an unrelated college major is valid, Winkleman said, because the cumulative effect of an artist being older and having no formal art training "says to me, 'enthusiastic amateur,'" which he is more apt to reject out of hand.

Yet another area of omission may be a range of years in which no exhibitions took place, for instance, listing group or solo shows between 1965 and 1975 and then from 1995 to 2005. Perhaps, the exhibits from 1965 to 1975 could be discarded, which might have the effect of suggesting the artist is younger and began showing work in 1995.

However, if the year of a college degree (say, 1963) is listed or if the artist and dealer meet, the question of the missing years will loom large, striking the dealer as deliberate deceit or as a lack of seriousness. Of course, there may be quite understandable reasons that an artist was not pursuing exhibition opportunities for the 1975–1995 period, such as a full-time job or parenting. These may not be "lost" years, simply a span of time in which the art that was created was not put on display.

Artists who have not focused singularly on their art careers are put in an ethical bind when composing a bio, forced to choose between honesty (revealing their age or the fact that art has competed with other activities and interests) and hoping that their elisions don't raise questions. Small wonder that so many artists present themselves badly; they have to select among unpalatable options.

Age, education, and exhibition history are not the only areas in which artists may get into trouble. Listing published reviews of group shows they were in but which did not mention their names or artwork looks deceitful, and banking on the possibility that the dealer doesn't actually read the review adds insult to injury. On the other hand, an online review has no less significance than one seen in a hardcopy publication (there is no need to include a link; just put the article title, author, date, and main URL of the site and let the reader find it). Listing the names of more prominent artists in a group in which one participated seems "lame," Winkleman said.

COMING TO TERMS

Landing a dealer, whether or not that person is a major figure in the art world, is not the end of an artist's art business concerns. If art dealers were as trustworthy as so many artists are trusting of them, there would not be a growing body of art law, nor would there be a growing number of lawyers specializing in artist-dealer conflicts. As much as artists want to be "just" artists when they finally find a dealer who will represent them, devoting their attentions solely to creating works of art and leaving the legal and business considerations of their careers entirely to people in other, less ethereal professions, artists must proceed with caution and a down-to-earth sense of their own rights.

Inquiring about the integrity of a particular dealer—finding out how long this person has been in business and whether or not the Better Business Bureau or state attorney general has received any reports about the dealer's business practices—helps artists make a critical decision. One way to check out the dealer is to find out how long the gallery has been in existence; another is to call a local museum curator for any information about the dealer; a third approach is to ask the dealer for a bank reference. Nothing is foolproof, but without some sense that the dealer is legitimate and in for the long term, the artist runs a potentially sizable risk.

Dealers come in a wide assortment. Some have strong contacts with established collectors and are able to sell most everything by artists in whom they believe; others may not sell very much, earning most of their money through framing pictures or consulting with private individuals and corporations on what art to buy and where to hang it. Others are artists themselves who have set up a gallery for the primary purpose of

creating a fixed venue for their own art and exhibiting other artists' work at the same time. Some dealers are personally and professionally supportive of the artists they represent, while others believe in letting artists find their own creative paths. Not all dealers are right for all artists.

Artists and their dealers may not be of the same mind on a variety of practical matters as well. Disagreements may arise over pricing, proper accounting, discounts, assigning of copyright, the frequency of exhibitions, and a host of other legal and business issues. These differences are not necessarily the result of ill intentions on the part of a gallery owner; rather, it is the power imbalance between artists (especially the younger emerging artists) and their dealers that often forces artists to accept otherwise unacceptable arrangements. To a degree, artists can only hope that success in selling their work will provide them with greater leverage for negotiating better deals later on. However, it is useful to have a firm idea from the start of what one's arrangement with a dealer is and to get that in writing if at all possible.

Written agreements can be broken as easily as verbal ones. Verbal agreements are legally enforceable, although disputes may be settled much more quickly when there is a clear agreement in writing signed by both parties. Certainly, the legal costs would be less if the dispute reaches that stage, because it takes less time to enter a legal document into evidence in court than gathering hours and hours of conflicting depositions by both sides, disputing what was said when by whom.

A number of artist advocates recommend that artists and their dealers sign explicit consignment contracts as a means of fully clarifying their relationship and avoiding conflict. Written contracts make sense and solve a lot of problems, but dealers frequently make sour faces whenever an artist offers one. There are many instances in which the modern business world and the tradition-bound gallery system are found to work at cross-purposes. Artists tend to be more eager to win the endorsement of a gallery that will represent them than they are assertive of their legal rights, and it is difficult to fault them. Dealers who profess to scorn contracts are disingenuous—they certainly sign contracts with banks, landlords and collectors—but the old rhetoric dies hard.

"A lot of the relationship between the artist and the dealer is based on trust, and you can't pin that down in a written contract," one prominent New York City dealer said. "In fact, the written contract may imply a lack of trust."

The threat of "turning off" a dealer may well make an artist reluctant to present any written agreement to his or her potential agent. However, artists and their dealers should speak with some specificity about how they will work together, and this should be written up by the artist in the form of a letter that the artist asks the gallery owner to approve and sign. Frequently, artists and dealers have a short-term agreement—a sort of trial marriage—to determine whether or not they work well together, and this may be renewed or expanded later on.

According to Caryn Leland, an attorney who frequently represents artists, "It could be a straight forward letter that starts out with, 'This letter will confirm our

understanding of your representation of me,' and ends with 'If this is acceptable to you, please sign below and send it back to me.'"

The letter should address the most pertinent issues, such as:

- The term of the agreement (how long the two will be bound by this contractual relationship). Initially, the term should be two or three years, which allows the dealer a reasonable amount of time to promote the artist and to see that investment pay off. An agreement of only six months may make the dealer reluctant to develop the market for an artist's work and may also lead to the dealer dropping the artist if works don't sell immediately. A much longer agreement may keep an artist whose work begins to sell well in a disadvantageous position if the contract is weighted toward the dealer.
- The nature of the relationship (exclusive or non-exclusive representation, for instance). The dealer may have the exclusive rights to sell all of the artist's work, or exclusive rights to sell only prints (another dealer has exclusive rights to the sculpture and yet another has the rights to the canvas paintings); perhaps the dealer has the exclusive rights to market the artist's work in North America or just New York City. The dealer may simply handle an artist's work without any claims to exclusivity. These situations should also be discussed directly with the art dealers involved since, in the very thin-skinned art world, hurt feelings and unhappy artist-dealer relationships may result from surprises. Possibly, dealers for the same artist will work together by coordinating exhibitions (when in the same city) or rotating an artist's works from one gallery to another, which makes it possible to keep artworks from sitting in the same gallery in perpetuity.
- An exact accounting of what is being consigned to the dealer. A paper trail should accompany every work that the dealer or gallery is sent, listing the title of the piece, medium, and size, and a signed receipt should be in the artist's possession. Galleries often maintain a large inventory, and works may be misplaced; if the gallery owner cannot locate something that he or she acknowledges having received, it becomes that person's responsibility to find the work or pay the artist. There is little to be gained from an "I-gave-you-that-work," "no-you-didn't" disagreement.
- Price arrangements (minimum amounts per work or prices for each work, as well as what sorts of discounts may be allowed). It is up to the artist, in consultation with the dealer, to determine the price of artworks. The dealer may have good reason to ask for flexibility in pricing by the artist—certain prestigious museums expect a 50 percent discount, and other prominent collectors may also seek more than the customary 5 to 10 percent discount—since placing a work well has long-term benefits for an artist. Still, an artist cannot abdicate the responsibility of setting prices.
- The percentage of the dealer's commission (30, 40, 50, 60, or 70 percent—the median is 50 percent, but artists and their dealers work out their particular

financial arrangements depending upon the prominence of the artists and the services rendered by the dealers; whatever the percentage, it should not come as a surprise to the artist).

- The responsibilities of both dealer and artist (how promotional efforts for a show will be handled, where advertisements will be placed, who will pay for framing and insurance, whether or not the artist will be compensated for the loss in the event of damage or theft).

- The frequency and nature of the exhibits (one-person exhibits, group shows, and how often and when in the year they are; how the work will be shown). In some galleries, it is very easy for an artist to get lost, shown only in group exhibitions at non-peak times of the year. Scheduling shows should be discussed at the outset of the relationship.

- A requirement for periodic accounting (who has purchased the works, how much was paid for them, where and when works have been loaned or sent out on approval). Artists have reason to know who their collectors are, not only to include on their curriculum vitae but in the event that a retrospective of their artwork is planned and pieces need to be tracked down. For artists in California, where a state resale royalty law is in effect, subsequent sales of their work would likely result in a royalty payment based on the presumed increased value of the resold pieces.

- Prompt payment by the dealer (sixty to ninety days should be the absolute limit, but thirty days is preferable). Some dealers will pay their artists as soon as the check clears, while others may receive payment from collectors on layaway and not send money to the artist until the last payment is received. (That latter method is patently unfair to the artist; the dealer receives a 50 percent down payment for the work. This represents the gallery's commission, leaving little incentive to hurry the buyer toward paying the remainder.) Some dealers wait for the buyers to "live with" the work for a period of time in order to insure that the collectors are satisfied with it before requiring payment (some time after that, the artist will be paid). The owners of some marginally profitable galleries flat-out tell their artists that they need to pay their rent, utility, and telephone bills first—the artists will be paid when money becomes less tight. In general, artists should not subsidize their dealers by allowing them to use the proceeds of sales for other purposes. However, artists should never be in the dark about where their money is and when they will receive it.

While the artist automatically retains copyright (that is, reproduction rights) for his or her work even after a sale, some artists may want written contracts for the sale of each piece, including, for example, a provision for resale royalties (requiring the buyer of the artwork to pay back some percentage of the profit when that person later sells the work).

Other provisions that might be discussed and formalized in a letter of agreement between artist and dealer include a mechanism for resolving disputes (such as present-

ing a disagreement before an arbitrator), protection of the artist's assets in the event that the gallery goes bankrupt in those states where artist-consignment laws do not exist. If the agreement requires that all attorney's fees be paid by the person who is in breach of the contract, this will encourage the dealer to act ethically.

The issues of bookkeeping and prompt payment are frequently the most troubling in the artist-dealer relationship. If the artist is selling throughout the year, the accounting should probably be monthly; at the very least, it should be quarterly. Artists should also carefully maintain their own records, knowing where their works are consigned or loaned as well as which pieces have sold and to whom.

It is wise to see the sales receipt for any consigned work after it is sold in order to ensure that the dealer has not taken too high a commission or paid the consignor too little. The practice of keeping two sets of books is not unknown, and artists are wise to check every step of the way. Many art galleries are notoriously poorly financed operations that often use today's sale to pay yesterday's debt, and many artists have had to find recourse in the courts when a dealer withheld money owed to them. Twenty-one states around the country—Arizona, Arkansas, California, Colorado, Connecticut, Florida, Georgia, Illinois, Iowa, Kentucky, Maryland, Massachusetts, Michigan, Minnesota, New Mexico, New York, Oregon, Pennsylvania, Texas, Washington, and Wisconsin—have enacted laws that protect an artist-consignor's works from being seized by creditors if the gallery should go bankrupt.

Even artists whose dealers are in other states than these have some protection from creditors seizing art on consignment in galleries. One recourse for artists is to file a UCC-1 form for works on consignment (available in the County Clerk's office and requiring a nominal filing cost), which stipulates that the artist has a prior lien on his or her own works in the event that the gallery has to declare bankruptcy. In the event that one's dealer disappears in the face of numerous creditors and leaves a warehouse full of art, the law permits artists who have filed the UCC-1 form to retrieve their work.

Another unfortunate possibility is that the artist's works may have been sold, leaving the artist owed money by a dealer who has disappeared. However, the dealer may still have assets in the state, such as jewelry in a safe deposit box or a house, which can be attached by the artist.

"If there are assets, the artist may have a preferred right to them," Martin Bressler, counsel to the Visual Artists and Galleries Association, said. "You would show your consignment form, listing the works you've sent to the dealer, the works you've received back or have received payment for, and the prices for all those pieces. You add up what you're owed and present that number."

In those instances where dealers have closed shop without returning consigned works to the artist or paying money that is owed and the dealer is still in the same state, the artist has some recourse to the law—contacting the city district attorney's office or the office of the state attorney general, or hiring a lawyer to recapture any works on consignment to the dealer or money owed through past sales. If the dealer has left the state, the legal possibilities become less clear and more difficult for the artist.

Sometimes, however, the reason that an artist has not been paid is quite innocent. Perhaps the artist has moved but neglected to provide a forwarding address to the gallery owner. The dealer, planning to retire and pay all outstanding debts, cannot locate the artist. Artists should always give notice in writing of any moves, even if only for six months.

Knowing what to beware of in dealers is important, but it is equally valuable for artists to develop strong personal and professional relationships with their dealers. The dealer should be aware of which ideas the artist is pursuing, any changes in the work, and other events in the artist's life (such as winning an award or receiving an honorary degree) that may help promote the artist's work. It is often the case that artists who don't communicate with their dealers are the ones who complain that their dealers do nothing for them.

FOUNDRY FEES AND COMMISSIONS

Few enough artists think that dealers are fully justified in charging a 50 percent commission on gallery sales, but most accept it as just the way things are done. Still, the commission may strike some artists as less fair than others. Sculptors, for instance, especially those who work with foundries to produce bronzes, have far higher production costs than most painters. A $2,000 painting may have cost only $10 in actual materials to create, while a $2,000 bronze may have set back the sculptor $600 or more. The 50 percent sales commission for the painter results in the artist netting $990, while the sculptor's earnings after expenses would be only $400. To break even with the painter, the sculptor could raise the price to $3,220, but that might put off buyers. "Sometimes, you just have to eat it," said sculptor Ann Morris, who lives in Lummi Island, Washington.

But not always. Morris, who works with several west coast galleries, often is successful in negotiating the commission down to 33 percent, especially when the gallery owner is told that the alternatives are raising the price or not having works by her on consignment. "I have less leverage when I'm the only bronze artist being shown, [and] everyone else is a painter," she said. "The dealers tell me, 'Well, I can't make an exception just for one artist.'" When there is more of a mix of media, she added, gallery owners are apt to show more flexibility.

For most of their careers, painters set prices based exclusively on demand, which is why less well-known artists' work is less expensive than that of more established painters. When they are starting out, for instance, artists tend to price their work in the same range as those of similar pieces by artists at a comparable point in their careers, and prices increase with the growth of their collecting audience. On the other hand, the work of bronze sculptors often is priced based on a mathematical formula—three times the foundry cost—for a substantial portion of their careers. "Of course, at very high prices, when you're charging $100,000 or more, it doesn't matter what the casting costs are," said Roy Tamboli, a sculptor in Memphis, Tennessee, whose average work is priced at $15,000 for which the average casting cost was $5,000 ("and that includes shipping costs"). He noted that he insists on gallery owners reducing their commissions to 40 percent ("they go along with it most of the time").

These types of agreements are negotiated individually between artists and gallery owners. The Copley Society of Boston, Massachusetts, actually has a written policy favorable to artists in this realm for its members' gallery ("The gallery commission rate is 60 percent artist and 40 percent Copley Society for regular gallery sales. For sales of bronze/precious metal sculpture, the artist receives the cost of casting plus two-thirds of the remaining amount"), but gallery manager Carolyn Vokey said she was unaware of anything similar at other galleries.

Lack of uniformity on the part of gallery owners may lead to artists being less consistent. For bronzes from the same edition, Morris has found herself managing a crazy-quilt of pricing and income: the same pieces may have identical prices at galleries charging a 33 and a 50 percent commission, while yet another gallery that takes half might show the sculpture at a 25 percent higher price. This is a recipe for disaster in the long run, if collectors discover that works from the same edition may cost less somewhere else, but balancing the need for widespread exposure and keeping one's income stable creates dilemmas for artists.

"It's too confusing to have different arrangements with different galleries," said sculptor Larry Young, who does most of his own casting in his studio in Columbia, Missouri. He "just [tries] to be consistent" in the pricing of his work, which ranges from the tabletop (six inches) to the monumental (thirty feet) in size and is priced from $1,000 to "several hundred thousand."

TO CONSIGN OR SELL?

The consignment arrangement between artists and their galleries is a periodic cause of contention: artists complain that not owning the work lessens both the commitment of the dealer to the art and the risks of not selling it; dealers respond that they couldn't afford to stay in business if they had to purchase everything they wanted to sell. Gallery owners frequently do better when they own the works outright. In a consignment relationship, the dealer typically keeps half of the sale price; when the gallery owns the work, the artist is paid a net price, and the dealer may sell the artwork for far more than double the artist's take. "Dealers certainly make more money on artworks they own than on those they consign," said Gilbert Edelson, administrative vice president of the Art Dealers Association of America, said. "The problem is trying up capital."

The association has never tracked what percentage of the works sold by its members involved in the primary art market were owned by the dealers rather than consigned to them. Ideally, the numbers should correspond to the percentage owned and consigned by the dealers, which would indicate that the galleries worked as hard to sell pieces they did not own as for works they did. Common sense what suggest that the percentage is higher for works the dealers owned. Perhaps for that reason, almost all print publishers require the galleries that represent their work to purchase them outright. Greenwich Workshop, for instance, has minimum ordering requirements for the galleries authorized to sell its prints (purchase works by at least ten of its artists) and minimum sales (no less than $5,000 per year) in order to spur the galleries to aggressively pursue

buyers. Other publishers have different agreements with galleries, but consigning is never a part of them. "We only sell work, we don't consign," said Kristin Heming, director of Pace Prints in New York City. "We have, on occasion, lent a few works out when a gallery is having a special exhibition, but that's only with galleries we've worked with and only after they've shown a real commitment to the work by buying it."

For both artist and dealer, consigning artwork entails more paperwork. Emerging artists are more likely to face a consignment situation than for those creators who are better-known—the dealers of well-established artists are more apt to buy at least some of the works they show or provide a stipend (a monthly payment, which is deducted from later sales) or guarantee minimum sales to the artists, realizing that if they don't they may lose the artists to other dealers who will—and reflects the power differential of the art world. "The question for most artists is not if they are going to consign their works but how they will do it," said Todd Bingham, a Vista, California, career advisor to artists. "Artists may consign work to a gallery they want to get into on a ninety-day basis. After ninety days, the gallery either returns the works or pays the invoice." After that trial period, the artist and gallery may regularly decide to exchange new pieces for old on a three- or six-month basis. He noted that, simply as a means of protection, artists should not allow their artwork to languish at a gallery indefinitely, which would increase its possibility of it being lost, damaged, stolen, or just forgotten about.

ARTIST-DEALER DISPUTES

There are basic understandings that an artist and a gallery have when they enter into a consignment agreement: The dealer takes a certain percentage as a commission, and the artist gets the rest. Well, maybe that's the only basic understanding, because everything else gets contentious (who pays for framing or insurance or advertising, how often there will be exhibits, and whether or not there will be discounts, among other technicalities) and even getting paid in a timely manner can make everyone testy. But even other points that might seem to be clear-cut turn out to be battles in waiting, even when it involves the win-win situation of artworks being sold. For instance, when a dealer sells an artist's work, doesn't the artist have a right to know who bought it?

"Some dealers make it a practice of telling their artists who bought their work," said Gilbert Edelson, administrative vice president of the Art Dealers Association of America, "but other dealers worry that, if they tell their artists, the artists will go behind their dealers' backs and sell directly, cutting out the dealers." He added that he is aware of no law to support an artist's right to know the names of collectors.

In some instances, gallery owners remove or black out an artist's address and phone number when there is a label on the back of a canvas. More recently, dealers have expressed concern to artists about their Web sites if the contact information includes anything other than the gallery's address and telephone number. These dealers view artists' Web sites as an extension of their own marketing; of course, it is rare that dealers offer to pay for the set-up and maintenance of these sites. Both the artist's desire for an online presence and the dealer's reluctance to finance it make sense, but this situation

sometimes leads to resentment. There are many ways in which the Internet, which would seem to bring people closer together, actually drives them further apart.

The issue of making known the identity of a buyer of art came up a few years ago for Corlis Carroll, a Lake Luzerne, New York, painter, who had been asked by a gallery owner to participate in a group show of artists who had created paintings on Monhegan Island, Maine. A recent graduate from the University of Albany, Carroll contributed four gouaches to the exhibit, one of which sold—her first-ever sale. "I asked who had bought it, and the dealer told me it was a college professor from the Utica area," she said. "I asked who it was, and he said he wouldn't tell me. He said that's how it's done in the gallery world, and he said it in a tone that suggested I was a complete idiot." Adding insult to injury, the dealer noted that if the buyer wanted to purchase another painting, the sale could take place through him.

The dealer's comments and tone bothered Carroll. "It was like a cancer growing in me," she said. "No one gets a 40 percent piece of me for the rest of my life. I didn't have a written agreement with this guy; I should know where my work is." Carroll was not without resources, however. Through the Internet, she discovered all of the colleges within one hundred miles of Utica and, by browsing their Web sites, found the e-mail addresses for their faculty. She sent a mass e-mail to a large number of these professors, telling the story of her frustration with this dealer, and was contacted within a week by the chairwoman of the classics department at Hamilton College in Clinton, New York, who said she had bought the gouache. Answering the question of who had purchased the painting wasn't simply to satisfy curiosity; Carroll asked to borrow the painting back in order that she could make a limited edition print of the image, a request to which the Hamilton College professor agreed.

Another instance in which a sale may lead to tension is when a gallery owner asks to purchase an artist's work at a discount. Since dealers already take a commission on art sales of, say, 50 percent, the discount is not based on the listed gallery price but on the wholesale price. Instead of earning half the proceeds of a sale, the artist might end up with only 30 to 40 percent. While those numbers don't look as good, turning down ready cash can be difficult, and saying no to one's dealer may sour the relationship.

Within a short period of time of each other, two galleries that had paintings by Lynnda Tenpenny on consignment asked the Knoxville, Tennessee, artist if they could buy them (both asked for discounts). "It's sort of a compliment," Tenpenny said, "but neither dealer realized that the question put me in a spot." She is not opposed to discounts and, through both direct sales to collectors and purchases at galleries, cuts the price of her work by 5 percent "when someone buys more than one piece. It doesn't really amount to much, but it makes the customers feel like they've gotten something extra." Selling a painting to one of her dealers at the regular wholesale price, Tenpenny realized, would be a true discount only if the gallery owner simply kept the work rather than eventually selling it. (Of course, if a gallery owner is buying artwork as a collector rather than as a dealer, shouldn't the discount start at the retail price instead of the wholesale?) As it turned out, neither dealer brought up the question again—both still have the paintings on display on consignment—and "nothing ever came of it."

Perhaps what has unsettled the artist more than anything else is the sense that "there is no protocol" in the art trade for accepted practices. "It's like buying a car; you don't know what's true, what's customary." And, like the experience of buying a car, someone may walk away wondering if that's the best they could have done, or if they gave away too much.

Sales make art careers possible, but sales may prove disconcerting to artists if they are occasioned by significant discounts, especially if those discounts are offered to buyers without the consent of the artists. As a matter of law, manufacturers cannot tell retailers what they must charge for products but only offer their preferences for pricing— automobile advertisements, for instance, refer to the "MSRP" (manufacturer's suggested retail price)—as this would violate the Sherman Antitrust Act. Consumers benefit from this, because they can comparison shop, purchasing nationally advertised products at lower prices, such as at Wal-Mart. The law applies not just to the manufacturers of appliances, however. Artists who create multiples, such as print editions that are sold at frame shops, at mall galleries, at tourist area stores, or on cruise ships, periodically find the prices of their work "slashed" in order to move inventory (when confronted, shop owners claim that it is the frame that is being discounted). Gallery owners deeply resent artists selling the same work they represent at lower prices in direct sales to collectors, and artists do not want their price structure to be undermined by gallery owners. How to deal with a discounter can be troublesome, however. "This area is a mine field in the law," said Washington, D.C., arts lawyer Joshua Kaufman, "and things have to be carefully worded. You can have a policy of not selling to discounters, but you can't tell a retailer at what price to sell your merchandise. You can cut off a gallery if you don't like the way it does business, but you also can't re-sign up a gallery if it agrees not to discount."

One artist who found herself navigating that mine field was Edna Hibel of Lake Worth, Florida, who is best known for her prints and collector plates. She was informed by one gallery that another nearby gallery that also sold her work was offering pieces at sharply discounted prices. Hibel refused to sell any more work to the second gallery, which resulted in that gallery owner bringing an antitrust lawsuit against the artist, claiming that she was conspiring with a competing gallery to keep prices up. The 1988 court judgment was in her favor because conspiracy was not proven (in fact, Hibel argued that the area could not sustain two dealers) and the artist showed that her actions were taken in order to maintain the image and integrity of her products.

If there is any protocol in the art trade, it is that when artwork is sold, the artist is paid the amount that the dealer doesn't claim as a commission on the sale. Unfortunately, any number of artists have had the experience of not getting paid in a timely fashion (within thirty to ninety days) or at all; sometimes, they aren't paid because they are never told that their work sold. However, even when they are notified of a sale and receive payment, artists may get less than they expected, since the gallery owner subtracts certain expenses that should have been discussed in advance but weren't; perhaps this arrangement was even mentioned, but the artist was too excited by the prospect of a show to pay close attention. It's not only young, emerging artists who fail to take precautions in the handshake world of the art trade. Los Angeles

gallery owner Douglas J. Christmas has been sued by painters Robert Motherwell (1978), Leon Polk Smith (1981) and Robert Rauschenberg (1983); sculptors Robert Graham (1979) and Jannis Kounellis (2006); and an assortment of collectors and dealers (landlords, too), because they weren't paid in full or in part after sales had taken place. The reasons in all instances were the dealer's costs in mounting the exhibitions for these artists' works. Susanna Singer, business manager for artist Sol Lewitt, who broke off with Christmas after a dispute over payments, said that Christmas's shows were more "lavish" and the gallery spaces always "larger and more fabulous" than anyone else's, which certainly increased their cost and, perhaps, impressed artists and collectors, and those costs were always charged against sales.

Sales would seem to be the end of an artist's troubles, but sometimes they are just the beginning.

SPREADING ONESELF TOO THIN

The problems for artists in maintaining more than one gallery relationship, of course, are significant: the artists must produce enough pieces to keep each dealer satisfied; the works cannot be better for one dealer than for another; the bookkeeping, insurance, and specific consignment agreements with each dealer or gallery require considerable organization on the artist's part; and it may be much more difficult to arrange major shows in one specific location when pieces are spread around the country.

In addition, the artist may be able to sell his or her works privately, and this should also be discussed with the dealer. Some dealers don't mind, but others do. Dealers who allow their artists to sell will privately demand that those prices not fall below what is charged in the gallery. Underpricing one's dealer will sour that relationship as well as diminish the overall value of one's work in collectors' minds.

SEVERING THE ARTIST-DEALER RELATIONSHIP

The end of the relationship between artist and dealer is often the result of hard feelings on at least one side—the dealer isn't promoting or selling work, the dealer does not pay promptly after sales take place, the dealer isn't showing interest in the artist, the artist made private sales, the artist isn't producing high quality work—and produces hurt feelings on the part of whomever has been left behind. Often, there is a complicated mix of reasons that an artist and dealer split up.

Sculptor William King left the Zabriskie Gallery in New York in part because "the gallery had a low ceiling, and I expected higher prices and more sales," but the precipitating event was the dealer's "refusal to give my girlfriend a show." He went to dealer Terry Dintenfass, who agreed to exhibit the work of his girlfriend. On the other hand, painter Jacob Lawrence ended his relationship with Terry Dintenfass because "I wasn't getting paid the money I was owed, I didn't get quarterly statements from her, and she was generally hard to work with."

One way in which artists often judge the solidity of their relationship with their dealers is the number of telephone calls from their galleries. "Artists want to hear regularly

from their dealers," Curt Marcus, a New York art dealer, said. "It's important that they know they are being thought about." Both Gregory Gillespie, a painter, and Faith Ringgold, a painter and sculptor, said that they are called by their respective dealers at least once a week for the purpose of relaying information on prospective buyers, past collectors, and new shows, as well as pleasantries like asking how the work is coming along or how their families are—the specific content may not be as important as the ongoing connection.

Painter Richard Haas noted that a sign of how his relationship with a dealer is "fizzling out" is that "the dealer is calling you most of the time when you're in the middle of it; when you find yourself calling the dealer most of the time, you're not in the middle of it anymore. There are not enough phone calls, not enough visits to your studio, you don't get invited to dinner. You know you're at an end."

Many artists approach their relationship with dealers cynically. "You get priority treatment from dealers when your work is selling," said painter and collage artist Nancy Spero, "and dealers have no time for you when sales are slow. In other galleries, the attention you get is based on where you are in the pecking order of artists that the dealer represents."

Haas said that the relationship between artists and dealers is based "on mutual needs, but those needs keep changing, and one is seldom in sync with the other." For Haas, who is best known for his murals, dealers lose interest because they are "object-oriented," whereas his living is based on commissions, which are more difficult to arrange than private sales. Painter and photographer William Christenberry left the Zabriskie Gallery "as a matter of conscience" after being awarded a commission from the federal government's General Services Administration in 1979, "and the gallery wanted a substantial part of the fee as their commission. They hadn't helped me get the commission, as a lot of other galleries do, and I didn't think they deserved any of it." Painter Peter Halley left dealer Larry Gagosian in New York because of the requirement that Gagosian be his exclusive agent. Dealers elsewhere in the United States and in Europe did not want to share sales commissions with the New York gallery, resulting in lost sales. "75 percent of my market is in Europe," Halley said. "My collectors are not likely to come to New York to buy. Dealers in Europe chafe under the requirement that they pay half of the commission they earn to my New York dealer." To his mind, Gagosian would rather lose sales than his commission.

At times, the point of contention is whether or not the artist feels free to develop artistically under the existing relationship. Jacob Lawrence noted that he ended his association with Élan Gallery because the dealer, Charles Allen, "wanted to buy all the work he showed, which put me in the position of creating for him. He didn't come out and say, 'I want you to paint in such-and-such a way,' but it still felt that way to me and I wasn't comfortable with that."

Similarly, Faith Ringgold, who was represented by New York art dealer Bernice Steinbaum from 1985 to 1993 before joining ACA Galleries, said that she "wanted a gallery that was more high-powered, that could get better prices and place my work in better collections. But it wasn't just the money; I wanted my entire career to move forward, and I sensed a tendency on Bernice's part for me to stay where I was."

Ringgold noted a mounting number of suggestions for and outright criticisms of her work from Steinbaum. "We weren't agreeing on anything anymore," she said. "It was just a constant aggravation that kept me from concentrating on my work. The only thing I could do was leave her gallery." When she decided to leave, Ringgold had her lawyer contact the dealer and arrange the split.

Most artists announce their decision to leave in person, sometimes in a letter, and hope that the breakup with the dealer will be painless and amicable. "I tell my artist clients, 'Don't go away mad. Just go away,'" Jerry Ordover, a lawyer who often represents artists, said. "When you start thinking about leaving a gallery, do it in steps: start by reducing the size of the inventory. Take back works that have been there two or more years to start with, then take more recent pieces. You don't want to leave hostages with a dealer whom you've just told you're leaving. You might find the works get kicked around, or you're told they are lost. Next, you want to get all the money owed to you, little by little if not in a lump sum. You want to settle the money part while the two of you are still on good terms."

Complicating the breakup may be the question of money owed to the dealer for advances against sales (sometimes called stipends); the costs of advertising, framing, and restoration; or the purchase of materials or the publication of a catalogue. An artist may not have the cash to immediately cover the debt and attempt to repay the dealer through works of art. When Jacob Lawrence left Terry Dintenfass, she had some graphic prints of his and he owed her some money; they agreed that she would keep the prints in exchange for wiping out the debt.

The problem isn't always resolved as easily. "If there is an agreement that money owed should be recompensed in art, you want to know how that art is selected," Martin Bressler, a lawyer and vice president of the Visual Artists and Galleries Association, said. "Does the artist pick? Does the dealer? Do they pick together?" When Hirschl & Adler Galleries in New York decided to end its relationship with painter Joe Zucker in 1993, following a private studio sale that the artist had made to a collector, the gallery refused to return twenty-six of his works until $36,000 in advances plus interest had been repaid. Zucker filed a lawsuit and, in 1996, the New York Supreme Court ruled against Hirschl & Adler. The artist and gallery eventually settled the debt by selecting four works that the gallery would keep.

Ending a relationship amicably is important not only since the dealer may be in possession of an artist's work but because "the art world is small," said painter Nancy Hagin, who left Terry Dintenfass in 1980. "It's not like I'm never going to see her again. I see her again and again and again." Within a small art world, an incensed dealer may begin denigrating the reputation of an artist both to other dealers and collectors, adversely affecting the artist's career. Even though their formal relationship has ended, the dealer may still remain a source of future sales and commissions, and some artists may return to a former dealer. William King returned to Terry Dintenfass after his experiment with Virginia Zabriskie, and Gregory Gillespie was invited back by dealer Nina Nielsen in Boston a couple of years after she had "asked me to leave following a big blow-up we had."

The experience of ending a relationship is almost always unpleasant, artists and their dealers report, but it is an unpleasantness that everyone tries to get over quickly.

Over the course of a career, an artist may change dealers any number of times, and knowing how to make a satisfactory exit is one more skill to acquire. Dealer Betty Parsons "wouldn't talk to me for a few years when I told her I was going to show my work at the Janis Gallery," said painter Ellsworth Kelly, "but we patched it up and even took a vacation together." When Kelly left dealer Sidney Janis for the Leo Castelli Gallery, "there was some initial bitterness there, too, but that didn't last long and we remained good friends."

The agreements that artists and dealers make when they start a relationship should contain some strong sense of how it might end, according to Joshua Kaufman, a lawyer in Washington, D.C., who noted that when he drafts a consignment agreement between an artist and a dealer, "I spend more time on the termination clause than on anything else. You don't want to leave this stuff up to when everyone's feelings are hurt."

The overall contract will indicate how long the agreement is in effect. Bressler said that the contract term should be a minimum of three years if the gallery is the artist's exclusive agent, because "anything less than three years doesn't give the gallery enough time to really promote the work." Far longer terms, however, may bind an artist to an arrangement that he or she has outgrown.

Some artist-dealer consignment agreements allow either party to terminate the contract at will if there has been a clear breach (for instance, the artist isn't paid, shows don't take place, or the artist violates exclusivity) or if either side is simply unhappy with the arrangement. Even if there is no specific termination clause, one cannot be bound by a contract indefinitely. According to Barbara Zucker, Faith Ringgold's attorney, "the contract may be terminable at-will" or, at worst, the statute of limitations will not permit the agreement to be enforced past one year.

Of course, when there is no written agreement between artist and dealer, either side may end the relationship at any time. However, the lack of some formal or informal (an exchange of letters) document may lead to other misunderstandings or even a drawn-out legal action that promises to be expensive and not necessarily conclusive.

GALLERIES CHANGE ARTISTS

"I have the reputation of being pretty loyal to my artists, regardless of whether they sell or not," said Andrea Rosen, a Manhattan gallery owner who specializes in mid-career artists. However, reputation, loyalty, and whether they sell or not took a backseat to other concerns in late August 2006 when the dealer booked a room in New York's Mercer Hotel and spent the next two days phoning and meeting with ten of the artists she represented to tell them that the gallery was being "restructured" and that they would no longer be part of it.

That situation wasn't an isolated one. In spring of 2007, dealer Edward Winkleman met individually over lunch ("I treated") with six artists he represented to inform them each of his own restructuring plans for his gallery of emerging artists. He explained that he could do a better job concentrating on fewer artists, and his decision on whom to keep was based in part on his experience at art fairs. "All you do at a fair is talk to people about your artists," he said, "and those I could talk about for hours without ever repeating myself and getting bored I decided to keep, and the others probably weren't as good a match."

The effect on the downsized artists in these galleries was sizable, both profession-ally and personally. Not only were they being dropped by a gallery, they were losing their portal to the New York art market. "There's no one there to sell my work," said Brooklyn, New York, sculptor Craig Kalpakjian, who had been represented by Andrea Rosen. "It's been really hard on my career." A couple of galleries in Europe have some pieces by him, including Galerie Edward Mitterand in Geneva, Switzerland, but, according to Stephanie Cramer, the gallery's director, "it's much easier to sell work when the artist has a gallery in New York. Collectors here want established artists"—meaning, ones with New York gallery affiliations. Sales were infrequent at the Andrea Rosen gallery, but at least it was a showcase, and a prestigious New York gallery may be particularly important for a college-level art instructor seeking advancement. (Donald Porcaro, chair of the fine arts department at Parsons School of Design, one of the two schools where Kalpakjian teaches, stated that "we all understand here what goes on in the fickle world of galleries, but we want our artist-faculty to be very contem-porary. They need to be showing their work, if not in New York then outside New York.") Most difficult for Kalpakjian has been the need to reintroduce and promote his artwork to gallery owners and exhibition curators. "It's putting me back to a place I didn't expect to be in again, and things have been happening more slowly than I had expected."

Kalpakjian, however, is fortunate to live in Brooklyn, New York, where the com-mute to Manhattan's art galleries is not so great. For Michael Ashkin, a sculptor and director of graduate studies in art at Cornell University in Ithaca, New York, or Ken Lum, a multidisciplinary artist in Canada's British Columbia, both of whom were let go by Andrea Rosen, the opportunity to meet potential New York dealers is more limited. Ashkin described a "feeling of loss or disorientation" in being dropped, and Lum said that he was "disappointed, but I'm not going to say traumatized. I sell far more in Asia and Europe than in the United States through galleries there."

The conversations these three and the other artists had with Rosen were emo-tional; Rosen told them she was working with too many artists and needed to cut back in order to better represent them (her stable of artists now numbers eighteen). "I told them I didn't let go of artists in order to get other artists, and sales didn't affect my decision-making," she said. However, Ashkin felt certain that "regardless of the reasons given for dropping the ten of us, the dominant reason was the market. She did say that after resisting the market for years, she was now giving in to it. This reason seems most consistent with my general understanding."

Wholesale dismissals of artists is rare in the gallery field, but a certain amount of turnover—say, one or two artists coming and going every year—is not unexpected. "There are many reasons for artists no longer showing with us," said Jane Young, direc-tor of Boston's Chase Gallery, citing reasons such as "the evolving aesthetic of the gal-lery, changing tastes of our collectors, the artists' own aesthetic changes no longer meshing with what we show in the gallery, sometimes, artists have too many commitments—they are stretched too thin and can't produce enough work for us." Peter Ted Surace, owner of Manhattan's Rare Gallery, noted that a dealer may be supportive

of artists and their work but just can't find buyers for it. "There comes a point when you just can't do anything more for an artist," he said. "A glitch develops, and you don't know why that glitch happens. People may not respond to the work anymore." Prices and demand may also increase beyond the level of a gallery's clientele, requiring the artist to look elsewhere. Other dealers claim that few collectors buy an artist's work in-depth anymore, preferring to purchase just one piece by each of a number of artists, which saturates the market very early on. Whatever the circumstance, an artist who does not fit well within a particular gallery must become "more assertive about promoting my career, instead of letting someone else be in charge of it," said Joe Fig, a photographer and sculptor in Norwalk, Connecticut, who was dropped by the Winkleman Gallery. Having felt for a number of years that the gallery was not the most appropriate for him and his work, which he had discussed more than once with Winkleman ("Ed told me to hang in there, give him more time, and I agreed"), Fig had established relationships with galleries in Boston and Germany, as well as with an art consultant in Manhattan. "When I had lunch with Ed and he told me of his plans for restructuring the gallery, I thought, 'You're breaking up with me? I'm breaking up with you.'" He knew that his sales at the other galleries "would tide me over until I got another New York gallery."

Having a job that pays the bills also helps when your gallery drops you, but other events also ease any pain. For Charlie White, a photographer and director of the Master of Fine Arts program at the University of Southern California, the 2007 publication of a book of his images (*Monsters*); a traveling solo exhibition of his work in Europe (England, Germany, Spain, and Sweden) in 2006; inclusion in a 2007 exhibit at the Shanghai Museum of Contemporary Art; and his plans to be part of another group show at the Contemporary Art Museum of Houston in 2008 have eased much if not all of the pain. "There have been major institutional acquisitions of his work in Europe and strong demand for his work internationally," said Nicholas Baker, director of the London, England–based F.A. Projects, his primary gallery. "His career is flourishing. When the time and the relationship are right, then I am sure he will develop a relationship with a gallery in New York."

Of course, more is involved in reestablishing oneself in the gallery realm than just searching for a new dealer. All old business needs to be resolved with the gallery with which the artist is ending a relationship, and that includes the return of all unsold consigned work and payment of all outstanding debts. If possible, the relationship should end as amicably as possible ("I had dinner with Andrea recently," Lum said. "Andrea knows I'm disappointed, but I still like her a lot."), as past collectors may contact the gallery about the artist's work, and for them to be directed to the artist or to other dealers selling the artist's work. In addition, the gallery may still want to have works by the artist available, even if it no longer represents the artist. "I still work with Ed—I'm still on the gallery's home page—even though he doesn't represent me, and now I can work with other people, too," said Alois Kronschlager, a Brooklyn, New York, sculptor whose relationship with the Winkleman Gallery was restructured. Rosen herself noted that she gave the ten dropped artists her "archives, so they know who has bought their work in the past."

Both Rosen and Winkleman offered to contact other dealers on behalf of the artists they were letting go. "I did that for several of the artists, although I don't think it

necessarily helped," Winkleman said. Being dropped by a gallery may stain an artist's reputation, at least briefly or until one is picked up by another gallery, to the degree that it raises questions: Was the artist somehow at fault (not producing enough work, not turning in the best work, producing artwork no one wanted to buy, making private sales behind the dealer's back, not conducting him- or herself professionally, having an irritating personality)? If not, why would the dealer decide to let that person go? "Dealers have called me about the artists I let go," Andrea Rosen said. "They wondered, what happened?" Rosen also stated that she has explained to dealers who have called up to ask why she dropped a given artist that "I found myself overextended. As time went on, I found myself further and further removed from the artists, the collectors and even from my staff. I've stopped using e-mail completely." Still, Rosen selected among the artists to pull the ones she no longer chose to represent, and the question of what the problem was with this artist or that still looms.

In many instances, the dissolution of an artist-dealer relationship is a no-fault zone. Along the continuum of concern, being dropped by a gallery ranks somewhere between getting fired from a job for cause and a divorce: it may need to be talked about, but it's not the mark of Cain. Increasingly in the gallery realm, it is the rare relationship that lasts for decades. Gallery owners don't represent artists so much as their "program," by which they mean a "vision" of art that is more than just the individual artists represented or shown. To a certain extent, nothing is new in this: galleries have always specialized—this one shows conceptual art, that one focuses on realist painting—but the discussion of a program suggests that dealers are taking on the mantle of style, vision, and philosophy that traditionally has been the domain of the artist. This may affect the relationship between an artist and a gallery owner as an artist's work evolves, moving into different territory that "no longer fits what the gallery is about," Manhattan gallery owner Stephen Rosenberg said. "Then, the artist might need to leave." The essential commitment is not between dealer and artist but, rather, about a certain idea of art. Winkleman, who had started his gallery as Plus Ultra Gallery in 2001 with a partner in Brooklyn, bought out his partner, renamed the gallery after himself, moved it to Manhattan, and began the process of refocusing its program. "Instead of doing things bit by bit," he said, "I decided to rip off the bandage all at once."

Few artists don't evolve conceptually or stylistically over time, and this transformation produces work that may be quite good but no longer is a proper fit with the gallery. "I had been doing different work," said Brooklyn photographer Nicholas Gaffney, "and I showed it to Ed, but I could tell from his reaction that he wasn't really into it." A lesson that he and other artists have learned from their experience is that the relationship between an artist and a gallery or dealer isn't necessarily a lifelong affair and that artists need to be as aware of the market as the owners of galleries that represent them. They also must learn (or relearn) to view art as a business, which requires their direct involvement and awareness of potential opportunities. Michael Ashkin noted that losing his New York gallery affiliation has forced him to "exercise much more control over what is going on. What surprised me was the speed with which any

feeling of loss or disorientation subsided and was replaced by one of empowerment and freedom. I deal directly with people. I am responsible for making all the connections myself. Ironically, I feel much more involved with the art world than I did before."

ART WORLD RELATIONSHIPS

When New York City art dealer Louis Newman describes working with collectors, he likens his job to "matchmaking," "understanding both the intrinsic value of the work and who the client is, what the client is about." In discussing working with artists, he compares it to "a marriage of sorts. I know not all marriages work out, but the divorce rate is better for artists and galleries." It can all sound a bit lovey-dovey but, in fact, most gallery owners talk in these terms, emphasizing the importance of relationships. "It get to know my collectors, their tastes in art, and other things (their birthdays, their children's birthdays)—it's not just about buying and selling," Chicago gallery owner Rhona Hoffman said, adding that she knows the artists her gallery represents in similar ways.

In the handshake business that is the art trade, relationships matter, but the burgeoning number of art fairs, the Internet, the growing amount of money being spent on art these days, and a growing assertiveness on the part of both artists and collectors are loosening these ties in many instances.

THE COLLECTOR-DEALER RELATIONSHIP

Take the art fairs, for instance. The dozens of them that take place in Asia, Europe, and North and South America have greatly expanded the art market by prompting art dealers to set up booths and displays where collectors and would-be collectors live, rather than assuming that all buyers will travel to their galleries hundreds or thousands of miles away. However, the opportunity to comparison shop, especially when more than one gallery carries works by the same artist, takes away from collector loyalty to a particular dealer. "They play one source off against another," said Washington, D.C. gallery owner Christopher Addison.

At times, collectors invite gallery owners to attend art fairs with them. The gallery owner acts as an advisor, splitting the commission when an artwork is purchased with the dealer who actually sells the work: that person's cut is 20 percent, but it is better than nothing, and it keeps the relationship with the collector going. "Going to an art fair is like going to a candy shop," Fay Gold, a gallery owner in Atlanta, said. "It can be too exciting for many collectors, who want someone to help them pick the right things. For me, it's like shopping with a friend."

Gold also participates in a number of art fairs annually, noting that if she loses clients to other dealers ("long-time collectors use income at an art fair that they might have used for you"), she picks up new collectors who may have strayed from other dealers. "You have to accept the fact that you can't own a client," she said. "In the early days, you could own them longer."

Perhaps more worrisome to gallery owner Stephen Rosenberg, the excitement and fun of many art fairs may be leading new collectors to only buy artwork there, rather than coming into a gallery and developing a more traditional relationship with a dealer. "People under thirty-five, who have grown up looking at TV and 1/8-of-a-second spliced images with subliminal messages, need to be educated that art is a different kind of experience," he said. "Art fairs allow people to walk in and out of a gallery without ever having an intimate moment." He noted that he and his gallery co-owner, Fran Kaufman, are in the midst of "changing our business model" to deemphasize showing and promoting artists and to work more as art advisors.

The Internet has also had an effect on more traditional collector-gallery relationships, as buyers no longer need be as reliant on dealers for information on prices or the availability of artwork. Anyone with anything to sell posts the information online. Dealers take on a consular role, helping collectors to whom they have sold in the past to evaluate what the collectors have found on the Web. "Collectors call me and say, 'I saw a particular work by so-and-so artist is for sale at a gallery in California,'" said Miami gallery owner Bernice Steinbaum. "They want to know what I think of it and do I have something that's better." As much as such a conversation reflects a changed, perhaps diminished, relationship with the collector, Steinbaum stated that the fact she is contacted reflects an ongoing connection that still has value. "Collectors are very smart, and they will go to the dealer who has shown an artist the longest period of time," she said. "They'll come home to mama first."

THE ARTIST-GALLERY RELATIONSHIP

Perhaps more than anything else, the Internet has changed relationships, dividing people as much as it brings them together. Most galleries have Web sites for listing upcoming exhibitions and displaying artwork, but so do a growing number of artists. Dealers have long worried that collectors will contact and purchase artworks from artists directly, bypassing the gallery completely. Suspicion and distrust become one more element of the artist-dealer relationship. "The Internet creates opportunities outside the gallery system, allowing for direct relationships between the artist and the consumer that hadn't existed before," said Paul C. Rapp, a lawyer in Housatonic, Massachusetts, and a professor of art and entertainment law at Albany Law School in New York State. "Those in the middle of that transaction must now rejustify their existence."

Perhaps rejustify, perhaps revamp the relationship. More and more, artists are taking control over their careers, rather than leaving all decisions about the marketing, sales, and overall advocacy for their work to dealers. Peter Halley, a painter and director of the graduate painting department at Yale, said that he left exclusive relationships with a succession of galleries in New York City and now works with a "constellation of galleries" in the United States and Europe, because he has greater leverage over how and to whom his work is promoted. "Some dealers just think in terms of one exhibition," he said. "They're good as impresarios; the exhibitions are very good, but they don't do anything between exhibitions. I want people to think about my work when there isn't a show, which means articles and books. I want the dealer to get my work in shows elsewhere: in galleries and museums in the U.S. and other countries."

It is not just artists, however; everyone in the art trade—collectors, artists, and even dealers—is becoming more assertive and proprietary. Gallery owners increasingly refer to their "program," by which they mean a "vision" of art that is more than just the individual artists represented or shown. To a certain extent, nothing is new in this: galleries have always specialized—this one shows conceptual art, that one focuses on realist painting—but the discussion of a program suggests that dealers are taking on the mantle of style and vision and philosophy that traditionally has been the domain of the artist. This may affect the relationship between an artist and a gallery owner as an artist's work evolves, moving into different territory that "no longer fits what the gallery is about," Stephen Rosenberg said. "Then, the artist might need to leave." The essential commitment is not between dealer and artist but, rather, between both individuals and a certain idea of art.

"It's always a concern if you make changes in your work, because the dealer might decide not to show it," said Galisteo, New Mexico painter Woody Gwynn, who has been represented by "at least eight or nine galleries" over the past twenty years. "Dealers want a hallmark style—they love that. To dealers, change gets in the way of business." New York City artist Richard Haas found that good relationships he has had with several galleries deteriorated as he began to devote more of his time to public murals. "Dealers tried to figure out how they could tap into that," he said, "and they couldn't. So, friction developed. They couldn't handle the fact that I wasn't just painting for their galleries." As a result, his personal relationships with dealers "have been strong, but the professional relationships have suffered."

For better or worse, it is the volume of money pouring into the art market that has led to evolving relationships between artists and dealers. "If you can't make money in this art market, you never will," said Fay Gold. However, big money may skew traditional relationships. For dealers, that sometimes means dropping an artist after one or two unsuccessful shows because rents are too high and other artists' work is too sought-after to put energy into nurturing one person's career. For artists, that may mean not committing to a long-term relationship with a gallery. "You do see a lot of money chasing artwork these days," said Santa Fe painter Michael Bergt, who has gone through several dealers over the past thirty years. "Even while you are comfortable with a particular dealer, you start thinking, Is this the right place for me right now? Should I be showing somewhere else? Is that new dealer promoting his artists more than mine is promoting me?" Ultimately, these questions lead to one at the heart of a relationship with a dealer, "Is loyalty a hindrance to my career?"

While the number of artists increases every year, competition among art galleries for their work has become even more heated, strengthening the artists' hand. Dealers no longer are reluctant to "poach" artists from other galleries, for instance. In addition, galleries that worked substantially in the secondary market have found that it is "harder to obtain consignments these days because people think the public auction is a better venue for sales," according to New York City gallery owner Renato Danese. They can't compete with the auction houses, their inventory and access to secondary market material has diminished, so they go after living, working artists who are not at auction." The relationships that dealers form with artists, he stated, are not as "paternalistic, as they had been in the past" but are more "tenuous, provisional" and, perhaps, just anxi-

ety-prone now. Danese noted that keeping artists happy in the relationship has led galleries to produce more exhibition catalogues ("Who should write the catalogue essay has become a huge issue.") and to work harder to get the artists' work into other exhibitions elsewhere.

The content of a relationship between an artist and dealer is as distinct as the individuals involved but, Danese said, it usually includes daily or weekly e-mails or telephone calls by the gallery owner ("For artists whose work is less in demand, there is less of a requirement, but they still know we're here."); periodic studio visits ("The artist usually makes it clear when that should happen,"); lunches or dinners with the artist (or other social outings); and some sort of acknowledgment of major events, such as Christmas or the artists' birthdays or the birthdays of their children. Some relationships remain more formal, while others lead a dealer becoming deeply involved in an artist's life. "When someone is having financial problems, I've made advances of money," he said. "I've gotten lawyers for artists when they're getting divorced or when they're buying a house. I found one artist a chiropractor."

Strong personal relationships between artists and dealers may fall victim to shortcomings on the business side, such as slow (or no) sales, reasonable price increases that are beyond the reach of the gallery's regular clientele, or the gallery's collector base simply drying up for a particular artist's work (after everyone has purchased one or two pieces). "In my experience, collectors will buy an artist's work for a period of five years, then they move on to buy someone else," said San Francisco gallery owner John Pence, adding that a number of young artists he has represented have moved to other dealers when they have "exhausted the buying base." However, painter Will Wilson, who has stayed with Pence for thirty years, noted that the dealer has continued to find buyers for all his work, which first was priced at $4,500 and now goes for up to $60,000. Several reasons have kept him from trying other galleries, including "laziness, I have to admit," and a belief that he wouldn't have any more luck elsewhere. "When I look at other artists who do the kind of work I do and have as much experience as I have, they don't seem to be doing any better," he said. Most important to Wilson, though, is his personal and professional relationship with Pence. "My studio is right above the John Pence Gallery, and he visits me two or three times a week." Thirty years ago, Pence acted more as a mentor to Wilson, offering encouragement, cheerleading, and occasional kick-in-the-pants motivation to produce more paintings, but "our relationship has evolved, the way a father and son's relationship evolves, to the point that we're more like equal business partners, and friends."

Amidst the changing art field, however, is the continuity of the importance of these relationships, and they remain a mix of the personal and the professional. "I join a gallery because I personally relate to the gallery owner," said Longmont, Colorado, painter Scott Fraser. "I have to be able to talk to them about my hopes and dreams, because they need to understand the work I make so they can sell it."

For Peter Halley, a dealer for whom he is preparing work for a show becomes a "primary, imaginary audience. I feel like I'm making paintings for this person." He added that the same feeling arises with each gallery owner. "Interest in my work" and

loyalty are his top priorities in building and maintaining a relationship with a dealer. "It matters that I have personal relationships with gallery owners who also have personal relationships with a group of collectors who trust the dealer's judgment. The great thing about the art world is that is can be social: people meet and have direct experiences."

ART GALLERY ETIQUETTE

It was an exhibition opening at Seattle's Greg Kucera gallery, and the artist whose works were on the walls was doing what artists do in these situations: accepting congratulations, chatting up visitors, and being agreeable. Another artist, a sculptor, approached him wanting to talk about the paintings. However, the sculptor expressed displeasure about the imagery and called the edges "sloppy." The painter, who asked that his name not be mentioned, defused the situation by walking away. "The guy didn't have any sense of protocol or sensitivity to the situation," he said. What is the protocol?

Certainly, there are other opportunities to have serious discussions about artwork, with or without the artist being present. An exhibition opening is an event to honor the artists and, perhaps, make a sale or two. It's a party, and people are supposed to be on good behavior, keep conversation light, not eat or drink too much, and not make a scene.

There is a lot of etiquette in the art world that, like most etiquette, tends to be understood implicitly rather than spelled out. Etiquette describes the expectations of social behavior, maintaining a shared zone of comfort for everyone involved. For instance, visitors tend to speak quietly (at least, about the art) in a gallery, in order not to impress their thoughts about the art on the experience of other people there; conversations with the artist at an opening tend to be brief, so that the artist may meet and greet as many visitors as possible; discussions with the artist at an opening should eschew mentioning how much the art costs. Was anything sold? What does the artist make in a year? It's probably not great manners to ask about if there are any good restaurants in the neighborhood, although like the prices of the art and the fact of sales, the name and location of a good eatery is not unreasonable to think about.

Brief conversations with the dealer talking about the artist, the artwork, or the prices (appointments should be made for lengthier discussions) also make sense, but exhibit openings are not good times for other artists to show their own artwork to the gallery director or to make a pitch for their own shows.

Speaking ill of other people generally is poor form and reflects badly on the speaker. Artist A who ridicules Artist B in front of collectors or dealers may adversely affect the fortunes of Artist B but, more likely, will make those collectors and dealers wary of having anything to do with Artist A, a person known to talk dirt behind someone's back. Being an artist, as the old saying goes, is an excuse to make art, not an excuse to behave badly.

Many artists look to break the supposed rules of art in their work, but the protocol of behavior at art events appears to be more fixed, in large measure because it is the same general code of conduct at other occasions. Everyone likes to hear (positive) feedback but far fewer want criticism, especially in person. Public criticism is itself a display and com-

petes with the art in the gallery. Critical comments in a published review or posted online may engender anger, but the criticism is not as immediate (it may have been written hours or days or weeks before) and it is not as personal (the writer is not speaking directly to the artist). There is time and distance to cool down. The painter at the Seattle gallery opening had the presence of mind to just walk away from the rude sculptor, which may have been the best response. If the offense had been inadvertent (the sculptor hadn't meant to irritate), the artist might have seemed overly sensitive, touchy, or egocentric. Had he lost his temper, his outburst might have been the only thing visitors recalled from the opening.

BAD DEBTS AND OTHER RECOVERIES

Don't pay the utility company, and your electricity will be cut off. Miss some auto loan payments, and your car will be repossessed. Forget about the credit card charges, and a collection agency will be in touch and your credit rating affected. Don't pay the artist for his or her painting, and you can keep the artwork and your money. What's wrong with this picture?

When artists go unpaid, they usually have two options: hire a lawyer whose legal work is likely to cost far more than the value of the artwork itself (lawyers' fees and court costs are rarely included in a settlement), or vent and fume.

In general, artists go unpaid in two different ways: their dealers sell works but continually find excuses for not turning over the cash (minus sales commission) to the artists; collectors who buy directly from artists, taking possession of the works with an agreement to pay for them over time, simply stop sending the artists money. In order to determine what to do after artists find themselves owed money, it is useful to examine what they might do before a sale is made.

"You need a clear understanding with the dealer or collector of the terms and conditions of payment," said John Henry Merryman, a professor at Stanford University Law School and coauthor of *Law, Ethics, and the Visual Arts.* "How much are you going to be paid? When are you supposed to be paid? What is the price of the artwork? Are there any discounts? What is the dealer's commission? If the dealer or buyer has a clear understanding with the artist about payment, that person is more likely to pay the full amount and on time."

Some lawyers recommend including legal language on consignment agreements between artists and their dealers, such as an indemnification clause or an arbitration clause. An indemnification clause, according to Patricia A. Felch, a lawyer in Chicago who has represented artists, strengthens an artist's ability to protect his or her rights by insuring that the cost of legal assistance does not stand in the way. Such a clause would say, in effect: "If full payment following the sale of a work is not received by the artist within x number of weeks, artist will be entitled to all expenses including attorneys' fees incurred by artist as a result of dealer's failure to pay." This language requires only modest alteration to apply to a collector in a private sale.

An arbitration clause requires both the artist and dealer (or artist and private collector) to submit their dispute to a neutral arbitrator, whose decision is binding and not subject to appeal. Arbitration is not free—the filing fee is usually $200 or $300 (sometimes more, depending upon the amount of money in dispute), and the arbitrator

is paid another $200 or $300 (sometimes more) per day—but it is generally less expensive than hiring a lawyer and bringing a lawsuit. The New York City-based Visual Artists and Gallery Association drafted a form consignment agreement with an arbitration clause, and California Lawyers for the Arts developed an arbitration and mediation service in order to help artists, collectors, and dealers resolve disputes.

Among themselves, lawyers involved in the arts argue whether or not dealers and galleries are likely to sign contracts with arbitration or indemnification clauses. "No dealer in his right mind will accept an attorneys' fees clause," John Henry Merryman stated. "They're not going to do something that would increase their exposure."

Felch, however, said that indemnification clauses she has drafted for artists have been signed by their dealers and galleries. "Calling it an indemnification clause frightens people," she stated. "It's a big word, and some people freak out. So don't label it an indemnification clause."

Arbitration, even if it is accepted by the collector or dealer, is itself not quite the bargain alternative to the legal system that many hope. "This is a legal process," Laurie Moss, director of marketing for the American Arbitration Association, said. "We inform people that to pursue arbitration without legal counsel is not wise." Artists may find themselves once again hiring a lawyer, first to advise them on whether or not arbitration will achieve what they are looking for, and second to accompany them to the hearing before the arbitrator. For a smaller fee of between $100 and $200, the Visual Artists and Galleries Association instructs an artist how to go into arbitration without a lawyer, but that may not be suitable for every artist.

"Arbitration is not circumventing the court system," Moss noted. "The reality is that, even if you win at arbitration but the dealer says that he refuses to pay the artist, the artist still has to go to court to affirm the judgment. That's expensive."

Artists are in the best position to protect their rights and receive what is owed to them when they have maintained good records of what has been consigned to their dealers and both sides have unambiguously agreed to certain conditions, such as the price, commission, discounts, and method and promptness of payment. The law may also add some muscle to the artist's position. The same laws in the twenty-one states around the country that protect an artists' works on consignment if the gallery declares bankruptcy (see above) also classify the dealer as a trustee for the proceeds of a sale; that is, dealers may not use those proceeds even to pay themselves until the artist is paid in full.

An artist's position is weakened when he or she has not maintained good records and if there was no clear understanding set out with the dealer or private collector for the financial dealings. The issue of how much money is owed by a dealer to the artist may also be muddied when there were advances made against royalties, framing or publicity charges, crating, and insurance and shipping expenses, as well as personal loans (with or without interest) and other fees.

"Sometimes, artists think they are owed money when they are not," Merryman said. "In some cases, the artists haven't been paid yet because the dealer hasn't been paid by the collector. Artists need to communicate more with their dealers. Artists

come out of a culture—I think they learn it in art school—that assumes that dealers are an enemy, a necessary enemy but an enemy all the same. They are prepared to think the worst about their dealers, which often becomes a self-fulfilling prophecy."

There are a variety of ways in which an artist may receive satisfaction that do not necessarily involve the high-priced legal system. Mediation may work in cases where the parties are willing to discuss compromises in the presence of a third party who directs the discussion. A growing number of volunteer lawyers for the arts organizations are offering mediation as a low-cost service, and others may direct artists to mediators elsewhere.

Many dealers and galleries belong to associations, which will set up arbitration (at no cost to the artist or gallery) when complaints are lodged against a member. "We take a very dim view of dealers not paying their artists," Gilbert Edelson of the Art Dealers Association of America said. "It is grounds for expulsion with us."

Another possible approach to getting payment in full or in part is contacting a collection agency. "Debtors know that eventually the creditors are going to get tired of calling and asking for their money, that they will get on with other things in their life, and that's just what they want," said Mike Shoop, president of the Denver-based Professional Finance Company, Inc. "But for us, collecting bad debt is all we do, and we will write to the debtor and telephone the debtor and visit the debtor, in order to convince that person of the benefits of paying the debt and the consequences of not paying the debt, until the debt is paid."

One of the consequences of being pursued by a collection agency is that a negative report is usually placed on one's credit report, which may prove troublesome for the dealer or private collector when that person looks to obtain a loan. Most galleries, as most businesses in general, survive on borrowed money.

There are thousands of collection agencies in the United States, but not all of them take on individual clients. More frequently, agencies serve the big company—such as a department store, with hundreds of potentially lucrative accounts—in their struggle to obtain payment from individuals. Most agencies work on a contingency fee basis, receiving as much as 50 percent of the money received from the debtor. (A source of information and prospective agencies is the American Collectors Association, P.O. Box 390106, Minneapolis, MN 55439; 952-926-6547; *www.acainternational.org*.)

As with everyone else, when artists are wronged, they want justice but may only receive small consolation. The legal system is not predictable in its results, for those willing to invest money and often years in resolving a dispute. Even those who win a lawsuit may still not be able to collect, for people who owe artists money are likely owe money to landlords, utility companies, credit firms, and others—there may be no money there to collect. In that case, artists would have to write off the loss as a bad debt on their taxes and hope to approach their next dealers or buyers with more knowledge about what could go wrong.

5

A Web Site

Type into any Internet search engine the word "painting," "sculpture," or "landscape," and millions of Web sites are found. Click this one or that and find some artist of whom you have never heard, eager for exposure on this worldwide medium, ready to sell. If I can find this person previously unknown to me so quickly and easily, lots of people will be able to find me through my Web site: this may be the break I've been waiting for! Certainly, a growing number of artists have created their own Web sites, hoping that someone (collectors, critics, dealers, publishers, other artists) finds them. However, as many have discovered, getting found is no easy thing, and what is supposed to happen after an artist's site is chanced upon is not necessarily obvious, either.

"Many people are very confused about how things work on the Internet," said Peter Platz, director of Internet marketing at Integrated Communications Enterprises in Rochester, New York. "They think, 'if you build a Web site, people will come,' and it just isn't true." Already, we are at the heart of the problem that this book aims to help solve: too many artists are reluctant to actively engage the world as producers of objects (in this case, of works of art) that they want to sell, hoping that someone will discover them— through word-of-mouth or osmosis or something—and relieve them of the need to learn marketing and sales. The Internet offers yet another means by which artists may go undiscovered because they believe that simply having a Web site with images of their work will magically produce interest among collectors, critics, curators, and dealers. The Web is a tool and, like any other tool, must be used properly in order to be effective.

THE BUSINESS OF MARKETING ART ONLINE

Geting potential buyers to come is a matter of a considerable difference of opinion. Geri Stengel, owner of the New York City-based marketing company Stengel Solutions, recommended that artists purchase e-mail addresses from companies (Web Promote and Net Creations, for instance, which charge twenty cents per address), and do a test marketing

of between 5,000 and 20,000, informing these people where their sites are and what can be found on them. Because the individuals on these lists have agreed to receive advertisements, she noted, the likely return rate—those who visit the site and decide to make a purchase—is between 2 and 5 percent. (Bad e-mail, where the recipients don't want solicitations, is referred to as "spamming" and is frequently deleted sight unseen.) Platz, on the other hand, said that he is "bombarded with e-mail all day long, and every e-mail tells me, 'Hey, take a look at the stuff on my Web site.' I delete all of those. I don't know why I should go there." He added that he prefers regular mailed postcards or brochures that show an artist's work and includes a Web address so that he can see more if he chooses.

Undoubtedly, the Internet has become a huge growth area in commerce, accounting for trillions of dollars in sales worldwide. The most popular items sold through the Internet are books and computer software, followed by apparel, music, and gift items. Most of these products are nationally known, and Internet buyers shop on the Web because of the convenience, the ability to compare prices, to avoid pressure from salespeople, to save time, to obtain information on vendors, and to learn the availability of products.

Selling works of art through the Internet doesn't fit any of those criteria for shopping. Rather than expecting numerous online sales, artists are more likely to make sales offline to those who encounter their work first on a Web site. Various types of artist Web sites may be spotted on the Internet, but they generally fall into three categories: The first is a personal Web site, the focus of which is to provide information about the individual (who I am, what I've been doing lately); there is as likely to be a photograph of that person's cat as samples of artwork. The second type resembles a portfolio, with representative images (but usually no prices) that an interested collector, dealer, or art director (for an illustrator or designer) might want to see. The third type has a more commercial feeling, with a sales pitch heading ("Best contemporary landscape painting") and prices next to each image; online galleries generally take this approach. All of them have some way of contacting the artist (e-mail or address and telephone number, and sometimes all three) and many contain biographical material, such as a curriculum vitae or biography and an artist statement.

Marketing experts generally recommend that artists promote their work in all the traditional ways (exhibiting, advertising, and meeting prospective buyers and corresponding with them) and use the Web site as a sales support tool, that is, more like a portfolio, which interested parties may examine for a more complete sense of the artists. Eric Rakov, director of Web development at IBS International, a business marketing company in Rochester, New York, suggested that artists put their URL (Web site address) on business cards, brochures, and any other piece of mail they send out. "You want to direct people as much as you can to your Web site and not just hope that they find you," he said.

In general, an artist's Web site rarely works in the manner of a merchandise catalogue from which browsers will pick something they like and place an order. The Web site permits browsers to look at the subject matter and style of artwork available as well as learn more about the artist. After that, the potential buyer may simply place an order but will more likely contact the artist through e-mail, telephone, or regular mail in order

to obtain more information about the artist (where studied, where exhibited, if and where represented by a gallery, who has collected his or her work in the past, in what publications the artist has been reviewed or profiled in the past) and the work (size, medium, price). People who shop online regularly are looking for the lowest prices for items about which they already have information, such as an iPod or a pair of size 10 ½ Nike sneakers. Unless their aim is exclusively bargain-hunting ("Look! I got this oil painting for just $35!"), they are inclined to know whether the artist is a professional or the eight-year-old child of very proud parents.

Because images on a computer screen or that have been downloaded on a printer are not likely to be as sharp as a photograph, the artist may be asked to send a JPEG or photograph to the prospective buyer. If the work in question is a limited edition print, artists may be required to provide the same type of information as art dealers (the size of the edition, who printed the edition, are there other versions of this print in existence), as well as documentation.

Payment can be a tricky issue, and there are a number of methods that may be employed. The first and most popular is through credit cards (the more cards that may be accepted, the better—see chapter 2), although many would-be buyers may require that the Web site is "secure," that is, third parties cannot gain access to the credit card numbers. Internet servers may be able to set up a page with TLS (Transport Layer Security) encryption, or artists may purchase encryption software on their own.

Traditional methods of payment, such as paper checks or cash on delivery (COD), may help buyers feel more secure. It is important for the Web site to list a physical address, rather than just a post office box or e-mail address, so that prospective buyers may feel confident that the artist is legitimate. Other collectors may be willing to provide their credit card numbers, but only through a telephone call or by FAX. (As calls may come in twenty-four hours a day, seven days a week, artists may want to set up a separate telephone line with an answering machine or use a voicemail service.) Offering browsers a range of payment options may alleviate a degree of anxiety.

Orders may also be accepted by third-party companies, which process the orders (forwarding them for fulfillment) and accept payment. The fees for these services range widely. Among the complexities that computer sales have added to the marketplace are digital cash (or e-cash), in which both the artist and the buyer have accounts with a bank that issues it, and e-charges that permit buyers to charge the cost of a purchase to their normal telephone bills.

As the Web is a global market, buyers may come from all over the world with various forms of currency. Credit card payments are the easiest to process, since the credit card companies will convert the currency into dollars at current market rates and with minimal fees for the service. (Individual banks may charge a 10 or 20 percent conversion fee for foreign checks.) Regardless of how individuals are permitted to pay, all prices should be in U.S. dollars; otherwise, fluctuating exchange rates might actually reduce the value of the work.

GETTING PEOPLE TO YOUR SITE

There are vastly differing opinions on how to get found on the Web, of which personally telling potential and past collectors is but one solution. Through networking, one can create a large inventory of names to whom postcards and brochures listing one's Web site may be mailed. However, the world and all the possible art collectors in it will inevitably be larger than one's mailing list, which is one of the benefits of the Internet. Between 75 and 85 percent of all Internet sales comes from browsers, who find Web sites through search engines, and some marketing analysts recommend that artists register with Internet search engines, news groups, and directories. One may be fully registered with most search engines in a matter of days, although Yahoo—the largest of the search engines—can take a month or two because actual people there look at each proposed Web site to insure that the key words are relevant to the site. (With a lot of smut on the Internet, many companies that have nothing whatsoever to do with pornography use sexual language in their keywords in order to attract browsers.)

Properly registering one's site may take as much thought and care as what is found on the Web page. Anyone who has ever done a Web search on one of the larger search engines, such as Google, Yahoo, Lycos, MSN, Ask, Excite, or Bing, finds that it is common for over one million sites to be located using even the most specific keywords. Search engines look for a group of words, and then rank the sites on the number of keywords found. One's Web site needs to rank high in a search, because no one is going to examine everything that a search engine finds. "If you rank below forty in a search, you won't be found," said Lorelei Teamore, president of Ad-Web Marketing in Lewiston, New York.

A Web site is indexed in search engines through what are called meta tags, which consist of a title, a description, and keywords, The keywords are the most important element, consisting of up to 255 characters, including punctuation. Teamore recommended that one test different keywords for different search engines in order to determine which ones bring the greatest browser response. Certainly, the more unusual the object one is selling, the more likely that distinct keywords can be found that will match a potential buyer who is looking for that very thing. Artists are less likely to be found by browsers who just want a painting to hang over the sofa, as artists usually don't describe their work in that way.

TRACKING THE NUMBER OF BROWSERS

A "hitometer," a service that generally costs $5 per month to use, will tally up how many visits there were to one's Web site, where they came from and when in the day they came. Other available services will check that one's Web site will display in different browsers and how many other sites are linking to one's own. (Someone else may link his or her Web site to yours unbeknownst to you. "If you have an interesting property," Peter Platz said, "people will want to link up to you," as it may induce browsers to come to their sites.) Artists may also find out how long it takes for their Web pages to load; slow-developing Web sites are often blamed for losing browsers, who lose patience and click off. According to Human Factors International, a company based in Fairfield, Iowa, that studies how humans interact with machines, the rule of thumb is fifteen seconds maximum for downloading sites: five seconds to figure out where you are, another five

seconds to take in the site, and a final five seconds to figure out where you are going in the site. Web sites featuring artwork are always going to be at a disadvantage in this count, because images simply take longer than text to fully materialize, and probably the fifteen-second rule is less applicable to artists' pages since browsers soon learn that the process simply takes longer. However, there is technology to compress images significantly and make them load more quickly.

As there are new sites coming online all the time, a Web site's place in a search engine is likely to fluctuate. The easiest way to determine one's ranking is to type in the keywords for a search and see how far down the list the Web site now is. Online businesses regularly track their Web pages, requiring them regularly to change keywords in order to improve their rank, and there are companies that will perform this service for the owners of Web sites.

LINKING TO AN ONLINE MALL

This constant worry about one's ranking on a search engine may be quite wearing for artists (corporations have Webmasters and marketing directors on staff whose jobs include the maintenance and of the Web site and how easily it is located) and, according to Platz, "you can't really force your place in a Web search anyway." In addition, no individual search engines cover more than 25 percent of the Web, which has grown to more than 11.5 billion pages, according to several studies. In other words, more than half of the Web currently is unseen by the search engines, and it is estimated that search engines will not catch up with the Web for another ten or twenty years. General Internet searches may not be the means by which art collectors discover artists, anyway. Todd Drake, an artist and Web designer for artists, prefers linking up Web pages to popular gallery (known as "directory" or "mall") sites, such as ArtistsOnline, ArtistsRegister, and others focusing on artwork.

"You can spend every waking minute trying to find the right keywords, but you're still likely to be only one of a million Web sites to search engines," he said. "But, in a good site, you get people coming directly to you." These gallery sites advertise themselves in publications that art collectors read, which may lessen the need for individual artists with Web pages there to make their own separate promotional efforts, and they direct browsers to specific artists or types of artwork. The database at a mall site allows browsers to select by category of medium, artist, and price.

There are costs associated with linking to a gallery site, such as annual fees for membership, one-time setup fees for a one-page portfolio, charges for changes in images or text, and they may range widely. ArtistsRegister.com, which is operated by the Denver, Colorado-based nonprofit Western States Arts Federation, has three levels of membership fees for artists— $30 (offering one image on one page that lists contact information and a link to one's own Web site), $75 (for a six-image portfolio that includes an artist biography, statement, C.V., and Web site link), and $100 (for a twelve-image portfolio)—although there are additional charges for changes. Artists would presumably want to freshen up their Web sites and links to them with changes in images and text.

These mall sites may or may not be actively promoted, either by direct mailings or advertising or with updated meta tags. A spokesman for World Wide Arts Resources (located in Granville, Ohio) claimed that the site receives 100,000 visitors per month, but there are no figures for the number of sales actually made on- or offline from the artists and galleries that have Web pages attached. ArtistsRegister also only has anecdotal information about works sold, commissions, and artists taken on by dealers or hired to lecture, teach, or give demonstrations. They only count the number of overall hits, not the quality or the result of browsing, and they do not actively survey their artists. The gallery sites remain in business because artists pay them for services and the rental of cyberspace. Success in making sales of art or contacts through these sites might need to be researched by e-mailing queries to some of the member artists.

There are many mall and directory sites on the Internet, which look to develop collections of Web sites attracting and retaining a large number of users, often referred to in e-commerce as "stickiness." The most successful of these directories try to combine in one site all of the services and resources that a likely browser would want. Success for a directory site is measured by the amount of time a user stays connected to the site, as the longer the user remains the greater the likelihood that he or she will come a customer for one or more of the businesses on the site. Before paying any money to a directory, artists should inquire as to the length of time that browsers stay there (on the average), how many visitors come on a weekly or monthly basis (and how is this information determined), how much turnover there is among artists on the site, and what types of advertising the company producing the gallery does and will continue to do. Finally, an artist considering an online gallery should visit the site regularly over a period of time in order to see how it looks, how easy or difficult it is to navigate, whether (and what kinds of) changes take place from one month to the next, and what quality of art is represented on the site.

"The problem with gallery sites is that there is too much for anyone to see," said Chris Maher, an artists' Web site developer. "No one has time to look at everyone's site." He recommended that artists market their work in traditional ways, using their Web site in the manner of a portfolio, "to refresh the memory of people who have heard about you through word of mouth or who have already seen your work and want to see a larger representation of your art. When real collectors come to an artist's Web site, they already know a fair amount about the artist, and the issue is not [whether] to buy but what to pick."

Buyers of artwork by artists they have never heard of before, he noted, are apt to purchase inexpensive pieces, such as a $25 lithograph of a wildlife animal that interests them. "It's stuff in the impulse range." It is through more personal associations that collectors become willing to purchase more costly artworks.

Maher praised the World Wide Web as an "extremely cost-effective way to show work, less expensive by far than putting on a gallery show or participating in an arts fair. However, simply marketing online is short-sighted and to not market your work traditionally is foolhardy."

Stickiness also means keeping visitors at one's site for an extended period of time—the greater the length of time, the more of an intellectual and emotional investment has been made in the artist's career and work. The main reason that visitors come to a Web site is for content, and that is also the reason why they stay. Artists should create content for their Web pages, such as articles (about the artist or reviews of the artist's work), biographical information, or a description of the artistic technique and a list of related links to other Internet sites.

There should be some mechanism by which visitors may contact the artist so that the artist can find out what browsers like (or don't like) and what they would like to see more of. Part of the job of generating the interest of visitors is listening to them and giving them what they want. Additionally, chat rooms and forums, as well as newsletters, allow visitors to feel part of a community, which strengthens their commitment to a particular artist.

No way of operating on the Web comes without risks. Take advertising, for instance: Internet advertising generally consists of banners across the top, bottom, or sides of another Web site that, when clicked, will lead browsers directly to one's own Web page. However, banners are expensive and are not likely to attract a serious buyer. The most customary way to advertise on the Web is by linking one's Web page with someone else's (presumably a site that is similar to one's own), which is often free, based on a mutual agreement; the visitors to another Web site will be able with a simple click to move to yours. However, the reverse is also true, since browsers to your Web page will gain access to someone else's—and they may never return. Their failure to come back may not be a reflection on the linked site having better art on display; one may have to click again and again to see things and, by the time a browser has done so, there may be too many back clicks to bother with (or the browser may have forgotten where he or she started).

SOME GENERAL RULES OF THE INTERNET
When an artist's work does not attract buyers from a Web site, does that mean that the artist is doing something wrong or that fine art is unlikely to sell in this way? Half of the homes in the United States are already connected to the Internet, and the rest of the world is moving slowly to catch up. Perhaps, in time, art will be regularly sold online, and the answer to this question will be more apparent. Until then, there are some general rules about developing a Web site that are applicable to artists.

- One's URL or "domain name"—*www.danielgrant.com*, for example—should be relatively short and easily remembered without having to be written down. Overly long routes to one's site (*www.server/artsorganization/art/writing/danielgrant/help*) create opportunities for typing errors and give prospective buyers incentive to look for something easier.
- Make sure that finding one's way through the Web site is clear and logical, putting the most important information first (first, what you are selling; second, who is the artist). Avoid tiny buttons, computer concepts unknown to users, and art-world jargon (speak like your users). Avoid clutter by creating groups

by color, proximity, shape, or alignment. Consider adopting a theme to aid users' understanding. Ask friends or acquaintances to inspect one's Web site in order to check how clear it is to navigate.

- Keep text brief and succinct. People's reading habits are very different on the Internet, according to studies conducted by Human Factors International, as almost 80 percent of Web users only scan text rather than read word for word. To increase usability, one might consider using bullets, tables, headings, bold type, graphics, and columns of text that minimize horizontal scanning.

- As one's Web site may be visited by people all over the globe, culturally insensitive idioms and stereotypes, as well as images of body parts, should be avoided.

- Avoid distractions, such as banner advertising (some other vendor's logo or promotional copy at the top of one's page or running down the sides), constant animation, or music (many Internet users already have a radio or TV on). If animation is used, it should stop after the page is fully loaded. In a physical art gallery, piped-in music helps to set people at ease or to set a mood; on a Web site, music tends to come across as a gimmick. If music is played, an on-off button should be offered to users.

- Art brings out a lack of confidence in many people, who fear that they will be making a mistake if they buy something. The Web site should answer as many of the questions as a visitor to an art gallery might ask: What is the size of the work? What is the artist's background and who has collected his or her work in the past? How soon could it be delivered? May one pay with a credit card? Does the artist guarantee to take the work back if the textures or colors aren't exactly as seen or described? It is frequently the case that colors vary from screen to screen and, knowing that, artists should reassure potential buyers that they will honor their money-back guarantees.

- Include a sign-in area on the Web page, asking visitors for their comments (Do they like the work? Which works in particular? What other types of work would they like to see? Would they like to receive a newsletter?), and save those e-mail addresses for future electronic mailings about new work, new exhibitions, or other correspondence.

- Change the content of the site regularly, which encourages visitors to return. In addition, some search engines will drop sites if the content does not change periodically.

- The domain name should be registered with InterNIC (*www.internic.net*), which costs $100 for two years. In addition, the domain name should belong to the artist rather than to any server since, if the site is moved to another server, the artist will be able to take along the name.

- Similar to the portfolios or slide sheets that artists present to a prospective dealer, all of the works shown on a Web site should be consistent in terms of style and medium. Unlike the presentation to a dealer, there is no fixed number of images

that should appear; there can be just a few images or dozens. "You don't want to overwhelm someone with one hundred works, but you can certainly have more than twenty," said artists' advisor Susan Schear. "What's most important is that the art makes a cohesive statement and isn't all over the board. You don't want someone to say, 'What's this doing here?'"

The jury is still out on the effectiveness of selling through the Internet for artists. However, a growing number of artists have created their own Web sites and, eventually, the benefits (or belief in the benefits) of having an online presence may be a given. Since Web sites can be expensive and time-consuming, artists should self-evaluate (Do I need one? Why do I need one? What do I expect will happen from it? How will collectors learn about it? Who will design the site? What existing sites are attractive and user-friendly?) before jumping on the bandwagon. Some artists (a small percentage) have reported making contacts with collectors and dealers, resulting in sales; others' experiences point not so much to actual sales but to useful connections with artists elsewhere who are exploring the Web and came upon their home page; yet others claim that their site has generated neither sales nor communication. Obviously, as all art is not equal, there are a variety of factors involved in why one artist may achieve success while another does not.

ONLINE SALES

As an alternative art market, the online realm has proven to be a work in progress. Artists and their work are accessible on their own Web sites or by links from the galleries that show their art, the membership organizations to which they belong, and the juried shows to which they have been accepted. Artists' pages show up on social networking sites, such as Myspace, Facebook and LinkedIn; sometimes, artists (and collectors) offer artwork for sale on eBay and Craigslist, or through one of the myriad mall sites (*www.art-exchange.com*, *www.starvingartistgallery.com*, and *www.originalartonline.com*, among others). Blogs and YouTube may also carry artists' words and pictures. Opportunities for exposure, promotion, and sales abound, but it is still the rare artist who can point to the Web as the source of the bulk of his or her earnings.

Maybe not as rare as all that. Marcia Baldwin, a painter in Shreveport, Louisiana, has been earning a living from selling equine and floral paintings on eBay since 2003, grossing a high of $157,000 in 2005. "The key to selling on eBay is to keep producing," she said, noting that she paints "one or two pictures a day, seven days a week." In the course of a year, she sells as many as five hundred paintings, with prices averaging between $289 and $500. Selling on eBay is not free, and the expenses add up to approximately 40 percent of the gross, perhaps the same as the amount an art gallery would take. (Her net earnings in 2005 were $98,000.) These include a 17 percent eBay commission on all sales, and the online auctioneer charges Baldwin $32 per artwork to list her paintings on the first page of a search (a typical eBay search under the category of "paintings" produces over one hundred pages with more than 10,000 offerings); PayPal, the online secure payment system for credit card purchases, takes another three to four percent of the sale price; there is also the cost of shipping the paintings to buyers

(custom boxes, packaging materials, FedEx Home Delivery, and insurance), which averages $30 apiece. The bookkeeping challenge of working this regularly through eBay is not for the faint of heart.

Producing a lot and keeping the prices relatively low for an audience that is bargain-hunting is essential for artists using eBay. "You learn not to mess around," said Diane Millsap, a painter in Prophetstown, Illinois, who produces four New Orleans-themed paintings a week and generally sells between eight and twelve per month, averaging $400–500 per picture. "You just do the work, without hemming and hawing, just finishing it and moving on." The payback is more than just money, she noted, as even bargain-hunters may appreciate art ("people who buy art are people with money and education") and purchase more than one piece by her, then recommend her work to others, who then become customers. Print publishers also have perused her offerings on eBay, "which has led to print licensing agreements."

On occasion, an art gallery owner has contacted her about creating an exhibition, usually stipulating in an agreement that "for the period of time of the exhibition, I won't promote my work on eBay." Dealers generally don't want to compete for buyers with the artists they are showing, and they may be reluctant to sign on with artists who are associated with low prices. For both Baldwin and Millsap, however, their presence on eBay has produced income and been a source of marketing, as buyers (and prospective buyers) have visited their respective Web sites to see more of their artwork and learn more about them.

The Web represents a technical and strategic challenge to artists (and others), but it also presents opportunities for direct Web site sales to a far wider audience, forgoing the percentage-charging middlemen in the brick-and-mortar or online galleries. In the early days of the Internet, the question was whether or not anyone would buy art in this way; more recently, the issue has been not if but how to identify and attract likely buyers, as well as up to what price point will collectors purchase artwork they haven't actually seen in person. Marketing is perhaps the greatest opportunity that the Web offers. A Web site itself expands the artist's potential reach to all corners of the planet, wherever there are computers and people interested in acquiring artwork, but availability doesn't necessarily lead to sales. The largest questions remain how an artist's site is found among the billions of others in the online realm and whether or not buyers will spend higher amounts of money for artworks they haven't seen in person and by someone they had not heard of before.

One of the industries that has come into existence as a result of the Web is Web development, which created a realm of expertise called search engine optimization—how to be found by someone looking for something online through one of the search engines. A search on, say, Google for a very general category ("landscape painting") is apt to produce over a million potentially relevant Web sites, displayed ten per page; Web marketers note that it is rare for anyone conducting a search to look past the fourth page, which means that the overwhelming majority of sites won't be visited. They point to the use of unique and specific "keywords"—the terms that someone making a search would type in—and the quantity and quality of "links" (a referencing tool allowing a browser to jump from one Web site to another) as essential in elevating a particular site's standing from back in the

pack to the first few pages. There are ways to shortcut the process: companies may buy advertisements on search engines (the ads appear in the top or on the side of the page where the search begins whenever certain keywords are used), and some purchase keywords so that their Web site appears at the top of the list. The cost varies, depending upon the popularity of the words (the more one is willing to pay in a bidding process, the higher up in a search the site will appear), whether they pay by the word on a daily or weekly basis or every time someone clicks on the site.

"Ads and buying keywords are a game for people with marketing budgets, because it can get expensive," said Chris Maher. "It's better to just come up with good keywords." When a Web site is created, certain reference terms (or keywords) are written into the site's HTML code and identify the content of the site. "The more specific, the better," he noted, adding that landscape painters might want to include the name of their studios, the towns they live in, the particular subjects of their paintings, and other unique qualities of their work that might help browsers find their Web sites more quickly and easily.

The algorithms of search engines also tend to give precedence to Web pages that are linked to other, high-traffic sites with similar content—popularity begets more popularity. "Incoming links, other Web sites that link to yours, indicates that other people think your Web site has value, and that makes a site more interesting to Google," said Larry Berman, a Web site developer for artists and craftspeople in Russellton, Pennsylvania.

One artist who has put this into practice is Linda Paul, an artist in Lafayette, Colorado, who has been earning a living exclusively from Web site sales of her giclée prints and painted tiles since 2000, earning over $200,000 in 2007. "I haven't spent a cent on search engine optimization," she said, but she has promoted links from other Web sites to her own. "I've got 2,000 sites pointing to me right now." Among her techniques are reciprocal links with other artists ("there are about five hundred right now, and each was done one at a time"), writing "blogs and articles on other sites and letting people post comments on my site," and promoting her work to print media that have their own Web sites. "I look for anything I feel my art is connected to," she said, noting as an example *Chile Pepper* magazine. "I've done images of chile peppers and sent them images of my work and information about me. They ended up writing about me, and their Web site [linked] to mine."

"I often get sales through my Web site," said Nashville, Indiana, painter Charlene Marsh. However, most of those who purchase her artwork online have met her personally at one of the fifteen to twenty arts fairs in which she rents a booth annually. There, she hands out brochures and business cards to buyers and visitors. She also collects their names and addresses for pre-Christmas mailings that again direct readers to the Web site. On one occasion, the reverse took place ("A woman found my Web site and ended up coming to one of my shows"), but Marsh has focused on generating interest in her Web site as an extension of herself and her art rather than promoting her artwork by way of the Web site.

Making connections and having a wide network—developing links—may create exposure but doesn't lead necessarily to sales. Rebecca Lathan, a wildlife artist in Hastings, Minnesota, has pages on both Myspace and Facebook that have expanded the number of fellow artists with whom she communicates ("They tell me about other artists' shows; they

tell me if they like my work, and they tell other people, too") but not so much her sales. That is probably to be expected, since the principal users of social networking sites are people in their teens or twenties who are not in a position to buy original works of art. Perhaps the time spent on these sites may be seen as an investment in the future. "I'm not finding buyers through Myspace directly," said Martin Creed, a British artist and 2001 Turner Prize winner whose installations reach $250,000 at his gallery, "but maybe indirectly. I want people to see my work. Teenagers are also people." A growing number of art galleries have created pages on Myspace as well, perhaps also signifying hope in the future.

The organizations to which artists belong frequently allow browsers on their Web sites to link to members' own sites, but Las Cruces, New Mexico, panter Robert Highsmith is "not sure if my link from the American Watercolor Society has ever helped me." Similarly, painter Morten Solberg of Spring Hill, Florida, who is a member of several groups (including American Watercolor Society, Artists for Conservation, Society of Animal Artists, and Wildlife Artists of America, all of which link from their sites to his), said, "I'm not quite sure if any of these links have led to sales, but I'm always linking to different sites for that purpose." The two artists know from Web tracking software that their sites are visited with some frequency, much of which they both attribute to the galleries where most of their artwork is sold; their dealers are likely to inform prospective buyers where they can obtain more information and see more images. Still, some of the Web traffic comes via the membership organizations, often coinciding with the annual exhibitions these groups stage. Every little thing helps. "I also have my Web site listed on my business card, which I hand out," Highsmith said, "and when I advertise in a magazine, my Web site is included."

ARTISTS' BLOGS

One might think that an artist trying to grow his or her market would not want to say things that could offend potential collectors and gallery owners, right? Doesn't that make sense? Have I said something we can all agree on? Nancy Baker, a painter in Raleigh, North Carolina, who writes a blog called Militant Art Bitch under the pseudonym Rebel Belle, thinks such worries are completely irrelevant. "Do I care? No, I don't care," she said, "I am opinionated, and I have a foul mouth, but people seem to like my candor." Those people principally are other artists, women artists for the most part, who seem to agree with Baker's feminist critique of the gallery and museum world and post their own affirmative responses as comments on her blog.

Posting images of her work, which both recall and comment upon early Renaissance painting of figures in the landscape, along with her opinions, Baker described as part of one blog her approach to gardening:

> Many times I have gone outside in my nightgown with coffee in one hand and
> a rake in the other. I could give a shit that Monet was equally as horticulturally
> driven, because I don't paint waterlilies. Alright, I did recently paint ONE, okay?
> I have no desire whatsoever to go to Giverny, or Arles, or any of those prissy
> dumbass precious places.

When asked if her description of Giverny and Arles as "prissy dumbass precious places" might offend people who like Monet and van Gogh, she said, "people who like Monet aren't going to like my work."

For those new to this realm, a blog is an online diary of sorts, containing usually brief thoughts and opinions, with new comments added every week or every day and sometimes more than once a day. Responses from readers are solicited, creating a dialogue or, when numerous people write, a round table. In contrast to the more static Web sites, which are updated every so often (monthly, perhaps, or less frequently), blogs have become the most interactive area of the online world. "Blogs are basically a free Web site, while a regular Web site can cost you hundreds of dollars that you have to pay a Web designer," says New York City art dealer Edward Winkleman, whose gallery Web site has a link to Nancy Baker's, "and I encourage all the artists I represent to start a blog. It gives you an immediate presence in the art world." Blogs also are the most informal and democratic area, in which there is no premium on the niceties of language, spelling, and grammar, and all opinions have a basic equality. "The only thing that right-wing bloggers and left-wing bloggers agree on," he added, is that "the world of blogging remains uncensored."

"It's refreshing when people let down their guard and are actually honest with each other," says New York magazine art critic Jerry Saltz. That type of honesty is "a way of showing each other respect." Perhaps this kind of honesty is easier to create when people aren't face-to-face, worrying about making a good impression or moderating one's opinions and language based on someone else's reaction to the views offered. Blog readers may be essentially self-selected, finding a particular Web site or blog through links from another Web site or blog that interests them. As a result, visitors to a Militant Art Bitch blog are likely already to hold feminist views and are looking to build a community of the like-minded. Blog writers and readers look to each other for information and confirmation. The use of saltier language and statements of their politics may have little to do with their art but loom large in their sense of who they are. For his part, Saltz says that he rarely if ever reads artists blogs, concentrating instead on blogs written by other art critics like himself. The subject matter covered and the style of writing and language used appeal to a specific audience, says Saltz. "They're tom-toms, smoke signals, secret handshakes," he adds, "all conversation is basically asking, 'Are we on the same page? What do we agree on? What do we share?'"

Of course, that's just his assumption, and similarly that of Nancy Baker. Someone may guess that his or her audience is, say, all feminist artists or all art critics if those are the people who post comments on the blog. There may be many others—artists, critics, collectors, curators, and people with no connection to or interest in the arts—who have read the blog, aren't on the same page, and don't agree, but don't post their comments to that effect. Voicing a disagreement opens someone up to criticism, perhaps stated hostilely, and reveals perhaps a name and certainly an e-mail address. A medium intended to encourage discussion may actually discourage it if the blog takes a street talk tone.

It is difficult to know in the vast, seemingly anonymous universe of the World Wide Web what the rules of conduct are, or if any restriction on freedom (to curse, to

criticize angrily, to talk frankly about intimate matters, to be heedless of other people's reactions) is just a quaint and irrelevant notion, like the prohibition on gossiping or discussing politics and religion in social settings. It's a new world: the La Boheme idea of artists is that they are free and uninhibited, but are collectors willing to buy artwork from artists whose exhibitionism violates their ideas of propriety?

Now, that's a bit of a leap: does anyone know if collectors read an artist's blog, even if it is primarily written for other artists? Some artists expect and want current and potential collectors to visit their Web sites and read their blogs. "I used to hold open studios and do art fairs, where I would always talk to collectors," says San Francisco artist Anna L. Conti, "but now I leave paintings with my gallery, and the people who buy my work never meet me anymore." She adds that she "started the blog as a way for people to check in and find out about me." Conti's blog is very much focused on the day-to-day life of herself as artist, offering one day a detail of a painting that will be on display at an upcoming gallery exhibit, another day the type of framing she used in one instance, and on yet another occasion, an installation view of the show. As an example:

> I mounted the paintings inside a flat wooden case which I picked up one day when I was walking past one of those urban nomads who was cleaning out his van. After a bit of cleaning, some paint, and some new hardware, it was just what I wanted.

Another painter, Elizabeth Torak of Pawlet, Vermont, also directs her blog toward collectors "who are already familiar with my work and want to find out more about me." She notes that "people say to me, 'I wish I could have stood by and watched you go through the entire process of doing a painting,'" and so her blog reveals in words and images the step-by-step process of creating a new work, from preliminary drawings to roughing out the shapes on a canvas and eventually culminating in a completed picture. The following is an in-progress posting:

> I spent my first hour of work today putting in the arm of the woman tasting the soup—not the one you can see but the one hidden in the shadows. Even though you hardly see that arm, I think it is very important to the painting. For one thing, it expresses the unconscious mind of the woman tasting the soup. It is the part of her body she is not aware of: she is thinking about the soup and her interaction with the salter but the level of tension in that hidden arm and hand and its subtle gesture can either reinforce or contradict what she is saying with the attitude of the head which adds alot [sic] to the lifelike quality of the figure. Not that I achieved all that today. In fact, what I mostly did was struggle with the foreshortening and the incredibly close and subtle values—and then I wiped out most of it anyway.
>
> It was a very exciting day, though. After I gave up (for the moment) on the struggle with the hand I started working on the carrots (yes, that's what they are) and the figure on the right. A characteristic thing happened. As I worked on the front of the painting the depth from front to back began to open up. I saw a big, conical volume

with a circle uniting the salter's hand and the carrots as its base and the little negative space under the taster's raised arm as the apex. A moving volume, a vortex of energy, it brought a big compositional rhythm into the depths of the painting. I got so excited I couldn't paint and took a break; by the time I came back the vision had cooled and I couldn't get it down the way I wanted to. I still see it though and I think I'll be able to develop the idea as I continue this study. Meanwhile the other big rhythms are beginning to come in. I always put the most recent state of this study on my computer desktop and I keep seeing new possibilities emerging.

In one instance, a couple that had previously purchased several paintings by Torak were interested in acquiring another but didn't see anything they wanted at her gallery. However, the gallery's director recommended that they look at her blog where, over the course of six weeks, they saw the progress of a new painting to its completion, and ended up buying it. Six months later, Torak met these collectors at the opening of her show, "and they told me how much fun they had had following the progress of the painting on the blog. I had been completely unaware that they were doing this and was surprised and pleased, and also relieved that I had kept my language on the blog upbeat and temperate."

Unlike many others who maintain blogs, Torak's postings are more sporadic, sometimes allowing intervals of months between postings, largely because she is using her time to paint. Blogging offers her benefits and drawbacks. On the plus side, writing about her work helps "clarify my ideas. Every time I wrote about my work, I'm amazed how thoughts come together, and that's a very satisfying experience." The negative is feeling "a pressure to continually post messages. I mean, there are only so many hours a day I can sit in front of a computer." Because blogging is an interactive endeavor, communicating with people who start expecting to see a new message every day or so, taking a hiatus from the online realm can lead to questions. "People say to me, 'Elizabeth, are you alright? I haven't seen any new blogs up for a while.'"

Putting up new messages on a regular basis is important for another reason as well. Part of the algorithm that the search engine Google uses to rank Web and blog sites in importance is the frequency of new postings. Artists (or anyone with a blog) who allow long periods of time to elapse between new messages may become more difficult to find in a search. Certainly, that isn't the only way in which sites are ranked in a search—messages that contain and repeatedly employ the words that someone using a search engine would use (such as "California coastline" or "plein-air"), as well as the number of links to and from the blog will make a site easier to find, but frequency does make a difference. Still, it may become quite burdensome and a source of dread to have to think up something fresh and interesting to write every day, which may explain the number of postings that simply track the local weather or the doings of the household pets. "That's what people in this field call 'blah-blah blogs,'" says Lorelle VanFossen, a search engine optimization consultant in Gaston, Oregon, who periodically teaches classes for artists in how to use the Web for personal and professional advancement. "The more focused your content, the more seriously readers will take you."

The "blogosphere" (as it is called) is large, with some people maintaining more than one blog to contain their thoughts, for instance, one blog dedicated solely to art and another to their pets or diets or politics. There are numerous blogs written by artists that have little or nothing to do with their own work but instead discuss art exhibitions they have attended, art books they have read, or just other art blogs. Marketing their own work and courting collectors would seem to be far from their thoughts, although some collectors may start reading these blogs anyway as part of their efforts to learn about the artists whose work interests them. Coarse language or flippant remarks may turn them off—a growing number of companies have come into existence within the past few years to remove intemperate statements from blogs and social networking Web sites such as MySpace, Facebook, or LinkedIn—or, VanFossen speculated, "they may afford artists a certain latitude because, well, they're artists."

WHERE SALES MAY BE MOST PLENTIFUL

"Ninety percent of my sales are on the Internet," said Jane Haslem, owner of a shop in Washington, D.C., which has its own Web site. "I used to have my shop open all the time, but now I'm open only by appointment because so much of my business is through the Web." Haslem noted that most of her online buyers know the kind of work she represents. "It is rare that someone I don't know calls me and says, 'I saw an image on your home page, and I want to buy it,'" she said. "In most cases, someone who has been a customer in the past calls and says, 'I am looking at an image on your home page. Please tell me more about it.' I will talk to that person and send a brochure. There will probably be more conversations and eventually, perhaps, a sale." The Web site does not replace the traditional brochure in her business, she added, but supplements it. "In a brochure, you can only show five or so images. On a Web site, I can do a complete retrospective, plus include everything else in my gallery's inventory."

More and more galleries are developing a Web presence, enabling buyers from around the globe to quickly see available work by artists in which they are interested, and dealers regularly send out e-mail announcements to collectors and curators and the press of exhibitions with JPEG attachments of the art that will be on display. (They also send out the more expensive full-color brochures or postcards for exhibitions, but gallery owners don't need to produce as many as in the past. Reducing publishing and mailing costs has helped some survive, although the cost of setting up and updating their Web sites may be considerable.) For the work of much sought-after artists in these galleries, some buyers will look to make purchases sight unseen (that is, only having seen the online picture of the artwork); more often, the images and information are a starting point for a conversation between the collector and gallery owner about a purchase that will eventually take place electronically, over the telephone, or in person. Otherwise, the Web sites primarily serve galleries just as they do artists: as marketing and sales tools that offer information to the curious.

6

When Does Investing in One's Career Become a Ripoff?

In the beginning (of the art world), there were just artists and patrons. Then along came art dealers, critics, museum officials, arts administrators, art advisors (to patrons), and artists' advisors (to artists) as well as business managers, and artists' representatives, all of them making a living off that primary artist-patron relationship.

There are many go-betweens and various services that have become available to artists, some quite expensive, which may or may not help advance a career.

BUSINESS MANAGERS

To prosper as an artist, career counselors to visual artists continually advise, one has to devote as much serious attention to the business aspects of art as to its creation. There is the matter of contacting prospective customers and art galleries; working out consignment agreements with dealers; photographing, crating, shipping, and keeping track of where every artwork is; preparing and mailing out promotional material; taking telephone calls; writing and answering letters; keeping a budget; overseeing accounts payable and receivable; determining business expenses for tax purposes; and all the other this-and-thats.

To some people, the business part of art may take precedence over anything else. "I always tell artists that they should research the market and have a marketing plan in place before they create for the market," Sue Viders, an artist's advisor, said. "There is no use creating something for which there is no market."

That may be a somewhat extreme approach for many artists, but all that business-of-art stuff still has to be taken care of. And what if you are not just very good at the business stuff or, like Corpus Christi, Texas, wildlife sculptor Kent Ullberg, you "dislike the business part of being an artist with a purple passion. If I have to haggle over a price or stew over a business letter, it can ruin my creativity for the entire day"?

Then you might want to consider hiring a business manager. Ullberg hired Robert Pitzer, who works full-time in the artist's studio with a range of administrative and

selling duties. "I keep track of inventory, the accounting, prepare advertising budgets," Pitzer stated. "I've created new markets, increased market shares with galleries already exhibiting Kent's work and increased galleries' production of sales."

Pitzer, who used to own an art gallery that sold Ullberg's work before going to work for the artist, earns a base salary plus commissions on sales (between 3 and 15 percent, depending on whether he personally arranged the sale or it took place in a gallery) plus "incentives" (another 5 to 10 percent after certain projected sales figures have been reached).

Daniel Anthony, business manager for Santa Fe, New Mexico, sculptor Glenna Goodacre, also works in-house (with roughly the same pay arrangement) assisting the artist with a variety of tasks, from selling to answering the telephone. "When I started here in 1987, Glenna didn't even have a secretary," Anthony, who used to manage a bronze foundry, said. "She sculpted with a phone cradle so that she could work with both hands when answering a call. Now, she doesn't have to talk to dealers, collectors, the foundry, reporters, [or] suppliers. She has more than doubled her output."

Increasing output for selling artists is vital, if only to earn the additional money required to pay such intermediaries as secretaries and business managers (as well as the costs of their health insurance, Social Security, and other taxes and benefits). "What I gained is time and money," Goodacre said. "Time is money. The amount of time I've gained from not having to deal personally with the foundries about every little thing is enormous right there." She added that "I can't chart exactly that I earn so much more to cover the added expenses, but I feel it."

Not all business managers are full-time employees—in fact, most are not. Friends and spouses frequently handle selling and administrative work for artists and, for many of the artists who earn enough money from their art—usually in excess of $100,000 annually—to afford to hire others, dealers or art galleries assume many of those tasks.

Some artists rely on their dealers to handle the day-to-day. Sculptor George Segal relied on his dealers, Sidney Janis and his son Carroll, to take "care of all the contract negotiations for me when, for instance, a work is loaned to a museum for an exhibition," the artist said. The dealers also arranged "to buy my materials and answer correspondence." Artist Robert Rauschenberg relied on the Knoedler Gallery in New York City to "handle publicity and marketing, respond to correspondence, and work on other business matters," according to Knoedler director Anne Friedman, but he also had an accountant, a lawyer, and an in-house, full-time curator, David White, who continues to do some business manager-type activities. "I do a lot of talking with museums and galleries on the phone or in person—a lot of office stuff."

A common complaint of artists, however, is that their dealers don't do very much for them—administratively, financially, or in terms of sales—and some of them have chosen to get additional help. Perhaps sculptor Donald Judd held the record for assistants by a contemporary artist with twenty-two, all of them are involved in a variety of activities, including overseeing contracts and financial matters with galleries, checking inventory, sales, and payment, acting as liaison between the artist and his galleries,

procuring materials, and answering mail and telephone calls, as well as running personal errands.

According to one of those assistants, Jeff, the purpose of all these helpers was not so much to free Judd's time to pursue his art as to see to the details of the numerous projects on which the artist was working. "The more people he has working for him, the more time he has to spend directing each of them on what to do," he said.

Business managers can mean and be many different things to artists. Some managers take part in the selling end and may be thought of as an artist's representative. At times, accountants, dealers, and lawyers for artists may take on some administrative or business functions for their clients. New York City accountant Rubin Gorewitz noted that the role he has had with Robert Rauschenberg, Jasper Johns, Martha Graham, and other artists grew from strictly accounting to financial and business manager.

"I've negotiated contracts with dealers and museums, paid their personal bills, worked out lease agreements with landlords, protected their copyright, handled taxes, and set up corporations and foundations, which give them a big income tax savings. I've negotiated a home purchase for some artists using their art as barter," Gorewitz said. "Artists are fair prey for many people, and they can be taken advantage of unless someone makes sure their interests are being protected." Gorewitz completely avoids the selling end of working as a business manager for an artist, as it is there that friction most often develops between artists and their managers.

There is considerable fluidity in the jobs that various assistants perform for artists. At times, business manager is another term for artist representative, whose duties include arranging exhibitions and fielding sales opportunities, and other times it just means answering the phone. "I've done business managing for artists, and I hated it," Nina Pratt, who has consulted to artists and art galleries on how to increase sales, said. "You work pretty hard to get an artist into a gallery and soon, the gallery and the artist are talking with each other and you get cut out. Dealers—and I understand this—don't want to share their commission with a third person." Karen Amiel, now an art dealer in New York City who worked as business manager/artist's representative for a half-dozen artists during the 1980s, noted bitterly that all of her artists dropped her as soon as they became established in galleries. "I ended up listening to a lot of complaints and neurosis for very little reward," she said.

Not only dealers occasionally find themselves at odds with an artist's manager. James Clark, former director of the New York City–based Public Art Fund, said that he much prefers to work with the artist than with the artist's business manager. "I prefer to know what the artist thinks, not what the manager thinks," he said. "I prefer to negotiate with the artist directly and avoid the manager completely, because that person may misrepresent what we're doing to the artist. I was talking with one manager on the phone the other day who got me so angry by almost willfully misunderstanding what I was saying that I almost said, 'I think we should hang up now. We're not going to get anywhere like this.'"

Another style of business management is found with Susanna Singer, who has been shared by three artists: Sol Lewitt, Robert Mangold, and Adrian Piper. Paid a

salary split by all three, the only things she doesn't do for these artists is create their work and become involved in selling it. Among her tasks, she indicated, are setting prices; keeping track of inventory; maintaining computer catalogue raisonnés; selecting writers for catalogues, editing, and approving the design of those catalogues; handling all correspondence and telephone inquiries; approving private and public art commissions; serving as an intermediary between the artists and both galleries and museums; crating and shipping their work; insuring that the artists have been paid what they are owed; authenticating their work; having their work photographed; and preparing all promotional material.

"The requirements for this job [are] that I am the artists' number one fan and that I know more about their work than anyone else," she said. "Sol [Lewitt] once said to someone, 'When you're talking with Susanna, you're talking with me. When you're dealing with Susanna, you're dealing with me.'"

A somewhat less all-encompassing (and less expensive) form of this kind of business management might be found in one of the companies that specialize in helping artists. Anne Kohs of the San Francisco-based Anne Kohs & Associates stated that "what I do, no one wants to do—a lot of artistic grunt work," such as tracking where all artwork is; maintaining records on past, present, and future exhibitions; writing on the artist; keeping up-to-date résumés and slides of artwork (and labeling them); and taking correspondence. For this service, she is paid a monthly retainer of between $100 and $500, depending on the artist and the kind of artwork that is created.

For artists who can afford a payroll or a bit of extra help, a business manager may make their creative time more productive and enjoyable. Managers don't ease all business worries for artists, though. Kent Ullberg noted that the only drawback to the arrangement he has with Robert Pitzer is "feeling a little extra pressure because I'm responsible not only for myself and my own family but for someone else's family. I can't just decide to sleep in some days or decide to take a sabbatical, taking off for Africa for two years. I know that I have to keep producing to keep him busy, especially because he works largely on a commission basis."

ARTISTS' REPRESENTATIVES

Among the most nebulous of the art world's middlemen are the artists' representatives. Unlike art dealers, they generally have neither gallery space nor inventory of art, and instead send photographs (or slides) of their artists' work through the mail or deliver individual pieces to potential buyers. Unlike art advisors, who are often hired by corporations to build a collection, they represent certain artists rather than potential collectors. Also unlike artists' advisors, who are hired at an hourly rate by artists to help focus their careers (creating a press kit, résumé, or portfolio, as well as examining potential markets and career goals), they are more involved in selling than in packaging.

Artists' reps act as agents for commercial and fine artists, soliciting buyers or consigners and taking a 25 to 30 percent cut of whatever sells. They are more of a presence in the realm of commercial illustration, where reps use their contacts among art

directors of magazines, book publishers, corporations, and advertising agencies to drum up business, but some reps work in the area of fine arts.

Artist reps can be anyone and frequently are friends or family members who believe in the artists and want to move their careers along. Having helped a brother or friend, these people then offer their services to others. They may have fewer professional art world contacts to draw upon but make up for it with extra ardor.

Artists' reps don't so much supplant art dealers as help find more markets and individual buyers for their clients' work. They often advertise their services in art magazines (for fine artists) and commercial directories (for illustrators), but artists frequently hear of them through word of mouth. Reps ask to see examples of an artist's work (tearsheets or promotional brochures for commercial artists; slides, photographs, or CD-ROMs of paintings and sculpture for fine artists) that will be test marketed if the agent feels a relationship is possible.

There are various issues that will have to be negotiated between artist and rep, involving a fixed period contract, varying methods of payment (a percentage or hourly rate), geographical coverage, and a method of sharing costs (advertising brochures or spots in magazines, for example). In addition, the artist's current needs (more commercial work) or career aspirations (getting into a fine arts gallery) will be discussed and planned for. The rep's job is to take care of the details. The rep, rather than the artist, will take the rejections from gallery owners, which may benefit an easily wounded artist but keeps the artist removed from the very people who might provide direct insight and advice. In large measure, however, reps look to generate direct sales rather than place artists in galleries.

There are some reasons for that. Gallery dealers are often unwelcoming and even hostile to agents they see as one more layer between the artist and the buyer, and both the dealer's and rep's percentage on any sale is less when the other is involved. A dealer, for instance, usually takes a commission between 40 and 50 percent for sales, while the rep's commission is closer to 25 or 30 percent. When a gallery consigns an artist's work through a rep, the dealer's take often goes down to between 30 and 35 percent while the rep makes closer to 15 percent.

PUBLICISTS

A growing number of artists have also turned to publicists and public relations firms to assist them in their careers. Again, as with artists' reps, the intention is not to replace dealers as the primary sellers of work; rather, it is to increase the artist's (and the work's) exposure to the public. Publicists may not be for everyone, but they do represent a positive effort by certain artists to take greater control over the business aspects of their lives.

"There are just not enough hours in the day to do everything," said Edward Ruscha, a Los Angeles artist who hired the New York City firm Livet Richard to help promote his work in Europe. "If I had tried to do all the business stuff—the letter writing and contacting people—I would not have been able to create as much art. I'd have to

cut up the pie, as it were, of the facets of being an artist. I also wouldn't have been as successful if I had tried to do it all on my own. The thing about public relations people is that they're so tenacious about it. I couldn't do what they do; I wouldn't want to do it."

The range of services publicists provide is vast, depending on what the particular artists are looking for. Usually with lesser-known artists, the need is to "package" the artists by putting together a comprehensive press kit so that they can present themselves more professionally. In fact, many newspaper art critics and art magazine editors first find out about new artists through receiving a press packet from some public relations company.

That often involves the publicist getting to know the artist and writing a biographical statement that also discusses the art, pulling together published write-ups of the artist's work, preparing black-and-white glossies or color slides of the art, and writing either a press release or cover letter for this press kit that lets the critic, curator, or dealer (or whomever is being targeted) know what the artist is about.

Knowing how to put one's life and artistic ideas into words is an important skill. "Some artists can speak and articulate their ideas very well, but they are definitely in the minority," Susan Hewitt, a freelance publicist, said. "The people you want to be contacting—the dealers, editors, curators—come from an academic background. They are 'word people' who are accustomed to people who are good with language. I try to help artists find the right words for who they are and what they are doing, and that usually goes a long way."

Some publicists also help artists in other, larger aspects of their careers, such as analyzing the strengths and weaknesses of their development, what collections the artist's work is in, who is buying the work, where the work is being shown and who represents the artist.

At other times, publicists can focus attention on something newsworthy happening in an artist's career, such as an exhibition of new work or the completion of a major project. Peter Max, who is best known for his psychedelic posters of the late 1960s, hired Howard J. Rubenstein Associates in New York City to publicize a 1988 exhibition of his paintings that showed a change in style from his customary hard-edge figurative to a more abstract, painterly look. Robert Rauschenberg sought out the international press contacts of Washington, D.C.-based Hill and Knowles for his 1985–1986 "Rauschenberg Overseas Cultural Interchange," which took the artist and his work to various countries.

Another Washington, D.C., firm, Rogers & Cowan, was hired by the Portland, Oregon–based dealer of painter Bart Forbes to inform the press that the artist had been selected to create thirty-one paintings for Seoul's Olympics Museum. The dealer, a publisher of art prints, hoped that the publicity would generate a demand for the artist's prints.

Dealers have traditionally taken care of all of the promotional work relating to their artists but, increasingly, these artists are complaining that their dealers do too little or nothing at all. Possibly, their understanding of the business aspects of the art world has made them impatient with the limited activity of these dealers.

Joseph Kosuth, a conceptual artist who has gallery representation in New York City, noted that his dealer "has a lot of artists to publicize, and it's hard to keep track of everybody, making sure every one of his artists stays in the public eye. Keeping photographs of all my work, letting people know where I'll be shown next, answering questions about me—they just can't do it all."

That realization brought him to Livet Richard in order to "generate good attention to what I'm doing or to projects I've done that have been ignored." He added that "there is a real need to take responsibility for how one's work is presented and made meaningful to the world, and that's what I need a public relations firm to help me do."

The price for this help is not cheap. Publicists and public relations firms charge anywhere from $45 to $150 an hour, and their work can be time-consuming. At Rogers & Cowan, promoting an artist's exhibition, which includes preparing and sending out a press release as well as following it up with telephone calls to critics, radio, and television stations, would run $1,200–2,000. William Amelia, president of Amelia Associates in Baltimore, Maryland, stated that his firm charged the late Herman Maril ("the dean of Baltimore artists," Amelia said) $5,000 a year to publicize his exhibits in Baltimore and around the country.

At these rates, many artists would need to see some demonstrable increase in sales to offset the fees, but that is something that cannot be guaranteed. Neither publicists nor the artists who use them claim that there is any cost-benefit ratio between the amount of money spent on public relations and additional sales that they can identify. For everyone involved, this is a matter of faith.

"We can't say to some artist, 'We're going to get you on the cover of *Time* magazine,'" Amelia said. "All we guarantee is our best effort." Amelia Associates took on the account of one painter, a health-care consultant who was completely unknown to the art world, but was unable to interest a single art dealer or museum curator in exhibiting or purchasing his works. The health care consultant spent $1,400 for that experience of rejection.

Another artist, San Francisco watercolorist Gary Bukovnik, spent over $2,000 over the course of a year with the large public relations firm Ruder and Finn to promote his work but only found himself in debt at the end of the experience.

"I had been working for a museum for a while and got to be familiar with Ruder and Finn through that," he stated. "They did the publicity for the King Tut show. I figured, if they could move King Tut, why couldn't they move a few Gary Bukovnik watercolors?"

They didn't (or couldn't). Bukovnik felt that he was the smallest account in the agency and that his work received minimal attention. He also said that he found careless factual errors in press materials on him that were prepared by the agency.

Artists can certainly come up with ways on their own to generate publicity about themselves or their work. They can write their own press releases, put together their own press kits, and create their own events. A typical approach is for an artist to offer a free "demonstration" of artmaking in his or her studio or at a community center. Another is to offer a talk on some aspect of the arts; yet another is to make a donation of

work to a hospital or some other charitable organization. Any number of activities give an artist public visibility.

ARTISTS' CAREER ADVISORS

Career advice to artists comes in a variety of forms. There are workshops that nonprofit arts service organizations offer from time to time, focusing on specific topics (tax-time accounting, law, and finding a gallery, for instance) and workshops—the online ones are referred to as "Webinars"—that for-profit organizations offer, which usually address the same topics. The continuing education divisions of some art schools or universities that offer art degrees may also hold workshops and classes on these and other subjects. State arts agencies periodically offer seminars on how to apply for funding to them. An assortment of business and career books for artists are available as well.

For those who prefer the more personal touch, artists may consult on a wide range of career matters with artists' advisors, either face-to-face or over the telephone, depending where each party happens to live.

Advice sometimes is free, oftentimes not. State arts agencies usually do not charge for their seminars, and continuing education talks are either free to the public or cost a nominal fee. Nonprofit arts service agencies generally charge their members lower rates for attending the workshops than nonmembers ($20, for example, as opposed to $30), and career books usually cost somewhere between $10 and $30. Artists' advisors are the most expensive option, charging hourly rates (not including the cost of the telephone call) of between $100 and $500 per hour. (Katharine T. Carter & Associates of Kinderhook, New York, adds travel time and travel expenses to that $500 fee when making an in-studio consultation.)

Artists' advisors can be distinguished from business managers (whose job is to run the artist's career), reps (whose aim is to sell work), and public relations firms (whose aim is to publicize) by the fact that their primary goal is to set the artist on a career path. Advisors may draft a press release or a press packet for an artist in the manner of a publicist, but more likely they will offer ideas on how the artist could create the release him- or herself. Rarely, if ever, will an artists' advisor take on the job of contacting members of the press.

In some instances, advisors will help artists set up simple bookkeeping procedures, establish a basic price structure for the art, provide rudimentary instruction on copyright and other legal protections for artists, and assist in negotiating any agreements with dealers or print publishers.

Advisors offer business and career information tailored to what individual artists need to know, and they also offer suggestions about a given artist's work. Some tell artists how to locate appropriate galleries or shows where their work might be displayed, while others produce a list of likely galleries or exhibition opportunities that the artist might try. Some take a very hands-on approach—suggesting that a particular artist concentrate on prints instead of painting, for instance, recommending an artist develop his or her work to a full extent before attempting to market it, or even advising an artist

use certain popular colors in a painting—while others choose not to meddle with the artist's own creative processes.

Some advisors are best equipped to help emerging artists, while others have experience assisting mid-career or even relatively successful artists. Some advisors have greater success with artists who work in a specific medium, such as prints, for example, and others may not know as much about the market for abstract or progressive art.

Artists should approach advisors not as supplicants but as critical consumers looking to find the best match for their art and for their own temperaments. They should not be timid asking about the rates or what specific services will be rendered. Artists need to know the basis of the advisor's expertise: How many years has the advisor done this kind of work? Has the advisor conducted any surveys or research about artists? Has the advisor ever written one or more successful grant proposals? Has the advisor ever been involved in the art trade? Artists should also ask for the names, addresses, and telephone numbers of artists with whom the advisors have worked in the past in order to verify what they have been told. Because many advisors have also written books or articles in which their ideas are expressed, artists should ask for copies as a way of evaluating the approach taken. In some cases, the books and articles may lessen the need for as many sessions with a particular advisor.

Some advisors are strictly business-focused, while others take on more nebulous realms, such as personality issues and spiritual motivation. Alyson B. Stanfield in Golden, Colorado, for instance, refers to herself as an art career expert, and her Web site (*www.artbizcoach.com*) offers a taste of her approach, containing helpful and practical hints for the marketing-challenged artist. Susan Schear in Newark, New Jersey (*www.artisin.com*), offers a strict diet of business planning and development, while the Web site of Caroll Michels in Sarasota, Florida (*www.carollmichels.com*), contains a resource directory of services for artists in addition to information about her workshops and consultations. Lucia Capacchione of Cambria, California, on the other hand, describes herself as a "Fulfilling Dreams Expert," while Molly Gordon of Suquamish, Washington, is a self-described "Entrepreneur Expert." Nancy Marmoleho of Anaheim, California, is a "Visibility Expert," and Mari Smith of San Diego, California, is a "Relationship Expert." For some artists, the issue is not so much how to compose a press release or make a sales pitch but whether or not they give themselves permission to nurture their creative interests. Some of the strictly business advisors also may address some of the emotional and self-esteem issues—Alyson Stanfield has a page on her Web site devoted to "affirmations" ("As an artist, I see things differently," "I am valued in my community," and "I practice gratitude every day" among them), which suggests that she will counsel on these areas if an artist-client wants—but it is less likely that a relationship expert will help establish an artist's marketing plan.

The world of artists' advisors is not huge, and many advisors know each other and know each other's work. If a particular advisor does not seem suitable, artists should ask for a reference for another. Advisors are not appropriate for everyone; their clients are rarely right out of school and have generally had experience exhibiting and selling (or, at

least, trying to sell) their work. The artists who are most likely to benefit from an advisor have established the kind of artwork that they want to pursue (rather than being all over the board in terms of style or medium), know that there is an audience for their work but want assistance in reaching that market. The more basics that have to be covered by an advisor and an artist ("Well, what kind of work do you want to specialize in?"), the longer and more expensive the process of putting a marketing plan into effect.

Advisors will evaluate artwork in terms of where best to market it, but they almost never offer a value judgment about its quality or level of interest. Dan Concholar, who has provided career counseling to artists for more than twenty-five years, noted that he has consulted with a number of artists who seem to have no talent, "but I've never said that to anyone. Telling someone that their art is bad is like telling them their children are ugly." Advisors see clients who will pay for their services; they may hold their noses the entire time, but they take their money. Fees are never based on the artist's success but on the advisor's hourly rate. "It's not my job to comment on their aesthetic ability," said Santa Monica, California, advisor Sylvia White. Her job is to make people feel that they can succeed in finding an audience for the art that they make. "Artists walk in the door with their shoulders hunched, feeling helpless, hopeless, and they leave an hour or so later feeling like they know what they have to do next." Calvin Goodman also views the problem of an artist not selling as a practical one, of the artist "not working in a direction that will get them an audience," and offers various types of advice, regardless of how likely he sees an artist-client ever selling work. The alternative—to say that he doesn't like the art or that he cannot do anything to make someone's art marketable—is "to commit a crime against the culture."

Susan Schear has recommended a therapist to certain clients. "Some artists live in a fantasy world and don't realize what's happening to them," she said. "They've created a lot of defense mechanisms that don't allow them to see clearly, and they need to treat these problems before we can do much for their art."

The job of an artists' advisor is not easily summarized, as it may involve a variety of chores—developing a marketing plan with this person, coaching another person to take a more positive attitude—and the line between career planner and therapist is often crossed. If the art world has its unknown soldiers—artists who forge on with their art even in the face of indifference or hostility—it also has its artists who exist on fantasies about their place in the art world or, to borrow a term from psychology, live in a state of denial.

Denial and other defense mechanisms may help artists protect themselves emotionally from the disillusionment, disappointment, and overall frustrations that the art world regularly metes out. However, the job of marketing—that is, of finding an audience for—one's art work requires clear-sightedness and a positive attitude.

"I've talked to a lot of artists who are constantly making up excuses for themselves," Concholar said. "They say, 'The art world is a political system. It's who-you-know,' and I say, 'Yes, that's true, but why don't you try to meet someone?' I've talked to artists who expect their work to get into the most prestigious galleries and won't consider any other places to show their art. I try to get them to start at the bottom and work their way up, but that idea is sometimes too much for them to handle."

Artists develop unrealistic expectations—notions of what they are unlikely to ever achieve—for various reasons: they may have absorbed a limited and limiting sense of the art world from art school; some might inflate their sense of worth as a means of mitigating years of having little or no professional success to show; they may view the art world too starkly in terms of superstar success (museum retrospectives, Whitney Biennial, top-name New York City galleries, cover of *Art in America*) or nothing. Ideas that are wrong or simply inappropriate for a particular artist may be the largest hurdle to overcome, as it tends to destroy the very real opportunities before them. In some cases, artists may need psychological counseling to overcome feelings of inadequacy and depression. Their productivity declines and they present themselves unfavorably, not believing that they can achieve success. Other artists may simply need to understand what they can achieve if they break it down into small steps.

"Too many artists are grasping at straws; they don't know how to begin, and the task in front of them looks so big," said Sylvia White. "If you give an artist a strategy—goals to accomplish in a methodical way—you give that person hope. The question isn't, Should this person make art? but, Where could this person be successful with the art they make?"

Advisors don't travel from artist to artist, and artists who do not live in the same town or state as a particular advisor usually must speak to them by telephone. As one advisor said, "I have a cauliflower ear, and my voice never gives out." Artists pay for their own calls, and consultation fees are paid either by check or credit card.

After an initial consultation in which basic questions about what the advisor will do and what the artist needs are decided, the artist sends one or more slide sheets (or photograph albums) of his or her work, as well as a résumé, clippings, and other documentary material, to the advisor. The advisor studies these in order to prepare recommendations. Those recommendations may come in the form of a worksheet or workbook listing a step-by-step method of what to do first, second, third, and so forth; or a time for a telephone call is arranged.

Because artists are paying for the telephone call as well as perhaps an hourly consultation (divided into fifteen-minute segments), they should come to the telephone with prepared questions and stick to the point.

The wide assortment in types of advice one may receive through various media (book, face-to-face, telephone, video, online) indicates the growing amount of information that artists require. If all the ideas that an artist needed could be found in one book, there would be no need for anything but that one book. However, different people have their own perspectives and their own sources of information, revealed in the less general tips they provide. Nowadays, artists need to develop their own resource libraries that include various career guides (books and/or videos) and telephone numbers.

PAYING TO PLAY THE ART GAME

What defines an artist as a professional? The Internal Revenue Service of the federal government has one definition based on an artist making a profit in three out of five

years, and dealers use the yardstick of having sold work in the past. Still others speak of that ethereal thing called seriousness of intent or artistic quality.

For some artists, however, professionalism means having a business card or stationery that, besides noting the artist's name, address, and telephone number, lists that person under the title of "artist." For other artists, it may be listing a series of prizes and awards on their C.V.s, as well as "investing" in their careers by renting a gallery for an exhibition of their work.

Visual artists, unlike artists in other disciplines, are people who have to pay for their career aspirations. According to one National Endowment for the Arts study, the average artist's costs (materials, studio space) are a little more than twice his or her earnings from the sale of works. With this in mind, it is especially important for artists to know what they are buying.

Artists are generally thought of as producers, but they are also consumers, targeted by individuals, companies, and institutions who offer a lot for them to buy. They pay for their art training, materials, and studio space and often the photography, framing, crating, shipping, and advertising of their work. The past few decades have seen the emergence of various services catering to artists—artists' career advisors, publishers of artist directories and how-to-make-money-as-artists books, for-rent exhibition spaces, mailing list sellers—whose benefit to artists is not always measurable. Perhaps this benefit does not even exist. More than anything else, most artists are desperate to find some way to show and sell their work, and they will often pay for these opportunities. Many people and companies are aware of that, and they are feeding that desperation.

SELLING ART THROUGH MAILING LISTS

Take, for example, mailing lists. A number of career advisors to artists sell lists of dealers, corporate art consultants, critics, art publishers, museums that show contemporary artists, art competitions, and other groups and organizations of interest to artists. These lists have hundreds, sometimes thousands, of names and addresses of potential buyers or contacts who have shown a specific interest in works by living artists.

Announcements about upcoming exhibitions or the completion of new works of art can be sent to the people on these lists, and perhaps some sales may result. Companies specializing in direct mail solicitations claim to average a 3 or 4 percent return; for artists sending out material to one thousand art galleries where their work might be represented, that suggests between thirty and forty positive responses.

The reality is less promising. The names on the mailing lists are not so carefully weeded through by the companies selling them that they don't include a lot of frame and card shops. Outside of major cities, lots of furniture stores and gift shops call themselves galleries, too. There is also no explanatory information with the labels to indicate which actual art galleries are primarily interested in abstract or representational works, the kind of media they prefer to show, and who are some of the other artists shown.

These companies don't check with the people on their lists to see if they want to be included (or are appropriate for inclusion), and they might only delete a name if an art dealer wrote or called to say that his or her gallery shouldn't be on it.

It is wiser for artists to market their works with greater precision than with random mailing lists; instead, as noted above, they must become familiar with their markets. As tedious as it may be, there is no getting away from artists having to research galleries. That kind of research is largely identical to, but more meaningful than, what the mailing list sellers do themselves. "There are two or three books in libraries that tell you which corporations collect art," said Constance Franklin, owner of ArtNetwork, which sells mailing lists and other books for artists and collectors. "For galleries, we also look in art magazines for ads by galleries."

Considering the fact that the prices for mailing lists cost as much as $299 depending upon how large they are, a few hours in a library looking at those same books and magazines might save artists some money and headaches.

There are also lists of collectors that artists may buy, which may be equally problematic and unproductive. "The fundamental problem with trying to sell your work to people on a mailing list is that collecting starts at the grassroots," said Boston art dealer Jennifer Gilbert. "You have to develop a relationship with people, educating them about your work. I've found that many clients become friends of the artists. Sending out a solicitation to someone you don't know personally may work for L.L. Bean, but it's not the way you sell art. However, my guess is that those who sell mailing lists have never sold a work of art in their lives." The one mailing list Gilbert recommended is from local realtors of new homeowners. "People who have bought homes want to buy a piece or two of artwork for their homes," she said. "Every gallery buys lists of new homeowners."

THE VALUE OF PRIZES AND AWARDS

Thousands of artists compete annually for awards and, for many, the awards and prizes section on their résumé is quite expansive. However, there is a wide range of opinion concerning to whom these prizes actually matter. On one end of the spectrum, there is a belief that prizes and awards do not matter at all. "It is absolutely of no importance to me whether or not an artist has won any prizes. It is absolutely of no importance to my collectors," Jill Sussman, director of the Marian Goodman Gallery in New York City, said. "None of the artists here get prizes. Those artists who get prizes just are not in our league."

"Winning an award is nice when it happens for the artist," Janelle Reiring, director of New York's Metro Pictures gallery, stated. "It makes the artist feel good, I guess. It doesn't make any difference to me or to the collectors I deal with. Our collectors are certainly concerned with what critics and museum curators think, but not at all with what prizes or awards the artist may have won."

Other art dealers take a different view. "Which awards the artist has won matters to me and matters to collectors," Benjamin Mangel, owner of the Mangel Gallery in Philadelphia, said. "They are especially beneficial to an emerging artist, who may have little else to show. I have collectors who need to see that the artist has credibility, and it

helps when I can talk about the artist's scholarships, awards, prizes. It's not a crucial factor in selling a work, but, when you've got someone who is on the fence and says, 'Let me read something about this artist,' if you show the collector a blank sheet of paper, that collector is not going to buy the work. If you can show that the artist has won awards and prizes—that the artist has credibility in someone else's eyes—nine times out of ten that collector is going to buy the work. The only time that kind of information doesn't matter at all is when the collector falls in love with the work and doesn't care who the artist is."

A number of other dealers around the United States agree that prizes are of greatest importance for artists who are younger or who need some kind of third-party validation because they don't yet have a reliable market for their work. Lisa Harris, an art gallery owner in Seattle, Washington, noted that when an artist is just starting out in his or her career, listing prizes and awards "helps affirm the collector's own feelings about the artist. As the artist enters a later stage of his or her career, those credentials tend to be jettisoned, and the prizes and awards category disappears from the résumé. The artist shouldn't need to refer to first prizes anymore."

The category of prizes and awards is frequently elastic, expanded by artists to include fellowships from foundations and governmental agencies, as well as project grants from those same (or other) sources. The differences in prestige between who gives awards or prizes may be enormous. A number of art dealers, who otherwise claim that the fact of an artist winning a prize is of no importance to them, stated that their interest is piqued by artists who have received a Guggenheim fellowship, for instance. "A grant or fellowship from the National Endowment for the Arts carries some weight with me," said Donald Russell, director of the Washington Project for the Arts, an alternative art space. "I think the panel structure they have is good, and the choices for who is on those panels is also quite good." Nina Nielsen, a gallery owner in Boston, Massachusetts, also claimed that she pays more attention to awards that are "well-decided."

Gregory Amenoff, a New York City painter, said that "when I am to give a talk somewhere, I am frequently introduced to the audience as the recipient of three NEA grants. Obviously, that has given me a certain status with some people, but I wouldn't want to overemphasize its importance. I've never heard a collector say, 'I heard you've received three NEAs and wanted to see what your work looks like.'"

PUBLISHING ONE'S OWN CATALOGUE

An artist's exhibition, while usually a source of great hopes, is often an evanescent event. Visitors and potential collectors walk through, perhaps some sales take place, but an art show rarely changes the world, and artists can only hope that those who saw their work (and liked it) will remember it by the time the next exhibit takes place—perhaps a year or more down the road. After the show comes down, most artists are left with nothing more to show than some receipts or press clippings, if they are lucky, and another line on their résumés.

This is why artists appreciate exhibitions that are accompanied by catalogues. Here is a tangible thing to come out of an art show, a record of an event that contains

reproductions of the work in the exhibit and an essay by a third party (not the artist, not the visitor or buyer) that makes a case for the art.

Art shows that have catalogues are rare, but the artist's hunger for them never abates. Some artists have sought to help themselves by producing their own catalogues of their current art, complete with their own penned essays on who they are and what distinguishes the artwork they create. It is an expensive way to fill a void in one's career, but a growing number of artists are attempting to give themselves and their real or perceived audience something to hold onto after they leave the exhibit.

These catalogues differ from brochures that many artists produce in order to publicize their recent work and to send to past buyers as well as those who have shown interest in the artist's career. Many artists develop mailing lists for exactly this purpose. Brochures generally have fewer pages than a catalogue—four or eight, or perhaps just one long page folded several times—and are unlikely to include more than the briefest text. That text, in fact, tends to mention where and when the artist's work may next be exhibited, prices, and, perhaps, a quick update on the artist's life and work.

Catalogues, on the other hand, are small books, reaching forty and sometimes more pages, with larger, full-color reproductions of more artworks than are found in most brochures and text that rarely (if ever) discusses the potential for buying something. They are frequently intended to be identified by readers as a traditional art gallery or museum catalogue rather than as a self-published promotional effort, although no artist has claimed that he or she aims purposefully to deceive anyone. Call it *trompe l'oeil* promotion, and the jury is not yet in on its effectiveness.

Many people are introduced to the ideas and artwork of Todd Siler through the twelve books and catalogues that he has written since 1979, many of which have been self-published. A painter with a doctorate in Interdisciplinary Studies in Psychology and Art from the Massachusetts Institute of Technology, Siler noted that these publications "present my ideas about how the mind works and the art I've created that illustrates my ideas. I'm not exactly making a catalogue for a show but, rather, an informative tool for the public."

That tool is not cheap, and the three thousand copies of his forty-two-page *Cerebralism* catalogue cost $16,000, although Siler was able to cut the cost in half through bartering some of his artwork with the printer. A large number of these catalogues are sent out to collectors, cultural centers, dealers, museum curators, and "newspaper people who have expressed interest in writing about my work"—Siler's own mailing list includes one thousand names—although the artist has been able to sell copies at galleries, where his work is exhibited, for $20 apiece. "I get three thousand printed and think, 'What am I going to do with all these catalogues?'" he stated, "but over a two- or three-year period, I find that they end up being sold out."

Siler's catalogues "pay for themselves," he believes, by bringing prospective buyers to his exhibitions and through direct sales. "I think of them as informative tools but, when people get the catalogue, a number of them call up and say, 'I'm interested in this or that piece. Has it been sold yet?'"

Siler's New York art dealer, Ronald Feldman, contributes between two hundred and 250 names from his own mailing list for the artist's mailings but does not offer to pay for any part of the catalogue's printing or postage. Nor is Feldman particularly interested in producing a gallery book on Siler's art with an essay by someone other than the artist. "Some dealers do that for their artists," Siler said. "Mine won't." Perhaps as a consolation to Siler, Feldman refuses to accept a commission on direct sales generated by the catalogue.

"I love writing, and I look at the book form as a way to express myself in another medium, to experiment in word form," he stated. "My catalogues are definitely not vanity publications, because I look at my essays as experimental, not self-aggrandizing and not self-promotional."

Many dealers are not convinced of the overall benefit of artists publishing catalogues about their own work, sensing a vanity element that implies no one else would go on record in discussing or praising the artwork. Siler's own dealer, Ronald Feldman, stated that he is "inundated by zillions of catalogues every day, many of them from and published by artists. I have to admit that self-publishing is a kind of red flag to me, because it immediately makes me wonder, 'Why does the artist need to resort to this?'"

Other dealers, however, claim that this kind of catalogue is an excellent way to present oneself to new collectors and reflects the self-confidence of an artist who will put up his or her own money in order to make a good impression. According to a number of art dealers, some of these catalogues, especially those containing a thought-provoking essay by the artist, are viewed later on in one's career less as promotional material and more in the category of artists' books, and their limited numbers make them prized, valuable possessions. In this regard, a self-published catalogue need not be specifically related to a particular exhibition, although most dealers believe that the concurrence of an art show makes them far more effective.

An artist's self-published catalogue is self-promotion, but so is an art exhibit a form of self-promotion. However, a self-published catalogue is not appropriate for every artist. An artist whose work may be evolving would be reluctant to publish a catalogue that promotes a certain look or style from which he or she may be in the process of changing. Also, because a particular catalogue is printed by the thousand—it is not economical to print up forty—the artist will need a large enough mailing list of people interested in his or her work to whom it should be sent. That, in turn, requires the artist to have been in the marketplace for a while.

An example of a riskier venture is the *Spiritrealism* catalogue for which painter Robert Masla paid $8,000 for a printing of 1,500. Without a regular dealer, an established market, or even an up-to-date mailing list ("I'm going to look into some of the lists I see advertised in magazines"), Masla used his catalogue as part of his "stepping back into the art market"—he had given up actively trying to sell his work for a period of four years starting in the late 1980s, during which time he taught art at various schools and "just painted."

So far, Masla claimed to have received favorable responses to his catalogue from those who have seen it, and some have purchased it for $10 apiece when he has an

exhibition. He believes that it is no more of a vanity publication than the books of art and poetry that William Blake self-published in the late eighteenth and early nineteenth centuries or Wassily Kandinsky's famous essay, "Concerning the Spiritual in Art," which the artist brought out in 1912. "I published *Spiritrealism* for promotional reasons," Masla noted, "to get my work to a larger audience."

As with Todd Siler, Masla's *Spiritrealism* catalogue is not oriented toward a particular art exhibition but, instead, was published "to air the philosophical content." Drawing on Eastern religions, Masla sees "The Supreme Personality of Godhead" manifested in painting "through the unity of content, context, image and symbol.... By dissolving false ego, the spirit can shine through the artist and become manifest in his or her artwork. That state of pure consciousness is transferred to the viewer, thereby uplifting the viewer's consciousness to the platform of the transcendental."

An artist's catalogue creates a permanent art exhibition, testifying to one's ideas and achievements. The degree to which they may actually expand an artist's market (in their capacity of promotional material) or be regarded seriously as an artist's book (rather than frowned upon as a vanity publication by the very collectors, curators, and dealers one hopes to impress) is not well determined. Certainly, they are an expensive long-shot, more or less of a waste of money depending upon what the artist does once the catalogues come off the press.

ENTRY FEES FOR JURIED SHOWS

No one would expect a dancer or actor to pay in order to audition for a part, nor would a writer be asked to send a publisher a check along with the manuscript for it to be read. The visual arts, however, are different. Visual artists usually must pay an entry fee to be considered for a juried competition. Whether they are selected to be in the show or not, they have to pay. People don't look at their work for free.

The thousands of invitational arts and crafts shows (many of which charge entry fees) taking place somewhere in the country throughout the year—held by private companies, nonprofit groups, and small towns—enable lesser-known artists and craftspeople to show their work to the public. A growing number of artists, however, have been voicing their objections to the entry fees, which, they feel, place the financial burden for these shows on the shoulders of people who have little money to begin with. The fact that almost none of these shows pay for insurance on the shipment of the objects in their displays or provide any security measures to protect them while the exhibition is up is like rubbing salt in artists' financial wounds.

"Entry fees are a bit like a lottery," said Shirley Levy, an official of National Artists Equity Association, the membership organization of visual artists based in Washington, D.C. "You pay for the privilege of having someone look at your slides, even if they are rejected. Emerging artists are told, 'Pay your own way until you've made it.'"

Levy and others noted that most show sponsors believe that artists should contribute something for these shows since they're the beneficiaries of them, but that is a faulty assumption. "Artists don't generally benefit all that much from a given show, but the

organizations that put on the shows often make a great deal of money by exploiting artists who need to show their work somewhere," she stated.

Originally, entry fees were established as a means both to control the number of participants in juried fine art competitions—it was assumed that rank amateurs could not afford the fees—and to provide organizations with upfront money with which to rent a hall, pay some notable art expert to evaluate the artists' work (or slides of the work) and to create prize money. Times have changed.

George Koch, president of National Artists Equity Association, complained that "the money a lot of these show sponsors are raising is far more than needed to meet their expenses." He added that they could easily earn this money in other ways than taxing artists, including soliciting contributions from local companies, charging admissions, creating prints of works on display, marketing a catalogue of works in the show, and auctioning some of the pieces.

National Artists Equity has been uneasy with the existence of entry fees since the organization came into being in 1947, and in 1981, it wrote up ethical guidelines for its membership, stipulating that artists should refuse to participate in events where there are these fees.

This issue has caught on. Other artists organizations in the United States and Canada have adopted similar guidelines. A statement by the Boston Visual Artists Union, for instance, notes that "Exhibitions do take money to mount. However, it is inappropriate for artists (accepted or rejected) to be a source of these funds," and Canadian Artists' Representation/Le Front des Artistes Canadiens in Ottawa also claims that its membership "does not consider that the payment of entry fees is appropriate to an exhibition of work by professional artists."

Artists Equity has pressed agencies of the United States government to develop a policy prohibiting them from funding groups that put on juried art shows requiring artists to pay an entry fee. So far, this effort has met with limited success.

The National Endowment for the Arts has been reluctant to create a policy of this kind although, on a practical level, it has generally refused funds for groups charging entry fees. Many of the applicants to the NEA's visual arts program are exhibiting organizations that may put on ten shows a year, one of which might be a regional juried show that requires a fee. It's unlikely that the panelists would deny a good organization funding because of the one show, although they are apt to decide that none of the money that's given to the organization can be used for that one show.

National Artists Equity has also attempted to pressure the U.S. Interior Department to drop the $50 entry fee it requires for its annual duck stamp competition. This is the only annual juried art competition sponsored by the federal government, and over one thousand artists a year pay the fee to submit drawings for a duck stamp commissioned by the Fish and Wildlife Service of the Interior Department. "Why," Koch said, "does the Interior Department need to make money off artists?"

The case against entry fees has found more sympathetic ears on the state and local levels, as both the Oregon Arts Commission and the New York State Council on the

Arts as well as the D.C. Commission on the Arts and Humanities in Washington prohibit funds from going to organizations that charge entry fees. The Berkshire Art Association in western Massachusetts decided in 1985 to eliminate its entry fee, and other small-town-sponsored events around the country have done the same, looking for money elsewhere. Many other show sponsors have chosen to maintain the entry fee system, however, realizing that there are so many artists around who are willing to send in money in order to have the chance to be shown that they might as well let them.

It may be too much to ask that artists individually refuse to take part in juried exhibitions that demand entry fees, as that may be tantamount to cutting off one's few opportunities. National Artists Equity's ethical guidelines are not intended to browbeat anyone into harming his or her career. However, artists can be effective in eliminating these fees by discussing their objections to them with show sponsors and, failing to find success there, organizing others to protest the policy.

ARE YOU DELUDING YOURSELF?

There are also rental art spaces, sometimes called vanity galleries, which offer limited benefit to an artist's career but certainly will drain a bank account. A four-week show at a Chelsea gallery space in Manhattan may reach $10,000 or more, when services and amenities such as press notices, brochure or catalogue, and opening reception are part of the package. Some artists will pay for this, or some portion of it, because they feel the need to have some outward measure of success in their careers. Studio art faculty, for instance, are required to exhibit their work in galleries in order to keep their jobs, and some will pay for the line on their résumé; retirees who have had success in one career and don't want (or don't believe they have enough time left in their lives) to start at the bottom in another field, will pay to circumvent the process of establishing themselves. A large percentage of the clients of artists' advisors are retirees or now have more time to devote to their art interests since their children have grown up and left home. For whatever reasons, many artists are willing to rent a space in which to hold an exhibit of their work. As with commercial art galleries, walk-in sales to collectors generally cannot be counted on to cover the overhead. Rarely do these kinds of shows result in sales—potential buyers who aren't friends or family members generally prefer to buy from third parties, such as dealers, who are putting their reputations on the line with the particular artist—but the point of the vanity gallery show for the artist is not necessarily to sell. Rather, it is a way to make them feel like real, professional artists.

Certainly, this issue of paying to exhibit is less black-and-white than twenty or so years ago. Gallery owners nowadays do less and less for the artists they show and represent, rarely paying for advertising or press mailings or producing a catalogue, except in the case of their most prestigious artists. Dealers may pay for half the cost of producing a catalogue, for instance, letting an artist pay for the other half—the split of costs is usually the same as the commission. There may be an opening night reception, but the artist has to supply the wine; the artist may also need to pay to paint the gallery walls. This doesn't turn an exhibition into a vanity affair, but it does demonstrate the changing

economics of the art business, where gallery owners may be paying tens of thousands of dollars per month in rent and just don't have the wherewithal to take care of artists in the manner that they or others had done in generations past. It is simply more expensive to be an artist now, and artists need to decide what they are willing to buy and what the goal is in making the purchase.

Some art publications have artist directories, which are simply pages on which artists may take out small ads. Sabrina Bertucci at *ARTnews* couldn't say if the ads artists buy in the spring, summer, and winter issues of the magazine—$525 for a 2½" x 3" ad, $998 for a 5" x 6" ad—produce sales for these artists or invitations to exhibit their work, but "we're told that their Web sites get a dramatic increase in the number of hits" after the advertisements appear. "Repeat advertising builds visibility," she noted, which is the advertising industry's mantra. It may be true: Ongoing exposure and repetition gets people to say Kleenex rather than tissue or believe that a Mercedes is a very high-quality automobile rather than just an expensive one.

Advertising exists in the fine art realm, mostly purchased by galleries at the time of an exhibition, and different dealers have their own purposes in mind when they place ads. Ads may bring visitors into the gallery who one day turn into buyers—of the particular artist in the advertisement or of someone else. The ads may serve as a reminder to specific collectors on a gallery's mailing list about the event. James Yohe, co-director of the Ameringer & Yohe Gallery in New York City, stated that advertisements, especially those with color images, make the artists feel better about their relationship with the gallery. "Artists want a reproduction of their work," he noted, "a document, as it were. It means a lot to them."

Taking out an advertisement, some dealers believe, also increases the chances of seeing a write-up of the exhibition in the particular publication. The ability to afford a large ad with photographic reproductions is seen occasionally as a sign of success, impressing artists and collectors. With other dealers, ads have greater importance for the long-term viability of the gallery than for the short-term exhibition. "An advertisement attracts attention," New York gallery owner Thomas Erben said. "It secures the gallery's position in the market. People have to see that we are still here. In effect, I'm advertising myself through the market."

Some artists also take out large ads in art magazines, which they hope will lead to something. The magazine advertisements for Lexington, North Carolina, landscape painter Bob Timberlake feature a black-and-white photograph of him looking contemplatively out a window; that picture fills up more than half the page, and underneath the photograph are three-color reproductions of his paintings, which are somewhat smaller than images on slides, and information on where his works may be seen or purchased. "What you do in advertising is the same thing over and over, so that people recognize you when they see you," Timberlake said, noting that he has been interviewed repeatedly about his artwork on television. "I've been told that I'm recognizable and that the name Timberlake is recognizable."

He spoke disparagingly about most artists' advertisements, which largely consist of one large reproduced image in a one-time ad, as not being part of any marketing plan.

He places ads in the same publications on a regular basis in order to familiarize readers with his name. "Do I want to sell the name or the product?" Timberlake asked. "I want to sell the name, because you'll see the name many more times than you'll see that one picture." His photograph "gives an air of who I am and where I'm from. It's all the mood and the person, adding that "the window is in my own studio."

Buying advertising space, purchasing mailing lists, paying for exhibition space, publishing one's own exhibition catalogue—this is a large and growing industry of services offered to artists that aims to help them build up their résumés. Artists have shown repeatedly that they will pay to load up their résumés with apparent accomplishments. Why? Because there are too many artists and not enough galleries and museums to show their work. As a result, artists have had to change their orientation from seeking to make a living from the sale of their work to trying to convince other people (and possibly, themselves) that they are not simply Sunday painters or hobbyists. No one would have ever thought to ask young Jackson Pollock about his résumé, but now, serious young artists are led to believe that they should keep a résumé up to date and packed with experiences and achievements.

And, like the resumes of other professionals in our society, the importance of these activities and achievements tends to become somewhat inflated. Unimportant exhibits and unread directories loom in significance as artists hope that someone will believe their careers have truly progressed and their work has received critical recognition. Paying for a show or a number of shows to include on a résumé might suggest to someone that the artist's career is progressing, even when none of these shows breaks even for the artist.

It's fair to say that Jackson Pollock set out to make paintings, not to build a résumé as a professional artist. Today's artists, however, feel they have to do both.

"Being an artist today is a lot harder than it was in the past," painter Chuck Close said. "There is a sense of raised expectations today, due to art schools and other institutions with which artists are associated. You see Frank Stella have a one-man show when he's twenty-one, or Julian Schnabel have a retrospective when he's thirty. If you've been hanging in there and haven't achieved any measurable success, you begin to ask yourself, 'What do I have to point to that shows I'm a professional, too?' An enormous résumé can help someone deny the reality of his situation. I mean, why am I an artist? I guess it's because I have a résumé that says I'm an artist."

Ultimately, the largest change in the art world since the end of World War II is the idea that artists can consider themselves failures if they don't achieve some quantifiable measure of success. Over the past few decades, there has been a great increase in the number of people who are able to support themselves from the sale of their work, but most still do not. That majority continues to hold various "day jobs" (the lucky ones teach) and dream through their résumés.

A lengthy résumé may suggest that an artist is in great demand when the items listed have importance in themselves. A résumé is ultimately a way for artists and others to keep track of their careers, and no quantity of listings on it is a substitute for high-quality exhibitions and a strong market. When a résumé is filled with group or

one-person exhibitions that turn out, on closer inspection, to be a few pictures that a bank placed in its windows or gallery shows in which the artist rented out the exhibition space, or when there is a vanity element to many or most of accomplishments listed, the résumé becomes a statement of failure. And the fact is, the very people whom the lengthy résumé is intended to impress can see that quite clearly. It is wiser to have a shorter résumé listing events that are truly meaningful—perhaps, in a category of "Selected One-Person Exhibitions"—than a massive hodge-podge of good, bad, and indifferent. Artists have good reason to put together a well-presented résumé, and there are various consultants (career advisors, artists' advisors) who can assist them in this effort. It is time, however, for artists to deemphasize the résumé as the barometer of how their careers are going.

Art dealers, for whom these résumés are often intended, are usually not impressed by the number of exhibitions an artist has had—once again, they select artists based on recommendation of others whom they trust (artists, critics, curators, and other dealers)—and who have bought that person's work in the past. No artists have ever been rejected by a dealer for having too short a résumé, although many dealers dismiss artists out of hand who have previously paid for shows, considering them not to be professionals. These days, artists have to be professionals from the word go.

With everything that an artist might pay for, the costs need to be weighed against the potential benefits. The costs are certainly real but, if the benefits are only a dreamy impression of good things, one may want to hold off for something more solid.

Some of these services do nothing more than play off the desperation of artists for whom finding a way to show and sell their work is inordinately difficult; others exist because someone thought up a solution and tried to convince others that they had a problem. Consumer advertising is full of success stories in this area, but the art world tends to act differently. Direct mail flyers, vanity galleries, and classified advertisements don't usually lead to fame and riches in the art world. Changing the way success is found in the art world may be, in the future, another service to add to the list.

7

Artists and the Law

I t probably doesn't occur to many art collectors to purposefully alter, mutilate, or destroy a work of art that they have purchased, but it has happened occasionally. Among others, it has happened to the creations of sculptors Alexander Calder, Isamu Noguchi, and David Smith, as well as painters Arshile Gorky and Pablo Picasso and a number of others who aren't quite as well known.

However, because of the Visual Artists Rights Act of 1990, it is less likely to happen in the future. The law, an amendment to the federal copyright law, provides visual artists (narrowly defined as painters and sculptors as well as printmakers and photographers who produce limited editions of two hundred or fewer copies of their work) with the right of attribution (to claim "authorship" of their work and object to false attribution). The law also affords artists the right to prevent the owners of their work from distorting or altering their creations without their consent and, in the case of works of "recognized stature," to prevent their destruction. In the years since then, a number of artists have filed lawsuits under the law—a few successful, most not—largely for works of public art. Laws, of course, are not judged on the basis of guilty verdicts but on how they influence behavior. In this regard, the Visual Artists Rights Act has proven to be a success.

Artists have become more versed in the law, and the legal profession has become acquainted with the arts. The Visual Artists Rights Act was the outcome of more than a decade of political activism on the part of artists, but it also was the outgrowth of an ongoing campaign around the country to regulate the art trade and ensure fair treatment for artists. Looking around, one sees a growing body of art law on the state and federal levels over the past twenty years.

Among the main points in this already sizable body of law are:

- Artist-dealer consignment laws in thirty-one states around the country (requiring dealers to whom artists have consigned their work to hold proceeds from sales in trust and out of reach of any claims by gallery creditors)

- Art print disclosure laws for the sale of limited edition graphic works of art in fifteen states (Arkansas, California, Georgia, Hawaii, Illinois, Iowa, Maryland, Massachusetts, Michigan, Minnesota, New York, North Carolina, Oregon, Rhode Island, and South Carolina) that require buyers to be furnished with detailed information (the name of the artist, whether the artist is alive or deceased, the medium, the reproduction process, the size of the limited edition, and the status of the master plate)
- Warranties of authenticity (requiring art dealers to take back works they had sold that had not been created by the artist ascribed to the works at the time of the purchase)
- Requirements for auction houses to indicate by some symbol the lots in which they have a financial interest, such as a guarantee or a loan made to a consignor (New York state), and that art galleries make clear to the public whether or not works on display are actually for sale to the public (New York City)
- Allowance for artwork to be used as payment of an artist's estate taxes (Connecticut, Maine, and New Mexico)
- Federal labeling requirements for art materials with potentially toxic ingredients
- State "moral rights" codes similar to the Visual Artists Rights Act and even (in California) a "resale royalties" statute that requires art collectors to turn over to artists a percentage of the profit when their work is sold again. In addition, three states (Massachusetts, New York, and North Carolina) permit artists to deduct the cost of their living/working space for tax purposes. Massachusetts even has a "Schlock Art" law (requiring dealers of low cost, imitative paintings to label these works "nonoriginal")

These and other laws reflect the growing sense that the art world is a business like any other, where a great deal of money changes hands and calls for increased governance. "Art has gotten more expensive and has attracted new laws," said Stephen Weil, former deputy director of the Hirshhorn Museum in Washington, D.C. "Anything that attracts that much money is bound to be a target for frauds and governmental legislation."

The art market has traditionally been a business where a good many of the deals are made on a handshake, without benefit of lawyerly provisos. That sense of trust and good faith has been eroded with the rise in prices for art as well as in the numbers of buyers and art galleries all over the country. These laws, as art sometimes is itself, are frequently imports—sometimes, not particularly welcome imports. For instance, the United States did not sign the Berne Convention, an international copyright law first devised in 1886 that stipulates moral rights for artists, until 1988.

The relationship between artists and the government is and always has been uneven. In 1965, with much fanfare, the National Endowment for the Arts was established by act of Congress, providing a mechanism for federal support of the arts. Since

1981, however, a steady effort has been underway to abolish the agency, which has not been met with success but led in 1995 to Congress cutting the arts endowment's budget by 40 percent, bringing it back to 1970s levels. This cutback strained the budgets of regional, state, and local arts agencies, many of which found themselves giving up individual fellowships. In 1969, the federal government revised the tax law to permit artists to declare deductions based on work-related expenses only if they made a profit in three out of five years (if that requirement isn't met, any net loss from the art activity is considered a nondeductible "hobby" expense); it also changed the law to allow artists to deduct only the cost of materials when donating a work of art to a museum or other charitable tax-exempt institution. (Collectors of art, on the other hand, are entitled to deduct the fair market value of the objects they donate.) The first rule has been a monumental headache for artists come the annual tax season; the second has proven a headache for museums, which saw gifts by artists to their collections drastically reduced. Before 1970, when the legislation took effect, museums with modern and contemporary art collections regularly received sizable quantities of objects from artists, usually toward the end of the year when these institutions also were given cash and art objects by other donors.

In truth, the hobby-loss provision was aimed not at artists but at "gentlemen ranchers" who annually declared great losses for what was not their prime source of income. (There has been an occasional instance where an artist has attempted to write off losses for pursuits unrelated to their vocations—for instance, musician Victor Borge and his rock cornish hen farm and portrait painter Peter Hurd and his ranch, both of whom were denied by the government.) The rights or interests of artists, as well as public financing of the arts, are rarely high on legislators' agendas; considering the fact that the arts have been a political battleground and one of the first areas considered for cuts when budgets are strained, perhaps that inattention is a good thing.

Artists should understand their legal rights, stay abreast of legislation affecting them and work in concert with others to insure that the law represents their interests.

COPYRIGHT

Alexander Calder made it clear what he thinks of copyrighting works of art. Somewhere in the South of France, he constructed a large metal cow defecating small "c"s with circles around them—the universal copyright symbol. Ironically, it is the only work the artist ever copyrighted, but it is hardly an endorsement.

Many artists see copyright as a commercial issue, not something for fine artists, and don't bother finding out more. Of course, if artists ignore copyright, so do many other people. Every year, entrepreneurs make unauthorized use of artists' work in order to create prints, posters, clothing, dishes, pillows, rugs, and bath towels with their imagery, and many artists find themselves unable to stop this or even to receive any of the money that others are making with their imagery. Furthermore, unauthorized use of imagery may reflect badly on the reputation of the artist when, for instance, colors are different from the original or shapes are distorted.

An uncopyrighted sculpture Calder created for the City of Grand Rapids, Michigan, was reproduced as an image on government stationery and also on the city's fleet of garbage trucks. Grand Rapids's city fathers were clearly proud of the work and viewed it as a civic logo, but their use of it was embarrassing.

Copyright is the right to reproduce one's own work, and it comes into being as soon as the artist completes his or her work. However, problems may occur when the piece is "published," that is, when it leaves the studio on loan, consignment or is sold. At this time, the copyright notice should be attached to the work and look like this: © Jane Doe 2010.

The spelled-out "copyright" or abbreviated "copr." is just as good as ©; initials or some designation by which the creator is well known ("Mark Twain" for Samuel Clemens, for instance) may be substituted for one's full name; the year, which can be spelled out (two thousand and ten) or written in Arabic (2010) or Roman (MMX) numerals or even something more eclectic (2K+10), refers to the date the object is first published and may only be omitted when the work is a useful article, such as a postcard, a dish, a toy, an article of clothing, stationery, or a piece of jewelry.

Most artists are reluctant to deface or, at least, distract people from their work by sticking a copyright notice on it and, under the old Copyright Law of 1909, artists were obliged to put the notice in the most conspicuous place possible in order to assure the public that copyright was claimed. However, under the Copyright Law that went into effect in 1978, artists are permitted maximum discretion in placing their copyright notice, which includes the back of a canvas, frame, or mat, or the underside of a sculpture. The onus is now on the potential infringer to determine whether or not the work is copyrighted. Also, since March 1, 1989, when the United States officially joined the international Berne Copyright Convention, omission of a copyright notice does not result in a loss of the copyright privileges. However, notice should still be placed on works so that maximum damages can be obtained from infringers.

The 1978 law clarified that copyright ownership and sale of the physical work of art had been separated. All a collector buys is the work itself. The reproduction rights remain with the artist. If the buyer wants the reproduction rights as well, he or she must now bargain for them, and smart buyers sometimes do just that.

The copyright is potentially worth money if, for instance, the image is used for prints, posters, tapestries, or whatnots that are sold to the public. A painting may sell for $5,000, but an edition of one hundred prints made from that image, each selling for $100, would bring the copyright holder $10,000. The copyright may be worth more than the original work (for which the artist received a one-time payment), and artists such as sports painter Leroy Neiman and Art Deco stylist Erte have become known more from prints than from their oil paintings.

Copyright confers several exclusive rights to an artist for the life of the creator plus fifty years: the first is the right to reproduce the copyrighted work; second is the right to make derivative works (making a motion picture from a book such as *Gone With the Wind*, for instance, or a poster from a sculpture); third is the right to control the first

sale of a work (of course, a buyer of a legally made copy may resell it); and last is the right to display the copyrighted work. The owner of a work has the right to display it to people who are physically present for the display, but people and institutions that borrow works have no right to display them without permission from the copyright owner. According to Paul Goldstein, a copyright expert at Stanford University Law School, "the copyright notice is like a 'no trespassing sign,' reminding people that the work is protected, and that helps to take away the innocence defense."

Artists may still bring legal action against infringers, but the amount of actual damages (generally, the infringer's net profit) awarded by a court are likely to be low—low enough to not even cover the artist's attorney's fees. An artist will be able to get injunctive relief—that is, stop the infringer from continuing to distribute the copies—and a federal marshal may be assigned to seize and impound the infringer's unauthorized copies.

The high cost of litigation may be a reason that few cases of copyright infringement in the visual arts are brought to court. "There is pressure on the artist to settle out of court," E. Fulton Brylawski, a Washington, D.C., copyright attorney, said, "but there is also the same amount of pressure on the infringer. There is not enough money in any of this to pay for the legal costs. When a claim is made, the settlement is usually easy to achieve, with the infringer paying a reasonable license fee to the artist."

The issue of how to publicize artworks has been a major area of tension among artists, dealers, and museums. Dealers and museums frequently seek to advertise works in their collections through brochures, postcards, and catalogues, as well as on the Web without regard for, and without displaying, copyright. The effect is to open the door for someone other than the dealer or museum to use the image to create reproductions without paying the artist anything or even asking for approval since the image has entered the "public domain."

There is, of course, "fair use" of a work of art, which usually refers to images that accompany a news article, parody, or critique or slides that may be used in teaching. Fair use, however, does not lessen an artist's ability to earn money or control the use of the image.

"To many elements of the art market, artists are tolerated as necessary evils, but a lot of people would be just as happy if all art were done by automatons," said Martin Bressler of the Visual Artists and Galleries Association, which acts as an agent for artists in negotiating licenses for publication of art and policing unauthorized use of their work. "Museums are the worst in this regard. To them, the best artists are dead ones with no estates. They don't like to pay royalties, either."

Bressler noted that museums, which are constantly in search of new sources of revenues, often treat works in their possession as though they were in the public domain, regardless of whether or not the objects are copyrighted. He cited the Baltimore Museum of Art, which made dinnerware, T-shirts, and tote bags using images from Matisse and Picasso without permission of the artists' heirs or estates, and the Art Institute of Chicago, which permitted a copyrighted scale model of a sculpture by Picasso to fall into the public domain when it exhibited the work without attaching its copyright notice.

Artwork can be registered with the Federal Copyright Office (Library of Congress, Washington, D.C. 20559-6000; 202-707-3000; *www.copyright.gov*). Registration prior to an infringement allows the artist to receive statutory damages of up to $20,000 for each work infringed, plus legal fees and court costs. One may call or write to request an application (Form VA for visual artists), which should be filled out and returned with a check for $45 along with a copy of the work (two copies, if the work has previously been published). A canceled check by the Copyright Office ensures that the work has been registered, and a copyright certificate will be sent out within four months. One may also submit a VA form online, submitting digital files and paying a reduced fee of $35.

While published works must be registered one at a time, unpublished works can be registered in groups for a single $45 fee. Also, valuable or unique art does not have to be deposited with the Copyright Office—instead, slides, digital images, or photocopies can be used.

A variety of copyright questions arise over time in an artist's career. There are a number of good sources of information, among which are the Visual Artists and Galleries Association (VAGA, 350 Fifth Avenue, New York, NY 10118; 212-736-6666; *www.vaga.org*) and the Graphic Artists Guild (32 Broadway, New York, NY 10004; 212-791-3400; *www.gag.org*) as well as any of the volunteer lawyers for the arts groups around the country. Basic information is provided to artists at no cost.

Below is a list of volunteer lawyers for the arts organizations around the country. In states where no such group exists, artists may contact the state bar association for the names of lawyers who handle arts and entertainment law matters, some of whom may take a case on a pro bono basis. (Those with asterisks have arts mediation programs, which provide an alternative to more costly lawsuits.)

CALIFORNIA
California Lawyers for the Arts
(Statewide)*
www.calawyersforthearts.org

Beverly Hills Bar Association Barristers
Committee for the Arts
300 S. Beverly Drive
Beverly Hills, CA 90212
(310) 553-6644
(310) 344-8720

California Lawyers for the Arts
(Oakland)
1212 Broadway, Suite 834
Oakland, CA 94612
(510) 444-6351
e-mail: *oakla@there.net*

California Lawyers for the Arts
(Sacramento)
926 J Street
Sacramento, CA 95814
(916) 442-6210
e-mail: *clasacto@aol.com*

California Lawyers for the Arts
(San Francisco)
Fort Mason Center, Building C
San Francisco, CA 94123
(415) 775-7200
www.calawyersforthearts.org

California Lawyers for the Arts
(Santa Monica)
1641 18th Street
Santa Monica, CA 90404

(310) 998-5590
e-mail: *usercla@aol.com*

San Diego Lawyers for the Arts
Craddock Stropes, Lawyers for the Arts
625 Broadway
San Diego, CA 92101
(619) 454-9696
www.sandiegoperforms.com/volunteer/
lawyer_arts.html

COLORADO
Colorado Lawyers for the Arts*
P.O. Box 48148
Denver, CO 80204
(303) 722-7994
www.coloradoartslawyers.org

CONNECTICUT
Connecticut Volunteer Lawyers
for the Arts
Connecticut Commission on the Arts
755 Main St.
Hartford, CT 06103
(860) 256-2800
www.ctarts.org/vla.htm

DISTRICT OF COLUMBIA
Washington Area Lawyers for the Arts*
1300 I Street, N.W.
Washington, DC 20005
(202) 289-4295
www.thewala.org

FLORIDA
Florida Volunteer Lawyers for the Arts
1350 East Sunrise Boulevard
Ft. Lauderdale, FL 33304
(954) 462-9191, ext. 324
www.artserve.org

Volunteer Lawyers for the Arts
of Pinellas County
14700 Terminal Blvd., Suite 229
Clearwater, Florida 33762

(727) 453-7860
www.pinellasarts.org/smart_law.htm

GEORGIA
Southeast Volunteer Lawyers for the
Arts*
c/o Bureau of Cultural Affairs
675 Ponce de Leon Avenue, N.W.
Atlanta, GA 30308
(404) 873-3911
www.glarts.org

ILLINOIS
Lawyers for the Creative Arts*
213 West Institute Place
Chicago, IL 60610
(312) 649-4111
www.law-arts.org

KANSAS
Mid-America Arts Resources
c/o Susan J. Whitfield-Lungren, Esq.
P.O. Box 363
Lindsborg, KS 67456
(913) 227-2321
e-mail: *swhitfield@ks-usa.net*

LOUISIANA
Louisiana Volunteer Lawyers for the Arts
225 Baronne Street
New Orleans, LA 70112
(504) 523-1465
www.artscouncilofneworleans.org

MAINE
Maine Volunteer Lawyers for the Arts
c/o Terry Cloutier, Esq.
477 Congress Street
Portland, ME 04101
(207) 871-7033
e-mail: *tcloutier@lambertcoffin.com*

MARYLAND
Maryland Lawyers for the Arts
113 West North Avenue

Baltimore, MD 21201
(410) 752-1633
www.mdartslaw.org

MASSACHUSETTS
Volunteer Lawyers for the Arts
of Massachusetts, Inc.
249 A Street
Boston, MA 02110
(617) 350-7600
www.vlama.org

MICHIGAN
ArtServe Michigan
Volunteer Lawyers for the Arts &
Culture
17515 West Nine Mile Road
Southfield, MI 48075-4426
(248) 557-8288, ext. 14
www.artservemichigan.org

MINNESOTA
Springboard for the Arts
Resources and Counseling for the Arts
308 Prince St., Suite 270
St. Paul, MN 55101
(651) 292-4381
www.springboardforthearts.org

MISSOURI
St. Louis Volunteer Lawyers
and Accountants for the Arts*
6128 Delmar
St. Louis, MO 63112
(314) 863-6930
www.vlaa.org

MONTANA
Montana Volunteer Lawyers
for the Arts
P.O. Box 202201
Helena, MT 59620-2201
(406) 444-6430
e-mail: *mac@state.mt.us*

NEW HAMPSHIRE
Lawyers for the Arts/New Hampshire
New Hampshire Business Committee for
the Arts (NHBCA)
One Granite Place
Concord, NH 03301
(603) 224-8300
www.nhbca.com/lawyersforarts.php

NEW JERSEY
New Jersey Volunteer Lawyers
for the Arts
c/o New Jersey Law Journal
230 Mulberry Street
Newark, NJ 07101
(973) 854-2924
www.amlaw.com

NEW YORK
Volunteer Lawyers for the Arts*
1 East 53rd Street
New York, NY 10022
212 319-2787
www.vlany.org

NORTH CAROLINA
North Carolina Volunteer Lawyers
for the Arts
P.O. Box 26513
Raleigh, NC 27611-6513
(919) 699-NCVLA
www.ncvla.org

OHIO
Volunteer Lawyers and Accountants
for the Arts-Cleveland
113 St. Clair Avenue
Cleveland, OH 44114
(216) 696-3525

Toledo Volunteer Lawyers and
Accountants for the Arts
608 Madison

Toledo, OH 43604
(419) 255-3344

OKLAHOMA
Oklahoma Accountants and Lawyers
for the Arts
211 North Robinson
Oklahoma City, OK 73102
(405) 235-5500
e-mail: *eking@gablelaw.com*

OREGON
Northwest Lawyers and Artists
Oregon Lawyers for the Arts
621 S.W. Morrison Street
Portland, OR 97205
(503) 295-2787
e-mail: *artcop@aol.com*

PENNSYLVANIA
Philadelphia Volunteer Lawyers
for the Arts
251 South 18th Street
Philadelphia, PA 19103
(215) 545-3385
www.pvla.org

ProArts
Pittsburgh Volunteer Lawyers
for the Arts
425 Sixth Avenue
Pittsburgh, PA 15219-1835
(412) 391-2060
www.proarts-pittsburgh.org/vla.htm

RHODE ISLAND
Ocean State Lawyers for the Arts
P.O. Box 19
Saunderstown, RI 02874
(401) 789-5686
www.artslaw.org

SOUTH DAKOTA
South Dakota Arts Council
(SDAC)
800 Governors Drive
Pierre, SD 57501
(605) 773-3131

TEXAS
Texas Accountants & Lawyers
for the Arts*
1540 Sul Ross
Houston, TX 77006
(713) 526-4876
www.talarts.org

UTAH
Utah Lawyers for the Arts
P.O. Box 652
Salt Lake City, UT 84110
(801) 533-8383

WASHINGTON
Washington Lawyers for the Arts
819 North 49th
Seattle, WA 98103
(206) 328-7053
www.wa-artlaw.org

As the art reproduction and multiples market has grown more and more in a world already overloaded with images, there is a declining need for the original work of art, much less its creator. Copyright represents the main way for artists to ensure their relevance in the art world—if they will use it.

COPYRIGHT AND THE INTERNET
This is a scene that could come from any of the past four centuries: an artist paints a picture and attempts to exhibit and sell the work. However, a scenario that has been only possible over the past decade is when the artist's image is scanned into a computer,

placed on the Internet, and downloaded worldwide, wherever someone wants a copy of the artwork.

Fortunately for Michael Whelan, a book illustrator in Danbury, Connecticut, a friend of his happened to be looking through a computer bulletin board when he happened to come upon a few of Whelan's images that were being offered for sale. Nowhere did it say that Whelan was the artist and, in fact, the copyright notice had been deleted. The images themselves had been somewhat altered with, in one case, mountains replaced by a sign that said, "Welcome to the World of Macintosh."

At least two copyright laws were violated by an unknown number of electronic services that had appropriated Whelan's work. If Whelan was lucky to have a friend find his work on a computer bulletin board, New York City illustrator Bill Lombardo was a little less fortunate. A friend found his work on a bulletin board but before he "could bring a lawsuit, the company that had done this had gone out of business."

It was slightly easier to steal Lombardo's work than Whelan's because Lombardo creates images directly on the computer—sending disks of his artwork to the companies that employ his services, which unfortunately allows anyone with access to these disks to copy his designs—whereas Whelan is a painter whose works were reproduced on or in books. To appropriate these, someone needs an electronic scanner to pick up the image from a book (or print or poster) where it becomes "digitized" within a computer.

The danger posed to an artist's copyright isn't a point of arcane concern for artists as most major advertising agencies, design studios, and magazines have this very advanced equipment. Picture resolution is so good with these high-powered computers that it is now far more difficult to determine which is the original and which is the copy than it was in the pre-computer past, when photographic reproduction was the main source of copyright infringement.

"The ability of so many people to gain access to an original work of art in this way [and] the ease with which images can be digitalized, manipulated, and then transferred overshadows the question of right and wrong for a lot of people," said Paul Bassista, executive director of the Graphic Artists Guild. "It is now so easy to do, and the chances of getting caught relatively nil, that people believe that infringing on an artist's copyright is basically OK."

New computer technology has presented a serious challenge to artists' copyright protections. Copyright, which refers to the right to make and distribute copies of one's artwork, involves the exclusive use of private property, while the computer world values usable and immediate public access. "The ethos of the Internet," said Marci Hamilton, a professor at Cardozo Law School of Yeshiva University in New York City, "is that anything online may be downloaded, cut, copied, and sent along to others."

The law gives artists the exclusive right to control their artwork, yet a new concept of what constitutes originality in a world where the ability of others to download images and make changes in them is so easy has been emerging. Proponents of traditional copyright protections are met by advocates of free access to information, who believe that more information disseminated widely is a public good and that it should be encouraged rather than impeded by antique legal concepts of limiting the use of

intellectual property. "The underlying theme is that copyright is rather ungenerous," Hamilton stated. "Increasingly, the courts have been saying that copyright should not prohibit the creation of interesting, original work."

A similar view was expressed by Ethan Katsh, professor of legal studies at the University of Massachusetts and author of *Law in a Digital World*, who noted that "the model that we have in copyright—I have this property, and I can control how this property is used for seventy-five years—is going to change." Katsh does not fault rap singers for "sampling," or borrowing, music from other singers' work as a violation of copyright, viewing the legally challenged practice as "fair use. I don't think sampling takes away from the market from the original work." Creating something does not mean controlling it absolutely. The new technology culture "tends to see that what you created was really built on something else," Katsh added. "The law should want to encourage people to take one thing and make something new out of it, and the question then becomes, When does something become new? That's a more interesting issue than, Should the original something be kept under tight controls?"

Technological changes have been so rapid that, as Michael Whelan said, "the law strains to deal with them. Artists can do everything correctly and still get ripped off, because it's hard to find the infringers, it's hard to go after them. What's more, it's not profitable to try and track down every single infringer. I'm annoyed that there are people out there who would require me to be a watchdog."

DOES "APPROPRIATION ART" TRANSFORM COPYRIGHTED MATERIAL?

Beauty, it is often said, is in the eye of the beholder, and so might be copyright infringement. Artist Richard Prince never denied that he made use of some photographic images he found in a 2000 book by Patrick Cariou called *Yes Rasta* (which documented the community of Rastafarians the French photographer encountered in the mountains of Jamaica) for collage paintings that were exhibited in 2008 at New York's Gagosian Gallery and reproduced in a book published by Rizzoli. The question is, was Prince's use of these images "transformative"—borrowing in the process of creating something that is entirely new—or just stealing? The copyright infringement lawsuit filed by Cariou against appropriationist Prince was one more battle in a growing war over what constitutes copyright infringement in these days of "sampling" and point-and-click downloading.

In his artwork, Prince scanned several of Cariou's images of people and landscapes into his computer and printed them directly onto his canvases, then defaced them in limited ways (placing an electric guitar in one Rastafarian's hands and daubing paint onto the face, for instance), as well as adding other elements to the paintings. Prince "didn't transform these photographs, he just used them," said Cariou's lawyer, Daniel Brooks, but it is Prince's contention that he took the photographer's images as raw material—in the manner of an assemblage sculptor's "found objects"—in order to create something that not only comments on the photographs' previous meaning but also gives them new meaning. Brooks noted that Prince could have avoided the problem

altogether by traveling to Jamaica and taking his own photographs that he would then scan onto his canvases, but the entire point of Prince's art is commentary on images that already exist in the world.

Other artists have stumbled into a gray area of the law, and it is quite likely that others will as well. "It's meant to be a gray area, because the copyright law is designed to be flexible," said John Koegel, a lawyer who successfully represented artist Jeff Koons in a similar infringement lawsuit by commercial photographer Andrea Blanch in 2005. "The law states that the use of a copyrighted image is transformative based on the ordinary lay observer's sense of if the new work is different and how different it is. It is very much of a visual thing, and there is no bright line that artists can go by."

In fact, Koons has been sued twice by photographers for copyright infringement, the first time in 1989 in a case that he lost, and the second time where he prevailed. In the 1989 case, a photographer, Art Rogers, had created a line of notecards with an image of a man and woman holding a litter of puppies, titling the picture "Puppies." Koons purchased one of these cards, tore off Rogers's name and copyright notice, and sent the card to Italian artisans (with whom he had worked in the past) with the instruction that they should copy the image as a sculpture, which was entitled "String of Puppies." Koons claimed that artistic freedom would be abrogated if artists could not make parodies or create work that somehow showed the influence of other artists. The court's reading of the copyright law, however, did not support Koons, finding that he had not parodied but simply copied the photographic image and "that Koons'copying of the photograph 'Puppies' was done in bad faith, primarily for profit-making motives, and did not constitute a parody of the original work." In the second case, Andrea Blanch's photograph, titled "Silk Sandals by Gucci," shows the lower part of a woman's bare legs crossed at the ankles, resting on a man's knee. The woman is wearing Gucci sandals, one of which dangles from her toes. The photograph appeared in an August 2000 issue of *Allure* magazine. Koons acknowledged that his painting "Niagara" copied the woman's legs, feet, and sandals, but omitted background elements in Blanch's photograph, inverted the image so that the legs are vertical (feet down) rather than horizontal, and added three other pairs of women's legs and feet. The judge in that case labeled Koons' use of Blanch's imagery "transformational," legitimizing Koons' actions under the fair use provision of the federal copyright law.

Working against artists, Koegel claimed, is the fact that "the law hasn't accepted two principals that are well understood in the art world. The first is that a change in medium is transformative. If you go from two to three dimensions, you are transforming something and it is experienced very differently than it had been. The second is that re-presentation is transformative; when you are taking something and making a comment on it, even when the thing you are commenting on is relatively unknown, that comment makes it protected as a fair use of a copyrighted image."

Like so much in the field of copyright law, those two principals are not absolute. Shifting from one medium to another is not a way of avoiding a lawsuit. For instance, turning a novel into a film makes a shift in medium, but without the permission of—and probably without a payment to—the author, the filmmaker would be in violation of the

writer's copyright because the author has the exclusive right to make "derivative" works or license the making of a film. "Where derivativeness ends and transformative begins is not at all clear," said Robert J. Kasunic, principal legal advisor at the U.S. Copyright Office in Washington, D.C. Also, he noted, a sculptural version of a copyrighted two-dimensional work would not necessarily be considered transformational if there weren't some element of creativity added to the new work. Similarly, justifying appropriation of copyrighted material on the basis of making a commentary or parody only works "if the average person can see" that some comment is being made, he said.

The ordinary viewer may not be familiar with the customs and logic of the art world, taking what they see at face value rather than with irony. It is that collision of two worlds that makes copyright issues fraught with uncertainty. Jessica Litman, a professor at the University of Michigan Law School, claimed that part of the reason that Koons lost the first case but won the second was that "the first time he came into court with a lot of art world attitude—'I'm the artist, I can do whatever I want'—and the second time he made a more reasonable statement about the kind of message that appropriation art sends. That goes a long way." The nature of the infringement was also different in the two instances, but the overall trend of court decisions between 1989 and 2005 (and the present) is to allow greater latitude for claiming that the new artwork is transformative. "There is more sympathy in the legal environment, maybe it has gone too far," Kasunic said.

There is no road map for artists whose subject matter includes existing images. To be safe, artists might request permission from the copyright holder of images they might use, although such a request might suggest that they knew they were infringing if a lawsuit is filed by a copyright holder who didn't agree to the use, although an artist then could counter that he or she sought to negotiate in good faith. What a headache. Koegel noted that there is no specific amount of changes to be made in a copyrighted image that allows it to be considered "transformed" into something else. Artists might want to consult a lawyer for an opinion on their artwork or "just to get a sense of the law." What constitutes copyright infringement, however, is determined on a case by case basis.

MAKING A COPYRIGHT SEARCH

In a world already filled with images, there is still a constant search for more. Publishers and entrepreneurs look for new designs for prints, posters, T-shirts and sweatshirts, wallpaper, coloring books, placemats, and almost any other flat surface on which an image may be printed. A publisher like Franklin Mint commissions artists to create new designs and buys all rights to the images, but others need to determine the copyright status of artworks they would like to use. As important as it is for artists to understand the protections that copyright affords them is comprehending the process by which someone else discovers the copyright status of their work.

As noted above, artists are most protected when the copyright notice is evident and their work is registered with the United States Copyright Office. Registration is required in order for an artist to bring an infringement suit and, if a work is registered before or within five years of publication—and, generally, before an infringement takes

place—the artist may seek statutory damages up to $20,000 (up to $100,000 if the infringement is ruled "willful") as well as attorneys' fees. The statute of limitations for bringing legal action against an infringer is three years. Considering the amount of money involved, artists should not be led to believe that, since affixing the copyright notice is now no longer strictly required, registering works of art most likely to be copied is optional as well.

The first place a law-abiding prospective copyright user would check is the Catalog of Copyright Entries in the Copyright Office, which is located within the Library of Congress. There, works are catalogued by title, author (or artist), and name of the copyright claimant if he or she is not the author. A search for work registered between 1870 (the first year that drawings, paintings, and sculpture were afforded copyright protection) and 1977 is made manually, and work registered between 1978 and the present is done on computer.

Registration of works of art before 1978 lasted twenty-eight years, with another twenty-eight years' renewal permitted. If that copyright was in its first twenty-eight-year term after 1978, the registration may be renewed for forty-seven years; if the copyright was already in its renewal period, the Copyright Office would extend the registration to ninety-five years from the date the work was first published. For works created within the past ninety-five years, a prospective publisher would want to know whether or not a work's copyright had been registered, to whom, and if it had been renewed (checking in the Catalog of Copyright Entries from twenty-seven through the twenty-nine years from the date of original publication). One may safely assume that works of art published more than ninety-five years ago are in the public domain.

The copyright law that was enacted in 1976 authorized copyright protection for works created on or after January 1, 1978, to last the life of the artist plus seventy years. For such works, one is advised to wait between seventy-five and one hundred years in order to reasonably assume that the copyright has fallen into the public domain.

So far, so good, but there are a variety of complications for those looking to use someone else's copyrighted images. John Singer Sargent's famous 1884 painting "Madame Gautreau" is in the public domain, but a particular copy of it—such as a photographic reproduction in an art history text—may be copyrighted in the name of the book publisher. A publisher of posters using Sargent's image might be found guilty of infringement unless it could prove that its "Madame Gautreau" wasn't taken from the textbook.

The work's title may have been changed or the piece may go by a different name—"Madame Gautreau" is also called "Madame X," for example. A prospective copyright user may be found guilty of copyright infringement for failing to know some basic art history. In addition, the copyright may have been reassigned by the artist or his or her heirs to one or more other persons (this company to make posters in North America, that company to produce posters in Europe, for instance) for short or extended periods of time. This information should be available in the Copyright Office's Assignment and Document File, if it has been recorded with the Copyright Office. In most cases, the transfer of copyright takes place privately between the artist and another party; on

occasion, the copyright has been reassigned more than once. Someone looking to use a copyrighted image may need to contact the artist, or whoever originally registered the artwork, in order to find out the names of the various parties with whom to negotiate.

In general, copyright searches are conducted by staff members of the Copyright Office at a cost of $20 per hour. Finding out whether or not a work of art has been registered and, if so, the date of its registration, the registration number, and who registered the work tends to take no more than one hour. A search of a copyright that has been assigned to someone else may take twice as long. There are a number of copyright attorneys and one company (Thomson & Thomson), all based in Washington, D.C., that do these searches for clients, charging more than the Copyright Office but also adding other services.

Although many works of art are registered each year, most are not, which means that a prospective copyright user will have a far more cumbersome search than simply looking through files and catalogues at the Copyright Office. Once again, a prospective copyright user would have to locate the artist (or his or her heirs) in order to either obtain permission or find out who currently owns the copyright.

TRADEMARK PROTECTION FOR ARTISTS

When is imitation not flattery? When the purpose of the imitation is to confuse the public and to undermine a better known artist's market. Some legal decisions have established a relatively new area of art law, protecting the trademark qualities of artists' work, such as the style and overall impression of the art.

Trademark law is usually associated with manufacturing or protecting a company's logo or other distinct mark, although it has been applied to the arts as rights of publicity, such as the face, name, signature, or endorsement of the artist. However, legal judgments have also extended trademark protection to "words, symbols, collections of colors, and designs." Trademark infringement is different from copyright infringement, and the artwork is not copied exactly or copied with only minor changes made (those are copyright issues), as it refers to aping significant elements of another artist's unique style.

Artistic style itself is not copyrightable—neither, for that matter, is perspective, color, medium, use of light, or subject matter—but the "feel" of the work is subject to trademark (in legal parlance, trade dress) protections under the Lanham Act. That federal statute, a law governing unfair competition, prohibits one individual or company from offering products or services that are confusingly similar to those of a competitor.

There is no fixed point at which one may claim that one artwork has been copied from another, and some judge or arbitrator will simply have to look at the two pieces for similarities that go beyond influence and conventions of the genre. In the legal cases that have been decided, compelling evidence has revealed specific intent to imitate another's work. Two of the most noted decisions have been for musical performers—Bette Midler and Tom Waits—who sued Ford Motor Company and Frito-Lay, respectively, as well as their advertising agencies, for hiring singers whose voices were very similar to Midler's and Waits's to sing songs identified with the noted performers for product commercials on television. Neither performer's name was mentioned, nor were the actual singers identified. However,

as neither well-known performer wanted to endorse these, or any other, products, the sound-alikes were found to have infringed on their trademarks, and the companies as well as their advertising agencies were ordered to pay substantial settlements and legal fees.

In the visual arts, there have been a number of decisions. One of these, in 1992, involved Israeli artist Itzchak Tarkay, whose painting was found to have been copied stylistically and thematically by another artist, Patricia Govezensky, at the bidding of an art distribution company, Simcha International. "At the trial," said Sondra Harris, one of the attorneys representing Tarkay, the "defendant's counsel mixed up works by Tarkay and Govenzesky. They were that close." There were no awards or damages assigned, she added, as "the company basically went out of business and, when Govezensky went back to painting, her work was in a completely different style."

Another case, decided in 1994, concluded that a Florida art dealer named Philip Wasserman persuaded a Florida sculptor, Dwight Conley, to create works in the unique "fragmentation" style of Paul Wegner. In that latter case, all of the waxes and molds for the offending Conley sculptures were ordered destroyed, the completed pieces turned over to Wegner along with payment of costs, damages, and attorneys' fees.

Consumer confusion may arise when similar-looking works are exhibited to collectors who do not immediately look for the artist's signature, according to Joshua Kaufman, who represented Paul Wegner. "Within a span of one week, Wegner received calls from three of his collectors who asked him, 'What happened to your work? It looks like it deteriorated.' They had seen Conley's imitations of Wegner's work from a distance and just assumed it was Wegner's. That can affect an artist's reputation as well as sales, if people think the quality has gone downhill."

Damage awards result from the fact that imitators' work is usually priced lower than that of the better known artist's, which also may affect sales.

Despite the degree to which artists attempt to find a unique mode of expression, similarities between artists' work, especially those working within the same genre or even at the same time, are bound to occur. Oliver Wendell Holmes once wrote that "literature is full of coincidences which some love to believe plagiarisms. There are thoughts always abroad in the air which it takes more wit to avoid than hit upon."

If so much art didn't look alike stylistically, at least to the non-expert, there would not have been a need for the decade-long Rembrandt Project, which deattributed 90 percent of the paintings around the world previously called Rembrandts. Museum labels in general tell the story of failed attempts at determining who painted which picture. This painting is the "school of" some Old Master, that picture was created by a "follower of" someone else. A designation of "workshop of" so-and-so gets one closer—the more famous artist may at least have seen the work or even participated in its creation in some minor way—but the creator's identity still remains unknown. Those disciples and followers were not accused of fraud unless they intentionally attempted to sell their own paintings as the work of the better known artists. The fact that many artists did not sign their works as well as the practice of apprentices learning to create in the style of their master artists resulted in headaches for later art historians.

Nowadays, deciding when one contemporary artist imitates the feel and impression of the work of another is not up to art experts but to judges of the legal system. There may be some factual evidence to rely upon: Did Artist B ever see the work of Artist A? When were the respective works made? Will someone admit to being told to stylistically copy another's work? Are there certain idiosyncracies or errors (misplaced thumbnail, for instance) in common? The strength of Paul Wegner's case rested on "sworn affidavits by three people who were on hand when Wasserman brought photographs of Wegner's work to Conley and said, 'make your work as close to these as you can,'" Joshua Kaufman said. However, in less clear-cut situations, much relies upon a judge finding a striking visual similarity between two works. In the Tarkay case, according to the written decision, the court examined "the color patterns and shading of the Tarkay works, the placement of figures in each of the pictures examined, the physical attributes of his women, the depiction of women sitting and reclining, their characteristic clothing I those portrayed by Patricia [Govezensky]" to find that "consumer confusion is a likely result."

The courts apply two main tests for trademark cases in determining whether or not one artist may have stylistically copied another: The first is establishing that the allegedly copied work is identified by the public with the particular artist (in legal parlance, the art has acquired a "secondary meaning"); the second is proving that the imitation is likely to cause confusion in the market. "What better for showing probable confusion than actual confusion," Kaufman stated. "Three people called up Wegner in one week."

COPYRIGHTED AND TRADEMARKED SUBJECTS IN ARTISTS' WORK

An artist sets up an easel at Times Square in New York City and paints a picture. Other than a passing thought as to muggers and pickpockets, the artist believes he has found in urban bustle a safe subject matter. But legal worries enter in: Am I infringing any trademarks by including company logos and advertising slogans, of which there are hundreds in Times Square, in the painting? Should the building owners and their architects be asked permission to include their buildings in the picture? If an image on a billboard, of which there are many in Times Square, is included in my painting, have I violated the copyright? If an individual on the street is recognizably portrayed in the picture, have that person's rights of privacy or publicity been violated? Should a lawyer have accompanied me to Times Square?

Lawyers hold differing opinions on these questions, and the issues are complicated by the way in which the finished artwork may be used and distributed and in what form. An original painting, for instance, has greater first amendment protections of free expression than a large edition of prints or images scanned onto limitless numbers of calendars or T-shirts. Artist Andy Warhol did not seek—nor was he required to seek—permission from the Campbell's Soup Company for his famous 1962 painting of a can of Campbell's soup because it was a non-infringing use of a trademarked label, created by Warhol in an artistic medium and displayed in an art setting. "The public was unlikely to see the painting as sponsored by the soup company or representing a competing product," said Jerome Gilson, a Chicago trademark attorney. "Paintings and soup cans are not in themselves competing products."

Freedom of commercial speech, on the other hand, is more restricted than artistic speech. "If Warhol had put the soup can image on T-shirts or greeting cards, he would have had more of a problem in defending a trademark infringement lawsuit because they aren't traditional artistic media," said J. Thomas McCarthy, trademark expert at the University of San Francisco School of Law.

He added that, by virtue of the volume and distribution of the T-shirts and greeting cards, Campbell's might have argued, "What's really selling the product is the product name rather than the artist's name or image? Therefore, people might have assumed that Campbell's authorized Warhol" to make T-shirts and greeting cards.

Many images are copyrighted or trademarked, and the legal use of them by artists is a matter of considerable debate; however, specific lawsuits are resolved not by an adherence to general principles but on a case-by-case basis. The issue of what artists may or may not legally be able to do came to a head in a lawsuit brought by the New York Racing Association against Averill Park, New York, artist Jenness Cortez and decided in 1997 by the U.S. District Court in the Northern District of New York. Cortez had painted horse-racing scenes since the mid-1970s, many of which take place at Saratoga Race Course in Saratoga Springs, New York. In addition to the original paintings, the artist markets a "Cortez Saratoga Collection" of lithographic prints.

Beginning in 1980, Cortez began to use her horse-racing images on greeting cards and, in 1992, on T-shirts ("art shirts" as they are called by the artist). According to the artist's husband and dealer, Leonard T. Perlmutter, the prints, cards, and T-shirts accounted for 80 percent of her annual sales during the early 1990s. The entirety of Cortez's work is sold either through a mail order catalogue sent out to past buyers or at an annual Summertime exhibition at the Holiday Inn in Saratoga Springs where her husband rents the ballroom for a one-person show. "We've never sold any works at the race track, and we've never asked to do so," Perlmutter said.

The New York Racing Association has federally registered trademarks on the words "Saratoga," "Saratoga Racecourse," "Travers," and "The Summer Place to Be," as well as for the logos for Saratoga and the racing association itself, all of which have appeared in one form or another on Cortez's work. Charging trademark infringement, the racing association demanded that she sign a licensing agreement for the use of these trademarked words and logos on the prints, greeting cards, and T-shirts or cease using them and the horse-racing scenes that suggest them.

The racing association claimed that her work gives the public the false impression that the organization sponsors or authorizes her work and undercuts the licenses signed with the fifty or so other artists and merchants selling horse-racing memorabilia (including keychains, notecards, pins, T-shirts, polo shirts, sweatshirts, and posters). "She is trading on our good name," said Steven Crist, director of communications and development for the New York Racing Association. "She is creating souvenir products very much like some of the merchandise sold by vendors with whom we have licensing agreements, and buyers are likely to be confused about which products we license and which we don't. This is purely a matter of protecting our licenses and our trademarks."

The artist contended in court papers and during the trial that her work represented the free expression of her ideas, and that the words and logos used are merely descriptive—that is, indicating a time and place—rather than suggestive of sponsorship. "The courts have always recognized that there is a difference between stealing a trademark and having one appear in one's work," Albert Schmeiser, the patents and trademark attorney representing Cortez, said. "In that regard, there is no trademark infringement. With regard to the question of whether an ordinary person would assume Cortez's work is sponsored by the New York Racing Association, there is no reason anyone would make that assumption. The work she creates has her name on it and isn't sold in the same way as the merchandise licensed by the racing association."

Trademarks are words, logos, or images (for instance, the Jolly Green Giant, Aunt Jemima, Betty Crocker, or Mickey Mouse) that specifically symbolize or refer to a company's products and services. The New York Racing Association cannot broadly assert the sole right to the town or name, "Saratoga." As Saratoga is the name of both a town and a county, the racing association's federally registered trademark cannot prohibit other companies (such as Saratoga Spring Water) from using the name Saratoga on their products. The racing association could not bar an artist from painting general scenes of horse-racing at the race course. The association, however, believed that images so specific to Saratoga Race Course as to be identified with the track, or which contained the trademarked words that symbolize the track, infringed upon the trademark by confusing the public as to the artist's sponsorship by the racing association. The court ruled that "even though plaintiff's registered marks appear in some Cortez paintings, the Court finds that the interest of free expression weighs conclusively in defendants' favor with respect to defendants' products displaying these paintings." She was enjoined, however, from using these same images for T-shirts and postcards without taking out a license, because these were more commercial and less artistic products.

There are not a lot of "precedents in this area," according to J. Thomas McCarthy, "No case law on point. Companies generally don't sue artists." Many other lawyers noted that much depends upon the particular image. "It's a gray area," said Tad Crawford, author of *Legal Guide for the Visual Artist*. "You don't always know how the public will respond; will it think the artwork is the product or an artwork?"

If the trademark is part of a street scene, he noted, the public is more likely to be warned that the image is something other than just a product. If there are a number of different companies' trademarks in an image, such as a street scene at Times Square, the public is unlikely to associate the picture with any one company.

In another victory for artists, this in 1999, the Cleveland, Ohio-based Rock & Roll Hall of Fame lost its attempt to prohibit Chuck Gentile from selling posters based on his photographs of the facility. Three years earlier, the Hall of Fame & Museum had sued the photographer for infringing on its trademark by selling posters of the I.M. Pei-designed building, and Gentile was initially ordered by a district court to destroy all of the works. However, a higher court overturned that decision, later affirmed by the U.S. District Court in Cleveland, claiming that "when we view the photograph in Gentile's

poster, we do not readily recognize the design of the Museum's building as an indicator of source or sponsorship. What we see, rather, is a photograph of an accessible, well-known public landmark."

The legal test for trademark infringement is what the "ordinary person" is likely to believe, and there is no rule of thumb concerning how much of the image may be taken up by the trademark before an artist is apt to lose an infringement lawsuit. "Is the trademark an incidental use as part of the scenery or so prominent that someone might think the trademark owner had something to do with the picture?" said William M. Borshard, a New York City trademark lawyer. "The principles of these laws are clear and easy to state, but the application of those principles to fact is not at all so clear."

Borshard added that difficulty in knowing in advance what may be deemed trademark infringement is compounded by the fact that judges generally have different beliefs as to how much protection a trademark deserves. "On one side, there is the view that trademarks help consumers distinguish between products, which is helpful in our free enterprise economy," he said. "The other view is that trademarks are anti-competitive in that they cause consumers to behave irrationally, selecting one product over another when both are identical. Judges take one side or another on the issue of trademark. The 'ordinary person' turns out to be the judge, and you don't know what kind of judge you'll get on any given day."

Just as a trademark may find its way into an artist's work, so might a copyrighted image, such as a billboard image or someone else's artwork. In general, an artist cannot use copyrighted subject matter unless as "fair use," that is, as commentary or criticism. Just as with trademark infringement, the legal test is whether or not an ordinary person would believe that mere copying has taken place.

The two main concerns the courts would have in evaluating a fine artist's fair use of copyrighted material are how much of the material is used in the artist's work and how does the use affect the value of, or market for, the copyrighted work. It is unlikely that a painting of Times Square that contains a large billboard for, say, Calvin Klein sportswear will affect the market for that clothing, yet the artist may still have violated the manufacturer's copyright—and is subject to fines—for including too much of the advertisement prominently in his or her painting.

Most paintings of Times Square are apt to include people and buildings, and both people and building owners may object to their recognizable inclusion for whatever reason. People generally have the law on their side; in most cases, the building owners do not.

The right to privacy is the right to be left alone, and an individual cannot be recognizably included in an advertisement or for commercial uses (such as in a painting or fine art photograph) without his or her consent. That permission is not required for news publications or specifically educational purposes. An artist, however, would have to either persuade the individual to sign a model release form—which may be difficult to achieve, especially when the person doesn't know the artist or the artist's intentions—or disguise the individual in such a way that no specifically recognizable characteristic is visible.

People who are not famous have no significant right to publicity, that is, the right to benefit from the commercial value of their name and image. This right applies to celebrities, living and dead, who may sue to stop the use of their pictures where they have not been authorized. Again, publications may use their pictures as part of news accounts, and a celebrity's picture is generally allowed in single and original works of fine art, but a more commercial use—such as on greeting cards or T-shirts—would likely invite a viable legal challenge.

Animals, such as dogs or even race horses, have no rights of privacy or publicity. Their owners, however, may prohibit an artist from access to the animals in order to create a likeness. Buildings and other inanimate objects also have no rights of privacy, and an artist can freely paint the exteriors, although an owner may charge an artist with trespassing if the artist enters the property grounds uninvited. On the other hand, an artist would likely need permission to paint the interior of a building, especially if entrance admissions are charged.

"There are a lot of competing rights, and it is difficult to say without looking at a particular picture whether or not an artist is violating someone else's rights," William Borshard said. "It probably isn't a bad idea to let someone, like a lawyer, look at your work to make sure everything is OK."

ARTISTS' MORAL RIGHTS
As noted above, the Visual Artists Rights Act of 1990 represented a sea change in the legal protections afforded to artists by the federal government. The law is based on legal concepts established in French law for decades, including the right to determine when a work has been completed (first brought to court by James MacNeil Whistler in 1900, later tested by the heirs of Georges Rouault), the right to always have one's name credited with the work (including advertisements), and the right to prevent one's work from being shown in a way that might harm the artist's reputation (tested in the French courts by painter Bernard Buffet in 1962).

"Moral rights" statutes reflect a changing view of property rights in this country, at least as far as artwork is concerned. Allen Sieroty, former California State Senator who sponsored the nation's first state "moral rights" law for artists in the mid-1970s, stated that "Americans are very concerned with private property and, when we were pushing through the legislation, we were constantly asked whether the concept serves as a deprivation of private property since artists will still retain an interest in their works. We had to convince legislators that there are already restrictions on the use of private property. Just think about what zoning is."

One of the first highly publicized instances of intentional distortion of a work of art occurred in 1958 when a black-and-white mobile by Alexander Calder, displayed in a building at the Greater Pittsburgh International Airport, was turned into a stationary sculpture and painted the city's official colors, green and gold. A few years before that, sculptor David Smith condemned a purchaser of one of his painted metal sculptures for "willful vandalism" for removing the industrial green paint and, in 1980, the Bank of

Tokyo outraged the art world when it removed a 1,600-pound aluminum diamond-shaped sculpture by Isamu Noguchi that hung in the bank's New York City headquarters by cutting it into pieces.

The problem hasn't been wholly confined to sculptors (a mural by Arshile Gorky at the Newark [New Jersey] Airport was subsequently whitewashed, and a painting by Pablo Picasso was cut into numerous one-inch square pieces to be sold through magazine advertisements as "original" Picasso works of art by a couple of entrepreneurs in Australia). One of those Australians commented at the time, "If this works, we're going to put the chop to a lot of old masters."

Mutilation or destruction of an artist's work (for which the artist owns the copyright) is now considered an infringement on copyright, and artists are able to sue for both compensatory (out-of-pocket) and statutory (up to $20,000) damages as well as actual damages. Those actual damages refer to harm caused an artist's professional reputation by the destruction or distorted appearance of his or her work.

This kind of copyright infringement would not be a criminal violation—the copyright law does include possible jail terms and fines for instances of commercial exploitation, such as bootleg films, books, or records—since the damage or destruction of artwork is seen as an area for civil litigation. An artist must hire an attorney to bring action against someone altering or destroying his or her creations.

The general term of copyright protection does not apply to the moral rights created in this new federal law. Instead, the moral rights last for the life of the artist, the same period of coverage for invasion of privacy, libel, slander, and defamation of character. One aspect of the law that is of particular interest to muralists and wall sculptors concerns artwork that is attached to a building, and there are special rules that balance the rights of artists and property owners. The owner of a building on which artwork is attached is required to notify the artist that the work should be removed if it can be removed. The building owner is to write to the last known address of the artist or, if there is no response, to the Copyright Office in Washington, D.C. A special department within the Copyright Office has been created by the Visual Artists Rights Act for the addresses of artists, and artists are advised to send a current address there.

Once the artist is notified that the building owner wishes the artwork removed, the artist has ninety days to remove it (at his or her own expense), at which point the artist regains title to the piece. If the artist fails to collect the artwork, or it cannot be physically removed, or the artist cannot be located, all rights under the Visual Artists Rights Act are negated.

WAIVING ONE'S RIGHTS

The law in Missouri is quite clear: if an art dealer sells an artist's work, the dealer must pay the artist what is owed and not use the money for any other purpose, except if the artist says it's OK to do so. The exception is known as waiving one's rights, and it is explicitly stated or implicit (not forbidden) in the artist-dealer consignment laws in the thirty states (Alaska, Arizona, Arkansas, California, Colorado, Connecticut, Florida,

Georgia, Idaho, Illinois, Iowa, Kentucky, Maryland, Massachusetts, Michigan, Minnesota, Missouri, Montana, New Hampshire, New Jersey, New Mexico, New York, North Carolina, Ohio, Oregon, Pennsylvania, Tennessee, Texas, Washington, and Wisconsin) and District of Columbia that have enacted them. "An artist," according to Missouri's 1984 law, "may lawfully waive the provisions . . . if such waiver is clear, conspicuous and in writing, and signed by the artist who is the consignor."

The ability to waive one's rights is not uncommon in the law, and waivers are written into numerous municipal, state, and federal statutes, as well as private agreements. (Almost every ski resort, for instance, requires skiers to sign a document that reads, "I have read and understood this release prior to signing it, and I am aware that by signing it I am waiving certain legal rights which I or my children or my or their heirs, next of kin, executors, administrators, assigns, and representatives may have against" the resort operators.) It might seem counterproductive for legislators to pass a law that corrects a problem, only to include a clause that allows the law to be circumvented, if both sides agree. However, practical considerations enter in: in some cases, allowing such a clause may have been the only way that enough legislators could be brought to support the statute. Allowing certain provisions in a law to be waived may also provide greater flexibility as the two parties to an agreement negotiate.

The 1990 federal "moral rights" statute, called the Visual Artists Rights Act, which aims to prevent the destruction or alteration of artwork without the consent of the artist, allows artists to waive those rights; in the case of public art commissions, waiving those rights is often a precondition for signing a contract with a commissioning agent. Economic pressure, therefore, is a principal reason for artists signing away the rights that others have worked hard to give them, the result of an unequal balance of power.

Recognizing the imbalance of what is right and what is powerful, some state laws contain a clause specifically prohibiting the signing away of rights. Illinois's 1985 Consignment of Art Act gives voice to the concern for artists in standard legal parlance: "Any portion of an agreement which waives any provision of this Act is void." Still, the seemingly ironclad law provides dealers with an out: the amount due an artist after the sale of artwork "shall be paid to the artist within thirty days of receipt by the art dealer unless the parties expressly agree otherwise in writing." Other states with no-waiving clauses also appear to make allowances for what had previously been outlawed if both sides provide a written amen. "A consignor may not waive his rights under this act unless the waiver is clear, conspicuous, and in writing," New Jersey's 1987 Artworks Consignment Act declares.

There are times when artists themselves look for others to sign away their rights. When artists hire someone to photograph their artwork, the photographer technically owns the copyright to the pictures taken, as well as the negatives. Regardless of how much advice and direction an artist provided in setting up the shoot, even paying for the photographer's time and materials, and despite the fact that the photographer could not

have taken the pictures without the permission of the artist, all the artist has purchased is a print (or slide) for personal use. The artist continues to own the copyright to the underlying artwork but could not make duplicates of the photograph or distribute them without the permission of the photographer, and the photographer could require the artist to license the image or set additional charges based on the use of the image.

The likelihood of artists and fine art photographers finding themselves locked in a legal contest is slim, but it would be eliminated completely if both sides signed an agreement that stipulates all of the uses the artist plans to make of the image (such as posters or prints, postcards or brochures, and T-shirts) in exchange for a negotiated payment. The artist might also seek the photographer sign away ownership of the copyright, in order that unspecified uses of the photographic image could take place without needing to renegotiate.

A similar situation arises when an artist works with a print studio or a sculpture foundry to create an edition. The studio or the foundry technically owns the copyright to the edition; even though the prints or sculptures are based wholly on an artist's copyrighted image or model, the technical know-how of the people involved in their creation has been seen by the courts as adding an element of originality, establishing a separate area of copyright ownership. As copyright owners of what is called a "derivative work," the studio or foundry enjoys the traditional right to reproduce, display, and sell the works. However, as a point of law, the derivative work cannot be completely separated from the underlying art, requiring the printer to obtain permission from the artist to fully utilize the privileges of copyright: the studio or foundry gains a right it cannot exercise. Still, the ownership of that copyright matters. If the copyright of the derivative work were infringed and the print studio or sculpture foundry did not pursue a legal action, the image could slip into the public domain, greatly damaging the artist's economic interests. The artist would be reliant on the studio or foundry to pursue a case where it did not have its own financial interests. James Silverberg, an attorney with the Washington, D.C., law firm, the Intellectual Property Group, stated that the matter is clarified and simplified when the artist is the sole copyright owner for both the copies and the underlying artwork. He noted that the written agreement between the artist and studio or foundry should include a statement, such as, "The artist shall own all rights, title, and interest into the copyright subsisting in the work produced for the artist by the printer."

As a practical matter, it is unlikely that a print studio or sculpture foundry would look to undercut the artists on whose patronage they rely—a bad reputation could destroy its business. More likely than a copyright dispute would be a breach of contract; for instance, if the artist orders the creation of an edition from the studio or foundry and does not pay, the studio or foundry may be permitted to sell the works that it produced in order to earn the money it is owed and, perhaps, also sue the artist for the difference, if the sales do not generate enough income.

Again, the contract between the artist and print studio or sculpture foundry should stipulate either that copyright of the derivative work is reassigned to the artist or

that the technicians are employed on a work-for-hire basis. Such a clause would probably not require any additional payment, while providing clarity to the question of who owns copyright of the actual work.

A final area of remote but potential concern is in the area of joint authorship of a work of art. Many artists use assistants who participate in the creation of the actual artwork, and these helpers may have reason to think of themselves as equal co-authors of the piece, even if their contribution was not equal. As such, they are also co-owners of the artwork's copyright, and as such, have the power to license and distribute it. According to Judith Bresler, a lawyer and co-author of *Art Law* (Practicing Law Institute), a simple letter of agreement between the artist and assistant, signed by both, should clarify that "the assistant is employed on a work-for-hire basis and that copyright vests with the artist."

CONFUSION OVER THE TERM "SITE-SPECIFIC"

There are various terms used commonly in the art world that mean something within the art world but to no one else. Art dealers may refer to a painting or sculpture that is "houseable," meaning that it fits onto a normal living room wall, and museum directors solicit "fractional gifts" of valuable artwork when they mean the whole thing. Yet another is the art world concept of, "site-specific." It refers to a work of art that is placed in a particular location and only fully meaningful in that location; removing a site-specific work from one place to another presumably would diminish it by altering its context. As much as this makes sense to some artists, it has not won over courtroom judges. A specific courtroom in Boston, where local sculptor David Phillips brought a lawsuit against Pembroke Real Estate for wanting to rearrange the placement of twenty-seven sculptures he had been commissioned to create for Eastport Park in the South Boston Waterfront District, decided against the artist as have several others. Phillips had been commissioned back in 1999 to create small and large abstract and representational sculptures for the park, which was opened to the public the following year. However, in 2001, citing a desire to improve public walkways through the park and increase the number of plants, Pembroke decided to redesign the park, placing Phillips's sculptural elements in storage until the job was completed, at which point the pieces would be relocated where they seemed most appropriate in the new design. Phillips sued Pembroke under the 1990 federal Visual Artists Rights Act, scoring one brief win and two decisive losses. In 2003, a local district court agreed with Phillips that his sculptural elements were site-specific, meaningful only in the particular locations in which the artist had originally placed them, and that changes to his layout violated the integrity of the entire work, thereby damaging it. Two subsequent appellate rulings, in 2004 and 2006, reversed the earlier decision. The Visual Artists Right Act "does not apply to site-specific art at all," the U.S. Court of Appeals affirmed in August, 2006, adding that "the plain language" of the law "does not protect site-specific art."

This is not the first courtroom defeat of site-specific as a type of legal right. A federal court ruled in 2008 that a flower garden that artist Chapman Kelley planted in

1984 and maintained thereafter in Chicago's Grant Park, which the City of Chicago reduced by half in order to create a public walkway, was not art enough to be protected by copyright law and as a site-specific artwork. In a more notable case, Sculptor Richard Serra described his 147-foot-long "Tilted Arc" in New York City's Federal Plaza as site-specific and deserving of legal protection when the General Services Administration, which had commissioned the piece in the early 1980s, decided to remove it later that decade. Seattle painter Michael Spafford also claimed that his "Twelve Labors of Hercules" mural in the state House of Representatives chamber was site-specific and could not be removed legally. Both artists sued and lost. Other artists have had the same experience, but has the art world actually learned anything?

The term site-specific has become standard usage in art-speak. New York City's Guggenheim Museum's Web site offers this definition: "Site-specific or environmental art refers to an artist's intervention in a specific locale, creating a work that is integrated with its surroundings and that explores its relationship to the topography of its locale, whether indoors or out, urban, desert, marine, or otherwise." The term would appear to have all the descriptive validity as other art terms, such as "cubist," "mixed-media," or "assemblage," yet the validity of those words don't get decided in court.

In part, the site-specific argument has lost in these Visual Artists Rights Act trials because the federal law identified site-specific as an area that the statute does not cover. Additionally, the term is overly subjective, relying wholly on an artist's report and not on more objective criteria. (Richard Serra has produced quite a few commissioned long, torqued pieces of leaning rusted metal; what was so specific to Federal Plaza about "Tilted Arc"?) The law prohibits "any physical defacement, mutilation, alteration, or destruction" of fine art. In reversing the decision of the lower court, the Massachusetts Supreme Court found in 2004 that Pembroke's actions in no way constituted physical damage or change: "The harm presented is decontextualization." We are a long way from chopping up a Picasso into a thousand tiny squares of canvas or making a Calder mobile into a stationary object, some of the key examples that were offered when the law was passed in 1990. Congress understood when enacting the Visual Artists Rights Act that defacement and alterations that are contrary to an artist's intentions could damage the artist's career and financial prospects, that they could be "prejudicial to his honor or reputation." "Decontextualization," on the other hand, theoretically might make some viewers of art less capable of understanding it, but failure to comprehend has rarely damaged an artist's reputation. (Far more people have praised Jackson Pollock's paintings than have understood them.)

Artists, of course, are able to protect the placement of their work by writing into their commissioning agreements that the statues must stay exactly where the artists placed them, unless they concur in any changes or their removal. (These stipulations would only apply to the next owner when, for instance, a building with a commissioned mural on one side is sold to someone else, if the agreement is recorded on the deed or if the new owner is told of the stipulation—otherwise, it is not binding.) It is common practice for commissioning bodies to include a clause in these agreements stating that

the artists waive their rights under the Visual Artists Rights Act, which may permit owners to get rid of an artwork they no longer want. A principal reason that Richard Serra lost his lawsuit against the General Services Administration was that the federal agency's contract with him included a clause allowing the GSA to remove it. Serra's First Amendment and artists' moral rights claims proved irrelevant when held up against a contract he had signed. Similarly, the state of Washington had signed a contract with Michael Spafford pledging not to destroy, damage, or alter his mural, but removal was never barred. The artist's First Amendment case against the state only persuaded arts supporters.

Freedom of speech and moral rights, however, are codified in law, whereas site-specific continues to exist as an art world shibboleth—meaningful within a small group but somehow not connecting with a larger society accustomed to regular changes, renovations and overhauls in its physical environment, as well as generally the right of property owners to do what they want with what's theirs. The Visual Artists Rights Act reflects a compromise between protecting an artist's work (and thereby, his or her reputation) in perpetuity and basic property rights.

"Artists should realize that calling a work site-specific has no magical effect," said John Henry Merryman, an art law authority and professor at Stanford University Law School. "Some day, the courts may reach the conclusion that moving a sculpture from one site to another violates its integrity, but it hasn't happened yet."

This split between how the art world and the law view the issue of site-specific may not be so deep after all, and it is not clear that the art world offers more than lip service to the concept. The fact is, the art world doesn't believe in site-specific as an absolute either. One regularly sees religious paintings and icons that were created for churches and had long resided in churches now exhibited under glass in museums. Perhaps their meaning changed—from awakening a feeling of devotion to something judged primarily by aesthetic criteria—or its original value was lost over time. A number of American museums (most notably, the Metropolitan Museum of Art, the Boston Museum of Fine Arts, the Getty Museum, and the Cleveland Museum of Art) have grudgingly agreed to return certain illegally acquired archaeological objects to the Italian and Greek governments, because those pieces could be shown to have been looted from underground sites and smuggled out of these countries. However, neither the Italian and Greek governments nor the archaeologists who have taken up the cause of cultural repatriation have any plans of putting these objects back into the ground, where presumably they have some "context." Something that was removed from a sarcophagus won't go back to the sarcophagus. The objects will again go into museums, just different museums, and scholars will do their customary job of providing context through labels.

THE RIGHT TO PRIVACY

What could seem more natural and time-honored? An artist takes an easel and paint set out to a field (a park, a beach, the woods, a city street—whatever) and paints the view. What could seem more representative of a litigious society? The same artist rushes

around to every person found in that view, waving a "model release" form and asking for signatures as protection against any lawsuit charging invasion of privacy and publicity.

Perhaps, the description is a bit overstated: artists aren't being hauled into court every time they include a recognizable face in their work, but the growing sense that one's likeness is a "property" that can be commercially exploited has led many artists to feel less secure in pursuing realistic figurative images.

Competing interests are at stake, the artist's right to free, creative expression and a subject's right to control how a likeness is used. In general, the artist's right is constitutionally protected by the First Amendment to the U.S. Constitution, but both artist and subject have economic interests in a likeness—the artist to sell the image in the form of a painting, sculpture, or print; the subject potentially to sell the visage to fans as posters or as a product endorsement—and the battle is played out on the state level over the right of publicity.

Unlike a federal statute, which supercedes state laws, the right of publicity (and of privacy) is wholly determined by each state, and there is significant variation from one to the next. Some state publicity statutes make specific exceptions for artwork, while others do not. Indiana exempts artwork in its statute, but New York case law has specifically extended the law to protect the first amendment rights of artists, which includes multiples (print or sculpture editions), while Indiana's law only stipulates one-of-a-kind pieces. On the other hand, in limited circumstances, California allows the image to appear on a T-shirt or some more commercial medium. California, Florida, Indiana, Kentucky, Nebraska, Nevada, Oklahoma, Tennessee, Texas, and Virginia allow publicity rights to be transferred. A number of states hold that the right of publicity ends with the subject's death, while almost all the states with publicity rights statutes permit the right to be inherited. Florida, for example, extended the right of publicity to forty years following the individual's death, while Indiana and Oklahoma allow one hundred years, and Tennessee crafted its law in 1984 to enable heirs, such as Elvis Presley's, to control the use of a name and a likeness indefinitely. In addition, Washington's and Indiana's statutes provide retroactive publicity rights protection of fifty and one hundred years, respectively. State right of publicity laws include minimum or statutory penalties for unauthorized use of a name or likeness—California's is $750, Indiana's is $1,000, Washington's is $1,500, and Texas's is $2,500—as well as reasonable lawyer's fees and possible punitive damages.

Uncertainty can develop when artists sell works outside the borders of their own states, for instance, at an art fair or gallery. "I advise my clients, wherever they live, to comply with the most restrictive state laws" of publicity, said James Silverberg, an intellectual property lawyer in Washington, D.C. The Internet also may create jurisdictional problems if collectors in one state may purchase works from the Web site of an artist living in another state, depending upon whether the site is active (allows one to buy pieces directly) or passive (requiring buyers to contact the artist).

A number of high-profile contests have been waged in the courts—model Cheryl Tiegs versus Mihail Simeonov in New York, Tiger Woods versus Rick Rush in Ohio,

and Comedy III Productions, Inc. (owner of the rights to *The Three Stooges*), versus Gary Saderup in California, all of which were won by the artists—but the right of publicity exists for everyone, not just the well-known (although celebrities have a greater economic stake in their names and likenesses). As a result, artists setting up their easels in a field or park with the plan of including in their compositions one or more persons they see may choose to change certain elements in their depictions that make the setting or subject less recognizable with different clothes, different pose, or different face or hairstyle. However, those changes may act to destroy the inspiration that led them to depict the scene in the first place. The alternative is to bring a model release form that a subject would sign before beginning the artwork.

Model release forms are used regularly by photographers in advertising and illustration, and they offer protection to both the model and photographer. The model knows precisely the use that will be made of the image (a book cover, for instance, but not a pornographic Web site), and the photographer is protected from any claim of having violated the subject's right of publicity. A standard form indicates that for the payment of a certain amount of money, the model irrevocably assigns to the photographer the use of the image for advertising, trade, or any other lawful purpose and waives any right to inspect or approve the finished version. If the model is a minor, a parent or guardian signs the release form. The agreement is irrevocable, protecting the photographer in the event that the model changes his or her mind, and waiving the right to inspection or approval insures that the photographer has full artistic control over the final product. The more specific the form, the less likely that the parties will find themselves in court arguing over what they agreed to.

Fine artists and their models have the same needs and requirements. The release form that artists would offer to a prospective model provides them with a maximum level of flexibility, such as the ability to use the image in all forms, media, and manners of use. That might include exhibitable sketches and a final painting, as well as a print version of the image, the use of the image on the artist's advertising brochure or Web site, and on T-shirts. The artist might also be able to license the image to a company that manufacturers calendars or notecards, among other items. A well-regarded sample model release form may be found in Tad Crawford's *Business and Legal Forms for Fine Artists* (Allworth Press). Less clear is how willing people in a field or park might be to sign a legal document thrust at them by some artist they don't know, giving the artist a lot of leeway and them none. (James Silverberg, who strongly recommended artists carry with them carefully worded model release forms, was himself silent on the question of whether or not he would ever sign one if an artist approached him.) There may need to be a fair amount of discussion between artist and subject about what the artist has in mind and even some last-minute rewriting of the release form.

Not every artist worries about being sued or getting every agreement in writing. Baltimore, Maryland, portrait artist Simmie Knox, whose Web site contains a gallery of past subjects, doesn't get written permission to upload the portraits, "but I get a verbal OK. I know to ask," and New York City artist Will Barnet claimed that the subjects of

his paintings are "often happy to have him reproduce their images elsewhere. They like what I've done." However, North Salem, New York, painter Daniel Greene was once threatened with a lawsuit by a woman who had commissioned him to create a full-length portrait that he used on the cover of a brochure and in a magazine advertisement. Though she was pleased with the actual painting, she did not want to see herself on public display. "I decided not to use that image anymore," he said, adding that "I now ask permission if I plan to reproduce the image on a brochure or ad."

Pop artist Andy Warhol made a career out of creating likenesses of famous people—Marilyn Monroe, Jacqueline Onassis, and Elvis Presley, to name just a few—but was never sued for violating their privacy rights. In part, according to Washington, D.C., lawyer Joshua Kaufman, it was understood that "the celebrity image is the raw material, and a collector is buying the work because of the artist, the artistic elements that Warhol brought to the subject." Additionally, he noted, "the right of publicity was not developed or enforced very much." The more recent court-defined test of whether the use of a likeness intrudes on publicity rights developed from the *Three Stooges* case, in which it was found that Gary Saderup's charcoal drawing of the three characters was not in competition with other *Three Stooges* memorabilia.

Warhol, however, may have been fortunate to have created these works in the 1960s, before most states had even enacted laws protecting the right of publicity. Right of publicity statutes were first adopted in the 1950s as an outgrowth of privacy laws, and currently thirty-five states have publicity laws (eleven other states have case law on publicity but no statutes, while the remaining four states have no statutes or common law). Privacy has been defined as "the right to be let alone" and protects individuals against unreasonable intrusion, publication of private facts, and being "held in a false light in the public eye"—in effect, to protect the individual's feelings and reputation. Publicity laws, on the other hand, are property rights protecting an individual's ability to make commercial use of that person's name or likeness. Had Andy Warhol begun his career now, he might have come up against celebrities who are far more savvy about how their names and images are used.

"We've become a very litigious society," James Silverberg said. "People can always make a claim, and it can be very expensive to defend against it. Art has become a hazardous endeavor. If you think walking on a scaffold thirty feet off the ground is dangerous, be an artist."

SIDEWALK ART
In the movie *Mary Poppins*, everyone was charmed by Bert, the chimney sweep, kite seller, and sometime artist whose sidewalk chalk pictures opened up into adventures. Real-life artists, however, often find that the world offers them and their work a quite different reception when sidewalks are involved. Drawing on a sidewalk is generally viewed as a form of defacement, comparable to graffiti and punishable by fines and imprisonment. (A sample ordinance by the City of Pineville, Louisiana, states, "It shall be unlawful for any person to write upon, paint signs upon, advertise upon, or in any

other manner whatsoever, deface the sidewalks or streets within the city"—art and advertising are viewed as one and the same.)

Artists who look to sell their work on sidewalks or in parks may find that the world is only slightly more tolerant and often just as willing to threaten fines or jail terms. (For instance, the ordinance in Hattiesburg, Mississippi, states: "It is hereby declared to be a public nuisance and it shall be unlawful for any person to solicit, accost, or canvas persons on the streets or sidewalks of the city for the purpose of selling any books, wares, merchandise, or articles of any description. Such practice is hereby declared to be obnoxious to the personal rights, convenience, and privileges of the public and is further declared as impeding orderly traffic the streets and sidewalk.") In some instances, store owners are the ones who complain the loudest, saying that they have to pay real estate taxes and should not have to compete with sidewalk vendors who don't. Some city leaders liken street vending and performances to panhandling, disturbing the peace, and generally blocking traffic. In Portland, Maine, the main objections to artists selling *en plein-air* appear to be safety—an easel, table, or display rack could hamper pedestrians, forcing walkers onto traffic-filled streets—and liability, in the event of someone tripping over an easel. Some artists were fined, while painter Ian Factor was told by Portland police to "move along." He actually had not been selling work but had set up his easel on a sidewalk outside his studio in order to paint a scene of some nearby street musicians when police confronted him with the question, "'You have a permit for that?' I said to them, 'This is a joke, right?'" It was no joke: city fines for placing a table, chair, or—in this case—an easel on city property, such as a sidewalk, without a permit range from $50 to $500, and the cost to obtain such a permit is $225.

Selling artwork on a sidewalk or in a park is not for every artist. "Given the choice, artists would prefer to sell their work in a gallery [rather] than on the street," said Andy Frankel, executive director of Philadelphia Volunteer Lawyers for the Arts, "but it is an option that does come up." It is the preferred manner of selling for New York City mixed media artist Robert Bery, who noted that "selling on the street is sometimes equivalent to a good outdoor art festival. Sometimes, you can be at a good festival, but no one is buying anything." He noted that his income from sales is good, "I pay taxes, I have an accountant," and he doesn't need to split the selling price with a dealer.

The issue of whether or not artists need permits to sell their work on the streets has been popping up with increasing frequency all over the United States, including Boston and Cambridge, Massachusetts; St. Augustine, Florida; Salt Lake City, Utah; Hollywood, San Diego, and San Francisco, California; Portland, Oregon; and Seattle, Washington. Dozens of "street artists" were arrested in New York City during the 1990s as part of then Mayor Rudolph Giuliani's campaign to improve the city's quality of life, but a number of them—including Robert Bery ("I was arrested quite a few times")—brought lawsuits against the city. In 1996, the U.S. Court of Appeals ruled in his favor, claiming that the constitution's first amendment protects not only the right to create art but the right to sell it. "Furthermore," the court held, "the street marketing is in fact a part of the message of appellants' art. As they note in their submissions to the

court, they believe that art should be available to the public. Anyone, not just the wealthy, should be able to view it and to buy it. Artists are part of the 'real' world; they struggle to make a living and interact with their environments. The sale of art in public places conveys these messages." The court also found that New York City issued new permits to street vendors rarely, requiring applicants to get on a waiting list that was backlogged fifteen years or more, resulting in a restraint of trade.

The Maine affiliate of the American Civil Liberties Union, which has taken on the cause of Ian Factor and other Portland artists, has also called the requirement for street artists to have permits unconstitutional. "Selling art is different than [sic] selling hot dogs," said civil liberties lawyer Zach Heiden. "There are legitimate health concerns in the sale of food, like hot dogs, requiring licenses and inspections. However, there is no reason ever for an artist to get a license. The courts have clearly held it to be a restriction on first amendment rights." However, while the decisions in those courts—in New York City, as well as in Hollywood, California, and St. Augustine, Florida—may prove influential, their rulings only apply to the specific municipalities and provide no precedent elsewhere. The large number of artists residing and working in New York City, and the degree to which their presence adds to the city's overall economy, may well have prodded a judge to rule in their favor, according to Sean Basinski, director of the Manhattan-based Urban Justice Center's Street Vendor Project. "Most cities are far behind New York on this issue," he said. "They consider unlicensed vending by artists a crime."

Artists who seek to challenge civic codes requiring them to obtain a permit would have to be prepared for the time and expense of a multi-year-long legal process, the outcome of which is uncertain. Many of the street vendor statutes around the country were enacted back in the nineteenth century, and they contain language ("pushcarts," for instance) that suggests they are still planning for hurdy-gurdy men. As a practical matter, Basinski noted, artists should look to obtain whatever permits are required of other vendors. "If there is nothing on the books, you should probably get written permission from someone, because the police may just decide to hassle you," he said.

The cost of these permits and where they may be obtained is different in every city, and there could be more than one agency per municipality that issues licenses. The Parks Department, for instance, may be in charge of public parks, while the police control vending on city streets. Those wishing a permit to sell non-food merchandise in Richmond, Virginia are required to first obtain approval for a specific site by a tax enforcement officer of the city's Department of Finance, then purchase a $300,000 liability insurance policy that names the city as co-insured, and finally, pay a $225 fee to the city's License and Assessment Division. In the City of Syracuse, New York, permit applications must be sent to both the Department of Public Works and the Police Department (the cost is $20 for one day, $50 for one month, or $100 for one year), while the offices of the City Clerk in Lincoln, Nebraska, and the Town Manager in Brandon, Vermont, receive applications for sidewalk vending, and each charges a flat $100 fee. In general, city hall is probably the wisest starting point for information on where to obtain an application, the cost, and restrictions on vending sites and activities.

Artists looking for information may also contact the municipal arts agency, nearest chapter of the Volunteer Lawyers for the Arts organization or a local arts organization. "You want to find out what other artists are doing," said Jamie Bischoff, a lawyer who works with Philadelphia Volunteer Lawyers for the Arts. "Maybe, there is a law on the books that works to the disadvantage of artists, but no one enforces it. Maybe there is a law that needs to be changed, so artists might want to join forces and find a lawyer who will take the case on a pro bono basis or even contact the ACLU."

Municipalities may legitimately restrict street vending to a certain section of the town and specify the hours of the day that the activity is permitted to take place—usually, no earlier than 7:00 A.M. and no later than 11:00 P.M. (licenses often define acceptable behavior by the permit holder). The municipal code in Anchorage, Alaska limits vendor sites to no longer than ten feet and no higher than six feet from the sidewalk, and they must be separated from any other vendor by at least ten feet; the permit from the city and a certificate of insurance must be visible at all times. In addition, the vendor cannot set up within fifty feet of "a business that traditionally sells the same goods or services that may be offered" by the vendor. For most municipalities, because of concerns of crowding, the number of permits that a city allows may be limited, and the determination of who receives a license may be decided by lottery or on a first-come, first-served basis.

Most sidewalk vending ordinances divide permits in terms of food and non-food sellers, and it is the rare regulation indeed that identifies artwork specifically as an acceptable type of goods. City officials may not determine which artist vendors receive permits based on the content of their work, although art deemed offensive or disturbing is likely to be barred with little reference made to who might find the work disturbing. For example, the relevant ordinance of Salt Lake City refers to the problem of artists "creating visual blight and aesthetic concerns," while any sound system used by a street vendor in Phoenix, Arizona, "[s]hall play only pleasing melodies." (Call out the American Civil Liberties Union again?) Trickier still is the issue of what types of art will be allowed. Usually, municipalities prefer original art—paintings, sculpture, and handmade crafts, for instance—and shy away from graphic or photographic prints, posters, and images on T-shirts. However, two New York City graffiti artists, Christopher Mastrovincenzo and Kevin Santos, won their lawsuit in 2004 against the City of New York after the Department of Consumer Affairs refused to issue them a permit to spray paint blank baseball caps (charging between $10 and $100 per hat) from a sidewalk stand. "Civilization," the U.S. district court judge wrote in his decision, "has traveled too far down the road in the evolution of art as embracing the whole spectrum of human imagination for the law to countenance a classification of an artist's design as art only when imparted in conventional shapes and forms sufficiently familiar or acceptable to a government licensor."

City officials around the country remain of two minds on allowing artists to sell their work—or, in the case of musicians, to perform—on the streets. They are reluctant to open the door to unruly behavior, noise, tax evasion, and littering (as a result of terrorist threats, the City of Boston sought to eliminate musicians in subway stations, worried that their music would drown out important messages, but then were convinced

that the trains themselves were much louder), yet urban planners are consistently pro-
moting the value of having artists in public spaces as a means of livening up otherwise
lifeless city streets. This newer attitude may be found in a city council resolutions in Salt
Lake City ("It is in the public interest to enliven and increase commerce and create a
festive atmosphere in the downtown area and in City parks by encouraging artists and
entertainers to express themselves on the sidewalks and in the City parks"), Cambridge,
Massachusetts ("the existence in the City of street performers provides a public amenity
that enhances the character of the City") and wherever the courts decide that artistic
expression is different than the sale of hot dogs.

ART THAT LOOKS LIKE OTHER ART

One talks of "drawing from life," perhaps of being a "plein-air" artist, but the fact remains
that most art looks more like other art than like life, nature or something else in the outside
world. It is through the similarities of one artwork to another that a history of art is identi-
fied and described; having reference to one group of works of art helps viewers develop an
understanding of others. Cubists, impressionists, and artists associated with a plethora of
other art movements and styles are grouped together based on how closely their work
resembles one another. So far, so good, but works of art that look too much alike veer into
the realm of copyright infringement, at least in this day and age (Braque and Picasso,
whose cubist work often looks identical, did not run to lawyers). The music industry is
long acquainted with problems of this sort—former Beatle George Harrison was found to
have (subconsciously?) infringed the Chiffons' "He's So Fine" for his song "My Sweet
Lord," for instance, and a judge decided that Michael Bolton's song "Love Is a Wonderful
Thing" contained the same melody and internal structure as the Isley Brothers' song of the
same name—and the design world also has its own disputes over originality.

In a more recent filing, Thomas Shine, an architect in Brookline, Massachusetts,
brought a lawsuit against another architect David Childs, claiming that Childs's design
for New York City's Freedom Tower strongly resembles one that Shine had presented as
a student at Yale, which Childs had seen while taking part in a studio critique and was
quoted as singling out in the Yale School of Architecture magazine. In another example,
a design for the logo of the Baltimore Ravens, submitted by a security guard and ama-
teur artist, was found by a Maryland district court jury to have been appropriated ille-
gally by the football team when it created its insignia. An appellate court affirmed that
ruling, claiming that there was a "striking similarity" of the Ravens' logo to the one
Frederick Bouchat had sent in. Even though there was no proof that anyone in the
Ravens organization had ever seen Bouchat's design, the judges determined that there
was a strong inference that various people within the ball club had seen the image,
resulting in the team's logo that looks like a copy.

In order to prove copyright infringement, two elements need to be demonstrated:
The first is that the individual bringing the complaint is the owner of a valid copyright,
which could be established by registration of the image with the U.S. Copyright Office;
the second is either direct evidence of copying, which is usually not available, or

substantial similarity as determined by an "ordinary observer" in a court of law. Two or more works of art may have the same title—think of all the "Madonna and Child" paintings that have been done—without breaking a law, except if the title is particularly unusual and the duplication can be shown to be confusing to the public.

In the fine art realm, the law provides wide latitude for artists pursuing the same subject matter, style, and inspiration. Jurist Oliver Wendell Holmes wrote, "Others are free to copy the original. They are not free to copy the copy," by which he meant that two or more artists might paint the same still-life scene, even coming up with largely identical images (each separately copyrightable), but an artist may not slavishly copy another's version of that still-life with impunity. Disputes may arise between artists whose work is similar, but copyright infringement would be a difficult claim to prove. In one of the few instances in which one artist sued another, California glass artist Richard Satava, who had designed and sold jellyfish sculptures "floating" in containers since 1990, brought a lawsuit against a Hawaiian glass artist, Christopher Lowry, who in the 1990s had also begun producing glass-in-glass jellyfish sculptures that resembled Satava's. A district court judge ruled against Satava in 2003, claiming that the Californian could not copyright the idea of producing glass jellyfish sculpture and that the physical similarities reflected not copying but the form following the concept.

"It would be dangerous to limit an artist's right to adopt a style or technique," said Paul Rapp, a lawyer in Housatonic, Massachusetts, who has represented a variety of artists. "Art builds on itself; if artists start to claim a proprietary interest in their artwork, the advance of art gets stopped in its tracks."

While the courts could not—and would not want to—punish followers, collectors reward those artists who developed certain ideas and techniques first with higher prices. Additionally, artists themselves have ways of policing their ranks, ensuring that lookalikes are not given prominence. An example of this is the Artists' Woods Group Show Competition in Amagansett, New York, which set as one of its entry rules and requirements that "Derivative work that replicates the design imagery, palette, compositional devices, or content strongly identified with another artist's personal style cannot be considered."

There is recourse to the law when the distinctive "feel" of an artist's work—the totality of its style, handling of paint, subject matter, color, and use of light and perspective (none of which are in themselves copyrightable)—is copied, causing collectors to be uncertain about which artist did which work. This is a subcategory of trademark law referred to in legal parlance as "trade dress," in which the look or feel of the artwork is strongly identified with a particular artist. As noted above, performers Bette Midler and Tom Waits successfully have sued companies that advertised products using unseen singers in commercials who sound remarkably like them, and fine artists Itzchak Tarkay, Paul Wegner, and Howard Behrens have also prevailed in legal actions against other painters who have imitated the elements that make their work unique. The courts apply two main tests for trademark cases in determining whether or not one artist may have stylistically copied another: The first is establishing that the allegedly copied work is identified by the public with the particular artist (in legal parlance, the art has acquired

a "secondary meaning"); the second is proving that the imitation is likely to cause confu-
sion in the market. "What better for showing probable confusion than actual confusion?"
Joshua Kaufman, a Washington, D.C., lawyer who represented Paul Wegner, said.
"Within a span of one week, Wegner received calls from three of his collectors who asked
him, 'What happened to your work? It looks like it deteriorated.' They had seen imitations
of Wegner's work from a distance and just assumed it was Wegner's. That can affect an
artist's reputation as well as sales, if people think the quality has gone downhill."

ARTISTS LOSE LAWSUITS

In 1987, sculptor Richard Serra launched a lawsuit against the federal government's
General Services Administration for removing his "Tilted Arc," a public artwork that
same agency had commissioned several years before for New York City's Federal
Building Plaza. Throughout the art world and beyond, people took sides, some arguing
along with the artist that the federal government had violated Serra's first amendment
rights (by censorship) and artistic "moral rights" (destroying the piece by taking it away
from the site-specific location for which it was solely created), while others condemned
the sculpture as ugly and unresponsive to the actual people who worked at the site. In
the end, Serra lost his case, not because the federal district court judge decided he didn't
like "Tilted Arc" but on the more straightforward fact that the contract the artist had
signed with the General Services Administration contained a clause permitting the
federal agency to move the piece. Much has been made of the state of public art in the
United States as a result of the "Tilted Arc" controversy, but perhaps the most important
lesson for artists to draw from the outcome is that "when you sign a contract, you're
bound by it," according to John Henry Merryman, a legal expert in art law.

Sometimes, it is easy for artists to forget that laws apply to them, too, such as the
artist who protested when a site-specific public sculpture she had not been asked to
create or install was removed from land she didn't own. Or the Milwaukee artist who
was told by the city to remove an earthwork she fashioned on municipal property, a
thirty-nine-foot-long, three-foot-high "snake"—"I thought I had permission," she said,
recalling a vague conversation she had with someone she thought worked for the city.
Any number of other artists have ignored municipal home occupancy ordinances that
disallow businesses operated out of one's home, especially those that create considerable
noise (such as metal sculpture) or traffic (selling from one's studio).

As noted above, conceptual artist Jeff Koons found that he was not above the law
after losing a lawsuit filed against him in 1989 by a photographer who claimed that
Koons had appropriated his work. As in the Serra case, many commentators in the art
world weighed in, many siding with Koons, claiming that artistic freedom would be
abrogated if artists could not make parodies or create work that somehow showed the
influence of other artists and that the commercial photographer Art Rodgers had not
suffered any financial loss—one of the main criteria for prevailing in a copyright
infringement lawsuit—because his audience and that of Koons were completely distinct.
Still, he lost that one.

The concept of what determines originality has been tested subsequently by other artists (including Damian Loeb, David Salle, and Barbara Kruger, all of whom have had to defend against copyright infringement lawsuits from artists whose imagery they used in their own) and the issue will likely be revisited in the courts again.

Certainly, fine artists tend to be more sinned against than sinning. Since they usually are in a weaker economic position than collectors, museum officials, and art dealers, artists are more likely to be taken advantage of by the people on whom they are dependent. Bringing a matter to court—such as nonpayment, copyright infringement, willful destruction of artwork, or any type of breach of contract dispute—can be so expensive, time-consuming, and damaging to the very relationships artists look to cultivate and maintain that many do not fully pursue their rights. "So many artists have clear claims but can't afford to bring them," said Ann Garfinkle, a Washington, D.C., lawyer who has represented visual artists clients.

Few of the claims that fine artists bring to any of the Volunteer Lawyers for the Arts organizations around the United States ever get to court. These organizations, which rely on the services of legal attorneys who are donating their time, seek to settle most disputes through mediation, which presumes that both sides of a disagreement are willing to resolve the problem amicably. On occasion, according to Elana Paul, executive director of Volunteer Lawyers for the Arts of New York, "one of our pro bono lawyers will send a threatening letter, which often has the desired effect." Artists with claims that can only be litigated are directed to outside legal counsel, who may or may not choose to pursue the matter. The main factors in that decision are, first, how much money is involved in the dispute and the likelihood of winning. "It costs a lawyer between $100,000 and $170,000 to pursue a case and an appeal," said Scott Hodes, a Chicago lawyer who has represented a wide assortment of visual artists. "If the lawyer doesn't feel he has a slam-dunk case, he won't take it," noting that too few artists have the financial resources to be able to pay if they lose.

There have been numerous instances in which artists have brought legal actions and won, which enhances the chances of other artists in similar situation to pursue their rights successfully. (Many more artists have had their lawsuits settled out of court, and sometimes the terms of the settlements include a "gag order" on publicizing the outcome, which speeds the process along for the injured artist but leaves other artists in the dark as to their rights.) As instructive as an artist winning a major case are instances in which artists do not prevail.

One lesson that artists often need to learn is "get it in writing," as Elana Paul said. Artists may have understandings with their dealers—perhaps tacit or even stated, but rarely written down. When there is a dispute, however, both sides may claim very different understandings, which a written agreement would have alleviated. The costs of deposing, or having lawyers interview, parties to the dispute would be lessened significantly. A second element to this, she noted, is that artists should read the agreements they sign: "Artists are handed a contract, and someone tells them what it means or says that it is a standard industry contract. After there is a problem, the artists come to

Volunteer Lawyers for the Arts, waving the contract and claiming that the dealer violated their agreement. We read over the contract and then have to tell the artists, 'You didn't sign what you thought you signed.'"

Some contracts, especially those in which an artist is commissioned to create a work, such as a portrait or public artwork (mural or sculpture), may need to be explicit about every possible contingency. Sculptor Howard Ben Tre, for instance, had never mentioned to the owner of a building in Baltimore, Maryland, who commissioned a glass sculpture for the lobby in the early 1990s that cracks generally appear in his pieces but would not compromise the work's structural long-term integrity. However, on seeing the eventual cracks, the building owner became upset, leading to an arbitration that forced Ben Tre to remove the work at his own expense and return the money paid to him. Similarly, in 1980, sculptor Robert Arneson was asked by the San Francisco Arts Commission to create a bust of Mayor George Moscone, who had been assassinated two years before by a member of the city's Board of Supervisors, whose legal defense for the shooting noted his alleged addiction to Twinkies. Arneson's maquette was approved, but the final work, when it was unveiled in late 1981 contained a variety of additional elements, such as the suggestion of bulletholes in the pedestal, bloodlike splatters of red glaze and the inclusion of the words "Bang, Bang, Bang" and "Twinkie." The Arts Commission rejected the work and refused to pay him on the basis of a breach of contract (the bust was later purchased by an art dealer). It was common practice for Arneson to write words on and make last-minute alterations to his work, but the Arts Commission was unaware of the artist's practice and neither the artist nor his agent had informed Commission members in advance.

Another instance in which an additional provision or two in a contract might have precluded a legal action occurred three times with sculptor Athena Tacha. She has received numerous commissions for public artworks, but the contracts never contained a clause requiring the commissioning bodies to provide routine maintenance or make any needed repairs. Works at the University of South Florida in Fort Myers and at Hyde Park in Cincinnati were destroyed after they had been allowed to rust and become an overall hazard to the public. A third work in Sarasota, Florida, was similarly permitted to deteriorate until a threatening letter from Tacha's lawyer, Ann Garfinkle, brought a promise to repair the piece. "Letting a work of art deteriorate to the point that the owner can declare it hazardous is a way to get around the provisions of the Visual Artists Rights Act," Garfinkle said, referring the 1990 federal law that provides "moral rights" to fine artists, such as prohibiting the willful destruction, alteration or distortion of a work of art of recognized stature. Because "there is no duty to maintain artwork under the Visual Artists Rights Act, you have to negotiate for that in the contract."

Like everyone else, artists cannot become overconfident about their chances of winning a lawsuit ("litigation is an uncertain process," Paul said, "where you may be confronted on the other side by a completely different set of factors, real, invented, or imagined") or greedy about what they are owed. In the fall in 2005, Seattle, Washington—based glass artist Dale Chihuly brought a lawsuit for copyright and trademark infringement against Bryan Rubino, Robert Kaindl (another glass artist with whom Rubino

collaborated), and a number of galleries that sold their work, claiming that the two had plagiarized his work. Eventually, he dropped the suit (a countersuit by Kaindl against Chihuly was also dropped in the agreement), stating, "If I had to do it again, I probably wouldn't." Dale Chihuly's experience proves that the old press agent's mantra—"There is no such thing as bad publicity"—is sometimes untrue. The glass artist's lawsuit brought him a great deal of unwanted attention for his legal action, his business ethics, and generally for his place as an important leader in the glass art movement. The lawsuit itself was reviled by newspaper and online columnists as a case of bullying (the big, rich artist using the law to beat down the competition). "Before it's over," *St. Petersburg Times* columnist Lennie Bennett wrote, "[the lawsuit will cost Chihuly] dearly, financially, and, probably worse, ethically. No one's going to win." Eric Scigliano in *Slate* online noted disparagingly that "[l]ike Seattle's software, bookselling, and coffee tycoons, Chihuly has triumphed by marketing and branding the hell out of his product, elevating it to something at once precious and ubiquitous." Online bloggers and an entire Web site have piled on. Next, articles in the *Seattle Post-Intelligencer* and *Seattle Times* began examining how Chihuly's well-publicized activities with charities actually involved the artist selling his work to charity groups, which in turn offered the pieces as incentives to donors, diminishing his stature as a humanitarian. Perhaps most damaging were accounts—all true, never hidden or denied but largely overlooked while his prestige was high—that Chihuly was partially blinded in a car accident back in 1979 and dislocated his shoulder in a surfing accident three years later and hasn't actually blown glass since then. He draws pictures, and studio assistants create the works that are called "Chihulys." The former studio assistant that Chihuly sued claimed that the artist was quite detached from the actual design and production of the glass pieces bearing his name; he brought a countersuit, using as evidence a fax from Chihuly to him that reads, "Here's a little sketch, but make whatever you want. We'll get everything up to Tacoma when you're done and I'll try to come down while you're blowing. Till then, Chihuly."

On Davis, for instance, sued Gap after the international clothing retailer used a photograph of an individual wearing his copyrighted decorative eyewear in an advertisement, asking for $2.5 million in unpaid licensing fees, a percentage of Gap's profits, punitive damages of $10,000,000, and attorney's fees. An appellate court agreed with the artist that "[b]y taking for free Davis's design for its ad, the Gap avoided paying 'the customary price,'" adding that "Davis was entitled to charge for the use of his design" Perhaps if he had simply sought to effect a compulsory licensing agreement with Gap, Davis might have received reasonable licensing fees without having to spend so much on legal costs. However, by pursuing a copyright infringement case so aggressively, the artist lost first in district court and then in appeals on the basis that his claims for actual damages and profits "were too speculative to support recovery," that he was not "eligible for statutory damages or attorney's fees because he had not timely registered his copyright," and further disallowed a punitive award (increasing payment to an individual whose copyright is violated through "willful infringement") "because Davis has failed to show willfulness on Gap's part."

VALUING AN ARTIST'S ESTATE

This story begins where most end: the artist dies. Unless that artist has sold every piece he or she ever created, there is likely to be a potentially sizable inventory of artwork that must be valued as part of the artist's estate for tax purposes. How to value that art can be tricky, as it involves speculating about the market for an artist's work when that artist is dead.

It was no easy matter when sculptor David Smith died in an automobile accident in 1965. The fifty-nine-year-old artist had only begun to receive major art world recognition and appreciation late in life. Between 1940 and 1965, he had sold but seventy-five works, only five of those in the last two years of his life. Part of the reason for this was the fact that Smith deliberately kept prices high, with the result that 425 sizable sculptures were in his estate when he died. Within two years of his death, sixty-eight of his works were sold for just under $1 million. The remaining body of work in his estate was originally valued at $4,284,000 when appraised at fair market value, ensuring that a hefty tax payment was due to the Internal Revenue Service within the standard nine-month period. After a hearing before Tax Court and some complicated negotiations between the IRS and lawyers for the Smith estate, the entire estate was discounted to 37 percent of the fair market value, greatly decreasing the amount of tax money due the federal government.

The Smith case developed in the field of artists' estates what is called the "blockage rule" or "blockage discount," which previously had only been applied to securities and recognizes that forcing an artist's heirs to sell most or all the art in the estate for the purpose of paying death duties would result in fire sale or "distressed" prices that are likely to be well below fair market value. Expected fair market prices are more readily obtained when individual works are sold gradually.

Over the years, this principle has been applied to such artists as Jean-Michel Basquiat (who received a 70 percent blockage discount), Alexander Calder (60 percent) and Georgia O'Keeffe (50 percent). There is no rule of thumb for determining the percentage discount, which clearly is elastic. "Different discount percentages reflect different judges, different jurisdictions, and different lawyers representing the estate, and some lawyers are better and more persuasive than others," said Bernard Rosen, a New York City attorney with a number of artist clients. Additionally, a number of other considerations are taken into account in determining the discount, such as the subject of the works, the period in the artist's career in which works were created, and the medium.

For instance, there were 1,292 gouache paintings in the estate of sculptor Alexander Calder. As these gouaches were not the artist's principal medium as well as the fact that Calder's estate executors claimed that it would take the art market twenty-five years to absorb this number of his paintings (at fifty-two per year), the IRS permitted the estate to discount these works by almost 68 percent.

Predicting what art is worth after the artist dies cannot be scientifically measured, and a number of factors may apply. "The death of the artist may sabotage the market," Karen Carolan, head of art evaluation at the IRS, said. "If the artist doesn't have a regular dealer, his death may have a very negative impact on prices." She added that having

"a ready market, being a well-known artist, being represented by dealers, selling work all over the country" make valuing artwork in an artist's estate considerably easier. Artists without one or all of those elements produce work that is far more difficult to appraise after they are dead.

Complicating variables are frequently found in these kinds of valuations: there may be a record of sales in a non-depressed art market but, when the market goes down, formerly saleable works have no prospective buyers. Some artists sell very well, but their success may be dependent upon their presence to actually sell the work—without the benefit of the artist's personality, works may not sell at all. Artists without a gallery connection may be the least likely to have works sell after they are dead. The IRS combs through auction records in order to see what prices were paid for an artist's work, but most contemporary art is not resold at auction (if it is resold at all). Another way in which the IRS often looks to determine the value of artworks is by examining an insurance policy, which requires an expert appraisal, but this is more applicable to collectors than to artists who rarely insure their own work.

Basquiat, Calder, O'Keeffe, and Smith, of course, were all renowned artists who supported themselves exclusively from the sale of their artwork. Many more artists hold teaching positions or other jobs (arts-related or otherwise) from which they receive their main income. These artists may also sell their work, however, the market is limited, perhaps almost nonexistent. What the deceased artist's work is worth is a question, on the answer to which lawyers and the IRS sometimes disagree. "A lot of people teach or do something else and sell one painting every three years to a cousin," James R. Cohen, an estates attorney in New York City, said. "The IRS couldn't really demonstrate that the art has any value. You don't get into the discount issue because no one is really buying their art in the first place."

Another New York lawyer, Susan Duke Biederman, agreed, noting that "you don't want someone who paints sixteen-by-twenty-four-inch oils, and only sells one painting a year for $1,000 and has a backlog of five hundred pictures when he dies, to have the art in his estate valued at $500,000. My interest would be to say the art is worth zero. If the IRS said that people have bought this work in the past, I'd say, 'You go find me five hundred people who want to spend $1,000 on each work.'"

Certainly, the IRS is in the business of collecting money, not selling artworks. Still, Karen Carolan stated, "you can't say that art has no value if the artist has sold during his lifetime. You have to place a value on all the property in the estate." The IRS has no rule-of-thumb cut-off for the amount of money earned through sales, or the percentage of one's income derived from sales, of art in order to determine whether a deceased artist's work has market value at all or if a blockage discount (and the amount of that discount) applies.

These artists may have just as many works in inventory as David Smith or Alexander Calder, but with a far less reliable market than either Calder or Smith, estate executors face a far greater challenge when determining value and any potential discount on that amount.

The problem is not necessarily immediate for all artists. The entire estate goes tax-free to the surviving spouse, and the first $600,000 of the estate is tax-free to the heirs. There is no need to individually appraise works of art in an estate if the entire estate is worth less than $2 million. In fact, according to Martin Bressler, counsel to the Visual Artists and Galleries Associations, if the rest of the estate is small, "it behooves you to value the art high enough to get as close to that $2 million number as you can. This protects the heirs if they some day sell the art. For instance, if an heir values a work at $10,000 and sells it for $15,000, he only pays a tax on the $5,000. However, if the heir claimed that the art was worth nothing and sells it for $15,000, he pays a tax on the entire $15,000."

Not everyone goes along with Bressler's reasoning. James R. Cohen stated that, as soon as an heir begins to claim that the art has some value, "reasonable men may disagree, and the IRS may come in and value the art higher, moving you above that $600,000 tax-free limit and then taxing the heir at 35 percent."

Certainly, some heirs may expect to eventually sell these artworks and earn a considerable amount of money from them. Sales during an artist's lifetime are no absolute indication of future value, of which the art of Vincent van Gogh is a clear example. During his life, van Gogh only sold three paintings, but his work became far more popular and earned record prices at auctions years later.

Competing values are involved in this issue: On the one hand, heirs look to minimize the value of an estate in order to lower inheritance taxes; yet, if they plan to sell works from that estate later on, heirs would hope to limit the tax burden on those sales. Many well-known artists, such as Adolph Gottlieb, Lee Krasner, Robert Mapplethorpe, and Andy Warhol, have resolved this problem in a third way: by establishing a trust or charitable foundation for their art through their wills and using the periodic sale of artwork to create and replenish the foundation's endowment. Others, including photographer Ansel Adams and painter Hans Hofman, donated a large number of their works to educational institutions. Artists who are concerned with keeping their inventory of works intact for their heirs might also plan for money, such as through a life insurance policy, that would pay the inheritance tax. Any of these choices is preferable to the decision by an Arizona artist in the early 1980s to publicly incinerate all of his paintings in order to spare his heirs the burden of paying taxes on them. Artists, their attorneys and their heirs need to examine what they reasonably expect to do with the artwork after the creator dies and plan accordingly.

No less important than properly valuing the artwork of a deceased artist is maintaining and developing the posthumous market. There is a widespread myth—it is quoted enough that it could have come out of the Bible—that "an artist is only appreciated after he is dead." However, the concept of the starving artist whose death gives his or her works new life is more mystique than truth. In a few, very rare instances do works immediately go up in value. In some cases, prices go up gradually (or eventually). In general, demand drops and the prices go with it.

Take, for example, Ivan Albright (1897–1983) and Philip Evergood (1901–75), well-known artists in their time and for whom interest diminished significantly after their deaths and prices took years to approach those achieved during their lifetimes. Another example is Bernard Karfiol (1886–1952), a Hungarian-born American painter who was a darling of the Whitney Museum in its early days. "After he died, everything came to a standstill," Bella Fishko, his dealer, stated. Yet another example is Mark Tobey (1890–1976), a Zen-influenced abstract surrealist for whom there had been a decline in the market since his death.

The factors determining whether prices will go up or down are much the same when an artist is dead or alive. They include the degree to which the market of an artist's work is controlled, changes in critical and popular appreciation, the manner in which dealers, heirs, or estate executors handle works in their possession and how collectors behave.

One of these factors is to keep the deceased artist's work in the public eye in order to maintain or improve prices. If the dealer does not continue to promote the artist, or there are no subsequent exhibitions, the market may fall apart. A second concern is how the artist's estate is handled. Lee Krasner, who managed her husband Jackson Pollock's estate until her death in 1984, provided an even flow of works onto the market in order to keep prices high and maintain a scarcity. The estates of painters Milton Avery and Philip Guston were also handled in this way. On the other hand, the estate of Mark Rothko (1903–70) was handled in a particularly egregious manner, resulting in a major art world lawsuit that removed the executors. With Rothko, a leader in the chromatic school of abstract expressionism, his death created far more excitement than his life but, unfortunately, in a way that depressed the prices of his works for a number of years.

Artists often own the largest collection of their own works—partly because they couldn't sell them and partly because they didn't want to (both of which were unfortunately the case with sculptor David Smith)—and heirs sometimes make mistakes with this vast quantity of pieces. The families of painters Raoul Dufy (1877–1953) and Thomas Hart Benton (1889–1975) helped depress the prices for their paintings by dumping a large number of them onto the market after their deaths.

The widows of sculptors Sir Jacob Epstein (1880–1959) and Julio Gonzalez (1876–1942) inadvertently hurt the market for their late husbands' works when they began recasting their pieces—failing to keep good records on how many reproductions were made in Epstein's case and failing to label the recasts as posthumous with Gonzalez. The widows of sculptors Ossip Archipenko and Alexander Lipchitz also recast many of their late husbands' works. In some cases, families are completing editions for the artists, but the opportunity to earn money also may be a major incentive.

Most of the time, the people who sell these posthumously created works indicate in some way that they are copies or recasts. There may be something in writing about the work being made from the original, for example. The price may also be a tip-off, or possibly the work itself may reveal its origins to the trained eye. Replicas lose the sharpness

of the original, and they are often a bit smaller than the original, as the wax recasts for the mold usually shrink 2 or 3 percent. The name of the foundry that recast the piece is often scratched into the copy, and experts in a particular artist will know from that.

Not only heirs but collectors, too, may flood the market upon the death of an artist, assuming a large jump in prices. Riehlman noted that Pablo Picasso's (1881–1973) paintings and prints as well as many of Alexander Calder's (1898–1976) pictorial works went down by 15–20 percent for a period of years following their deaths because of a flood of their pictures coming onto the market.

The prices for Josef Albers' (1888–1976) paintings also fell shortly after his death as "the market became flooded with collectors trying to sell the 'Homage to the Square,'" Nicholas Webber, director of the Josef Albers Foundation, said. "Everyone saw that there were going to be an endless number of 'Homages' on the market, and it cut the prices dramatically." He stated that whereas before Albers died, his paintings were selling for approximately $1,000 per square inch, they have sold for between $500 and $750 per square inch ever since.

"I would have to say that a deathwatch does exist for many older artists," Robert Schonfeld, a private art dealer and one-time head of the appraisal department at Sotheby's auction house, said. "This has been a common practice as far back as I can remember. All dealers and collectors anticipate changes in circumstances that make works more available or more valuable. There's nothing morbid about it."

The concern with an artist's age does frequently lead collectors to start hoarding, or buying up, works by artists who are getting on in years or who are in poor health. "A lot of people speculate in the works of older artists," Gilbert Edelson, administrative vice president of the Art Dealers Association of America, said. "They think they'll make a lot of money when the artist dies."

Possibly, the biggest bottoming-out of a market was felt with Norman Rockwell (1894–1978). The Rockwell deathwatch had been strong following a 1971 auction at Sotheby's in which one of his paintings sold for $40,000—more than twice what had been estimated, according to Martin Diamond, a Rockwell dealer. This had been the first time any of the artist's works had gone to auction, and the results were a surprise to those who never before took Rockwell seriously as an artist. Prices went up continuously in expectation of enormous profits. However, when he died, the market turned out to be all sellers and few buyers, and prices took years to stabilize.

It is more likely that an artist's work will go up in value after he dies if the market for pieces is already strong and there is some sort of waiting list. When Robert Smithson, an environmental artist, died in a plane crash in 1973 at the age of thirty-five, the sudden realization of the rarity of his drawings created a tremendous jump in prices for them.

Art is long and life is short, the ancient Romans said, but artists and their families must bear in mind that, if the art is to be esteemed and sought-after, the marketing of it must be an ongoing process with nothing left to chance. Artists need to talk with their dealers, estate executors, children, relatives, and spouses about how their work will be distributed to the market, making sure to leave clearly written instructions.

8

From School to the Working World

W hat do fine artists do when they graduate art school? Teach? Sell their art? Win state and federal grants and fellowships? Dream of better things while working in a company's mail room?

Certainly, they can keep each other company since there are so many of them. According to the National Association of Schools of Art and Design, in June 2007, 7,460 Bachelor of Fine Arts and 1,173 Master of Fine Arts degrees were awarded to fine art students (the numbers are composed of majors in drawing, fine arts, painting, photograph, printmaking, sculpture, and video). It is unlikely that the art market expanded to accommodate and support this throng. It is even less likely that many, if any, of these graduates found teaching positions, since (according to the College Art Association) schools in the market for experienced artist-teachers received, on the average, 150 to 200 applications for every job opening.

What degree-holding art students do right after completing school is not documented, although there are many anecdotal unhappy stories. While they are in school or immediately after, artists should begin to think about a second career. In effect, there are two not-necessarily-related goals for the recent graduate: The first is to earn a living, which may be easier for younger people without children, spouses, or parents to support (perhaps themselves supported by parents) than for those with dependent family members and possibly student loans to repay; the second is to begin building a track record of exhibitions and eventual sales. The process of working at a job often takes artists away from their art, sometimes permanently. Career advisors to artists have recommendations for first steps after graduation.

Dan Concholar, an artist's career advisor in New York City, stated that art school graduates need to "conduct a skills assessment for themselves to see what they are able to do and try to find a job in it." In some instances, the work artists find has little relationship to their art interests. For instance, Concholar's own first job out of art school in

1961 was as a janitor "because there were no illustration jobs." Eventually, he began to find work as a sign painter and a display artist, later teaching courses to students at art schools.

Sooner or later, he noted, artists find a type of work that suits their styles: "Sculptors tend to be macho, and many of them do sheetrocking or other physical kinds of work. It may be physically exhausting, but you can do it mechanically and it's not a drain on your creative energy. A job with set hours also gives you a steady income and time to work on your own art."

While non art-related jobs may not impinge on an artist's personal work, they do take time, energy, and commitment if the job will be a long-term one. Can the belief in oneself as an artist first and something else second last indefinitely? "Based on what I've seen," said Susan Joy Sager, an artists' advisor, "five years after graduating art school, most people are not doing their art anymore." The commitment to a job makes Sunday painters of a lot of talented artists.

A job that does not somehow refer to one's art training may lead artists away from art permanently. People may say that they plan to take ten years to make some money so that they can be an artist. However, the further away they get from their art, the more likely they will feel out-of-it or too old and not have faith in themselves to want to start again. Jobs related or unrelated to art may lead artists away from their own work unless they stay in contact with other artists and the art world in general. Sager recommended that they join a local, state, or national artists' club, society, or association, which builds a network with others. Many of these groups also send out newsletters, providing information on exhibition opportunities and other artist news. Subscribing to an arts magazine, teaching art at a local arts center on weekends, and even taking a class through the local adult education program ("they don't cost much, and you get to use expensive equipment," she noted) also helps keep one involved. "Another idea is to move into an artists' studio building," Sager said, "which is a built-in community of artists. Even if you have a paycheck job, you still have art-making going on around you, and that tends to push people to keep doing their own artwork. Otherwise, it can be very hard to work alone in your apartment."

Being an artist means developing careers on two tracks: the first is the finding a paying job, and the other is creating a presence in the art world. In time, perhaps, the art may become the entire source of income, or art sales will supplement an income; for some, the job and the artwork may be so closely related that the two tracks do not seem to be disparate activities.

There are methods of earning money in a setting that reflects one's art background, such as working as an artist's assistant or apprentice or in an art gallery. With one, artists may learn what a professional art career consists of, and, in the other, they may see what the public likes; with both, there are opportunities to meet people who may be helpful in their careers.

Perhaps, as opposed to a skills assessment, artists might conduct a self-assessment in order to determine their commitment to developing an art career: If they want to be

artists full-time, are they really willing to do all the administrative and business duties and paperwork involved to make themselves public figures? Artists may find that their goals in art are not to make a full-time living from it but would be fulfilled by pursuing it part-time or principally through an organization, such as the American Watercolor Society or the National Sculpture Society.

Artists' advisors generally suggest that young artists hire an advisor—or at least read one of the many business-of-art books on the market—in order to help them in their skills and personal assessments, setting them on a practical course for exhibiting and selling their artwork. However, most of them noted, it is rare that any of their clients are under thirty; these artists have tried one thing or another, and, with little or no success on their own, have finally decided to get help. It may also be that those years of fumbling are a crucial part of the maturation process for many artists as they learn to know themselves. It is rare that people right out of art school are fully formed personally or as artists; some may be too idealistic for the kind of nuts-and-bolts assistance that a career advisor would offer. Few independent art schools and almost no university art departments do much if anything (such as offering business-of-art courses or workshops) to ready their students for life or career after graduation. Many art students spend their last year at school preparing for a senior or masters show, and the issue of what they will do next may not arise until after they have left school behind.

APPRENTICING AND INTERNSHIPS

Catching the eye of a noted critic or meeting people at art openings or other social gatherings are ways to make contact with the larger art world. Another way is to work alongside artists, dealers, or museum curators in some professional capacity. Besides meeting important people, this can provide an opportunity to learn how the art market operates, how to set up a studio or prepare a portfolio, how to write a grant proposal, where to purchase different kinds of art materials, and generally how to approach the business of being an artist in a professional manner.

Graduating art school often comes as a slap in the face to young artists. Usually departing without a plan for how to pursue a career as an artist, students leave behind a world in which they had free studio space and use of expensive equipment, time to develop their art, fellow students with whom to share ideas regularly, and professional artist-instructors who paid serious attention to them. They enter a world of high rents, small apartments, and low-paying jobs that may have little relationship to their skills. Professional artists they encounter may have little interest in, or time to spare, for a mentor relationship, and fellow starting-out artists are only likely to offer their own tough-luck tales of not knowing how to meet the right people, wanting a better-paying job, or having little time or space in which to create their art.

Getting started as an artist is perhaps the most difficult problem art school graduates face. One possibility that offers some rewards—and perhaps a drawback here or there—is to work as an assistant or apprentice to a professional artist. Working for an

established artist enables young artists to learn both technical skills (how to paint or sculpt or make prints in a particular manner, how to use certain tools or machinery) and career lessons (how to bargain with a dealer, how to apply for a grant, how to organize one's time and inventory). Assistants are also able to meet collectors, critics, dealers, and other artists—fellow apprentices as well as colleagues of their employer—as well as to create art (albeit someone else's) every day in a professional studio. In order words, it can mean a foot-in-the-door entrance into the art world.

Becoming an artist's assistant is generally not something done by answering an advertisement in the newspaper. Art dealers could be contacted, since they tend to know which, if any, of their artists may be looking for an assistant, and gallery openings provide opportunities to meet these artists. The pay is often not high (starting salaries are not far removed from minimum wage), health insurance is a rarity, and the turnover is sizable, which indicates that opportunities are never long in coming and that this is not a career for everyone. Frequently, the work is more menial than artistic, such as cleaning the studio, crating work, and making telephone calls to suppliers or movers, and one's artistic input is only permitted within certain narrow parameters. Christo, for instance, sometimes uses hundreds of assistants on his major projects who, according to his wife and collaborator, Jeanne-Claude, "are not hired as artists but as workers. We generally need people to carry heavy things." Christo's workers are paid twenty-five cents above minimum wage and are provided workmen's compensation but no medical insurance coverage. She added that the people working under Christo learn that "art is not easy. Your knees are bruised, hands are bleeding, backs in pain. People also learn to be persistent [and] generous and not to give up. They learn that by example."

Some of today's more renowned artists have groups of people working regularly with them, often acting as personal secretaries (answering the telephone, making appointments, etc.) and occasionally working directly on the work of art itself. One artist's assistant, who worked for Julian Schnabel and for Richard Haas, noted that he "schedules appointments, books reservations, and, if needed, will strip down and model."

Most people who work as artists' assistants are in their early- to mid-twenties, staying for between a few months and five, six, or even ten years. They generally obtain these jobs through recommendation, such as from an artist's dealer or another professional artist, although some art schools place their students in an artist's studio as part of their degree program. The Great Lakes Colleges Association, a consortium of schools in the Midwest, arranged in the early 1960s for sophomore painting major Walter Hatke to apprentice in Jack Beal's New York City studio for a semester. "It was the first time I ever lived and worked in New York," Hatke said. "It was the watershed period of my life. I was around other artists, like Red Grooms, Al Held, Lee Bontecou. Jack and his wife, Sondra, were such gregarious personalities and were always being visited by artists whom I had only read about in art magazines. I remember visiting Al Held's studio. He had a really huge studio. Jack, Sondra, and I were walking past the building one night and we saw the light on. Jack yelled from the street, 'Hey, Al,' until he heard and let us up."

At other times, artists may be approached directly about taking on an assistant. Nicholas Maravell, a painter who worked for Alex Katz from 1978 to 1987, had a brief conversation with the artist during a break in a seminar at New York's School of Visual Arts. "I asked him if he needed an assistant," Maravell stated. "He took my name down on a piece of paper, but I didn't really expect to hear from him. I thought he was just being polite, but he called two days later and offered me a job."

Over the years, artists like Jack Beal and Alex Katz have seen scores of young assistants come and go. These assistants may have learned a lot or a little, and what they learned may have helped them develop their own professional careers as working artists or it may have been the closest they ever came to this career. Only rarely do these and other artists know what became of their former assistants, which suggests that making and using contacts to further one's career is only a slight possibility. Apprenticeship is clearly not a ticket to success; rather, artists' assistants need to both help the artist—the job they were hired for—and to learn by the artist's example, identifying which factors enable the artist to achieve success both in a work of art and in a career.

Those lessons may be varied. Nicholas Maravell claimed that he learned about "the process of painting more than how to paint. I saw all the steps Alex took from the initial drawing to the final painting, and I learned a professional attitude: how to concentrate on your work, putting aside other distractions." Dana Van Horn, a painter in Philadelphia who worked for Jack Beal from 1975 to 1983, stated that he was able to learn what, for an artist, makes for a good art dealer ("a long-term commitment by the dealer to the artist without worrying whether the gallery is making a profit") and what kinds of dealers to avoid ("people who whine, or don't tell you what they think of your art, or don't understand your art to begin with").

Jonathan Williams, who has worked off and on for Richard Haas since 1976 and for Frank Stella from 1988 to 1991, noted that from Haas "I learned how to draw, how to drink, and everything in between, including a few vices." For both he and Robert Franca, who worked for Haas from 1984 to 1989, the majority of their paying work now comes from painting scenery for television and motion pictures, a type of artwork that is not far removed from the trompe l'oeil architectural murals that Haas is commissioned to create.

Franca stated that, besides picking up a lot of mural techniques from Haas, he also learned "how to work quickly in broad areas for commission. I learned how to meet a deadline, how to get hired." He added that working for a well-known artist also has significant résumé value, noting that "for those who know Dick's [Haas] work, telling them that I worked on this or that piece has been very helpful in getting commissions."

Besides working directly with an artist, one can also take on an internship with an art dealer or nonprofit art center (running the gamut from alternative spaces to major museums), although this tends to be as much a career path for a future dealer or student of arts management as for an artist. One of the fastest ways to find out which

organizations have internship programs is to ask by writing or calling, and then to apply, with a résumé and cover letter, following up with a telephone call to arrange an interview. The National Network for Artist Placement (935 West Avenue 37, Los Angeles, CA 90065; 213-222-4035) also publishes a *National Directory of Arts Internships* ($35) that lists programs of this sort at small and large arts organizations around the country.

Artists might contact state and local arts agencies, which sometimes keep listings of, and sometimes just hear about, job openings at cultural organizations and institutions. Another way to learn about potential positions in the arts field is through publications that list available jobs, such as *Artjob* (WESTAF, 1743 Wazee Street, Denver, CO 80202; 303-629-1166; *www.westaf.org*; $25 for three monthly issues, $40 for six, and $75 for one year), *Artsearch* (*www.artsearch.us*), *Hire Culture* (Massachusetts Cultural Council, *www.hireculture.org*), and *Jobs in the Arts* (New York Foundation for the Arts, *www.nyfa.org*). Some artists advertise their need for assistants on Craigslist.com. Certainly, the principal dealer for an artist is often in touch with the studio and may be a good source of information. Other artists often know which studios are more likely to hire assistants, perhaps offering a reference or an introduction. Artists sometimes contact art schools when they need help, and these institutions also may arrange internships and assistant-ships for their current students and alumni. Katharine Schutta, director of career development at the Art Institute of Chicago, noted that during an interview "it's important that you know and express excitement about the artist's work," as well as brings up the skills that the would-be assistant has to offer. Much of the actual job will be administrative, such as preparing artworks for shipment, record-keeping, developing and updating a Web site, researching grant opportunities, photograph-ing art, or proofreading a press release, and in addition to that, "you may be just fetching things."

An internship is a useful way for artists to learn about the art world and to sup-port themselves while continuing to do their artwork. Many artists have some museum or art space experience on their résumés, regardless of their later renown. Conceptual artist Sol Lewitt, for instance, worked for a time as a museum guard at New York City's Museum of Modern Art. Painter Howardena Pindell lasted longer than Lewitt, working in various curatorial capacities in the Department of Prints and Illustrated Books at the Museum of Modern Art for twelve years, before she finally left to devote more time to her own art (she also teaches at the State University of New York at Stony Brook).

Being an employee of the museum had previously tainted relations with the deal-ers Pindell approached. "A lot of their actions seemed to say, 'I'm only looking at your work because you're with the museum, and I want you to help me out there,'" she said. "There was a sigh of relief by a lot of people when I left that 'she's finally out of there.' People would say to me after I left the museum, 'Gee, your work has gotten better,' when they had actually seen the same painting two or three years earlier."

There are some hazards to working for an arts institution or with a successful artist, as many artists have discovered. Pindell found that her life became more coherent after quitting the Museum of Modern Art. She no longer worked days at one full-time job and nights and weekends at her painting, maintaining two separate résumés, neither of which referred to the life she led in the other. In addition, Pindell found that artistic expression was not wanted in the curatorial realm.

"The best thing that has happened for me since leaving the museum is that no one says to me now that I must be speaking for the university when I have something to say," Pindell stated. "Back then, it was assumed that I spoke for the museum, which was nonsense. There is academic freedom, and there isn't curatorial freedom. There may be people at the university who despise me, who don't believe in cultural diversity or equality for women, but the stance of the university is diversity of opinion, and what I say is protected. I'm also tenured and my job is protected. At the museum, your job isn't protected, and you have to present a corporate front, which controls the way you speak, the way you look, and your politics."

Working for an artist may also stunt one's development. One painter who has worked for Frank Stella ("mostly paperwork") over the period of a few years, complained of feeling "pressure when I do my own artwork. You are so exposed to someone else's sensibility that you can become stymied. Stella's works are so supported by the art business world that my own starts to seem so insignificant." She added that "people who work with Stella have largely stopped doing their own art. It's hard knowing how to deal with these problems."

It is frequently the case that assistants learn how to assist a noted artist all too well, as their own artwork comes to resemble that of their artist-employer, and it requires a break in the relationship for the assistants to fully emerge as expressive artists in their own right. That problem is to be expected in some degree, as it is the job of the assistant who works directly on the artwork to "get into the artists' minds, figure out what the artists are after, what they mean to do, in their work," Williams noted. Walter Hatke also stated that his job was "to learn to paint in such a manner that what I did would pass, for all intents and purposes, as a Jack Beal." After a full day of adopting a specific style or approach to painting, it is likely to be difficult to settle down to one's own artwork. All artists' assistants need to keep in mind what their role is, which is not self-expression but carrying out another artist's plans.

"One of the main things I look for in an assistant is, Can I work with that person vis-a-vis his or her ego?" Richard Haas said. "If someone's ego becomes a problem, it leads to tensions and a bad experience. There have been many instances over the years where mistakes were made in hiring assistants. The person had a personality flaw that led to a conflict where parting was not sweet—sometimes, the parting involved lawyers, once a cop."

However, tensions aren't only a result of assistants who want the final artwork to look different, Haas noted. "Where the assistant's work is too close stylistically to mine, there can be tensions. I don't encourage people to copy me—the opposite is true—because someone else doing your thing isn't flattering or comfortable. What I really want

is an artist whose own talents challenge me, whose ideas are fresh and interesting, not derivative."

Haas' expectations can be a very tall order: an assistant who can ultimately work in his style yet brings new ideas that can be subsumed into Haas's art without a conflict of artistic egos. Perhaps this is the reason that most assistants do not stay very long with a particular artist. "As I matured," Williams said, "I didn't want to give my ideas away anymore. I wanted to save my ideas and my techniques for my own work."

It is also the case that the more established an artist is, the less likely he or she will want an ongoing turnover of assistants, each of whom stays a year or two or less. "It takes a couple of years in order to get an assistant to do his work efficiently," Alex Katz said. "I like it when they stay around five or six years. I lose time and money with kids right out of art school who leave as soon as they're trained. The younger ones also destroy a lot of things because of their lack of experience, and that costs me money, too."

Philip Grausman, a sculptor in Washington, Connecticut who has used apprentices since the late 1970s, noted that it is rare for an assistant to stay as long as two years. "With only a few of them have I ever gotten anything back on my investment in time and materials," he stated. He added that his expectations for his largely short-term assistants are limited. "I have to design my pieces for the skills of the particular people who work for me, breaking down each process into very small steps." The final artworks are "maybe a little different than [sic] if I had done it all myself" and, because he has lost patience with apprentices who aren't "serious or committed," Grausman has decided to rely increasingly on foundries for help in fabrication.

He added that apprentices sometimes become very "possessive of specific work they've done. I'll come in later and take it all apart, and they get very upset. They don't understand their role here."

Whether or not it is realistic to expect that young artists will be willing to devote themselves selflessly for many years to the production schedules of established artists is uncertain. However, it is likely that the interest of established artists in stability and the desire of their younger apprentices to strike out on their own will collide regularly and create tensions.

In addition, while the established artists are inevitably getting older, their short-term apprentices are forever in their early twenties, which may lessen the ability of both sides to communicate effectively. Richard Haas, for instance, noted dryly that "I have better conversations with people who are older," and Alex Katz flatly stated that "I don't talk much with my assistants." Jonathan Williams's experience of Frank Stella also did not include much conversation other than shop talk. "Everything that mattered with Stella was the work at hand, and we really didn't talk about anything else," Williams said. "I don't remember him ever asking me much about myself."

Certainly, there are risks in asking an assistant personal questions, for instance, that the action may be reciprocated, and established artists may prefer that their employees not know potentially compromising information about themselves. Perhaps a reason

that relationships may not become personal is that certain jobs that may be assigned to an assistant (such as sweeping the floor) are contrary to friendship. Younger artists may assume they will have a more intense, even collegial, relationship with the artists for whom they are working than in a traditional employer-employee situation, and those upset expectations may lead to tension in the studio.

"Once upon a time, I had an apprentice," sculptor William King said, "but there were days when there was nothing for him to do. I asked him to clean up the shop, and he didn't want to do that. He was a budding artist, not a janitor." King added that he does not recommend working as an apprentice to younger artists. "You have to get out on your own and find out things for yourself. If you have anything to do with other artists, do it as a peer, not as an underling."

Another assumption that younger artists may have, especially those who work three-dimensionally, is that they will be able to use the tools and machinery in the established artist's studio for their own work. Sometimes, the artist will permit it; sometimes not. Some artists will charge an hourly rate for using studio machinery or allow only certain, long-term assistants to use it. This issue, and a number of other hopes on the part of the would-be apprentice, should be discussed before the young artist agrees to work in the studio.

Many assistants also discover that there are drawbacks to becoming closely identified with another artist. "An apprentice's work may not be taken so seriously," Dana Van Horn stated. "If there is any resemblance in the work, it is the kiss of death for the apprentice." Jack Beal also pointed out that "when you take artists away from their own work for too long, the experience proves too influential on their own work and careers. I tell every apprentice to get all they can from me and then move on."

Developing one's own artistic voice, and generating the energy to create one's own art, however, may begin to seem futile for artists' assistants when confronted with daily reminders of how sought-after an employer's artwork is. If working for an artist is conceived as a means of establishing a career as an artist, artists' assistants should stay alert to signs that their apprenticeship may have lasted too long and is becoming an obstacle to their careers. One who recognized that possibility was Constantin Brancusi, the Romanian-born sculptor who left Rodin's studio, saying, "Nothing will ever grow in the shade of a big tree."

The artists' assistants of today are far different from the journeymen apprentices of the Middle Ages or Renaissance. Then, the relationship between master artist and apprentice was that of teacher and pupil, and young hopefuls were contracted out to artists for specified periods of time, doing certain duties in exchange for instruction. Often, these duties included helping the artist complete a piece. One began as an apprentice, then became a journeyman, and then a master, in turn. The studio of Peter Paul Rubens, for example, had such promising apprentices as Anthony van Dyck and Franz Snyders, who worked directly on the master's paintings.

By the seventeenth century, the officially recognized art academies in Europe spelled the end of the guild system, although apprentice-type conditions lingered on, if in different form. Academies were the creation of artists who wanted their profession elevated into something higher than artisan; they brought more structured art schools into existence. With the advent of romanticism, there was a greater emphasis on individual style and on working alone. Being able to do the same kind of art as one of the great masters was no longer highly regarded, as distinctiveness became the predominant artistic virtue.

Still, the master-disciple relationship continued in various forms and exists today. Eugene Delacroix, often considered the father of romanticism in painting, worked with several apprentices (most of whom are not household names), as did classicist Jacques Louis David, who taught such notable talents as Baron Antoine-Jean Gros, Jean-Auguste-Dominique Ingres, and Theodore Gericault. Jackson Pollock, one of the most original artists of the twentieth century, worked first with Thomas Hart Benton in something like an apprenticeship, and later with Mexican revolutionary muralist David Alfaro Siqueiros. Pollock learned much about painting from both artists and made contacts that helped him later on.

An artist who has assistants and "fabricators" is more and more the norm. Sculptor Henry Moore made small models and handed them to others to turn into large pieces. Andy Warhol had what he called "the factory," from which works that ultimately had his signature on them emerged. Red Grooms's family and friends helped him out. Art is very much the process of doing it and not solely the conception in the artist's own mind, but the complicated processes of creating works and of being a successful artist these days lead many artists to look for assistance from others.

While most, if not all, of the young artists who go to work as assistants look to achieve similar professional and financial standing as the established artists they work for, the number who will actually arrive at this point (or even set up their own studios) is small. Some assistants find that their career has become helping artists with their work, perhaps working at a sculpture foundry or print studio (where many artists bring their projects, looking for help in technical areas) or sticking with a particular artist for a very long period of time. Robin Roi, who has worked since 1983 for Jeff Green, owner of the New York City-based Evergreen Studios, which is commissioned to paint murals in homes and commercial spaces, stated that establishing an independent art career involves "a lot of networking, meeting dealers and other artists, and you need to have your life being about networking and meeting people. Right now, my life is about my family and raising two small children. I need the steady paycheck more than I want the insecurity of trying to be a full-time artist. What I do at Evergreen is very connected to my own style, and I try to impart my ideas to the work."

Roi did pursue an independent art career, selling paintings through a noted New York City gallery for a number of years before becoming an artists' assistant. Joel Meisner, on the other hand, never got around to creating his own artwork at all. Not

long after he received his Masters of Fine Arts from Columbia University in 1960, Meisner got married, needing to support a wife and, soon afterwards, a child. By chance, he happened to read in a magazine that the assistant to Jacques Lipchitz (the Lithuanian-born School of Paris sculptor who had been living in New York City since 1941) recently had been drafted into the army, and Meisner called the seventy-year-old sculptor to ask for the job.

Lipchitz was not overly encouraging toward Meisner's own artwork, setting aside the younger man's portfolio and saying, "You should go to museums more and try not to invent things that have already been invented," but he gave him the job. Meisner helped Lipchitz make enlargements from the artist's maquettes as well as restored models as they came out of the foundries. Meisner's work with Lipchitz had nothing to do with the design but with seeing that foundries Lipchitz used made the sculpture editions properly. In time, Meisner's expertise became foundry work.

"The problem that Lipchitz had with foundries was that the nuances of his work were being lost," he stated. "He was always retouching the waxes. Over time, I developed a process that helped duplicate the nuances, the fingerprints (as it were) of the sculpture."

Meisner called working for Lipchitz "the best thing that ever happened to me. I found that foundry work was something I really could do and do well. I rededicated my life to founding other people's art. I made a judgment on my own work, that maybe I'm really not that good but that I could use my understanding of art to help other artists. I also realized that I could frankly make a better living at foundry work than trying to sell art that I could make."

Shortly after starting work with Lipchitz, Meisner convinced a commercial foundry in Long Island, New York, to let him establish an artist's foundry section. "What really opened the door for me," he stated, "was telling the foundry owner that I was Lipchitz's assistant." In 1973, Meisner bought the entire foundry and renamed it the Joel Meisner Foundry, and it currently works with scores of artists all over the country.

THE SKILLS THAT ARTISTS LOOK FOR IN ASSISTANTS

At age fifty-one, painter Susan Schwalb claimed that she didn't have "the time or the patience" to learn how to do all but the simplest tasks on her computer, and hers is a big job. The Watertown, Massachusetts, artist has been attempting to inventory every artwork she has ever created as a professional (title, medium, dimensions, framed or not, where signed, where exhibited, where and when sold, sale price, and current location, as well as an image) in a computer database. Her lawyer, offering some estate planning advice, recommended that she get a better handle on what she has in her possession and other works are. "I'm creating my own catalogue raisonné, which may be very useful when exhibitions are planned," she said. All well and good, but Schwalb still needs someone to do this work for her, because she cannot, and her choice of employees are young artists.

"I advertise for assistants through the art schools around here," including the Art Institute of Boston, the Massachusetts of Art, and the School of the Boston Museum of Fine Arts. Artists have a better understanding of what she as an artist needs and considers important, she believes, than some computer geek who may have only the technical know-how. Schwalb also looks for artists who have been out of school for at least a year ("students are always changing their schedules and want to quit after they've made a little money") and can commit to working for her year-round for one day per week ("that's all I can afford").

It is not uncommon for successful artists to have assistants, but there is no specific job description for them as there is for, say dental assistants or sous chefs. To be an artist is to run a small- or a large-scale business—involving billing, bookkeeping, photographic documentation, record-keeping, sales, promotion and marketing, shipping, inventory, and purchasing office and material supplies, as well as design and production of items to be sold—and in some or all of these realms, assistants may be needed. While Susan Schwalb's principal concern is the computer inventorying of her artwork, her assistants occasionally have been asked to crate her work for shipping and once to write a letter. "It's nice if they can talk on the phone," she said, adding that no one has been asked to cook or clean for her. And, while assistants have helped put her canvases into frames, "I haven't had them work on the surface" of the canvas. Making the artwork is her sole dominion.

Not so with New York City artist Jeff Koons, whose eighty or so full-time assistants are hired on the basis of their portfolios, which need to show competence at photorealistic and academic painting. "About half of the employees here have Masters degrees," said Jaclyn Santos, who noted that most of them paint directly on Koons' canvases, although not all at the same time.

There are various benefits and drawbacks to working as an artist's studio assistant, but probably the chief attraction is the potential entrée to the professional art world that it represents to younger artists. For Schwalb's assistants, they learn how to organize a career; those working for Koons share in the artistic process; and the assistants of both Schwalb and Koons have the opportunity to meet the people (collectors, critics, curators, dealers, and other artists) who come into the studios. It has happened that lightning strikes: visitors strike up conversations with assistants that have resulted in exhibitions and sales of their own work. That happens seldom, but assistants generally learn something from their experience about how the art world operates, how an artist sets up his or her studio, and how the business of art really works.

On the downside, pay is rarely good, and benefits (health insurance, paid sick or vacation days, retirement plans) nonexistent. Credit for work done on an artist's own piece is not given, and assistants with Bachelor's and Masters degrees in art may find it demeaning to sweep an artist's floor or fetch the mail.

Often, the pluses and minuses get all mixed together, as do the various tasks that studio assistants are asked to do. "Tom," meaning sculptor Tom Sachs, "wants the highest skills for the lowest wage," said Liz Ensz, a fiber artist who worked for Sachs for one

year (starting at $15 per hour and ending at $17 per hour), creating various components for a lunar module installation based on photographs that the artist gave her ("I got to make some really cool things"). The elements were made of Fiberglas, resin, and Styrofoam. During that year, the number of assistants in the studio ranged from six to fourteen. She got the job through another of Sachs' assistants, J.J. Peet, the boyfriend of one of her former teachers at the Minneapolis College of Art and Design. "His referral was enough," she said. "Tom trusted J.J.'s judgment, since he was his main builder." Her interview with Sachs consisted of the artist looking at online images of her work. Sachs "decided where I would fit in."

At the end of her year as a studio assistant, in 2007, the artwork was exhibited at New York's Gagosian Gallery where Ensz and the other assistants came to the opening, but all the applause there was for Sachs. "I don't feel weird about that at all," she said. "I'm actually grateful for the experience. I learned more in Tom's studio than I did in art school."

Not every studio assistant finds the anonymity of the job as easy to swallow. "I do think about not getting credit," said Claire Taylor, an artist who worked for sculptor Tara Donovan for nine months. "It's her work, her ideas, but her work ends up becoming your whole life; it just consumes you, and it is very hard after eight hours of constant work in her studio to come home and push yourself to do your own work."

Donovan never asked to see Taylor's portfolio but gave her a day-long tryout, gluing Styrofoam cups together in a particular pattern, which in fact was one of the activities she did regularly for a large project that the artist was developing. In addition, during that nine-month period of working in her studio, Taylor repaired Mylar disco balls and rolled adhesive tape loops, connecting them and spraying it all with a sealant. Most of the five to ten other assistants in the studio were similarly aspiring artists, and Taylor claimed that an unstated element in the tryout was determining if "I could mesh with everybody. Everyone is constantly around each other, in a relatively confined space, and you don't want tensions to interfere with the work that needs to be done." In fact, she found that "people got along really well. If someone doesn't want to talk all day, no one makes you talk, no one takes it personally. Everyone knows what it's like to roll tape all day."

On occasion, a studio assistant learns something else that helps them develop a career, although perhaps a different career than they may have assumed. Carmella Saraceno stretched canvases for Jean-Michel Basquiat, glued plates onto canvases for Julian Schnabel, and "was invited to every party and every opening," but she discovered her real calling after she began working with sculptor Alice Aycock. "I had heard through some people that Alice Aycock needed a truck unloaded," and she came to Aycock's Manhattan studio at 8:30 the next morning and spent the day pulling out and hauling up to the artist's studio one piece of lumber after another, the one woman among several men. The lumber didn't fit easily into the freight elevator at the studio, but Saraceno took charge of directing the process of maneuvering the pieces in and out. "Alice watched me do this all day long and, at the end of the day, she asked me if I wanted to work for her."

The "work" was varied, to say the least. "I got the keys if she was locked out, I got the car before it was towed," and she offered comfort when the artist had a blowout with her husband at the time. More importantly, Saraceno figured out how to put together and install the public sculptures for which Aycock provided designs. "Alice never said no to any project. Something would come up; someone would say use this space, and she'd say yes and then try to figure out how to do it. Someone would ask her to do a project that involved electrical power, and she'd say, 'OK, I can do electrical,' but she knew nothing about electrical."

In 1990, Saraceno started her own business in Chicago, called Methods and Materials, that helps artists, art galleries, corporations, museums, and public arts agencies rig, assemble, install, de-install, and relocate large-scale artworks. "What I do now is figure out how to do things," she said. "I wouldn't be doing this if not for having worked for Alice Aycock." Her business currently employs nine artists, who are afforded health insurance and 401(k) pension plans.

ARTISTS' ASSISTANTS AND THE IRS

Sometimes, gray areas are gray because no one wants them any other color. Take the issue of artists' assistants, for instance: are they the artists' employees, or are they "independent contractors"? There are reasons why artists may want them to be a little bit of both.

Many employers, including artists, prefer to forgo the paperwork and payment of employee taxes (withholding unemployment insurance and social security, among others) by labeling those who work for them independent contractors. The IRS simply needs to receive a 1099 tax form from the employer for the independent contractor, listing the amount paid to that person, who is otherwise responsible for reporting his or her own income and paying estimated taxes on that amount.

Attempting to make the issue of who is an employee more black-and-white is the Internal Revenue Service, which initiated a drive in 1995 to collect unpaid taxes from employers in all sectors of the economy for independent contractors who are actually salaried employees. "There has been concern for some time about compliance with IRS guidelines," said Ken Hubenak, a spokesperson for the federal agency. "Some employers aren't withholding taxes as they should, and some aren't even filing 1099s for the people they claim are independent contractors."

For artists, the IRS action has meant that they must establish a new relationship with their assistants, one that involves more structure and accountability than the traditional flow of artistic help in and out of their studios. "The IRS wants to make everyone who works for me employees," said painter Tom Wesselman. "To my mind, everyone who works for me are independent artists, who work out of their own studios as well as in my studio. They have their own income apart from me and deduct the costs of their own materials and studios. The IRS is causing complications for me and for a lot of other artists who hire assistants."

New York City accountant Rubin Gorewitz also noted that "an artist's studio isn't like General Motors or AT&T. The people working in the studio are more involved

specifically in the arts and are hired for their aesthetic sense, which they pursue in their own art." He added that, increasingly, "I tell artists to hire a business manager who will be in charge of the employees and who can see that things get done so that the artists can do their own work."

Accountants for a number of major artists have been busy readjusting the payroll taxes for the assistants their clients employ. One who came into conflict with the IRS over the issue of independent contractor versus employee was Seattle glassmaker Dale Chihuly. Another, who shifted accounting procedures in advance of an audit, is Arman, the New York sculptor. "We used to treat these assistants as independent contractors, but then we saw the writing on the wall," said Arman's accountant, Kenneth Goldglit, "and we changed them to employees."

While some artists prefer not to pay taxes for their assistants by calling them independent contractors, their assistants may have a legal basis to be considered joint authors of the artists' work if they were involved directly with the finished pieces, a right that employees do not have. That joint authorship would be dependent upon the degree to which the assistant could prove that his or her original ideas and decision-making is part of the final work, according to Joshua Kaufman, a Washington, D.C., lawyer who often represents artists. "Employees, on the other hand, have no claims to copyright ownership," he said. "Artists would rather their assistants be independent contractors for tax purposes, but prefer them to be employees for the purposes of retaining copyright," he said.

There have been a number of lawsuits brought by former assistants against the artists for whom they worked for joint copyright ownership of works, but they have all been settled out of court. Proving that one has made a significant contribution to another artist's work is not a simple process "as it is usually only the artist and the assistant who knows who did what, and ego gets in the way," Kaufman said. "If I say to an assistant, 'finish the sky in my painting,' that person might be able to make a good case for being a joint author, but if say, 'do this area here just as I blocked it out,' joint authorship becomes more difficult to establish.

Kaufman, who in 1989 successfully argued before the United States Supreme Court the right of sculptor James Earl Reid to claim copyright ownership of a work that a nonprofit group had commissioned him to create, noted that employers should require assistants whom they hire as independent contractors to waive all claims to copyright for all works created during the period of their relationship.

It is not uncommon for certain artists to have a large number of assistants in their employ. The complexity of the process involved in sculpture and printmaking, for example, often requires artists to hire others to perform certain technical tasks, from creating maquettes and inking printing plates to ordering materials supervising foundry work. Other artists' assistants may work in bookkeeping, clerical, or marketing positions, and often the tasks demanded depend upon what needed to be done on a particular day. Artists with very high-volume sales sometimes seem like the presidents of small companies, with office managers and department heads overseeing a variety of

activities. Peter Max, for instance, has separate retail and wholesale marketing staff as well as two publicists, a receptionist, and assistants performing various other functions, in total adding up to more than thirty-five employees. Many of these employees have voice mailboxes. Robert Rauschenberg employed more than a dozen people in his studios in New York City and Captiva Island, Florida. Dale Chihuly has between fifteen and twenty employees, among them a comptroller, several bookkeepers, publicists, sales staff, and others who assist this partially blind artist in creating his work.

The IRS developed a list of twenty criteria for establishing whether or not someone is actually an independent contractor or an employee. An independent contractor, for instance, may be defined as someone who determines his or her own hours, hires his or her own assistants, decides how a particular job is to be performed, and supplies all materials necessary to complete the work. On the other hand, an employee is under the control and direction of the employer, given specific instructions on how the work is to be done, with set wages and fixed hours at the employer's work site. There are also a dozen or so criteria, many of them virtually the same, for determining who is an independent contractor and who an employee in questions of copyright ownership.

The rules for deciding whether or not an assistant is an actual employee are clear, Kenneth Goldglit said, "and the amount of taxes an artist will have to pay are really not all that significant. These are normal costs of any business. If the artist earns enough to hire an assistant, he's making enough to pay the taxes on that person. And if the artist can produce more works because of the assistant's help, then he'll have more to sell and make more money."

FINDING A JOB AS AN ART TEACHER
The decision whether or not to obtain an art degree on the Bachelors or Masters level is not purely an economic one. Students enter these programs with the intention of becoming professionally trained artists, developing technical and intellectual skills that will advance and inform the artwork they aspire to create. It is a fact, however, that many artists earn some or all of their income through teaching at the college level, and the Master of Fine Arts degree is a requirement for most of these jobs. However, there is no direct path from earning an MFA to landing a college teaching position, in part because there are so many MFAs around these days—more than sixty-eight for each available teaching position at the college or university level, according to a survey conducted by the College Art Association—and partly because instructors are required to show some level of experience as professional artists outside of academia. That experience includes exhibitions (group and one-person shows), as well as other indications of professional activity, such as curating an exhibit or published writing about art in some periodical, in addition to teaching experience. (How to get teaching experience in order to be hired to teach is one of those conundrums that college graduates face in almost every field.)

The sixty-eight-to-one ratio may not sound hopeful to most artists, but it is better than the situation at Yale University School of Art in New Haven, where two to three

hundred applications come in for each available job, or at Pratt Institute in Brooklyn, New York, where, according to Mel Alexenberg, chairman of the fine arts department, "we may save one résumé out of one hundred. We never really hire anyone unless someone on our faculty knows the person." About half of all college art teaching positions are fixed-term, or non-tenure track, and the artist will soon have to look elsewhere for employment.

Pratt Institute may truly embody the dilemma facing artists. The school gives out more MFA degrees—five hundred a year—than any other institution in the country, yet it would be unlikely to hire any teachers unless they were "at least ten years out of school" and "had gone out into the world and made it as artists" while "gaining teaching experience" somewhere along the way, Alexenberg said. Most hires at these schools are in their late twenties or early thirties; no one goes right from graduate school to teaching.

The prospects for teaching are not wholly dire for artists. Moving away from modernist canons of art, most schools are looking to maintain a wide range of styles and artistic ideas—from realistic to conceptual—in their departments, and they are also increasingly hiring women and members of minority groups for teaching positions. Artists who have technical skills in more than one area, such as painting and operating a printing press or sculpture and digital media, are more apt to be hired by schools that may want the flexibility of reassigning staff as their needs and students' interests change.

The College Art Association has also found an increase in non-university teaching jobs for artists, such as at museums and nonprofit arts centers, as well as teaching opportunities at less prestigious institutions, including junior colleges, summer retreats (art camps, cruise line art classes), senior citizen centers, Veterans Administration hospitals, and YMCAs. One finds these jobs through contacting the individual institutions, as each has its own availabilities and budgets.

Another growing area of hiring for art teachers, according to the National Art Education Association, is the nation's public schools where twenty-nine state boards of education across the country now require high school students to take at least one art course in order to graduate—a requirement that did not exist before 1980. In addition, 58 percent of the country's elementary schools have full-time or part-time art teachers, a substantial increase since the early 1980s. There are approximately 50,700 public school art teachers working in the nation's 15,600 school districts, with a turnover rate of between 2 and 5 percent, or four hundred and one thousand jobs, a year. These jobs, however, are available only to those holding state teaching licenses or certification (or both), and requirements differ from school to school and from district to district. Nowhere is the road to relevant employment easy for artists.

Private schools, which must be contacted individually, do not have the same requirements for teachers and may be worth pursuing. Charter schools, on the other hand, while frequently emphasizing the arts more than many traditional public schools,

are still public schools and have the same state licensing mandates for their teachers. While a source of potential employment, professional artists generally do not arise out of the faculty of private and public primary or secondary schools; perhaps the reason has been that career-minded artists historically have not pursued this avenue as an art-related career option. Another factor is that K-12 art projects focus on the product—something to have finished in fifty minutes to bring home to show the parents that very day—rather than the process, including slow development of skills and experimentation with materials. Where school art classes are more than once a week, such as at certain charter schools, there may be an opportunity for real art teaching and art-making, but those who are committed to serious teaching or who want to be accorded respect as professional artists will likely feel more comfortable at the college or university level.

An additional concern for artists who teach in public and private schools is the fact that they may be placed in the position of censoring the work that their students create. The National Art Education Association discourages any form of censorship in a policy statement: "The art educator should impress upon students the vital importance of freedom of expression as a basic premise in a free and democratic society and urge students to guard against any efforts to limit or curtail that freedom." However, as a practical matter, students' work is regularly censored (not hung up in the classroom, not permissible for classroom assignments and grading). Bruce Bowman, a public high school art teacher in the process of completing a doctorate in art education from the University of Georgia, conducted a formal survey of art teachers in Georgia in which he found that drug, gang, racist, or sacrilegious imagery, as well as artwork depicting sexual acts, gambling, obscene gestures, nudity, and violence were often censored by teachers. The reasons for this action ranged from "it challenged school policy," "it disturbed the class," "it offended the general public," and "it celebrated illegal actions," to "parents complained," and it was "produced just to shock." Clearly, there is a wide disparity between what the National Art Education Association claims as a right and how art teachers must operate in the school system. Even outside the school system, K-12 art teachers who exhibit their work may realistically worry that their own potentially offensive imagery results in increased scrutiny of their classrooms or even dismissal. Faculty whose training is primarily in education rather than in studio art may find the issue of censorship far less worrisome. There is less overt censorship of students' work at the college level or even at community art schools, but it still occurs, which may place teachers in a very uncomfortable position.

ART SCHOOLS AND CONTROVERSIAL ART

In our post-Duchampian world, art can be anything the artist calls art, and it is generally seen by supporters and detractors alike as a free-for-all. Perhaps nowhere is it as free as in art schools and university art programs where student work is not inhibited by the perceived interests and tastes of the marketplace. Students try out different materials, media, styles, theories, and personas in order to discover what affect their work

produces; along the way, they may "push the envelope," "transgress," or otherwise seek to shock their fellow students and instructors with or without a definite goal in mind. Everyone has a right to be young.

With few exceptions, studio art faculty generally try to facilitate that experimentation, offering technical advice and critical perspective rather than directives for what students should or shouldn't do. "Freedom of expression and inquiry must be supported and protected," reads a section of the code of ethics of the College Art Association, and one would be hard pressed to find a studio art faculty member or college administrator who would disagree. No one supports outright censorship, but art as free-for-all sometimes creates considerable controversy either within the school or from outside groups, which often catches both faculty and administrators unprepared.

After two controversial student exhibitions in the late 1980s at the School of the Art Institute of Chicago—one by David Nelson featuring a portrait of then Mayor Harold Washington wearing lingerie (resulting in thirty-seven bomb threats and the work being confiscated by several African-American city council members) and the other including an American flag on the floor that visitors were invited to step on by Dread Scott Tyler—"the school developed a culture of paranoia," said Joyce Fernandez, the director of exhibitions and events at the school from 1983 to 1993. "Any kind of publicity became the subject of intense scrutiny." During the flag show, she found herself stalked by men in militia uniform, blamed personally for the work by visitors to the gallery and arrested when she put the flag back on the floor after an Illinois state senator picked it up and stapled it to a flag pole ("the school's lawyer told me I should drive carefully until the arrest was cleared up," she said). Fernandez noted that it took her several years to overcome the trauma of the experience of working at the art school. During her most harried days at the School of the Art Institute, she "went to work worrying about what would go wrong today."

In large measure, the loudest complaints about what goes in both art schools and university art programs is directed at the student exhibitions. Some schools have tried to protect the public more by putting up signs that warn visitors of potentially disturbing artwork or by making more controversial pieces less accessible. Valencia Community College in Orlando, Florida, once kept its gallery locked during an AIDS-related exhibition of nude men, only allowing visitors to enter when accompanied by a docent to explain the artwork. Carol Becker, dean of faculty at the School of the Art Institute of Chicago, recommended placing certain pieces not in the main corridors of an exhibition space but around corners "so people don't have to see it." She added that exhibitions are planned with considerable care: "I will meet with faculty and the gallery director and the students to plan out which works may need signage or a press release, planning in advance for controversy—who might be offended, what might happen as a result, and how we should respond." At the School of the Art Institute and elsewhere, there is more than one gallery available for student work, one of which will be for the more free-for-all, anything-goes type of work, while another gallery will present artwork that is less likely to offend the public or that might be unsuitable for children.

These measures raise a number of questions that are difficult for art school faculty and administrators to answer. Is protecting people from art a form of censorship? Is making art more difficult to see or find, or letting visitors know that they have a "choice" not to see it an answer to controversy? Art is thought of as a public good until at least some members of the public denounce it as a symptom of a sickness or a disease in itself. Encouraging free expression and fearing to offend are concepts that coexist uneasily. One sees more of free speech succumbing to public sensitivities at colleges and universities with fine arts programs than at art schools—colleges and universities generally have a more diverse population, including people with a limited exposure to and knowledge of art—but art schools are no less concerned about their status in the community.

Art frequently challenges received wisdom and customs but, sometimes, it is the teaching itself that is under attack. Michael Auerbach, an art faculty member of Vanderbilt University and chairman of the Professional Practices Committee at the College Art Association, was summoned to a state legislative hearing to defend the school's right to use live, nude models, which the state of Tennessee might have outlawed along with topless dancing in saloons. Preparing for the worst, Vanalyne Green, an associate professor in the video department at the School of the Art Institute who is offering a "production course" in pornography, consulted with the school's lawyer "to make sure that the school and I are protected." Green noted that, when she had studied art herself, it had never occurred to her "that someday I would need a lawyer to decide what I can and can't do in art school."

In large measure, artists learn how to teach from the experience of having been taught, and the rest is usually trial and error. What is an instructor supposed to do when a student's work is overtly racist, sexually explicit, or physically threatening? "Some teachers believe it's their job to produce revolutionaries and to push the edge. It's all anything goes," Auerbach said. On the other side of the free speech issue, he noted, there are teachers who attempt to moderate or disallow objectionable work. "Some teachers grade down students based on their political beliefs, forcing students to adjust their work to get the grade. I've known a teacher or two who has required psychological counseling for students."

Knowing what a teacher should say to a student about work that is likely to engender an immediate and powerful reaction is quite difficult. The ideal pedagogic goal is not to grade content but to lead the student to a greater understanding of their intention for the work and what the audience for the work should experience, and evaluvate how successful the work is in creating that experience. In addition, all this should occur without making the student feel defensive. It may be quite difficult to view racist art, for instance, as an educational opportunity, but, as Auerbach said, "I feel it's my obligation to work the students to determine if they are trying to be ironic or satirical or just provocative, to help them see what the response to their work might be. Maybe, my job as teacher is to help them make their statement stronger."

The focus on how people might respond to a student's work is very much at the core of an art program's critique sessions, in which other students and faculty members evaluate pieces produced during a semester. Carol Fisher, director of undergraduate and graduate programs at the Minneapolis College of Art and Design, defined critiques as "looking at what's there and coming up with some sort of resolution through a group process." Ideally, this interaction should be respectful of the artist, without any ganging up or "group think"—hazards that sometimes beset art schools and art programs. Schools are emphasizing more and more how art is experienced by others, and three schools—the Corcoran College of Art, the San Francisco Art Institute, and the School of the Art Institute of Chicago—offer "artist as citizen" courses that view the role art plays in the general society. Artists should not think of art as anything-goes, according to De. Leslie King-Hammond, dean of graduate studies at the Maryland Institute College of Art in Baltimore. "Artists must learn to be responsible to the community and culture they live in."

Carol Becker lamented the fact that Dread Scott Tyler's flag piece went into a show by jurying rather than through a critique, "because other people's input might have kept what happened from happening. Tyler didn't care that he put everybody in jeopardy. We lost donors and millions of dollars, and his piece obliterated every other work in the show, but he just wanted to make his political statement, and that was that."

Of course, it may be impossible to provoke without offending someone. All school administrators and faculty may be able to do with a clear conscience is to limit the damage to the educational institution itself. When Roger Shimomura, an art professor at the University of Kansas at Lawrence, offers his annual class for performance art, students are given at the beginning of the course a list of thirteen things they may not do. These include hurting themselves or others, the use or discharge of firearms, bloodletting or the exchange of bodily fluids, harming animals, sex acts or acts of sadomasochism, use of drugs or other illicit substances, setting fires or igniting stink bombs, calling in a false alarm to the police, or intentionally vomiting. (Over the years that he has offered this class, all of these have been tried at one point or another. Vomiting took place half a dozen times.) If students create a mess, they must clean it up; in one instance, in which a student threw food around the room, that person was required to pay for the cleaning of everyone's clothes. To a degree, the rules insure that lives are not put in danger and property is not damaged, but to Shimomura, an equal concern is that "nothing is done that threatens the offering of this class in the future."

That threat may define how faculty and administrators see the problem of controversial artwork. Some worry that their institutions may be tarnished by negative publicity or that their jobs may be threatened. Buffeted by the calls for almost limitless free speech and the potential black eye that negative publicity over controversial artwork may create, schools and universities tend to establish few rules about what is

unacceptable—those that are codified stipulate that students can't cause property damage or hurt someone or destroy someone else's art—but many are also reluctant to fully support their students and faculty in the event of complaints over the content of the art. As a result, faculty may feel inhibited about speaking freely to their students.

Bill Paul, a professor of art at the University of Georgia whose AIDS-related art- work became the focus of a Christian Coalition campaign against sexually explicit art and whose classes have been picketed by local ministers, noted that he has "become increasingly careful about what I say in class. I'm not so worried about being fired; I've been here for thirty-four years. The younger faculty might find themselves in trouble in terms of promotions and tenure if they do what I've done. I just don't want all the flap anymore."

Don Evans, a teacher at Vanderbilt University, also noted that the experience of controversy "has changed the way I teach." Back in 1994, the students in a photog- raphy class he taught were asked to do a report on any photographer that interested them, and one of those students did a class presentation on the work of Robert Mapplethorpe, bringing in copies of some of his more sexually explicit works that were in the university's library. Another student, offended by those photographs, brought a complaint about them—and about Evans, for allowing the pictures to be shown in class—to the dean of the college of arts and sciences. The university admin- istration then began an investigation of Evans, holding confidential interviews with every student in his class about what they thought of him and his teaching abilities. "The dean never asked the girl who brought the complaint if she had ever talked to me about not being comfortable seeing these photographs in class. She never said a word to me," Evans said. "The administration just tried to see what they could get on me." Eventually, news of the investigation was picked up first by the school newspa- per, then by the *Nashville Tennessean* and other newspapers around the country. Evans found that his situation became one more battlefield in the ongoing national culture wars between right- and left-wing groups. "The university looked bad for the way it handled the complaint, and I became known as the guy who teaches nude in front of his class," he said. "The whole experience was emotionally debilitating." Eventually, the complaint faded away without anything said or written to Evans by the university administration.

The fears about what could happen if controversial art is presented in class not only affected Evans but others in the art department as well. "I was scared that something like that could happen to me," Michael Auerbach said. "No one wants to be investigated. Everybody likes to talk about academic freedom and free speech, but what does that mean anymore? There are things that I used to talk about in class, but not anymore. I may speak privately about those things to students after I've gotten to know them."

He noted that "I used to show a video about [sexually explicit cartoonist] R. Crumb in one of my classes, but I won't now. I won't even go there. I did a few years ago and a couple of girls walked out. I thought, 'Oh, no, here it starts again.'"

WEIGHING THE PROS AND CONS OF TEACHING

The benefits of college-level teaching are clear—long vacations, time and space in which to pursue their own work, and having to teach only part of the day—but they may also be overstated. Artists have not always felt at peace with the academic life, and many find themselves uncomfortable with it now. In the past, there used to be a lively tradition of artists meeting in a few central locations (at a studio or tavern, perhaps) and hashing out ideas and comparing notes. They were able to both create art and live in the world more immediately. With the growth of teaching jobs in art around the country, the result has been to separate and isolate artists in far reaches of the country, limiting their ability to converse and share ideas.

Looking at this very issue, the critic Harold Rosenberg wrote, "If good artists are needed to teach art, the situation seems irremediable. Where are art departments to obtain first-rate artists willing to spend their time teaching, especially in colleges remote from art centers? And, thus isolated, how long would these artists remain first-rate?" The result, he found, is that many artists lose their sharpness and their students begin to get more of their inspiration and ideas from looking at art journals than from paying attention to their instructors.

The academy has become a main source of employment for artists in all disciplines, and the entire structure of art in the United States has been affected by this. When artists are spread out around the country, removed from the major art markets and critical notice, their ability to exhibit their work becomes much more limited and the desire to show their artwork grows more intense. Members of college or university art faculties frequently find themselves at war with the directors of the institution's art gallery over whether or not their work will be exhibited.

The division between the two is obvious. Artists want to use the available space to show what they do, which is a principal way they can maintain their belief in themselves as artists first and teachers second. On the other hand, university gallery directors don't want to be simply booking agents for the faculty, but prefer to act as regular museum directors, curating their own exhibits and bringing onto the campus the work of artists (old and new) from outside the school. Each side has a point, but it is often an irreconcilable area of contention unless, as at some colleges, there is more than one gallery for art shows on campus. Some schools have galleries that are student-run or that are principally for student exhibitions, while other spaces exist for the faculty and out-of-town artists or traveling shows. When there isn't this multiplicity of art spaces, a state of war may develop at a college that embitters the artist and exhausts his or her time not in art-making but in departmental in-fighting.

Away from the major art centers, stimulation may be lacking for artists who need to have things going on around them, and academia tends to have its own special set of concerns. "In the hinterlands," Robert Yarber, a painter who has taught in California and Texas, said, "all the other artists you meet are teachers, and that can be inhibiting." Bill Christenberry, a painter and photographer at the school of the Corcoran Art Gallery in Washington, D.C., mentioned that he was offered tenure at Memphis State University

and was making a good salary there, "but I thought, 'Heck, if I'm not careful, I'm going to be trapped here.' I never regretted leaving Memphis."

When there is not a community of artists but, rather, an art faculty, discussions about art become less centered within a particular group of artists and may be limited to taking place in formal settings, such as at the annual meetings of the College Art Association (where teachers otherwise convene to look for jobs) or are in the form of critical articles in specialized journals. The ascendance of theory as a starting point for art-making over the past two or three decades may reflect the degree to which teaching artists find each other through a discussion of ideas rather than by shared experiences and close proximity. Additionally, teaching artists are asked to both provide technical instruction, frequently offering an analytical discussion of works by the old and new masters (and by their students), and be creative artists themselves, finding the inspiration to make their own art. This is an age-old problem, one that will continue as long as artists also teach.

Another problem for artists who teach is balancing their own professional careers with what they do for their students. Artist-faculty members, as faculty members in every school department, are required to hold office hours for their students, attend staff meetings, and participate in some campus activities. This is essential for both the students and the college or university as a whole, although it does take time out of the artist's day. It is unlikely that someone would be hired for a teaching position who made his or her lack of interest in these activities known.

MAKING PEACE WITH THE ACADEMIC LIFE

It is said that when the Italian Renaissance artist Verrocchio saw the work of his student, Leonardo da Vinci, he decided to quit painting since he knew that his work had certainly been surpassed. The story is probably apocryphal—it is also told of Ghirlandaio when he first saw the work of Michelangelo, of the father of Pablo Picasso, and of a few other pairings of artists—but the idea of a teacher selflessly stepping aside for the superior work of a pupil makes one's jaw drop.

More likely, many artists who teach today would tend to agree with Henri Matisse who complained during his teaching years (1907–09), "When I had sixty students, there were one or two that one could push and hold out hope for. From Monday to Saturday I would set about trying to change these lambs into lions. The following Monday, one had to begin all over again, which meant I had to put a lot of energy into it. So, I asked myself: should I be a teacher or a painter? And I closed the studio."

Most artists fall somewhere between Verrocchio and Matisse, continuing to both teach and create art but finding that doing both is exhausting. Giving up sleep is frequently the solution.

"My schedule was very tight," said painter Will Barnet, who taught at the Art Students League and Cooper Union in New York City for forty-five years and thirty-three years, respectively, as well as over twenty years at the Pennsylvania Academy of Fine Arts in Philadelphia. "It was tough to find time to do my own work, but I could get

along on very little sleep and was able to work day and night on weekends. Also, I never took a vacation."

Many, if not most, of the world's greatest artists have also been teachers. However, between the years that Verrocchio and Matisse were both working and teaching, the concept of what a teaching artist is and does changed radically. Verrocchio was a highly touted fifteenth-century painter and sculptor, backed up with commissions, who needed "pupils" to be trained in order to help him complete his work. Lorenzo di Credi, Perugino and Leonardo all worked directly on his paintings as the final lessons of their education. It would never have occurred to Matisse to let his students touch his canvases. In the more modern style, Matisse taught basic figure drawing rather than how to work in the same style as himself.

Teaching now obliges an artist to instruct others in techniques and styles that, at times, may be wholly opposed to his or her own work. Even when the teaching and creating are related in method and style, instruction requires that activity be labeled with words, whereas the artist tries to work outside of fixed descriptions—that's the difference between teaching, which is an externalized activity, and creating, which is inherently private and personal. Anyone agreeing with Ernest Hemingway's comment, "When you talk about it, you lose it," would likely feel uncomfortable in the academic environment.

Teaching, which has long been held out as the most sympathetic "second career" for artists who need a way to support their principal interests, may work insidiously at times to destroy or undermine an artist's vocation. Hans Hofmann, for instance, gave up painting for a long stretch in his career because he was fearful of influencing his students in any particular direction. Staying open-minded to various possibilities in painting was problematic to his career when he did paint, critics have argued, as his work bounced around in a variety of techniques and styles. To be a more decisive, fully realized artist, it was necessary for him to finally give up teaching.

"The experience of teaching can be very detrimental to some artists," said Leonard Baskin, the sculptor and graphic artist who taught at Smith College in Massachusetts between 1953 and 1974. "The overwhelming phenomenon is that these people quit being artists and only teach, but that's the overwhelming phenomenon anyway. Most artists quit sooner or later for something else. You have to make peace with being an artist in a larger society."

Artists make peace with teaching in a variety of ways. Baskin noted that teaching had no real negative effect on his art—it "didn't impinge on my work. It didn't affect it or relate to it. It merely existed coincidentally"—and did provide a few positive benefits. "You have to re-articulate what you've long taken for granted," he said, "and you stay young being around people who are always questioning things."

A number of artists note that teaching helps clarify their own ideas simply by forcing them to put feelings into words. Some who began to feel a sense of teaching burnout have chosen to leave the academy altogether in order to pursue their own work

while others bunch up their classes on two full days so as to free up the remainder of the week. Still others have developed strategies for not letting their classroom work take over their lives.

Painter Alex Katz, for instance, who taught at Yale in the early 1960s and at New York University in the mid-1980s, noted that he tried not to think about his teaching when he was out of the class—"out of sight, out of mind," he said.

Others found their teaching had so little to do with the kind of work they did that forgetting the classroom was easy. Painter Philip Pearlstein, who has taught at both Pratt Institute and Brooklyn College, stated that his secret was to keep a distance from his students.

"I never wanted to be someone's guru," he said. "I never wanted to have any psychological or spiritual involvement with my students, getting all tangled up in a student's personality or helping anyone launch a career. I call that using teaching as therapy, and when you get into that, you're in trouble."

Teaching, however, is not all negatives or full of potential pitfalls for these or other artists, and many claim that the experience has been positive overall and, indirectly, beneficial to their work. "Sure, I get exhausted by teaching," photographer Emmet Gowin, who has taught at Princeton University, said. "I come home some nights not wanting to talk for a month, just curl up on a couch and see no one. But if it's physically wearing, it's mentally stimulating. Teaching and creating are the same thing to me because you are bringing to your class or to your work what's important to you at the moment. You're always exploring whether or not things go together. And when it works, whether it's a class or a work of art, it's magic. That's vivifying."

With other artists, the very need to do away with some sleep or vacations or social outings in order to make time for creating art has, in a number of instances, instilled a discipline that makes their use of time all the more effective.

"I think that having a job has led to an intensification of my work," Pearlstein stated. "I had to use the little time I had to paint, and it made me work all that much harder. Something had to give, so I cut down on my social life. I decided it was more important to stay home and paint."

ARTIST-IN-RESIDENCE PROGRAMS

Amidst the ongoing struggle to obtain government (local, state, and federal) support for the nonprofit arts and the din of what was called the "culture wars" has been a growing interest around the country in helping artists create more work. Some of this has been on the part of government, as one city after another has looked to use grants, loans, and tax credits to produce affordable places for artists to live and work, while other programs that financially assist artists are private, nonprofit endeavors (Center for Cultural Innovation, Creative Capital, and United States Artists, among others). Another form of help to artists that has been on the rise is residency programs, where artists are provided time and space to do their artwork.

"Most residency programs for artists have been created in the last twenty-five to thirty years," said Caitlin Strokosch, director of the Alliance of Artists' Communities (*www.artistcommunities.org*), which has over 250 members around the United States. "There seem to be about ten new programs that come into being every year." She noted that between one-quarter and one-third of the Alliance's members look principally for emerging to mid-career artists, "and most of the newer programs appear to be aimed at emerging artists."

The definition of an artist-in-residence program has been expanding with the number of programs. An artist-in-residence at Skidmore College in Saratoga Springs, New York, for example, is one more adjunct studio faculty member, who (according to the school's Web site) will "teach and sit in on classes and seminars, supervise students, consult with faculty, and of course demonstrate his/her talents." The artists-in-residence at Yaddo, the renowned artist community in Saratoga Springs, on the other hand, are housed and fed three meals a day, as well as provided a stipend of varying amounts while given time and space to work on their own art. Between the two is a wide range of variations, including artist communities that one must pay to attend, others that provide housing but no food and no stipends, others that require twenty hours per week of community service or groundskeeping or contribution of an object the artist has created, and some that are bed-and-breakfasts or resorts holding art workshops.

Approximately twelve thousand artists (in literary, performing, and visual arts) are in residence at one retreat or another, and most of them are in rural areas, where the idea is to get away from all the distractions that keep artists from pursuing or completing their work. There are opportunities for fellow resident artists to socialize at Yaddo, for instance, at sit-down breakfasts and dinners in a common room, and people are free to choose their own company in the evenings. However, during the day, artists are expected to work on their own without interrupting others, and bag lunches are left at their studios so that their creativity and thought processes are not disturbed. Yaddo is, perhaps, more the exception than the rule in the field of artist communities, where being around other artists is often as important as having time and solitude to do one's work, but in every residency program there is a focus on the work.

"In our definition," Strokosch said, "an artist-in-residence program provides dedicated time and space for an artist to do work. It's not permanent, like a live-work site, but usually for between a few weeks and a year. There are also competitive criteria for artists to be there, in that they are selected by some means, such as through jurying or a curator." Finally, the sponsoring organization need not necessarily be a nonprofit—it may charge fees—but "it is subsidizing artists, for instance, by having them pay below market rate."

Among those that the Alliance credits with having a particular interest in emerging artists are:

Anderson Center for Interdisciplinary
Studies
163 Tower View Drive
P.O. Box 406
Red Wing, MN 55066
(651) 388-2009
www.andersoncenter.org

Aperture Foundation Work Scholar
Program
547 West 27th Street
New York, NY 10001
(212) 505-5555
www.aperture.org

Arrowmont School of Arts and Crafts
556 Parkway
P.O. Box 567
Gatlinburg, TN 37738
(865) 436-5860
www.arrowmont.org

Artcroft Center for Arts and Humanities
2075 Johnson Road
Carlisle, KY 40311
www.artcroft.org

Artists' Enclave at I-Park
P.O. Box 124
East Haddam, CT 06423
(860) 873-2468
www.i-park.org

Bemis Center for Contemporary Arts
724 South 12th Street
Omaha, NE 68102
(402) 341-7130
www.bemiscenter.org

Blacklock Nature Sanctuary
www.blacklock.org

The Bullseye Connection
300 NW 13th Avenue
Portland, OR 97209-2908

(503) 227-0222
www.bullseyeconnection.com

Center for Furniture Craftsmanship
25 Mill Street
Rockport, ME 04856
(207) 594-5611
www.woodschool.org

CEPA Gallery
617 Main Street
Buffalo, NY 14203
(716) 856-2717
www.cepagallery.com

The Clay Studio
61 Bluxome Street
San Francisco, CA 94107
(415) 777-9080
www.theclaystudio.org

Contemporary Artists Center
71 Old Mill Street
Troy, NY 12180
(518) 320-0628
www.thecac.org

The Cooper Union School of Art Summer
Residency Program
30 Cooper Square
New York, NY 10003-7120
(212) 353-4100
www.cooper.edu/artsummer

Cornucopia Art Center, Lanesboro
Residency Program
103 Parkway Avenue
N - P.O. Box 152
Lanesboro, MN 55949
(507) 467-2446
www.lanesboroarts.org

Creative Alliance
3134 Eastern Avenue
Baltimore, MD 21224

(410) 276-1651
www.creativealliance.org

Dieu Donne Papermill
315 West 36th Street
New York, NY 10018
(212) 226-0573
www.dieudonne.org

Djerassi Resident Artists Program
2325 Bear Gulch Road
Woodside, CA 94062
(650) 747-1250
www.djerassi.org

Fabric Workshop and Museum
1222 Arch Street
Philadelphia, PA 19107
(215) 568-1111
www.fabricworkshopandmuseum.org

Fine Arts Work Center
24 Pearl Street
Provincetown, MA 02657
(508) 487-9960
www.FAWC.org

Franconia Sculpture Park
29836 St. Croix Trail
Franconia, MN 55074
(651) 257-6668
www.franconia.org

A Gathering of the Tribes
285 East Third Street
New York, NY 10009
(212) 674-3778
www.tribes.org

The Hall Farm Center for Arts and
Education
392 Hall Drive
Townshend, VT 05353
(802) 365-4483
www.hallfarm.org

Harvestworks
96 Broadway
New York, NY 10012
(212) 431-1130
www.harvestworks.org

HERE Art Center
145 Sixth Avenue
New York, NY 10013
(212) 647-0202
www.here.org

Highpoint Center for
Printmaking
2638 Lyndale Avenue South
Minneapolis, MN 55408
(612) 871-1326
www.highpointprintmaking.org

Longwood Arts Project
450 Grand Concourse at 149th
Street
Bronx, NY 10451
(718) 518-6728
www.longwoodcyber.org

Lower East Side Printshop
306 West 37th Street
New York, NY 10018
(212) 673-5390
http://printshop.org

McColl Center for Visual Art
721 North Tryon Street
Charlotte, NC 28202
(704) 332-5535
www.mccollcenter.org

Millay Colony for the Arts
454 East Hill Road
P.O. Box 3
Austerlitz, NY 12017
(518) 392-4144
www.millaycolony.org

Nantucket Island School of Design
and the Arts
P.O. Box 958
23 Wauwinet Road
Nantucket, MA 02554
(508) 228-9248
www.nisda.org

Oregon College of Art and Craft
8245 S.W. Barnes Rd.
Portland, OR 97225
(503) 297-5544
www.ocac.edu

Peters Valley Craft Education Center
19 Kuhn Road
Layton, NJ 07851
(973) 948-5200
www.pvcrafts.org

Pilchuck Glass School
430 Yale Avenue N
Seattle, WA 98109
(206) 621-8422
www.pilchuck.com

Pyramid Atlantic
8230 Georgia Avenue
Silver Spring, MD 20910
(301) 608-9101
www.pyramidatlanticartcenter.org

Sculpture Space
12 Gates Street
Utica, NY 13502
(315) 724-8381
www.sculpturespace.org

Sitka Center for Art and Ecology
P.O. Box 65
Otis, OR 97368
(541) 994-5485
www.sitkacenter.org

Smack Mellon Studios
92 Plymouth Street
Brooklyn, NY 11201
(718) 834-8761
www.smackmellon.org

Soaring Gardens Artists' Retreat/Ora
Lerman Charitable Trust Artists'
Residency
RD2 Box 228
Wyalusing, PA 18853
(212) 645 0834
www.lermantrust.org

Socrates Sculpture Park
P.O. Box 6259
Long Island City, NY 11106
(718) 956-1819
www.socratessculpturepark.org

St. Petersburg Clay Company
420 22nd St. S
St Petersburg, FL 33712
(727) 895-5770
www.stpeteclay.com

Studio Museum in Harlem
144 W 125th St.
New York, NY 10027
(212) 864-4500
www.studiomuseum.org

Sundance Institute
P.O. Box 684429
Park City, UT 84068
(435) 658-3456
http://institute.sundance.org

Three Walls
119 N Peoria
Chicago, IL 60607
(312) 432-3972
www.three-walls.org

There are certainly more opportunities for artists in the early stages of their careers than just this group. The La Familia Artist Residency (117 Predontaine Place South, Seattle, WA 98104; 206-903-0627) accepts up to twenty-nine emerging and mid-career artists per year (between three and four at a time, sharing living and work space, for stays of between four and eight weeks), who are not required to pay but must provide twenty hours per week of community service. Another residency that requires a form of community service takes place during the month of January at the Seaside Institute (P.O. Box 4730, Santa Rosa Beach, FL 32459; 850-231-2421), in which literary, performing, and visual artists are provided housing, studio space and a $149 weekly meal allowance; their applications must identify a type of public presentation, such as a lecture, demonstration, visit to the local charter middle school, or something else that they will offer. The Fine Arts Museums of San Francisco (100 34th Avenue, San Francisco, CA 94121-1693; 415-750-7634), has one-month residencies for local artists, who are provided a stipend and work space (but no housing or meals) at the Legion of Honor in the city's Lincoln Park; the opportunity to give lectures or workshops is optional, and the main requirement for artists is that they be on site at least four hours per day, five days per week.

The requirement of community service is a notable element in many of the newer artists' communities, reflecting a beliefs that artists are not (or should not be) isolated from the world and that the arts should be integrated into a larger program of ecological and public awareness. Embodying this holistic view is the Sustainable Arts Society at Blue Ridge (P.O. Box 1, Atlanta, GA 30318; 404-688-1970), which offers two- to four-week residencies for up to six artists at a time (charging $65 per day for room and board, as well as Internet access) and requiring some events for the community and daily work (gardening, egg collection, milking the goats, and making cheese) on the farm. Similarly, the Salina Art Center (P.O. Box 743, Salina, KS; 785-827-1431) offers two six- to twelve-week residencies per year to artists who will create their own work (an exhibition at the Art Center is a possibility at the end of the residency) and perform community outreach in the form of conducting weekly studio tours, workshops, and demonstrations. Participating artists will be given housing and studio space but must pay for their own food, travel, and materials, which may be offset by a stipend of between $500 and $1,000, depending upon their length of stay.

In-residence programs come in a variety of types. The National Park Service (1849 C Street, N.W., Washington, D.C. 20240; 202-208-6843; *www.nps.gov*) has an artist-in-residence program for writers, performing and visual artists, and 29 parks around the country participate. As opposed to artist communities, the National Park Service program brings in one artist at a time. Housing but no stipend is provided, and an individual residency lasts for a period of three weeks. Artists are required to donate to the Park Service's collection some piece of their art that represents their stay, and they also may be asked to hold a demonstration or a talk for park visitors. The participating parks are:

Acadia National Park
Artist-In-Residence Program
Acadia National Park
P.O. Box 177
Eagle Lake Road
Bar Harbor, ME 04609
(207) 288-3338

Amistad National Recreation Area
Artist-In-Residence Program
4121 Veterans Boulevard
Del Rio, TX 78840
(830) 775-7491, ext. 211

Badlands National Park
Artist-In-Residence Program
Badlands NP
P.O. Box 6
Interior, SD 57750
(605) 433-5245

Buffalo National River
Artist-In-Residence Program
402 N. Walnut
Harrison, AR 72601
(870) 741-5443

Cape Cod National Seashore
Provincetown Community
Compact, Inc.
P.O. Box 819
Provincetown, MA 02657

Cuyahoga Valley National Park
CVEEC Artist-In-Residence Program
3675 Oak Hill Road
Peninsula, OH 44264
(440) 546-5995

Delaware Water Gap National
Recreation Area
Peters Valley Craft Education Center
19 Kuhn Road
Layton, NJ 07851
(973) 948-5200

Denali National Park and
Preserve
Artist-In-Residence Program
P.O. Box 9
Denali Park, AK 99755
(907) 683-2294

Devils Tower National Monument
Wyoming, MT 82714
(307) 467-5283

Everglades National Park
Artist-In-Residence-In-Everglades
40001 State Road 9336
Homestead, FL 33034
(305) 242-7750

Glacier National Park
Artist-In-Residence Program
P.O. Box 128
West Glacier, MT 59936
(406) 888-7942

Golden Gate National
Recreation Area
Residency Manager
Headlands Center for the Arts
944 Fort Barry
Sausalito, CA 94965
(415) 331-2787

Grand Canyon National Park
Artist-In-Residence Program
P.O. Box 129
Community Building
Grand Canyon, AZ 86023
(928) 638-7739

Herbert Hoover National
Historical Site
Artist-In-Residence Program
110 Parkside Drive
P.O. Box 607
West Branch, IA 52358
(319)643-7855

Hot Springs National Park
Artist-In-Residence Program
101 Reserve Street
Hot Springs, AR 71901
(501) 620-6707

Indiana Dunes National Lakeshore
Artist-In-Residence Program
1100 North Mineral Springs Road
Porter, IN 46304-1299
(219) 926-7561

Isle Royale National Park
Artist-In-Residence Program
800 East Lakeshore Drive
Houghton, MI 49931-1895
(906) 487-7152

Joshua Tree National Park
Artist-In-Residence Program
74485 National Park Drive
Twenty-Nine Palms,
CA 92277
(760) 367-5539

Mammoth Cave National Park
Artist-In-Residence Program
Mammoth Cave, KY 42259
(270) 785-2254

Mount Rushmore National
Memorial
Artist-In-Residence Program
13000 Hwy. 244, Bldg. 31
Keystone, SD 57751
(605) 574-3182

North Cascades National Park
810 State Route 20
Sedro-Woolley, WA 98284
(360) 856-5700, ext. 365

Pictured Rocks National Lakeshore
Artist-In-Residence Program
P.O. Box 40
Munising, MI 49862
(906)387-2607

Rocky Mountain National Park
Artist-In-Residence Program
1000 Highway 36
Estes Park, CO 80517
(970) 586-1206

Saint Gaudens National Historic Site
Artist-In-Residence Program
RR 3, Box 73
Cornish, NH 03603
(603) 675-2175, ext. 107

Sleeping Bear Dunes National Lakeshore
Artist-In-Residence Program
9922 Front Street
Empire, MI 49630
(231) 326-5134

Voyageurs National Park
Artist-In-Residence Program
3131 Highway 53
International Falls, MN
56649-8904
(218) 283-9821

Weir Farm Trust
Artist-In-Residence Program
735 Nod Hill Road
Wilton, CT 06897
(203) 761-9945

Yosemite National Park
Yosemite Renaissance
P.O. Box 100
Yosemite National Park, CA 95389

Most residencies are not free to the participants—even the program of the National Park Service assumes that artists will provide their own food and art materials in addition to paying rent and any other expenses at home—and finding the means to pay

for them is no simple matter. A high percentage of the participants at artists' communities are faculty members on sabbatical, and summers tend to be when these facilities are most full ("They accommodate academic schedules," Strokosch said). Others seeking help paying for a residency have some options. A number of state arts agencies around the country offer career and professional development grants to individual artists, which may be used to pay for workshops, seminars, mentoring, and specialized training, as well as (in some cases) travel costs to where they will take place. Nineteen states permit that money to be used to pay residencies at artist communities, including:

ALASKA STATE COUNCIL ON THE ARTS
411 West 4th Avenue
Anchorage, AK 99501-2343
(907) 269-6610
www.eed.state.ak.us/Aksca
Career Opportunity grants from $100 to $1,000 usable for unique, short-term opportunities that do not constitute routine completion of work in progress.

ARIZONA COMMISSION ON THE ARTS
417 W. Roosevelt Street
Phoenix, AZ 85003-1326
(602) 771-6501
www.azarts.gov
Professional Development Grant up to $750

DELAWARE DIVISION OF THE ARTS
State Office Building
820 North French Street
Wilmington, DE 19801
(302) 577-8278
www.artsdel.org
Professional and Artistic Development: An individual or collaboration may request up to 80 percent of the cost of the opportunity with requests not to exceed $750.

FLORIDA DIVISION OF CULTURAL AFFAIRS
R.A. Gray Building
500 South Bronough Street
Tallahassee, FL 32399-0250
(850) 245-6470
www.florida-arts.org
Artist Enhancement Grants are awarded in the amounts of either $500, $750, or $1,000.

IDAHO COMMISSION ON THE ARTS
P.O. Box 83720
Boise, ID 83720-0008
(208) 334-2119
www.arts.idaho.gov
Professional Development grants up to $500.

KENTUCKY ARTS COUNCIL
Capital Plaza Tower
500 Mero Street
Frankfort, KY 40601-1987
(502) 564-3757
http://artscouncil.ky.gov
Grants are up to $500 for Individual Artist Professional Development Grants, although the amount of the grant may not exceed one-half of the project's actual cost. Artists must match the Kentucky Arts Council grant with a one-to-one match. For example: If a workshop costs $500 to attend, the artist may ask the KAC for $250 (one-half of the cost). The artist would provide the remaining $250.

LOUISIANA DIVISION OF THE ARTS
Capitol Annex Building

1051 North 3rd Street
Baton Rouge, La 70802
(225) 342-8180
www.crt.state.la.us/arts
Artistic Career Advancement grants up to
$3,000 to support creating new work,
mentoring, equipment purchase, travel for
professional opportunities and attending
workshops, institutes, retreats and
residencies.

MINNESOTA STATE ARTS BOARD
Park Square Court
400 Sibley Street
Saint Paul, MN 55101-1928
(651) 215-1600
www.arts.state.mn.us
Artist Initiative Grants: $2,000 - $6,000.

Montana Arts Council
P.O. Box 202201
Helena, MT 59620-2201
(406) 444-6430
http://art.mt.gov
Professional Development Grants up to
$750 for individuals.

NEW HAMPSHIRE STATE COUNCIL ON
THE ARTS
2½ Beacon Street
Concord, NH 03301-4447
(603) 271-2789
www.nh.gov/nharts
Artist Entrepreneurial Grants: $250
−$750.

NEVADA ARTS COUNCIL
716 North Carson Street
Carson City, NV 89701
(775) 687-6680
http://nevadaculture.org/nac
"Jack-Pot" grants up to $1,000 may be used
for a variety of career-furthering endeavors,
including attending workshops and
retreats.

NORTH CAROLINA ARTS COUNCIL
MSC #4632
Department of Cultural Resources
Raleigh, NC 27699-4632
(919) 807-6500
www.ncarts.org
The N.C. Arts Council sponsors one- and
two-month residencies for artists in a vari-
ety of disciplines at residency centers in
California and Vermont. Two artists will
be selected for residencies at Headlands
Center for the Arts and at Vermont Studio
Center as part of this program.

NORTH DAKOTA COUNCIL ON THE ARTS
1600 East Century Avenue
Bismarck, ND 58503-0649
(701) 328-7590
www.nd.gov/arts
Professional Development grants up to
$500.

OREGON ARTS COMMISSION
775 Summer Street N.E.
Salem, OR 97301-1280
(503) 986-0082
www.oregonartscommission.org
Career Opportunity Grants from $300 to
$1,500.

TENNESSEE ARTS COMMISSION
401 Charlotte Avenue
Nashville, TN 37243-0890
(615) 741-1701
www.arts.state.tn.us
Professional Development Support grants
from $500 to $1,000.

VERMONT ARTS COUNCIL
136 State Street, Drawer 33
Montpelier, VT 05633-6001
(802) 828-3291
www.vermontartscouncil.org
Artist Development Grants from $250 to
$1000.

WASHINGTON STATE ARTS COMMISSION
P.O. Box 42675
Olympia, WA 98504-2675
(360) 753-3860
www.arts.wa.gov
Professional Development Grants up to
$500.

WEST VIRGINIA DIVISION OF CULTURE
AND HISTORY
The Cultural Center
Capitol Complex
1900 Kanawha Boulevard East
Charleston WV 25305-0300
(304) 558-0220

www.wvculture.org
Professional Development grants: First-time applicants can request up to $2,500, representing 75 percent of the cost of each item or service requested, and provide the remaining 25 percent cash match.

WYOMING ARTS COUNCIL
2320 Capitol Ave.
Cheyenne WY. 82002
(307) 777-7742
http://wyoarts.state.wy.us
Individual Artist Professional Development grants up to $500, which must be matched on a one-to-one basis by the applicant.

Additionally, at least one local arts agency (Marin Arts Council, 555 Northgate Drive, San Rafael, CA 94903; 415-499-8350) offers Career Development Grants that help Marin County artists pursue opportunities, such as at an artist community, to further their professional artistic development. The grants go up to $1,500. The Sponsoring Partners program of the Headlands Center for the Arts (944 Fort Barry, Sausalito, CA 94965; 415-331-2787), an artist community, also works with the North Carolina Arts Council and the Ohio Arts Council to underwrite residencies for artists in those states at Headlands. Several nonprofit organizations allow artists to apply for funding that may be used to pay for the cost of a residency:

JEROME FOUNDATION
400 Sibley Street, Suite 125
St. Paul, MN 55101-1928
(651) 224-9431
www.jeromefdn.org
The Travel and Study Grant Program awards grants to emerging creative artists. Funds support periods of travel for the purpose of study, exploration, and growth. (May be used for residencies when teaching or collaborative activities are involved.) Open to residents of Minnesota and New York City.

LEEWAY FOUNDATION
The Philadelphia Building

1315 Walnut Street, Suite 832
Philadelphia, PA 19107
(215) 545-4078
www.leeway.org
Specific grants are available for emerging and established women artists. There is also a Window of Opportunity Grant which helps artists take advantage of unique, time-limited opportunities that could significantly benefit their work or increase its recognition.

NEW YORK FOUNDATION FOR THE ARTS
155 Avenue of the Americas, 6th Floor
New York, NY 10013-1507
(212) 366-6900
www.nyfa.org

Strategic Opportunity Stipends (SOS), a project of the New York Foundation for the Arts, working in collaboration with arts councils and cultural organizations across New York State, are designed to help individual artists of all disciplines take advantage of unique opportunities that will significantly benefit their work or career development. Literary, media, visual, music, and performing artists may request support ranging from $100 to $600 for specific, forthcoming opportunities that are distinct from work in progress.

Another private funding source, the Herb Alpert Foundation (1414 Sixth Street, Santa Monica, CA 90401-2510; *www.herbalpertfoundation.org/foundation_home. shtml*), pays for residencies at a shifting group of artist communities (most recently, Hedgebrook, MacDowell, Ragdale, and Ucross). However, it does so on a nomination basis and will not accept applications.

MUSEUM ARTIST-IN-RESIDENCE PROGRAMS

Nowadays, museums seem to do everything but give visitors a room for the night: they provide food, plan vacations, organize parties, offer concerts and opportunities for shopping, help single people find a date, and teach classes. They also exhibit one thing or another, and a growing number of them have established artist-in-residency programs that allow artists to display their work (finished and in-progress) to, and interact with, the public. The result is a win-win situation for all concerned, as both artists and museums benefit from their joint efforts.

At the Coral Springs Museum of Art in Florida, which created an artist-in-residence program in 2000, for instance, artists receive a stipend of $9,000 for their one to three-month residencies, free materials, a studio in the museum, room and board (staying either with staff or patrons of the museum), and a separate payment for the purchase of the artwork they create on site. "What they create becomes part of the permanent collection," said Barbara O'Keefe, director of the museum. "We're a small museum, and we have no budget for acquisitions. We found that it is less expensive to have an artist-in-residence program than to raise and maintain an acquisitions budget." She added that sources of financial support—both individuals and public and private agencies—are more willing to provide money for a program that involves both an activity and acquisitions than just one or the other.

For the artists involved, the end result of their residencies is not just one more line on their résumés but "a lot of coverage in the local papers" (Hollywood, Florida, textile artist Barbara W. Watler), "a lot of calls from people interested in commissioning a piece" (South Lake Tahoe, California, mosaic artist Patricia Campau) and the actual purchase of a work by a museum patron—"I was told to bring other, completed pieces with me to the residency" (Gray, Maine, sculptor Roy Patterson). Justine Cooper, an artist living in Brooklyn, New York, who has completed residencies at both the Bellevue Art Museum in Seattle and the American Museum of Natural History in Manhattan, the experience has been helpful when applying to funding sources for other projects: "It gives me a proven track record or receiving money and doing something with it."

The term "artist-in-residence" is used broadly, elastically in the art world. Artist communities, such as MacDowell in New Hampshire or Villa Montalvo in California, provide a rural, away-from-it-all retreat for artists in different disciplines to pursue their individual work "in-residence," while college art departments use the term to refer to short-term adjunct out-of-town faculty. A museum's artist-in-residence program exists somewhere between the two. There is often a public component, such as leading a workshop (for school children, in many instances) or giving an evening lecture (for adults), and the artist at work is on display for museum visitors to see. The institution usually receives something that the artist creates, but there are generally no limits set on what the artist does. "They do whatever they want. There are no restrictions," said Patricia Kernan, staff illustrator and residency coordinator at the New York State Museum in Albany, which has had an artist-in-residence program since 1996.

There is no one type of museum artist-in-residence program. In many institutions, the artist-in-residence program is run out of the museum's education department with a very specific mandate to develop and complete projects with school-age children, and there may be no studio or materials for the artists or opportunities for them to exhibit their own work. "They're brought in to be a presence in the community, more as a creative catalyst than as a maker of art," said Kelly Armor, educator coordinator at the Erie Art Museum in Pennsylvania, which brings in artists as short-term (three days to two weeks) residents in conjunction with exhibitions the institution is staging of their work. "They are here to be teachers, reflecting not a particular technique but now they think about art and articulate that." Artists do not apply to be residents but are selected by recommendation of other artists, critics, curators, and whomever else has the ear of museum staff. Good art may be enough to get an exhibition, but to be an artist-in-residence, "they have to enjoy being around other people," Armor said. "I've approached artists who didn't feel comfortable conversing or leading discussions and don't think it's the best use of their time."

Similarly, artists chosen for the artist-in-residence program at the Rockford Art Museum in Illinois "must have teaching experience," said education coordinator Mindy Nixon. The program, which began in 1996, is "structured for youths; they tour the museum and do an activity with the artist-in-residence."

The Aspen Art Museum in Colorado, on the other hand, which established its artist-in-residency back in 1979 but let it languish, restarting the program again in 2006, has no teaching or workshops required, "unless the artist feels like it," according to assistant curator Matthew Thompson. The average residency is one month, although it may be as short as two days or as long as two months. Artists are given a workspace in one of the museum's galleries (viewable by the public), and it is there that exhibition of what the artist has created during the interim takes place. In addition to studio space, artists receive accommodations and an allowance for food, along with money for materials and equipment and to pay assistants. Since the Aspen Art Museum is not a collecting institution, what the artist creates does not go into a

permanent collection, although "if the piece is sold, we may try to recoup our costs," Thompson noted.

It is not only artist museums that have artist-in-residence programs. A number of science and natural history museums also have worked with artists, establishing more or less formalized residencies. On the less formalized side is the American Museum of Natural History, which allows artists to work at the institution on projects for which they arrange financial support and of which the museum gives approval. Justine Cooper's 2003–2004 project of photographing behind-the-scenes storage and collection facilities at the museum was funded by both the New York City-based Greenwall Foundation and the Australia Council. Thomas A. Bennett, a painter in Wallace, North Carolina, proposed the idea of creating eighty paintings of extinct or endangered bird species of the southeastern United States to the North Carolina Museum of Natural Sciences in Raleigh back in 1999, which started and sums up the museum's artist-in-residence program. (He doesn't expect the project to be completed before 2015.) In exchange for a stipend that ranges from between $15,000 and $50,000 per year (based on the museum's success in fundraising), Bennett donates the original paintings to the institution's collection, "although I own all rights and can make prints," he said. His self-published print editions, which vary in size from one hundred to 750, are priced between $175 and $1,450.

Being the museum's artist-in-residence has led to considerable exposure when he is seen working in the museum or his paintings are seen in the museum (some visitors to the museum have commissioned him to create specific wildlife paintings), and in a wider sphere as well. In 2005, he was given an award by the South Carolina Audubon Society, and the Missouri Department of Conservation requested the use of one of his paintings (one of a South Carolina parakeet) in the museum's collection for an exhibition.

Perhaps, the artist holding the record for longest artist-in-residency is watercolor artist Peggy Macnamara, who has been associated with the zoology department of Chicago's Field Museum since the early 1980s. "Initially, I went to the Field Museum to do drawing," she said. "It's all a still-life waiting for me; there is no other way to get a zebra to hold still." After becoming a fixture in the museum's galleries, a zoology staffer asked to display her paintings as part of a permanent display of birds, mammals, and reptiles ("I own the work," she noted. "They are on indefinite loan to the Field Museum"), and the museum's education department offered her a contract to teach a three-hour art class once a week under the newly created category of Artist in the Field. Over the years, she has been invited on the museum's scientific expeditions to Central and South America, as well as Africa. In 2005, a Field Museum book on insects of Illinois, for which Macnamara provided the illustrations, was published by the University of Chicago Press.

Over time, a full artistic career emerged. She currently teaches a scientific illustration class for the School of the Art Institute of Chicago at the Field Museum and exhibits natural history paintings at Chicago's Aron Packer gallery, selling print

images of those works through her Web site). A number of the paintings Macnamara has created at the Field Museum have been purchased by staff scientists, and the head of the museum's board of directors purchased a six-foot-tall and twenty-foot-long painting of sand hill cranes. "I don't rely on the Field Museum for my income, thank God, but they give me total access to the collection and to any members of the staff," she said. "It's an ideal life."

Among the museums that have artist-in-residence programs in the United States are:

CALIFORNIA
California Science Center
Exposition Park
700 State Drive
Los Angeles, CA 90037
(213) 744-7446
www.californiasciencecenter.org

Cartoon Art Museum
655 Mission Street
San Francisco, CA 94105
(415) 227-8666
www.cartoonart.org

De Young Museum
Golden Gate Park
50 Hagiwara Tea Garden
Drive
San Francisco, CA
(415) 750-3614
www.thinker.org

COLORADO
Aspen Art Museum
590 North Mill Street
Aspen, CO 81611
(970) 925-8050
www.aspenartmuseum.org

FLORIDA
Coral Springs Museum of Art
2855 Coral Springs Drive
Coral Springs, FL 33065
(954) 340-5000
www.csmart.org

ILLINOIS
The Field Museum
1400 S. Lake Shore Drive
Chicago, IL 60605-2496
(312) 665-7106
www.fieldmuseum.org

Rockford Art Museum
Riverfront Museum Park
711 N. Main Street
Rockford, IL 61103
(815) 972-2880
(815) 968-2787
www.rockfordartmuseum.org

MASSACHUSETTS
The Art Complex Museum
189 Alden Street
Box 2814
Duxbury, MA 02331
(781) 934-6634
www.artcomplex.org

Fuller Craft Museum
Art Aspire
455 Oak Street
Brockton, MA 02301
(508) 588-6000, ext. 112
www.fullermuseum.org

Isabella Stewart Gardner Museum
280 The Fenway
Boston, MA 02115
(617) 566-1401
www.gardnermuseum.org

MINNESOTA
Science Museum of Minnesota
120 West Kellogg Boulevard
Saint Paul, MN 55102
(651) 221-9444
(800) 221-9444
www.smm.org

MISSOURI
Kemper Museum of Contemporary Art
4420 Warwick Boulevard.
Kansas City, MO 64111
(816) 753-5784
www.kemperart.org

MONTANA
Hockaday Museum of Art
302 Second Avenue East
Kalispell, MT 59901
(406) 755-5268
www.hockadaymuseum.org

NEW JERSEY
The Newark Museum
49 Washington Street
Newark, New Jersey 07102-3176
(973) 596-6550
www.newarkmuseum.org

Noyes Museum of Art
733 Lily Lake Road
Oceanville, NJ 08231
(609) 652-8848
www.noyesmuseum.org

NEW MEXICO
Harwood Museum of Art
238 Ledoux Street
Taos, NM 87571
(505) 758-9826
www.harwoodmuseum.com

NEW YORK
American Museum of Natural History
Central Park West at 79th Street

New York, NY 10024
212-769-5800
www.amnh.org

The Studio of The Corning Museum
of Glass
One Museum Way
Corning, NY 14830-2253
(607) 974-6467
www.cmog.org

New York State Museum
The Edmund Niles Huyck Preserve,Inc.
P.O. Box 189
Rensselaerville, NY 12147
(518) 797-3440
www.nysm.nysed.gov

Roberson Museum and Science
Center
30 Front Street
Binghamton, NY 13905-4779
(607) 772-0660
www.roberson.org

Studio Museum of Harlem
144 West 125th Street
New York, NY 10027
(212) 864-4500
www.studiomuseum.org

NORTH CAROLINA
North Carolina Museum
of Natural Sciences
11 West Jones Street
Raleigh, NC 27601-1029
(919) 733-7450
www.naturalsciences.org

OHIO
Taft Museum of Art
316 Pike Street
Cincinnati, OH 45202
(513) 241-0343
www.taftmuseum.org

PENNSYLVANIA
Erie Art Museum
411 State Street
Erie, PA 16501
(814) 459-5477
www.erieartmuseum.org

The Fabric Workshop and Museum
1315 Cherry Street
Philadelphia, PA 19107
(215) 568-1111
www.fabricworkshop.org

9

The Materials that Artists Use

As important as it is for artists to know how to create art is their understanding of the physical properties of the materials they use and the durability of the works they make. Collectors, viewers, and other artists assume that art should last a long time; pieces that fall apart or lose their color within a few years can greatly damage an artist's reputation.

But beyond consideration of the durability of a work of art, there is another imperative: artists should have a clear understanding of the materials they are using for quite personal reasons—their own health.

SAFE ART PRACTICES IN THE STUDIO

Many people—sixty-three million in this country, according to the United States government—like to work on arts and crafts projects as hobbies. That is a quarter of the total population, or one person in every other dwelling in America busy with painting, pottery, weaving, or doing some other similar activity. Unfortunately, part of that vision is many of these same people poisoning themselves through using inappropriate materials, unaware that many of these products contain extremely toxic substances. Working on arts and crafts projects at home can be a source of both fun and chronic ailments for professional artists, amateurs, and, especially, children.

Knowing what's in these products is the first step. Federal and state "right-to-know" laws have made this much easier for those artists who have art-related jobs, such as in publishing or teaching. Employers of these artists are required to provide information about the hazards of the products used on the job in the form of special data sheets. These sheets are called Material Safety Data Sheets, and they include the products' manufacturers and distributors.

Self-employed artists may also write to manufacturers for these Material Safety Data Sheets, although in many states the manufacturers and distributors are not required to provide them. Most responsible companies, however, will supply this information.

The data sheets are necessary because art materials labels do not list ingredients. And, until recently, only acute (immediate) hazards, such as severe eye damage from splashes or poisoning due to the ingestion of small amounts of a product, had to be listed.

In 1988, the federal government enacted a labeling law requiring art supply manufacturers to list chronic (long-term) hazards associated with the product on the label. This enables buyers to make safer choices, and if artists understand the hazards of particular chemicals, they can use the warnings to identify the contents. For example, a yellow material labeled with warnings about cancer and kidney damage is likely to contain a cadmium pigment. A material labeled with warnings about reproductive damage, birth defects, or nerve, brain, or kidney damage may contain lead. (Unlike ordinary consumer paints, artists' paints are still permitted to contain lead.)

Some of the most common toxic materials found in arts and crafts materials are:

Chemical	Art Material	Major Adverse Effects
Ammonia	Most acrylic paints	Irritates the skin, eyes and lungs
Antimony	Pigments, patinas, solders, glass, plastics	Anemia, kidney, liver and reproductive damage
Arsenic	Lead enamels and glass	Skin, kidney and nerve damage, cancer
Asbestos	Some talcs and French chalks	Lung scarring and cancer
Barium	Metals, glazes, glass, pigments	Muscle spasms, heart irregularities
Cadmium	Pigment, glass and glaze colorant, solders	Kidney, liver and reproductive damage, cancer
Chromium	Pigment, glass and glaze colorant, metals	Skin and respiratory irritation, allergies, cancer
Cobalt	Pigment, glass and glaze colorant, metals	Asthma, skin allergies, heart damage, respiration
Formaldehyde	Most acrylic paints, plywood	Irritates skin, eyes, and lungs, allergies, cancer
Hexane	Rubber cement and some spray products	Nerve damage
Lead	Pigments, enamels, glazes, solders	Nerve, kidney, reproductive damage, birth defects
Manganese	Glass and ceramic colorants, pigments, metals	Nervous system damage reproductive effects

(Continued)

| Mercury | Lustre glazes, pigments, photochemicals | Nervous system damage, reproductive effects |
| Uranium Oxide | Ceramic, glass, and enamel colorant | Kidney damage, radioactive carcinogen |

The federal law was clearly necessary. Many chronically toxic substances are used in art materials, including metals (see table above); toxic minerals such as asbestos, silica, and talc; and a barrage of solvents. Exposure to these substances in art materials has resulted in many instances of injury to artists and children. Some artists and children are especially at risk because they work at home where exposure is intimate and prolonged.

Michael McCann, an industrial hygienist and director of the nonprofit Center for Safety in the Arts and Crafts in New York City, found in a survey he conducted that a high proportion of professional artists did their work in rooms in their homes where their families lived and ate.

Half of the artists surveyed said that they worked at home, and half of those artists said their workspaces existed in living areas. Even more disturbing than that, however, was that 40 percent of women artists with children did their work in living areas, presumably because when they had children they lost their art studios.

There is a strong correlation between parents making art in living areas and the numerous calls that various local and regional poison control centers receive concerning children swallowing turpentine, pottery glazes, or other toxic substances. It is not unusual for an artist-parent to put turpentine or a similar material in a milk carton or other food container. Children, believing that there is milk or something else they like in the container, will take a drink from it.

These data are reinforced by findings from other polls and surveys. There are also individual cases of children who accidentally swallowed turpentine and other toxic art materials. The Centers for Disease Control, in a report on "Preventing Lead Poisoning in Young Children—United States," specifically mentioned home activities involving lead, such as making stained glass or casting lead objects. Working at home with toxic paints, pastels, ceramic glazes, and other materials could be equally hazardous.

Exposure of family members to the toxic effects of art materials can occur in many ways. For example, they can breathe in dusts from pastels or clay, as well as vapors from turpentine and paints or inks containing solvents. Dusts and vapors can travel all through the house and may also be ingested when small amounts drift into kitchen areas, contaminating food.

To combat this kind of exposure, parents are generally advised to segregate their art activities to rooms that have a special outside entrance and that are locked to prevent small children from entering. Work tables and floors should be wet-mopped regularly. Ordinary household and shop vacuums ought not to be used since their filters will pass

the small toxic dust particles back into the air. Sweeping is even more hazardous, for this will cause dust to become airborne.

Running water should be available in the studio. Floors should be sealed to facilitate easy cleaning, and spills must to be wiped up immediately. Separate clothing and shoes should be worn and left in the studio in order to avoid carrying and tracking contaminants into the house.

Dust and debris should be disposed of in accordance with local, state, and federal disposal laws; one can find out what is required by calling the local sanitation, environmental protection, or public works department. These laws vary widely depending on the type of waste treatment in one's community. Pouring solvents down the drain is against environmental laws everywhere as well as being a danger to the artist and his or her family. Solvents in drains and sewers tend to evaporate, producing flammable vapors in the drain that may cause explosions.

Many communities have a toxic chemical disposal service that will accept waste solvents and other toxic waste created by households and hobbyists (defined for this purpose as people who do not make money from their work). Professional artists may be required to hire hazardous waste disposal companies to pick up their toxic refuse.

Usually, ordinary waste from consumer art paints and materials can be double-bagged and placed in the regular trash. Lead metal scraps, on the other hand, can be recycled. Again, one should call local authorities for advice on disposal of art materials, as the fines for violating the laws can be quite high.

Monona Rossol, an industrial hygienist and president of a nonprofit organization—Arts, Crafts, and Theater Safety—in New York City, recommends that studios be properly ventilated. The ventilation should be tailored to fit the type of work done in the studio. For example, all kilns need to be vented, and there are several commercial systems that can be purchased for them. More complex equipment may require an engineer to design a proper system.

One simple system she recommends for many individual studios requires windows at opposite ends of the room. The window at one end is filled with an exhaust fan, and the other is opened to provide air to replace that which is exhausted by the fan. This system should not be used in studios where dusts are created, although it is acceptable for painting and other arts activities that produce small amounts of solvent vapors.

The hazards associated with certain arts and crafts materials have been a growing area of concern for toxicologists and others. In a number of instances, the connection between the ailment and the materials is discovered posthumously. Doctors have suggested, for instance, that both van Gogh's insanity and Goya's mysterious illness resulted from ingesting lead paints they used, perhaps by "pointing" their paint brushes with their lips or just by poor hygiene. Dr. Bertram Carnow of the University of Illinois School of Public Health has speculated that the blurry stars and halos around lights in van Gogh's later works may have been caused by a swelling of the artist's optic nerve, which can be attributed to lead poisoning. Eyewitnesses reported that paint and turpentine covered the clothes he wore and the food he eventually ate. The theory about van

Gogh stems from the knowledge that he used large amounts of white lead in his paint and occasionally fixed himself a "cocktail" of absinthe and turpentine and goes against the longstanding view of him as either schizophrenic or syphilitic. Likewise, Goya's bouts of mysterious illness always occurred after intense periods of work.

Children are considered to be at a much greater risk than adults when using hazardous art materials because they have a higher metabolic rate and are more likely to absorb toxic elements into their bodies. Younger children have incompletely developed body defenses, making them more susceptible to disease. One victim, thirteen-year-old Jon Glowacki, who died in February, 1985, spent a lot of his free time at home working on art projects that involved rubber cement. Rubber cement contains a form of hexane that has been known to cause nerve damage and irregular heartbeat, and Glowacki (according to the coroner who performed his autopsy) died from inhaling it.

Adult supervision of children's use of art materials is one way to lessen the risks but, according to Monona Rossol, the underlying rule is that "adult art materials are for adults. Children should simply not be using products that haven't been specifically tested to be safe for them. I've seen very young children using airbrushes and spray-painting, which creates a lot of toxic mists. I've seen kids using solvents that give off vapors that are really neurotoxins—that is, they are narcotic, because they'll do just the same sort of damage."

For instance, adult permanent felt-tip marking pens, as well as many oil paint solvents and varnishes, contain these kinds of solvents. Most adult acrylic paints contain ammonia (irritates the skin, eyes, and lungs) and formaldehyde (irritates the skin, eyes, and lungs; causes allergies; and is a suspected of being a cancer agent). Dusts from ceramic and sculpture clays contain lung-scarring silica and talc.

Children should use only water-based markers and paints, and clays that are low in silica and talc-free. Clays and paints should always be purchased and used premixed to avoid children's exposure to the powder or dust. In addition, all art materials for children should be known to be safe, such as dustless chalks, oil pastels, and dyes using vegetable or food coloring.

The Arts and Creative Materials Institute (P.O. Box 479, Hanson, MA 02341-0479; 781-293-4100; www.acminet.org) has a list of products they have approved for children that includes all these kinds of materials. For additional information, one may contact Arts, Crafts, and Theater Safety (181 Thompson Street, New York, NY 10012; 212-777-0062; www.artscraftstheatersafety.org).

SUBSTITUTE INGREDIENTS IN ARTISTS' PAINTS

As noted above, federal law has been enacted to require art supply manufacturers to label the potential chronic health risks from ingredients in their paints and other products. That may answer questions, such as: What is in the materials I use? Which known health risks do I face? But, sometimes, answers don't resolve problems as much as lead to more questions. Of course, the manufacturer's label may not answer the health questions unless known chronically hazardous ingredients are present.

What many have discovered in examining the new, more inclusive labels is that some of these supplies contain synthetic and substitute ingredients instead of what they believed they were buying. What painters thought was cadmium in a tube of paint was actually, in many cases, napthol or thioindigold red; similarly, "cobalt blue" doesn't contain any cobalt at all but ultramarine (itself now a synthetically produced pigment), phthalocyanine blue, or something called Pigment Blue 60. Lemon Yellow is another pigment that, traditionally composed of barium yellow, is now nickel titanate.

What happened to the real stuff? The fact is, industry officials state, that until labeling became a common practice, artists were not aware that the colors they were using might not be what the labels said they were. In the past, art supply makers took the position that substitutions were implicit. They said, in effect, "Look what we're charging. No one would think it's real cadmium at that price." Now, there is a different system.

That system, established by the Conshohocken, Pennsylvania-based American Society of Testing and Materials, is to call pigments "hues" when they contain substitute ingredients but still use the generic designation of, for instance, cadmium red or cobalt blue. Some laboratory-created colors, of course, have long been known to contain substitute ingredients. Included are pigments marketed under company names, such as Windsor & Newton Red, or sold under traditional names, such as Naples Yellow. Historically, Naples Yellow was lead antimoniate, but most companies have reformulated this color from mixtures of other pigments for safety and economic reasons. The "hues" are a newer phenomenon.

To a significant degree, substitute pigments are a result of permanency and price. Certain colors, such as alizarine crimson or Hooker's Green, are terribly fugitive and tend to fade quickly. The color ingredients used to replace the traditional pigments are said to make these colors much more permanent. The cost of other pigments, such as cadmium and cobalt, for example, has become so high that some artists wouldn't be able to afford them.

High prices for certain materials are due either to scarcity or huge demand (or both). Cadmium, for instance, is used in batteries and for processing diamonds, while cobalt has a role in tempering blades in jet engines as well as in nuclear devices and cobalt therapy. The major sources for cobalt also happen to be the republics of the former Soviet Union and Zaire, where export is not an inexpensive or simple matter.

Prices for the synthetically produced "hues" are between two-thirds and one-half the cost of the real thing. In one art supply store, the retail price for a small tube of Winsor & Newton Cadmium Red Medium was twice the cost of its Cadmium Red Hue, and Liquitex's Cerulean Blue cost 30 percent more than the Cerulean Blue Hue. The permanency rating for the "hues" is largely the same as the traditional colors they might substitute for—Wendell Upchurch did point out that "ultramarine is not as permanent as cobalt in the 'hue' form"—and the colors will not be identical.

The cadmium red hue and the cobalt blue hue, for instance, shift a bit to the violet, while phthalocyanine sometimes shifts to green. If they choose paints with synthetic ingredients, artists will pay less, but they'll have to be more observant and correct the color shifts by adding yellow to the cadmium hue and green to the cobalt hue. The hues

are not the same, and artists find themselves having to work harder to preserve what they thought they had.

Perhaps between 20 and 30 percent of all professional artist paints contain synthetic pigments, increasing to perhaps 40 percent for supplies just under artist-grade, with almost all student-grade paints being substitute ingredients.

The substitute pigments clearly have benefits and some drawbacks—or, at least, give rise to new battles among art supply manufacturers. The more expensive iron oxides, such as burnt sienna, Indian red or yellow, and raw umber, are literally dug out of the ground and tend, because of their source, to have impurities. The lab-created pigments, on the other hand, have few impurities and a higher tinting strength, requiring the addition of inert pigments—such as aluminum hydrate, berium sulphite, and calcium carbonate—to tone down the color. The result is that the new generation of paints tend to have less cadmium in cadmium and less cobalt in cobalt, with other ingredients—such as enhancers or toners—added for opacity, body, consistency, brightness, and value, and to eliminate excess oil. All this requires artists to assume less about the paints they use and learn more about what goes into their supplies.

This becomes a problem because not all manufacturers of artists' materials label their products in the same way. Part of the system established for labeling by the American Society of Testing and Materials requires manufacturers to list on the product label the enhancers used when they comprise more than 2 or 3 percent (by volume) of the material. Not all American companies, however, subscribe to the ASTM standard, and few European suppliers do. The result is that artists may find themselves purchasing what is labeled pure cadmium but actually contains a considerable amount of toner (dye color). It is a concern for which few artists or hobbyists these days are prepared.

"In the old days, artists learned chapter and verse what you can and cannot do with materials," George Stegmeyer, technical consultant to Grumbacher, the paint manufacturer, said. "That aspect of art training has been largely eliminated from our culture, replaced by the intellectual and theoretical aspects of becoming an artist."

Only a handful of schools—among them, the School of the Art Institute of Chicago, Boston University, University of Delaware, University of North Carolina at Greensboro, the Pennsylvania Academy of Art, and Yale University School of Art—offer courses on art materials, instructing students in the composition of the products they use and their durability. Artists who are accustomed to simply purchasing materials at a store and assuming that everything is basically the same as it always was, find that they now have more information (through the product labels) but not necessarily the ability to understand it.

Permanence and price are not the only factors that have led to the use of synthetic pigments, according to various people concerned with art materials. "I think the health concerns about some of the heavy metals have definitely resulted in, or at least accelerated, the use of substitutions," Michael McCann stated. "You have cadmium and the cancer question, and then there's cobalt and manganese. Companies now have to put warning labels with them. It's better to try to find a substitute, and they get to save money at the same time."

There will never be a return to nineteenth-century paints, and few artists would want it even if it were possible. Today's materials are purer, more affordable and permanent, more buttery in texture, less damaging to one's health, and available in a far wider range of colors. Still, synthetic substitutes are not the same as the original pigments, and artists can be a traditional bunch. Barium, for instance, is often used with cadmium to screen out ultraviolet light and thereby make the color more permanent but also reducing the tinting strength. The victory for permanence is potentially an uneven one. New concerns about what they are using are the price artists must pay for progress.

Increasingly, artists should refrain from making assumptions about the materials they purchase; instead, they ought to contact the manufacturers—specifically, the technical advisors at those companies, if the customer service representatives cannot answer detailed questions—in order to obtain a fuller understanding of the products.

A PRIMER ON PAINT LABELS

What information should be on the label of a tube of paint? Presumably, prospective buyers would want to read about what is inside the tube, such as the pigment, medium (oil or acrylic, for instance), other admixtures (additives, binders, coarse particle content, extenders, preservatives) and the durability (or lightfastness) of the product. As noted above, art supply companies are also required by federal law to indicate which ingredients are known to cause either acute or chronic illnesses (". . has been shown to cause cancer"), what those ailments are, and how the product should be used properly, as well as the name, address, and telephone number of the manufacturer.

Unfortunately, not all art supply makers provide all this, and many offer bits and pieces of information, often using proprietary names and terms or codes that mean different things to different manufacturers.

The hues and proprietary color descriptions are obviously one example. Most tubes of artist paints include a number that corresponds to a standardized color index, a nine-volume reference that is jointly produced by the Society of Dyers and Colourists in England (P.O. Box 244 Perkin House 82 Grattan Road, Bradford West Yorkshire BD1 2JB; 011-44-1274-725138; *www.sdc.org.uk*) and the American Association of Textile Chemists and Colorists in the United States (One Davis Drive, P.O. Box 1215, Research Triangle Park, NC 27709-2215; 919-549-8141; *www.aatcc.org*). This reference is expensive, costing $900 in a hard copy and $1,300 on CD ROM, but it may be found in technical and art libraries. It lists by C.I. (color index) the name and number of all commercially available dyes and pigments and their intermediates. One may also contact the American Society of Testing and Materials (100 Barr Harbor Drive, West Conshohocken, PA 19428; 610-832-9500; *www.astm.org*) for precise descriptions of pigments and their durability. For alkyds, oils, and resin paints, the specifications are contained in ASTM D-4302; for watercolors, the ASTM D-5067; for acrylics, the ASTM D-5098. Each ASTM standard costs $12. Artists may want to write to the manufacturers when tubes do not indicate the color index number or that number is not clear. The label for Liquitex's Cadmium Red Medium, for instance, says "Munsell 6.3 R," which is the index number (the R refers to a shift to the red).

Permanency ratings is another area in which one might contact the manufacturer for more information if the label is not clear or decipherable. The American Society of Testing and Materials rates paints I, II, and III for their resistance to fading in daylight, or lightfastness, with I the most resistant. Liquitex follows the ASTM format in its lightfastness ratings, but Van Gogh ratings are +++ and ++, with +++ the highest degree of lightfastness and ++ what the company calls "normal degree of lightfastness." Rembrandt lists lightfastness, starting with the most permanent, as A, B, C, and D. Winsor & Newton has two different rating systems: ++++, +++, ++ and +, and AA, A, B, and C (++++ and AA are the most lightfast).

The ASTM standards are quite useful in terms of understanding the actual color, performance, and quality of an art product. Unfortunately, Mark David Gottsegen, a member of the committee on artists' paints and related materials at ASTM and research director for the Art Materials Information and Education Network in Cleveland, Ohio, stated that "very few companies are conforming to these standards. You pay $12 for a standard that few companies bother with."

Part of the system established for labeling by the American Society of Testing and Materials requires manufacturers to list on the product label the enhancers used when they comprise more than 2 or 3 percent (by volume) of the material. Not all American companies, however, subscribe to the ASTM standard, and few European suppliers do.

The paint's durability as well as its color index name and number are optional for manufacturers to include on the product label, but health and safety information is not. Since 1990, the federal Labeling of Hazardous Art Materials Act requires that all art materials sold in the United States include a conformance statement ("Conforms to ASTM D-4236") that insures the manufacturers submitted their product formulas to a board-certified toxicologist for review. The toxicologist determines what labeling is required under the standard. Also required is a telephone number in the U.S. from which additional information may be obtained. There are a number of board-certified toxicologists working with art materials companies. Many companies subscribe to the labeling program of the Boston-based Arts and Crafts Materials Institute: "AP Nontoxic," "CP Nontoxic," and "Health Label" seals appear on the labels of their paints. Both "AP" and "CP" indicate that the Institute certifies the products are safe even for children ("AP" specifically refers to nontoxicity, while "CP" includes both non-toxicity and performance requirements), and "Health Label" signifies that the warning label on the product has been certified by an ACMI toxicologist and, if hazards are found, appropriate warnings are printed on the label. After review, the Institute's toxicologist can allow the product to carry one of its seals. However, the same paints may be sold by a mail-order company but without the ACMI emblems to indicate their safety.

Very small tubes of paint are exempted from including most of the required federal labeling. The safety information on a tube of Windsor-Newton cadmium red watercolor paint, for instance, was condensed to three words—"Warning: Contains Cadmium." By this standard, a cigarette pack might simply inform buyers that the product contains tobacco.

The appearance of a conformance statement and a health label does not instill confidence in every art product user that all acute and chronic health risks are identified and described. According to the U.S. Public Interest Research Group, which issued a report in October 1993 titled, "Poison Palettes: The Lack of Compliance of Toxic Art Supplies with Federal Law," the question of nontoxicity is a loophole-filled designation, and the labeling law is itself buffeted by insufficient compliance. The report found that warnings about chronic health hazards and the manufacturers' telephone numbers were frequently missing from the product labels.

"Art materials are not as safe as many people have been led to believe," said Bill Wood, a researcher for the research group and author of the report. "Many products may be labeled nontoxic if they have never been tested for toxicity. The Environmental Protection Agency has complete test data on only twenty-two of the more than 70,000 chemicals produced by chemical manufacturers in this country. To call something non-toxic when you don't actually know is misleading."

Monona Rossol added that "a benzidine dye that hasn't been tested can still be marketed as nontoxic, even though it breaks down to free benzidine in the body, which is well known for causing bladder cancer as well as other diseases."

The "ASTM D-4236" on the label is supposed to mean that the toxicologist has reviewed the product's formula but, Rossol said, "there are mislabelers out there that just put this on the label. Artists should choose to buy paints from one of the large, reputable companies that has the proper label."

However, Woodhall Stopford, a consulting toxicologist for the Arts and Creative Materials Institute and director of the Occupational and Environmental Safety program at Duke University Medical Center, claimed that the U.S. Public Interest Research Group report was flawed in that it made no distinctions between higher-risk, industrial uses of art materials, such as spray-painting an automobile, and the more limited exposure in art-making.

"With fine art materials," he noted, "you are dealing with amounts so small that the risks—even assuming that a child is going to be using the product, and ingesting, inhaling, or having it in contact with skin on a daily basis—are minimal."

A last word: in these environmentally anxious days, when everyone is striving to be more eco-friendly and green, a growing number of artists' materials suppliers are marketing themselves as being safe to the planet and nontoxic. The Earth Pigments Company in Cortaro, Arizona, for instance, claims, "All of our pigments, binders, and mediums are safe, nontoxic, [and] environmentally friendly," in large measure because they do not contain certain hazardous metals, such as arsenic, cadmium, chromium, lead, mercury, or tin. That's fine as far as it goes, but many artists want more than just earth tones. They will end up looking for metals, such as the cadmiums and cobalts, and their choice is simply to purchase it from some other supplier. It is important to note that artists' materials suppliers don't make or produce pigments themselves but purchase pounds and kilos of them from mining companies abroad whose main buyers have industrial uses in color-making. In fact, these companies are not necessarily mining for pigments at

all and instead are seeking a certain kind of ore when they happen to run across a vein of ochre or something else. This will be sorted out and sold to middlemen who are the suppliers to the makers of artist materials. The mining companies themselves operate under different national laws, which are generally strict and (one hopes) enforced.

Being green is often more difficult than it sounds: almost all acrylic based products are made from petroleum, as are any of the synthetic organic colorants used, which means that the "carbon footprint" is large. Going "green" requires more than just buying certain materials or from specific manufacturers but the artist's own practices, particularly in the area of the disposal of leftover paint. Titanium dioxide, the common metal colorant used in white paint, for instance, should not go to landfills because it may leach into the water supply, potentially causing irritation to the eyes, lungs, and mucous membranes (according to the Centers for Disease Control). It should instead be disposed of as a hazardous material. Artists should take responsibility for this, but paint suppliers would be helpful if their products included instructions on safe disposal methods.

With companies that produce artists' paints, the "green" claims principally involve how they dispose of waste. Golden Artist Colors, a manufacturer of water-based paints in New Berlin, New York, for instance, has a multi-step process of treating the two thousand gallons of wastewater produced each day. The water is not dumped down the drain but put through an initial filtering process that separates the acrylic solids from the clear water, according to Ben Gavett, the company's director of regulatory affairs, said. Those solids form a largely dry "waste cake" that goes to a landfill, while the remaining water undergoes a reverse osmosis filtering system that separates chemicals in one stream (sent to a waste treatment facility) and clean water in another (to be reused back in the factory). "We recycle many different things—electronic equipment, paper, printer cartridges, you name it—but our largest concern is the water we use here," he said.

Gamblin Artist Colors has another way of reusing what otherwise might be viewed as waste material. The company uses an air filtration system to protect employees from exposure to pigment dust. Every year, this pigment is collected, and rather than being sent to the landfill, is used to form a generally dark gray paint, which it calls Gamblin Torit Grey (named after the company's Torit Air Filtration system) and markets toward the end of April, around Earth Day.

Monona Rossol noted that she is often skeptical about the "green" claims of many art supply companies. "You need to separate their environmental practices from what is safe for you in the studio," she said. She noted that citrus oil, which is regularly marketed as a safe substitute for turpentine, "is considered 'green,' because it's biodegradable. However, it's every bit as toxic as turpentine for you." In fact, citrus oil, which often contains d-Limonene, may be more toxic than turpentine, according to Gamblin Artist Colors, which rates the product as having a much lower permissible exposure level than turpentine and being a potential source of liver and kidney damage. On the other hand, the Winter Haven, Florida-based Florida Chemical Company, one of the makers of d-Limonene, describes the product on its Web site as "extremely safe," despite noting elsewhere that it is customarily diluted in water at concentrations of between 5 and 15 percent.

Two other "safe" alternatives to turpentine—Turpenoid and Gamsol—are odorless (meaning they have no aromatic hydrocarbons) mineral spirits, but are still potentially harmful enough that their manufacturers recommend that they are used "with adequate ventilation," which means more than just open windows. "Adequate ventilation, in my opinion," said Gottsegen, "is ten to twelve complete room air changes per hour. All of the air in a studio should be replaced with fresh air from the outside every eight to ten minutes. That means a big, noisy fan."

A problem in the safe purchase of art supplies and in a myriad of other products is that there is no industry definition of, or U.S. government regulation for, the term "nontoxic," only of the word "toxic." Gottsegen stated that ideally a manufacturer would only be able to claim true "nontoxicity" if it had tested "every ingredient in its products and reported the results in a standard language compared to the maximum blood content levels recommended by a toxicologist." That kind of rigor is rarely exercised by art supply makers, Rossol said. The safety and nontoxic labels on the tubes of most artists' paints, which were devised by the Art and Creative Materials Institute, conceal as much as they reveal, she claimed, because most of the artists' materials manufacturers "won't tell you all the ingredients in their products" on the federal government-required Material Safety Data Sheets. "Many of the ingredients in their products have never been tested for toxicity, so how can they claim they won't harm you?" Golden Artist Colors devised a different labeling system for its own paints, because of the problematic nature of making claims for a product's safety. "We have seen the leap made from the 'absence of known hazards' to the declaration that a product is 'nontoxic,'" the company states on its Web site, acknowledging that, first, "toxic chemicals are likely present at some level in all products, regardless of risk assessment; second, it is inappropriate to assume that all possible chronic hazards of chemicals are currently known; and third, personal exposure should be prevented when using chemical products. Over the years, feedback from our customers indicated that reading 'nontoxic' on the label implied the paints could be used for things we did not intend, such as body painting, painting with the fingers or tongue, tattooing, and decorating dishware."

ARTISTS MAKING THEIR OWN PAINTS

When he was just starting out as a painter in the early 1970s, Carl Plansky's main criterion for buying paints was "whatever was on sale. I was very poor." Even as he earned enough from one job or another to afford better art supplies, the Brooklyn, New York, artist was still not satisfied with the selection. "I needed colors that Delacroix and Turner had used in their paintings. There were many magnificent pigments available, but I couldn't get them, because for the manufacturers they weren't profitable for them to produce as paints."

So began this painter's entry into the world of making his own colors: finding and ordering specialized pigments around the world ("people thought at the time that I was very exotic") and grinding and mixing them with linseed oil. He didn't get the hang of making his own paints overnight, but found that cobalts and cadmiums worked best for him when ground again and again ("I try to make it as fine as I can get it, so that the

maximum amount of light can travel through it, to create a stained glass effect") but that viridian became dull ("just the color green") if it was ground too much.

Plansky's interest in where to get pigments and how to produce paints grew from curiosity to a passion, which only increased when he began working for an art supply shop. "I was the guy artists came to about colors," he said. One of those customers, abstract expressionist painter Milton Resnick, gave Plansky his pigment grinding mill on condition that Plansky would agree to make paints for him. The number of artist clients increased and, in 1984, he started his own art supply manufacturing company, Williamsburg Artist Materials, which both makes artists' paints, as well as other products, and sells pigments and binders for artists like him who prefer to make their own.

There are many reasons for and against making one's own paints. On the pro side, the cost of purchasing the components in artists' paints add up to considerably less money than the price of buying commercially available tubes, plus the fact that those who make their own usually buy in bulk, which increases the savings. For example, Gamblin Colors—a Portland, Oregon–based company that was founded by Robert Gamblin, another painter-turned-paint-maker (who still continues to paint)—charges $7.95 for four ounces of burnt sienna dry pigment and $8.95 for a two-ounce tube of burnt sienna artists' paint. (Artists would also need to purchase a certain amount of binder and a stabilizer, but the comparable cost of the component ingredients would still come to about half that of the paint tube.) Perhaps even more valuable is the knowledge acquired of the materials and the manner in which they react under specific conditions, as well as how to create colors that no manufacturer has produced and how to modify the paint (add more or less pigment or oil or beeswax or sand or anything else) in order to achieve certain effects.

On the down side, grinding pigments and mixing them with binders and stabilizers takes time—at the beginning, there will be considerable trial and error to produce something usable and then reproduce it exactly—when an artist may just want to go out or into the studio to paint. It is unlikely that an artist will ever be able to grind pigments by hand as small as those of the large paint manufacturers, which have invested in large machinery for that purpose, and this will adversely affect the ability of those pigments to disperse evenly in oil. However, the differences between commercially available paint and the most optimal homemade type are quite subtle, and the resulting artwork will be judged not by the paint itself but by traditional art criteria—the brushwork, composition, tonal values, and inherent quality of the image. This is truly the realm of paint nerds.

"A better paint changes the nature of a painting, and people really do notice," said Raoul Middleman, an instructor of painting and drawing at the Maryland Institute College of Art in Baltimore and a former president of the National Academy of Design, as well as a decades-long maker of his own paints. "There's a physicality in the paint that brings the art to life." Part of what we admire in the work of the Old Masters, who mixed their own colors, he claimed, is the paints they used. "I think Rubens's paintings are about vermilion. I think Rembrandt's paintings are about white lead."

His paint-making also reflects a criticism of most commercial manufacturers of artist-grade colors, which he accuses of placing too many additives (extenders, drying

agents, stabilizers) and too much oil in paints. "There's not enough tinting strength. You put a little white in there, and the color disappears." Manufacturers, he claimed, also strive to give every one of their paints "the same ubiquitous buttery consistency. Pigments have different weights and transparencies, but when every paint has the same consistency you lose the essential properties of the pigments."

Art-world nerdiness—or maybe it is romanticism. Certainly, in this time when much contemporary art focuses on ideas and theories rather than technical prowess (few art schools teach their students much of anything about the materials in use), a growing number of artists have sought a greater connectedness to their art, making handmade paper and picture frames and even their own painting supports. "A lot of people are enchanted by the idea of making their own paints," Plansky said. "There is a poetry to it. It is often as creatively satisfying as painting itself." That, however, can also be a drawback, because making one's own supplies takes away time and energy from creating art. The companies that sell artists' pigments, binders, and other paint-making materials find that repeat customers are relatively few. "A lot of artists like the experience of making paint but switch back to tube colors after a short while," said Scott Gellatle, product manager at Gamblin Colors. "Painters who make a living making art these days either have to demand a lot of money for each piece or they have to be very prolific. Most need to be prolific, and time spent on making paint is time spent away from painting."

Plansky and another Brooklyn painter-turned-art materials-supplier, Art Guerra, also noted that many enthusiastic artists fall by the wayside when "they find the whole thing is too much work," Guerra said. "People have gotten very used to picking up a tube of paint." Additionally, the likelihood of most artists in their homes or studios being able to produce a paint that is as good as, let alone better than, commercially available colors is low, because grinding pigments by hand is tiring and not as uniform as the three-roll mills the manufacturers use. Individuals may purchase these mills, but they are quite expensive. One of the largest sellers of them in the United States is the Lindenhurst, New York–based Keith Machinery Corp., which charges $12,750 for a mill with 2½-inch diameter by five-inch-long cylinders (producing a quart of paint per hour) and $15,000 for a mill with four-inch diameter by eight-inch-long cylinders (producing two gallons per hour). The company has larger machines, costing up to $250,000, but these smaller ones "are what we've sold to artists," said Jon Hatz, the founder and owner of Keith Machinery.

Making an oil paint is not itself an overly complicated business. To start, pour a small amount of dry pigment forming a mound onto a nonporous slab surface, such as glass or marble; then, make an impression in the center of the mound and, into that, pour a small amount of linseed or other oil. Not a lot of oil is needed, and it is wiser to start with too little and add more than pour too much oil and have to add more pigment. The pigment should be worked into the oil using a palette knife until all the pigment has been dispersed and a paste consistency has been formed. Use a muller, which is a glass or stone grinding device, to spread the paint into a thin layer on the glass or marble; more pigment or more oil may be added, depending upon whether the paint is too runny or too thick. In paint jargon, thicker paints are referred to as "short," thinner ones as "long." One may paint

with it immediately or scrape it in a tube (art supply stores sell empty tubes) or jar, covering it with a lid in order to limit exposure to air, which causes the paint to harden. Many artists planning to store their handmade colors add some melted beeswax to the paint (2 percent per volume of paint is recommended), which adds to its flexibility, lengthens the drying time, and keeps the pigments from forming clumps in the oil.

Artist do-it-yourselfers also need to be aware of some basic safety rules. Some pigments are less dangerous than others, depending upon whether they can be metabolized into the body, but they never should be accessible to children. Artists should wear dust masks that cover their nostrils and mouth while handling pigments, as well as an apron or other protective clothing. Gloves should be used, especially if there are any cuts through which toxic substances might enter the bloodstream. Pigments should never be heated, as toxic fumes may result. Certainly, artists should not eat or smoke while working, as potentially harmful substances may enter their mouths; additionally, they ought not to answer a telephone unless their hands are washed. If pigments get into one's eye, rinse it with running water and seek medical attention. The room in which the paint is made should have some ventilation system, and it is also a good idea not to sleep in the same room where one works in order to limit potential exposure. Dust on the glass or marble slab should be cleaned off with a damp paper towel or sponge, in order that the dusts are captured and not put into the air, and all trash should be enclosed in plastic and disposed of in accordance with local or state hazardous materials guidelines.

The issue of how to produce one's own artists' paints begs the larger question of whether the end results are worth the time and effort. This simply may be a subject on which artists and the rest of the world agree to disagree.

"If you have ever seen Carl Plansky's paintings in the flesh, you notice that he uses a lot of paint on the canvas. It's really thick," said his New York dealer Lawrence diCarlo of the Fischbach Gallery. "Of course, he gets his paint wholesale." The dealer went on to laud Plansky's "vibrancy of paint" and how "his love of paint comes through" but conceded that the quality of the paint itself is lost on "people coming into the gallery. Critics don't seem to pay much attention to it either."

OWNING A PRINTING PRESS

Painter John Himmelfarb had been making etchings for almost forty years, but it wasn't until Hudson Hills Press produced a catalogue raisonné of his prints in 2006 that the artist realized "prints weren't just a back-door activity," but an essential part of his career, generating 10 percent of his income. Looking over his career, he saw that he usually created a yearly average of ten editions (in edition sizes of between twenty-five and ninety) that sell for between $125 and $4,000 per print; monoprints were in the $3,000 range. A year after the book came out, Himmelfarb bought himself a printing press.

"It gives me the ability to do things, and to do them on the spur of the moment," he said. "When I have an idea or an inspiration, I don't need to rent a shop or wait to get invited by a publisher or a university to do a print edition. It's all right here." "It" is a $17,000 seven-foot-long, four-foot-wide etching press that occupies a chunk of

Himmelfarb's studio in Chicago. No longer will he have to pay $300-plus a day and be "creative on demand" during shop hours, nor will he need to worry about the clock if he obsesses over one image all day. "I'm on my own turf, instead of being on someone else's, and I can control the process more. It's added a lot to the enjoyment of my studio." If sales continue as they have in the past, he figured, the printing press will have paid for itself within one year.

Most artists won't spring for a $17,000 piece of equipment, but his discovery—that owning one's own printing press is both liberating and cost-effective—is one that many artists have subsequently made, which has pushed up sharply the sales of artist printing presses over the past decade. Additionally, because most artists are not looking for the massive presses that commercial print publishers use, this demand has led to a growing number of lighter, less expensive machines.

"I started out as a printmaker and engineer," said Mel Whelan, president of the Santa Fe, New Mexico-based Whelan Press, a manufacturer of printing presses, "and I got tired of moving 1,800-pound presses through windows and doors." Putting his engineering know-how to work, he developed a line of smaller presses, which range from under one hundred pounds (usable for paper sizes up to 22" × 30" and costing $1,495), to 396 pounds (for 30" × 44" papers and costing $6,000).

Whelan sells approximately two hundred printing presses per year, almost all to artists, and the majority of his artist customers are women. Artists represent only 10 percent of the customer base of Takack Press Corporation, a printing press manufacturer in Albuquerque, New Mexico, but that is up 50 percent over the past decade, according to the company's vice-president David Takach, Jr. The bulk of Takach's sales are large and costly ($10,000 to $40,000) models to commercial printers and university print studios (including Minneapolis College of Art and Design, Purdue University, Rutgers University, the University of Washington, and Virginia Commonwealth University), but the company also manufacturers smaller, more lightweight machines, such as a 250-pound printer (with an 18" × 36" bed size, costing $3,600) and a three-hundred-pounder (24" × 48" bed, costing $5,000) that are favorites of artists. "You just take it out of the box, and it's ready to print," he said.

Artists, art supply retailers and manufacturers all report a new wave of interest in creating original prints, bolstered by the growing availability of lightweight, easy to use and set up presses. "I believe we are seeing an upsurge in sales of printing presses, in part because we're selling more, in part because there are more players in the market (which is a pretty good indicator of demand) and in part because there is a correlation in the purchase of printing press materials, which are also up," said Dean Clark, president of both Printmakers Machines Co. and Graphic Chemical and Ink Co., which are both based in Villa Park, Illinois. The three categories of his customers are stores, schools, and individuals, and it is in individual orders that there has been a "significant increase." Many of these buyers purchase online, focusing on tabletop and small table presses, of which the most popular have been ones weighing fifty-five pounds (9" × 18" bed, costing $675) and ninety pounds (12" × 24" bed, costing $1,405), as well as larger models

weighing 270 pounds (18" × 48" bed, costing $2,840) and 550 pounds (27" × 48" bed, costing $4,400).

Other manufacturers and distributors report the same. "We redesigned our presses a few years ago to be smaller [and] more stable and economical, really to be suitable for someone's home," said a spokesman for Dick Blick, the Galesburg, Illinois-based catalogue art supply company, adding that the most popular presses sold are the most portable—one weighs thirty-eight pounds (9" × 18" bed size, costing $464) and another weighs twenty-six pounds (12" × 24" bed, costing $432). Similarly, just more than half of all printing press sales for the Jack Richeson & Co. in Kimberly, Wisconsin is for its two "Baby" presses—a sixty-nine-pounder manufactured in Brazil (12" × 19" bed, costing $475) and a forty-five-pound model made in Italy (7¼" × 12½" bed size, costing $350). "The market has demanded a more user-friendly, portable press," said Colleen Richeson, the company's vice president for sales and marketing. "Artists with bigger presses also have a baby press. It's the iPod Nano of printing presses."

The Seattle, Washington-based Daniel Smith art supply catalogue company, which sells printing presses by Ettan, Richeson, and Whelan, as well as printmaking supplies, some of which (inks, tools, felts) the company produces itself, also sells many of the lightweight, portable models to individuals, particularly the "over-forty female market," said Christopher Ramsey of Daniel Smith's educational services department. "They can put it in the car [and] take it offsite to an art fair, for instance. It's just what they want."

For many artists, who may have first learned printmaking techniques in college or at a commercial print studio, the smaller presses are a novelty but still applicable to their skills. However, there is a growing selection of models, with similar but sometimes quite distinct features. As opposed to inks or paints or clays and other art media that artists may purchase online or at art supply shops, trying them out at relatively small cost, there are not many opportunities to test drive a printing press. "Some artists come to our offices, some drive in from other states, to try a press out," Dean Clark said, but he claimed that printmakers are learning about the differences between printing presses through online discussion forums. (Among these printmakers' forums are Middle Tennessee State University [www.mtsu.edu/~art/printmaking/wwwboard] and Baren Forum [www.barenforum.org], which offer a wealth of information. In addition, the American Print Alliance [www.printalliance.org] publishes technical articles for printmakers.)

A variety of factors are driving some artists' move to purchase one's own printing press. The number of fine art print studios around the country has been shrinking, and those that remain have become more expensive. "Many artists want to make prints in their own studios, rather than traveling somewhere else, generally farther and farther away, to do it," said Amber Millen, a saleswoman for Ettan Press Company in La Jolla, California, which manufacturers printers, ranging in weight from forty pounds (12" × 24" bed size, costing $1,395) to 680 pounds (36" × 72" bed size, costing $7,295). Additionally, many artists have thought of printmaking in terms hazardous chemicals whose long-term

exposure is associated with cancer and skin and lung diseases, but the new generation of materials features water-based inks and nontoxic solvents that make home studios less a source of worry. For all artists, the degree or control is a major consideration.

"I decided early on that I was in the Tony Fitzgerald business," said Tony Fitzgerald, a Chicago artist who creates etchings and drawing-collages, by which he meant that he didn't want to work for the benefit of others, particularly print publishers. Producing a print at a commercial print studio and selling the work at a gallery (arguably, he works for the benefit of art dealers) meant that middlemen and others take a substantial portion of his income. "I'm not giving away two-thirds of my living," he said, which convinced him back in the 1990s to buy his own printing press. The price was a few thousand dollars, but "I made an astonishing number of prints right after getting the press," selling them to an audience of collectors, who "were so happy they could get one of my prints for less than one of my drawings," and the cost of the press was recouped within three months.

Of course, not every artist who purchases a printing press has a success story to tell. One must learn or know how to etch or make a lithographic image on a printing plate, followed by the need to understand the operation of a printing press, and then there's the issue of finding buyers of these prints. The inability to master any of these skills may doom the printing press to collector of dust. Mel Whelan speculated that half of his artist customers have collectors and a track record of sales, while the others are "trying it out." His company doesn't track the experiences of customers, and what he surmises comes from questions raised by artists when making an order. Dave Takach similarly described a half-and-half scenario in artist clients. "I'd say half of the buyers are painters who decide to try printmaking," he said. "They buy a press, do it a little bit, and then go back to painting."

For artists not wishing to make as large a commitment to printmaking may be content with renting print studio facilities and perhaps taking advantage of the expertise of the trained technicians and a master printer. Among the commercial print publishers, print collaboratives, and print studios around the United States are:

ALABAMA
Wycross Press
P.O. Box 2311
Auburn, AL 36830
(334) 887-6836

ARIZONA
Segura Publishing Company
51 East Main Street
Mesa, AZ 85201
(480) 894-0551
www.segura.com

CALIFORNIA
Analogue Press
701 East Third Street
Los Angeles, CA 90013
(213) 687-8760
www.analoguepress.com

The Arion Press
1802 Hays Street
San Francisco, California 94129
(415) 668-2542
www.arionpress.com

Aurobora Press
147 Natoma Street
San Francisco, CA 94105
(415) 546-7880
www.aurobora.com

Cirrus Gallery
542 South Alameda Street
Los Angeles, CA 90013-1708
(213) 680-3473
www.cirrusgallery.com

Crown Point Press
20 Hawthorne Street
San Francisco, CA 94105
(415) 974-6273
www.crownpoint.com

Eastside Editions
416 Second St. East
Sonoma, CA 95476
(707) 933-1480
www.eastsideeditions.com

Gemini G.E.L.
8365 Melrose Avenue
Los Angeles, CA 90069
(323) 651-0513
www.geminigel.com

Hamilton Press
1317 Abbot Kinney Boulevard
Venice, CA 90291
(310) 396-8244
www.hamiltonpressgallery.com

Kala Art Institute
Print Studio/Media Center/Gallery
1060 Heinz Avenue
Berkeley, CA 94710
(510) 549-2977
www.kala.org

Mixografia
1419 East Adams Boulevard
Los Angeles, CA 90011

(323) 232-1158
www.mixografia.com

Paulson Press
1318 Tenth Street
Berkeley, CA 94710
(510) 559-2088
www.paulsonpress.com

Trillium Press
91 Park Lane
Brisbane, CA 94005
(415) 468-8166
www.trilliumpress.com

COLORADO
Open Press Ltd. Studios
40 West Bayaud Avenue
Denver, CO 80223
(303) 778-1116
www.openpressltd.com

Shark's Ink
550 Blue Mountain Rd.
Lyons, CO 80540
303-823-9190
www.sharksink.com

CONNECTICUT
Center for Contemporary Printmaking
299 West Avenue
Norwalk, CT 06850
(203) 899-7999
www.contemprints.org

FLORIDA
Atelier Blue Acier
109 West Columbus Drive
Tampa, FL 33602
(813) 272-9746
www.bleuacier.com

Flying Horse Editions
P.O. Box 161342
Orlando, FL 32816
(407) 823-4178
www.cas.ucf.edu/flyinghorse

USF Graphicstudio
3702 Spectrum Boulevard
Tampa, FL 33612-9498
(813) 974-3503
www.graphicstudio.usf.edu

HAWAII
Hui Press Publications
Hui No'eau Visual Arts Center
2841 Baldwin Avenue
Makawao, HI 96768
(808) 572-6560
www.huipress.com

ILLINOIS
Mad Dog Press
115 D East University Ave.
Champaign, IL 61820
(217) 403-0276
www.maddogpress.com

Manneken Press
1106 East Bell Street
Bloomington, IL 61701
(309) 829-7443
www.mannekenpress.com

MARYLAND
Goya Contemporary
Mill Center, Studio 214
3000 Chestnut Avenue
Baltimore, MD 21211
(410) 366-2001
www.goyacontemporary.com

Pyramid Atlantic
8230 Georgia Avenue
Silver Spring, MD 20910
(301) 608-9101
www.PyramidAtlanticArtCenter.org

MASSACHUSETTS
Center Street Studio
P.O. Box 870171

Milton Village, MA 02187
(617) 821-5458
www.centerstreetstudio.com

Zea Mays Printmaking
221 Pine St. Studio 320
Florence, MA 01062
(413) 584-1783
www.zeamaysprintmaking.com

MICHIGAN
AFA Press
P.O. Box 8
Lakeside, MI 49116
(269) 469-2818
www.afapress.com

Stewart & Stewart
5571 Wing Lake Road
Bloomfield Hills MI 48301-1250
248.626.5248
www.stewartstewart.com

MINNESOTA
Highpoint Center for Printmaking
2638 Lyndale Avenue South
Minneapolis, MN 55408
(612) 871-1326
www.highpointprintmaking.org

MISSOURI
Island Press
1 Brookings Drive
School of Art, Box 1031
Washington University
St. Louis, MO 63130-4899
(314) 935-6571
www.islandpress.wustl.edu

Lococo Fine Art Publisher
9320 Olive Boulevard
St. Louis, MO 63132
(314) 994-0240
www.lococofineart.com

Wildwood Press
1627 Washington Avenue
St. Louis, MO 63103
(314) 436-4316
www.wildwoodpress.net/wwp1.swf

Pele Prints
9400 Watson Road
St. Louis, MO 63126
(314) 750-7799
www.peleprints.com

NEBRASKA
UNO Print Workshop
Department of Art & Art History
University of Nebraska Omaha
6001 Dodge Street
Omaha, NE 68182
(402) 554-3763
*www.unomaha.edu/~fineart/prints/
pwkshop.html*

NEW HAMPSHIRE
Wingate Studios
941 Northfield Road
Hinsdale, NH 03451
(603) 239-8223
www.wingatestudio.com

NEW MEXICO
Hand Graphics
2312 West Alameda
Santa Fe, NM 87501
(505) 438-0987
www.handgraphics.com

Landfall Press
1589 San Mateo Lane
Santa Fe, NM 87505
(505) 982-6625
www.landfallpress.com

Tamarind Institute
108-110 Cornell Drive SE
Albuquerque, NM 87106

(505) 277-3901
http://tamarind.unm.edu

NEW YORK
Axelle Fine Art
148 Spring Street
New York, NY 10012
(212) 226-2262
www.axelle.com

Baron/Boisante Editions
421 Hudson Street, #419
New York, NY 10014
(212) 924-9940
www.baronboisante.com

Brooke Alexander Editions
59 Wooster Street
New York, NY 10012
(212) 925-4338
www.baeditions.com

Derriere L'Etoile
313 West 37th Street
New York, NY 10018
(212) 239-7133

Dieu Donne Papermill
433 Broome Street
New York, NY 10013
(212) 226-0573
www.dieudonne.org

Editions Fawbush
448 West 19th Street
New York, NY 10011
(212) 604-0431
www.fawbush.com

Edition Schellmann
210 11th Avenue
New York, NY 10001
(212) 219-1821
www.editionschellmann.com

Harland & Weaver, Inc.
83 Canal Street
New York, NY 10002
(212) 925-5421
www.harlanandweaver.com

Jungle Press Editions
61 Pearl Street
Brooklyn, NY 11201
(718) 222-9122
www.junglepress.com

Lower East Side Printshop, Inc.
306 West 37th Street, 6th Floor
New York, NY 10018
(212) 673-5390
www.printshop.org

Pace Prints
32 East 57th Street
New York, NY 10022
(212) 421-3237
www.paceprints.com

Parkett Publishers
145 Ave. of the Americas
New York, NY 10013
(212) 673-2660
www.parkettart.com

Pelavin Editions
13 Jay Street
New York, NY 10013-2848
(212) 925-9424
www.cherylpelavin.com

Two Palms Press
476 Broadway, 3rd floor
New York, NY 10001
(212) 965-8598
www.twopalmspress.com

Procuniar Workshop
19 Mercer Street
New York NY 10013

(212) 226-6619
www.ProcuniarWorkshop.com

Solo Impressions
601 West 26th Street
New York, NY 10001
(212) 229-9292
www.soloimpression.com

Spring Press
524 Broadway, Room 208
New York, NY 10012
(212) 226-7430
*http://colophon.com/sprpress/
spr_x.html*

Universal Limited Art Editions
1446 North Clinton Ave.
Bay Shore, NY 11706
(631) 665-2291
www.ulae.com

VanDeb Editions
313 West 37th St. 7th Floor
New York, NY 10018
(212) 564-5553
www.vandeb.com

Diane Villani Editions
285 Lafayette Street
New York, NY 10012
(212) 925-1075
www.villanieditions.com

Watanabe Studio
644 Pacific Street
Brooklyn, NY 11217
(718) 622-7944

Women's Studio Workshop
P.O. Box 489
Rosendale, NY 02472
(845) 658-9133
www.wsworkshop.org

Yama Prints
140 West 30th Street
New York, NY 10001-4005
(212) 222-3992
www.yamaprints.com

NORTH CAROLINA
Cockeyed Press
P.O. Box 3669
Chapel Hill, NC 27515
(646) 242-4959
www.cockeyedpress.com

OKLAHOMA
Mimosa Press
1204 E 48th St. North
Tulsa, OK 74126
(918) 425-6319

OREGON
Mahaffey Fine Art
2134 N.W. Hoyt Street
Portland, OR 97210
(503) 295-6666
www.mahaffeyfineart.com

PENNSYLVANIA
C.R. Ettinger Studio
144 Vine Street
Philadelphia, PA 19106
(215) 928-9897

Durham Press
892 Durham Road
P.O. Box 159
Durham, PA 18039
(610) 346-6133
www.durhampress.com

TEXAS
Coronado Studio
901 Vargas Rd.
Austin, TX 78741
(512) 385-3591
www.coronadostudio.com

Flatbed Press
2830 East MLK Jr. Boulevard
Austin, TX 78702
(512) 477-9328
www.flatbedpress.com

Hare and Hound Press
127 Grant Avenue
San Antonio, TX 78209
(210) 828-1634
www.harehoundpress.com

StoneMetal Press
1420 South Alamo
San Antonio, TX 78210
(210) 227-0312
www.stonemetal-press.com

The University of North Texas
School of Visual Arts
P.R.I.N.T.
PO Box 305100
Denton, TX 76203-5100
(940) 369-7575
www.art.unt.edu/print

VIRGINIA
Hand Print Workshop International
210 West Windsor Avenue
Alexandria, VA 22301
(703) 519-4300
www.hpwi.org

WISCONSIN
AGB Graphics Workshop
1021 South Park Street
Madison, WI 53715
(608) 251-7277
www.andrew-balkin-eds.com

Tandem Press
University of Wisconsin
201 S. Dickinson St.
Madison, WI 53703
(608) 263-3437
www.tandempress.wisc.edu

ART MATERIALS INFORMATION ON THE LINE

Jonathan Lasker, a New York painter with a long exhibition record and whose works are in the permanent collection of such museums as Washington, D.C.'s Corcoran Gallery of Art, the Los Angeles County Museum of Art, the High Museum in Atlanta, and the Whitney in Manhattan, has been interested (quite understandably) in the durability of the paints he uses. So, it was with some horror that Lasker began noticing how the sap green paint he regularly mixes with white to form a pastel green background for his paintings began fading to white "all of a sudden. I had been using the same paint for years and this had never happened. Why was it happening now?"

The technical support people he contacted at the manufacturer of the paint had no answers, but a conservator he asked about the problem explained to him that the manufacturer had changed the color pigment compounds, perhaps for reasons of economy, making the paint less reliable from Lasker's vantage point. It is not the first time that the conservator, Albert Albano, who is also executive director of the Cleveland, Ohio-based Intermuseum Conservation Association, has consulted with an artist about some problem with the materials he or she uses (his Rolodex is filled with the names of artists who have called him at one time or another). However, Albano recognized the need for a national clearinghouse of information about art materials that would answer artists' questions from the most basic to the very complicated. With financial backing from the Berlin, New York-based paint maker Golden Artist Colors, he and Mark David Gottsegen founded the Art Materials Information and Education Network, based at the offices of the Intermuseum Conservation Association (2915 Detroit Avenue, Cleveland, OH 44113; 216-658-8700; *www.amien.org*).

"Contemporary artists know less about art materials than any other group of artists in history," said Gottsegen, who is the organization's materials research director. "Almost their entire training consists of theory and critique, with very little focus on the properties of the materials they use." Worse, art supply manufacturers "rarely are in contact with artists about problems they are having or what they actually need," and the small but growing number of contemporary art conservators "talk amongst themselves or write journal articles that are too specialized for artists," which keeps them unaware of what artists want to do and the problems they are experiencing.

The information provided comes from three sources—Gottsegen's own testing of materials, published findings of other researchers, and results from a private laboratory in New England that is periodically contracted to perform tests on art supplies. The Web site also has a forum page in order that artists may pass on information to each other. There is no charge for using AMIEN ("Artists can just register on the Web site and get unlimited access to research and available information," Gottsegen said), although donations are encouraged.

In addition to answering letters, telephone calls, and e-mails, AMIEN offers online courses, two- and three-day workshops, art teacher training, and a dispute resolution service for artists dissatisfied with a manufacturer's products, as well as lab testing of specific art materials (for manufacturers). Gottsegen noted that there are "nominal" fees for these services to cover costs.

The purview of the new Art Materials Information and Education Network is wide, encompassing painting, photography, printmaking, digital imagery, and sculpture, "and if I don't know the answer immediately, I know how to get the answers." A benefit of being housed at the Intermuseum Conservation Association, the nation's oldest regional conservation center, currently serving thirty-six midwestern museums, is that "we have a whole range of materials expertise on staff," Albano said.

The questions that artists pose run the gamut, from how-to-do-it and can-I-do-it ("One artist asked, 'If I use colored pencil over acrylic paint, can I protect it with a varnish?'" Gottsegen said) to health and safety concerns ("I've told some artists to find a substitute for a certain solvent"). New York artist Sylvia Plimack Mangold had two related questions, the first concerning the drying time for certain paints and the second how to take off the glassine wrap that had gotten stuck to a not-yet-dry painting—Albano told her to use ice. Another New York artist, Tom Nozkowski, stretched linen over wood panel, adhering it with rabbit skin glue, to use as the support for his paintings ("I needed a hard surface but with the nubbiness of canvas"), but the linen began to fall off the panel, and Albano went through a series of corrective measures to help solve the problem.

"Artists invent tools that are unique to them," Nozkowski said. "They cobble together solutions to problems. Sometimes, those solutions work, and sometimes they need help figuring better solutions."

TRYING OUT NEWER, LESS EXPENSIVE MATERIALS

Sculptor Alex Wagman had a big idea for his next piece and, like most of his other artworks, he planned to create it in bronze. Called "Brainstorm," the work is a six-and-a-half-foot-tall human head with thought bubbles emerging from a cleft in the top, and it is his first sculpture in Fiberglas. "I can't afford to do it in bronze," he said. As simple as that.

As well as trying out a new material, the artist, who lives in Old Westbury, New York, is experimenting with different patinas, particularly ones that give more of the look of bronze. "I sprayed the surface several times with an epoxy in which I added silver metal powder. Then I used abrasives on it, and it looks like polished metal. You can't really tell the difference, although the base is Fiberglas." He applied a colored wax to the surface for added protection, "and it's fine for outdoors. You treat it exactly like bronze. There's no problem with it being outside."

Such experimentation and hopes are becoming more widespread, as sculptors look to find alternatives to metals that have become so expensive over the past few years. Bronze particularly has gone up two or three times in cost in the recent years. Dale Smith, owner of Artworks Foundry in Berkeley, California, stated that he spent $1.60 per pound of bronze in July 2005 and $4.00 for the same amount in July 2008, while Marjee Levine, manager of Tallix Foundry in Boston, said that the price had risen from $2 to "almost $5" during that same period. Prices have risen and fallen sharply based on demand, but the overall outlook is for bronze to remain expensive because of the demand for copper—and bronze is 95 percent copper—in the developing world. Labor

costs also have risen but not as much as the cost of transporting objects and the firing up of foundry furnaces, both of which have gone up with the price of fuel.

Bronze has long been the gold standard for large, and especially outdoor, sculptures. However, outdoor sculptures in Europe, North America, and Australia have been stolen for their scrap metal value, which has not yet soured collectors from purchasing these works, probably because their art is insured. Insurance, unfortunately, didn't help Cornville, Arizona, sculptor John Waddell after eight figurative bronzes that he had created during the late 1980s were stolen from his backyard in early 2007 by thieves who sold them for scrap (the thieves were not prosecuted because the evidence was melted down). The insurance settlement he received of $23,000 equaled what Waddell had paid for foundry work in the 1980s, but recasting them cost $86,000 this time around. He wasn't looking to limit his loss by switching to another material. "Bronze has a life of one million years," he said. "Resins may last fifty to one hundred years, and no one really knows. I like the medium of bronze, and I feel as though I'm communicating with a creature way in the future."

It is difficult for everyone to see so far into the future when there are bills to pay today. Sculptors who pay for materials and foundry labor in the hope of selling their work to recoup their costs and then some, have needed to make difficult dollars-and-cents decisions about what they and would-be buyers can afford. The traditional rule-of-thumb, that a bronze sculpture should be priced at three times the casting cost, does not make sense in the current environment. "If I had done 'Brainstorm' in bronze, I'd have to charge $70,000, instead of $20,000," Wagman said. That higher amount likely would have repelled his regular customer base, which usually buys his work in the $9,000-25,000 range, depending upon size.

Other artists have been forced to make hard choices, hoping that their collectors will understand. Gina Novenstern, a New York City sculptor, has stayed with bronze and has raised her prices 25 to 30 percent, moving her top price from $15,000 to $20,000. "I've looked at other materials," she said, "and I've seen that with resins you can achieve great effects, but I think buyers want and expect bronze, so I've raised my prices and swallowed some cost increases." Lillian Engel of Woodside, New York, on the other hand, has largely shifted from bronze to what is called bonded or cost-cast bronze—really, plastic resins with the addition of bronze powders that give works a surface look of bronze—and even plaster as a means of producing work she can afford to make and collectors are willing to pay for. "The pieces are a lot lighter and less expensive to make and to buy," she said. "I think there are benefits for everyone."

Mark Fields, owner of The Compleat Sculptor, a sculpture supply store in Manhattan, noted that a growing number of artists are looking to other materials, such as Aqua-Resin, concrete, Fiberglas, gypsum- and polyurethane-based resins, plaster, and terra cotta, which are less expensive and can be produced into sculptures right in the studio without the high labor costs of a foundry. "You do see sculptors doing more of the work themselves, which cuts costs and maintains control." He added that many of his customers are buying metal and mica powders that are poured into molds or applied as a patina to give a "faux finish" that resembles bronze or other metals.

A growing number of artists are offering different works—and sometimes the same works—in different media, in order to give prospective buyers choice of how much they want to pay. "Nearly all my works are available in more than one material," Michael Alfano, a sculptor in Hopkinton, Massachusetts, said. "It makes it more open and affordable to everyone." The gain in savings is somewhat mitigated by the less certainty artists have when describing the durability of their work, especially pieces that will be exposed to the elements. Few buyers are likely to understand that cold-cast bronze doesn't really mean bronze at all, which may come back to haunt the artists if cracks appear within a few years.

Artists who remain wedded to bronze are less willing to make an order to a foundry before they have firm commitments from buyers and know ahead of time what their costs will be. Martin Glick, a sculptor in Pomona, New York, makes samples in cold-cast bronze of new work that he displays to collectors, but he can only tell them the price after he calls the foundry "to verify the price of bronze and the price of energy. Sometimes, they won't even give me a price, telling me that it will cost whatever they have to pay that day."

Certainly, the high cost of bronze has affected sculptors' relationship with the foundries they have used over the years. "We haven't had as many reorders," Marjee Levine said. Sculptors who previously had used the foundry to produce half the edition at a time now are just ordering "one or two at a time. Everything is a bit slower." Other sculptors are seeking estimates from foundries far from where they live and work, in the United States and elsewhere, not because the price of bronze is lower but because labor costs are. "I can't afford any of the foundries on the East Coast," said bronze sculptor Mary Sand, who lives in Philadelphia and uses Artworks Foundry in Berkeley, where the overall costs are lower. The savings might be greater if she were the type of artist "who just sent them the model [and] let them cast it and ship it back," but she prefers to be involved in every stage of the process, which adds to the labor costs. "I also have to travel out there and stay somewhere, and that probably eats up all the money I think I'm saving."

THE CHANGING RELATIONSHIP OF SCULPTORS AND FOUNDRIES

The relationship between sculptor and foundry would seem a relatively uncomplicated affair. "The tradition has been, artists wheel something in and say, 'We want that in bronze,'" said Paige Tooker, president of Manhattan's New Foundry, said. That is to say, the artist brings in a model—a maquette—that he or she put together back at the studio, and the foundrymen do the technical stuff (enlarge, make molds, pour metal, polish and patinate the surface) to the sculptor's specifications. Voila, an edition. That relationship, which developed with the growing use of poured metal foundries back in the early nineteenth century (largely wiping out stone-carving in the process) in Europe and the United States, continues to this day, but it increasingly seems to be more the exception than the norm.

Certainly, not much of the tradition continues at New Foundry and at many other foundries as well, for a number of reasons. Less and less art foundry work tends to be discreet gallery- or home-sized bronze objects; increasingly, the job is constructing

sprawling installations involving different metals and plastics as well as electronics and lighting, or large-scale public art projects that call for skills in engineering, municipal safety codes, and budget preparation. What we call the technical stuff has expanded exponentially.

With it, the relationship between artist and foundry has changed. To a degree, the shift stems from artists themselves whose training in schools now is more focused on conceptual issues than with hands-on making things. "Artists come in here with a very rough sketch and say, 'I have this idea for something, how do I make it?'" Jeffrey Spring, president of Modern Art Foundry in Queens, New York, said. "Part of the services we now provide to artists is brainstorming." That wouldn't work well with the old style foundrymen, but things are different with them, too. The old foundrymen now are apt to be called fabricators, and many of them have degrees from art schools; their job is not just to pour metal for an edition but to build or carve or assemble something based on the artist's specifications. One speaks more and more of fabricators "partnering" with artists, helping to conceptualize a project and then to devise something that can be built, figuring out the materials, time and cost along the way. Tooker noted, "It's our job to be sensitive to what the artist is trying to convey." She claimed that foundry staff work with those rough sketches and with the artists to make a maquette, often on the computer. When that is approved, the foundry will take the next step by making a three-dimensional model—followed by more discussions and potential changes—and, finally, the finished artwork.

That itself is perhaps too much of an abbreviated version. The Digital Atelier in Mercerville, New Jersey, regularly works with artists who are making proposals to public art agencies, and ensuring that a project costs what a predetermined budget will allow is a primary concern. "A lot of our work is job costing, working within the parameters of a public art committee," said John Lash, chief executive officer of The Digital Atelier. "Once we scan the data into the computer, we can look at the project in many ways. Say, the budget is $100,000 and the design so far calls for five hundred square feet of surface area. If the project won't work with the budget, we might scale the project back—we call it cube backwards—to maybe 280 square feet of surface, and see how that works." The Digital Atelier may substitute different metals to bring the price down, then estimate costs of shipping and crating, engineering, footings, mold-making, and other foundry work. Pouring metal and assembling the finished project is the end of a long process of collaborative work.

It is not always different metals that may be substituted for reasons of cost; increasingly, resins (or plastics) are proposed. At times, Lash stated, a maquette usable for a presentation to a public art agency will be made up in "clay or plasticene or plaster" or foam that is "hard-coated in a urethane or epoxy spray"; at other times, these models themselves may be exhibited and sold as original artwork in galleries.

"Foundries are different now," Tooker claimed. "Other places will just pour bronze. We are artists' assistants on an extreme basis, figuring out what the artists are trying to do. It doesn't really matter what the material is, like the beeswax cube we made

for a Terence Koh performance. The artist decided he wanted actual bees stuck onto it, and there was a lot of discussion of how many bees and where to put them. I feel like I'm making art with these people, and that's the fun."

It is also part of the challenge. Christoph Spath, cofounder and vice president of the Digital Stone Project in Mercerville, New Jersey, which scans maquettes into computers that mill stones into sculptures, noted, "A lot of our clients have never worked with stone or with any materials." They don't even need that experience, because the Digital Stone Project will take the idea, make a model, and then produce the sculpture in stone. In many instances, the artists know almost nothing at all about stone (Spath explains to them that there are over one hundred types, some more fragile than others), but just like the idea of producing a stone sculpture. "We get requests that really wouldn't work in stone," he said. The models may be "very fragile or have interior forms that couldn't be made in stone, things that are too thin or couldn't stand up—a figure on one leg, for instance. Traditional carvers wouldn't know that, but I'm working with quite a few younger artists who have never carved anything or even worked with clay." Approximately half of the projects there, and almost three-quarters of the company's revenues, are public artworks.

Partnering with artists on their projects has its own pleasures and drawbacks. Clearly, helping sculptors put ideas into a tangible form is more stimulating than the wholly artisanal job of making molds, melting wax, pouring metal, assembling parts, and coating metal. Artists like the idea that they are working with people at the foundry who appreciate and understand what they are trying to do. Still, at the end of the process, the artists receive the praise and the big money, and their "partners" back at the foundry just get their regular paychecks. "We don't really get credit for what we do," Spath, a sculptor in his own right, said, adding that "I made a choice of doing this for the time being." Dylan Farnum, director of special projects at the Walla Walla Foundry in Washington State, noted that artist-clients expect foundry staff to show complete dedication to the projects they bring in and don't hold resentments: "If you are bitter about anything or thinking mainly about your own career goals, you wouldn't be giving the job your all," he said.

Not all sculptors, of course, take the same approach to, or have the same relationship with, foundries. Many artists take a hands-off attitude, producing their own maquettes but then shipping them off to a foundry with which they will communicate by telephone and e-mail, with comments made on images that are transmitted back and forth. To a degree, this may reflect the fact that they are too busy with other projects to spend time at the foundry. "We work a lot with PaceWildenstein," the powerhouse New York City art gallery, Tooker said. "Galleries just want artists to drop off the stuff and get onto other works. (She added that the artists want to be in the foundry "and involved with what's going on, but they have their gallery to contend with.") Spath also added that "most of the artists we work with through galleries are not very hands-on involved. They drop off the model and don't even look at the finished product. It just gets shipped to the gallery."

An even larger cause for artists to be relatively unengaged with the foundries they use is distance. Higher labor costs on the East Coast than in the western half of the country and overseas has led sculptors to give their work to foundries thousands of miles away. The artists could travel to these foundries and be part of the fabrication process, but the travel, food, and lodging costs (not to mention time taken away from other work) would consume those savings and defeat the purpose. "Price drives all my decisions about what foundry I work with," said New York sculptor Tom Otterness, who has been working steadily over the past several years with the Walla Walla Foundry. He visits the foundry perhaps twice a year, "when I have multiple projects going with them, and I can be very productive over a two-day stay." Otherwise, there are telephone calls and the transmission of JPEG images ("It's hard to judge color and patina quality precisely," he said, "but you can see form and communicate basic questions"). Numerous projects over a period of years has allowed relationships to build and develop with foundry staff, so that people there know what he is looking for and when there might be a problem. Still, the foundry is three thousand miles away from his Brooklyn, New York studio, and "we are still refining the relationship."

There is significant competition for business among foundries, with each promoting its cost-savings and array of services. Farnum noted he regularly travels east to meet with artists in their studios in order to make a pitch for his foundry, crediting projects from Keith Edmier, Maya Lin, Roxy Paine, and Kiki Smith, among others, with these forays. Michael Maiden, owner of Maiden Foundry in Sandy, Oregon, said that "few, really almost none, of our clients are in driving distance anymore. Art foundries are marketing nationally and internationally. I talk to people in Canada, in Hawaii, in Mexico. The world has shrunk," although not literally, because the sculptors would be at the foundry more if it had. "We tend to see artists on the back end, when it's all over, not so much in the process."

That can be chancy if mistakes aren't caught along the way. "The two main mess-ups we've had are when artists don't come until the end," Farnum noted, and Maiden stated that he occasionally sends his mold-makers and molds to artists' studios for approval and consultation. "We're mobile now, and it is a necessity for competing."

SELECTING A PRINT STUDIO OR FOUNDRY

Art is often a solitary pursuit but, sometimes, even the most reclusive artists must seek out the help and services of others. Artists who make graphic prints or sculpture editions usually look to print studios or foundries to provide the expensive equipment and technical know-how. They are brought together by the desire to create works of art, but this is also a business relationship that needs to be negotiated carefully.

The decision on which foundry or print studio to use is complicated by issues of location, price, the right fit of services, and the media available. No less important is the quality of the work, turnaround time, and a foundry's or studio's ability to keep promises made to artists, and this can be ascertained by asking others who have worked with them in the past. Both fine art foundries and studios have one or more people on staff whose job is to work directly with artists, communicating their direction and changes to

staff; these people should be accessible, helpful, organized, and enthusiastic. This relationship is likely to make the difference between a positive and negative experience.

PRINT STUDIOS

The relationship with a print studio begins with a conversation concerning what the artist wants to do and the various services that the studio can offer to turn a concept into an edition. The physical size of the print, the size (including proofs) and subject matter of the edition, the manner of printing, the length of time allotted to produce the edition, the number of proofs that the printer keeps, the number of colors, and the type of paper to be used are the basis of the estimate that the studio provides. However, revisions, additions, and alterations during the process are likely to increase the fees. Assuming some level of revisions, the written estimate will usually note some leeway of 10 percent, above which the studio will ask for approval from the artist. Fees may be based on an hourly rate or for the entire project, with payment made at the end, usually within thirty days of completion, although payments also may be scheduled. (Print studios working with an artist for the first time usually request the individual to submit a credit application and provide half of the estimated cost upfront with the rest payable at completion; subsequent jobs with that artist will be completely at the end.) Rush orders and requests to work overtime or on weekends will increase fees by as much as double, and mistakes (the artist didn't catch an error on a proof) or delays attributable to the artist are not the responsibility of the print studio. It is not uncommon for studios to tack on interest charges—for instance, 1.5 percent per month or an annualized 18 percent—for late payments.

Things happen. The artist may not like the work that the studio staff is doing, or there may be a reason that the entire project has to be canceled. Rejection or cancellation prior to the completion of an edition usually entails a kill fee of 50 percent; if the edition is completed, the artist will be expected to pay the full agreed-upon amount.

Any agreement with the print studio should indicate that the artist is the creator of the edition (and owns all copyrights) and retains artistic control, who owns the printing plates (it should be the artist after full payment has been made), whether or not the plates are to be canceled (that is, defaced, for which the artist should receive a cancellation proof), and that the printer only has been given a one-time right to produce an edition. Tiki Studios in Big Pine, California, stipulates in its contract that it "always reserves the right to reproduce or use any work created by us for the Client in any reasonable way for our own marketing and self-promotional needs." Many print studios include a similar clause. As copyright owner, the artist would want to include that his or her artwork cannot be used for promotional purposes without express authorization or payment.

FOUNDRIES

Certainly, the decision of which foundry to use is complicated by issues of location, price, the right fit of services, and the media available. No less important is the quality of the work, turnaround time, and a foundry's ability to keep promises made to artists, and this can be ascertained by asking other sculptors who have worked with the foundry

in the past. Fine art foundries have one or more people on staff whose job is to work directly with sculptors, communicating their direction and changes to the foundry staff; these people should be accessible, helpful, organized, and enthusiastic.

The cost is determined based in part on what the foundry is asked to do—make molds, build a supporting structure, cast the piece, patinate, create a base, install the finished work, transport and store the molds and completed artwork, insure the molds, complete work by a certain date, contract outside engineers and other sources of expertise—but the first thing that sculptors should ask for is a quote. Probably included in that estimate is the cost range of a change order, because alterations in the design or fabrication are made during the process. Since material and labor costs fluctuate, the quote should have a lifespan of ninety days.

A payment schedule should be established as well. Typically, this would be in two or three stages, such as 50 percent initial deposit with the remainder paid at completion or 30 percent down payment with another 30 percent at some midpoint approval stage and the rest paid at the completion. Other agreements may spread out payments evenly over a period of months. Whatever the deal, the plan needs to be agreed upon and should work for both artist and foundry.

Distance may limit the ability of sculptors to take an active part in the fabrication of their artwork, but artists generally need to approve the wax for investment (making sure there are no air holes and that seams are repaired and concealed, for instance), as well as the metal prior to patination and the patina. The work is all about creating a work of art, but some foundries are reluctant to have the sculptor around a lot, adding a "shop" charge to the overall bill. Artists should know in advance the degree to which a foundry welcomes their presence.

At times, the molds become a source of contention, because artists complete their editions over a period of years, requiring the foundry to store (taking up considerable space) and insure (determining their value is difficult and they do deteriorate over time) them during the interim. The question of who owns the molds should be established at the outset (the artist, who must pay for them), as well as the issue of who is responsible for keeping them (storage and insurance charges may be part of the final bill). It is a lot to ask that a foundry keep a mold indefinitely.

10

Getting Ready to
Handle the Pressures

The life of a visual artist is frequently one of continual pressure and tension. Like lawyers, doctors, and other highly skilled professionals, they must live solely by their wits; yet, unlike these professionals, there are no prescriptions, laws, or standard rules on which they may rely—artists must forever chart their own paths, both artistically and career-wise.

It is often a wonder that it can be created at all. Artists are pulled by many conflicting needs. On the one hand, they are creating an intense moment—the art itself, which aspires to what Aristotle called a "catharsis," a spiritual renewal—yet their intensity is disrupted by the need to do some kind of work, often unrelated to their skills as artists, in order to pay the bills, and then there is the business of being an artist. They may receive no recognition throughout their entire careers, but they must maintain their personal identity as artists and not let bitterness interfere with their ability to work.

Artists live always with the knowledge that many are called and few chosen; they suffer the agony of self-reliance as their subject matter, especially for those whose realm is nonobjective art, must come full-blown out of their own heads. They take chances and risk public ridicule; they often feel guilty about "selling out." Small wonder, then, that many artists seek psychological counseling. Certainly, a large segment of society already views artists as mentally defective.

If the art world has its unknown soldiers—artists who forge on with their art even in the face of indifference or hostility—it also has its Willy Lomans. Just as the central character of the Arthur Miller play *Death of a Salesman* continues to talk up his successes and how well thought of he is, even as his life and career collapse around him, there are artists who exist on fantasies about their place in the art world or, to borrow a term from psychology, live in a state of denial.

Denial and other defense mechanisms may help artists protect themselves emotionally from the disillusionment, disappointment, and overall frustrations that the art

world regularly metes out. However, the job of marketing—that is, finding an audience for—one's art work requires clear-sightedness and a positive attitude.

"I've talked to a lot of artists who are constantly making up excuses for themselves," said Dan Concholar, a New York City artist career advisor. "They say, 'The art world is a political system. It's who you know,' and I say, 'Yes, that's true, but why don't you try to meet someone?' I've talked to artists who expect their work to get into the most prestigious galleries and won't consider any other places to show their art. I try to get them to start at the bottom and work their way up, but that idea is sometimes too much for them to handle."

Artists develop unrealistic expectations—notions of what they are unlikely to ever achieve—for various reasons: they may have absorbed a limited and limiting sense of the art world from art school; some might inflate their sense of worth as a means of mitigating years of having little or no professional success to show; or they may view the art world too starkly in terms of superstar success (museum retrospectives, Whitney Biennial, top-name New York City galleries, cover of *Art in America*) or nothing. Ideas that are wrong or simply inappropriate for a particular artist may be the largest hurdle to overcome, destroying the very real opportunities before them. In some cases, artists may need psychological counseling to overcome feelings of inadequacy and depression. Their productivity declines, and they present themselves unfavorably, not believing that they can achieve success. Other artists may simply need an idea of what they can achieve in small steps.

"Too many artists are grasping at straws; they don't know how to begin, and the task in front of them looks so big," said Sylvia White, director of Contemporary Artists' Services in Santa Monica, California. "If you give an artist a strategy—goals to accomplish in a methodical way—you give that person hope. The question isn't should this person make art, but where could this person be successful with the art they make?"

Learning how to handle the pressures of creating art or of being an artist is something each creator must do for him- or herself. For example, when painter Philip Guston wanted to obliterate all the art history he had filling his mind and forget the work of other artists in order to ready himself for something new, he would take in a double feature. Painter/sculptor Lucas Samaras claimed, "I generally clean the house a few times, go shopping, all sorts of stuff to wipe my consciousness clean of what everyone else is doing."

Other artists have been more self-destructive when responding to pressures, relieving their psychological stresses by harming their bodies. Some artists have adopted the view that such behavior enhanced their art. Alexander Calder overate, Pablo Picasso vented his anger on women, Jackson Pollock and Franz Kline both got drunk, and Jean-Michel Basquiat took drugs. Some artists simply have found the pressures on their lives too great to be borne.

Some ways of handling talent and artistic pressures are clearly preferable to others. Unfortunately, stories about self-destructive artists have given the world an image of what an artist is and does, and many younger artists seek to live up to the bohemian image. The likelihood, however, is that this leads to more ruined lives than good art.

In his study, *The Thirsty Muse*, literary historian Tom Dardis wrote about "what a number of . . . great talents have sought in [alcohol and] drugs: an altered state of consciousness that permits the artists a freedom they don't believe they possess in sobriety. The fact that this freedom is illusory is beside the point; many artists have convinced themselves that they obtain it in no other way."

Feelings of rejection and loneliness or being marginalized and silenced and the anxiety of spending months or years producing something and then waiting for some sort of response (and being perceived as overly sensitive when that response comes) are common to all artists, regardless of how well their careers have gone. No discussion of the pursuit of an art career can avoid some of these emotional issues because they are as central to the lives of artists as whether or not they produce a winning press release or say the right thing to an important dealer or collector. Clearly, it is important for artists to know what some of the potential pressures will be in their lives and careers in order that they may be prepared.

POST-EXHIBITION BLUES

Artists often think about the exhibition going up—a year or two's worth of work hung on the walls, the opportunity for praise, congratulations, reviews, sales—but not so much about the show coming down. And down they always come, after three or four weeks, to be followed by someone else's chance at attention. The exhibit recedes into memory and life goes on: time for the artist to start something new. It is not always that easy to get moving again, however, since many artists suffer a letdown, a feeling of emptiness—some psychologists liken it to postpartum depression—after the show is over.

The feeling usually doesn't last very long, and within a week artists are entering a regular rhythm of activity, but it is an emotionally drained state common to artists. And it is a very worrisome feeling that often leads artists to doubt themselves, thinking, Do I have anything left to say? I don't feel like doing anything. All this work for nothing—what's the point?

The letdown has a biological basis, according to Dr. Patricia Saunders, clinical director of New York City's Metropolitan Center for Mental Health, which regularly counsels fine and performing artists. "Psychologists refer to the concept of flow, which is an altered or peak state of consciousness in which most creativity occurs, where areas of the brain that don't usually work together do so," she said. During the flow, the brain is highly energized. "When that ends, the brain shifts back to the normal function, and some people experience that as less than normal." For most, the feeling of emptiness is not long-term, but those whose depression continues may need counseling or medication to treat mood disorders, she added.

A colleague at the Metropolitan Center for Mental Health, Dr. Cheryl Knight, noted that artists with some type of psychological disorder may feel the letdown after the completion of a project more intensely than others, because the project "sublimated other symptoms, and when the project is over here comes all your issues and problems again. It can feel worse, because you have all this time on your hands."

The prevalence of a feeling of emptiness or sadness at the conclusion of a project among artists is great enough that psychologists suggest advance planning. Saunders noted that this includes not putting pressure on themselves to begin a new project when artists feel "psychologically depleted," since that only adds anxiety to the mix. Some artists turn to illicit drugs and alcohol to gain control over depression, Saunders recommended physical activity, "the best antidepressant there is," which both is healthy and helps regulate moods.

As much as the brain may be temporarily reoriented toward the big project at hand, so is the artist's life. The end of an exhibit or commission means that a certain regimen of activity has come to a close, requiring the artist to return to whatever took place before. "It is important to rely on a daily structure," said Manhattan therapist Mary Herzog. "Human beings don't function well without structure, but it is common for artists to forget how they've done things in the past. They start to lose their identity." She advises artists to recreate a daily pattern of work, such as going into their studios at regular hours, perhaps using the time to read articles in art magazines or look through a sketchbook. "Immerse yourself in the reasons you do art in the first place," she said.

The experience of activity, followed by a letdown at its conclusion, is not a once-in-a-lifetime event, but may recur with subsequent shows and commissions. Knowing the feeling from one instance may help artists prepare for it the next time. A number of psychologists involved in the arts field suggested that artists should plan a vacation or a celebratory party, or just take on activities that had been put on hold while the project was dominating their lives. Additionally, it may be valuable to take on other creative projects with which the artist does not have as large an investment, such as a portrait for a landscape painter, which may stimulate new ideas just provide fresh challenges. "Picasso took time off from painting every so often to do ceramics and sculpture. David Hockney has done prints, even stage designs for operas," said Dr. Nancy C. Andreasen, professor of psychiatry at the University of Iowa College of Medicine and the author of *The Creating Brain: The Neuroscience of Genius* (Dana Press, 2005). "Trying new and different things keeps you out of ruts."

Graham C. Jelley, a psychologist in Providence, Rhode Island, who works with both professional artists and students at the Rhode Island School of Design, stated that he talks with artists about their expectations for some project in order that they not built up unrealistic hopes that will add a sense of failure to the feeling of letdown. "You want to enter a project with your eyes open," he said. "I ask artists, 'What are you imagining about this exhibition? Are you seeing it as a breakthrough, the long-awaited chance for recognition?' Artists are creating a story in their minds about what they hope to have happen, and it is important to articulate that story to see if it is realistic."

Of course, not every artist experiences the end of an exhibit or commission with sadness; some find relief that something all-consuming is over, and others gain confidence and energy (which may carry over into the next endeavor) from the knowledge that they saw a major effort through from beginning to end. Artists are often viewed by psychologists as psychologically fragile, more prone to neurotic or psychotic tendencies than

the general population. Still, artists are aware that much rides on their infrequent exhibitions and other projects; whether the issue is a chemical balancing act in the brain or the gap between art world hopes and reality, artists often experience (and sometimes talk about or write in blogs) a feeling of emptiness at the conclusion of a show. It should be noted, however, that psychologists distinguish between feelings of letdown, which tend to be transitory, and an artists' block, which is tied to anxiety and is more deep-seated.

Cheryl Knight, who, in addition to training as a clinical psychologist, also has worked as an actress for twenty-five years, identified three stages of post-show letdown: the first is physical exhaustion, the second is emotional exhaustion, and the third is a renewal of energy. The total recovery period may depend on how long the project was a major part of the artist's life or, possibly, it is dependent on whether the artist relies on external goals, such as a commission, or internal motivation.

In most cases, an artist who feels blue after an exhibition comes down may experience a letdown after the next show as well, but not quite as intensely. Some may plan ahead, lining up new activities or projects that eliminate or lessen the down period as a way of preparing for the feeling of depletion and, because they are expecting it, they "take down the intensity of it," Knight said. "Also, by knowing what happens, it also shortens the amount of time you feel letdown."

CHANGING ONE'S STYLE

During the winter of 1906 and 1907, Pablo Picasso painted "Les Demoiselles d'Avignon," a work that was a breakthrough for both figurative and cubist art. Drawing on African influences and defying the western art tradition of visual perspective, Picasso developed a style that appears to present a clumsy relationship between parts but that actually creates its own more personal order.

For thirty years after its creation, however, "les Demoiselles" was almost more legendary than real as few people had actually seen it, although more had heard of it. Having received some initial criticism and fearing that people would not understand the painting, Picasso turned the canvas to the wall and only the few who came to his Paris studio—artists and dealers, mostly—ever saw it until its first public exhibition at the Petit Palais gallery in Paris in 1937.

Most artists won't wait thirty years before showing their developing art but, if their work is well-known and they change their style, they may easily understand Picasso's reluctance to exhibit "les Demoiselles."

Style has become all-important to an art market where investments, high prices, and the desire by dealers and collectors to "package" an artist in a particular mode or school have been paramount. Up and coming artists are given major media attention early—Frank Stella was only thirty-four when the Museum of Modern Art in New York City held its 1970 retrospective of his work—and less time is permitted for an artist to develop and formulate ideas.

How an artist changes his or her style and to what degree are questions as significant to buyers and sellers of art as the specific content or formal qualities of a work.

Most artists see changes in style as part of an evolution and not as a radical departure, with the change reflected in the form works take but not in their basic meaning. Pressures to change or not to change come from a variety of sources, including friends and peers, critics, collectors, dealers, and, of course, the artists themselves.

One of the most notable examples of an artist leaving a successful style to work in a different manner is painter Philip Guston, who died in 1980 at the age of sixty-six. Originally a social realist, heavily influenced by Mexican revolutionary painters David Siqueiros and Diego Rivera (who himself started out as an orthodox cubist painter in Paris), Guston switched to an abstract expressionist style in the 1950s. Lauded for this abstract work by critics, collectors, and peers, he shocked many when in 1970 he returned to the more figurative, albeit cartoonish, social realist style of his youth.

No works sold from his 1970 show at the Marlborough Gallery in New York City, and the gallery quickly dropped him from its roster. Some fellow artists were quick to register their disgust with Guston, capped by a *New York Times* review of the exhibit that concluded, "In offering us his new style of cartoon anecdotage, Mr. Guston is appealing to a taste for something funky, clumsy, and demotic. We are asked to take seriously his new persona as an urban primitive, and this is asking too much."

Guston himself was "uncertain about his own works and somewhat fearful to show them," according to his dealer, David McKee. "He was worried about what people thought as no one knew what to expect." McKee noted that Guston needed "more nourishment from his own work than abstraction allowed" and looked to bridge the separation of art from social realities for his own survival as a painter and for the survival of painting as a serious activity.

Guston's two dramatic changes in style were not, however, complete breaks in the entire body of his work. There are clear similarities in the palettes for the various phases of his work, and he was always searching to revitalize painting. The differences, however, were what got pointed out, drawing the sharpest criticism. Guston was deeply affected by the negative response of many of his peers and was quite grateful that his friend of many years, fellow painter Willem de Kooning (who himself went back and forth between total abstraction and elements of figuration), liked his work, assuring him in the midst of the storm that "this is all about freedom."

Freedom is an essential ingredient of the best work, but many artists claim that their freedom is limited by outside forces influencing how they change their style and in what direction. Artists tend to point the finger at dealers.

"When you are talking about art as a commodity, dealers are mainly selling a look," said Sol Lewitt, whose own art has ranged from painting to minimalist sculptures to wall drawings. "If you change your look, dealers have to resell the artist all over again. This is all about product recognition."

"Changing a style really means changing an audience," painter Alex Katz said. "If an artist has a small audience, changing a style is no problem. If he has a large audience, then many people become upset. Dealers are in the commodity business and generally are concerned with keeping the same look year after year."

The ways in which dealers may put pressure on an artist are usually quite subtle. Regular exhibitions may not materialize, for instance, or dealers may relay criticism from "potential collectors." The result is that many artists are pushed to do the same work again and again. Sol Lewitt noted that dealers said to him about his newer work, "'I like it, but I really like the work you were doing from 1967 to 1974,' or something like that. What I usually tell them is, 'You'll get used to it.'"

For other artists, the greatest pressures come from peers. Artists often feel that the only other people who know anything about art are other artists. Philip Guston was far more hurt by the unfavorable reaction of his peers than by that of critics or collectors, and he responded with anger and outward feelings of rejection. In general, however, artists criticize each other in the form of silence.

Sculptor George Segal stated that his artist friends were his toughest audience and that they have gotten the most upset over every change he has made in his work over the years. Renowned for his white, plaster-cast sculptures of human figures in common outdoor urban settings, Segal said that "when I began introducing color a number of years ago, friends said, 'Don't give up white!' They complained that I was changing their idea of what my sculpture was." He added that "if you have the nerve to withstand criticism from close friends, you can stand it from anyone."

At times, collectors, dealers, and critics may react quite sharply to changes in an artist's work, as though aiming to confine that person to a single style. Guston's work from all his periods now sells quite well, and many or his paintings hang in museums around the country, but the negative *New York Times* review of the 1970 show greatly affected sales at the time.

Clement Greenberg is often cited by artists and dealers as the archetypal critic strongman, emphatically promoting a certain style of work and scorning all others. Willem de Kooning claimed that he once threw Greenberg out of his studio after the critic pointed at various canvases, saying "You can't do that. You can't do that."

For his part, Greenberg stated that the influence of dealers and critics has been greatly overplayed in discussions of what artists do. Noting that nobody now worries about what critics said about Matisse or Courbet, he said that the pressures that "make artists do less than their best" come from within. These include being afraid of having their work look different than it has in the past because it will sell less, "or it may just be a fear of their own originality. Artists will change anyhow. I've never known an artist who works dishonestly."

Art collectors are no less a part of the equation, and may also react favorably or unfavorably to changes in an artist's style. Many dealers, aware that collectors frequently lag behind artists in terms of style changes, promote prints in the styles with which these buyers are more familiar, allowing their artists time to evolve.

Most artists have made some significant changes in their art at some time in their careers, although few do so when their careers have reached a pinnacle. Of course, there are some exceptions. Picasso had a half-dozen distinct "periods," and de Kooning shocked many when, for a time in the 1950s, he left behind his totally abstract pictures

to do his "Women" series. The look of Frank Stella's painting also changed radically in the 1970s, losing its flat, linear appearance and becoming more gestural and three-dimensional. However, all three artists were well enough established that their careers did not suffer but, in fact, were enhanced by the changes and evolution in their work.

Unless there is some movement in an artist's career, his or her work will tend to fall into a decorative vein or just be repetitive. Even though art is usually seen as a calling for the very sensitive, it is not a profession for the thin-skinned. Artists whose work suffers because they have succumbed to the demands of market, or who cringe from possible criticism and never experiment, have no one to blame but themselves.

CHANGING ONE'S MEDIA

"With painting, you can get a high you find nowhere else," artist Lila Katzen said. "When you're painting, you move in a rhythmic way. There's a lot of give-and-take. With sculpture, on the other hand, you're taking intractable materials and trying to make them into something else. There's so much excruciating work, and it takes so long."

So why, then, is Katzen a sculptor rather than a painter? She started out as a painter, studying for three years with Hans Hofmann and turning out abstract expressionist pictures before giving that up in the 1960s for sculptural installations composed of aluminum, plastic, mirrors, fluorescent liquids, and ultraviolet lights.

Ultimately, the answer is that she wanted something more than what the painted canvas could provide. Many artists, in fact, start out in one medium and eventually turn to another as their needs change or their wish to express themselves looks for new forms. To most people, art is painting, and most would-be artists enter the field with the desire to learn how to paint. (Far fewer start out with the idea, 'I plan to be a performance artist,' or something like that.) Drawing, which more naturally leads to painting than sculpture, for instance, is almost every artist's main introduction to art. Michelangelo jokingly commented that "with my mother's milk, I sucked in the hammer and chisels I use for my statues," although it was really drawing—which led Michelangelo's father to apprentice his son to a painter before Lorenzo de Medici borrowed the young artist for his newly formed sculpture academy—that was his first love.

For Lila Katzen, the switch from painting to sculpture reflected the sense of dissatisfaction that, with a painting, "you move into it through your eyes and then your mind. I wanted the viewer to have more physical contact with this two-dimensional thing." The change did not take place overnight. Her paintings grew in size, sometimes measuring twelve by twelve feet. In order "to get the painting to come out in three-dimensional space," she began using fluorescent paint, placing black lights under the paintings, and creating a painted wooden base on which several painted acrylic sheets were mounted. Still, this sculptural painting did not fully satisfy her, and she stopped painting altogether for a short period of time in order to collect her thoughts.

"I realized that I was more in love with the forms and shapes than with the canvas," Katzen stated. "Canvas was only a means to an end, and I could get that physical contact with the viewer more readily with sculpture than through a painting."

George Segal, whose figurative plaster-cast sculptures evoke the pathos of everyday life, also studied as a painter and had a number of exhibits of his work during the late 1950s and early '60s. Like Katzen, he "loved painting, but it was the ideas about what painting should and shouldn't be that were being taught at the time that gave me trouble. There were all these rules and regulations that had to be followed: the surface of the canvas had to remain intact; there could be no illusion of depth; the complete rejection of figuration. I was asked to shut out the validity of what I could see and what I could touch. After a while, the only space I understood was the space between my own body and the canvas."

Ironically, it was the attraction of abstract expressionist painting that impelled Segal to transfer from Pratt Art Institute to New York University, where this kind of art was being taught and discussed. When he gradually switched from painting to sculpture, he found the change liberating.

"There were strictures to painting that didn't seem to apply to sculpture," he said. "I could use real world materials in my sculpture, whereas that was impossible in a painting. I could pick up a piece of discarded scrap, turn it over, examine its history, use, associations, shape, and look into my own experience of it, as opposed to following a prescribed idea of what painting is. I have to tip my cap to [Marcel] Duchamp and [John] Cage, who were pioneers in reintroducing the poetry of reality into contemporary art."

He added that "my generation broke out of the strictures of art, releasing an explosion of form possibilities." Subsequent artists found themselves thrust into this artistic ferment, frequently looking for a different means of expression than the painted canvas. Painting student William Wegman, for instance, claimed that "painting really seemed dead in the 1960s," and he experimented first with video and later with photography, by which he established his reputation.

John Baldessari, who also had started his career as a painter before becoming associated with conceptual art, "became increasingly aware that there was more to art than just painting and sculpture. What I was doing as a painter started to seem elite, as though I was speaking in a private language. Photographic imagery and text was more accessible, because people are used to seeing photographs and text in newspapers."

Viewing a photograph in the same way as a painting—"an organization of patches of light, dark, and color on a surface"—Baldessari, like Katzen, considers the physical act of painting to be "very pleasurable, about as pleasurable as anything I've ever done, but that sense of pleasure is less important to me than communicating, which I think photography does a little better."

Changes in one's ideas lead to the search for new forms in which to contain or express those ideas. Sometimes, there is a relationship between the new and old work. For example, Reuben Kadish's murals and easel paintings of the 1930s contained heavy, three-dimensional forms, which were not wholly unlike the monumental rough-hewn figures in the sculpture he began to create in the 1950s. A turning point for him occurred during a ten-year period after the Second World War when he operated a dairy farm in Vernon, New York. He left off painting and began to experiment with sculptural forms, creating figures out of mud and later moving to terra cotta and bronze.

David Smith, like Kadish, started as a painter before making his name as a sculptor, always maintaining that he was really a painter working in three dimensions. "My student period was involved with painting," he wrote in *Arts* in 1960. "The painting developed into raised levels from the canvas. Gradually, the canvas was the base and the painting was a sculpture." He drew his inspiration from painting, or more precisely certain cubist painters, but established his own unique style.

The descendant of a pioneer blacksmith, Smith pursued his painting while taking factory jobs as a way to earn a living, such as assembling metal parts at Studebaker or welding in a defense plant during the Second World War. In 1928, however, he first saw pictures of the welded metal sculpture of Julio Gonzalez and Pablo Picasso in the periodical *Cahiers d'Art* and, in the early 1930s, began to apply his knowledge of welding to creating works of art.

Like welded metal, ceramics was not viewed as a fine art medium until someone trained originally in painting began to make art out of pottery. Peter Voulkos spent a number of years as an abstract expressionist painter, but he also maintained an interest in ceramics based on a pottery class he took at the California College of Arts and Crafts. "Ceramics was a required course for applied arts students—so was belt weaving," Voulkos said. "The college assumed that everyone would go into teaching, and they wanted you to know a little of everything. I was forced to take this clay course, and I fell in love with it."

In time, his pursuit of painting fell off, and his abstractly shaped, non-utilitarian ceramic sculptures achieved renown—not only on the West Coast where, during the 1940s and '50s, an aesthetic grew that focused on the physical properties of materials rather than on older European distinctions between art and craft, but around the world.

Leaving one principal medium for another doesn't mean never pursuing one's first love again. William Wegman began to draw again and eventually paint—semi-abstract landscapes—in the mid-1980s after his photographic model, his dog Man Ray, died. Although he is still principally a photographer, Wegman's drawings and paintings have been exhibited in a number of galleries and museums. The most notable example of an artist returning to an earlier medium, of course, is Michelangelo, who told various listeners, "Painting is not my profession," and had a clearly deficient understanding of frescos, but was still summoned by Pope Julius II in 1508 to paint the Sistine Chapel.

Many artists move back and forth between media throughout their careers. The same freedom they found in opening up new possibilities in art allows them to range over a variety of plastic forms. Peter Voulkos is one who continues to paint now and then, sometimes exhibiting his pictures with the sculpture or without. "I've always vacillated between painting and sculpture," he said. "Working with clay is sort of like working with thick paint—you mix it and push it around."

HANDLING CRITICISM
It's the cry of every scorned artist—"The critics hated the Impressionists, too!"—but the claim is only partly true. Within a decade or so of their first major exhibitions, the

critical tide had turned in the Impressionists' favor, especially as unceasing stylistic developments within the School of Paris soon made the work of Monet and company look relatively tame. By the time he was in his late seventies, Monet was lionized, an acknowledged Old Master of modernism.

Into his nineties, Andrew Wyeth was still scorned by almost all the major art critics, perhaps for being the Old Master of un-modernism. Wyeth's painting, according to critic Peter Schjeldahl, is "formulaic stuff not very effective even as illustrational 'realism,'" and Robert Storr, curator of contemporary painting and sculpture at New York's Museum of Modern Art, wrote of Wyeth as "our greatest living 'kitsch-meister.'" Hilton Kramer, editor of *The New Criterion*, has complained about Wyeth's "scatological palette," a comment echoed by critic Dave Hickey who referred to Wyeth's palette of "mud and baby poop." *Time* magazine's Robert Hughes disparagingly described Wyeth's art as suggesting "a frugal, bare-bones rectitude, glazed by nostalgia but incarnated in real objects, which millions of people look back upon as the lost marrow of American history."

Andrew Wyeth claimed not to be "bitter" about the quantity and intensity of negative criticism he has received "because I've been so successful in my career." However, he stated that since the public attention and critical firestorm that met his "Helga" series of paintings and drawings in 1986, "there has been a real dampening of interest in me. I don't feel I'll ever get another favorable review in my lifetime."

He claimed to have read everything that is written about him, "which is nowadays absolutely negative," and that he has never "developed a thick skin. Negative criticism really knocks you flat, like a stiff haymaker to the midsection. So much of it is so unfair."

Wyeth is anomalous in the art world, vastly popular with the public and unanimously condemned by critics. Most successful, better-known artists have enjoyed a far more favorable balance of positive and negative reviews, but the example of Wyeth does point up the degree to which critics and the public are wide apart in their appreciation of artwork. Who's right is not the issue, but it is likely that a review has different meanings for readers, critics and artists. Artists themselves have the most complicated relationship with write-ups of their artwork.

Artists, especially those who have achieved some recognition, tend to shrug off negative reviews of their work and stress how it's more important to concentrate on one's own art. "That's part of the game." "It just makes me laugh." "I don't care what they say as long as they spell my name right." However, not far below the surface, anger at some art critic or critics in general lies waiting to be tapped.

"One reviewer said about my work, and I'm paraphrasing, 'Is this art? Why did someone go to the bother to make this thing?'" sculptor Donna Dennis said. "Another time, a critic with a Marxist point of view said that the scale of my work suggested the upper classes looking down on poor people. My problem with art critics is that they often have a set point of view to which they want your work to conform, and they refuse to open their minds to see where you're coming from."

For his part, painter Leon Golub noted that negative reviews "irritate and sometimes depress me," while Larry Rivers, another painter, stated that he "can be stung by

something I've read about my work. I remember what was said, but I try not to let it weigh on me." When she has become angry or depressed by a review that seems "nasty or personal," sculptor Marisol has gone to the lengths of sending the critic "a letter insulting him, in order to get even." Clearly, success doesn't make an artist's anger or insecurities go away when a review is unfavorable.

In fact, success may seem to raise the stakes on whether or not the write-up is favorable or otherwise. Robert Longo, a painter in New York City, stated that negative reviews are "harder to deal with now than in the past," as "the quality of my work demands a certain kind of attention, which is greater than when I first started out." Donna Dennis also noted that "a poor review affects me financially now, whereas when I first started out, it only hurt my feelings."

Perhaps, commercial success should compensate for criticism's version of Bronx cheers, and it may be that the critical nay-saying is a result of the commercial success. Newsweek's former art critic Peter Plagens noted that "critics seem to say, 'This artist already makes a lot of money and is so popular, why should I add to it?'" Perhaps, negative criticism may reflect the degree to which an artist's work is unsettling to critics. Art historian Robert Rosenblum, who claimed that he neither loves nor hates Andrew Wyeth's work, said that "Wyeth is treated as an enemy by so many critics, because he represents a challenge to modern art long after the public triumph of modern art. The fact that he is such a crowd-pleaser may suggest that this triumph isn't as complete as some may have thought."

The "problem" with Andrew Wyeth is complex and doesn't even stop with the artist himself. His sister, Carolyn, also an artist, sought to be represented by the Tatistcheff Gallery in New York City in the 1970s and was told by gallery owner Peter Tatistcheff that he would need to check with every one of his other artists for their consent. "My personal feeling toward the whole Wyeth phenomenon is that I wouldn't want to participate in it," Tatistcheff said. In another example, the first show that Wyeth's painter son Jamie had in New York's James Graham Modern gallery, in September 1993, was well-attended and sold well, but there was not one write-up in any of the city's newspapers or art magazines. "I think the name Wyeth itself sends out red flags," Jamie said.

This was not Jamie Wyeth's first encounter with the name phenomenon. His first New York show at age nineteen in 1965 at the Knoedler Gallery drew a "scathing review" from the New York Times, Jamie stated. "Something along the lines of, 'Here is another generation of the Wyeth family whose work is being trumpeted.' The review went on like that without ever mentioning my artwork. Later, other reviews came out in New York papers and magazines that attacked the Times's review: 'How could you be so harsh on a young artist?' and stuff like that, again without ever mentioning my work. It was an interesting introduction to the art world for me."

Coping with criticism, both adverse and positive, is one of the most difficult tasks for any artist. Is there any truth in what someone else is saying? Does a negative review mean that the work is bad? Do misinterpretations by a critic suggest that the work isn't communicating clearly with the public? Should one just write off all art criticism as, in the words of painter Jules Olitski, "the lowest, most scurrilous area for writers to go into"?

To a certain degree, reviews and criticism serve different purposes for the writer (of the review) than for the artist (whose work is being reviewed). Critics generally like to establish their own presence in a review—as judge of art or of the ideas conveyed in the art or as a wit (Dorothy Parker: Katharine Hepburn "runs the gamut of emotions from A to B") or even to make sweeping statements about trends in art—while artists first and foremost see the write-up as a public acknowledgment of their presence in the art world. Being written up in a newspaper makes one's show an event, something that readers may want to attend regardless of the content of the review, which tends to be forgotten sooner than the fact of the exhibition. A picture of one's work next to the review has a lot longer staying power in a reader's mind than the words describing the piece, which is why press photographs are deemed so essential. "I don't care what they say about me since people don't usually read it," painter James Rosenquist said, "but they may look at the picture and remember that."

That more cynical approach to criticism does not tell the whole story as artists often read and remember what is written about their work even if most readers do not. An art exhibition is a form of public exposure, revealing a variety of vulnerabilities. (Critics, on the other hand, do not indicate anywhere near as much about themselves.) More mature artists learn to keep an open mind to potentially valuable opinions and suggestions while maintaining a steely confidence in their own work and vision. The more negative the critical reception, the more one's inner resources are tested. "If what someone writes about me effects my work, if I don't have any conviction in what I'm doing, then God help me," Andrew Wyeth said.

The critic, at his or her most basic level, is a conduit of information to the public that such-and-such an artist exists and whose artwork may be seen at such-and-such place. At a more gratifying level to the artist particularly, the review indicates that the creator is being taken seriously as a professional, which may take the edge off the sting of any negative commentary.

There may be a great temptation for artists to respond to misinformation in a review, a problem creators complain of frequently. Environmental artist Christo noted that the titles of his work are frequently misspelled, as are his and his wife's names, and facts such as his nationality (Bulgarian) are often incorrect. "Some critics wrote that I am Czechoslovakian," he said. "One person wrote that I was born in Belgium." Donna Dennis pointed out that the scale of her work doesn't reflect class differences (as the Marxist critic had written) but "the scale of my own body, which a feminist critic would have understood." Most artists, however, see reasons to check the impulse to respond.

"I've never responded to criticism, even when I thought that facts needed to be corrected," Jules Olitski stated. "It's unseemly, demeaning, and gives the critic too much importance. I compose the letter in my mind but never send it."

Beyond the questions of the critic's value in making public mention of the artist and of responding to potential misinterpretations is the deeper issue of whether or not criticism resonates as true. Larry Rivers suggested that criticism may prove most valuable and constructive when it parallels one's own private doubts and concerns. Criticism, whether favorable or otherwise, can often open up ideas and provoke discussion.

"Criticism has expanded my vision when the person has tried to make an intelligible and intelligent statement," Leon Golub said. "It's like a goad, a provocation thrown at you, and it energizes me and my work. Sometimes, I respond to criticism through my work."

Not all criticism is unfavorable, of course. Smaller circulation newspapers rarely knock artwork, and editors often try to help locals—artists or galleries. Frequently, the artist may be met with praise, which certainly makes the creator feel good but also may involve a pitfall or two. One can start believing in one's own touted "genius" too much, interfering with one's ability to work boldly.

"Artists who have been pushed around a little should know not to let praise go to their heads," Golub stated. "Sure, I'm happy when I get praise, and I get depressed when something negative comes out. If you let it go to your head, you're a schmuck; if you let it stop you from working, you're self-destructive. You can't let either praise or damnation take over."

Artists may be able to hear criticism only from critics, from friends, peers, and family members, or perhaps, from no one. Some people respond to criticism in certain ways, regardless of whether they are artists or shoemakers, but the real issue is how confident the creator is in his or her own work. Criticism can come too early and too hard for some artists, and James Rosenquist recommends that creators hold off displaying their art until they feel secure in what they have made—secure enough to make it public and, as a child, let it go off into the world. Once a work of art leaves the studio, it no longer belongs exclusively to the artist; rather, it belongs to the world. It is liked and understood according to the tastes and knowledge of the people who see it, and the creator becomes just one more person in this chain. Sometimes, criticism opens an artist's eyes to facets of the work that he or she hadn't before realized. The artist learns to step back, watch the processes of the art world, pick up what good can be gleaned, and go on to the next creation.

REJECTION LETTERS

Nothing irks artists more than criticism and rejection, probably rejection more since criticism implies that someone presumably is taking their artwork seriously, whereas rejection means the person isn't taking it at all. A lot of meaning is imputed to what is often a form letter: the art isn't good; the artist is a bad artist; the artist is an idiot for having submitted artwork in the first place; and the person who sent the letter is stupid and biased or expresses the considered opinion of the entire world.

Handling adverse—or even favorable—reaction to one's work is a learned behavior, the result of maturity, confidence, and just experience of how art dealers, exhibition jurors, and collectors think. "When I reject an artist, it's generally because the artist and the gallery aren't a good fit," said Franny Koelsch, owner of Koelsch Gallery in Houston, Texas, which receives "proposals and portfolios from artists often." The phrase "good fit" takes in a wide realm of possibilities: it may be that the

artist's style or subject matter isn't compatible with other artworks in the gallery, perhaps that prices for the artist's work are too high or too low for the collector base. An artist's work may be too large for a gallery, or the dealer may only show artists who are local or whose work reflects local subjects. Koelsch stated that a standard rejection letter is in her computer, and she may "modify it a little" for different artists.

One of the artists her gallery does represent, painter Deanna Wood of Denton, Texas, has been affected by rejections enough over the years that she has written about the experience repeatedly on her blog (*http://artistemerging.blogspot.com*). With her blog, Wood intended to offer useful marketing and personal tips, based on her own experience, to other artists at the beginning stages of their careers, but this was a subject more for commiseration than advice.

> Personally, I do get a little depressed when I receive a rejection letter from a gallery that I really liked or a show that I really wanted to get into. But I just file it and try to figure out what to do next. Well, that didn't work out, what can I do now?

"I just put all my rejection letters in a folder," she said, adding that she has never counted them all, because "that might make me more depressed." Included in that folder are forty-four rejection letters from 2005, when she sent out a proposal for a solo exhibition to fifty nonprofit and university galleries around the country. She also received six acceptances, and ended up showing her collection of paintings in Iowa, Kansas, Nevada, and Oklahoma, but it is the rejection letters that haunt her more than the success. "I had a stronger emotional reaction to the rejections. I took it very personally, thinking they were rejecting me and not my work." In yet another posting on the subject of rejection, Wood offers some sample rejection letters to any gallery owners reading her blog in order that they might avoid hurting the feelings of the many artists they inevitably will find themselves rejecting.

She is not the only artist for whom rejection seems a more vibrant subject than more welcome news. Others (on their Web sites) describe creative ideas for reusing rejection letters, such as wallpaper and Christmas wrapping paper, or their responses to those who rejected them. James Culleton, a Canadian painter living in Winnipeg, turned a stack of rejection letters into an art project, laminating all of the letters he had received over a four-year period and riveting them together into a "suit of armor that will provide protection from future rejection." They include letters from grant-making agencies, juried competitions, art galleries, and art schools (all ten he applied to for Masters of Fine Arts programs said no). Suzanne Clements, a figurative painter in Palm Bay, Florida, who is represented by galleries in Florida and North Carolina, created a Web site (*http://myrejectionletters.blogspot.com*) specifically for publishing her rejections. Among the postings is this:

> Recently, I entered two pieces for consideration by the local museum for their juried art show. I thought about submitting more edgy work, but on a last minute whim I submitted the following two pieces:

Today I received electronically the letter regretfully informing me of their decision:

"Dear Artist,

On behalf of the Local Museum of Art and Science thank you for submitting your work to the 2007 Juried Exhibition. The juror had a challenging job choosing from over 300 submissions. We regret to inform you, your submission was not selected this year. We hope you will apply next time.

We wish you continued success in all of your creative endeavors.

Sincerely,

2007 Juried Exhibition Committee"

"All in all," Clements added as commentary, "it's not a bad letter."

In a telephone conversation, she explained that putting her rejection letters online "gives a purpose" to her experience and may encourage other artists who have also received far more rejections than anything else from the art exhibition world. "It's important for all of us to deal with the problem of rejection, and I've learned that rejection isn't necessarily personal or serious; it's not even a big deal. It's just part of the process." She finds the more personal rejection letters helpful ("they give me pointers for when I apply next year"), considering these opportunities "near-misses," but unfortunately the overwhelming majority of them are form letters into which little can be read. "So many of them are photocopies with a checked 'yes' or 'no' box on it."

Clements's Web site is intended for other artists but, of course, the Internet is an open door for anyone with a computer, including prospective collectors of her work who might question their interest in buying the artist's work after viewing a published record of rejections. Not to worry, according to Raymond Voelpel, owner of the Tidewater Gallery in Swansboro, North Carolina, which represents Clements: "True collectors are confident in their judgment and not as influenced by what others think as first-time buyers."

Success may mitigate the sting of rejection but not eradicate it. Not being accepted taps very basic emotions of personal connections (mother-child, community-individual), which may be why a single rejection letter sticks in one's craw long after a string of successes should have erased the memory. Probably every artist present and deceased has experienced rejection of some quantity and magnitude, but the story of renowned artists is principally told through their achievements and successess. Only Vincent van Gogh's commercial failures (only one painting sold during his lifetime) are such an important part of his biography, because of his published letters to his brother Theo that detail the adverse reaction he continually faced. Otherwise, successful people and their biographers prefer to discuss what they accomplished, not what didn't take place, because the public display of rejection is a sign of not having achieved much.

Rejections do mount up, particularly in the early years of an artist's career, and a growing number of artists attempt to look at them in a positive light. "In a weird way, one hundred rejection letters are a good thing," Wood said, "because it means that I'm putting my work out there for people to see." Perhaps, rejection is a "badge of honor," since it suggests that one has "taken risks, broken taboos," according to Catherine Wald, a writer who created a Web site (*www.rejectioncollection.com*) that features her own rejection letters and those posted anonymously by other writers and artists. She developed the site as a response to her own experience of having written at novel in 2001 and spending two years trying to interest publishers in it. None were. "The reality that it really wasn't going to be published hampered my ability to do my work"—she earns her livelihood as a freelance corporate report writer. Being rejected so often made Wald feel "ashamed, as though it's a deep, dark secret," but she came to realize her experience was one shared by many others. "I wasn't alone. It's not so shameful." Wald developed "three or four book ideas" on the subject of being rejected, all of which were rejected by publishers, before starting her Web site. A history of being rejected "speaks to your professionalism," she noted, because "you're willing to stick with your art."

Of course, she added, it is important for all artists and writers to assess whether rejections indicate something lacking in their "craft or artistry or for reasons that have nothing to do with that, such as the forces of the marketplace over which they have no control." Part of the job of being an artist is determining which one applies, and there is no Web site as yet to help with that.

HANDLING ART WORLD PUBLICITY

In 1949, *Life* magazine published an article whose title asked the question, "Is Jackson Pollock the Greatest Living Painter in the United States?" Although the article's tone seemed to ask readers to answer in the negative—which, based on the letters to the editor that were published, they did—it heralded a new attitude by the media toward art. Despite a portrayal of Pollock as an oddity whose work and mode of art-making defied comprehension, the art was described in terms of his success in selling his works. If he sells, it is assumed, the rest is OK.

Money talks, and in the art world it publicizes. Exhibitions of the work of van Gogh in Paris, Chicago, and New York City have not done as much for the widespread acknowledgment of the artist's greatness as the sales within a small span of years of several of his paintings in the 1980s for $20 million, $40 million, $53 million, and $82 million.

Publicity has become a staple of the art world, affecting how artists see themselves and how dealers work. On its good side, this publicity has attracted increasing numbers of people to museums and galleries to see what all the hullabaloo is about and, consequently, has expanded the market for works of art. More artists are able to live off their work and be socially accepted for what they are and do.

On the other hand, it has made the appreciation of art a bit shallower by seeming to equate financial success with artistic importance. At times, publicity becomes the art itself,

with the public knowing that it should appreciate some work because "it's famous" rather than because it's good, distorting the entire experience of art. Seeing the touted works of art may be anti-climatic, especially when—as in the case of Georgia O'Keeffe—the poster images of an artist's paintings are often larger than the actual pieces themselves.

Certain artists, artworks, and art collectors have become celebrities in the same way that the latest supermodel, the Hope Diamond, and society page figures turn ordinary occasions into notable events by their very presence. One must not forget the essential irony of Andy Warhol's comment about everyone's fifteen minutes of fame—that this type of notoriety is hollow, more to be watched in a detached manner (Warhol's art in film, painting, and prints was a documentary on celebrity) than taken to heart.

The focus of publicity in the art world has changed in the years since the *Life* magazine article. Back then, the radical look of the artwork was highlighted; later, in the 1960s, the spotlight shifted to the artist's lifestyle and, after that, to the buyers of art. Clearly, money has made itself known with art taken along as a passenger.

The artists who were most affected by the media interest in the arts were the abstract expressionists in the 1950s. Although their works and goals were almost too diverse to truly label them as a group, these artists, who had grown up during the same period and shared many similar experiences, were united by a mood that they all shared—alienation. That shared isolation was broken up by the new attention their work began to receive, as some artists who were less successful felt bitter about others who were more so. They all felt a degree of anger at the loss of their seclusion and at how their lives had suddenly gone public, as well as guilty that they had become commercial—they were all committed leftists, after all, whose decision to abandon politically conscious art for total abstraction had been difficult.

Feuds, alcoholism, and bitterness poisoned these artists' lives. Franz Kline, William Baziotes, Bradley Walker Tomlin, and Ad Reinhardt all died relatively young. Arshile Gorky and Mark Rothko committed suicide—Jackson Pollock's car crash (the last of many) can be called an "accident" only with quotations—and the male survivors (Willem de Kooning, Conrad Marca-Relli, Philip Pavia, and Jack Tworkov) complained of feeling passed over by the media for the next generation of artists.

"The art world, by which I mean critics, dealers, everyone except the artist, is interested in the new and forgets everything else," Jack Tworkov noted not long before he died. "Some artists got put on the back burner after a while. It is inevitable."

Whereas in the 1950s the art attracted the most attention—treated with curiosity, disdain, and bewilderment by a public that was unused to such stuff—the focus shifted in the 1960s to the artist's life. To many, it represented an alternative lifestyle for those disenchanted with middle-class society; to others, it became chic for the socially ambitious to rub elbows with artists and become a museum trustee. Within relatively few years, in fact, the boards of trustees at the nation's major art institutions changed from old money and old families to new wealthy businesspeople who brought a whole new set of values to the operation of museums. Openings at museums and galleries also became major social events during this time, and artists were courted by politicians and tycoons.

A growing number of artists thrived on this recognition, while others—who found that their lives had become a matter of public concern, limiting their freedom—did not. Many aspects of the artist's lifestyle—with the exception, of course, of the general poverty of most artists—were appropriated by members of the middle class, the most obvious example being loft-living. Artists found themselves priced out of the abandoned warehouse buildings into which they had settled as the glamor of living in a spacious loft (as opposed to the suburbs) gained popularity in Boston, Chicago, Los Angeles, New York City, Philadelphia, and elsewhere.

The spotlight in the 1970s shifted from the art and the artist to the buyers of art, largely because of the record-setting prices paid for works, and the focus of publicity has remained there since. The managers of hedge funds on Wall Street, Saudi sheiks, Russian petrochemical company owners, the new class of billionaires throughout the U.S., Europe, and the developing world receive much more attention than the art they buy. In fact, their purchases are viewed as a reflection of their business and aesthetic acumen, of where the art market is heading, rather than as significant objects on their own. The artist's success became their success in being wise or wealthy enough to acquire an expensive artwork. Various art magazines now annually devote whole sections or issues to who the top buyers are in any given year, and a number of home and architecture magazines regularly feature the houses and collections of wealthy art buyers.

In some cases, they erected monuments to their art interests. Eli Broad created the Broad Art Foundation to house and loan out his vast collection of contemporary art, rather than donate it to a museum (the Los Angeles County Museum of Art had built a contemporary art wing and named it after Broad with that very intention). Conglomerateur Norton Simon purchased the Pasadena Museum of Modern Art in 1974, renaming it the Norton Simon Museum of Art at Pasadena, and reserved 75 percent of the museum's space for his own works. He began selling off many pieces in the museum's original collection that were not his personally. Others have set up whole museums, or had other art institutions add wings, that bear their names, and often some strings are attached to ensure that their persons are not forgotten amidst the art. Robert Lehman, for instance, whose collection went to the Metropolitan Museum of Art in New York City, which built a wing (the Lehman wing) for it, stipulated that the display be set up to exactly resemble the donor's home, with works (and furniture) placed just as Lehman liked them.

To a degree, the focus on collectors, what they spend, and their vision suggests a lack of any consensus about aesthetics or standards of taste. Without a clear conception of inherent quality, the only certainty about art becomes the amount of money paid for it. A new definition of art is the result: art is whatever someone puts down money for and says, "This is art." The corollary of this is that quality is identifiable only in terms of the sums spent. A $200 piece is nothing special; a $2,000 piece is OK, a $20,000 work is significant; a $200,000 piece is excellent; and, at $2 million, the artwork starts to be called "priceless." There had traditionally been in the art world a distinction between commercial success and what is called *success d'estime*, the prestige and influence of a

work. More and more, the distinction has been blurred as critical and monetary values have become intertwined.

Capturing publicity becomes a means of nabbing dollars, and artists have become in many instances as infected with the excitement as dealers, auction houses, and collectors. Small wonder, then, that so much art of the present day goes in for theatrics, exaggeration, and rhetorical stances, as the getting and keeping of public attention has become a central part of contemporary art-making. Attuned to the requirements of marketing, many artists are reacting to their times.

LOVE AND MARRIAGE

There are a number of reasons that people marry or divorce, and sometimes it is because they are both artists. Another artist will understand the art one is attempting to create, will accept the lifestyle and serve as an in-house supporter as well as an experienced eye. Another artist may also be in-house competition and one's fiercest critic, resentful of one's success and scornful in his or her own.

It is not infrequent that artists marry each other, as the people they tend to meet in their art studies, at gallery openings, or through their professional associations often are involved in the art world. Leon Golub and Jack Beal, for instance, met their wives (Nancy Spero and Sondra Freckelton, respectively) while attending the school of the Art Institute of Chicago.

Despite the real benefits for an artist of marrying (or living with) another artist, the identical careers—regardless of how dissimilar their respective artwork may be—create tensions for the two of them. Being an artist requires an ego of considerable size; two such people may find themselves clashing frequently, even if their disputes have nothing to do with their art or careers. Strong, unbending wills have destroyed more marriages than anything else.

Some artists approach these issues in advance by talking out a list of potential concerns. Jack Beal proposed to Sondra Freckelton three times before she finally accepted. "At first, he had the idea that I might be Madame Matisse, but I said 'no' to that. I didn't study art in order not to have a career on my own," she said. The back of their 1953 marriage certificate includes a written "agreement of partnership" establishing that they are equal partners.

"Artists have to outline what the dangers are, could be, might have been," said Miriam Schapiro, a painter who has been married to another painter, Paul Brach, for over forty years. "You have to discuss whether or not to have the same or separate friends, whether you want to be treated as a couple or as individuals, whether your careers allow you to have a family, where you want to live, whether you want to be in the same gallery or not. They're all difficult subjects, but married couples—especially those with the same career—have to be able to communicate."

Other artists attempt to resolve the tensions of both spouses being artists through establishing separate studios (sometimes never even visiting each other's studios), using different dealers, and generally staying out of each other's careers. One

example of this was the house that Mexican muralist Diego Rivera had built for himself and his painter wife Frida Kahlo. There were two separate buildings, containing two separate living units and art studios, connected by a bridge on the second-floor level.

Having two distinct studios, one for her in the garage and one for him away from the house, is "a physical manifestation of what is already going on," said Scott Prior who is married to Nanette Vonnegut, both of whom are painters. "If we are too close, we sort of step on each other's toes. We do talk about each other's work, but there are times when Nanny would just as soon that I not say anything about her work because I can be disruptive."

It is relatively seldom that both artists in a marriage receive the same degree of attention and success in selling their work. At times, one artist's career is clearly on the rise while the other's has peaked, a scenario played out in the film *A Star Is Born*. Collectors, critics, and dealers may come visit one artist's studio and not the other's, which can be especially painful when the two artists share the same space. Competition and anger may enter a relationship.

"When my wife's career is doing better than mine," Leon Golub stated, "I don't feel as good about myself and may develop resentment." Golub added, however, that he directs that resentment elsewhere—at limited thinking in the art world, for instance—and not at his wife.

The tension and sense of competition may be too great for some marriages. The wives of Edward Hopper and Philip Pearlstein gave up their art careers, for instance, believing that there could only be one "genius" in the family. Sally Avery said that her "career has flourished over the past twenty years" after her husband, Milton Avery, died. While he was alive, "I wasn't trying to promote my own work. I tried to promote his work, because I thought he was a better artist than me."

Problems are not necessarily lessened when an artist marries a non-artist. Janet Fish, a painter who first married and divorced an artist, then married and divorced a non-artist, and currently lives with another artist, noted, "Problems about being an artist are really symptomatic of other problems in the relationship. Men simply have more problems than women with competition. There is something in their upbringing that requires them to be the breadwinner. The bad relationships I've had have been when the man's ego has been too tender."

She added that "I know some women artists who say their husbands never come to their openings or to see their shows, as though they are trying to deny these careers exist."

While artists marrying artists has a certain logic, the history of art reveals many examples of artists preferring a caretaker. Almost the entire abstract expressionist movement of the 1940s and '50s, for instance, was supported by the wives of the major artists. Barnett Newman's wife, Anna Lee, for example, was a typing instructor; Mark Rothko's wife worked as a model, and Adolph Gottlieb's wife, Esther, taught school. In Europe, it was a tradition for artists to marry "working girls." Goethe married his housekeeper, as did Pierre Bonnard and Marc Chagall—when his first wife left him,

Chagall married his next housekeeper. This kind of marriage (and this kind of support for male artists in general) has largely disappeared with the advent of the women's liberation movement.

Marriage, of course, isn't a professional decision but a personal one. The success rate of marriages is not necessarily improved when artists marry critics or dealers and, in many respects, the marriages of artists are no different than those of everyone else. Some artists get along well enough both personally and professionally that they, like Claes Oldenburg and Coosjie van Bruggen or Edward and Nancy Reddin Kienholz, are able to collaborate on art projects. Others, whose artistic ideas are not easily compatible, keep their marriage out of their careers as best they can.

"I think it's hard to be an artist married to an artist. I think it's generally hard to be married and be an artist," painter Lois Dodd, who was once married to sculptor William King, said. "When you're married, you have to think of another person, and art is a very selfish activity."

THE BENEFITS AND PITFALLS OF CENSORSHIP
AND CONTROVERSY

"I've refused to become a prisoner of 'Piss Christ,'" said photographer Andres Serrano, referring to his photograph of a crucifix submerged into a glass filled with urine, but the fact remains that he has become a very wealthy prisoner of that work. The picture, created while a recipient of a $15,000 grant from the Southeastern Center for Contemporary Art in Winston-Salem, North Carolina, which itself had received a grant from the National Endowment for the Arts in fiscal year 1987-88, drew fiery condemnation from religious groups around the United States and members of Congress, including North Carolina Senator Jesse Helms. Coming at the same time as the controversy over the indirectly government-sponsored exhibition of the work of photographer Robert Mapplethorpe, the outcry came close to abolishing the federal arts agency.

The dispute over "Piss Christ" has proven to be a "double-edged sword," the artist said. "Collectors rushed to support me. I've sold a lot of work, and I wouldn't have sold anywhere near that much if the controversy hadn't occurred." The other side is that the flap broke up the artist's marriage ("I was a little paranoid for about nine months") and made Serrano a symbol, represented by this one work that colors all he has ever done or will do. "'Piss Christ' has been over for me for a long time; for other people, it may never be over."

Great public controversies or instances of censorship can't help but affect an artist in a significant way. For certain artists, there is a clear up-side. "I like to think that my career would have reached this level without the help of the FBI," said photographer Jock Sturges, whose San Francisco studio was raided in 1990 by the Federal Bureau of Investigation, which confiscated and destroyed many of the artist's prints and negatives of nude children before a federal grand jury failed to indict Sturges. "Certainly, the feds pushed my career ahead by ten years."

David Hammons gained considerable publicity and new collectors when his sculpture of a blond and blue-eyed version of Jesse Jackson (titled, "How Ya Like Me Now?") was attacked in 1989 during an outdoor exhibit in Washington, D.C., with sledgehammers by a group of black men who felt the work disparaged Jackson. The artist repaired the piece in time for a more recent retrospective, adding to the work sledgehammers and the logo of the cigarette maker "Lucky Strike" since "it was lucky for me that those men struck the piece with sledgehammers, because that got everyone to notice me."

However, for most artists, the sword is not double-edged. The controversy elevates an artist's name and face long enough for the individual to become the focus of death threats, hate mail, and snubs from collectors, dealers, and curators, with little but a tarnished reputation to show for it.

"Controversy hasn't been a fast track to success for me in the art world," said Kate Millett, whose 1970 "The American Dream Goes to Pot" featuring an American flag partially stuffed into a toilet behind prison bars has been picketed by veterans groups and others whenever it has been displayed. The work was most recently exhibited as part of an "Old Glory" show at the Phoenix Art Museum in Arizona in 1996, where it was met with protests and condemnations from Senator Jesse Helms, House of Representatives Speaker Newt Gingrich, and then-presidential candidate Bob Dole. "I've gotten a sort of notoriety because of that piece and some others I've done but, in another way, the controversy hasn't affected me a lot because I've never been able to sell my sculpture. All my life, collectors and curators have backed away from me. No dealer has come to me for any purpose whatsoever. I think I've sold only a couple of works to friends, for $350 apiece."

Controversy worked in her favor after her 1971 book *Sexual Politics* was published, which became an instant classic among feminists, but her artwork has never benefited. Why one artist's career is aided by controversy but another's is not may not be easily understood. Senator Helms denounced both Serrano and Millett, both of whom produced work that cause viewer discomfort; collectors, critics, curators, and dealers rallied around Serrano but avoided Millett.

The studio of photograper Marilyn Zimmerman, a tenured professor at Wayne State University in Michigan, was raided in 1993 by police who confiscated prints and negatives in a manner similar to the FBI raid on Jock Sturges. She, like Sturges, took photographs of a nude child—her own daughter, in fact—and the district attorney decided to drop all charges in the face of protests. However, "there was no great surge of interest from collectors in buying my work or from dealers who might show my work," she said. The fear that this raid created in her life "did stop me from photographing the nude. I use other, appropriated images instead. Frankly, for a long while, I lost the heart to make images." She also lost her daughter as her ex-husband used the photograph controversy to gain primary custody in court.

Instances of censorship effectively ended the art aspirations of two young artists, David Swim in Austin, Texas, and David Nelson in Chicago. Swim's figurative plaster sculpture of a nude man was removed in 1993 from a public art show. His lawsuit against the city, the mayor and the head of the local Art in Public Places program was

supported by the Art Censorship Project of the American Civil Liberties Union and the National Campaign for Freedom of Expression, but "support for me in Austin was pretty nonexistent. The Austin Visual Arts Association, which receives money from the city, tacitly supported the city's decision." In addition, the area galleries in which Swim had been showing his work became "concerned about the work I did, and no other dealers came to pick me up."

The controversy and lawsuit (eventually dropped after a trial, several appeals and an overturned conviction) proved too distracting for him to get back to work. "I wasn't in an emotional place where I could create any art," he said, and he stopped producing art altogether, instead taking a job as a computer technical support representative for Apple.

David Nelson was an art student at the School of the Art Institute of Chicago in 1988 when he placed in a student show a portrait of the late Chicago Mayor Harold Washington dressed in frilly lingerie. Several black aldermen came into museum's gallery and took the picture away, inciting an ACLU-sponsored lawsuit and several protests on both sides. According to the registrar's office at the School of the Art Institute, Nelson lives "somewhere in the Midwest and doesn't pursue art anymore, to our knowledge."

Controversy invariably requires that an artist take time away from his or her work to speak with police, the press, lawyers, other artists, and even groups that ask the artist to give a public talk. It also takes an emotional toll. Dread Scott Tyler, whose 1989 work in an exhibition in Chicago, "What is the Proper Way to Display the U.S. Flag?" requires viewers to walk on a flag in order to read from a book, noted that he has received death threats in the mail, that his mother has received death threats at her home and office, and that other black artists have received these same threats. "People don't know what I look like," he said. "They see black artists and assume they're me."

Millett also noted that she felt frightened when Speaker Gingrich "denounced me on the floor of Congress. In another society, I would be arrested and jailed or worse that day. There is something about being the target of all this animus. It's different than just a bad review when the government is attacking you. It has the power of social force behind it."

Artists are sometimes accused of deliberately seeking publicity by courting the outrageous, then taking advantage of the notoriety in order to sell their work, but "would you trade what Sturges went through just to get your name out there?" asked David Mendoza, former executive director of the Washington, D.C.–based National Campaign for Freedom of Expression. Within the first five weeks of the FBI raid on his studio, Sturges said that he had spent $80,000 on legal fees, "lost forty pounds, I couldn't sleep; I was anxious all the time. If I had been convicted, the sentencing was ten years. I thought I was going to prison. I had read that child pornographers were usually raped and brutalized in jail, and I would get AIDS. I thought I was under a death sentence." He sought psychiatric help.

In the relatively small art world, artists have a large measure of control over the context in which their work is placed through the exhibition of that art. Public

controversies bring artwork into a far larger realm—photographs of Dread Scott Tyler's piece appeared on the front pages of the *Chicago Tribune, New York Daily News*, and *Village Voice*, among others—where artists have little to no control. Serrano is the "Piss Christ" artist, Sturges a child pornographer. Karen Finley, the performance artist for whom a grant from the National Endowment for the Arts was recommended by a peer review panel but denied by the agency's advisory council in 1990, has been labeled the "chocolate lady" for some much-debated performances years ago in which she smeared chocolate on her body. Their entire careers have been reduced to one or more images that encapsulate the public controversy generated. At other times, their work has been cited by their opponents in order to make points about something else.

"I saw a picture of my flag-in-the-toilet reproduced in a newspaper, accompanying an article on why the NEA should be abolished," Millett said. "I've never received a cent from the NEA, but that didn't apparently matter to this newspaper or to the person who wrote the article. I feel horrible about being used in this way."

OUT OF THE SPOTLIGHT

Most people tend to limit their memories to either what is personally important to them or what is currently being talked about. It is always with a sense of astonishment that anyone thumbs through a ten- or twenty-year-old art magazine and remembers the artists who were being lauded right and left. The obvious question is, "Whatever happened to...?"

The language used to describe these artists' then-current work is learned, partisan, and enthusiastic. This artist's work is a "significant contribution," that artist is having a "major show" while another is the "leading spokesman for his generation." So, many of them never seem to get written up again and, years later, one wonders what happened to them. Did they die? Did they stop working? Was their subsequent work so bad that everyone thought it best just not to mention it ever again?

They largely continued to live and do work of the same quality, but they all learned how uneven attention can be in the art world. They also learned what it is to go out of fashion. "America is a consumption society," Marisol, a folk-pop art sculptor who was the toast of the art world during the mid-1960s, said. "They take you and they use you and then they throw you away."

Marisol was in all the art and fashion magazines and her opinions on fashion, culture, and cuisine were meticulously noted. People hungering for her pronouncements have had little sustenance since the late 1960s when she seemed to disappear—at least from the periodicals. Exhibitions of her work became fewer, and her name fell into that area of consciousness that includes the name of President Eisenhower's Secretary of Agriculture and the first movie one ever saw.

"The people who count don't forget," she said, "but you do wonder, when all the noise dies down, what all the attention was about. Was all that excitement really about your work or just excitement about being in" fashion. She added that she never stopped working—"but now I just do it more privately."

All art is created privately, anyway. An artist goes into his or her studio to commune with the Muse, not with the art magazines, in order to produce a work of art. But creating art is not just a form of self-therapy, and artists need some way of gauging their audience. Most artists want to project themselves and get more than an echo.

The feedback they receive is often short-lived and not without some drawbacks. Historically, since impressionism, no single art movement has dominated the art world for as long as ten years. By the time one group of artists begins to receive recognition, a new generation has grown up and starts to express itself. The old group recedes, having made its mark on history, but no one wants to be historical in one's lifetime—one might as well be dead.

Painter Ray Parker claimed that he has been through the popularity-neglect mill several times now: "Taste changes very rapidly," he stated. "One day, everyone loves you, the next day no one remembers you. But the changes are fast enough and cyclical enough that, at least in my case, people come back. Then, they go away again. You learn to get used to it."

Other artists handle the seeming fall from grace in their own way. Painter Robert de Niro, father of the actor, was highly respected and touted in the 1950s but, when his works seemed to be ignored during the 1960s and '70s, he retreated into a scornful silence. The career of Adja Yunkers, who died in the mid-1980s, went through a period of prolonged submergence in the 1970s and the artist himself grew increasingly cantankerous as a result. "I was all over the place in the '60s," Yunkers said shortly before he died. "You couldn't open an art magazine without finding my name in it."

By now, most artists in the public eye know that some day they will be replaced, and they must prepare themselves for that eventuality by investing their money now, producing as much as possible while they're hot, and attempting to change their style with the turns of the market. One of the unwritten credos of today's art world is that a young artist (just as a young rock star) may well be considered through by the time he or she is forty, and one should rush to strike while the iron is hot. Isn't that what hype is all about? Commitment by an artist means persevering even when recognition is not there.

For all those artists in the old magazines about whom one hasn't heard anything since, the real issues may be whether or not they deserved the attention in the first place—were they just hot starlets of only passing interest?—and if the attention they received had less to do with their work's qualities than with then-current fads.

THOMAS HART BENTON HAS A MESSAGE FOR ARTISTS

Many artists, especially long-lived ones, have felt themselves bypassed by changes in taste and mood, but no artist described how it felt as clearly as Thomas Hart Benton, who wrote his autobiography in 1937, adding another final chapter to the next edition in 1951 and a final chapter to the third edition in 1969, six years before his death. In this tale of two chapters, an artist sees his changing place in art history and swallows hard, finally coming to an acceptance that others have taken the spotlight he once assumed was his for good.

There was probably no better time for Thomas Hart Benton to write his autobiography than in 1937. *An Artist in America* describes the artist's life and thoughts, his tumultuous place in the art world, and his plans for further glory with a bravado that could have been accomplished only by an artist at the top of his powers and at the height of his renown. By the mid-1930s, Benton may well have been the most famous artist in America and, for all his squawking about money in his book, perhaps the best paid. However, Benton, who was born in 1889, was to live another thirty-eight years, during which time much of the certainties of his world would evaporate and his own artistic reputation would plummet. The modernism that he eschewed in Paris and Manhattan ("a purity divorced from the common ways of the day," "adrift from the currents of our land and contemptuous of them," the "high temple of aesthetic pose and lunatic conviction") gradually took over the galleries and museums in one wave after another: abstract expressionism, color field painting, pop art, Fluxus, body art, performance art, happenings, minimalism, conceptualism, process art, and on and on. Within those thirty-eight years and subsequently, Benton became an historical artifact, reflective of a period of American art and history that the postwar world felt well rid of.

Of course, all artists reflect their times; according to the old Roman adage, art has a long life, but some art looks dated within a relatively short period. Benton had outraged sectors of the contemporary art world, but it was not so much because of his art, with the possible exception of a reclining nude he exhibited that excited the locals (it "had so drawn the male population of the city that a rope had to be thrown around the area where the picture was hung"), but as a result of his abrasive personality. Reveling in his hard-drinking, man-of-the-people persona, Benton particularly attacked the manhood of people with whom he disagreed.

> Between the forces of the narrowly conservative and the doctrinaire radical, another influential forces thrives in the city. This last is even more completely withdrawn from the temper of American than either of the others It comes from the concentrated flow of aesthetic-minded homosexuals into the various fields of artistic practice. Aestheticism in its more fragile forms seems always to accompany sexual aberration when that is represented by the simple predominance of feminine characteristics rather than the cultivated vices of bisexualism. In the case of the latter, male sexual buffooneries, accompanied by a more or less open sadism, offset any exaggerated artistic delicacy. But in the homosexual circles of artistic New York there are few who, like the gentleman in the Klondike poem, are ready to jump anything from a steer to a kitchen mechanic. Our New York aberrants are, for the most part, of the gentle feminine type with predilections for the curving wrist and outthrust hip.

Certainly, there is a context to this display of prejudice and just nastiness. Benton was quite aware of how marginalized artists were in American society, and he made it his business to "cowboy up" the image of the artist in America. His book is a travelogue of the country, respectfully describing to Main Street America somewhat in the style of a

politician the values of common people ("These [Mississippi River] people would not, as a rule, trade their wandering life on the water for any certain security. They know that the price of security is a loss of freedom. . . . ") and how much of a regular guy he was to understand all this and get on with so many common types ("What is called society is, of course, like the froth on a glass of beer, of no consequence"). Benton was rough-and-ready; he could drink with gamblers and parley with wealthy art patrons Albert Barnes and Julia Force; he had had girlfriends and now a wife; he had been to Europe and but knew that America was best. And, dammit, he could paint.

"So, you're an artist, Shorty?" one of my tormentors asked skeptically.

"Yes, by God! I am" I said. "And I'm a good one."

He was also not a bad writer, offering reflections on his own life and experience and descriptions of people and places, mixing in homilies and aphorisms and boasts, always maintaining the salt-of-the-earth persona. The battle Benton waged with the stereotype of the artist as effete and lazy would be picked up by others—for example, Jackson Pollock's Wyoming background became an early point in his favor, and Barnet Newman always demanded to be photographed in front of his paintings wearing a jacket and tie in order to demonstrate the fact that he really was at work.

These issues of the art world seem so long ago, because they have so little relevance to our own time. Establishing something that was an "American art" proved to be an obsession for artists of the first four decades of the twentieth century, but abstract expressionism quickly became the leading style not only in the United States but throughout the industrial world. Rural life as the seat of American core values quickly lost its appeal as a massive population shift to cities was well underway. What might before have seemed to be purely aesthetic values—abstract ideas, self-expression as an end in itself, artistic taste as a barometer of intellectual achievement—became widespread throughout the culture. People wanted something new, and artists were providing it.

Perhaps Benton's identification of modernism with European effeteness and homosexuality reflected his worries for the future of representational art, and he thought that the ad hominem attack would work to his advantage, but he was probably less a homophobe than a failed tactician. As many people before and after him, Benton donned a populist persona that he thought would enshrine him as a hero but ended up tainting him in the minds of the subsequent generations whose esteem for him he hoped would continue and grow.

Abstract expressionism hit the art world like an earthquake in the late 1940s and early '50s, and like an earthquake, it left a number of institutions in shambles. Among the ruins were American realist (regionalist and social realist) painters who had dominated the galleries and museums displaying work by contemporary native artists and who found interest in their work tumbling. They saw all of their most cherished beliefs about art upended. Art no longer needed to address itself to the concerns of the common

man, depicting in recognizable imagery aspects their lives and work and values. The new art was concerned with color and formal problems of art, implicitly rejecting mass political efforts for personal solace and expression. At the time and even today, the argument has been raised that abstract expressionism served the interests of a more politically conservative McCarthyist climate by eschewing social concerns and establishing a more elite (and wealthier) audience.

Arguments over artists' intentions aside, the new art did pose a very practical problem for those social realists who still believed in their art but sought to make a living. "The big change in the art world damn near buried me," painter Jack Levine (who was born in 1915) stated, adding that the market for his works shrank considerably for a number of years. Some artists—the most notable being Philip Guston (1912–80)—jumped ship and became abstractionists. Others slogged on and hoped for a change in the winds of the art world.

"I felt more and more that I was not painting in the popular mode," Lee Jackson, who first gained prominence in the 1930s with his social realist images of life in the city, said. "It felt like the air you breathed, the ground you stood on was suddenly pulled out from under you and left you dangling. I felt deflated as people all around me who had been doing social realism suddenly began doing abstraction. For a lot of us, it was a period of self-searching and disappointment."

Some social realists attempted to combine their social concerns with the new emphasis on color as an expressive entity in itself and on the more formal concerns (flatness, the painting surface, lack of illusionism) of the abstractionists. Isabel Bishop, for instance, showed new interest in the 1950s with movement in a painting as well as spatial relations between figures in a composition, and Ethel Magafan's (1916–93) pictures became considerably more abstract. Ben Shahn (1898–1969) was another painter who refused to eject politics from his work, yet he too began to focus less on specific instances of social or political injustice by the 1950s and more on broader allegorical themes of humanity. Some scholars have also noted a greater interest in more formal, compositional problems of art. His widow, Bernarda Bryson-Shahn, stated that the artist "recognized that abstract expressionism had a great formal power, and he was certainly good friends with people like [Alexander] Calder, [Willem] de Kooning, and [Franz] Kline. What bothered him was that abstract expressionism had no political meaning."

Certainly, most of the social realist artists—such as Philip Evergood, William Gropper, Robert Gwathmey, and Stefan Hirsch—continued in the same vein of painting, refusing to allow changes in fashion to dictate their style or subject matter, but the price of that decision was to become relatively or totally obscure. "I wouldn't sink so low," Jack Levine remarked when asked if he had ever tried an abstract painting. A number of the social realists refused to believe that the interest in abstraction was not a spoof, a scam that would soon pass, allowing their work to be appreciated once again. Devoted dealers continued to display the ongoing work of the social realists for what was becoming a niche audience, but for most art enthusiasts, it was as though an entire

school of artists had mysteriously died. Perhaps, abstract expressionist painter Arshile Gorky captured the feeling best, judging the art of the 1930s "poor art for poor people." Books on twentieth-century American art reinforce that impression by highlighting these painters' work in the 1930s and never after.

Modernist and postmodernist art tends to be urban art, while by and large traditional realists have directed their attentions to countryside America. It is for this reason that critics have tended to see realist art as sentimental and nostalgic. There are not just differing ideas about art at stake but competing visions of America. When the New York School of abstract expressionism began not only to dominate art stylistically but seemingly surpass all previous European work, a major shift in thinking took place: American culture became identified with a long historical line of Western art and the cities that produced it.

One senses a feeling of bitterness in the second edition of *An Artist in America*, which was published in 1951, two years after *Life* magazine had profiled Jackson Pollock ("Is Jackson Pollock the Greatest Artist in America?") in a cover story. Just as Jackson Pollock had a vocal defender, Clement Greenberg, who rose to fame with that artist, Benton had had his own champion, Thomas Craven, who lauded Benton's murals and focus on American subjects. Greenberg's writings remain in print and are still debated as live issues, quite apart from discussions of Pollock, while Craven's *Men of Art* is now a used-book find, his ideas used to illustrate someone's point about what went on in—or wrong with—the 1930s.

In a new final chapter, titled "After," one senses that Benton sought to remind the New York art world, which he had so bitterly castigated fourteen years before, that he still breathed and created new work. Lost is the cockiness of the first edition (" . . . a few people have, at times, expressed a belief that I was not the most desirable kind of fellow to have around. But, all in all, my differences with the home folks, when looked at in perspective, have not amounted to much"), although Benton continues to trumpet how famous and successful he is:

> For nearly ten years I lived in a generally continuous glare of spotlights. Like movie stars, baseball players and loquacious senators, I was soon a figure recognizable in Pullman cars, hotel lobbies and night clubs. I became a regular public character. I signed my name for armies of autograph hunters. I posed with beauty queens and was entertained by overwhelming ladies like Hildegarde and Joan Bennett, I was continuously photographed and written about by the columnists. I received fan letters by the hundreds. Some of these, not so polite, told me where to get off. People wrote me from Europe, from Germany, Italy, and Spain and even from France and from far-off Japan, India and Siam.

Updating one's autobiography, like editing one's résumé, is not uncommon, but the overall tone had changed substantially. Benton was now in his early sixties, perhaps more tired and less up for a fight. He described the move from one house to another, the birth of a daughter, his discomfort with nude beaches, an interest in music, and how he

has less energy than when he was younger ("Working all day and partying all night wasn't my game anymore")—"After" reflects the standard narrowing of the world as one ages and takes stock.

However, there would have been little point to this coda were it just to be these musings on his own life and aging. A final ten pages brings him to the real personal story he wanted to tell, how the art world—his art world—had been hijacked by modernists, idealists, and purists. He began by apologizing for not mentioning in the first edition two artists, John Steuart Curry and Grant Wood, with whom he had been "linked under the now famous name of regionalism. We were different in our temperaments and many of our ideas, but we were alike in that we were all in revolt against the unhappy effects which the Armory show of 1913 had had on American painting. We objected to the new Parisian aesthetics which was more and more turning art away from the living world of active men and women into an academic world of empty pattern." Citing the "now famous name of regionalism" is Benton's first public recognition that he had become someone tied to the past, complete with a coinage. He described the three artists' objections historically, but as one reads on, it is clear that little has changed to alter his thinking in the present.

Benton was certainly a very intelligent man, although not an intellectual, and the rough-rider persona he had long before developed got in the way of an ability to take on his opponents philosophically: name-calling and cussing was his favored approach, which perhaps bought him some cheap laughs among the common folk he was trying so hard to impress (if they cared about his work or art in general) but won no arguments. The chapter ends somberly with a description of how Curry and Wood had become despondent over their falling place in the art world: his attack on contemporary art had become wholly emotional, as though to identify soulless art with heartless treatment of these warhorses. Visiting Curry shortly before his death, Benton sought to cheer up his former colleague.

> "John," I ventured, "You must feel pretty good now, after all your struggles, to know that you have come to a permanent place in American art. It's a long way from a Kansas farm to fame like yours."
>
> "I don't know about that," he replied, "Maybe I'd have done better to stay on the farm. No one seems interested in my pictures. Nobody thinks I can paint. If I am any good, I lived at the wrong time."

One can truly date the advent of modernism in America: February 17th, 1913, when the Armory Show opened at the Sixty-ninth Regiment Armory in New York City, later traveling to Boston and Chicago, where it was seen by between 250,000 and 300,000 people. This massive exhibit presented (for the first time, to most people) the work of Bonnard, Braque, Cézanne, Derain, Duchamp, Dufy, Gauguin, Kandinsky, Kirchner, Léger, Matisse, Picabia, Picasso, Redon, Seurat, van Gogh, Vuillard, and a

variety of other European modernists and their American counterparts—1,600 works in all, mostly paintings.

Prior to the Armory Show, the most brisk market for art in America was for European Old Masters of the Renaissance and Baroque periods. Henry Clay Frick, Samuel Kress, Andrew Mellon, J.P. Morgan, and others used their enormous wealth to purchase paintings, sculpture, and drawings by long-dead artists from impoverished European noblemen. In time, most of these works went to public museums, enriching Americans' understanding of artistic traditions, although this buying gave the impression to artists, other buyers, and the general public that contemporary American art was of little value. The show marks the start of contemporary art collecting in America, led by wealthy collectors who created their own museums to show the work of contemporary European and (later) American artists. In New York, there was Katherine Dreier's Société Anonyme, A.E. Gallatin's Museum of Living Art, Peggy Guggenheim's Museum of Non-Objective Art, Duncan Phillips' Memorial Gallery, and Gertrude Whitney's Whitney Museum of American Art. The Museum of Modern Art in New York, which under Director Alfred Barr became the leader in identifying major modernist art trends, was also established in 1929. In Pennsylvania, Walter Arensberg put together an impressive collection of modern art, which now hangs in the Philadelphia Museum of Art and, in the neighboring town of Merion, Dr. Albert Barnes created the Barnes Foundation. The Armory Show also led, within a few years, to the establishment of new art spaces that exhibited both European and American artists. Being "up" on current trends in art became a sign of breeding, and associating with artists no longer was synonymous with slumming but was felt to be a must for the well-heeled.

The 1930s represented both a seeming setback and an underlying advance for modernism and American art. The Great Depression turned the country more inward, rejecting an artistic experimentation and European models, and many artists followed suit. Both Marsden Hartley and Max Weber, for instance, discontinued their geometrical abstract explorations and returned to representational work. However, the Roosevelt Administration's Federal Art Project (under the Works Progress Administration) employed more than five thousand artists in public service jobs during this time, a number of whom continued to follow the artistic currents of European modernism, expressing themselves in the more progressive styles by the mid-1940s.

Abstract expressionism was a turning point for American culture, providing the United States with its first full-fledged indigenous art movement, and it unleashed a tremendous amount of artistic energy that continues to this day. Whether one likes it or not, the painting and sculpture of the predominant art movements of the postwar era still look fresh and can excite as much controversy now as when these works were first exhibited. The same cannot be said about 1930s social realist painting or the work many of these artists executed after the Second World War, which tend to look dated. Art that is so based on an impassioned moment in time may lose its hold on the viewer after that moment passes.

Clement Greenberg, the leading critic of the postwar era, posited two basic tenets that were adopted by museums and scholars alike. These ideas were, first, that a painting either creates the illusion of three-dimensionality or, in more modernist works, reflects its inherent flatness and, second, that the subject of modern painting was the paint medium itself and the tensions between the colors and forms. The external world was no longer even a point of reference for works of art. Greenberg saw the recent history of art in terms of a general flattening of the painted image and a growing concern with its medium, beginning with Manet and continuing with Cézanne and Picasso, which led to abstract expressionism and color field painting. Taking their lead from Greenberg, most modern art museum curators and directors organized their collections along the Manet-Cézanne-Picasso-Pollock axis. Artists not associated with this line of development, such as German expressionists, Dadaists, surrealists, American regionalists, social realists, and those associated with other forms of representational art, were usually afforded less museums, viewed implicitly as minor creators.

German expressionism, Dadaism, and surrealism eventually made a partial comeback, but most scholars and museum curators seem to have tacitly pronounced social realism and its practitioners dead, viewing the art of the 1930s in the United States without any influence on the art that came after. Politically inspired art, especially in the form of installations and performances, gained currency in the 1980s and '90s, but (with the possible exception of the painter Sue Coe) there has been virtually no effort on the part of the more recent artists to reclaim their elders. And, in fact, the political art of recent years is so different in look and feeling that little carry-over can be identified. So avidly sought-after by museum curators and directors before the end of the Second World War, now most of these social realist paintings now are only to be found in basement storage areas. Many of the next generation of curators and scholars were happy to see the end of an art that required rather little art expertise to appreciate and that looked out of place in galleries and museums.

Perhaps social realism and American regionalism were themselves aberrations, dead-ends that certain artists pursued in the mistaken belief that the masses would rise if prodded by ever-more menacing images of capitalist bosses, or that there was something American in American artists' work, a last gasp of isolationism in an increasingly global world. Of course, impressionism might also have become a dead end if subsequent artists had not continued the themes, styles, and ideas that those artists had developed.

Perhaps, by 1968, when the third edition of *An Artist in America* was published, Benton understood that, too. Another final chapter is included—titled "And Still After"—that begins in the manner of "After" with an effort to bring readers up-to-date on subsequent successes, praise, exhibitions, and this and that. He still is ready to argue the value of his brand of realism ("I still felt that my pictures needed a human content, or something of life that suggested such a content, to be effective in more than a decorative way"), but that is not the point or focus of the new chapter, the last Benton would write. At almost eighty years old, he began to recast himself: his legacy was not just the

artwork he left behind but his influence, particularly on Jackson Pollock, whose art exactly represents the type of modernism Benton had been railing against for decades. "It is well known that Jackson Pollock began his first serious art studies under my guidance," he began. "It is less well known that he was also, for nearly ten years, on very close friendly terms with me."

Subsequent art historians have pointed up the strong influence that Benton's rounded forms and manner of painting had on the early work of Pollock, as well as the effect of the older artist's Americanism on how the future abstract expressionist leader would see his own role. Benton makes little allowance for a talent he could not understand—"Although, as I have said, Jack's talents seemed of a most minimal order, I sensed he was some kind of artist. I had learned anyhow that great talents were not the most essential ingredients for artistic success"—but he hoped to smuggle his own reputation into the juggernaut that was Pollock, the New York School, and modernism in general. Benton described Pollock as a student and a houseguest at Martha's Vineyard, once needing to be bailed out of jail following a disorderly conduct arrest while drunk. The anecdotes do not obscure what Benton clearly hopes to identify as an artistic debt. "A good deal has been said lately about Jack Pollock's indebtedness to me," he noted. "Even after I had castigated his innovations and he had replied by saying I had been of value to him only as someone to react against, he kept in personal touch with me and with Rita." Two famously cantankerous artists were able to make peace with one another, and that bond with youth brings Benton into the present: "With all this deep-reaching personal stuff in memory, I could not but feel a considerable satisfaction in Jack's final success."

Many artists, noted for their work during some short heyday, are better recalled as teachers by subsequent generations. Robert Henri, the leader of the Ashcan School, was a figure of power in New York's art world until the Armory Show turned him into a has-been overnight. We subsequently think of him more as the author of *The Art Spirit* and the teacher of Edward Hopper, Charles Sheeler, Guy Pène du Bois, and a host of other artists than as an artist, primarily because his paintings don't seem as interesting and dynamic as they did briefly. Now, they just look like dark scenes with figures, requiring a professor to explain why this was considered a big deal. In his own way and on his own terms, Benton identified what his future legacy would be and summarized it in his now twice expanded autobiography. For the social realist and regionalist artists and for those who subsequently replaced them and were, in turn, replaced by yet another group with newer ideas, they learned that the art world holds open a window of opportunity for a brief period of time. Art is about universal concerns of life, the world one inhabits and the ability to express oneself, but life, the world and the meaning of self-expression change in increasingly brief spans of time. Since the impressionists, no one style of art has dominated the art world for longer than a decade, and artists have found that they must seize their moments, tenaciously hold onto them or risk being passed by.

11

Contests and Commissions

Over the span of a career, any number of people may pass judgment on an artist's work, from critics and collectors to curators and dealers, as well as grant and fellowship panelists at foundations and government arts and public art agencies—and then there are people who are set up as art judges. These judges evaluate applicants for art fairs and art competitions. The knowledge and experience of these various people who have some say over an artist's career vary, and it is easy to get touchy about what is being said and who is saying it. There is rarely a time in most artists' careers when they are not essentially on trial, needing to make or prove their case for attention and appreciation, so it useful to know something about these courts of opinion.

COMMISSIONS FOR PERCENT-FOR-ART PROJECTS

Governments don't need reasons to support the work of artists, but they frequently enact laws to make that support easier to justify. The statute that the federal government, some states, and some municipalities have created is known as the Percent-for-Art law. This requires the appropriate federal, state, or city agency to spend between .5 percent and 2 percent of the construction or renovation costs of a government building on one or more works of art for that building. Percent-for-Art programs tend to be somewhat recession-proof, in part because capital projects are years in the making and are rarely canceled at the last minute, as well as the fact that putting up or renovating buildings is a customary form of stimulus that governments do to revive a lagging economy. Additionally, because Percent-for-Art programs are enacted by a legislature, removing them would require another act of legislators.

Public art projects may be sponsored by a state or municipal arts commission, the airport or transit authority, planning and development, department of parks and recreation, department of business and economic development, department of community services, or any number of other public agencies. Almost every state has some public art program somewhere.

The federal government and a number of states have Percent-for-Art ordinances. On the federal level, the United States government commissions works of art through both the Veterans Administration (810 Vermont Avenue, N.W., Washington, D.C. 20402; 202-827-1000; *www.va.gov*) and the General Services Administration (18th and F Street, N.W., Washington, D.C. 20405; 202-566-0950; *www.gsa.gov*).

A number of sources exist for artists seeking information on opportunities for commissions online and in hard copy. Art Deadlines List (*www.artdeadlineslist.com*), the Chicago Artists' Coalition (*www.caconline.org*), and the New York Foundation for the Arts (*www.nyfa.org*) have opportunities and resources pages on their Web sites containing information on commissions. There are approximately 350 private and governmental (largely, Percent-for-Art) programs around the United States offering regular public art commissions. This list has been collected by the nonprofit Americans for the Arts' (*www.artsusa.org*) Public Arts Network, and information on requests for proposals is available to subscribers to the organization's listserv (mailing list), which costs $50 per year. The monthly periodicals *Public Art Review* (2324 University Avenue West, St. Paul, MN 55114; 651-641-1128; *www.publicartreview.org*) and *Sculpture Magazine* (1633 Connecticut Avenue, N.W., Washington, D.C. 20009; 202-234-0555; *www.sculpture.org*) also contain requests for proposals from many of these same programs, as well as others that may commission artists rarely or sporadically. Two free online sources of information are Artists Register (*http://artistsregister.com/opportunities.phtml*) and Arts Opportunities (*www.artsopportunities.org*). An additional source is two publications, *The Guild Sourcebook of Residential Art* ($45) and *The Sourcebook of Architectural and Interior Art* ($10), both published by The Guild, 931 East Main Street, Madison, WI 53703; 800-223-4600; *www.artfulhome.com*. These books, which are distributed at no cost to architects, interior decorators, and designers who may be looking for small or large art pieces for their clients, consist of advertisements by artists of the type of art they create. Per-page advertising rates range from $2,000 to $3,000, with potential discounts for artists who place ads early.

THE COMMISSIONING PROCESS

In general, a work of public art is created for a site that is readily accessible to the general public, such as in a park or inside or outside a building and where it may be seen and enjoyed. The commissioning body may have certain eligibility requirements for artists, such as residency in a particular state or being an American citizen, and it is also responsible for providing specific information to both artists and the public, consisting of the reason for commissioning the artwork, the kind of artwork to be commissioned (such as sculpture or mural), the location of the finished work, project budget and the source of matching funds (if applicable), materials suitable for the site, and the theme or subject for the artwork. The commissioning body is also responsible for overall project coordination, advertising and promotion, site preparation, jury selection and organization, fundraising, and documentation and reporting. Many agencies base their commissioning contracts on model public art agreements written up by either Americans for the Arts (*www.*

publicartindianapolis.org/publicartresources.aspx) or the Art Law Committee of the Bar Association of the City of New York (*www.collegeart.org/guidelines/publicwork.html*).

The process of selecting an artist to create a public artwork consists of two to three stages. In the first stage, there is a "call to artists," a general invitation that identifies the type of artwork being sought, its proposed location, and the project budget. This call is placed as classified advertising in art publications and selected Web sites, mailed to artists who are members of certain organizations or who are on state rosters or sent specifically to individual artists who are thought to be likely candidates for this commission. All interested artists are asked to submit résumés, images of current work, information concerning past commissioning experience, and a stamped, self-addressed envelope in which to return the above items. Artists do not submit proposals at this stage and no artist's fees are paid.

In the second stage, the competition jury selects certain artists (usually between three and five) who have provided the necessary background information to develop specific proposals which include scale models, maquettes, or sketches for the project and an outline of materials to be used, providing technical details where necessary. Artists may be asked to do a personal presentation. It is common practice to pay each artist an honorarium (ranging from $100 to $1,000 or more for a sketch or a full-scale model) for the proposal package requested by the committee. The packages become the property of the commissioning organization. Each of the stages may take between one and three months to complete.

The winning artist will receive a contract that stipulates what the work will be, where it shall be sited, and when it must be completed; assigns liability for injury while creating and installing the piece; includes a requirement that the piece will be durable in its setting (artists generally must warrant a permanent public work for two years); and specifies a system of payment. Usually, the artist will be paid half of the commission on the signing of the contract, which is designed to cover the purchase of materials, the expenses of operating a studio, and the hiring of technical assistance where necessary. Often another portion of the commission will be paid at a specified stage, such as a halfway point, which may be another 25 percent or more. The remaining payment will be supplied upon the completion, installation, and acceptance of the finished work by the committee.

GENERAL SERVICES ADMINISTRATION

The General Services Administration has, since 1962, been the largest sponsor of commissioned artwork by contemporary American artists, installing during that time more than three hundred sculptures, murals, stained glass windows, graphic pieces, environmental works, and other permanent works at the sites of newly constructed federal buildings all over the country. On occasion, the GSA buys a finished work, but mostly, the agency prefers to commission new pieces for which the artist may evaluate the site with the building architect, creating something that forms a visually aesthetic whole.

Public art, while an old idea, is a relatively recent term, dating from the 1960s or early '70s. Before that, people spoke of monuments and statues, which tended to

commemorate great leaders (the man on horseback) or the sacrifices of many (the fallen of World War II, for example), created by artists who became known for this type of work. The General Services Administration inaugurated this country's public art program through its Percent-for-Art policy, acquiring artwork that would be a permanent fixture in the building, such as a mural or, more commonly, sculpture. Since the 1970s, cities and states around the country have imitated this system, purchasing and installing artworks at the sites of public buildings on a Percent-for-Art basis. What distinguished these programs as well is the decision to seek out the most renowned artists in contemporary art for commissions—creators better known for their work in art galleries and museums—rather than monument creators, in order to place high-level artworks in the public domain. Built into the General Service Administration's public art program, therefore, were some inherently contradictory forces: on the one hand, the artist's freedom to envision and create a work that reflected his or her sensibility, and on the other hand, the tastes and beliefs of a public that often had not advanced beyond impressionism—that would only be resolved in highly successful artworks.

Between fifteen and twenty-five commissions are made each year, ranging in value from $14,000 to several hundred thousand dollars, annually amounting to a little over $2 million. The GSA is always looking for new artists to commission, and the list of artists who have been hired over the past three decades includes both the well-known and largely unknown. Those who wish to be considered should download the application form on its Web site (*www.gsa.gov*), returning it to the Art-in-Architecture program of the agency along with twenty digital images of their work. The images are placed in the agency's permanent registry and continually reviewed. When deemed appropriate for a particular project, images are submitted to the artist nomination panelists for their consideration. It is advisable for artists to update their images and applications every five years, as the agency is unlikely to track down those who have died or moved.

As one might expect, the sculptural works commissioned are the most expensive. Additionally, most of the pieces commissioned for the lobbies or courtyards of these federal buildings—85 percent, in fact—are abstract art. However, the agency does commission other, more figurative styles and other media.

There is a multi-step process to selecting an artist for a commission. It starts with the project architect, who works with the National Endowment for the Arts, members of the GSA's Art-in-Architecture program, and selected members of the local community to develop a proposal for where the art should go and what type it should be.

The arts endowment then appoints a panel of art experts to meet with the architect in order to review visual material from the GSA's slide registry. The panelists may have some specific artists in mind, or they may simply try to pick certain artists whose work fits a look—for instance, abstract and minimalist sculptures or colorful, figurative murals. The final selection is made by the GSA's administrator who then negotiates a fixed-price contract with the artist. The contract award amount covers all costs associated with the design, execution, and installation of the piece.

STATE AND MUNICIPAL AGENCIES

Some of the Percent-for-Art laws (such as in Florida, Hawaii, Michigan, New Jersey, Ohio, South Carolina, and Texas) are not mandatory but permit the state to spend either .5 to 1 percent of construction costs on purchasing works of art. Some states (California, New York, Tennessee, and West Virginia) have no specific Percent-for-Art legislation but do commission public works through special line-item appropriations. Some state Percent-for-Art laws require special administrative appropriations. Some states permit out-of-state artists to compete for projects. Most of these programs are administered by the state arts agency, while others are run by a department of capital planning or other state agencies, but the arts agency is the best place to look for information on how and where to apply.

The state arts agencies will be able to indicate which cities or counties within the state have their own Percent-for-Art laws as well as private groups sponsoring public art projects. Pennsylvania, for example, does not have a Percent-for-Art statute, yet the cities of Philadelphia and Pittsburgh both commission artists for public works, and thirty-five cities or counties in California have their own Percent-for-Art or other public art programs.

THIN SKINS AND STRONG STOMACHS

At the General Services Administration, efforts have been made over the years to increase the percentage of local artists doing local projects and, with smaller commissions, the chances that lesser-known artists may be considered are improving. In the midst of all this and while the chosen artist is preparing the work, the GSA attempts to involve the local community in seeing the proposed site and the design of the work as well as in meeting the artist to discuss the ideas behind the piece. In one case of a GSA-commissioned piece by Alexander Calder in Grand Rapids, Michigan, the agency conducted an adult education class to acquaint the public with the artist and his works so that what came out would not be a total shock. This isn't the norm, but it was considered helpful, as many people are quite dumbfounded by contemporary art. Some of those people react negatively.

Sculptor Guy Dill was commissioned by the GSA to create a large steel work in Huron, South Dakota, where, according to Dill, "they had never heard of art and all of a sudden were getting a sophisticated piece of art. They didn't want it." A plumber in Huron headed up a campaign to have the work removed. He was able to get several thousand signatures on a petition for this, although many of the names were found to be invalid.

Sam Gilliam, a Washington, D.C., painter, found himself blasted in the local press while he was working on a GSA project in Atlanta for which he was paid $50,000. "I heard people complain about how people were being laid off, how they wanted government help, and here was someone getting $50,000 for a work of art," he said.

THE EFFORTS TO CONTAIN PUBLIC ART CONTROVERSY

In 1989, after several years of controversy, legal wrangling, and numerous public forums, Richard Serra's sculptural installation "Tilted Arc" was removed. The employees in the building had objected strenuously to the large, rusted metal work, claiming that it blocked the sun and took away the space where they ate their lunch and enjoyed occasional outdoor concerts.

No one came out of this looking good: the General Services Administration struck the employees in the building, many political leaders, and much of the public as insensitive to the public interest; Richard Serra's art reputation was blackened, and he was personally characterized as unwilling to listen or compromise; those complaining about the installation were denigrated as philistines, and Serra's apologists looked out-of-touch with the rest of the world as they described the artist's standing in the art world and defended the panel system that had selected the work in the first place.

In the intervening years, a sea-change has taken place in the field of public art, as both public and private commissioning bodies have increasingly altered the way in which they select new works (and the types of pieces they select) and the way in which they are sited and installed. Studying public art controversies has itself become a growing field, represented by a flood of books and commissioned studies, that aims to help agencies head off complaints before they occur and lessen the intensity of them after they arise.

"Controversy is a result of a process of commissioning and installing a work of public art that didn't work well. It's not so much because of the content of the art," said Cynthia Abramson, director of public art programs at the Project for Public Spaces in New York City and a frequent essayist on public art. "The customary approach to public art, which was absolutely the case with Richard Serra, was to put art that's hard to take in an environment that is inhospitable to the enjoyment of art."

She noted that the public art commissioning process tends to fail in three areas: The first is that people working in the building where the art will be situated or who live in the area are not involved in the selection or placement; the second is that the panel making the selection is unaware of how the site is currently used (the people who work or live in the site are not consulted about the work, and no time or money has been directed for a site study); third, the way in which the art is introduced to the people working or living there is too abrupt (the term used in the field is "plop art"), as there is rarely an educational process about the work or the artist. As a result, local people take offense at the installed piece.

Chastened by the Serra controversy, the Art-in-Architecture program of the General Services Administration has taken steps to include more local residents, including those working at the sites, in deciding which works are picked and even in making changes in an artist's proposed design, according to Susan Harrison, program manager for the Art-in-Architecture program. "We're trying to strike a balance between selecting work by the best artists with lessening controversy that their work sometimes excites," she said.

An example of this effort was a proposed Jenny Holzer installation of fourteen granite benches outside a federal courthouse in Allentown, Pennsylvania, in 1995. Holzer had planned to incise a series of aphorisms or "truisms" on these benches, which drew the objections of a resident federal judge, who crossed out a number of the proposed sayings. Among the truisms deleted were "Men don't protect you anymore," "A man can't know what it's like to be a mother," "In some instances it's better to die than to continue," "Murder has a sexual side," "Romantic love was invented to manipulate

women," and "Fathers often use too much force." In place of those deletions were more benign, less provocative remarks substituted by the artist, such as, "A positive attitude makes all the difference in the world," "It's better to be a good person than a famous person," "Solitude is enriching," "Routine is a link with the past," and "Being alone with yourself is increasingly unpopular." The Allentown experience was not a novelty for Holzer, who had similarly made content changes in public pieces commissioned for courthouses in Sacramento, California, and Kansas City, Missouri.

"Judges have a history of being involved in courthouse art, and they don't want to seemingly place an official stamp on something that is questionable," said Steven J. Tepper, a fellow at Princeton University's Center for Arts and Cultural Policy Studies and the author of a 1999 study on how the public responds to public art commissioned by the General Services Administration. "The judges didn't want some Jenny Holzer remark being used by an attorney in a trial as part of a defense."

Community editing of an artist's design for a 1994 public art piece occurred in Kansas City when muralist Richard Haas was asked by a group of Native Americans to change several American Indian figures from a kneeling position to a more dignified stance, and another group recommended that more European settlers be included. Haas acceded to both requests for his painting, titled "Justice and the Prairie," and like the Holzer commissions, it was eventually installed—with controversy.

Artists may find that the absence of a public outcry over their work comes with a large price. "I have to make a decision when these kinds of requests come in," Haas said. "Do I make the change or not? I have to be convinced that this is what I want, that it doesn't take away from the integrity of the piece. How can I satisfy this group or that without compromising the piece?"

In the end, Haas noted, "I had to make compromises. I was forced to do it. When criticism comes from the community, rather than from an individual sponsor or a panel of art judges, it's much more serious if not necessarily more valid. Criticism will land in the press, and the press can take it and warp it, and you've got a battle on your hands that you know you can't win. When there is an overwhelming community reaction to your work, you know you're in trouble. In the post-'Tilted Arc' world, artists have gone to safer shores; more cutting-edge art is out."

Controversy may take a variety of forms, from minor complaints (a few letters to the editor) to a more serious airing (a newspaper editorial or the mayor of the city coming out against the art) to organized and official protests (for instance, a rally or a citizen letter-writing campaign). At the most extreme, government officials demand a work's removal. In 1998, for example, the Carlsbad (California) City Council voted to remove (and thereby, destroy) a "functional" artwork by Andrea Blum that had been commissioned in 1987 by the city's public art commission. The work, which consisted of a reflecting pool, concrete benches, some landscaping, and metal barriers along a bluff overlooking the Pacific Ocean, had generated a significant outcry from residents, shop-owners and political figures. "Carlsbad is an ultraconservative town, and people are particular about their ocean views," an official of the public art commission noted.

In 1992, the artist had agreed to certain changes in her piece, removing some of the metal bars, and the city authorized a five-year cooling-off period after which the city council could review and, in this case, demolish the work.

The search for less controversial artwork and commissioning processes has led to new policies and practices. The majority of public art programs in the United States are based on Percent-for-Art statutes at the federal, state, and municipal levels, in which up to 1 percent of the building or renovation outlays for public facilities are legislatively mandated to be spent on one or more works of art at the site. In the past, the building is constructed or renovated, and an artist is brought in to create a sculpture (mostly), mural, or hanging for some open area within or outside the facility. The more recent focus on the community has meant that the process no longer works in this vacuum, as both the commissioning agency and the artists develop greater contact with the people who live and work there, learning about the history of the community and even (in some cases) including aspects of that history or actual objects from the area into the final piece.

Making public art an important and valued part of the community may mean installing it in a place that matters to the community ("not a throwaway traffic island," Abramson said) and understanding how the piece will effect this as a community gathering space ("not just plopping it down somewhere"). Public art may be used as part of neighborhood revitalization (a city making an investment in the community) or to celebrate local heroes. Agencies are also seeking to conduct more outreach to members of these communities in order to bring them into the process. "The usual excuse that commissioning bodies give is, 'We held a public meeting, but no one showed up,' which may be true, but it isn't good enough anymore," Abramson said. "They may seem apathetic now, but they won't be when the work is installed and they don't like it."

An example of an agency's failure to take into account local needs and interests was a New York Metropolitan Transportation Authority commissioning (through its Arts in Transit program) of an outdoor sculpture for a new commuter rail station in Croton-on-Hudson by the artist Donald Lipski in 1989. "There had been a long history of terrible relations between the town and the MTA," Lipski said. "The station didn't have benches, lighting, or bathroom facilities, and commuters had been complaining about this for years, first with the old station and now with the new station. There was a problem of PCBs dumped into the water by the MTA, which had upset a lot of people. There had been acrimonious labor relations between Metro-North [which operated the trains] and its employees in the town. There was a blind couple that had a newspaper concession in the old station but weren't given a place in the new station, and that made a lot of people angry. It was a hornet's nest of bad relations, which I had known nothing about."

Lipski designed canopies at the station on top of which on which figures of barnyard animals were to be placed, "and people responded very negatively. They thought I'm some city guy who thinks they're all farmers since they live out of the city. Some people thought I saw them as animals being herded onto the train. If there hadn't been so much antagonism between the town and the MTA, people might have seen my work in another way. But all they could see was $250,000 being spent on sculptures of barn-

yard animals placed on the roof and no one seeming to care about them and their needs. I was just in the middle." The final outcome was that Lipski withdrew from the project and no art was ever placed there.

Abramson noted that agencies are increasingly using public education programs and enlisting community leaders in a "user community" task force in order to increase awareness of the public art project before it is completed. Temporary installations of public art are sometimes devised to get the local community and building employees accustomed to seeing artwork in a particular site. Agencies and local art institutions have also worked together to create exhibitions of the public artist's other work, lessening the surprise factor. Other initiatives have included bringing in the artist to talk about the work at local schools and community centers, as well as with various groups; creating design changes for the site, such as adding benches, to make it more comfortable; surveying the community to elicit reactions about the proposed work or the site chosen; and promoting the upcoming work at various community events and activities, such as farmer's markets or jazz concerts.

Troubleshooting, of course, cannot completely eliminate the potential for controversy, and in some communities or with some types of art, disputes may be unavoidable. Tepper's study found that abstract art proved more controversial in smaller cities (with populations under 250,000), where the population is "more homogeneous and traditional." In larger cities, the population is more cosmopolitan and accepting of contemporary art styles; amidst all the other attractions, abstract "art just gets lost in the kudzu." Representational, and especially, figurative artwork is more controversial in large cities, he added, because of "identity politics—everyone will find something to complain about. In smaller cities, there are fewer minorities, and they are not as organized or as empowered."

Other than simply the demographics of a particular area, Tepper found that studying the recent population changes of the public art host city may also be a key in determining how to select appropriate art and what might be picked. "Population change is a larger determiner for controversy than anything else. Where there are rapid political, economic, and demographic shifts taking place—in short, social instability— art becomes a lightning rod for discontent," he said. "There may be no way to completely head off controversy and just try to use the conflict in a productive way to get the community to talk about the changes that are going on."

A last area in which many researchers have seen a need for improvement is how to have a useful dialogue about art, bridging communities rather than emphasizing the divisions. When public art controversies have arisen, Tepper said, the debate rarely focuses on the content of the work itself. Instead, "the art's defenders talk about how important the artist is and how art is good for society." The art's opponents, on the other hand, also frequently avoid discussing the art's content and instead coin some term to describe it, such as "the Jolly Green Giant's Urinal" (a 1980 yellow abstract sculpture by William Goodman in Las Cruces, New Mexico) or "Tinker Toys" (a 1975 abstract wood sculpture by Tom Doyle in Fairbanks, Alaska). "This country still has a long way to go before it can talk civilly about art."

PRIVATE PUBLIC ART COMMISSIONS

In the spring of 2006, Inigo Manglano-Ovalle, a multimedia artist in Chicago, received the good news from the public art committee of the City of Miami Beach that he had been selected to create a sculpture (a white marble "iceberg") for South Pointe Park. The budget for the commission was $500,000. It was what he received next that was the bad news—a twenty-five-page contract for the commission from the city's legal office, full of penalties, potential liability, legal remedies, and assignment of risk for this, that, and the other. "It seemed to me I would be opening myself up to a whole lot of problems if I signed it," he said. "It was a bad contract," said his Chicago lawyer, Scott Hodes, who tried (not all that successfully) to renegotiate the terms of the deal.

While public agencies grab most of the headlines, most commissions are not from public agencies but come from private sources, such as airports, churches, schools, hospitals, corporations, museums, individuals, and private nonprofit organizations, according to Jack Becker, executive director of Forecast Public Art, a consulting and grant-making organization in St. Paul, Minnesota. "More new buildings are put up by private developers than by government," he said, noting that for private developers "commissioning art isn't a regular thing. They don't have people on staff who do this regularly, so when their lawyers try to create a commissioning agreement, they cobble together ideas from other areas of the law that they think make sense." The result often is the artist hiring a lawyer to negotiate the contract, which adds time and expense to the project, which may be unavoidable. "I'm taking the chance that all the money I'm spending on my legal representation will be well spent," Manglano-Ovalle said. On rare occasion, no agreement can be reached. "I've walked away from one project I was selected for," he said, "because the terms were so horrific, and they wouldn't budge. There are other commissions that I never applied for, because I knew what I'd be getting into."

In a different variation on this theme, Scott Hodes stated that some corporations and institutions, which seek to acquire a single piece of public artwork, recognize that they do not know art world practices or what should be in a commissioning agreement and assume that the artists do. These artists will be expected to produce a contract. Certain artists who regularly are chosen to create a public work of art have become familiar enough with the legal fine points to handle all the contractual negotiations on their own. "I've written up my own contracts. I know what they need to contain," said muralist Richard Haas, who added that he has "saved a lot of money over the years by doing this part of the job myself." In all instances, however, artists should be familiar with the basic concepts of an art commissioning agreement.

- What are the dimensions, materials, subject matter, making processes, and finishes of the artwork being created? How will it be mounted, framed, hung, or otherwise installed? Where exactly will it be installed?
- The artist should provide a realistic completion date, which may be very specific or approximate, using such language as "on or about," "by such a date at the latest," or "between such and such dates."

- The artist should write up a budget detailing all expenses, using realistic numbers rather than inflated (in order to bilk the commissioning party) or heavily discounted (to seem like a bargain) figures. It is often the case that artists will discount the value of their own work when making a public art proposal, precisely because "they want their work to be exposed to a wide audience," said Thomas C. Danziger, a New York City lawyer who has negotiated numerous public art agreements. "A 20 percent discount is the norm."
- Being selected for a commission eventually involves payment, but the process of applying also consumes an artist's time and energy, which should be reimbursed. Finalists for public art competitions and individuals asked to submit proposals should be paid for their work, regardless of whether or not they are selected.
- Site preparation is the responsibility of the commissioning body, and installation costs and the hiring of an engineer to approve specifications should also be paid by the sponsor.
- How will the artist be paid? There should be a method of payment, and many agreements employ the one-third rule—one-third on signing the commission, another third when work is two-thirds complete, and the final amount when the work is completed and installed—or some variation). The artist should be paid whether or not work is accepted, and there may need to be an allowance for travel (site research), equipment, and research.
- Even after a proposal is selected, there is an approval process, usually in stages, that may consist of rough sketches, drawings, and maquettes. These stages are usually equal to the number of payments, and they also permit dialogue and discussion about the artwork and any modifications that may be needed. However, changes resulting from discussions may increase costs, and those expenses need to be negotiated. Andrew Epstein, a lawyer in Boston, Massachusetts, noted that agreements should not include any sort of final "to your satisfaction" clause—"that's the worst kind of language to put in, because you may be dealing with someone who is unreasonable, and you don't want payment to be dependent on satisfying someone who won't be satisfied." The stages of a multi-step approval process should catch problems well before that point.
- Disputes may develop during the process, which may be resolved informally or through the mechanism of mediation or arbitration. A contractual clause covering dispute resolution may keep a commission from being cancelled or prevent the parties hiring lawyers and going to court.
- Does the person who is negotiating with the artist have final authority for commissioning the project and approving the designs, as well as accepting and paying for the completed work? Often, people in authority whom the artist has never met turn up at some late stage with veto power. Haas stated that, in a corner of a mural at a California bank, he painted a medieval gargoyle,

which a senior bank director decided was "an image of the devil, and it was because of this person who hadn't taken part in any stage of the process that the bank wouldn't make the final payment." Haas offered to "make the image more neutral if they paid my way out there and put me up in a hotel. They agreed to that. I went out there with my paint box, and it took me all of five minutes."

- Public art, as the name suggests, also includes the ideas and feelings of the public, and individuals or groups may react negatively to an artist's commissioned work. Representational art is particularly prone to attacks by groups who object to how they are depicted, which Haas found after he created a mural at The Tombs, the New York City jail, in 1989. A Down With the Mural Committee was formed within a year by Latinos, who criticized the figure of a drunk lying on the street next to a building with the word "bodega" on it as defaming the Latino community. "The people who had approved every stage of the design and execution of the mural suddenly couldn't be found, and I was left to answer all the criticism myself," he said. Again, he negotiated for more money and set about repainting a section of the mural.

- Situations and ideas change over time. The people who were enthusiastic about a mural or sculpture ten years ago may become less enthusiastic, or new people will replace them who, for instance, want to own the building but not the mural on the side of it. The Federal Visual Artists Rights Act, an amendment to the Copyright Act, prohibits owners of artwork created after 1990 from altering, moving, or destroying the art without receiving the living artist's permission. As a result, in many public art commissions, artists are asked to waive their VARA rights in order that future owners may remove the artwork for whatever reason. Usually, artists accede to that request, but they may ask in return that the artwork be given back to them or put in storage at the owner's expense.

- What does the individual, group, or agency intend to do with the artwork being commissioned? In some cases, there may be plans to publish the image or make replicas of the artwork for promotional or sales purposes, which would violate the artist's copyright unless there is a signed agreement to that effect. "Artists should resist giving up their copyright," Scott Hodes stated, only permitting limited use of the images under separate licensing contracts.

- As a physical object, artwork may cause injury if it falls on top of someone or if edges are too sharp. Sculptural elements may give way under their own weight, and paint might crack and fall off. It is reasonable for artists to warrant the design and fabrication flaws and structural integrity of the materials for a period of one year but, their lawyers counsel, not more than that. The dispute between the City of Miami Beach and Manglano-Ovalle specifically involved who pays for insurance, court costs, legal fees, and settlements in the event of someone becoming hurt on or around his artwork. Manhattan

arts lawyer Donn Zaretsky advises artists not to accept any liability for injuries as part of a public art commission. "The commissioning agency should pay all legal fees and judgments," he said. "I call it the artist-can-sleep-at-night clause."

- As physical objects, artwork may require regular care or conservation treatments. Artists should provide detailed written instructions on the type of care needed and how often. During their lifetimes, they should be given the opportunity to make or supervise repairs and restorations at a reasonable fee.

Not every contract is fair. Artists with major reputations are more likely to resist demands to waive their VARA rights or to accept modifications in their designs, while others who see public art commissions as a career boost are more apt to give way. Andrew Epstein stated that he once represented an artist who had been selected for a project outside a government building in New York City and was given a contract that he termed "onerous, just horrible. They could make changes to the artwork without contacting the artist; all liability was shifted to the artist; the artist had to pay for insurance in perpetuity. It was ridiculous." However, despite his reservations, the artist "made the decision that she wanted the artwork hung in that particular location more than getting a fair deal. The lawyer for the commissioning agent knew the contract was one-sided, but he said it was take-it-or-leave-it, because there was a waiting list of artists wanting to install work in that location. What can you do?"

DAMAGE AND NEGLECT OF PUBLIC ART

Just a few years after completing her granite public artwork for the City of Sarasota, Florida, in 1991, Athena Tacha's "Memory Path" was becoming unrecognizable due to stains and corrosion. The photographic images sandblasted into sections of the stone were quickly losing their clarity, and the formerly smooth surface was becoming increasingly pitted. Why? The reason was that city maintenance workers were using recycled water to hose down the piece and water the surrounding grass. Recycled water is undrinkable because of its high bacteria count and acidity, but its potential effect on the public artwork was not considered by the parks department or by anyone else involved in commissioning the piece. Repairing the work has been a slow and not altogether satisfactory process.

"Memory Path," however, received a better fate than "Marianthe," another public work of art commissioned of Tacha by the University of South Florida at Ft. Myers in 1986, which was torn down and scrapped in February 2000. Constructed of bricks and metal supports in a spiral maze, "Marianthe" was given no maintenance, which resulted in significant rust development that weakened the entire structure and made it a potential hazard to students who might walk on or near it.

"I leave very specific maintenance instructions, and no one follows them," a frustrated Tacha said. She added that "a damaged work is detrimental to my reputation, and removing a work both damages and lessens my reputation: first, because there is nothing left for people to see, and second, because it leaves the impression that my work isn't durable."

The condition of outdoor monuments and other artworks has been a subject of concern since the 1980s. A five-year study by the Washington, D.C.–based nonprofit organization Save Outdoor Sculpture, completed in 1995, identified thirty-two thousand artworks throughout the United States, half of which were in need of significant conservation treatment and 10 percent of which were in urgent need. The main causes of the deterioration were vandalism (for instance, graffiti); pollution (such as acid rain) or the climate in general (intense sun, heat, dryness, or humidity); cars or trucks that crash into works; the fragility of the art materials (a Lucas Samaras sculpture in New Orleans made of unfinished Cor-Ten steel was placed in storage the General Services Administration after a conservation treatment failed to stop rust); and failure to provide regular and appropriate maintenance (including repainting, cleaning off bird droppings or rust, and filling in cracks or repairing damaged areas).

A growing amount of public (frequently outdoor) works of art has been commissioned since the 1970s, spurred by Percent-for-Art regulations that require governmental agencies to spend between .5 and 1 percent of building construction or renovation funds on the acquisition of artwork for those sites. In addition, many airports and transportation authorities, corporations, and universities have also set aside money for the purchase of large-scale artwork (sculpture, mostly, and some murals). With this growth have been increasing complaints that no one is taking care of these pieces, allowing them to deteriorate rapidly.

"They never kept my work in good repair," New York City sculptor Nancy Holt said about her 1984 "Waterwork" installation on the grounds of Gallaudet College in Washington, D.C., which finally removed the piece in 1995. "They just slowly let it fall apart." Another New York sculptor, Judy Pfaff, found that a 1992 public piece anchored to a Miami police station, which had been commissioned by the Dade County Percent-for-Art ordinance, was badly damaged by a roof leak at the station. That work, ironically titled "Aqua Vitae," was taken down and destroyed.

In the early 1990s, a public work representing a sharecropper shack by Athens, Georgia, sculptor Beverly Buchanan, which was owned by the City of Atlanta and sited in a municipal park, was damaged by homeless people. Instead of repairing the piece, the city removed the bolts that kept the sculpture in place and put it in storage, where it has remained. According to Buchanan's lawyer in Atlanta, William Gignilliat, "we've been able to keep the city from destroying it, but that's about it. They have no intention of repairing it or putting it on display ever again."

Art is not thought of as having a life expectancy, but the growing maintenance issues raise the question of just how permanent is permanent public art. "Personally, I'm a proponent of temporary public works of art," said Jack Becker, editor of *Public Art Review*, the leading journal in this field. "The owners of too many of these works just don't accept responsibility for them."

Tom Eccles, former director of the Public Art Fund in New York City, which primarily commissions temporary, or short-term, installations of public works of art,

agreed. "Contractually, twenty years is as far as anyone can go," he said "A private developer may commission a work and be very enthusiastic about it, but buildings change hands over time, and no one wants to be tied to a work in perpetuity." That is certainly the problem faced by Forrest Myers, an artist in Brooklyn, New York, whose 1972 sculptural installation on the exterior wall of a building at the intersection of Houston and Broadway in Manhattan became a source of contention with the property's new owner. In 1997, the owner announced that he wanted to remove the sculpture and replace it with billboard signage, through which he could earn thousands of dollars.

The city's Landmarks Preservation Commission stopped the owner from taking down Myers's piece, but, according to the artist, "he switched tactics, using what I call 'demolition by neglect.' He is not making repairs on the wall or repainting it; he put scaffolding around the wall and my work, claiming that there is a safety hazard. Basically, he wants to make it look so bad that the city will require him to take it down." Myers noted that he has formed a committee to raise money to save the wall.

Changing ownership was also the problem faced by Athena Tacha. In the early 1990s, the University of South Florida sold the land on which "Marianthe" was sited to Edison Community College, which never repaired or provided maintenance to the work, even after Save Outdoor Sculpture notified Edison that repairs were needed. Although her commissioning contract with the University of South Florida required the institution to provide regular maintenance, Tacha, who lives in Washington, D.C., said that she "cannot afford a protracted breach of contract lawsuit in Florida courts against two institutions with unlimited legal resources, nor can I afford the emotional drain of it." For its part, Edison Community College claimed that the extensive rust that made the piece unstable within only fourteen years proved that the work itself was improperly constructed and composed of nondurable materials. As the contractor she used to construct the work had died and the Ohio-based engineer who had assisted in the design of the piece had retired, Tacha decided that all she could do was "walk away" from the piece.

Legal complications and emotional turmoil also convinced Judy Pfaff not to pursue her contractual rights for the work at the police station in Miami. Similarly, New York sculptor Alan Sonfist decided to forgo a lawsuit against the City of St. Louis when it tore down a work that city maintenance workers had not properly maintained. Ultimately, Tacha, Pfaff, and Sonfist were paid in full for their respective works, and the loss was primarily to their reputations. Their work exist now only as photographs (documentation) of the installations.

Artists have been protected from unsought-after changes to, or the wholesale destruction of, their work by the Visual Artists Right Act, which was enacted into U.S. law in 1990. An amendment to the federal copyright law, the act allows artists to disassociate themselves from artworks that have been altered and bring a lawsuit in the event of destruction. The law does not cover damage to work caused by a lack of maintenance

(an exception exists in the law for the "modification of a work of visual art as the result of the passing of time or inherent nature of materials"). Only one legal case filed under the act has been decided in the artist's favor, involving Indianapolis, Indiana, sculptor Jan Randolph Martin, who sued the City of Indianapolis in 1996 for demolishing a public sculpture that he created on land that the city subsequently acquired. He was awarded $20,000 in statutory damages and $131,000 in attorney's fees and court costs. Although the decision created a useful precedent for other artists who seek to defend their rights under the Visual Artists Rights Act, the high cost of legal and court fees as compared to the potential payment for damages reveals why some artists choose not to pursue their legal options, and instead walk away.

"You make something, you put it out in the world and hope that people will respond," said New York City sculptor Mary Miss. "Certainly, you hope at the very least that it will not be so damaged or neglected that it's no longer the same piece you created. Under the law, you can remove your name from it—that's not much consolation."

The key to insuring that one's installed public artwork is properly maintained, lawyers for artists claim, is to write maintenance instructions clearly into the commissioning agreement. Ann Garfinkle, an attorney in Washington, D.C., who has represented Tacha and other artists involved in public art commissions, stated that contracts should ideally include clauses requiring a budget for maintenance and repairs; periodic inspections of the work (with photographs taken of the piece and a condition report written up by the inspector); regular maintenance (such as cleaning, re-grouting, or repainting, as needed); immediate notification of the artist in the event of damage; a requirement that the artist meet with someone to discuss the best response to the damage; mediation if there are disagreements over how best to conserve the work; and monetary damages to the artist if the owner fails to live up to the maintenance agreement.

At times, the ongoing care of a public work will require more specialized attention than a regular grounds and building maintenance worker is able to provide. The people assigned to take care of outdoor public art are the same maintenance workers who keep the elevators running and the floors mopped, and they are rarely given special training in preventing the kinds of damage that may ruin a mural, tapestry, or sculpture. "A lot of maintenance people are challenged in some way, and they won't know what looks right or not," said Alicia Weber, chief of the fine arts program of the General Services Administration of the federal government, the largest commissioning body of public artwork in the country. In the commissioning agreement, Garfinkle noted that the owner might be required to contract out the inspection and maintenance services to a local conservator or to a university, which will be more sensitive to the needs of the artwork.

A growing number of cities and counties with Percent-for-Art statutes—including Broward County, Florida; Buffalo, New York; Dayton, Ohio; Denver, Colorado; Richmond, Virginia; and St. Paul, Minnesota—have adjusted these laws to include

money for maintenance. "We changed from a 1 Percent-for-Art program to a 2 Percent-for-Art program, using the extra money for care and preservation," said Nancy Knutson of the Broward County Cultural Affairs Office, which oversees the public art program. The General Services Administration's annual budget for maintenance and conservation edges close to $1 million. Some private nonprofit organizations (including the Fairmount Park Art Association in Philadelphia, New York City's Municipal Art Society, and Chicago's Friends of Lincoln Park) have also made the preservation of public artwork a priority. In New York and Chicago, the groups have enlisted the support of the public through an Adopt-a-Monument campaign, using the money raised to provide regular care for outdoor pieces.

Artists themselves need to use the most durable materials and understand the types of care that their materials and designs require. "Part of the challenge of creating public art is combining appropriate materials and an artistic vision," Alan Sonfist said. "If you are putting something into the ground, you have to consider the acidity of the soil. If you are working in a place that is very humid or very dry, you have to know how your materials will interact with that environment. And when the piece is created and installed, the maintenance should be clearly spelled out in writing for the owners."

In many cases, the artists don't know how their work will hold up, nor do they understand how to maintain it or repair damage. Early on in the General Services Administration art conservation program, "artists came in to do conservation, and deterioration recurred," Weber said. "After that, we stopped using the artists and relied exclusively on conservators. Artists generally seem happy to defer to the conservators anyway."

It is rare that the individuals or panelists involved in selecting public art include conservators, engineers, or others with a specific knowledge of how an artwork, which they see in design or as a small-scale model, should be cared for and the long-term costs of its upkeep. Two notable exceptions are the Leigh Yawkey Woodson Art Museum in Wausau, Wisconsin, and the Fairmount Park Art Association in Philadelphia, Pennsylvania, where maintenance and conservation concerns are part of the selection process.

"We're too small a museum to have a full-time art conservator," said Jane Weinke, curator of collections at Leigh Yawkey Woodson, "so I've spent a lot of time with conservators at the Upper Midwest Conservation Association"—a regional conservation lab that works for small museums in the geographical area—"to learn how to take care of works and to spot the kinds of works that are going to need a lot of care. Seeing as a conservator sees certainly makes you look at artworks differently." That knowledge of the durability of materials and how they interact with the environment has benefited the museum, which regularly purchases artworks for its sculpture garden. (In fact, three of the museum's twelve outside sculptures are regularly brought in for the winter for repair and to limit their exposure to the elements.) She noted that artists sometimes provide instructions for the maintenance of their work, but their

ideas are frequently not appropriate to the conditions at the museum. "The waxes and patinas that they recommend may work where they live, but they don't work in the upper Midwest," she said. "When we've followed their suggestions, the works haven't weathered well."

At the Fairmount Park Art Association, how the pieces are going to hold up is a key element in the commissioning process, and staff works with artists to "find the most durable materials that still meet the integrity of the artistic idea," according to Laura Griffith, assistant director.

One project on which this maintenance-conscious approach has worked successfully is Jody Pinto's "Finger Span," a 1987 piece of functional art (a bridge) located in Fairmount Park. The idea for the bridge over a waterhole went through numerous permutations before it was finally constructed, starting first as a wooden pier, switching to Cor-Ten steel and finally developing an open-lattice weave of the Cor-Ten for the floor of the bridge in order to permit drainage of water and lessen the likelihood of continuous rusting of the metal. The Fairmount Park Art Association's knowledge was hard-won, since it has seen the damage caused by collecting water to an early commissioned piece by Louise Nevelson, "Atmosphere and Environment XII" (1970). In that work, made of Cor-Ten steel, water filtered through cracks and eventually began pushing out the boxes that comprised the work. The work had to be completely disassembled, and drainage holes drilled in, before it could be put back outside.

The Art Association required an engineer to approve the design and its materials before it went into construction, and Pinto worked with an engineer in Philadelphia, Samuel Y. Harris, who found the most appropriate gauge of steel and the types of joints and bolting needed for the work's structural integrity. The project offered a great learning experience for Pinto, who has subsequently done a number of other functional public artworks. "The needs of maintenance really changes the design," she said. "When you try to develop an idea with maintenance and conservation in mind, it does get you to simplify the design."

WHO DECIDES ARTISTIC MERIT?

Not everyone fits well into the grant awards process. Albert Einstein, who stated, "I am a horse for single harness, not cut out for tandem or team work," devised the theory of relativity while employed in a patent office, and Sinclair Lewis's bittersweet novel *Arrowsmith* was based in part on the experience of scientist Paul de Kruif at the Rockefeller Foundation.

Coming up empty when applying for a grant or commission is an ever-present possibility, but hope should never be lost. Successful grant recipients, like most recent contenders for the United States presidency, tend to try again and again until finally getting approval somewhere. Funding priorities and the people who make the final decisions change from year to year (as do application forms and deadlines for their submission at foundations and governmental arts agencies), and rejection may result only from this year's crop of deciders.

Every year, thousands of artists are selected to be in exhibitions and receive awards and stipends. The quality of their work is judged (largely) sight unseen (based only on slides), and an industry of artwork photographers has come into being in order to help artists present their creations in the best possible light.

But who are the judges determining an artist's career based on one-inch-by-one-inch, transparent slides? With more than ten thousand juried arts and crafts shows taking place annually and fellowships offered by municipal, state, and federal government arts agencies as well as private foundations, there is no one type.

There is also no single number of jurors that is generally recognized as best for making these decisions. Many private, nonprofit organizations make do with just one person—who decides which of the applicants for a juried art show are to be included—while most governmental agencies, which provide fellowships to resident artists in a variety of disciplines, use between three and five.

However, every organization or agency has its own rules and ways of doing things. For instance, the Pollock-Krasner Foundation in New York City, which makes grants to emerging artists, involves ten people in the process (three program staff members, the four people on the Committee of Selection, the foundation's chief operating officer, and the two members of the Board of Directors), and some other organizations—such as those run by artists—will go as high as a fifteen-member artistic committee.

Ethical considerations are paramount, regardless of the actual number of people making decisions. If it is a one-person jury, the better exhibitions will use different people for each show in order that no aesthetic prejudices are established from one year to the next. Multi-person juries or panels are also often rotated on and off to maintain a flow of ideas. The Artists Foundation in Boston, according to outreach coordinator Cyrus Cassells, looks for "distinguished people in their field from out of state so as to take politics right out of judging"—that is, a local juror knowing a local artist.

Many art organizations outside major urban centers that hold juried exhibitions seek jurors from the big cities. Often, the reason is prestige, which was perhaps a factor in the decision of the American Association of Retired People to choose Susan Larsen, former curator of the permanent collection of New York City's Whitney Museum of American Art and now a professor of art at the University of Southern California, to judge a show of members' artwork. Another reason is the assumption that someone from a major urban institution will maintain high standards of quality in assessing works by regional artists.

A third reason may be exemplified by Berkshire Artisans in Pittsfield, Massachusetts, which has a very conscientious policy with regard to the person selected as the annual juror. That organization chooses people who have been judges elsewhere and whom no one in the organization has ever met.

"If they know the artists whose works they are jurying, they may be swayed by personal feelings," Dan O'Connell, artistic director of Berkshire Artisans, said. "I don't

think any of the people who have done jurying for us have ever seen the gallery or have ever been to Pittsfield. I can only guess whether they've ever been to Massachusetts." One of those jurors was an official at the Texas Commission on the Arts. Another was Renato Danese, then-director of New York City's prestigious Pace Gallery and now a private dealer.

A former curator at the Baltimore Museum of Art who worked in both the museum services and visual arts programs at the National Endowment for the Arts in Washington, D.C., in the 1970s, Danese said that he tries "to approach individual works of art without preconceived notions. I look for quality in whatever style or medium I'm looking at. In all candor, what you'll find in a regional juried show is a great range of work, from traditional academic painting to work by artists who have their nose in the avant-garde and are influenced by it."

Although the Danese Gallery is known for its exclusively avant-garde work, much of which is based on abstraction, he noted that he has "no prejudices against realist landscapes, for instance. A lot of the best art ever produced in America are realist landscapes, and I know to judge each work on its own merits."

Susan Larsen also felt that she can evaluate art that is wholly in contrast to that which is displayed at the Whitney, saying, "I'm not prejudiced by the way something looks. I look for evidence of a personal statement. I look for a voice that I haven't heard before and, unless I hear that voice, I'm not terribly interested in the art no matter what it looks like."

She added that much of the work she sees in exhibitions outside of the major urban centers tends to look alike, which she attributes to "various factors: One is the influence of a single teacher; another is a consensus in the community of what they like and will buy; the third is how-to books that everyone reads and everyone obeys down to the letter."

On occasion, however, she will find someone whose work is truly striking. That doesn't necessarily translate into that artist finding him- or herself immediately selected to be in the next Whitney Biennial, "but it might lead to a word-of-mouth recommendation. Someone may ask me if I've seen anyone good in the Northwest, and I'll remember some artist whose work I thought was really good and mention that person's name. That can go a long way."

Judging artists' slides is not a money-making enterprise for anyone, as the payment ranges anywhere from $50 to $1,300 and often involves many hours, days, or weeks of work that all has to be done quickly, considering the mountains of slides and applications to go through. Jurying tends not to be something art experts do for the money; rather, it is for the exposure to different art than they might otherwise see. Especially for those jurors who are art dealers or curators, looking at art is what they do for a living anyway, and they usually like it.

Many artists look to juried shows to bring in new buyers (or new orders), and the failure to be included in a particular prestigious display may damage one's livelihood

and career. Frequently, the charge of bias is raised at jurors by a particular artist who is not chosen, and that is why many groups go to such lengths to establish an impartial jurying system. Rotating jurors—that is, alternating the subjective opinions that put a display together—may mean that certain artists are in one show, but not in another. No one should be rewarded for selection in last year's show with inclusion in this year's, for these shows do not exist simply to help market a specific group's work; rather, these shows are intended for the public, and different work needs to be seen in order for visitors to remain interested from one year to the next. Artists who put too much of their emphasis on certain shows for their livelihood instead of diversifying their marketing strategies will always look to the jurying system with longing and dread.

JURYING ART—DESCENDING FROM THE IDEAL

If artists must give up their paranoia about having their art judged, they must also keep their eyes open to very real problems in juried art shows. Artists must demand a prospectus for any competition they may choose to enter and should study it carefully. They may also need to look beyond what the prospectus says to what it does not say.

With judges, for instance, what are they actually going to do and how will they do it? The practice of "jurying" is not limited to one specific method; it means different things to different people. Although the show sponsors bank the prestige of their events on them, are the judges able to vouch for the ethics and reliability of the sponsors?

On a more basic level, what does it take to be a juror for an art competition—renown in the art world, affiliation with a notable institution, experience as an art judge? Perhaps some or all of those things, and also, sometimes, just picking up the telephone when a show sponsor calls.

"Someone—who was that?—called me up, asking me to jury some show," Carl Belz, former director of the Rose Art Museum of Brandeis University in Waltham, Massachusetts, stated. "I said, 'Sure, why not?' They were going to send me a bunch of slides, and I'd jury them and get paid—I don't know—$100. They didn't tell me all that much about the show."

That show of arts and crafts objects, which was sponsored by the Saddle River Art Society in Nanuet, New York, and took place at a rental gallery in lower Manhattan, had eleven judges (all museum curators or directors) whose knowledge and information about the event ran from practically nothing to hardly anything.

None of the judges appeared to have asked any questions. For instance, Salvatore Cilella, director of the Columbia Museum of Art in South Carolina, said that he didn't "know a thing about the Saddle River Art Society," its director, its history in putting on art competitions, or even where the actual show would take place. "My focus is on the art and not on the association that's doing the show," he said. "I'm here in the deep South, and if some organization in New York or New Jersey asks me to look at work, I consider that a privilege, as it gets me away from all the purely regional work I see here."

Another juror, Jay M. Fisher, curator of prints, drawings, and photography at the Baltimore Museum of Art in Maryland, conceded that he "didn't really scrutinize the offer to jury the show very much. They said they would ship the slides to me, which meant that I didn't have to travel, so it would be pretty easy." Fisher noted that he "remembered having some questions about the show sponsors—who are they, have they ever done this before—but I never got around to asking them."

He stated that he "wouldn't like to jury a show for a commercial group that plans to make money off artists," but never asked whether or not the Saddle River Art Society is a nonprofit organization. Similarly, Daniel Kletke, a curator of medieval art at the Metropolitan Museum of Art in New York, said that he is "opposed to the practice of charging artists entry fees" in order to be included in juried shows, but he never inquired whether or not the show had entry fees.

One curator, Christopher Mount, who works in the architecture department of New York's Museum of Modern Art, didn't ask any questions when he was called about judging the Saddle River show: "I said, 'Sure, I'll do it, but send me some written information on the show.'" He never received any, although his name was included as a juror on the flyer for the show.

There is nothing particularly out of the ordinary about the Saddle River Art Society or its show. The extraordinary part is how standard this process of finding jurors tends to be in many competitions. In a world of thousands of competing juried art events, show sponsors look to enlist notable judges in order to lure artists through the prospectus. In exchange for a (usually small) jurying fee, the judges bolster their credentials as experts and rarely ask a question. The interests of participating artists may be left behind.

As noted above, the prestige of a juried art show is largely dependent on who the jurors are, since artists want their work to be seen and evaluated by recognized authorities, and the search for distinguished judges may become intense. The same individuals are frequently asked time and again to jury various shows. In a worst case, as in "State of the Art '93," a juried art show sponsored by the New England Fine Art Institute and held on Memorial Day, 1993, in Woburn, Massachusetts, jurors are listed who haven't been contacted about nor are in any way associated with the event. In the best of circumstances, the jurors travel to actually examine the objects and even attend the exhibition itself to see the installation and meet with the artists.

In many, perhaps the majority of, competitions, jurors work from slides without viewing the actual pieces and have no further contact with the show or its sponsors.

As much as notable jurors lend a competition prestige, they also provide it credibility—an artist is likely to think, If so-and-so curator will be part of this show, I can trust that it will be a well-run event. Certainly jurors must take more responsibility for the conduct of these shows, determining the qualifications and track record of the sponsors, how the event will be operated and financed, and how artists and artwork will be treated.

WHEN JURORS MAY NOT SEEM FAIR

Is it sour grapes, or are the charges some artists make about being unfairly excluded from certain juried shows founded? Probably, there is a bit of both, although proving that an artist is rejected for who he or she is may be near impossible. An artist complains about a show promoter's failure to publicize the event as promised, and that artist is never accepted into the show again. The promoter's defense: the artist's work is not of high enough quality anymore; we already have too many works in that category; we're looking for something a little different this year. It's enough to make anyone paranoid. That many artists will speak with absolute certainty about being "blackballed" by a show promoter, but few for quotation and virtually none with their real names attached to their comments, attests to a widely held belief.

If blackballing exists, it does so out of the spotlight and is unlikely to adversely affect visual artists industry-wide in the same way that blacklisting alleged communist sympathizers during the 1950s in movies, television, and the performing arts destroyed the careers of many actors, directors, and writers. There are an estimated ten to fifteen thousand shows that take place annually throughout the year around the United States, and show promoters are too numerous and varied to join in a campaign of shutting out specific artists.

Individual promoters are more likely to exclude certain artists, which may still adversely affect that person's career if there are a series of shows involved, such as a string of thirty malls, for instance. The promoter's ability to shut out the blackballed artists is also only possible where there is no independent jurying. Rightly or wrongly, some promoters may exclude an artist who has passed off another artist's work as his or her own, whose work is of poor quality, whose booth display is unprofessional, or whose business practices (late deliveries, overcharging, double billing, wrong works) are themselves unethical.

There is a lot of sifting through paranoia and an overall problem in handling rejection in looking for instances of blackballing. Part of the problem is the diversity of methods for jurying artists for shows. Promoters who themselves select artists are the most susceptible to charges of personalizing rejections. However, even when there are independent jurors, there is no standard approach among all the thousands of shows, which leads many artists to conclude that the whole process is flawed.

The least objected-to method is an independent juror (or panel of jurors) reviewing all slides that came in with applications before a stated deadline. No limitations are placed on the juror's decision-making, nor any instructions other than to select the works that he or she thinks best; and the juror has no knowledge of the names, sex, ethnicity, or race of the artists and can only judge the works on their own merits.

However, "jurying" is a large rubric for a variety of practices used in choosing works for art shows. For instance, there is also rolling jurying, in which slides and applications are judged as they come in rather than as part of a large group. Five realist painters may be sought for a particular show, and after they are selected, the work of an

arguably better realist is rejected for the reason of having sent in an application after the given slots were already filled.

Musicians for symphony orchestras are usually chosen through what are called "blind screenings," in which the musician performs behind a screen that prevents knowing whether or not that person is a woman, Asian, African-American, or anything other than capable of playing music competently. "In the visual arts, unfortunately, blind screenings are not common," said George Koch, national president of National Artists Equity Association. "Every time you are asked to submit slides for a show, you are told to put your name on them. That, at least, raises the possibility that jurors will reject your work because they know you and don't like you, or that they want to get more men in the show so reject you because you are a woman, or that they don't want blacks, Hispanics or Asians."

When there is jurying by medium, artists whose work is multimedia may feel themselves discriminated against. Rotating jurors from one show to the next, another standard practice, may result in an artist being selected one year and rejected the next. The increasingly common practice of preselecting, or tenuring, artists into a juried show because they have a long (or even short) track record may mean that lesser-known applicants have less opportunity to display their work before the public. Of course, there are two sides to this issue: Artists who have been regularly juried into a show complain about the potential capriciousness of jurors who may adversely affect their careers, while others who are just starting out dislike tenuring because it increases the competitiveness for them alone. In a show that has, say, one hundred slots for artists, preselection may leave only twenty or thirty spaces available.

JURORS WITH CLEAR BIASES

In many cases, jurying may not be independent—that is, not done by someone unaffiliated with the sponsoring organization but conducted by those within the organization itself. Mystic Maritime Gallery in Mystic, Connecticut, for instance, holds an annual juried Mystic International Exhibition of maritime art. The works in the show are selected by gallery director Russell Jinishian and a few other gallery employees, and outside jurors are brought in solely to pick which of the previously chosen artworks should receive particular awards. Usually, the work of between 110 and 120 artists is included in the Mystic International Exhibition. Jinishian noted that the gallery has a core group of sixty or so artists, and "the majority of them get into the show. We try to pick good things that have merit."

If tenuring helps artists gain greater financial stability, a show sponsor selecting artists he happens to represent allows him to solidify his market, not leaving commercial considerations to chance with outside jurying. "When a gallery holds a juried show," George Koch, president of National Artists Equity Association, stated, "artists should have no illusions about fairness. The gallery uses the show as a way

not to have to go to the artists' studios, because the artists will just send their works to the gallery."

The deck may seem stacked against certain artists in other ways as well. Independent jurors—that is, judges not associated with the sponsoring individual or organization—may be given explicit instructions by the show organizer on how to evaluate works, and certain otherwise important criteria may be excluded. Artists advisor Sue Viders noted that "salability" is a major emphasis in judging for show sponsors who want works to sell in order to make money. At other times, marketability is pointedly not a factor at all. "A lot of artists enter works into show, assuming that they will be judged on the basis of expression and creativity, and they may try for something new," she said. "The show sponsor, however, may be more concerned with selling a certain type of art. So I as a judge rate the works in the categories the sponsor wants using a one-to-five scale, and whoever gets a certain number of points is in the show. Whoever gets the highest number of points wins whatever award is offered. It may not be, to my mind, the best artwork. People who run these shows should make it clear to artists the criteria on which the works will be judged."

If show organizers do not include criteria for judging works on a prospectus, it is advisable for artists to ask. With probably most juried shows, the jurors make their selections without the artists present, and they aren't on hand when the artists do come. Some shows, however, want—and will pay for—the jurors to come back to see the exhibition. Opportunities for artists to discuss with jurors the basis for judging works in or out should be encouraged, as it is helpful for the artists and adds an element of good will in the relationship of artists and the show organizers.

That someone has been blackballed may be difficult to prove, but it often seems quite evident that certain artists are favored by a show sponsor. "It's not just paranoia on the part of artists," painter and national academician Everett Raymond Kinstler said. "In a number of institutions, the officers and boards don't change for twenty years. The same people get in the shows and get awards; it's all very locked in."

Rolland Golden, a painter, resigned from the American Watercolor Society in 1989 "because it was too political. I saw the same people winning awards, sitting on juries for the society's annual show and serving as officers in the society. It just didn't seem right."

The life and career of any artist is one of more rejection than acceptance, and in some cases, seemingly endless rejection. There are far more reasons that jurors or show sponsors may not want to exhibit an artist's work—wrong size, wrong medium, wrong subject matter, wrong style, too expensive, just don't like it—than that they will. When seething about a rejection, artists must first ask themselves, Am I personalizing this rejection? If there are valid reasons to either question the jurying or conclude that the artwork was rejected for personal reasons, artists basically have three options. The first, as in the example of Rolland Golden, is to resign from an organization whose jurying practices are questionable. The second is to rally a group of artists who will petition the

show sponsor or organization to reexamine its approach to jurying. That may or may not prove effective in changing policies, but it lessens the likelihood that an individual artist will be targeted for reprisals.

The third option is to direct one's attentions elsewhere. With between ten and fifteen thousand juried shows taking place annually throughout the United States, many of which are highly esteemed and attended by affluent collectors, there is no reason to focus too exclusively on any one show.

12

The Search for Grants and Gifts

Art is not only often expensive to buy but costs money to make—in some cases, a lot of money. There are materials to purchase, studio space and machinery to buy or rent, perhaps assistants or a foundry to hire, and the artwork, in order to leave the studio, must be crated, insured, and shipped. The world needs to be alerted to the existence of this art, which may require photographs and mailings. And, of course, let's not forget the basic overhead of the artist, who needs food, clothing, and shelter.

Affording to make art is a central concern to most artists, who generally pursue second (or related) careers until—and even after—their artwork begins to sell.

APPLYING FOR LOANS

Artists, as other small businesses—let's call them sole proprietors or independent contractors—sometimes need money they don't have to complete their work—perhaps to frame a show of paintings, fabricate a sculpture, or produce an edition of prints. Where will that come from? Numerous public and private grant programs exist, but the process of applying, being accepted (or rejected), and then receiving money generally takes months. Opportunities can come and go during that wait. Banks are another option, but they tend to be quite reluctant to make small loans of perhaps just a few hundred or a few thousand dollars, first, because the return on investment is so low and, second, because it costs as much administratively to make a small loan as a large one. Additionally, small-scale borrowers might not have collateral for the loan or their available collateral doesn't fall into a bank's customary notion of assets. Banks also are fearful that self-employed people, especially those working out of their homes and particularly those who call themselves artists, cannot be relied on to repay their loans.

The remaining options are hitting up parents and friends or maxing out credit cards (or both). For some, another possibility looms.

A handful of funds exist around the country that specialize in small loans, often called "microloans," specifically for individual artists and arts organizations. Among

the most recent of them is the Los Angeles Arts Loan Fund, established by the Center for Cultural Innovation in late 2005, which can lend from $1,000 to $25,000 to individual artists and up to $50,000 for organizations for medium-high interest and for relatively short terms. "The need has to be arts-related," said Bruce Rosen, senior program executive for the Arts Loan Fund. "We're not here to make car loans." These loans are also not for emergencies, such as paying an artist's medical bills (other organizations have funds for catastrophic events), but opportunities, such as a performance for which ticket revenues or other earned income will repay the loan or an exhibition through which the sale of artwork will produce the money to cover the loan.

The Arts Loan Fund also offers "bridge" loans for individuals and organizations that have been notified of being accepted for a grant but have not yet received money—the grant notification secures the loan and serves as collateral. "The goal is to keep the average loan plans one or two years," Rosen said. "We want to be able to recycle the money."

A longer-standing program has been operated by the St. Paul, Minnesota-based nonprofit Springboard for the Arts, which has made approximately a dozen loans to craftspeople and visual and performing artists of between $1,000 and $5,000 since 1991, to be repaid within one to three years. According to Chris Osgood, director of artist services for the organization, the loan fund currently has $130,000 available to lend. He noted that Springboard, unlike most banks, is "unafraid to work with people with spotty or no credit history. We have worked with people who have declared bankruptcy; we practice brinksmanship." For collateral, Springboard emphasizes flexibility, accepting "anything of value, as long as it is insured," including such assets as automobiles under ten years of age and guitars—"anything but the artist's artwork. We don't want a liquidation sale." If the loan is for the purchase of a computer, the computer will be the collateral for the loan in the same way that a GMAC loan will be collateralized by the General Motors car a buyer purchases.

This type of flexibility and willingness to lend to riskier borrowers has an occasional downside, as 4 percent of Springboard's borrowers have defaulted on their loans and others have been late or delinquent in making payments. Again, the nonprofit attempts to make things right, working with borrowers to develop a more workable repayment plan and correcting problems in marketing and financial management that may have led to setbacks.

Not every artist or arts organization applying for a loan is accepted; the lending organizations require the individuals or groups to have a three-year record of accomplishment and to demonstrate the ability to stage performances or produce artworks that generate revenue. Just as for any bank loan for a larger company, applicants need to provide financial statements and to produce a business plan. Part of what distinguishes smaller microlenders is their willingness to instruct would-be borrowers in "what they need to know to apply for a loan, such as becoming familiar with the language of financial institutions," said Susanne Ross, a program officer at the San Francisco-based Northern California Grantmakers, a granting agency that established an Arts Loan

Fund in 1981 that provides bridge loans to individual artists up to $5,000, repayable within six months. The focus on learning the language of business is also central to another organization, the Community Partnership for Arts and Culture in Cleveland, Ohio, which does not actually make loans but has established an Enterprise Institute in order to prepare individual artists and the leaders of arts organizations for the process of obtaining loans from banks.

The directors of the arts loan programs also see artist borrowers not as long-term clients but as being in transition, "ready to take their art to the next level," Bruce Rosen said, describing the Los Angeles Art Loan Fund as "an opportunity fund, helping artists to produce more or better art than they might otherwise." Learning the language and practices of the business world, increasing their presence in the art world, as well as developing a positive credit history through borrowing money and repaying it, enables artists to have a better chance at receiving traditional bank loans in the future. "We want clients to graduate to banks."

If banks often view artist-borrowers as inherently risky, the directors of arts loan funds have found many artists to view borrowing money from banks as "'bad.' They don't want to go into debt, preferring to maintain their independence, and they find the process of obtaining a loan intimidating," Rosen noted, adding that artists and the financial industry "have a lot to learn about each other."

The number of organizations lending money specifically to individual artists is relatively few, consisting of the Los Angeles Arts Loan Fund, Springboard for the Arts, Northern California Grantmakers' Arts Loan Fund, Fractured Atlas, and the Artists Community Federal Credit Union in New York City. The Seattle, Washington-based Artist Trust currently runs a business training program for artists (preparatory for them to write grants and apply for commercial loans) and has plans to establish a loan fund for individual artists in late 2006. Yet another arts loan fund for artists, operated by the Penn Avenue Arts Initiative in Pittsburgh, Pennsylvania, lends money for exterior or interior building rehabilitation, as well as the purchase of arts materials and equipment specifically for artists residing in an artists' live-work cluster of buildings along Penn Avenue between Mathilda and Negley Avenues.

Other lending programs in the arts—established by the Alliance of Resident Theatres in New York City (Bridge Fund); Center for Nonprofit Management in Dallas, Texas (Nonprofit Loan Fund); the Denver Foundation (Colorado Nonprofit Loan Fund); the Community Foundation of Greater Atlanta (the Arts Loan Fund); Fine Arts Fund (Paul Sittenfeld Revolving Loan Fund) in Cincinnati, Ohio; Fund for the City of New York (Cash Flow Loan Program); New York Foundation for the Arts (Revolving Loan Program); and the Sacramento Metropolitan Arts Commission (the Bridge Loan Program)—focus solely on small to mid-size arts organizations. Similar to many individual artists, the directors of nonprofit arts organizations also believe that "borrowing is bad. They're afraid of debt and, if they need money, will try to get it from board members, credit cards, or [by] shifting resources away from one program to help pay for another," said Lisa Cremin, director of the Atlanta Arts Loan Fund. "We encourage arts

organizations to develop relationships with banks. We have identified banks that are willing to lend to nonprofit arts organizations, and we will provide an introduction. If something positive develops, good. If not, we're there."

An additional drawback to the loan programs designed with individual artists in mind is that eligibility to participate in these programs is limited to borrowers residing within a tight geographical area. For instance, loans from Northern California Grantmakers are available only to artists in San Francisco and Oakland, while those of the Artists Community Federal Credit Union are only available to credit union members, and membership is restricted to those in the Greater New York metropolitan area, meaning the five boroughs of New York and immediately surrounding suburbs in New York State, New Jersey, and Connecticut. "It's harder to track people down who have delinquent loans if they live further [sic] away," said John Lumberg, manager of the credit union.

Artists have other small loan options than just the organizations whose programs have "arts" in the title. There are hundreds of other nonprofit microlenders around the United States, which also provide business counseling and training to applicants, and many of these organizations themselves borrow money from the federal government's Small Business Administration at discounted rates in order to make loans to small businesses in a variety of fields. These nonprofits make loans to eligible borrowers in amounts up to a maximum of $35,000. The average loan size is about $10,500, and repayment plans range from a few months to six years (the average is three-and-a-half years). The Small Business Administration guarantees between 50 and 75 percent of the principal amount of its guaranteed loans, thus reducing some of the risk in lending to start-ups that might not have enough collateral or a solid credit history.

As opposed to banks, microlenders don't assess penalties for early repayment, since they are not-for-profit organizations and seek the return of their loan money to lend again. "We're in the ownership business, not the loan production business," said Malcolm White, a spokesman for the Durham, North Carolina-based Self-Help, which since 1980 has provided almost $22 million in financing to more than 1,950 small businesses (including artists and craftspeople), nonprofit organizations, and home buyers in North Carolina. Self-Help's loans range in size from $1,500 to $25,000, with interest rates of the prime rate plus four points and a term of five years maximum. The nation's largest microloan provider, Accion USA, which is based in Boston, has made $150 million in loans to 15,000 entrepreneurs around the country since 1991, "and that includes artists," said Erika Eurkus, the organization's New England program director. Two-thirds of its borrowers are women, and a large percentage of them work out of their homes. "They can't get loans from banks," she stated. "They often have no or poor credit history and no collateral to put up as security for a loan." She added that "we don't do different things than a bank would—we look at credit and cash flow and a business plan—but we also listen to ideas that banks might not think are worth their while." Accion's loans start as low as $500, increasing to $25,000, with terms of between two months and five years and fixed interest rates of 12.5 percent.

Many of the country's microlenders are members of the Association for Enterprise Opportunity (1601 North Kent Street, Suite 1101, Arlington, VA 22209; 703-841-7760; *www.assoceo.org*) or may be located through a small business development center (*www.sba.gov/sbdc*). Some microlenders target particular groups, such as women or minorities, for assistance, while the majority is more general in its focus.

The interest rates for microloans tend to be higher than for loans offered by banks, in part because the borrowers are more risky and in part because of the greater amount of time that the lenders spend in helping them achieve creditworthiness. With some exceptions, these rates tend to fall somewhere between bank loan and credit card interest rates. In the arts loan fund realm, the Artists Community Federal Credit Union has a range of fixed rates for loans of between 6.5 and 16 percent (depending upon the size and length of the loan, the available collateral, and the purpose of the loan), while Springboard for the Arts charges the prime rate—the interest rate charged by banks to their most creditworthy customers (usually the most prominent and stable business customers)—plus one point and the Los Angeles Arts Loan Fund charges prime plus two points. The highest interest rate charged by Northern California Grantmakers is 6 percent.

APPLYING FOR EMERGENCY ASSISTANCE

Many things may happen in an artist's life and career, including perhaps a museum retrospective, a MacArthur Foundation "genius" award, sold-out gallery exhibitions, and rave reviews in the art magazines. The artist might also fall off a ladder or fall prey to cancer. Unable to work and facing enormous medical expenses, often without sufficient or any health insurance, the artist's world may quickly implode. "They're distressed and, by the time they apply to us, they're pretty desperate," said Babette Bloch, president of the New York City-based Artists' Fellowship (47 Fifth Avenue, New York, NY 10003; 646-230-9833; *www.artistsfellowship.org*), which provides no-strings-attached money to artists and their families who find themselves in dire financial need as a result of a medical emergency, disability, or natural disaster.

The list of artists applying for help to Artists' Fellowship is long and the number of recipients is shorter, based on the amount of money available to give and the degree to which the awards—currently ranging between $1,000 and $4,000—can actually help. There is the artist in his eighties who suffered a stroke, another in his seventies needing hip replacement surgery, another with breast cancer in her fifties, the young man in his twenties who needed extensive dental work after a vicious mugging, the elderly artist whose declining health doesn't allow him to produce the kind of art that used to pay his bills, the artist with AIDS, the artist with muscular dystrophy, the elderly artist who can't pay his rent, the artist whose health insurance pays for physical rehabilitation but not the cab fare to get to and from rehab, the artist who is healthy but whose child has been diagnosed as bipolar and requires expensive treatment. Artists' Fellowship helps thirty to sixty artists per year through the organization's $4 million endowment raised exclusively by members' dues, gifts, and bequests. "We can't solve most people's problems with the money we give," she said, "but we try to give to those

where our money can do the most good." She added that the money provides "a psycho-logical lift, because artists know there is a community of artists out there wanting and ready to help."

The organization is the oldest of its kind in the United States, formed originally as the Helpful Society in 1859, subsequently renamed the Artists' Mutual Aid Society, and finally, in 1925, incorporated as Artists' Fellowship, Inc. Artists' Fellowship has approxi-mately four hundred dues-paying members, and there is a board that receives and evalu-ates requests for help. A five-member Relief and Assistance Committee of the full board makes the initial review, weeding out ineligible applicants and contacting others for more information, before making its recommendations to the full board, which then votes on awards. Among the board members are a doctor (who helps evaluate the medi-cal records) and a psychologist advisor (who often contacts applicants in order to help the board better understand the artists' situations and makes recommendations regard-ing the need for ongoing assistance). Some of the decisions require little discussion, while others take more, such as the thirty-three-year-old woman artist with lung cancer who had medical coverage but was interested in alternative treatments that her insur-ance did not cover—she received an award.

Fellowship recipients needn't be members of the organization; in fact, many had never heard of the group before but were told about it by a member or someone else. Confidentiality is of paramount importance, because it is difficult for so many applicants to admit that they have fallen on such hard times and need immediate help. "Personal information remains personal," Marc Mellon, a sculptor and Artists' Fellowship former president, said. "We receive applications from some very well-known artists who have fallen on hard times. It makes you shake your head wondering what happened, but the information stays confidential." He added that "we're all a traffic accident or fall-off-a-ladder away from being hit by enormous medical bills."

Artists' Fellowship's application is brief—just two pages—and asks for a limited amount of information: Is the applicant a professional, self-supporting artist? Does the individual have medical insurance? What is the artist's individual or household income? What is the nature of the emergency? Applicants are asked to send in slides of their current work, but decisions are made completely on the basis of need and not on any assessment of the work's quality or the interest it may hold to board members. "Our taste in art is no factor," said portrait artist Everett Raymond Kinstler, a former Artists' Fellowship president. "If they have the credentials as professional artists and can show they are in financial distress as a result of hardship, we try to help."

Various board members note that there are many things that Artists' Fellowship is not—it isn't an insurance carrier, it isn't a pension, it isn't a scholarship fund or granting foundation, it doesn't have an inexhaustible amount of money, and it isn't for people who haven't earned their livelihood as fine artists (e.g., painters, sculptors, and graphic artists). Younger artists have received assistance—the twenty-five-year-old victim of the mugging was mentioned by several members—but the primary recipients are middle-aged or elderly. "Younger applicants who are basically healthy or have a

spouse who is healthy and can work are less likely to get help," Mellon said. The aim of Artists' Fellowship is twofold: to help artists struggling to get back on their feet (those tend to be middle-aged) and to ease the financial burdens of artists during the final period of their lives.

The financial crises of artists may develop quickly—surgery needs to be planned, the rent is due—and Artists' Fellowship is able to respond quickly by having no set application deadlines, holding monthly meetings, and moving even faster with a flurry of telephone calls among board members when a particularly desperate situation arises. What the organization doesn't do, and probably can't do considering the fact that everyone is a volunteer (with their own families, livelihoods, and health to attend to), is follow up on their award recipients: Did the good they intended to do actually help? Sometimes, the same word of mouth that brought the applicant to Artists' Fellowship will convey information about the effect of an award. Certainly, the Relief and Assistance Committee, the doctor and psychologist and all the other board members attempt to scrutinize an applicant's situation in advance to determine that the problem is money and that money can make a difference. Success stories are often anecdotal—a recipient writes to thank the organization and to tell how the money helped, a recipient returns the money years later after having regained a more solid financial footing—but warming nonetheless. "Meetings are often hard on board members," Mellon said. "There's so much bad news out there, but sometimes people leave the meetings all invigorated, because it's clear the small amounts of money we give really can do an enormous amount of good."

Although the oldest of its kind, Artists' Fellowship is not the only organization offering emergency assistance to artists in the United States. A variety of nonprofit groups and foundations provide rapid response aid programs for artists in need, although they all differ from Artists' Fellowship in important ways. The Adolph & Esther Gottlieb Foundation, which was established in 1976, two years after painter Adolph Gottlieb's death, has a grants program directed principally toward older professional artists ("a minimum involvement of ten years in a mature phase of his or her work") who have experienced "an unforeseen, catastrophic incident," such as a fire, flood, or medical emergency. Dental work and chronic conditions, however, are not covered. Typical awards are $4,000, and some may go as high as $10,000. The Pollock-Krasner Foundation, which was set up in 1985, helps artists who are in financial need, including those in emergency situations, but its principal focus is "to get artists going in their careers and help them with their personal needs," according to the foundation's executive vice president Kerrie Buitrago. Receiving approximately two thousand applications annually, Pollock-Krasner provided $3,216,400 in funding to 185 artists in 2006, or an average of $17,385 per grantee. Yet another, the Fulton Ross Fund, which was established in 1999, provides up to $10,000 to artists, but only those living on the west coast of Florida. Below is a list of many of these and other programs. Because artists frequently have talent and experience in more than one realm, a few literary and performing arts groups are also included:

Arthouse
Texas Fine Arts Association
700 Congress Avenue
Austin, TX 78701
(512) 453-5312
www.arthousetexas.org
Emergency grants for artists

Authors League Fund
31 East 32nd Street
New York, NY 10016
(212) 268-1208
*Interest-free, open-ended loans to profes-
sional writers with health-related concerns*

Marshall and Mary Brondum Special
Assistance Foundation
P.O. Box 3106
Missoula, MT 59806-3106
Grants to folk artists

Capelli D'Angeli Foundation
P.O. Box 656
Canton, CT 06019
(860) 693-6208
www.capellidangelifoundation.org
*Fellowships up to $500 for artists who are
survivors of cancer or currently in treat-
ment for cancer.*

Carnegie Fund for Authors
One Old Country Road
Carle Place, NY 11514
(516) 877-2141
*Authors who have published at least one
book commercially are eligible for grants
as a result of injury or illness.*

Change, Inc.
P.O. Box 54
Captiva, FL 33924
(212) 473-3742
*One-time emergency grants up to $1,000
for artists of any discipline who can
demonstrate need.*

Craft Emergency Relief Fund
P.O. Box 838
Montpelier, VT 05601-0838
(802) 229-2306
www.craftemergency.org
*Awards to craft artists who have suffered
medical, financial or business reversals.*

Dancer's Group's Parachute Fund
Dancer's Group Studio Theatre
3221 22nd Street
San Francisco, CA 94110
(415) 824-5044
www.dancersgroup.org
*Financial support to San Francisco Bay
area dancers facing AIDS or other life-
threatening illnesses.*

Emergency Artist Support League
P.O. Box 7895
Dallas, TX 75209
(888) 563-2316
www.dallasartsrevue.com/EASL.shtml
*Financial assistance to North Texas visual
artists and arts professionals in dire tem-
porary distress because of an unforeseen
medical emergency or other catastrophic
event.*

Adolph & Esther Gottlieb Foundation,
Inc.
380 W. Broadway
New York, NY 10012
(212) 226-0581
www.gottliebfoundation.org
*Emergency Assistance Program provides
one-time financial help up to $10,000 for
artists facing specific emergencies, such as
fire, flood or medical care.*

Berkshire Taconic Community
Foundation
271 Main Street
Great Barrington, MA 01230
(800) 969-2823

www.berkshiretaconic.org
Artists Resource Trust provides financial assistance for mid-career artists in New England

Chicago Artist's Coalition
70 East Lake Street
Chicago, IL 60601
(312) 670-2060
www.caconline.org
Ruth Talaber Artists' Emergency Fund

Clayton Memorial Medical Fund
c/o OSFCI
P.O. Box 5703
Portland, OR 97228
www.osfci.org/clayton/index.html
Financial assistance for professional science fiction and fantasy writers in Oregon, Washington, Idaho, and Alaska with medical ailments.

J. Happy-Delpech Foundation
Around the Coyote Arts Organization
Flatiron Arts Building
1935½ West North Avenue
Chicago, IL 60622
(312) 342-1359
Grants to Midwest artists with AIDS or other serious illnesses.

Jazz Foundation of America
322 West 48th Street
New York, NY 10036
(212) 245-3999, ext. 24
Financial assistance for full-time jazz musicians who are underinsured or have no health insurance and require medical treatment.

Katrina Artists Trust Fund
Contemporary Arts Museum of Houston
5216 Montrose Boulevard
Houston, Texas 77006-6598
(713) 284-8251
www.camh.org/kat.html

Financial support for visual artists in Louisiana, Mississippi, and Alabama who were affected by Hurricane Katrina.

Louisiana Division of the Arts
P.O. Box 44247
Baton Rouge, LA 70804-4247
(225) 342-8180
www.crt.state.la.us/arts
Director's Grant-in-Aid Program (for special opportunities and/or emergency situations)

Max's Kansas City Project
P.O. Box 2067
New York, NY 10013
www.maxskansascity.org
Funding and resources for emergency situations, including medical aid, healthcare, legal aid, housing, food, and grants to individuals in the arts.

The Mayer Foundation
20 West 64th Street
New York, N.Y. 10023
www.fdncenter.org/grantmaker/mayer
Grants of $2,500-$5,000 to individuals burdened by poverty

Montana Arts Council
P.O. Box 202201
Helena, MT 59620-2201
(406) 444-6430
www.state.mt.us/art
Opportunity Grant (for special opportunities and/or emergency situations)

Musicians Assistance Program
Local 802, American Federation of Musicians
330 West 42nd Street
New York, NY 10036
(212) 244-1802
Emergency financial aid for Local 802 members.

Musicares
156 West 56th Street
New York, NY 10019
(212) 245-7840
or
3402 Pico Boulevard
Santa Monica, CA 90405
(310) 392-3777
or
1904 Wedgewood Avenue
Nashville, TN 37212
(615) 327-0050
or
1300 West Belmont Avenue
Chicago, IL 60657
(773) 880-2423
or
P.O. Box 82061
Austin, TX 78708
(512) 873-0204
www.grammy.com
Musicares Program provides financial assistance to artists in emergency situations.

PEN American Center
588 Broadway
New York, NY 10012
(212) 334-1660, ext.101
www.pen.org
PEN Writers Fund awards grants or loans up to $2,000 to professional published or produced writers.

Pollock-Krasner Foundation
836 Park Avenue
New York, NY 10021
(212) 517-5400
www.pkf.org
Emergency assistance grants for artists who have suffered a catastrophe.

The Martha Boschen Porter Fund, Inc.
145 White Hallow Road
Sharon, CT 06064

(860) 364-5942
Grants of $1,000-4,000 to needy artists residing in northwest Connecticut or New York City.

The Fulton Ross Fund For Visual Artists
P.O. Box 15022
Sarasota, FL 34277
(941) 928-4539
www.fultonrossfund.org
Grants up to $10,000 to Florida west coast artists in financial need.

Santa Fe Art Institute
Emergency Relief Residency Program
P.O. Box 24044
Sante Fe, NM 87502
(505) 424-5050
www.sfai.org
Supported residencies for artists and writers whose lives and work have been disrupted by domestic, political or natural disasters.

Screen Actors Guild
Catastrophic Health Fund
5757 Wilshire Boulevard
Los Angeles, CA 90036-3600
(323) 549-6773
www.sagfoundation.org
Grants to guild members and their dependents suffering from a catastrophic illness or injury, who are unable to afford the Screen Actors Guild's health plan.

Science Fiction and Fantasy Writers of America
Medical Emergency Fund
P.O. Box 877
Chestertown, MD 21620-0877
www.sfwa.org/org/funds.htm
Interest-free loans to members facing unexpected medical expenses.

Society of Singers
6500 Wilshire Boulevard
Los Angeles, CA 90048
(866) 767-7671
www.singers.org
Financial assistance for singers with personal, medical or family crises.

George Sugarman Foundation
448 Ignacio Boulevard
Novato, CA 94949
www.georgesugarman.com
Grants for painters and sculptors in need of financial assistance.

Sweet Relief Musicians Fund
4150 Riverside Drive
Burbank, CA 91505
(818) 563-5140
(888) 955-7880
www.sweetrelief.org
Financial assistance to professional musicians facing illness, disability or age-related problems.

Visual Aid
116 New Montgomery Street
San Francisco, CA 94105
(415) 777-8242
www.visualaid.org
Grants to artists with cancer, AIDS or other life-threatening illnesses.

Herbert and Irene Wheeler Foundation
P.O. Box 300507
Brooklyn, NY 11230
(718) 951-0581
Emergency grants to artists of color (for housing, medical, fires, floods)

Will Rogers Memorial Fund
10045 Riverside Drive
Toluca Lake, CA 91602
(877) 957-7575 or (818) 755-2300
www.wrinstitute.org
Short-term payment of rehabilitative medical expenses for members of the entertainment industry.

Writers Emergency Assistance Fund
1501 Broadway
New York, NY 10036
(212) 997-0947
http://www.asja.org/weaf.php
Financial relief assistance to professional writers, sixty years of age or older, of nonfiction books and magazine articles.

Additionally, Americans for the Arts (100 Vermont Avenue, N.W., Washington, D.C. 20005; 202-371-2830; or One East 53rd Street, New York, NY 10022; 212-223-2787; *ww3.artsusa.org/get_involved/emergency_relief_fund/default.asp*) provides financial assistance to local arts agencies affected by disasters.

Other emergency medical funds unrelated to the arts may be found around the country, providing limited amounts of money to residents of a particular community. The Volunteer Center in San Francisco, for instance, operates both an AIDS Emergency Fund and a Breast Cancer Emergency Fund for low-income San Franciscans, while the Walpole Emergency Medical Aid Fund in Walpole, Massachusetts, pays for medical supplies, wheelchairs, and prescriptions for local residents in financial need. At the Brackenridge Hospital in Austin, Texas, the Dr. Bud Dryden Emergency Medical Fund provides up to $100 in prescription medicines to emergency room patients unable to pay for their medications. The Boston-based National Network of Abortion Funds provides assistance to women throughout the U.S. needing money to pay for the

procedure, and the Brain Injury Association of Arizona in Phoenix offers financial assistance to individuals with brain injuries and their families who live within the state. A number of colleges and universities have established emergency aid funds for their students, faculty, and staff, and other institutions draw on discretionary funds for the same purpose. Perhaps the most ambitious program is the Commonwealth of Virginia's Uninsured Medical Catastrophe Fund, which helps uninsured state residents needing money to pay for treatment for life-threatening illnesses or injuries; state legislators elsewhere and members of the House of Representatives have proposed bills to create similar funds on the state and federal levels, so far unsuccessfully.

ARTISTS' FOUNDATIONS

Like many other artists advancing in age, Lee Krasner began to think about what would happen to her art and other assets when she died. And like a number of other artists with significant artwork and other assets, she created a nonprofit foundation through her will to shelter her estate from high death taxes. But what sort of foundation should this be? What would be its purpose? Most artists' foundations serve the posthumous interests of the artists, as trustees and administrators arrange exhibitions of their work, prepare a catalogue raisonné, inventory work, and make documents and archival material available to scholars. The Henry Moore Foundation in England, for instance, was set up in 1977 to "advance the education of the public by promoting their appreciation of the fine arts, particularly the work of Henry Moore." In somewhat more inflated language, the foundation created by Salvador Dali in 1983 in Spain aims to "promote, boost, divulge, lend prestige to, protect, and defend in Spain and in any other country the artistic, cultural, and intellectual oeuvre of the painter . . . and the universal recognition of his contribution to the Fine Arts, culture, and contemporary thought."

Certainly, protecting her art and that of her late husband, Jackson Pollock, from being quickly sold off or given away to museums in order to avoid estate taxes, as well as educating the public to their respective artistic accomplishments, was on Krasner's mind. However, it was when her lawyer, Jerry Dickler, reminded her that "but for the grace of God, she might have had to apply to a foundation for a grant, if any foundation like that might have existed," she decided to make the main activity of the Pollock-Krasner Foundation the support of artists.

Since 1985, when the Pollock-Krasner Foundation was established (the year following Lee Krasner's death), awards of between $2,000 and $3,000 have been given to painters, sculptors and artists who create works on paper. In all, $33 million in no-strings-attached grants have been awarded, making this the largest private foundation giving grants to artists in the world.

A number of artists' foundations have a similar interest in helping artists who are "emerging," "under-recognized," or facing a medical or financial emergency. The W. Eugene Smith Foundation, which is administered by the International Center of Photography in New York City, provides a grant of up to $30,000 "to a photographer whose past work and proposed project follows in the tradition of W. Eugene Smith."

In general, it is at the direction of the artist that a granting program be established. For instance, the sculptor George Sugarman wrote in his will that, upon his death (which took place in 1999), the George Sugarman Foundation would come into being, making awards to painters and sculptors based on the proceeds from the sale of his loft in the SoHo section of Manhattan. The foundation made $40,000 in awards in its first year to nine artists, in amounts ranging from $500 to $10,000. Similarly, painter Joan Mitchell (who died in 1992) "wanted very much to provide funds to painters and sculptors who are under-recognized in their careers" and established the Joan Mitchell Foundation through her will, according to Carol Summers, the foundation's sole employee. That foundation makes ten grants of $15,000 apiece, as well as ten others of $5,000, to promising Masters of Fine Arts students in the year of their graduation.

On a rare occasion, the decision to make grants comes from the trustees. Painter Sam Francis's will stipulated the transfer of assets from his estate to a foundation in his name but without a clear sense of what the foundation would do. One idea that arose was the creation of a museum of his artwork in mind, but "it's impossible to sustain a museum. It's just too expensive," said Fred Nicholas, an administrator of the Sam Francis Foundation. As a result, the foundation's trustees have moved to amend the organization's charter to permit a granting program. The Josef and Anni Albers Foundation made a small number of grants (to organizations) during the artist's lifetime, but the granting program was greatly expanded by the trustees after his death, according to its administrator, Jackie Ivy.

Fifty or even thirty years ago, there were not so many artists' foundations. However, "post-1960 artists have done much better than many earlier artists who often didn't have the wherewithal to set up a foundation," said Sanford Hirsch, executive director of the Adolph and Esther Gottlieb Foundation, which made forty-one grants to individual artists in 2001 in amounts ranging from $2,000 to $20,000 ($345,000 overall). Starting with the New York School artists, there has been a burgeoning number of artists who have made a great deal of money from the sale of their work and whose art will continue to be highly prized after their deaths. "The issue arises, therefore, of how to deal with those assets." There are tax benefits from sheltering assets in a foundation, but artists do not need to set up a foundation solely to solve the estate tax problem. Under current United States tax law, the surviving spouse is not taxed, and subsequent heirs may donate objects from an estate to museums and other nonprofit institutions in order to defray a sometimes hefty inheritance tax or sell pieces to pay it. Also under current tax law, many foundations are required to distribute at least 5 percent of their assets annually, which creates the opportunity for a granting program.

Among the artists' foundations that make awards to individual artists are:

The Archipenko Foundation
P. O. Box 247
Bearsville, NY 12409
(845) 679-8191
www.archipenko.org

Change, Inc.
P.O. Box 54
Captiva, FL 33924
(212) 473-3742

Richard A. Florsheim Art Fund
4202 E. Fowler Avenue Usf 30637
Tampa, Florida 33620-9951
(813) 949-6886
www.florsheimartfund.org

Samuel L. Francis Foundation
5440 McConnell Avenue
Los Angeles, CA 90066
(310) 577-0757
www.samfrancisfoundation.org

The Adolph and Esther Gottlieb
Foundation
380 West Broadway
New York, NY 10012-5115
(212) 226-0581
www.gottliebfoundation

Nancy Graves Foundation
450 West 31st Street
New York, NY 10001
(212) 560-0602
www.nancygravesfoundation.org

The Willem DeKooning Foundation
c/o John Silberman Associates
145 East 57 Street
New York, NY 10022
(212) 319-3737
www.dekooning.org

Jacob and Gwendolyn Lawrence
Foundation
P.O. Box 5533
New York, NY 10027
(212) 368-2030
www.lawrencefoundation.org

Pollock-Krasner Foundation
863 Park Avenue

New York, NY 10021
(212) 517-5400
www.pkf.org

Joan Mitchell Foundation
P.O. Box 1902
New York, NY 10025
(212) 865-8491
or
89 Reynolds Street
Bronx, NY 10464-1517
(718) 885-2759
www.fdncenter.org/grantmaker/
joanmitchellfdn

Judith Rothschild Foundation
1110 Park Avenue
New York, NY 10128
(212) 831-4114
www.fdncenter.org/grantmaker/
rothschild

George Segal Foundation
136 Davidson's Mill Road
North Brunswick, NJ 08902
(732) 951-0950
www.segalfoundation.org

W. Eugene Smith Foundation
c/o International Center for
Photography
1133 Avenue of the Americas
New York, NY 10036
(212) 860-1777
www.smithfund.org

George Sugarman Foundation
448 Ignacio Boulevard
Novato, CA 94949
(415) 713-8167
www.georgesugarman.com

APPLYING FOR GRANTS AND FELLOWSHIPS

A frequently hoped-for option is receiving a project grant or fellowship from some private or public entity that pays for all or a substantial part of the costs. There are certainly a variety of options in this area for artists and arts organizations, including applying to

local, state, regional, and federal arts funding agencies, private and governmental public art agencies, foundations, corporations, and even churches.

Fellowships are the most sought-after form of artistic support, as they permit artists to pursue and enhance their careers without requiring artists to produce something in order to be paid. Fellowships are offered by the National Endowment for the Arts, the regional arts agencies, most states, a few local arts councils, and a small number of private foundations. Fellowships are paid to individual artists, while project grants—the more popular type of arts support—go to organizations. Individuals are not eligible for project grants. Occasionally, the term "fellowship grant" is heard, but that usually refers to an artist or scholar pursuing a specific project or area of research, such as during a sabbatical leave from a college or university.

To the uninitiated, the search for arts funding is a matter of asking for money from a certain group of well-known arts patrons: there is the National Endowment for the Arts in Washington, D.C.; fifty state, seven regional, and a multitude of local arts agencies; and a variety of foundations and corporations that provide either (or both) project or fellowship grants. So look up the address, submit an application, and take your chances.

In fact, the funding situation is far more intricate, with varied sources of potential financial assistance for artists—some international, some national, some regional, some local—that require a significant amount of research. Money for individuals (including artists) comes in a variety of forms: there are year-long (sometimes renewable) scholarships and fellowships, most of which are for undergraduate or graduate study, that do not require a completed project in order to receive the entire sum of funding; project grants (payments for short-term projects, such as painting a mural, or services, such as teaching a workshop); and project fellowships (sabbatical money, for instance, for an academician studying a specific subject). In addition, technical assistance (donated services of lawyers, accountants, or marketing specialists, for example) and in-kind support (such as tools, machinery, and office equipment) are non-cash forms of help that corporations and governmental agencies sometimes provide.

The amount of money available from funding sources is wide-ranging. Some fellowships are designed to support an individual (without the need for another job) for the entire year, while others are more like a clap on the back. The Arrowhead Regional Arts Council in Duluth, Minnesota, offers fellowships of $1,200, and the Massachusetts Cultural Council's artists fellowships are for $7,500. The National Endowment for the Arts has $20,000 fellowships for writers, and Pew Fellowships in the Arts in Philadelphia, Pennsylvania, provides $50,000. Few people grow rich on a project grant, as the money covers the work-related costs (including the artist's own labor) of completing the project.

FISCAL MANAGEMENT

Most financial support for the arts comes in the way of project grants, which are predominantly made not to individual artists but to private nonprofit "umbrella" organizations that sponsor the artist and provide financial management for the grant allotment. Most foundations are prohibited by their charters from making grants to individuals, and corporations only receive a tax write-off for their monetary gifts to not-for-profit

organizations. These organizations, acting as middlemen, take responsibility for insuring the project's success and absorb responsibility in the event of failure, relieving the funding source of the need to defend itself as vigorously (a governmental agency and angry constituents or a corporation and its stockholders).

Research is the key element, finding the most appropriate umbrella organization, locating the most likely funders. There is no typical umbrella organization, nor is there any list of such organizations. An umbrella can be any nonprofit group that agrees to sponsor an artist's project for the purpose of attaining funding from a third party source. An umbrella organization need not be specifically arts-oriented; a chamber of commerce, church, civic, or community organization, historical society, hospital, museum, school, self-help group, United Way, YMCA, or any other group may sponsor an artist. Some organizations regularly sponsor artists, while others may only do so once. Many of these fiscal managers charge fees, usually a flat percentage of the grant (no more than ten percent), and the services that they offer to artists range widely. As when they are hunting for a dealer or gallery to represent them, they should look for the umbrella group that most closely fits their ideas and working style and that doesn't charge too much.

In general, these organizations help artists, whose projects they have agreed to sponsor, focus their ideas into a proposal that is clearly stated and fundable. They also help locate the most appropriate funding sources. Artists usually must fill out their own grant applications, but the umbrella organization will submit a letter of support, which lets the funding source know that the project has been pre-screened and found acceptable—in effect, the organization puts its imprimatur on the artist. Then, when the project is funded, the organization will receive the money and administer it, distributing it to the artist (usually on a reimbursement basis) and taking care of all other bookkeeping. The organization submits a final report to the funding source at the completion of the project.

The best places to find out information about potential umbrella organizations for an artist's project are the funding sources themselves. Any of them may direct artists to organizations with which they have worked in the past, as well as indicate which groups are not thought of as reliable. "An organization may be in trouble with a funding agency for not living up to its end of a bargain on a past project," Gary Schiro, director of the individual artist program at the New York State Council on the Arts, said. "The organization may not have submitted a final report or handled its bookkeeping properly, and it will be ruled ineligible for future funding."

Another useful source of information is the Washington, D.C.–based National Association of Artists' Organizations (308 Prince Street, St. Paul, MN 55101; 651-294-0907; *www.naao.net*), which has over 350 members, many of which have acted as fiscal managers for artists at one time or another. Groups that agree to act as an umbrella organization tend to work locally—a Pittsburgh nonprofit organization is unlikely to sponsor a project in Arizona—and artists are well advised to investigate local artist-run groups as potential sponsors.

Beyond this, artists should contact other artists who have used the organization as an umbrella to find out exactly how much and what kind of assistance was offered, whether or not the group's administrator seems trustworthy, and what (if any) fees were charged. Another point to ask: If there were disputes along the way, how were they resolved?

With organizations that regularly sponsor artists in this way, a formal agreement probably already exists. Groups that have not acted as fiscal managers in the past are unlikely to have a standard contract, and artists should establish in writing what the respective roles and responsibilities are. Among the points that would be included in this agreement are how the artist is to be paid (as a lump sum or in installments, throughout the project or after its completion), how the work is to be installed and maintained (and who pays for installation and maintenance), how the artwork will be promoted and insured (and who pays for promotion and insurance), what services the organization will provide the artist (including the use of support staff, office equipment, and studio space, not-for-profit mailing privileges, and assistance in finding suitable funding sources), and what the organization charges for these services. Some groups act as an umbrella organization for free, believing this kind of work to be a service to the field. However, most others charge a percentage of the money raised for the project, ranging from 3 to 10 percent.

The New York State Council on the Arts refuses to provide funding for any umbrella organization that charges an artist more than 10 percent. The New York Foundation for the Arts, which holds a free seminar the third Friday of every month on how to choose a fiscal manager and acts as one itself, takes 8 percent of the money raised by individual artists, although the group also charges a $100 initiation fee "in order to start the paperwork," according to Penelope Dannenberg, director of Artists' Services and Programs. On the other hand, colleges and universities regularly take 50 percent of the research grants that their professors and scientists are given. Of course, they provide the facilities in which the actual work can be done.

Auditing and bookkeeping, monitoring the artist's progress, helping to locate potential funding sources, writing letters of support or a final report to a private or governmental agency, and assisting the artist in shaping his or her artistic idea into something workable takes time, and many organizations may chose to forgo the opportunity to act as an umbrella if the total project cost is too small, for instance, under $2,000.

SO WHO WILL PROVIDE THE FUNDING?

There are basically five categories of funders: private nonprofit foundations; government on the federal, state, and local levels; corporations; individuals during their lives or through wills; and a more miscellaneous grouping of associations, clubs, local organizations, unions, and societies. If they all operated with the same procedures and goals, one could submit the same proposal to any number of them. However, they are all different and none should be sent a proposal or application without first learning a particular

funder's procedures and history of giving. (It is wise, for instance, to submit a proposal to a specific individual rather than to a "Dear Sir" or "To Whom It May Concern.")

Grant seekers need to maintain a wide perspective when approaching the issue of fundraising. The project may be an arts event or the creation of a specific artwork, but the realm of potential funding sources need not be limited to those agencies that support the arts. Most art presents a vision of the world and its inhabitants, and there are funding sources available for almost every global and human concern. Artists should ask themselves: Does the project have an educational component (agencies that provide funding for education might be interested, for example)? Does the project involve the environment, science, history (cultural, economic, political, or social), or specific groups (African-American, Asians, the elderly, the handicapped, Latino, Native American, religious denominations, or youth, for example)? Who will benefit from the project (a target audience or a general population within geographical boundaries)? It might be beneficial for artists to create a chart of the subject areas involved in the project and its potential interest to constituency groups—this chart will prove helpful when it is time to prepare an application.

In general, one may say that all granting agencies and organizations are more likely to provide money for the types of projects and programs they have funded in the past than for something completely new. What should be fresh is the manner in which the artist tackles a familiar problem.

FOUNDATIONS

Most foundations that support the arts (their charters, filed with a state attorney general, indicate the areas of charitable giving) tend to focus exclusively on nonprofit organizations (again, their charters must specifically state individual fellowships if they are to award them). The Elizabeth Greenshields Foundation, which is located in Montreal, Quebec, Canada, but gives half of its fellowships to United States applicants, awards $12,500 (Canadian) specifically looks to "aid talented artists in the development of their careers." The Bush Foundation in St. Paul, Minnesota, provides $50,000 fellowships to individual artists in a variety of media and disciplines, and a sizable proportion of the recipients can be described as "emerging." This money goes to "artists at all stages of their careers," according to assistant director Kevin Bitterman, who added that of the fifteen awards made every year, between two and four are to artists under thirty. Similarly, one-third of the artists who receive Pew Fellowships are "in the early part of their careers," Melissa Franklin, Pew's program director, said. "They're in their late twenties, early thirties; they've been out of school for a few years, which is when a lot of artists stop being artists, so they've shown their commitment. The next crisis point for artists is when they reach forty."

A number of community foundations around the country, which primarily raise money in order to fund social service programs within a region, also have specific fellowship programs for individual artists, such as the California Community Foundation in Los Angeles (The Fellowships for Visual Artists); the Silicon Valley Community

Foundation with locations in Menlo Park, San Mateo, and San Jose (Emerging Artist Fund); the Vermont Community Foundation in Middlebury (New Works); the Princeton Area Community Foundation in New Jersey (Thomas George Artists Fund Grant Award for emerging artists); the Arts Fund of Santa Barbara in California (Individual Artist Awards Program); the San Francisco Foundation (Fund for Artists); the Berkshire Taconic Community Foundation in Great Barrington, Massachusetts (Martha Boschen Porter Fund); and the Waterbury Foundation in Waterbury, Connecticut (Lois McMillen Memorial Scholarship Fund for women who would like to pursue an artistic career).

Foundations are probably the best tracked group of funding sources in the arts (and everywhere else) because of the Foundation Center, which collects information about foundations from the Internal Revenue Service and conducts regular surveys of foundations. According to Rayburn Chan, coordinator of grantmaker services at the Foundation Center's New York branch, 14.2 percent of all foundation grants (or 12.4 percent of all foundation grant dollars, totaling $899 million) in 1999 were directed to the arts, culture, and humanities. Of that pot of money, the visual arts and architecture received 3 percent, with the lion's share going to museums (32 percent) and the performing arts (33 percent).

The Foundation Center publishes a variety of information sources, which may be accessed online on a subscription basis, such as The Foundation Directory ($19.95 per month), Foundation Grants to Individuals ($9.95 per month), and FC Search ($1,195). Among the other sources of information are the *National Guide to Funding in Arts and Culture* ($155) and *Grants for Arts, Culture and Humanities* ($75). The information in these books and online is invaluable, providing an alphabetized (by state and within states) listing of foundations, contact names, current addresses, and telephone numbers, the size of typical grants, the types of projects funded and where (for instance, limited to Newark, New Jersey), the names of officers and trustees of the foundation, and when and how to apply for grants. One may look through them for free at the Foundation Center's two main locations in New York City (79 Fifth Avenue, New York, NY 10003-3076; 212-620-4230) and Washington, D.C. (1001 Connecticut Avenue, N.W., Washington, D.C. 20036; 202-331-1400), as well as its field offices in Atlanta (Suite 150, Hurt Building, 50 Hurt Plaza, Atlanta, GA 30303-2914; 404-880-0094), Cleveland (1356 Hanna Building, 1422 Euclid Avenue, Cleveland, OH; 216-861-1934), and San Francisco (312 Sutter Street, San Francisco, CA 94108; 415-397-0902), and a network of 213 cooperating libraries in all fifty states. A small amount of the same information is available on the Foundation Center's Web site (*www.foundationcenter.org*), which also lists all 213 libraries. The only cost for library visitors is for photocopying or printing from a CD-ROM.

Some foundations also publish annual reports that may be examined for its list of grants given, future commitments of funding, officers and staff, application procedures, and deadlines. One might also ask to get on a foundation's mailing list, where much of the same information can be found. While the Foundation Center collects information from the returns that foundations file with the Internal Revenue Service, one may view the entire returns at the Foundation Center offices or their cooperating libraries. Those

full returns contain basic financial data, names, and addresses of officers (although not necessarily staff) and a complete list of grants (recipients' names and amounts but usually no descriptive information).

Making a detailed search of exactly to whom or what a foundation provided money is an essential element in the process of fundraising because it saves time and clarifies what the organization is truly interested in supporting. The listings in the Foundation Center's books consist of what each foundation writes about itself, and the funding areas are noted in generic terms—"arts," "education," and "health care," for instance. A particular foundation, for example, may indeed provide money for education, but those funds only go to support a particular school or for scholarships for a specific ethnic group. An arts project with an education component is unlikely to receive an award from this foundation, regardless of its merits.

Some foundations provide grant money on a national or international basis, but most direct their philanthropy locally. A search of community foundations, which provide grants to address problems and areas of interest (primarily, health care, social welfare, education and arts, and culture) within a defined geographic area, is the best place to start. The Council on Foundations (1828 L Street, N.W., Washington, D.C. 20036; 202-466-6512; *www.cof.org*) is one good source of information on community foundations. Another source of information on foundations in one's own area is the Regional Association of Grantmakers (*www.rag.org*), which is composed of twenty-nine organizations around the United States. By clicking on the Web site map, one can quickly obtain the membership list of each organization. At the Connecticut Council for Philanthropy, for instance, there are corporate members (Aetna Foundation, The Hartford Foundation, and Lincoln Financial Group's Community Partnership Program, among others), family and independent foundations, community foundations (including Community Foundation of New Haven, Hartford Foundation for Public Giving, Middlesex County Community Foundation, and Waterbury Foundation), and other grantmakers (such as Combined Health Appeal, Junior League of Hartford, and United Way of Connecticut). If a nonprofit dispenses grant money and is not set up as a private foundation, they fall under the classification of a grantmaking public charity. Many of these may not have a track record of giving to the arts, but a proposal that fits into other areas of their past funding may generate interest.

An additional source of information and potential money is The Funding Exchange (666 Broadway, New York, NY 10012; 212-529-5300; *www.fex.org*), a group of fifteen politically active, left-of-center private foundations around the country that occasionally provide funds for art projects related to community organizing or current social issues.

CORPORATIONS

Under current law, businesses are permitted to take charitable deductions of up to 10 percent of their pre-tax net income, although it is quite rare indeed to see corporations granting away that much of their money. Company executives must answer to stockholders, who are sometimes not excited about charitable giving programs in the first

place, and this also explains why corporate grants are usually small and opt for less adventurous projects. 90 percent of all corporate support is spent on the local level, where a company has its headquarters and in the cities in which it has operations, according to the New York City-based Business Committee for the Arts. Because of this, one should contact the local chamber of commerce for the names and reach out to people in businesses that have contributed money to the arts and culture in the past. One may also contact the local Better Business Bureau (their locations may be found through the Council of Better Business Bureaus, 4200 Wilson Boulevard, Arlington, VA 22203; 703-276-0100; *www.bbb.org*).

Companies make charitable grants for a number of different reasons: it helps them to create a positive public image, to influence legislators and opinion-makers, to build community relations, to keep up with the competition, to please special interest groups, to support employee services, to increase productivity, to entice prospective employees, and to associate with quality. However, most corporations tend to be rather secretive about their giving programs, publishing no brochures on how to apply or what they give money to; the annual report rarely mentions giving in anything but vague terms. In many cases, companies prefer to treat their support for the arts not as charitable gifts but as standard business expenses, such as commissioning artists to decorate a lobby or offices, hiring musicians or dancers to perform for employees, using a portion of the public relations budget for a fair or festival, even lending out their employees or equipment to assist with an arts event or project.

Without the myriad of publications available at the Foundation Center available for corporations, grant-seekers must do their own sleuth work. Grant-seekers must ask themselves what the company would gain by supporting their projects (Is the idea potentially profitable to the company? Will it serve the employees? Will the proposal help the company realize its corporate giving goals?) and tailor their proposals accordingly.

Additionally, grant-seekers must know what the company produces and what its future plans are. (Trade associations and articles in the business press are apt to reveal that information.) They must also know the organizational structure of the company. (It is not enough to have ideas—one must know how new projects are proposed, accepted, and implemented within the company.) There are a number of books and online subscription services through which one may obtain significant information about a company and its top management, including Standard & Poor's *Register, Ward's Business Directory of U.S. Private and Public Companies, Dun & Bradstreet Million Dollar Directory*, Thomas Register (all of these titles are updated periodically, with the exception of Standard & Poor's Register, which is updated annually). *Macrae's Blue Book* is available as a CD-ROM ($699) and the *Directory of Corporate Affiliations* is produced by Lexis/Nexis and available by subscription ($2,195). Many businesses also have annual reports and a Web site. Some corporations and most graduate business schools at universities have their own libraries where specific information about its history of giving may be found (one may need to make an appointment). R.R. Bowker's *American Library Directory* ($309) and Gale Research's *Directory of Special Libraries and*

Information Centers ($825) may additionally lead grant-seekers to libraries bearing pertinent information about businesses with giving programs.

One may also have to simply inquire by telephone, asking whether or not the company supports programs in the community. Does the company provide financial support for arts and culture (and what has been sponsored in the past)? What are the guidelines for support and how should a proposal or application be submitted (and to whom)? There is no standard method for how businesses donate money or even if they will make charitable gifts from one year to the next (that is usually dependent upon profits). The individual in charge of giving may be the president or chief executive officer or the public relations or marketing person. A telephone inquiry about whether the company ever supports arts projects might result in the call being transferred to the very person making decisions about giving, who will start asking about the specifics of the caller's proposal—so be prepared.

CORPORATE FOUNDATIONS

There are perhaps two thousand corporate foundations in the United States, which are designed to separate charitable giving from the regular activities of a company but often are still quite tied to that business. Take, for instance, the Herman Goldman Foundation, which was created in the 1940s by the New York City law firm Brauner, Baron, Rosenzweig & Klein and has a $32 million endowment. The foundation gives approximately 150 grants per year, totaling $1.7 million (the average grant is $6,000-$7,000). Of those 150 grants, only about twenty are to organizations to which no one on the foundation's board has a personal interest, according to Rich Baron, director of the foundation. All of the board members are involved with the law firm in some way (each board member is paid $1,000 per month to attend the monthly meetings), and "the vast majority of grants are made where board members have some personal involvement," he said. That involvement includes a friend's or business associate's strong connection to a nonprofit organization (for example, a college that a board member's child is attending), a board member who is also a board member of another nonprofit organization, clients who are involved with an organization (for instance, a hospital where a family member was treated) or organizations in the town where a board member lives (spreading money around adds to one's personal prestige in a community). One of the board members of the Herman Goldman Foundation directed a number of grants to various synagogues, all of which then gave the law firm their business. In general, there is a strong relationship between the grantees and the firm, and most of the board members' individual grant recommendations need not be voted on individually.

The twenty grants not pertaining to board members' personal and professional interests are generally made from Rich Baron's small discretionary funds. "I've been told by board members here not to network," Baron said. "They don't want a high profile—they don't want any profile. They don't want the phone to ring off the hook." Those looking for a grant from a corporate foundation should probably make it their business to meet and become friendly with a higher-up at the company.

GOVERNMENT

Government arts agencies are public entities (and not involved in national secrets), so their support for arts and culture on the local, state, and federal levels should be the relatively easy to identify. However, not all funding to the arts in a given state is conducted through the single state arts agency. For instance, Kansas has an accessible arts program for the blind through its Department of Education, while Massachusetts has an arts therapy initiative through its Department of Social Services and Hawaii has a dance program for prison inmates through its Department of Correction. Departments of Parks and Recreation or of Travel and Tourism may also be sources of support for arts organizations and activities. Then there may be arts-related line items in the state budget, such as funding to a museum or other cultural institution, with appropriated money outside of the state arts agency budget. Ferreting through what a particular government funds, or through what means, can be difficult and frustrating. or capital improvements for a performing arts center or a literacy program in the state libraries.

Finding the individual state arts agencies is the easy part (locate them through the Web site of the National Endowment for the Arts—*www.arts.gov*—clicking on NEA partnerships, then on state and regional arts agencies). More complete information on state government programs and agencies may be found from the National Conference of State Legislators (*www.nacl.org*) and on the Web site of the Documents Center for State Government and Politics in the library of the University of Michigan (*www.lib.umich. edu/govdocs/state.html*). One might found out how and where the federal government spends its money through the online Catalog of Federal Domestic Assistance (*www.gsa. gov/fdac/queryfdac.htm*). The *Federal Register* (*www.gpoaccess.gov/fr*) is the federal government's newspaper, and it lists new programs, funding guidelines and deadlines and public meetings. A final source of information on federal government programs that have some arts connection is the Web site of the National Endowment for the Arts (*www.arts. gov/partner/federal/index.html*). There, one sees that the federal government provides money for cultural activities through the Departments of Commerce, Defense, Education, Health and Human Services, Homeland Security, Interior, Justice, State, and Treasury, as well as other federal agencies. The awards process differs from one agency to the next.

LOCAL ARTS AGENCIES

There are an estimated 3,800 local arts agencies around the United States, two-thirds of which have discretionary funds with which to make grants. According to Randy Cohen, director of research for the National Assembly of Local Arts Agencies, "'benefit to the community' tends to be the top priority. Local arts agencies are about all of the arts for all of the people, and artistic excellence is not necessarily the single most important concern." Benefit to the community often results in an emphasis on social issues—using art or art-making to bring diverse groups together—or it may mean using agency money for an arts festival or to enhance art-in-the-schools programs. It is otherwise difficult to predict funding priorities and patterns: some local arts agencies give most of their money to a few local major arts institutions, with little remaining for other

organizations (that may work to the detriment of emerging artists), while others have no qualms about making grants to organizations that do not have 501(c)(3) nonprofit incorporation. As public agencies go, local arts councils have the least money to give, with average grants of $1,200 for communities with populations under thirty thousand, and $23,000 for cities of more than one million people. Most local arts agencies are completely run by volunteers, who make all decisions about funding. For information on local arts councils near you, contact Americans for the Arts (927 15th Street, N.W., Washington, D.C. 20005; 202-371-2830; *www.artsusa.org*).

Most local arts agencies in the United States have very little money, and that tends to be used for area institutions or specific projects, but some of them have fellowship programs. For instance, the Houston Arts Alliance in Texas has fellowships for emerging artists (defined as "artists who have actively pursued their profession for less than three years," awarding $3,000) and established artists ("pursued their profession for more than three years," $5,000), while the Marin Arts Council in San Rafael, California, offers $10,000 fellowships and the Arts Council of Silicon Valley in San Jose, California, provides $4,000 to six artists annually. Most of the recipients in Marin County and Silicon Valley are in their late twenties and early thirties. Other local arts agencies have grant programs for individual artists that are not fellowships, such as commissions for the creation of artwork benefiting the community by the San Francisco Arts Commission ($10,000) and the Lower Adirondack Regional Arts Council in Glen Falls, New York ($2,500), as well as the $100 to $500 opportunity grants from the Five Wings Arts Council in Staples, Minnesota. The Durham Arts Council's Emerging Artists Grant Program in North Carolina provides financial assistance for artistic projects that the applicant artists view as "pivotal" to their careers.

STATE ARTS AGENCIES

Every state in the union and all six American territories have governmental arts agencies. Like the local arts councils, an important criterion for funding is making the arts accessible to people, insuring that public tax dollars are spent in the interests of the public. However, artistic excellence is a higher priority than at the local level, and applicants are usually judged by peer-review panels. These panels change from one year to the next, maintaining diversity in the process of artistic selection. The conventional wisdom about state arts funding is that agencies give smaller grants to more organizations. Almost every state arts agency provides fellowships, usually on an alternating yearly basis (crafts and visual arts one year, performing arts the next year, literary the following year, etc.) in amounts ranging between $1,000 and $10,000. Eligibility requirements are broad (applicants must be eighteen years of age or older, not full-time students, and professionals rather than amateurs) and these awards are not specifically for young or emerging artists, although Kelly Barsdate, chief program and planning officer for the National Assembly of State Arts Agencies, noted that their main goals are "first, to encourage the creation of new work, and second, career advancement." Career advancement is more likely at an earlier stage of an artist's career and, as one state arts

agency program director said, "it's easier to fund promise," that is, youth. Competition may be intense for these fellowships ("Artists without a preexisting portfolio will be at a disadvantage," she said), but the majority go to artists in their twenties and thirties who are still in the process of building a career.

According to Barsdate, approximately 32 percent of all individuals applying for fellowships and 55 percent of all organizations seeking grants from state arts agencies receive some award, the average amount being $6,700. That average varies widely from state to state. In Virginia, the average was $2,000, whereas in Minnesota the amount was $15,000. New Jersey's average was $42,000, and Hawaii's an even more generous $62,000, which reflects the fact that most of these states' arts money is assigned to general operating support for major institutions, leaving relatively little for project support and other artist initiatives.

For more information about state arts agencies, contact the National Assembly of State Arts Agencies (1010 Vermont Avenue, N.W., Washington, D.C. 20005; 202-347-6352; *www.nasaa-arts.org*).

REGIONAL ARTS AGENCIES

There are seven agencies around the United States, set up and supported by both the National Endowment for the Arts and the state arts agencies (with additional fundraising from corporations and individuals) in order to provide assistance to individual artists and arts organizations on a regional level. They are:

Arts Midwest
Hennepin Center for the Arts
528 Hennepin Avenue
Suite 310
Minneapolis, MN 55403
(612) 341-0755
Serving Illinois, Indiana, Iowa, Michigan, Minnesota, North Dakota, Ohio, South Dakota, and Wisconsin

Consortium for Pacific Arts and Culture
2141C Atherton Road
Honolulu, HI 96822
(808) 946-7381
Serving American Samoa, Guam, and Northern Marianas

Mid-America Arts Alliance
20 West 9th Street
Suite 550
Kansas City, MO 64105

(816) 421-1388
Serving Arkansas, Kansas, Missouri, Nebraska, Oklahoma, and Texas

Mid-Atlantic Arts Foundation
11 East Chase Street
Suite 1-A
Baltimore, MD 21202
(410) 539-6656
Serving Delaware, the District of Columbia, Maryland, New Jersey, New York, Pennsylvania, Virginia, and West Virginia

New England Foundation for the Arts
330 Congress Street
Boston, MA 02210-1216
(617) 951-0010
Serving Connecticut, Maine, Massachusetts, New Hampshire, Rhode Island, and Vermont

SOUTHERN ARTS FOUNDATION
1401 Peachtree Street, N.E.
Suite 122
Atlanta, GA 30309
(404) 874-7244
Serving Alabama, Florida, Georgia,
Kentucky, Louisiana, Mississippi,
North Carolina, South Carolina, and
Tennessee

WESTERN STATES ARTS FOUNDATION
207 Shelby Street
Suite 200
Santa Fe, NM 87501
(505) 988-1166
Serving Alaska, Arizona, California,
Colorado, Hawaii, Idaho, Montana,
Nevada, New Mexico, Oregon, Utah,
Washington, and Wyoming

The stated intent of the seven arts agencies is to promote the arts of their respective regions. "We allow more artists and arts organizations in the Midwest to get grants than they would if they only had the National Endowment for the Arts to apply to," said Susan Chandler, development director at Arts Midwest. "It always seems in the NEA's panel system that the East Coast and the West Coast get a lot higher percentage of grants. The Midwest just doesn't get enough attention financially or stylistically from the NEA." As at the state level, funding decisions are made by peer review panels whose members change annually. The other main emphasis of the regional arts agencies is promoting interstate cultural activities, such as providing financial support for a theater company's regional tour, arranging collaborative efforts between arts organizations within the region, or holding a conference. Each regional arts agency works differently, but they all tend to make awards to between 60 and 80 percent of their organizational applicants and to 5 percent of their individual fellowship applicants.

NATIONAL ENDOWMENT FOR THE ARTS

As one moves from local and state to regional and federal arts agencies, there is more and more prestige attached to grant recipients, but there is also stiffer competition for awards and more paperwork involved in the application process. The prestige results from the increasing emphasis on artistic excellence as the central factor in receiving a grant, especially at the federal level. The degree of competitiveness is heightened by the fact that applicants throughout the United States, rather than simply from one's own region, state, or town, vie for funds. Between 2 and 3 percent of the applicants in the literature fellowship category receive awards, which range from $5,000 to $20,000.

According to A.B. Spellman, associate deputy chairman for program coordination at the arts endowment, competition is also greater at the federal level because "it's less likely that [peer-review] panelists will be familiar with the applicants. It's also easier to recognize regional styles on the more local level." Grants and fellowships are decided in all institutional, literary, performing, and visual arts categories by peer-review panels, which consist of seven people. The National Endowment for the Arts, a federal agency,

provides fellowships to literary artists and jazz musicians, but not to fine artists with the exception of those working in folk and traditional art forms. For fellowships, a panel is made up of five practicing writers, one critic or academician, and one "lay person," such as a publishing executive. Different panel members are appointed every year, so there is no possibility of characterizing what the arts endowment supports or doesn't support. Artists may have to apply again and again until the right mix of panelists chooses to provide financial assistance to their particular style or type of work. The NEA attempts to find panelists with stylistic, ethnic, and geographic diversity as well as a gender balance. The agency also tries to bring in people who reflect the applicant pool—that is, living in the same states or regions as the bulk of the applicants. Panelists in any of the media are not given a number of how many artists they may select for a fellowship.

Arts endowment guidelines also require projects and applicants to have "national significance," vague language that means the art has broad implications for its medium, advancing the discipline and speaking beyond the merely local. For that reason, Spellman said, the arts endowment is often seen as more amenable to avant-garde art styles, whereas there is more interest in traditional realists at the state level. For more information, contact the National Endowment for the Arts (1100 Pennsylvania Avenue, N.W., Washington, D.C. 20506; 202-682-5400; www.arts.gov).

One is permitted to apply to the National Endowment for the Arts and to the regional arts agencies at the same time. In fact, one Maryland sculptor received fellowships in 1993 from both the arts endowment and the Mid-Atlantic Arts Foundation, although such coincidences are rare (the regional agencies tend to look to support artists who are unlikely to receive fellowships on the national level). After one receives an NEA fellowship, however, an artist is prohibited from applying to a regional agency for ten years.

INDIVIDUALS

"People spend a lot of time courting foundations and corporations for charitable gifts, but it is really individuals who do the bulk of all giving," said Ann Kaplan, director of research at the New York City-based American Association of Fund-Raising Counsel. Annually, individuals provide approximately 85 percent of all charitable gifts—well ahead of foundations (9.3 percent) and corporations (5.7 percent)—and the bulk of that giving (between 60 and 70 percent) comes from people whose household income is under $200,000. Almost half of all charitable contributions by individuals goes to religious institutions, and most gifts are made locally.

As with corporations and foundations, one needs to understand why a particular individual is making a gift (individuals, by the way, make "gifts," while corporations and foundations provide "funds"). The potential reasons are varied: to add to a personal sense of self-esteem or to one's reputation within the community as a supporter of the arts, to appear to other people as a generous person, to share vicariously in an artist's success (the person may be a frustrated artist), to receive a much sought-after publicity, to create a sense of indebtedness in the recipient, in return for some form of allegiance or gratitude from the recipient. (There may be times when a "gift" has strings attached that

are unacceptable to a recipient and must be rejected by the would-be recipient.) Once the donor's motives are determined, a solicitation can be properly targeted.

"Giving is a form of exchange," said Andrea Kihlstedt, a fundraising consultant in Lancaster, Pennsylvania. "You need to become familiar with what the donor needs to get back." The process of obtaining personal information about potential contributors is not "brain surgery," she noted, adding that "people are happy to talk about themselves, their lives, their families, and their interests, even with relative strangers. You want to know how they live, how much money they earn above what they need to live, how much traveling they do, and where they go. You want to know if they collect things, and what they collect. What you need to do is find among this personal information what leads them to support the arts, where your interests and their interests dove-tail."

Although they are the largest group of charitable gift-givers, individual donors remain the least documented, in part because there are so many of them. There are no books published on who donates how much money and for what causes; the Internal Revenue Service receives much of this information because of declared deductions for charitable gifts, but the federal agency does not make individual taxpayer's returns publicly available. (Also, even if the IRS did release information, the full extent of individual giving would not be told, since many non-itemizers do not declare their charitable gifts.) Tax deductions generally are not a primary reason that individuals make a charitable gift to a nonprofit organization. For example, there has been no decrease in giving by individuals since the top marginal tax rates were reduced from 88 percent to 35 percent in the early 1980s. According to Kaplan, changes in the federal tax code changes the timing of gifts but not giving itself, and even the timing isn't changed all that significantly for most people. "A deduction is useful for individuals who are giving to organizations," said Halsey North, a New York City fundraising consultant, "but it is far less important when there is a personal relationship. A deduction is a way to give patrons a tax benefit for something they probably would have done anyway."

There are methods to identify likely contributors, starting from one's own circle of family, friends, colleagues, acquaintances, and past collectors and expanding from there. The connection to the donor may be someone who graduated from the same school in the same year or who has children in the same schools or on the same soccer league or is a board member of another organization with this person. "You want to determine with whom you or the organization sponsoring your project have a linkage," Kihlstedt said. "From there, you look to see who has the interest in giving and who has the ability to give." She recommended circulating a list of names of wealthy individuals and known donors to members of the board of directors of the umbrella organization in order to determine who knows these people (or know people who know them). This may provide information about the potential donors and a means of meeting them.

Some information, especially for individuals with whom an artist or an artist's network does not have a personal relationship, is available in business, university, or public libraries. Biographies and even newspaper or magazine articles about well- or lesser-known figures would reveal considerable information about their tastes, interests,

and spending habits. Club rosters, social registers, or a Who's Who directory would note the professional accomplishments, club or association memberships, and philanthropic interests of potential donors. The newsletters or annual report to members of nonprofit organizations and institutions (such as artists' clubs, historical societies, hospitals, libraries, museums, nature conservancies, public radio or television stations, and schools) often list their individual and institutional donors. Playbills and programs for performing arts groups are also quite valuable as a resource in that they not only indicate who has made a donation but at what amount (listing categories of contributions such as donor, sponsor, benefactor, producer, patron, angel, or other terms). Business publications, such as Dun & Bradstreet's Million Dollar Directory, Standard & Poor's, The Corporation Records, and Moody's Manuals, will offer information on the individuals who are members of the board of directors or senior officers of publicly traded companies, for these are likely to be wealthy individuals. Besides being a publisher, Dun & Bradstreet is also a credit-rating service for businesses and sells financial analysis reports on both private and public companies, which reveal the names of executives and board members. One may obtain Securities & Exchange Commission records on public corporations, as well as information on executive salaries and the major stockholders, online from Lexis-Nexis (*www.lexis-nexis.com*) through subscription; often, universities and business schools are subscribers and make the service available to students and other users for free or at a reduced rate.

Once a list of potential donors is assembled, one must collect information about them: their addresses; telephone numbers; financial worth; educational backgrounds; military service; religious and political affiliations; business affiliations (name, address, and telephone number of the company, what the company produces, the individual's title within the company); other business affiliations (board members of a corporation, perhaps); membership in clubs and organizations, awards received, publications, previous gifts made (and to whom); and personal data on spouse, children, interests, and hobbies. Those seeking financial support should discover if an individual donor works for a company that has either or both a matching contributions program or a corporate foundation from which, through the influence of that individual, a grant may be made.

"Individual giving happens between individuals," said Ann Butterfield, a fundraising consultant in Harvard, Massachusetts. "It happens when people meet face-to-face and after a personal relationship has been established." The wrong approach, she noted, was just calling up or sending a letter to someone you don't know, asking for a contribution. A better method, she suggested, is asking a mutual friend to set up a lunch date in which the potential donor's interests in the arts are noted and the artist's projects (past, current, and future) may be discussed.

In general, asking for money ought not to come up at the first meeting a potential donor. The courtship should be slow, first discussing the mutual connection that put artist and possible benefactor in touch, then describing the artist's past and current work and inviting the individual to visit in order to see what's going on. The individual could be invited to events—openings, performances, receptions, lectures, or

demonstrations—to view the work in progress and to volunteer their services. "Involvement begets investment," Kihlstedt said, "so you want to figure out ways to involve potential donors." It may take as many as five or ten visits in order to build the relationship to the point that one may request a contribution. To a degree, this courtship is a game that both are playing, but experienced donors expect their counsel and interest to be solicited and not just their money.

There are various approaches to fundraising, the most common being either direct mail and telephone solicitations, which tend to elicit smaller donations (in the $10 to $50 range) or personally cultivating a small group of larger contributors. Mailers and phone calls are certainly more labor-intensive activities, with lower potential returns, and one will have to do all the same work the next year or next time a project needs financial support. The benefit of cultivating larger donors is that one may actually come to understand what they individually want from their gifts and be able to personally give it to them.

According to Kihlstedt, the hard part may seem to be actually asking for money, but it is only hard "if you haven't figured out why they'd like to give. If you have figured that out, the only question is negotiating the terms of the gift." The terms, or the most appropriate means of making the gift, may be an immediate payment of cash, donations on a schedule (for instance, regular contributions of $1,000 per month), a gift of stock (usable as dividend income or in a sale), a gift in the form of a trust, or a bequest. Fundraising is not an exact science but its own type of art, and those looking for contributions will have to feel their way through the relationship they are cultivating with potential donors. Individual artists need to express themselves clearly in stating their ideas—outlining what they hope to do—and sense whether or not the person listening to them shows any excitement: If not, the likelihood of a donation is small; if so, an artist may invite the individual to be part of the next step in the process of designing or creating the project. The other hard part may be how artists feel about asking people for money, viewing themselves as supplicants or hucksters. North noted that artists should not "look at it as fundraising but as developing a cadre of people who like and support your work. You are actually sharing your creativity with people."

Governmental agencies, corporations, and foundations all want to have their contributions noted in some visible way, such as a mention on a brochure, banner, or press release, but individual contributors frequently need to be appreciated in a more personal manner. Larger institutions sometimes name a building or hall after a contributor, but even on a smaller level, donors should receive a personal letter of thanks with invitations to current and future openings or even a potluck dinner. "A thank-you letter is crucial," North said. "You can't say thank you enough." He added that one might send large donors a "gifty of some kind, not a regular work necessarily, but something smaller or something humorous. That kind of token will mean a great deal." In general, one should maintain the level of involvement that was developed prior to asking for money. An appreciation for a past gift is the first step towards the next gift.

MISCELLANEOUS FUNDERS

A variety of groups and organizations make awards and scholarships or offer prizes, usually for very specific areas of endeavor and to particular individuals. A sports club, for instance, may provide a scholarship for a promising athlete or sponsor the athlete in competitive events, such as a track meet or Olympic tryout. It is not outside of reason, however, to believe that the club might pay for a sports-related mural or sculpture or even pay a dancer to teach members of a football team about movement. Artists need to be as imaginative in their search for financial sponsorship as in their artwork. Among the groups that might be considered are:

- Business groups, such as Elks, Lions, or Rotary clubs, frequently make awards, and Rotary International regularly sends students and young professionals to foreign countries for study.
- Fraternal organizations, such as the Knights of Columbus, provide scholarships.
- Labor unions, guilds, and leagues offer medical and emergency funds for members, and some also pay for training.
- Sports groups make awards, provide scholarships, and sponsor athletes.
- Veterans, hereditary, and patriotic organizations offer loans, grants, prizes, and scholarships.
- Greek-letter societies provide scholarships and occasional fellowships.
- Trade, business, and commercial associations usually offer medals and plaques, but sometimes make research grants.
- Scientific and technical organizations offer fellowships, internships, and residencies.
- Hobby groups may make awards and provide research grants.

Some of these more miscellaneous organizations prove to be highly generous supporters of the arts, even when that is not their primary objective. The American Legion, for instance, has a National Committee on Education that helps veterans returning to school (including art school) cover tuition costs. The Elks Club has the Elks National Foundation, which offers scholarships to its "Most Valuable Students," while the Knights of Columbus provides scholarships for students working toward Bachelor's degrees at Catholic colleges and universities, the Lion's Club makes scholarship awards on the local level, the Masonic Lodge's Knights Templar Educational Foundation provides financial assistance to students completing their final two years of college, and Rotary International's Rotary Foundation Ambassadorial Scholarships Program sends students on foreign exchanges.

Many other organizations target the interests of particular minority groups—and we all in the United States belong to some smaller group—based on race, religion, or national origin. For example, the United Negro College Fund in Fairfax, Virginia, offers a $5,000 Catherine W. Pierce Scholarship to black (non-Hispanic) students currently or

soon-to-be enrolled in a UNCF college or university and majoring in fine art. Similarly, the Rocky Mountain Women's Institute in Denver provides a $1,000 stipend and studio space to professional women writers, photographers, and fine artists in Denver, and Six Points Fellowship of the National Foundation for Jewish Culture in New York City sponsors artists whose work has a Jewish focus with a two-year, $25,000 fellowship in addition to a $20,000 project grant. Many other group-specific charitable organizations that do not have programs focusing on the arts may also provide money to artists for various art-related purposes. The Jackie Robinson Foundation in New York City, for example, which was set up in 1973, currently provides scholarships of $7,200 for "underserved high school students" to attend the college of their choice. The Jeannette Ranking Foundation in Athens, Georgia, which since 1978 has helped hundreds of low-income women attend college, and the American Indian College Fund of the American Indian Graduate Center in Albuquerque, New Mexico, which has assisted Native Americans pay for college since 1989, have no prejudice against art schools, as long as the institutions are accredited.

Among the other organizations that provide scholarships or fellowships to art students and professional artists of a particular group are: the Romare Bearden Foundation in New York City (scholarships for African-American art students); Delta Sigma Theta in Washington, D.C. (Myra Davis Hemmings Scholarship for sorority members interested in careers in the creative arts); TELACU Education Foundation in Los Angeles (scholarships for Los Angeles Latino high school seniors planning to major in art in college); Orange County Community Foundation (Hispanic Education Endowment Fund for Latinos interested in studying the arts in college); Japanese American Citizens League in San Francisco (Henry and Chiyo Kuwahara Creative Arts Award to help Japanese-American students pursue the study of art as undergraduate or graduate students); American Indian Student Services in Milwaukee (George Amour Scholarship and Circle of Art Scholarship for Wisconsin residents planning to study art in college; American Indian Arts Council of Dallas (scholarship program for under-graduate and graduate students preparing for a career in the arts); the Leeway Foundation in Philadelphia (Edna Andrade Grants for Emerging Women Artists); the Kentucky Foundation for Women in Louisville (Art Meets Activism Program); The Paul & Daisy Soros Fellowships for New Americans in New York City (scholarships for resident aliens holding a Green Card, naturalized U.S. citizens or the children of parents who are both naturalized citizens); and the College Art Association in New York City (Geraldine R. Dodge Foundation Fellowship for artists who have been underrepresented in the field because of their race, religion, gender, age, national origin, sexual orientation, or disability).

ASKING FOR MONEY

The search for project grants and fellowships is a two-part process: on the one hand, there is a hunt for appropriate and likely funding sources, and the process of winnowing down that field is long and difficult; on the other side is the process of developing an idea

for a proposal and tailoring it to a particular funding source (in terms of the objective, budget, how and when money is spent, statement of need, and the type of endorsements included). Obviously, there is more to requesting funding than remembering to say, "please." There is an elaborate process of both locating financial sponsors and making an application for that money.

The nature of the application often differs from one granting agency to the next. Corporations rarely have formal applications, while governmental agencies always do; the largest foundations often have application forms, and the smaller ones sometimes do. Contacting the funding source in advance allows one to gather information about which types of projects are most likely to receive an award—enabling grant-seekers to tailor their proposals—and how the organization wants to be approached. Many state arts agencies permit grant-seekers to download application forms from their Web sites.

In all cases, it is valuable to establish a personal relationship with the specific individual making the funding decisions by means of a telephone call or a letter requesting an appointment. This type of letter is straightforward, describing an idea in general terms (not so specific that it cannot be modified according to the interests of the funding source) that would interest the individual receiving the letter.

SAMPLE LETTER

Melissa Painter
1827 Dempster Avenue
Evanston, IL 60207
(847) 741-1445

[date]

Name [executive director, for example]
Title
[organization, agency, company, society]
Address

Dear _____,

I am interested in meeting with you to discuss an important project that deals with _____.

In researching this field, I have observed serious, active interest on the part of [name of the funding source] in projects of this type.

As I continue to develop this idea, your input would be most valuable in advance of making a formal proposal. A few minutes of your time would enable me to meet your needs more closely.

I will call you to request a brief meeting at your convenience.

Sincerely,
Name

When application guidelines state "no telephone calls" or "no appointments," one may attempt to make contact with other staff or board members of the granting agency through networking and advocates. In looking for funding, artists cannot think of themselves as alone and unknown: they need to draw upon all of their (and their spouses' and friends' and relatives') relevant contacts. A board member or officer of the umbrella organization sponsoring one's project, for instance, might know someone (or know someone who knows someone), write a letter on one's behalf, or set up a telephone appointment or actual meeting. A member of an association to which one belongs, a religious leader, or even a member of Congress might also be approached to lend support for a proposal by letter or arranging a meeting with someone at the funding source.

If a meeting is arranged, dress according to one's information about the funding source (some are more formal and straitlaced that others) and bring one or more visual images that offer a reasonable sense of what the completed project might look like, as well as background information (curriculum vitae, news clippings of one's past work, and lists of previous awards and grants received) and a rough budget. As they may not be used to being questioned about their work, artists might rehearse or role-play their presentation and answers to general questions with friends, a spouse, or family members until they feel comfortable. It is useful to have questions to ask, among which might be: How do you review the proposal and who actually does it (outside experts, staff, board members)? Are your funding deadlines the same as last year? Would you look over my proposal if I finished it early? Is the budget estimate realistic? Is the amount I am looking to request realistic? May I see a proposal you have funded that you feel is well written? Can you suggest other funders who would be appropriate for this project?

The value of a personal connection cannot be overemphasized. By speaking with you over the telephone, or better, in person, the individual involved in grant-giving makes an investment in time and interest, which they will not want to view as wasted. That same individual will also take very seriously endorsements by staff, board members, and other noted figures—in short, grant-seekers want to make themselves hard to turn down.

Eventually, a request for funds will need to be put on paper and submitted by a certain date. In certain instances, a one-page letter may suffice. However, even in the most informal of proposals, four main points need to be made:

1. Clearly define the nature of the art project and its importance as well as indicate that it is doable. Documentary material, such as a drawing of the project or a maquette, helps reveal what the artwork will actually look like.
2. Note the experience and qualifications of the person, team, or organization planning to accomplish the project. Reviews or other notices of the artist's past work of this type are useful.
3. Note that other factors (such as facilities in which to site the art project; the support of colleagues, an institution, or town body; the availability of materials; and other sources of financial support), which ensure the project will be successfully realized, are in place.

4. The project should be of the sort that the foundation or arts agency to which one is applying has shown a decided preference. That final point needs to be discovered through research in the various publications. Potential sponsors who have clearly indicated an interest in projects that assist the educational process in public schools, for instance, may be more interested in an arts-in-the-schools idea than a community poetry reading.

One should also keep in mind that funding agencies receive a great many proposals, some of which are likely to be similar. An artist's project needs to stand out from the competition, which requires the proposal to stress the unique qualities of both the project and the artist. Perhaps on a worksheet, the artist should note what makes the project unique (such as experience and training of the artist, new design, or that a very large population will be served), and those distinct advantages should have a prominent place in the description and discussion of the project in the application.

THE PROPOSAL PACKAGE

When submitting an application or project proposal, remember that the "visuals" are the main focus of concern, so the presentation of the artwork must be excellent. Objects should be well photographed (proper lighting, unobtrusive background, no distorting angles) and the slides good (correct colors, no scratches). There should be more than a slide of just one exquisite object for panelists to view, and the works chosen should be varied, in order to show one's range and not bore the panelists, but stylistically coherent—that is, not such a wide range of styles and materials that panelists are unsure what kind of work the applicant actually prefers to create.

A more formal proposal would include the following.

COVER LETTER. This letter generally begins, "Please find enclosed," then lists the package contents. It should be addressed to a specific person rather than "Dear Sir" or "To Whom it May Concern" (find out that name through a telephone call, an annual report or other printed material, or application guidelines).

TITLE PAGE. The title page makes the proposal look organized, neat, and professional. Used only for proposals over three pages, it should include the basic information—applicant's full name, address, and telephone number; name of the sponsoring organization; name of the funding organization; amount requested; purpose of the grant (short, descriptive title); and timeframe of project.

ABSTRACT. At 250 words or less, the abstract is the summation of the project and will help the individual reviewing the proposal develop a quick understanding. (Without an abstract, the funding staff member often will create one anyway for the benefit of others examining the proposal, and that write-up may contain misconceptions or factual errors.)

INTRODUCTION. The introduction serves two purposes: First, it describes the artist's own credentials (background, previously funded projects), how the artist is uniquely qualified to carry the project through to completion and success, and the relationship to the sponsoring organization; second, it notes how this project fits into the grant-making goals of the funder.

STATEMENT OF NEED. This indicates why the idea needs to be realized and funded. Kept short and factual, the statement identifies a problem for which the idea is a solution (for instance, the park would be used by more people if there were a sculpture at the center). There are many ways to prepare a "needs assessment" for potential funders: solicit testimony from important members of the community, such as elected officials, community and religious leaders, agency heads, or school administrators; organize a community forum to elicit opinions and responses, notes from which can be submitted with the proposal; create a "case study" involving a select group of individuals from the target community to show the problem they face and their need for the project in question; marshal available statistics, or develop one's own study, to present a "statistical analysis" in order to demonstrate the need; and survey the population to gather information on needs. There are benefits and drawbacks to each method, and some are considerably more time-consuming than others, but they all show a reasonable effort on the part of the applicant to make case that the project is needed.

OBJECTIVES. This describes precisely what the artist expects to accomplish ("The senior-citizen art class will improve technical skills in painting and instill an appreciation of contemporary art").

PROCEDURES. If the introduction answers the question of "who," the statement of need "why," and the objectives "what," the section on procedures looks at "how." Usually the longest component of a proposal package, the procedures area describes how the objectives will be accomplished, establishing a chain of events that follow a logical sequence. It includes design (the approach to be used and why), who (if anyone) else will be participating in the creation of the project, how long the project will take (start and end dates), and how the finances will be handled.

BUDGET. The budget is a picture of what the project looks like in dollars and cents. The total cost of the project, and the amount requested of the funder, should be based on actual expenses rather than dreamy wishes. The general range of expenses are salaries (for the artist and any assistants); insurance (liability or workmen's compensation, for instance); consultants and contract services (such as movers or landscapers); space (including studio rental); equipment (to be rented or purchased); food, travel, and accommodations; telephone and miscellaneous (postage, printing, fees and licenses, dues, etc.).

FUTURE FUNDING. As projects don't always begin and end neatly within funding cycles, the overall budget may include expenses that will need to be paid for by subsequent grants. Funding sources are not opposed to renewing a grant, and once they have invested money into it, they are likely to want to see the project completed and successful. LEF Foundation, for example, which provides funding for public art projects, notes in its application guidelines that past grantees may reapply "for two additional years, provided all final reports have been filled. After a third year of funding, the Foundation requests that grantees allow a two-year hiatus prior to reapplication."

APPENDIX. The appendix to a proposal is frequently several times larger than the proposal itself. A grab bag that adds heft to a proposal, it may include an artist's complete résumé, endorsement letters from knowledgeable people in and out of the arts, newspaper or magazine clippings of articles about the artist's work, a list of past support from other funders, a list of awards and prizes won, permits or certificates from local or state agencies, information about the artist or his or her project by the organization sponsoring the project, statistical charts or graphs, and photographs of the artist's work.

A proposal package is the ideal method of presenting one's ideas and projects, as artists lay out all the information in a manner that affords them maximum control. Often, however, one is given a standardized application to fill out, answering the funder's questions in very small spaces. Applicants may still try to be more expansive, writing in those small spaces, "See Document A," and attaching a separate sheet; few funders will reject a proposal because the grant-seeker needed more space. However, one still must answer the funder's questions, rather than reformulating the questions more to one's liking. The same information contained in a proposal package (introduction, abstract, statement of need, objectives, procedures, and budget) should be included somewhere.

REPORTING REQUIREMENTS FOR GRANT RECIPIENTS

Just as in most stories, the fundraising process has a beginning, a middle, and an end: the first part is the request (usually filling out an application) to some private or public agency for money; the middle sequence is actually performing the work or service for which the funding was requested; and the final part usually is letting the agency know what was done with its money.

The last area is probably the least structured and consistent in the fundraising process, as the requirements for a final summation differ from one agency to the next. Some allow artists to tell in narrative (perhaps even handwritten) form what went on during their project or fellowship period, while others send out questionnaires of between one and four pages that must be filled out. Some agencies require fellowship recipients to detail how the money was spent, while others show little interest in the subject. Other funders hold back a certain percentage of the award until the final report is in, while others put no strings on the disbursement of funds.

It is not possible to generalize about the reporting requirements for any particular class of funders—for instance, that public arts agencies call for more documentation than private philanthropies, or that smaller or local agencies require less paperwork than their larger or federal counterparts—and they must all be viewed individually.

The Adolph and Esther Gottlieb Foundation and Artists Fellowships, Inc., both of which are private nonprofit organizations that provide emergency assistance to artists in financial need, have very different ideas about reporting. The Gottlieb Foundation demands that recipients describe by letter how money was used within six months of

receiving their grants. The letter accompanying the Foundation's check states, "You should be advised that the Foundation may request copies of receipts, which document your expenditures." Artists Fellowships, Inc., on the other hand, requires no reporting whatsoever, believing that the essential documentation took place as part of the application process.

At times, a private or public funding agency's application guidelines indicate how and under what terms money will be released to an individual artist or organization. Even when that information is provided, many applicants will overlook it, as they are concentrating so intently on describing their projects and monetary needs in a way that is most likely to appeal to the granting agency. As a result, agency reporting requirements may come as a surprise, pleasant or otherwise. Artists and organizations may not decide to forgo applying to a particular funding agency because of its reporting or other requirements, but they would want to know what they are getting into.

Among the issues that artists should be aware of early in the process are:

INTERIM REPORTS. Not only do agencies ask for final reports, but some ask for progress or interim reports during the period of the project or fellowship. Bush Artist Fellowships, which offers fellowships of $36,000 to artists in seven counties of Minnesota and the Dakotas, requires quarterly reports of approximately one hundred words that describe the recipient's activities during the preceding three-month period. The money is paid over a twelve- or eighteen-month period, and some foundations "can withhold payments if quarterly reports aren't submitted," said Kathy Polley, a grants officer. The Philadelphia, Pennsylvania–based Pew Fellowships in the Arts, on the other hand, which provides grants of $50,000 for fellowship periods lasting up to two years, asks for brief reports or "updates" every six months, and most of these are the length of a paragraph.

The National Endowment for the Arts requires fellowship and project grant recipients to submit a progress report after they have received two-thirds of their allocation in order to receive the remainder of the money. In a very different approach, the Elizabeth Foundation for the Arts in New York City contacts grants-in-aid recipients three times during the grant period by telephone—in March, July, and October—in order to discuss their work. "We don't just forget them but try to see what else they need, what else we can do for them," said Jane Stevenson, director of the Elizabeth Foundation. She added that recipients are also asked to complete a two-page questionnaire at the end of their grant year, detailing how the money was spent and the effect that the funding had on their work.

GRANT DISBURSEMENT. Every agency has its own ideas about how money should be paid out. Pew Fellowships provides a monthly stipend (the same amount each month during the fellowship period), while the Kentucky Arts Council and the Massachusetts Cultural Council award the entirety of their fellowships and project grants up-front. Bush Artist Fellowships spread out payments evenly over the fellowship period, although it will make an initial pay-out of up to $10,000 when asked. Such a request may be the result of the costs of purchasing materials or equipment, without which the project could not be accomplished smoothly.

The Ohio Arts Council pays half of the fellowship amount in one calendar year and the remainder in the next calendar year in order to not burden artists with a large tax liability in one given year, while The Elizabeth Foundation allows artists to receive half of their grant in July and the rest in January or to take the entire amount all at once. The Guggenheim Foundation and the National Endowment for the Arts have the most artist-friendly approach, distributing fellowship awards in whatever manner the artists want them.

PUBLIC SERVICE REQUIREMENTS. Fellowships essentially mean monetary awards with no strings attached. Artists can use the money to create a new work or simply to pay their rent and buy groceries. It is unclear why an agency would require a final report for a fellowship recipient when it makes no demands on how its money is used, and some artists may feel obliged to claim that the award helped to complete a new work when it was actually part of a down payment for a house.

At times, a fellowship comes with a specific public service requirement, such as a demonstration, lecture, visit to a school, or something else. Both the New York Foundation for the Arts and the Seattle Artists Trust pay artists 90 percent of the total amount of the fellowship, holding back the final 10 percent until a community service function has been performed. The New York Foundation for the Arts allows an artist up to eighteen months following the completion of the fellowship to fulfill the public service requirement, and "we suggest to the artists specific organizations or people who could help them in setting up a public service opportunity," said Jennifer Feil, assistant director of artists programs at the agency. "We write to the artists, we may call them once or twice, to remind them that they will forfeit the final 10 percent if they don't perform their public service."

FINAL REPORTS. Whereas an application for a grant or fellowship is often read by a number of people (a program director, peer review panel, agency director, board of directors), it is never quite clear who reads an interim or final report and what is done with that information. It may be just one person at the agency checking to see that a certain amount of information has been included. The funders who send out questionnaires usually have something specific they want to know, such as the attendance at a certain event, the demographic breakdown of an audience, how their money was spent, or what artistic achievements their grants helped to create. This information may be used solely for statistical purposes or to show an agency's accomplishments to legislators or the public.

At other times, final reports are examined by one or more agency personnel in order to determine the effectiveness of a program and whether or not changes should be made. "I read the final reports," said Julyen Norman, program officer for creative arts and technology at the Mid-Atlantic Arts Foundation in Baltimore, Maryland. "They don't just get filed." Norman, who oversees the agency's artist-in-residence program, noted that both artists and their sponsoring organizations are asked to fill out separate forms and, in effect, evaluate each other. "We ask the artists, Were they paid on time? Were they treated well by the organization? Would they do it again? This is

really the only way we have of knowing how organizations treat artists. If we receive criticism of an organization, we may not penalize it by taking away a contract, but we will try to work with it to solve some of the problems the next time we provide funding for a residency."

Information gleaned from these forms in the past has led him and other staff members of the agency to make more site visits during a residency and to offer additional technical assistance (non-financial help) to the sponsoring organization.

For the questionnaire to the organization, the Mid-Atlantic Arts Foundation wants to learn about the artist's temperament and ability to work with people (in the event that the same artist is eligible for another residency elsewhere) and to "measure the activity generated by the residency," Norman noted. "We want to know how many people attended events and what kinds of people." Also asked is what kinds of matching grants were raised for the residency by the sponsoring organization.

The two-page final report form of Bush Artist Fellowships is, in many ways, typical of most agencies' questionnaires. On the first page are three prompts—to describe the activity for which the artist needed funding, to describe what the artist had hoped to achieve during the fellowship year, and to note what actually the artist accomplished. The second page asks the artist to provide a "best estimate" of how the fellowship money was spent, listing seven categories (materials and production costs, transportation costs, food and lodging, insurance costs, utilities, taxes, and miscellaneous).

Prodding artists and organizations to complete their questionnaires is a major activity at most arts agencies. "We send out a reminder a couple of months before the final report is due, and then we generally have to call the artists once or twice to remind them again," said Jeff Swain, grants director at the Arts Council of Winston-Salem/Forsyth County in North Carolina, which runs an individual fellowship program. The Arrowhead Regional Arts Council in Minnesota, which also offers fellowships, sends its one-page final report questionnaire along with the check ($1,200), and "artists frequently say that they have forgotten about it or just lost it by the time the year is over," said Robert DeArmond, executive director of the Council. "Considering the fact that the amount of money is so small, we try to make the questionnaire as simple as possible to answer, and we don't get too angry if the artists just don't bother."

Julyen Norman also stated that he has to "keep chasing his artists to get them to fill out their forms. However, once the money has been spent, there is no money in it for them to do the final report." As a result, the Mid-Atlantic Arts Foundation decided to withhold the last $500 (10 percent of the grant) until the final report has been submitted in order to provide artists and organizations with an incentive to complete this part of the job. The National Endowment for the Arts has taken an even stricter line with regard to final reports, declaring those artists and organizations who fail to submit the completed four-page questionnaire on time ineligible to receive funding from the federal agency for five years.

Some individual artists may worry about incurring disapproval from an agency over what they actually accomplished during a grant or fellowship period and do not submit a final report. Robert Bush, a consultant to nonprofit organizations, noted that, in fact, "agencies tend to bend over backwards to make things easier for artists. They know artists need help filling out a final report, and they generally provide support in many ways."

There is a hierarchy of difficulty in final reports. Fellowships tend to require the least paperwork and take the most relaxed attitude about what the report says, while project grant recipients (typically organizations) have to provide more documentation about what was done and how well as well as provide an accounting of expenditures. In some instances, organizations receive a certain percentage of the project grant award (say, 75 percent) up-front and the rest at the conclusion of the project after the report and budget have been submitted; at other times, payment is only available on a reimbursement basis—submitting specific receipts to the agency for which a check will be issued. The most onerous reports are those by recipients of operating support grants, who must usually provide the agency with quarterly financial statements and pay for an audit.

KEEPING PERSPECTIVE

The first and last thing artists need to keep in mind about applying for a grant is that they may not get it. Rejection leads some artists to bitterness and dejection, an I-won't-get-burned-twice attitude that cuts off future options and attempts. The failure of a grant application to be approved may be taken personally as a negative judgment about the artist and his or her work or talent. Meanings are read into form letters and into the psyches of those who approve or disapprove applications—many of whom serve as jurors on selection panels for only one grant cycle—are examined to discern prejudices and favoritism. Hell hath no fury like an artist scorned.

It is wiser to realize that all funding sources these days are besieged by applicants—that's the reason for the form rejection letters—and that grantmakers need to look for reasons not to allocate money. Applicants who don't fill out the grant form completely or neatly, who are not residents of the right area (for instance, a German applying for a National Endowment for the Arts fellowship or a Maine resident seeking project funding from the Oregon Arts Commission), who are not professional artists but art students, who are applying for money from the wrong organization (such as seeking a fellowship from the New York State Council for the Arts, which makes no individual grants), whose projects are not described succinctly or whose budget sounds inflated (or too low)—these are the easiest to dismiss and are eliminated eagerly as the decision-makers whittle down the stack.

Artists should seek information about the granting process before they apply and after the decisions are made. Public agencies especially are obligated to provide information on why a particular proposal was rejected (written notes are taken and filed), and that feedback is welcome. Problems in an application or an overstated budget or a lack of documentation or something else may have been the reason, and they can be corrected for the next round of funding or when applying to another granting agency.

* * *

There is a reason why the subject of grants and fellowships comes at the end and in the last chapter in this book. When I entered the arts service field in the mid-1970s, the most commonly asked question was how and where to apply for grants, and most of the career books for artists of that time and into the 1980s devoted the majority of their pages to this topic. Perhaps the reason was that public arts agencies were being created on the national and state levels during the 1960s and '70s, and their budgets increased every year. Career seminars for artists during this time also focused almost exclusively on the grant application process, and still today, the most common form of "technical assistance" that state arts agencies provide to artists and arts organizations is information on how to fill out their grant application forms. (In fact, state arts agency Web sites primarily exist to allow applicants to download applications: the Internet is a labor-saving tool, rather than an interactive one, for these agencies.) In this new millennium, the question of how and where to apply for a grant seems less central to the careers of most serious artists. Ongoing and increasing public financing of the arts seems less assured than it did just twenty or thirty years ago. The budgets of many public arts agencies and some private foundations have been reduced or have just not kept up with inflation, and the competition for every available dollar is ferocious. Artists who tie their career hopes to grants and awards are likely to meet with repeated frustration. Instead, artists must see themselves as entrepreneurs, learning how to earn rather than simply apply for money.

About the Author

Daniel Grant, a contributing editor of *American Artist* magazine, was an art critic for *Newsday* in Long Island, New York and *The Commercial Appeal* in Memphis, Tennessee. He has taught at Lyme Academy College of Fine Arts in Connecticut, as well as lectured on artists' career development at Yale School of Art, Amherst College, Smith College, and a variety of other colleges and universities. He is the author of several Allworth Press books, including *An Artist's Guide—Making It in New York City, Selling Art Without Galleries, How to Grow as an Artist, The Fine Artist's Career Guide, The Artist's Resource Handbook*, and *The Writer's Resource Handbook*. These books appeal to artists at all levels in their careers. "When I made the decision to come here from the Midwest in 1968, there was no guide like Daniel Grant's *An Artist's Guide—Making It in New York City*. If there had been, I might have smoothed over some of those endless bumps in the road," muralist Richard Haas said. Artist Sue Coe lauded *The Artist's Resource Handbook* as a "marvelous book [that] reveals the tools that help keep an artist less isolated," and painter Audrey Flack praised *Selling Art Without Galleries* for revealing "the inner workings of the art world." Grant's articles and essays have appeared in such publications as *The Wall Street Journal, ARTnews, Art in America, New York Times, Washington Post, Christian Science Monitor, Boston Globe, Chicago Tribune, Miami Herald, Philadelphia Inquirer, Humanities, Museum Magazine, Sculpture Magazine, The Nation, New York, Art & Auction,* and *Art & Antiques*. He lives in Amherst, Massachusetts.

Index

Books from Allworth Press

Allworth Press
is an imprint
of Allworth
Communications, Inc.
Selected titles are
listed below.

Art Without Compromise★
by Wendy Richmond (6 × 9, 256 pages, paperback, $24.95)

Artist's Guide to Public Art: How to Find and Win Commissions
by Lynn Basa (6 × 9, 256 pages, paperback, $19.95)

Selling Art Without Galleries: Toward Making a Living From Your Art
by Daniel Grant (6 × 9, 288 pages, paperback, $24.95)

How to Start and Run a Commercial Art Gallery
by Edward Winkleman (6 × 9, 256 pages, paperback, $24.95)

Learning by Heart
by Corita Kent and Jan Steward (6 ⅞ × 9, 232 pages, paperback, $24.95)

The Quotable Artist
By Peggy Hadden (7 ½ × 7 ½, 224 pages, paperback, $16.95)

Guide to Getting Arts Grants
by Ellen Liberatori (6 × 9, 272 pages, paperback, $19.95)

Legal Guide for the Visual Artist
by Tad Crawford (8 ½ × 11, 256 pages, paperback, $19.95)

The Artist–Gallery Partnership, Third Edition: A Practical Guide to Consigning Art
by Tad Crawford and Susan Mellon (6 × 9, 224 pages, paperback, $19.95)

Fine Art Publicity: The Complete Guide for Galleries and Artists, Second Edition
By Susan Abbott (6 × 9, 192 pages, paperback, $19.95)

Business and Legal Forms for Fine Artists, Third Edition
by Tad Crawford (8 ½ × 11, 176 pages, paperback, $24.95)

The Artist's Complete Health and Safety Guide, Third Edition
by Monona Rossol (6 × 9, 416 pages, paperback, $24.95)

Caring for Your Art: A Guide for Artists, Collectors, Galleries, and Art Institutions
by Jill Snyder (6 × 9, 192 pages, paperback, $19.95)

An Artist's Guide: Making It in New York City
by Daniel Grant (6 × 9, 224 pages, paperback, $24.95)

Artists Communities: A Directory of Residences that Offer Time and Space for Creativity
by Alliance of Artists Communities (6 × 9, 336 pages, paperback, $24.95)

To request a free catalog or order books by credit card, call 1-800-491-2808. To see our complete catalog on the World Wide Web, or to order online, please visit ***www.allworth.com***.